THE SECULAR FURNITURE OF

E. W. GODWIN

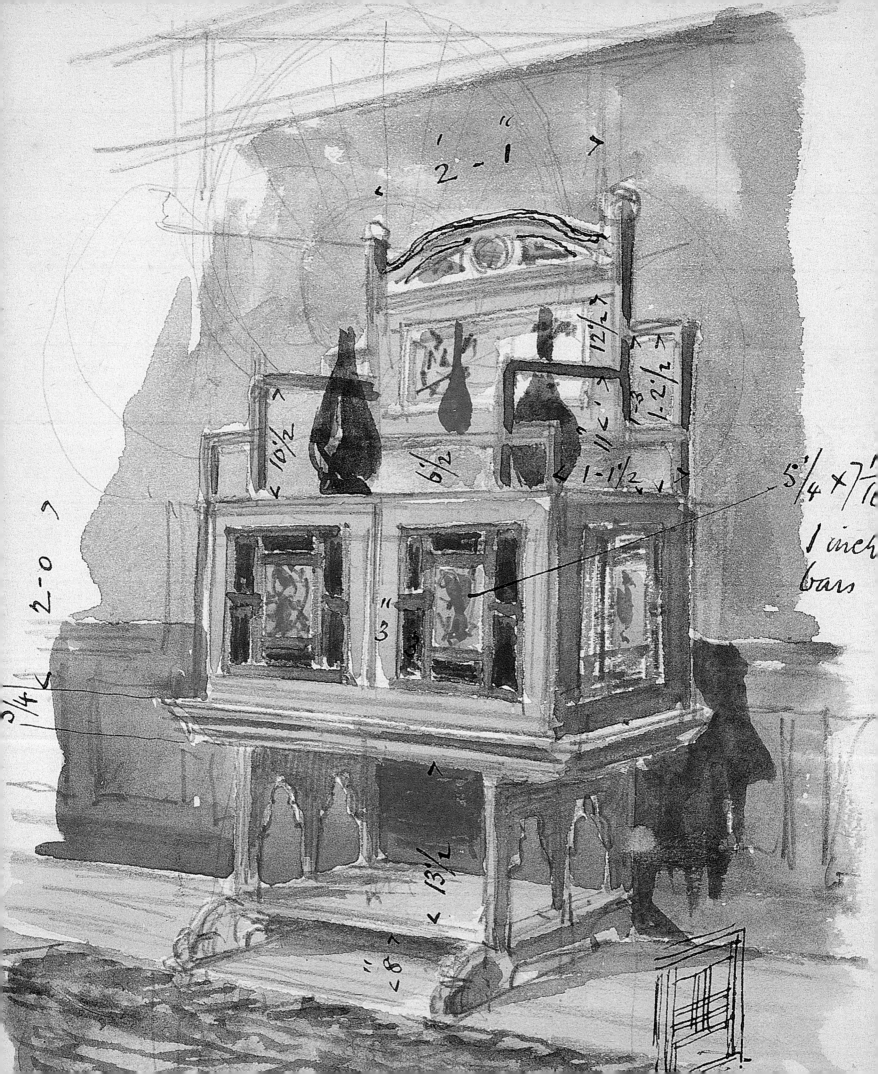

THE SECULAR FURNITURE OF
E. W. GODWIN

with Catalogue Raisonné

Susan Weber Soros

published for The Bard Graduate Center, New York,
by Yale University Press

Typeset in Monophoto Ehrhardt by Best-set Typesetter Ltd., Hong Kong
Designed by Sally Salvesen
Printed in Singapore

LIBRARY OF CONGRESS CATALOGING-IN-PUBLICATION DATA

Soros, Susan Weber.
 The secular furniture of E.W. Godwin / Susan Weber Soros.
 p. cm.
 Includes bibliographical references and index.
 ISBN 0-300-08159-6 (cloth: alk. paper)
 1. Godwin, E.W. (Edward William), 1833–1886 Catalogue raisonné
I. Godwin, E.W. (Edward William), 1833–1886. II. Title.
NA997.G6A4 1999a
749.22–dc21 99-33079
 CIP

FRONTISPIECE: Watercolour sketch for *The Beatrice Cabinet* (CR 374) Victoria & Albert Museum (V&A PD E.233–1963, fol. 103)

TITLEPAGE: Detail of a *Hanging Bookcase*, ca. 1867–85, made by William Watt Private collection (CR 305)

CONTENTS

For George

who helped me achieve my dreams

ACKNOWLEDGMENTS

This book is the result of several years spent in the company of Edward William Godwin, pursuing his writings and ideas and studying his achievements in furniture and the other decorative arts. It is an outgrowth of my doctoral dissertation written under the supervision of the late Dr. Clive Wainwright of the Victoria and Albert Museum, who helped with all aspects of this project, spending many hours discussing Victorian design with me and reading and commenting extensively on my manuscript. He sadly died in the summer of 1999, before publication. I will always be grateful for his observations and generous assistance.

This project would not have been possible without the dedication, passionate interest, and thoughtful insights of my very talented research assistant, Catherine Arbuthnott. During the past three years, she has attended to all the organizational and logistical details, guided me through the numerous archives and libraries in Great Britain, and assisted with the photography of Godwin material in Great Britain. Thanks are also due to Leon Botstein, President of Bard College, Kenneth Ames and Pat Kirkham of The Bard Graduate Center, and Laurie Schneider Adams, Professor of Art History, John Jay College, CUNY, The Graduate Center, all of whom read my work and offered advice and criticism. Peter Haiko of the Institut für Kunstgeschichte, Vienna University, provided useful information and help through the archives of Vienna.

I would also like to offer personal thanks to Fanny Baldwin, Joanna Banham, Richard Hayes, Juliet Kinchin, Lionel Lambourne, Linda Parry, Aileen Reid, and Nancy Burch Wilkinson, fellow Godwin enthusiasts who generously shared their time and knowledge.

I am also most grateful to the many dealers who have done much of the ground-breaking research on Godwin, who so willingly opened their archives to me and introduced me to many of the Godwin collectors: Martin Levy of H. Blairman and Sons, London; David Bonsall, London and Belper; Meg Caldwell, New York; William Clegg, The Country Seat, Henley-on-Thames; Jeremy Cooper, London; Peyton Skipwith and Andrew McIntosh Patrick of the Fine Art Society, London; Michael Whiteway of Haslam and Whiteway, London; Margot Johnson, New York; Scott Elliot, Kelmscott Gallery, Chicago; Paul Reeves of Paul Reeves, London and Cirencester; Tim Sullivan, New York; Reg Wingfield, Bradford-on-Avon; and the staff at the Moderne Gallery, Philadelphia. Special thanks to Annamarie Stapleton of the Fine Art Society, Helen Dunstan of Haslam and Whiteway, and Richard Bryers of Paul Reeves for endless research assistance.

All of the collectors of Godwin decorative arts gave me access to their collections. I gratefully acknowledge the kindness of Mr. and Mrs. Matthew Argenti, Saretta Barnet, Ivor Braka, Peter Brant, Charlotte Gere, Stuart Grimshaw, James Joll, Gary

Kemp, Ng Lu Pat, Mary O'Connell, Jimmy Page, Andrew McIntosh Patrick, Lynda Resnick, Peter Rose and Albert Gallichan, Sheri Sandler, Mr. and Mrs. William Taubman, Mr. and Mrs. Valsecchi, Paul Walter, and David Warren.

I also thank all of the owners of Godwin buildings and the keepers of Godwin-designed churches and town halls who allowed access and helped with this study of Godwin's work: Revd. P. W. Rowe, Almondsbury Church; Peter McKay, the Estate Office, and Sue Hoggs, Castle Ashby Conference Centre, Castle Ashby; Jamie MacGregor, Ashley House, Bristol; Mr. and Mrs. H. Pratt, Beauvale House; Canon John Ayres and John Goulstone, St. Christopher's Ditteridge; Revd. Angela Berners-Wilson, Colerne Church; David Dingle, Council Works Department, Congleton Town Hall; Revd. Stewart Rayner, George Clifford and Dorothy Freeman, Eggington Church; Revd. N. Boundry, Sheila Moorgreen Bisset, and Clare Coles, Highbury Chapel, Bristol; Mrs. N. Stewart, The Manse, Moorgreen; Mrs. Vaughan, Frank Miles House, London; Jennifer West, Mr. Bancroft, Mr. and Mrs. Spencer, Sheila Davis, Maggie Guillon, Charles Knott, Moorgreen; John Dunkley and Roger J. B. Morris, Northampton Guildhall; Mr. B. Fawcett and Mr. P. Searle, 10–11 Rockleaze, Bristol; Revd. Anthony Charles Smith, St. Botolph, Northfleet; Revd. Canon Malcolm Widdecombe and Mr. Riley, St. Philip and St. Jacob's Church, Bristol; Mrs. Kerswill, Stockland Church, Bristol; Sandra Cronin, Tower House, London; Revd. J. F. Smart, Walton Parish Church; and Revd. R. J. Thomas, Winterbourne Down Church.

I am particularly pleased to acknowledge the help of Edward Anthony Craig (who died before publication), Helen Craig, and Tom Craig. As Godwin family members they provided many interesting records, photographs, and recollections.

Many museums in Great Britain, the United States, and elsewhere generously granted access to their collections and shared their accumulated knowledge of Godwin. Bodelwyddan Castle Trust, Rhyll: Debby Davis. Brighton Museum and Art Gallery: Stella Bedoe. Bristol Museums and Art Gallery: Alan Justin and Karin Walton. The British Museum: Judy Rudoe. Camden Arts Centre: Martin Holman. Carnegie Museum of Art, Pittsburgh: Sarah Nichols. Cecil Higgins Art Gallery, Bedford: Caroline Bacon. Detroit Institute of Arts: Alan P. Darr. Dorman Museum, Middlesbrough: Genette Harbron. Centre for Whistler Studies, Glasgow: Margaret MacDonald and Nigel Thorpe. English Heritage, London: John Thornycroft. Hunterian Art Gallery, Glasgow: Martin Hopkinson. Judges' Lodgings Museum, Lancaster: Steven Sartin. Keeper of Social History, Northampton Museums: Judith Hodgkinson. Kensington Palace Staff Apartments, London: Nigel Arch and Jenny Lister. Lady Lever Art Gallery, National Museums and Galleries on Merseyside: Lucy Wood. Leighton House, London: Reena Suleiman. Lotherton Hall Gallery and Museum, Aberford: Adam White. The Metropolitan Museum of Art, New York: William Rieder (European Sculpture and Decorative Arts); Mechtild Baumeister (Sherman Fairchild Center for Objects Conservation). Minton Museum, Stoke-on-Trent: Joan Jones. Musée d'Orsay, Paris: Marc Bascou. Museum of Fine Arts, Boston: Jeffrey Munger. National Gallery of Victoria, Melbourne: Terence Lane. The National Trust, Ellen Terry Memorial Museum, Smallhythe Place, Kent: Margaret Weare. Paxton House, Scotland: Martin Purslow. Royal Institute of British Architects, British Architectural Library: Charles Hinde and the staff. Staatliche Museen zu Berlin, Kunstgewerbemuseum: Barbara Mundt. Victoria and Albert Museum, London: Frances Collard, Sarah Medlam, Wendy Monkhouse, Mattew Winterbottom, James Yorke, and Christopher Wilk (Furniture and Woodwork Department); Linda Parry and Debbie Sinfield (Department of Textiles); Cathy Haill (Theatre Archive); Susan Lambert, Michael Snodin, and Charles Newton (Prints and Drawings); Haydn Hansell (Picture Library); Eva

White (Archive of Art and Design). Virginia Museum of Fine Arts, Richmond: David Park Curry. Walker Art Gallery, National Museums and Galleries on Merseyside: Andrew Renton. Whitworth Art Gallery, Manchester: Christine Woods. Wightwick Manor, Wolverhampton: Monty Smith. The Mitchell Wolfson Jr. Collection, The Wolfsonian-Florida International University, Miami Beach: Wendy Kaplan. In addition, I offer sincere thanks to the staffs at the following institutions: Cleveland County Museums Service; Geffrye Museum, London; Hamburg Museum für Kunst und Gewerbe; Manchester City Art Gallery; The Museum of Modern Art, New York; National Gallery of Victoria, Melbourne; The National Trust, Standen, West Sussex; Powerhouse Museum, Sydney; Rhode Island School of Design, Providence; and Staatliches Museum für angewandte Kunst, Munich.

Innumerable librarians and archivists at the institutions, collections, and agencies provided valuable assistance: Antiquarian Booksellers Association; the Arts Club, London; The Avery Architectural and Fine Arts Library, Columbia University, New York; Bedford Estate Archive, Woburn Abbey; Bodleian Library, Oxford; Bristol Architecture Centre; Bristol Central Library; Bristol Record Office; the R. W. A. School of Architecture Library, Bristol University; the Royal British Architect's British Architecture Library; Manuscripts Collection, The British Museum; the British Newspaper Library, Colindale; Bury Metropolitan Archive; Compton Family Documents, Castle Ashby, Northamptonshire; Chelsea Library (Local Studies Collection); Cheshire Record Office; Church House, London; City of London Record Office; Cleveland Archive and Record Office; Companies House; Council for the Care of Churches; Country Life Photographic Library; Libraries of the Courtauld Institute of Art; Derby Church House; Derbyshire Country Archive and Record Office; Art Library Section, Edinburgh City Library; Eton College Library; Family Records Centre, Islington; Thomas Ford and Partners, Chartered Architects and Surveyors; Free Library, Philadelphia; Special Collections, Glasgow University Library; Gloucester Record Office; Harpenden Library; the Greenall Group, Newcastle on Tyne; Guildhall Library, Corporation of London; Hertfordshire Record Office; Hyde Collection, Four Oaks Farm, Somerville, New Jersey; Historic Royal Palaces Agency; Holborn Library, Camden (Local Studies Section); Hulton Getty Photo Archive, London; Irish Georgian Society; Jackson Solicitors; the Judges' Lodgings Museum, Lancaster; Keele University Library; Kilby Fox, Chartered Accountants; Labyrinth Group (B. T. Batsford); Kingston Library (Local Studies Section); Lambeth Palace Library; Lancashire Record Office; Library of Congress, Washington, D.C.; Limvaddy Library, County Londonderry (Local Studies Section); Limerick Central Library; Lincolnshire Library Services (Tennyson Research Centre); London and Continental Stations and Property Limited; London and Provincial Antique Dealers Association; London Metropolitan Archives; The McLaren Society; Melbourne Hall; Central Library, Middlesbrough Reference Library; National Health Service Estates; National Library of Ireland; National Monuments Record Centre and the Royal Commission on the Historical Monuments of England, Swindon and London; the New York Public Library; National Trust; Northampton Library (Local Studies Collection); Northamptonshire Record Offices; Nottinghamshire Country Library; Nottinghamshire Record Office; Proctor and Palmer, Architects, Clevedon, Somerset; Public Record Office, London and Kew; Redland Park United Reformed Church ("Highbury Chest"); Reece Winstone Archive, Bristol; Rockwell College, Cashel; The Royal Collection Trust (The Royal Archives); Royal Commission on Historical Manuscripts; Royal Holloway College, University of London (Department of Victorian Studies); Royal Institute of British Architects (British Architectural Library); The Royal Library; Shakespeare Birthplace Trust; Society

of Antiquaries; Society for the Protection of Ancient Buildings; South Tees Health Authority; Southwell Diocese Church House; Surrey Record Office, Kingston on Thames; the Tennyson Society; the National Trust, Ellen Terry Memorial Museum, Smallhythe Place, Kent; The Theatre Museum Archive, London; Tiles and Architectural Ceramics Society; Tower Hamlets Library and Archive, London; Victoria and Albert Museum (Archive of Art and Design; Museum Archive and Registry; National Art Library); Victoria Reference Library; Victorian Society, Northern Office; Warner and Company Archive, London; Watson Library, The Metropolitan Museum of Art, New York; Weidenfeld and Nicolson Archive; Westminster Archives Centre, London; Whicheloe MacFarlane Architects (Bristol Society of Architects Archive); and Wolverhampton Central Library (Archive Section).

Finally, I am indebted to the staffs of various auction houses for sharing information and photographs: Christie's, London and Glasgow; Louis de Courcy Auctioneers, Limerick; William B. Fitt Auctioneers, Limerick; Clevedon Sales Rooms, Clevedon, Somerset; Nestor and Conshannahan, Limerick; Phillips, London and Edinburgh; and Sotheby's, London.

The photography provided by David Allison, Harland Walshaw, and the photography department of the Victoria and Albert Museum makes a remarkable contribution to this catalogue. Additional photography was done by Danika Volkert of the Bard Graduate Center. Assistance in England was provided by Simon Cuff.

Special thanks to Heather McCormick, graduate student at the Bard Graduate Center, who proofread and checked the footnotes; Janis Mandrus, who organized the bibliography and the photography; Jean Wagner, who styled the bibliography and the notes; and my assistant, Sandra Fell, who arranged for photographic permissions and did endless retyping. Helen Baz undertook the trying task of the catalogue index with great care.

I am fortunate to have worked with John Nicoll and Sally Salvesen at Yale University Press in London on the production of this catalogue. Sally's design and editorial guidance were extraordinary. Thanks are also due to Mary Gladue, style editor, for her skillful efforts.

Finally, I would like to give deep thanks to my family, for their encouragement, understanding, and support during the writing of this book.

Susan Weber Soros

NOTE TO THE READER

This book has been written to redress the paucity of scholarship in relation to Godwin's secular furniture. It is based on my doctoral dissertation, "E. W. Godwin: Secular Furniture and Interior Design," which I completed in June 1998 at the Royal College of Art in London,[1] and has benefited from the works of earlier scholars, particularly Harbron, Aslin, Pevsner, and Cooper. It does not, however, venture to provide Godwin's biography or an overview of his architecture, theatrical career, or in fact any of his other many interests except where they have a direct connection to his furniture. (For essays on the life and work of this immensely talented man, I refer the reader to *E. W. Godwin: Aesthetic Movement Architect and Designer*, an exhibition catalogue I edited to accompany the 1999 exhibition at the Bard Graduate Center, New York.)

The first section of this study is an essay that traces the development of Godwin's secular furniture designs and style, examines their sources, and assesses their historical importance. (Other aspects of Godwin's career, including his church commissions, are discussed only where pertinent.) Godwin's ideas on design, about which he regularly wrote in the press, have been used insofar as they shed light on particular projects rather than to produce a history of design theory. Unfortunately, the information I have compiled does not include any of the business records or ledgers of the firms for whom Godwin worked; these accounts, to the best of my knowledge, no longer exist. Their discovery could, of course, clarify a good many issues.

The main section of this book takes the form of a catalogue raisonné. It documents and reproduces all the known examples of Godwin's secular furniture and related furniture designs in private and public collections throughout the world. The manufacturer, probable dates, materials, measurements, provenance, and auction and publication citations are provided, if known, along with a detailed analysis. The catalogue has been divided into four primary sections – chairs (100s), tables (200s), cabinets (300s), and miscellaneous pieces (400s) – plus a section for pieces made "in the style of" Godwin (500s) but whose attributions to him are weak at best. The numbering system for the catalogue was chosen to accommodate new entries in possible future editions, for it is my hope that examples of Godwin's secular furniture will continue to surface.

The entries in each of the five sections of the catalogue raisonné are arranged chronologically. Dating the pieces and designs is problematic since many of them were in production for a period of at least eight years. When a model has many versions, the first entry is assigned a number and subsequent entries have a lower-case letter attached. The decision on which version to list first has been based on the availability of color photography and is thus totally arbitrary. Those pieces that are part of a set or belong to a pair have a roman numeral attached to the entry number.

Corresponding materials are attached to an entry with the figure number first and then a decimal point followed by a number. The footnotes and the literary and exhibition citations are in shortened form and can be found in their complete form in the selected bibliography at the end of the book. Measurements are given in inches followed by centimeters. Height precedes width and depth. In a number of cases it has not been possible to remeasure pieces and I have had to rely on the sizes given in other sources. Those pieces that do not have a related sketch or drawing, inclusion in the Watt *Art Furniture* catalogue, a William Watt label, or Collinson and Lock stamp – among other firms that Godwin is known to have worked for – can only be attributed to Godwin. Since not all of the pieces manufactured by these two firms had either a label or a stamp, I have had to rely on comparative evidence to accord a Godwin signature to some pieces. A very small number of perhaps doubtful pieces make their appearance here nevertheless. It is my hope that as time passes more and more pieces will be identified and a greater amount of his work will be able to be analyzed.

The selected bibliography includes articles written and/or illustrated by Godwin himself as well as secondary sources that pertain to his work. A full bibliography of primary and secondary sources, including the hundreds of articles he wrote and/or illustrated, can be found in the above mentioned exhibition catalogue, *E. W. Godwin: Aesthetic Movement Architect and Designer.*

LIST OF ABBREVIATIONS

CR	Catalogue Raisonné (denotes catalogue number)
RIBA	Royal Institute of British Architects, London
RIBA MC	Royal Institute of British Architects, British Architectural Library, London. Manuscript Collection
RIBA DC	Royal Institute of British Architects, British Architectural Library, London. Drawings Collection
V&A	Victoria and Albert Museum, London
V&A AAD	Victoria and Albert Museum, London. Archive of Art and Design
V&A PD	Victoria and Albert Museum, London. Department of Prints, Drawings, and Paintings

1. Photograph of E. W. Godwin with
sketchbook in hand, ca. 1880.

PREFACE

Edward William Godwin (1833–1886) was a British architect, designer, interior decorator, antiquary, and theatrical producer as well as a prominent reformer, writer, and critic (Fig. 1). Described by Max Beerbohm as "the greatest aesthete of them all,"[1] Godwin was one of the most original and innovative figures in the nineteenth century, and has recently, with his streamlined and functional designs, been recognized as a forerunner of the Modern movement.

Godwin was one of a handful of people who embodied the aesthetic conscience of Britain between 1865 and 1885, and one of the few designers committed to addressing design issues related to the growing mass market for furniture, furnishings, and interior design – areas in which he achieved notable success. He exhibited furniture at some of the great international exhibitions of the second half of the nineteenth century: Vienna in 1873, Philadelphia in 1876, and Paris in 1878. His reputation abroad led to commissions ranging from James Goodwin in Hartford, Connecticut, to Prince Esterhazy in Vienna, but his main work was carried out in Britain, where his clients represented a wide spectrum of society, from art collector and physician Dr. George Bird to the third Earl of Limerick, and from fellow architect Richard Norman Shaw to Middlesbrough industrialist William Randolph Innes Hopkins. Notably, however, Godwin was also the designer of choice for some of the leading creative artists of his generation, including James McNeill Whistler and Oscar Wilde, although in the main his clients came from the middle classes in the major cities, especially London.

Godwin was engaged as a designer for many of London's leading art manufacturers, including, among others, Collinson and Lock, William Watt, and Gillow and Company. Although he is best known for his Anglo-Japanese furniture designs, Godwin was also inspired by a great many other design sources – ancient, Gothic, Jacobean, vernacular, and Queen Anne. The ebonized Anglo-Japanese sideboard he designed in 1867 is considered an icon of nineteenth-century furniture (CR 304), and the spindle-legged coffee table he designed for William Watt was one of the most frequently plagiarized forms of the 1870s and 1880s (CR 207). Godwin's furniture was made available to the general public through the publication of the catalogue *Art Furniture, from Designs by E. W. Godwin, F.S.A., and Others, with Hints and Suggestions on Domestic Furniture and Decorations*, published in 1877 and again in 1878 (Fig. 2). Plates from this catalogue are reproduced as Appendix A herein.

The enormous scope of Godwin's talent carried over into his schemes for interiors in which wallpapers (Fig. 3), textiles (Fig. 4), stained glass, carpets, floor cloths, lighting fixtures, and even ceramics were designed by his guiding hand. His textiles, wallpapers, and floor coverings reflected his keen interest in the decorative arts of

2. E. W. Godwin. Frontispiece to *Art Furniture*, 1877.

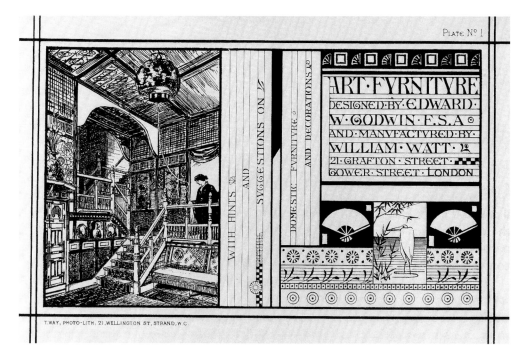

Japan as well as other cultures. With their bold flat patterns, asymmetrical compositions, and stylized ornamentation, these decorative elements revolutionized home furnishings. Jeffrey and Company, Lightbown Aspinall and Company, James Toleman and Sons, and the Papyrotile Company all manufactured some of Godwin's wallpaper designs; he designed fabrics for Warner and Ramm, and Cowlishaw, Nicol and Company, and carpets and floor cloths for Waugh and Sons. Godwin even tried his hand at designing ceramics, for W. Brownfield and Sons, Cobridge, Staffordshire, and tiles for both Minton and Hollins, Stoke-on-Trent, and Wilcock and Company, Burmantofts Furnace Works in Leeds. Godwin's metalwork designs included fireplace accessories, light fixtures, and hardware.

Godwin was attentive to the precise placement of each of these elements as well, and departed from the canons of contemporary interior design practice by devising innovative ways to hang curtains, decorate walls, and arrange furniture. Prominent in the reform movement in British design, Godwin pioneered the use of plain walls in distemper, bare wood floors covered with Oriental carpets or Indian matting, lightweight ebonized furniture, simple window treatments, and Japanese and Chinese accessories in spacious settings. His elegant decorating schemes played a leading role in shaping aesthetic taste in Great Britain, America, and Australia in the 1870s and 1880s. His versatility, however, was tempered by his overriding concern that objects and interiors form a coherent visual whole.

Godwin wrote frequently and forcefully on contemporary design issues, producing more than 450 articles for the leading architectural publications of his day, among them *Building News*, *British Architect*, and *Architect*. He also contributed to a variety of periodicals such as *Archaeological Journal*, and over the years even wrote and illustrated a number of books – *Handbook of Floral Decoration for Churches* (1865); *Artistic Conservatories, and Other Horticultural Buildings . . . from Rough Sketches by E. W. Godwin, F.S.A., and from Designs and Drawings by Maurice B. Adams, A.R.I.B.A.* (1880); and *Dress and Its Relation to Health and Climate* (1884), among others.

The range of styles at which Godwin was adept corresponded to the broad range of furniture types he designed to meet the demands and social habits of the rapidly growing middle class. Between 1860 and 1886, for example, Godwin not only

designed a wide variety of seating furniture – from lightweight chairs to elaborate daybeds and couches – but also tables for writing, eating, and playing games, display cabinets, bookcases, wardrobes, and dressers as well as items such as pianos, gongs, easels, and standing mirrors, items that lay outside the normal remit of nineteenth-century furniture-making firms.

In keeping with the broad scope of his interests, Godwin did not tie himself morally or aesthetically to any one style. He was eclectic in the best sense of the word, practicing what he described as "judicious eclecticism"[2] and encouraging others to do the same. He believed that the way to the future was through study of the past, but his antiquarian interests never outweighed his search for a style suitable to the time in which he was living. His scholarship informed and enriched rather than dictated the forms of his design work. He studied design traditions from all parts of the world, especially Japan, but in all his work he used the design repertory of each particular culture in highly original ways, producing stylish designs that appealed to contemporary sensibilities.

His "judicious eclecticism" entailed restricting the range of his work to six major styles: Gothic Revival, Anglo-Japanese, Anglo-Greek, Anglo-Egyptian, Queen Anne or Cottage Style, and Old English or Jacobean. Each style differed greatly from the others, the common thread being the high degree of inventiveness he showed in his interpretations of it. The majority of Godwin's known domestic work was in the Anglo-Japanese and Gothic Revival styles, followed, in descending order, by Old English or Jacobean, Queen Anne and Cottage, Anglo-Greek, and Anglo-Egyptian. Most individual designs drew on one main style but some drew on more, for example the "Lucretia Cabinet" for Collinson and Lock (CR 332), whose cornice decoration is in a Celtic meander pattern derived from a series of repeating patterns Godwin sketched in the Royal Irish Academy,[3] whose curved supports, or brackets, are from Chinese hardwood prototypes, and whose painted decoration depicts the Rape of Lucretia, a classical story from ancient Rome.

Godwin's eclecticism was by no means unique in a century marked by a strong historicism in many aspects of its culture, which witnessed the "battle of the styles."[4] Some architects and designers, such as A. W. N. Pugin after the 1840s or William Burges after the 1850s, had committed themselves to working only in the Gothic Revival style, but Godwin (among others working in the 1860s, 1870s, and 1880s) was not so exclusionist. The products of the firm of Morris and Company, for example, reveal stylistic influences similar to those utilized by Godwin (though in very different ways), particularly Gothic, Japanese, classical, and Queen Anne. It is clear that the styles Godwin used in the years following 1865 formed the basis of the design vocabulary of the progressive designers of his day, yet Godwin used that vocabulary to produce work much more idiosyncratic than that of his contemporaries. It is this broader eclecticism, rather than the diversity of his client base, that best explains the range of Godwin's output.

The design vocabularies of other periods and cultures raided by Godwin found some resonance in contemporary British sensibilities. The historicist styles offered a variety of references to Britain's national glories, both past and present, as well as to much of her cultural distinctiveness. Some styles evoked more directly than others an ethos of nation and Empire, an accepted belief in Britain as the fount of enlightenment and civilization.[5] It could be argued that Godwin was one of the first designers to capture such an ethos. His use of classical motifs – expressed particularly in his Anglo-Greek furniture – referenced simultaneously the notion of Britain as a great democratic nation through associations with ancient Greece, whereas Imperial Rome offered more parallels to the notion of Britain as "Empire" and her concomitant expansionism. Such references denoted culture and civilization, and

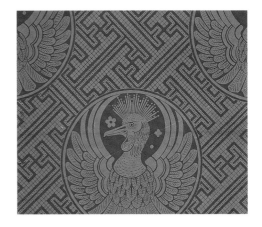

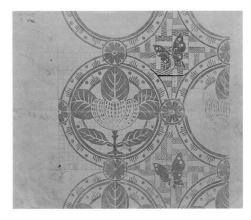

3. E. W. Godwin. "Peacock" Wallpaper. Jeffrey and Company, ca. 1873. Whitworth Art Gallery, Manchester City Art Galleries 1934.22/19.

4. E. W. Godwin. Design for "Butterfly Brocade," a woven silk furnishing fabric designed for Collinson and Lock and woven by Warner, Sillett and Ramm, London, ca. 1874. National Gallery of Victoria, Melbourne P108/109.

conjured images of the "Grand Tour" – that mark of the cultured aristocrat and gentleman in the eighteenth century.[6] The Gothic Revival signaled aristocratic chivalry as well as incipient nationhood and embryonic democracy. The less distant past of the Jacobean period referenced the glory of Britain through the reputation of William Shakespeare, the international cultural icon accepted by many as the greatest playwright ever, just as Britain was accepted, by most, as the world's greatest power. These associations were made in a very explicit manner by Godwin in the Shakespeare dining room suite (CR Fig. 176.1) he designed for William Watt.

Godwin's designs made material some of the underlying ambivalences of the culture in which he lived. His clientele had experienced the industrial and political transformations of the late eighteenth and early nineteenth centuries. If the late eighteenth century conformed to Jürgen Habermas's model of a new role in the formation of taste, the creation of ideology, and the direction of politics, its descendants became heirs to a middle-class self-image that was at once confident and insecure.[7] Something of that insecurity was reflected in an ambivalence toward the industrialization, urbanization, and shift to a more secular society that marked the modern, so-called "enlightened," world. Living in London or, indeed, in any of the large industrial cities of Britain, made one painfully aware of the likelihood that modernization was destroying forever a world increasingly described in terms of natural and spiritual harmony. The nineteenth-century auto-critique of modern conditions, expounded by A. W. N. Pugin as early as 1836,[8] fueled a desire to relive the supposed halcyon days of the preindustrial world through the objects within one's home. Thus, Gothic, Jacobean, Queen Anne, and Georgian, even Greek and Egyptian, became popular styles in the nineteenth century as city dwellers surrounded themselves with evocations of a lost past.

Although such evocations were part of a constructed myth, that myth, like Godwin's designs, forged a link between past and present. Godwin's historicizing aesthetic helped shape the illusion of a common past, free of class distinctions. The appropriation of historical styles, mostly from an aristocratic past, on the part of a middle class reveals what Arno Mayer refers to as "the persistence of the old regime."[9] He maintains that bourgeois insecurities were revealed in the assumption of aristocratic tastes and style in the form of designs with such obvious debts to tradition. In this way, Godwin and other historicist designers played a part in the construction of a particular national identity in the nineteenth century, helping to generate a sense of continuity by fusing historical and modern elements.

Godwin's integration into British design of non-Western and preindustrial elements also played a part in forming the self-image of the nation. Ironically, the staunchest defenders of the Empire in the late nineteenth century were not the old aristocracy but the new plutocrats – civil servants and professionals – many of whom bought goods designed by Godwin.[10] His Anglo-Japanese sideboard in the Victoria and Albert Museum – with fragments of Japanese wallpaper shorn of their original context and reused to adorn a new British sideboard (CR 304-b) – can be viewed as a metaphor for British world dominance. It offered an association with the exotic and with "other," but did so without replicating a specific object or style from the plundered culture. It is not so surprising, then, that Godwin advised students to study all styles and civilizations, warning them not to work in one particular style and to reply "my own" if ever asked in which style they worked.[11]

Godwin's own furniture designs are, in a sense, a mirror, reflecting aspects of British colonialism and imperialism in the homes and semipublic spaces of the British middle class, which, thanks to an active daily press, was keenly aware of political developments across the world. Godwin's work formed part of a domestic appropriation of imperialist fantasies and his furniture and accessories offered a

material connection to Britain's internationalism. More directly related to Godwin's designs and orientalism in general were the solidification of the British hold on China after the Tientsin Treaties of 1858 and the impact of renewed contact with Japan after 1853.[12] In 1862 a Japanese delegation arrived in London and later that year Japanese goods were shown at the international exhibition held in London;[13] soon Japan became a new frontier for commercial trade.

The products Godwin designed fulfilled the expectations of a clientele that devoured guidebooks and travel literature in its passion for anything foreign and exotic.[14] What made the exotic so alluring was not merely that it was different but also that it was safe. As Edward Said has shown,[15] the exotic is always regarded as less worthy and, therefore, is viewed as subordinate to the dominant power. As a result, the passion for "other" is used by societies (in this case, Britain) to reinforce feelings of superiority and to justify imperialist practices. This also holds true in scholarly as well as more popular approaches to the study of those artistic expressions, although Godwin certainly had a greater appreciation for the Japanese culture than did most of his contemporaries.

Godwin's ability to respond to cultural dualities and ambiguities, together with his scholarly and erudite knowledge of the past and other cultures, resulted in highly original combinations of design elements and principles. This originality is clearly evident in such works as his "Four Seasons Cabinet" (CR 344), now in the Victoria and Albert Museum, London, and his occasional table with staggered shelves now at The National Trust, Ellen Terry Memorial Museum, Smallhythe Place, Kent (CR 211-a), where traditions as diverse as those of Japan and Georgian England are fused into coherent and elegant wholes. Until the recent collapse of the hegemony of Modernism, which favored novelty and innovation in design,[16] eclecticism and associationism in design were not highly valued. Designers such as Godwin were admired as innovators rather than creative synthesizers, thus helping to obscure the eclecticism and cultural cross-referencing that enriches his work as well as the actual forms developed within modern, "progressive" design at the time. Godwin's ability to play off past and present and East and West in fluid and dynamic compositions should be seen as testimony to a highly developed sense of design relevant to the middle class of his day rather than an inability to predict the design forms privileged by "progressive" architects and designers of the 1920s and 1930s.

Despite the diversity of their sources, Godwin's designs were always rooted in the need for types and forms of furniture appropriate for modern living. He experimented with modular and built-in furniture long before it became widely popular, in the mid-twentieth century.[17] He grappled with affordability, utility, and function, concerns that would preoccupy many designers throughout the twentieth century, from Josef Hoffmann in Austria to Alvar Aalto in Finland, and Charles and Ray Eames in the United States.[18]

Questions of hygiene as it was understood in the period also entered Godwin's design consciousness, resulting in furniture without dust-catching ornamentation and often mounted on casters so that the floor underneath could be easily cleaned. This concern with hygiene carried over into the layout and design of entire rooms. Bedrooms in particular were sparsely furnished so as not to harbor dust and dirt. To Godwin, "abundance of light, air and cleanliness" was the primary objective in a decorative scheme,[19] and his concern for cleanliness and simplicity, rooted in the health-reform movements of the period,[20] was paralleled in the design preferences of the Arts and Crafts movement with its emphasis on simplicity. Nevertheless, Godwin was one of the few designers of his day to consistently campaign, through his writings as well as his designs, for more hygienic homes and furnishings – an aspect of his work which has been underrated. He had similar "modern" concerns about the size, weight, and cost of furniture for contemporary homes.

At the same time as his work showed a concern for utility and ease of cleaning, there remained in Godwin an attraction to pattern and decoration as well as an ability to handle it with confidence and flair. His "Butterfly Cabinet" (CR 369), with its abstract cloud, butterfly, and chrysanthemum decoration painted by James McNeill Whistler, and the "Beatrice Cabinet" (CR 374), with its painted panels representing the Four Seasons, show a great talent for incorporating pattern into furniture and diversifying furniture by means of patterns and color.[21] In some of his designs, the tensions between simplicity for its own sake as a guiding principle and concerns for expressing aestheticism, as well as between those and client desires for elaborate furnishings, worked at times to produce elegant furniture designs with memorable visual qualities.

The luxurious furniture designed by Godwin for Collinson and Lock and Gillow and Company reveals little of the dogmatism that informed some of Godwin's utterances on design. It is noteworthy that someone so involved with the Aesthetic movement, rooted as it was in the concept of "art for art's sake," was also quite puritanical on many fronts. The question of excess is crucial, and Godwin's insistence that excess, like laziness, was morally wrong lies uncomfortably with orthodox interpretations of the late nineteenth century and aestheticism as decadent.[22] Despite a personal life full of scandalous liaisons and unconventional living arrangements, the moral force of Godwin's position in his crusade for better design allies him with the adherents to the more moral crusade of the Arts and Crafts movement rather than with the amoral stances of the aesthetes with whom he associated.

Several dualities and oppositions play off against each other with varying degrees of subtlety within Godwin's work. The dual concerns of function and aesthetics resulted in work that was often light and restrained. This is best seen in his designs for octagonal center tables with their superstructures of radiating spindles on brass casters (CR 215). Tensions between the sparse and the decorated appear in his display cabinets of simple outline but with shelves staggered to exhibit objects to greatest advantage (CR 323). The dialogue between past and present informs pieces such as the Dromore bookcases (CR 311.I–III), which were based on medieval cabinets but adapted to the contemporary need to house the greater number of books available in the late nineteenth century, while traditional and modern impulses are reconciled in Jacobean-style furniture scaled down to accommodate the smaller living quarters and appetites of contemporary life.

Godwin's most productive years in the 1860s and 1870s coincide with Matthew Arnold's diagnosis of the state of modernity put forth in 1869 in his tract *Culture and Anarchy*.[23] In spite of Arnold's inherent pessimism, he offered a blueprint of an educative agenda in which design and the cultivation of taste were crucial. Although Godwin came of age during a period in which the confident claims of progress were questioned, there is little doubt that amidst the evocations of the past the modern client wished some affirmation of the superiority of the present over the past. Arnold's "modern" preoccupation with cleanliness, efficiency, light, practicality, and the use of up-to-date techniques of manufacture corresponds to Godwin's own. Godwin was skillful in utilizing newspapers and the architectural press for the "modern" task of self-promotion. His communications skills notwithstanding, the commercial success of his work suggests that his design work, in which historicism, nationalism, and the exotic merged seamlessly with contemporaneity in a remarkable fusion of originality and eclecticism, was appealing on many levels – artistic, economic, and ideological.

It was a fortunate conjunction that in one man an acute interest in the needs of the world around him and in cultures other than his own met with considerable creative talents in design. The result was a visual manifestation of many of his ideas

for "progressive" living in the modern world. Paradoxically, he and many of his clients marked their very modernity by admiring cultures that were less developed (and therefore inferior, in their view); to be modern was also to be anti-modern.[24] Godwin's furniture designs fused these aspects of "advanced" artistic life from the 1860s through the 1880s, and created forms that were translatable into commercially viable furniture as well as more expensive one-off commissions.

<p style="text-align:center">* * *</p>

Godwin died on 6 October 1886 in his rooms at 6, Great College Street, Westminster, from complications following an operation to remove kidney stones. He is buried at Northleigh, near Witney, Oxfordshire, in an unmarked grave because he did not like gravestones.[25] At the time of his death in 1886 he was known as one of the most versatile talents of his age. Although his death was marked by an enormous number of obituaries noting the passing of what one commentator called "an architect who had no compeer in England and a designer of consummate skill,"[26] Godwin's critical reputation began to recede almost immediately after his death, and in the closing years of the nineteenth century his achievements were referred to by only a handful of designers and critics.[27]

By the beginning of the twentieth century the Aesthetic movement in general was associated with decadence and Godwin's furniture was seen by critics such as H. J. Jennings as "that excrescence of nineteenth century art . . . effeminate, invertebrate, sensuous and mawkish."[28] Twenty years later this view was still commonly held: the painter and critic Roger Fry wrote of this style as a "horror – a genuine modern style which as yet has no name, a period of black polished furniture with spidery lines."[29] Although Fry inadvertently recognized its importance by viewing it as "a genuine modern style" and German architect and historian Hermann Muthesius recognized Godwin's importance as "foreshadowing the idea of the modern interpretation which was soon to follow,"[30] Godwin's reputation had been totally eclipsed by a new generation of designers and critics interested in modern design who frequently overlooked nineteenth-century precedents. Even Nikolaus Pevsner's first edition of *Pioneers of the Modern Movement from William Morris to Walter Gropius*[31] failed to include Godwin in its groundbreaking examination of the architecture and design of the nineteenth century.

Godwin's work seems to have been ignored for most of the first half of the twentieth century, with the exception of three brief and somewhat inaccurate entries: Maurice Adams described Godwin as a genius but considered his career a failure;[32] an entry in the *Dictionary of National Biography* listed Godwin's principal achievements as his assistance to William Burges's design for the new law courts and to Robert Edis for the Parliament House in Berlin.[33] The third mention, however, foreshadowed a dramatic change to Godwin's critical reputation. In his article "1874 and After" in *Architectural Review* in 1931, C. F. A. Voysey, a prominent architect-designer of the Arts and Crafts movement, admitted that his work owed a great deal to earlier architect-designers such as "William Burgess [*sic*], E. W. Godwin, A. H. Mackmurdo, Bodley and others [who] regarded nothing in or outside a home as too small to deserve their careful consideration. So we find Burgess designing water-taps and hair brushes; Godwin and Mackmurdo furniture; Bodley, like Pugin, fabrics and wallpapers."[34]

In 1945 Dudley Harbron published the first scholarly essay on Godwin in *Architectural Review*,[35] marking a turning point in Godwin studies. In this five-page article, Harbron summarized Godwin's achievements and illustrated them with a few line drawings taken from nineteenth-century architectural journals. Three years

later, Nikolaus Pevsner praised Godwin's wallpaper designs in his article "Design and Industry through the Ages" for the *Journal of the Royal Society of Arts*.[36] In 1949 Harbron published the first biography of Godwin,[37] a small book sparsely illustrated (with merely seven photographs and six line drawings) and poorly referenced. Nevertheless, this biography raised critical interest and brought Godwin out of obscurity.

Godwin's work now came to the attention of a new generation of authors, critics, and museum curators. Articles published in *Architectural Review* began to uncover the spectacularly broad range of his work – for example, H. Montgomery Hyde's article "Oscar Wilde and His Architect," based on a cache of letters between Oscar Wilde and Godwin he had discovered.[38] In 1952, however, prompted by the first showing of Godwin's oeuvre in a museum context (the Victoria and Albert Museum's exhibition of "Victorian and Edwardian Decorative Arts" [VEDA]), Pevsner penned an article entitled "Art Furniture of the 1870's" in which Godwin was featured as one of the major designers of the period.[39] The following April Pevsner again wrote about (and provided the first photograph of) Godwin's ebonized sideboard,[40] which became one of the most widely illustrated and discussed pieces of nineteenth-century furniture – and the first piece of Godwin furniture to be purchased by the Victoria and Albert Museum.[41]

The exhibition of Godwin's furniture in the VEDA show reverberated throughout Scandinavia and even reached the shores of New York. A Scandinavian scholar wrote a theoretical study of Victorian design themes in which he identified Godwin and Christopher Dresser as major designers who helped formulate the functional modernism of the twentieth century, a view shared by Edgar Kauffman Jr., curator at New York's Museum of Modern Art.[42] Godwin was also considered an important interpreter of Japanese forms and motifs instrumental to the development of Art Nouveau.[43]

During the late 1950s and early 1960s Godwin began to be mentioned in early histories of Victorian furniture. Peter Floud was the first to include Godwin in a chapter on "Victorian Furniture" written for the *Concise Encyclopedia of Antiques*.[44] To Floud, Godwin's Anglo-Japanese work was most memorable, particularly the sideboard on display at that time in the Victoria and Albert Museum (CR 304-b). Symonds and Whineray also recognized Godwin's Anglo-Japanese work in one of the first book-length studies devoted to nineteenth-century furniture,[45] as did Charles Handley-Read, one of the earliest collectors of Godwin furniture.[46] At the end of the 1960s Hugh Honour devoted an entire chapter to Godwin in his *Cabinet Makers and Furniture Designers*.[47]

While pioneering works on nineteenth-century furniture were recognizing Godwin's Anglo-Japanese furniture, a different group of critics with more modernist eyes were beginning to appreciate the abstract and functional nature of some of his designs. In the third edition of his *Pioneers of Modern Design*, published in 1960, Pevsner finally mentioned Godwin in one brief paragraph and illustrated a line drawing of Whistler's White House (Fig. 5).[48] However brief the inclusion, Pevsner's endorsement of Godwin as a pioneer of modernism ensured that future generations would consider Godwin in their assessments of the Modern movement.

It was Elizabeth Aslin's work in the 1960s, however, that did the most to rehabilitate Godwin's career, particularly in the decorative arts. In her book *Nineteenth Century English Furniture* (1962),[49] Aslin devoted two pages to Godwin's achievements and illustrated his classic coffee table (CR 207) and a chair for Dromore Castle (CR 113). In 1967, in her article "The Furniture Designs of E. W. Godwin,"[50] she drew on the Victoria and Albert Museum's recent acquisitions (from Godwin's second son) of Godwin's sketchbooks, diaries, ledgers and cash books, letters, and

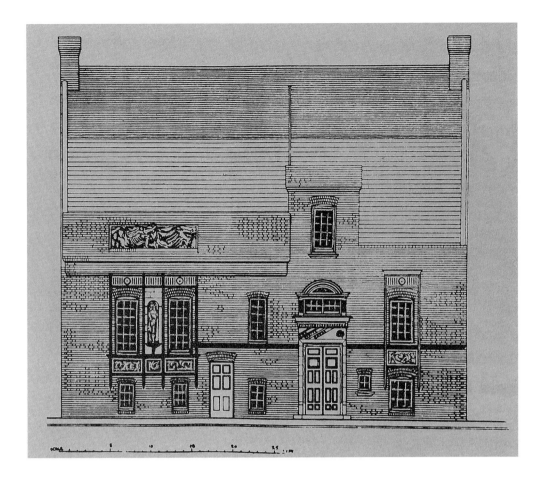

5. E. W. Godwin. Line drawing of Whistler's White House (1877). From Nikolaus Pevsner, *Pioneers of Modern Design: From William Morris to Walter Gropius* (first published in Pevsner's 3d. ed., Harmondsworth, England: Penguin, 1960; reprinted here from Pevsner's 1975 edition, p. 64, fig. 18).

architectural plans to begin to identify the diverse range of his sources and his furniture production. In Aslin's *Aesthetic Movement*, published two years later,[51] Godwin figured prominently as one of the earliest collectors and promoters of Asian artifacts.

The rediscovery in the 1970s of nineteenth-century art and design led to a number of exhibitions in museums and commercial galleries that displayed Godwin's work and also included it in the accompanying catalogues. In 1972 the Diploma Galleries of the Royal Academy hosted an exhibition of "Victorian Decorative Art" that showcased the spectacular collection of the late Charles Handley-Read and his wife, Lavinia. Four pieces of Godwin furniture were exhibited, although only the "Four Seasons Cabinet" (CR 344) was illustrated in the accompanying catalogue.[52] In 1973, when Godwin's "Butterfly Cabinet" (CR 369) was purchased by the Hunterian Art Gallery in Glasgow, it was still described by a prominent art critic as a "monstrous erection" and "a fairly awful example of High Victorian insensibility."[53]

Several exhibitions during the 1970s highlighted Godwin's work.[54] In 1974 the British Council in Canada staged "High Victorian Design," the largest exhibition ever devoted to mid-nineteenth-century Victorian design. Surprisingly, Godwin was represented by a single item, a line drawing of Northampton Town Hall; his contributions to the decorative arts were totally overlooked.[55] In 1976 the Bristol Museums and Art Gallery curated a show of furniture designed by Godwin and by Marcel Breuer, two designers with links to Bristol who were well represented in its permanent collections. This was the first exhibition of the full bequest of fourteen Godwin pieces the Gallery received in 1949 from Godwin's daughter, Edith Craig.[56] After the exhibition, the pieces went back to the attic of The Georgian House (which belongs to the Bristol Museums and Art Gallery), where they remain today.

In 1978 Garland Publishers reprinted William Watt's *Art Furniture* catalogue, together with a catalogue for Messenger and Company, as one of the most important books of both the Aesthetic and the Arts and Crafts movements.[57] Furthermore, London scholar-dealers such as Jeremy Cooper, Martin Levy of H. Blairman and Sons, Michael Whiteway of Haslam and Whiteway, and Andrew McIntosh Patrick of the Fine Art Society began to collect, study, and sell Godwin's work to collectors and museums, thus bringing it to an ever-broadening audience.

The 1980s saw a few small exhibitions as well. "Architect-Designers: Pugin to Mackintosh" at the Fine Art Society presented Godwin as one of almost thirty nineteenth-century architect-designers responsible for "many of the best objects" of the period.[58] In 1986, to mark the centennial of Godwin's death, Victoria and Albert Museum curator Lionel Lambourne mounted the first retrospective of Godwin's work based on the museum's collection. (Unfortunately, Godwin was not considered a sufficiently important designer to merit an accompanying catalogue.) Museums outside Great Britain took note of Godwin as well. The Museum of Modern Art in New York, for example, had one of his sideboards on view (CR 304-c) and the Musée d'Orsay in Paris bought a hanging cabinet (CR 320-a).[59]

Another important development in Godwin studies occurred with the publication in 1986 of Elizabeth Aslin's *E. W. Godwin: Furniture and Interior Decoration*.[60] Although this rather slim book relied heavily on the collection of the Victoria and Albert Museum and was mostly derived from her previous writings, it did illustrate about eighty-five pieces, including examples of furniture, textiles, wallpaper, and stained glass. The following year Jeremy Cooper's *Victorian and Edwardian Decor* was published, a seminal study in which Godwin's work was placed in the context of the Aesthetic movement, discussed in the company of Norman Shaw, W. E. Nesfield, Christopher Dresser, and Thomas Jeckyll,[61] and in which many pieces were published for the first time. In 1987 the first dissertation on Godwin was completed by Nancy Burch Wilkinson, who used the figure of Godwin as a "guide to Japonisme in England."[62]

By the close of the 1980s more and more Godwin pieces were appearing on the art market and an increasing number of museums and collectors were beginning to acquire his work. Despite this recent interest, however, Godwin's multifaceted career remains largely unexamined. Perhaps this is due to the complexity of his career and the ephemeral quality of his later work in the theater, but it also reflects a general lack of interest in the Victorian period, which until the past twenty years was considered "the dark ages of art, an aesthetic no-go area whose vast multiple artifacts were either beneath contempt or merely objects of derision."[63] Although many recent publications on nineteenth-century design including Joanna Banham, Sally MacDonald, and Julia Porter's *Victorian Interior Design* (1991) and Charlotte Gere and Michael Whiteway's *Nineteenth Century Design* (1993) identify Godwin as one of the period's major design reformers and reproduce ad nauseam Godwin's ebonized Anglo-Japanese sideboard and/or "Butterfly Cabinet," a thorough study of his accomplishments is still lacking over a century after his death.

INTRODUCTION

Although he was trained as an architect and had moderate success with a number of highly original buildings, ranging from the Gothic Revival Northampton Town Hall (1861–64) to the 1878 proto-modern house/studio at Tite Street, London, of James McNeill Whistler (1834–1903), furniture played a significant role in the career of E. W. Godwin. Art historian and critic Nikolaus Pevsner writes that Godwin was "more a designer than an architect,"[1] and in truth his Anglo-Japanese designs for furniture, particularly his ebonized sideboard of about 1867 (CR 304-b) and his square coffee table of comparable date (CR 207), are considered major monuments of nineteenth-century design.

During a period of some twenty-five years Godwin designed at least four hundred pieces of furniture for exclusive private patrons, public and ecclesiastical commissions, the commercial trade, and his own use. This is not surprising since a significant part of his architectural practice included decoration and furniture design, whether as part of the overall architectural plan of a building or as an independent commission. Godwin wrote in 1874 that a sizable percentage of his revenue came from the design of furniture and related decorations, and he foresaw a time when "in this branch alone the architectural student of the future will find more and more opportunity of employment."[2] He was not unique in this; a generation earlier, the architect-designer A. W. N. Pugin (1812–1852) had designed several hundred pieces of furniture for the same range of clients. Unlike Pugin, who remained wedded to the Gothic Revival and Jacobethan styles of furniture, Godwin was capable of working in all the historicist styles that popular taste demanded, including Gothic, Anglo-Egyptian, Anglo-Greek, Jacobean or Old English, Cottage, Queen Anne, and of course Anglo-Japanese, which he is credited with originating and popularizing. Unlike that of so many of his contemporaries, Godwin's work rarely falls into the category of historical reproduction or excessive eclecticism. No matter what style he worked in or what sources he borrowed from, he always came up with his own distinctive interpretation and original design solution: "It is easy enough to make up furniture in *direct imitation* of any particular style. . . . What I have endeavored to secure in design, has rather been a modern treatment of certain well-known and admired styles."[3]

Godwin believed – as did, for example, Pugin and William Burges (1827–1881) as well as William Kent, Robert Adam, and other architect-designers of the eighteenth century – that every detail of the interior as well as the exterior should be under the control of the architect, and, as a follower of John Ruskin, the idea of a unified scheme of decoration was central to Godwin's approach. He expounded this unified approach to design in "The Sister Arts and Their Relation to Architecture," a lecture prepared for the Bristol Society of Architects in 1863. The central thesis was

that the arts of painting, sculpture, and architecture were no longer dependent on each other as they had been in the Middle Ages, and that until they were reunited under the control of a unifying spirit – i.e., the architect – they could not flourish. He warned architects that "when each room and each article of furniture shall be found to be but resolutions of the same key-notes . . . *then* may we hope to have an art of our own."[4]

Godwin's earliest designs for furniture were part of his ecclesiastical commissions of the 1850s, a major part of the practice of architects in the mid-nineteenth century. His renovation and restoration efforts for the fourteenth-century church of Saint John the Baptist, Colerne, in 1853, commissioned by Reverend H. F. Atherley, probably included his first furniture commission as well, a Gothic-style reading desk and stone pulpit.[5] An early sketch of the reading desk shows a sturdy piece of furniture with a profiled ratchet and plinth base (Fig. 6).[6]

Unlike Pugin, who was trained by his father,[7] Godwin seems to be largely self-taught. Godwin had no formal connections with the furniture trade or with any school of design; he was educated at Exley's School in Highbury, Bristol. Although he had served an apprenticeship with Bristol architect, surveyor, and civil engineer William Armstrong, he seems to have learned little from his master, claiming Armstrong "knew nothing whatever about architecture – a thing by no means of rare occurrence; but he did know something about engineering."[8]

Godwin's sketchbooks provide some clues as to how he mastered the art of design. From an early age he was a compulsive sketcher and note taker; his early sketchbooks are full of drawings of architectural fragments in and around Bristol. One of his earliest sketches, annotated "from Lower Garden," depicts a section of a per-

pendicular window, a bracket in the form of an angel, and a gargoyle (Fig. 7).[9] These were taken from "the fragments and crumbling bits from old churches" that his father, a currier who was also a partner in Godwin, Smith & Company, a building and decorating business in Bristol, collected in their garden at Earl Mead's House, on the outskirts of Bristol.[10] These early sketches already demonstrate that the young Godwin shared his father's antiquarian interests.

Godwin also studied architecture and furniture from a small library of books he assembled, including A. C. Pugin's *Specimens of Gothic Architecture* (1821–23), Thomas Rickman's *An Attempt to Discriminate the Styles of Architecture in England from the Conquest to the Reformation* (1817), Matthew Bloxham's *Principles of Gothic Architecture* (1829), and James Barr's *Anglican Church Architecture* (1842).[11] Godwin's interests went far beyond architecture and its related arts, however. He consulted the Bible and works by Chaucer and Shakespeare, as well as books on costume and heraldry.[12]

Godwin's interest in architecture led him to study the ruins and historic buildings at more than 145 sites throughout Britain.[13] Sketchbooks dating from the 1850s show that during his travels Godwin was constantly taking detailed notes and making measured drawings, such as a sketch preserved in the Royal Institute of British Architects (RIBA), dated July 1855, which shows a pew and pulpit from the Church of Saints Peter and Paul in the town of Weston-in-Gordano (Fig. 8).[14] Some of these sketches would be expanded into detailed illustrations for his antiquarian papers published during the 1850s and 1860s.

When Godwin's interest expanded to include secular furniture he examined specimens ranging from ancient Egyptian chairs in the British Museum to Japanese

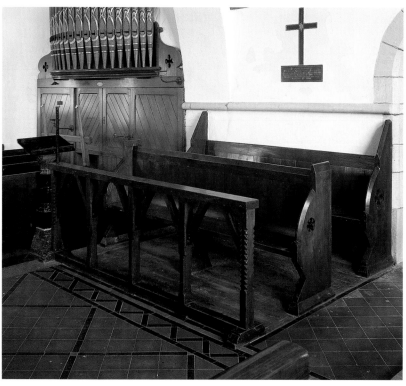

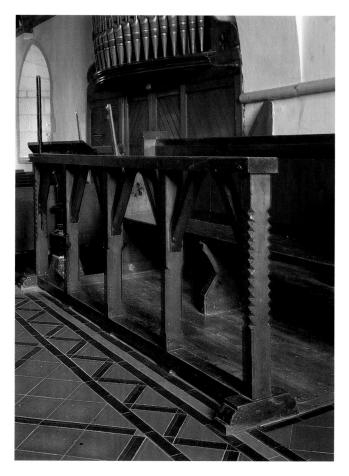

9. E. W. Godwin. Chancel pews (ca. 1860–61). Church of St. Grada, Grade, Cornwall.

10. E. W. Godwin. Chancel desks (ca. 1860–61). Church of St. Grada, Grade, Cornwall.

11. E. W. Godwin. Timber framing of the chancel roof (ca. 1860–61). Church of St. Grada, Grade, Cornwall.

12. Attributed to E. W. Godwin. Nave seats (1860). Church of St. Wynwallow, Landewednack, Cornwall.

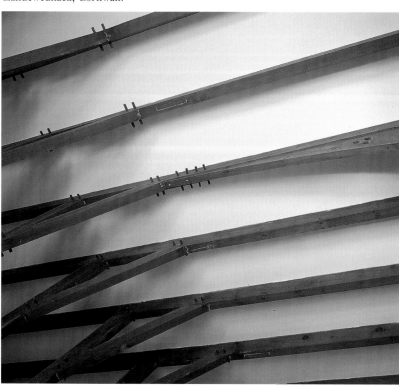

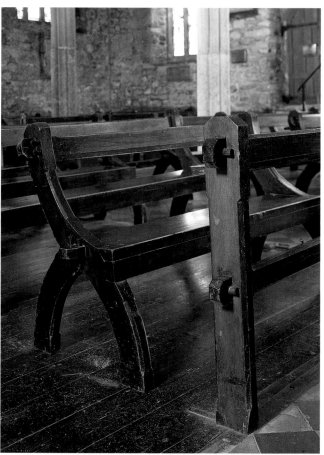

lanterns in Liberty's Anglo-Japanese warehouse in London, and his sketchbooks abound with these studies. Moreover, his sketches did not suffer from the inability to draw furniture that plagued fellow architect Alfred Waterhouse (1830–1905), who wrote of chairs as "peculiar things to design [that] cannot be judged in drawings so well as by their actual execution in wood."[15] Godwin's ideas for furniture were so accurately rendered that they were easily translated into actual designs to be put into production by the many well-established cabinetmakers that flourished in Britain during the nineteenth century. It was Godwin's contention that: "Cabinetmakers always prefer architects to design for them when they can get them,"[16] and the number of firms in London for which Godwin supplied designs bears this out – Art Furniture Company, Cox and Son, Gillow and Company, Green and King, W. A. and S. Smee, James Peddle, Waugh and Sons, and William Watt. Firms outside London included Reuben Burkitt of Wolverhampton and Webb of Reading. In addition, the fashionable London firm of Collinson and Lock, 109 Fleet Street, paid him a monthly retainer from 1872 to 1874 and authorized individual payments for special commissions.[17]

EARLY CHURCH FURNITURE

Two surviving church commissions provide the earliest extant Godwin furniture: the church of St. Grada, Grade (restored 1860–61), and the church of St. Wynwallow, Landewednack (restored 1860), both in Cornwall. Executed in the Reformed Gothic style, this furniture shows the influence of A. W. N. Pugin, particularly his structural Gothic work.[18] Like Pugin, Godwin studied the timber-frame construction of medieval architecture and made measured drawings throughout his travels.

Another source for Godwin were the Reformed Gothic works of both G. E. Street (1824–1881) and William White (1825–1900), two architects who also worked in Cornwall in the late 1840s and early 1850s. Godwin first discovered Street's work in 1853: "the view of his design for Cuddesdon College, [Oxford] published in *Illustrated News* of 28 April 1853 . . . first attracted me, then a student to this accomplished architect."[19] Street's church of St. Mary, Par in Cornwall (1848–49), his restorations of the church of St. Probus (1849), and the church of SS. Peter and Paul at Shevlock in Cornwall (1851) reveal functionalist interiors and furnishings derived from Pugin's church commissions.[20] William White's restoration and refurnishing of the church of St. Gerant at Gerrans in Cornwall (1849) also demonstrated the constructional principles prevalent in Pugin's designs.[21] Godwin designed similarly broad, severe forms with the revealed construction, geometric supports, and use of solid wood (rather than veneer) that had been popularized by Pugin twenty years earlier. This taste for severe and massive furniture is evident in Godwin's oak chancel pews of St. Grada Church, which have minimal ornament (Fig. 9). The revealed tenons at their ends and the vertical planking of their backs emphasize the structured orientation of these pews. The only concession to decoration is the pierced sexfoil design in the arms of the seating form. The overriding architectural quality of this furniture is expressed even more fully in the chancel desks (Fig. 10), whose saw-tooth edges and Y-shaped braces with revealed tenons echo the timber framing of the roof (Fig. 11). Comparable structural Gothic furniture can be found in the church of St. Wynwallow, Landewednack, Cornwall, particularly in its pews. A new structural form, however, is introduced in the seats (which Godwin designed for the chancel but are used in the nave): the crossed X-brace stretcher, another device borrowed from Pugin and ultimately derived from medieval sources (Fig. 12).

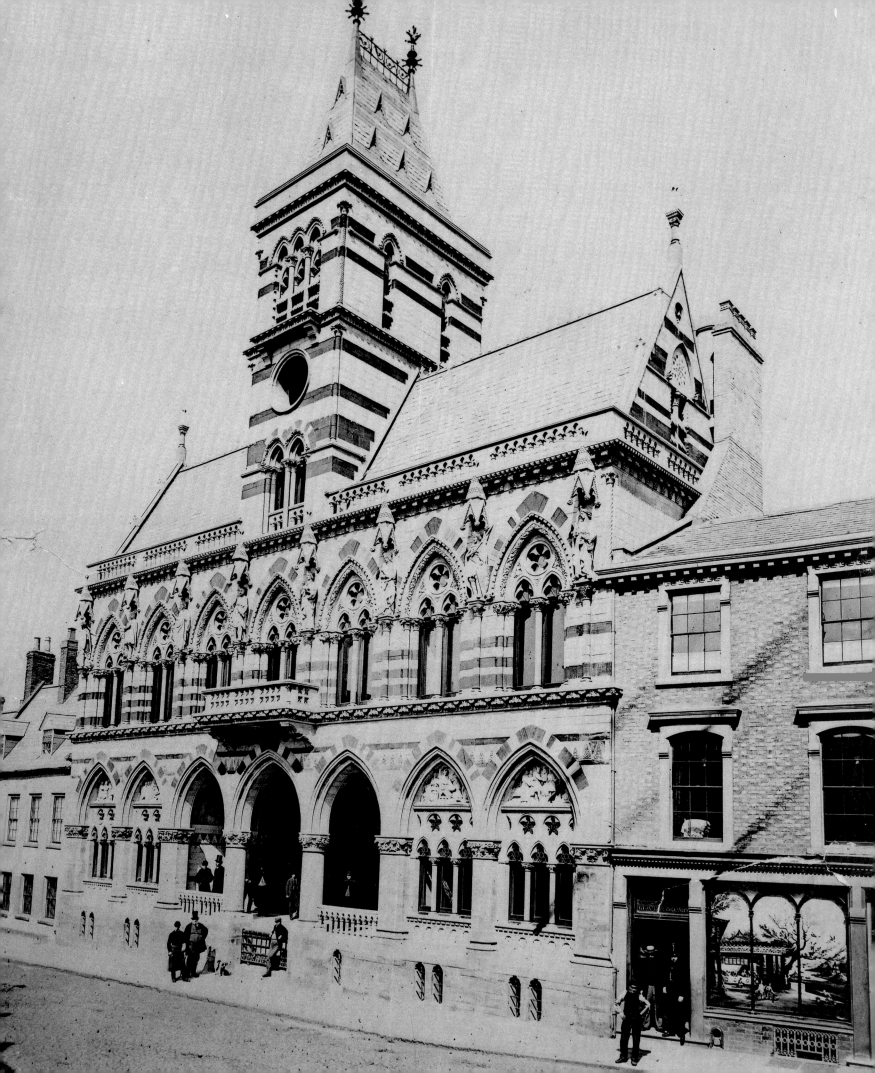

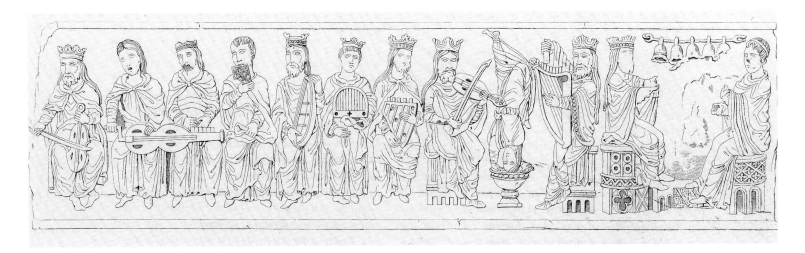

NORTHAMPTON TOWN HALL

Godwin's first major architectural commission was Northampton Town Hall (1861–64) (Fig. 13). Influenced by sources such as John Ruskin's *Stones of Venice* (1853) and the more amply illustrated *Brick and Marble in the Middle Ages: Notes of a Tour in the North of Italy* by G. E. Street (1855), the town hall was in Italian Gothic style. Godwin continued to demonstrate his taste for severe forms with a strong emphasis on structure in the design of the interior furnishings, which took their cue from the exterior architecture.

Godwin's ledger of 1863 reveals that on 21 September he received an order to prepare designs for furniture at ten percent commission.[22] The furniture was to be made by the London firm of Green and King of 23 Baker Street, who advertised themselves as artists and decorators. The firm had already been engaged to work on some of the building's painted decoration, including the elaborately painted roof trusses of the main hall.[23] Godwin designed a great deal of furniture for this commission, from hall stands to cupboards. Similar in design to his earlier church furnishings, these massive pieces of oak furniture are in the reformed Gothic style. The furniture in the Council Chamber, still in use in its original setting today, is the earliest documented Godwin furniture made for a non-ecclesiastical setting. With its large-scale, solid, roughly worked forms, it vividly invokes the spirit of the Middle Ages, when furniture was made to correspond to heavily fortified architectural settings.[24]

The Councillors' chairs, with their semicircular back rail, spindle supports, and rounded legs with decorative inlay, are deceptively simple in their appearance (CR 100). Their stylized forms, however, indicate a designer very much aware of furniture history. They seem to have been inspired by the barrel-back throne chairs that originated in the ancient world and survived into the Middle Ages. Godwin could have seen such chairs in the medieval illuminated manuscript collections of the British Museum and of his friend and fellow architect William Burges.

Godwin was a consummate antiquary and as often as possible went to original sources for inspiration. An illuminated manuscript of the fifteenth century reproduced in Nicolas Xavier Willemin's *Monuments français inédits pour servir à l'histoire des arts depuis le VI^e siécle jusqu'au commencement du XVII^e....* (1839) depicts two solidly built barrel-back chair forms that may have been the prototype for Godwin's semicircular Councillor's chair (Fig. 14).[25] Moreover, Willemin's illustrations of

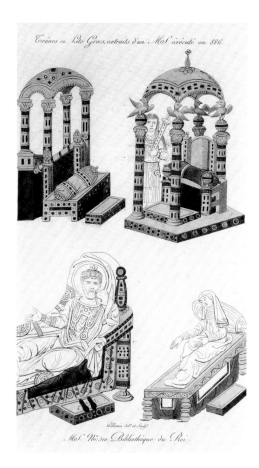

15. N. X. Willemin. Thrones and beds: "Trones et Lits Grecs, extraits d'un Ms. éxécuté en 886." From Willemin, *Monuments français*, plate 14.

"Trones et Lits Grecs, extraits d'un Ms. éxécuté en 886" (Fig. 15)[26] and "Siege Bibliothèque Imperiale. Instrumens de musique en ornemena (Bible de Charles-le-chause Ms. du milieu du IXme Siècle)"[27] were probably the source for Godwin's Greek-inspired inlay design of stripes and circles. The unusual bird's-tail, single-rear leg support is a design solution borrowed from the back stool, or *sgabello*, hall chair popular in fifteenth-century Italy. Godwin would again experiment with this unusual rear support in his Eagle chair for Dromore Castle (CR 114). Surviving designs for the Northampton commission as well as extant examples indicate that the Councillors' chairs were originally designed to be placed on four casters (for easy movement) and to be covered in green leather tacked with a row of nail heads. The latter element may point to the influence of Pugin, who wrote that green leather was the best upholstery for oak, a preference that Godwin seems to have adopted.[28] Green was the principal color Pugin used in furnishing the House of Commons, and both the green leather upholstery and the row of nail heads appear in his House of Commons chair from 1850.[29]

Other pieces from this commission also demonstrate informed borrowing and adapting of historical prototypes. The Mayor's chair, with its floriated finials, in general outline is based on a medieval precedent (CR 101), the Coronation chair of Westminster Abbey (1297–1300). The State chair, with its crocketed triangular splat, is even closer to this specimen (CR 103). The Council tables in the Councillors' Chamber (CR 200, 201) and the tables in the room beyond the Mayors' Names Gallery (CR 204) point to fifteenth-century trestle tables, such as the examples drawn from the Great Hall, Penshurst, Kent, and illustrated in Thomas Hunt's *Exemplars of Tudor Architecture Adapted to Modern Habitations* (1836).[30] The bench – originally designed for the Court Room but currently in the hallway of the Council Chamber staircase – with its Y-braces and roughly hewn framework (CR 104), recalls the medieval fixed benches and tables in the hall of Winchester College.[31]

The wealth of pieces designed for this first commission reveals that Godwin was already capable of designing the number – and variety – of pieces necessary for a town's administrative center. The pieces of furniture were slightly varied yet conformed to an overriding, unified style. That these pieces were highly successful in function as well as attractiveness is borne out by the fact that most of them are still in use in their original settings.

DROMORE CASTLE

Godwin's ability to design significant furnishing schemes carried over into the domestic sphere with his commission for Dromore Castle, County Limerick (1865–70), for the third Earl of Limerick (Fig. 16). Godwin designed the exterior of Dromore castle in an Irish vernacular Gothic style, but the interior, which encompassed a wide range of furniture, interiors, metalwork, and tiles, reveals a more eclectic approach, combining Gothic, Celtic, Chinese, and Japanese features.

Many detailed documents and specifications relating to this commission survive, as does a great deal of the furniture. For the furniture designs – from simple, light-weight bedroom chairs (CR 115) to an elaborate inlaid chess table (CR 209) – Godwin received a ten percent commission.[32] Some of these pieces were made by the London firm of William Watt but not all, as has been assumed. Most were executed by Reuben Burkitt and Company of Cleveland Road, Wolverhampton.[33] Godwin's ledgers reveal that his commission included a £260 bill from William Watt and a £894.7s.6d bill from Reuben Burkitt.[34] The extent of Burkitt's services are further confirmed in a letter from Godwin to William Burges asking for an arbitration for his design fees. Godwin lists the total amount of the furniture as

16. E. W. Godwin. Photograph from the 1940s of Dromore Castle, County Limerick, Ireland (1866–73).

£1154.7s.6d, the combined amount of Watt's and Burkitt's bills. This letter also lists some of the items, including "sideboard, Table, Chairs (easy & others), Sofas, bookcases, chess table (with animals carved), wardrobe with decoration."[35] Since the specifications for furniture for William Watt still exist in the RIBA, it is possible to deduce that at least the wardrobe, table, sideboard, and bookcases were made by Burkitt. Moreover, another letter in the Victoria and Albert Museum states: "The little doors containing pierced work in Buffet will be sent to Wolverhampton & made right."[36]

An account sent to Lord Limerick reveals that the hardware was supplied by the firms of Hart and Son (on Wych Street, off the Strand, London) and Benham and Froud (at 40–42 Chandos Street, Charing Cross, London), both well-known metalsmiths. Hart and Son's bill was for £206.16s.0d, while Benham and Froud's was for £274.9s.7d.[37]

Although one can certainly see Japanese influence beginning to permeate the design at Dromore Castle, it is difficult to know whether Godwin intended the overall aesthetic to be Japanese or medieval. Godwin himself was well aware of shared design elements between these two cultures. In a two-part article entitled "Japanese Wood Construction" that he wrote in 1875 for *Building News*, Godwin discussed certain similarities between Japanese and medieval craftsmanship. Of Japanese door paneling, he wrote "the doors are single or double-framed, and boarded between like our own Mediaeval examples."[38] And Godwin compared Japanese parapets and balustrades to "the wave parapet found in fourteenth-century churches in our own country" and "different kinds of plain balustrading which are closely related to the various examples of old English paling."[39]

Godwin's incorporation of Japanese motifs into the Gothic-style furniture for Dromore Castle was not unusual for the time. Architect-designers such as William Eden Nesfield (1835–1888) and Thomas Jeckyll (1827–1881) were integrating Japanese details into their furniture in the 1860s, and William Burges (1827–1881) had been collecting Japanese and Chinese objects, as well as medieval artifacts, since

the mid-1850s. In his review of the 1862 International Exhibition in London for *Gentleman's Magazine*, Burges commented on the close relationship between Gothic and Japanese art: "If . . . the visitor wishes to see the real Middle Ages, he must visit the Japanese Court."[40] Whether Godwin attended the International Exhibition is not certain, but he had been well aware of Japanese art for a decade by the time of the Dromore commission in 1868–69. As biographer Dudley Harbron wrote: "When he was able to please himself, his designs had a Japanese character. . . . He had, from 1860 onward, devoted as much time to the study of Japanese art and its principals [*sic*] as . . . he had employed upon mediaeval research."[41]

Certainly the sparseness of ornament, the rectilinear outline, and the use of natural wood grain are suggestive of both traditions. However, the use of wainscot oak, the sturdy architectural solidity of many of the case pieces, and the medievally inspired hardware of ringed pulls with circular escutcheon plates shared by all the pieces strongly point to the medieval tradition. This blurring of design sources was already noted by a contemporary reviewer, who wrote: "Mr. Godwin . . . appears to be perplexed by a divided duty between Ireland and Japan, with an occasional leaning to the Mediaeval glories of Europe."[42]

Analysis of several of the surviving pieces from this commission reveals a sparse, reformed Gothic style with Japanese details. A pine corner washstand in a stripped-down Gothic style (CR 310) contains panels of plaited rattan inserted into its triangular pediment, which corresponds to the timber framing of the pointed arch and supporting truss of the castle's interior (Fig. 17).[43] The plaited rattan refers to a Japanese source, however, and in fact similar specimens of rattan were shown in the Japanese display of the International Exhibition in 1862.[44] An oak escritoire has three sliding doors in the cupboard section, in imitation of sliding *shoji* panels (CR 315).

Other pieces, particularly those designed for the dining room, show less pronounced Japanese influence and more Gothic detailing. A pair of wainscot oak armchairs with ring-turned uprights and carved leonine heads, echoing the lion in the Limerick coat of arms, have stamped gold decoration on their leather upholstery (CR 112.I–II). This stamped pattern is in the form of medieval discs, derived from those used to decorate fabrics in the fourteenth and fifteenth centuries. In his *Dictionnaire Raisonné*, which Godwin is known to have owned and even reviewed on its publication in England,[45] Viollet-le-Duc illustrated a canopy with the same pattern of discs taken from a medieval manuscript of the fifteenth century (Fig. 18). To correspond to these dining room chairs Godwin designed a matching pair of large oak refectory-style tables with baluster legs and planked tops (CR 208.I–II).[46]

The dining room was dominated by a massive oak buffet with a gabled canopy (on which was depicted the family coat of arms), tall floriated finials, cupboard doors with pierced roundels, and round pull handles with circular escutcheons of the type used in medieval furniture (CR 313).[47] A carved peacock sits on the pinnacle of the central gable, a motif that in Godwin's work has traditionally been attributed to Japanese influence. Although it would become a favorite of the Aesthetic movement, Godwin had already used the peacock motif in the pinnacle of the fireplace in the Council Chamber of Northampton Town Hall in 1861. The peacock is not necessarily proof of Japanese influence, however, for it was also used in medieval sources as a symbol of the resurrection. Willemin depicted a peacock in his *Monuments français*, and John Ruskin illustrated a peacock from San Marco in *Stones of Venice* that is also embossed in gold on the binding. Godwin, like all of his contemporaries, knew *Stones of Venice*[48] and as a medievalist would almost certainly have used Willemin as a source book. In addition, Godwin's friend William Burges owned a Japanese wood-block print with a peacock image, which Godwin would probably

18. "DORSAL." From Eugène Emmanuel Viollet-le-Duc, *Dictionnaire raisonné du mobilier français de l'époque carlovinginenne à la renaissance* (Paris: A. Morel, 1871–75), vol. 1, p. 95.

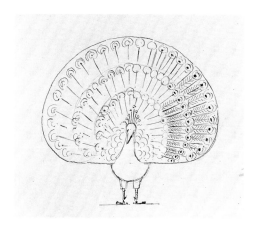

19. E. W. Godwin. Drawing of a Peacock (1870), from a sketchbook. Victoria and Albert Museum PD E.272-1963, fol. 35.

have seen on one of his visits to Burges's home.[49] Drawings of real birds in Godwin's sketchbooks do include a peacock with outstretched feathers, however, so it is quite possible that the source for Godwin's peacock at Dromore Castle was a live example (Fig. 19).[50]

A pair of pine wardrobes (CR 309.I–II), which have been attributed to this commission on the basis of their door fittings,[51] have a great many Gothic details as well – a stylized castellated cornice, studded brass banding extending around each side, and lock plates with central escutcheons and ring handles reminiscent of the Gothic armoires from Bayeux and Noyon Cathedrals. Godwin most likely had seen these illustrated in W. Eden Nesfield's *Specimens of Mediaeval Architecture* (1862).[52] Similar examples dating from about 1500 could be found in England at the Zouche Chapel in York Minster.[53] Bookcases from this commission, of which six identical examples survive, also display a strongly medieval flavor, with pierced triangle end brackets, arched bracket supports, and vertically paneled backboards (CR 311.I–III).

Godwin had obviously studied Gothic furniture originals and made some adaptations for nineteenth-century methods of production and use. He dispensed with the boarded construction and painted decoration of many Gothic examples, and introduced more modern features, such as neatly integrated paneled doors, well-fitted shelves and drawers, and exposed wood grains. Godwin also dealt with issues of function and adaptability. He mounted pieces on casters for easy movement and elevated bottom drawers and shelves well above the floor for easy cleaning. A pair of pine dressing tables with large pivoting mirrors is typical of the inventive and functional furniture that Godwin designed for the bedrooms at Dromore.[54] With their crenellated galleries, paneled doors, and square escutcheons with round pull handles, these dressing tables resemble the medievally inspired furniture yet have the practical additions of casters and mirror glass (CR 312.I–II).

Chinese details also appear in some of the pieces for Dromore Castle. The inward-curling feet of the large oak sideboard designed for the dining room (CR 313),[55] for example, come from the horse-hoof feet or cabriole legs common to the hardwood table and seating forms of the Ming dynasty (Fig. 20).[56] The designs for an ebonized chess table (CR 209) and settee (CR Fig. 119.1),[57] part of a large suite of ebonized mahogany drawing-room furniture, had side panels of latticework decoration that are similar to panels found on many Ming and Qing dynasty forms, including couches and daybeds (Fig. 21), narrow tables, bookshelves, and clothes racks.[58] Even Godwin's specification for the upholstery for the drawing room mentions a Chinese prototype: "yellow satin in colour like that known in China as

20. Ming dynasty waisted daybed with cabriole legs. Museum of Classical Chinese Furniture, San Francisco. From Wang Shixiang and Curtis Evarts, *Masterpieces from the Museum of Classical Chinese Furniture* (Chicago and San Francisco: Chinese Art Foundation, 1995), p. 9, plate 4.

21. Early Qing dynasty low-back bed with three-panel screen railings. Private collection, United States. From Tian Jiaqing, *Classic Chinese Furniture of the Qing Dynasty* (London: Philip Wilson, 1996), p. 210, plate 95.

Imperial yellow."[59] The exotic combination of "mahogany ebonized by penetrating stain and dry polished" with the yellow satin must have been quite eye-catching.

EARLY DOMESTIC FURNITURE DESIGN

The simplicity and functionality of the designs for the Dromore Castle commission were carried a step further in the pieces Godwin designed in 1867 – simultaneously with the Dromore commission – for his own interiors, representing some of his earliest known furniture. The most famous of the pieces he made for his own use was the ebonized Anglo-Japanese sideboard (1867), which would be made in several versions over the next twenty years (CR 304, 304.a–i). With its gridlike rectilinear form, complicated interplay of solid and void, and lack of superfluous ornamentation, this piece fulfilled the intentions Godwin had for designing furniture appropriate for his own use. Writing some ten years later Godwin explained:

> When I came to the furniture I found that hardly anything could be bought ready made that was at all suitable to the requirements of the case. I therefore set to work and designed a lot of furniture, and, with a desire for economy, directed it to be made of deal, and to be ebonized. There were no mouldings, no ornamental metal work, no carving. Such effect as I wanted I endeavoured to gain, as in economical building, by the mere grouping of solid and void and by a more or less broken outline.[60]

Some of this earliest domestic furniture was made by the short-lived Art Furniture Company, 25 Garrick Street, Covent Garden, which advertised itself in November 1867 as "Prepared to supply at ordinary trade prices, domestic furniture of an artistic and picturesque character designs by C. Eastlake, A. W. Blomfield and W. [*sic*] Godwin and other architects."[61] Godwin designed sixteen pieces for the firm, from Japanese to Gothic Revival. His earliest Anglo-Japanese buffet (CR 304-a) made in deal was executed by them, as were some of his Gothic Revival chair designs for Dromore, including the Eagle chair (CR 114).[62] By 1868 they were out of business; their failure was noted by a reviewer in *Building News* who theorized: "Either the business operations of the company have not been characterized by sufficient commercial energy, their goods were far too expensive, or love of art has made very

little progress, and the common public still prefer the meretricious designs of the modern upholsterer."[63]

Other early Godwin pieces were made by the firm of Gillow and Company of Lancaster and London. Notes in Godwin's ledger books indicate that they made a wicker chair, round armchairs, dining room chairs, an escritoire, music stand, table, dressing table, and wardrobe.[64] An ebonized table, stamped "Gillow" and similar to Godwin's classic coffee table design, now in Lotherton Hall, Aberford, may relate to a Gillow commission (CR 220).

The firm of Green and King, responsible for the Northampton Town Hall commission in 1864, made domestic furniture according to Godwin's designs – including dining room chairs (with and without arms), escritoire, music stand, and table.

By 1868, especially after the failure of the Art Furniture Company, the firm of William Watt, 21 Grafton Street, London, was producing the majority of Godwin's domestic furniture.[65] Little is known about the Watt firm except that the business was established in 1857.[66] While Godwin's ledgers, cashbooks, and diaries indicate that the Dromore commission was probably his first business dealing with Watt, the scope of their professional association is documented by the catalogue *Art Furniture from Designs by E. W. Godwin, F.S.A., with Hints and Suggestions on Domestic Furniture and Decorations* (1877).[67]

Twenty plates of Godwin's work in all the popular historical styles, in addition to the Anglo-Japanese, were lithographed. This fashionable catalogue also included whole interior schemes with accompanying instructional notes to illustrate and explain to middle-class consumers how to incorporate articles of decoration in a tasteful and unified interior. The preface contained a letter from Godwin to its readers and the instructional notes, though under the signature of William Watt, were largely written by Godwin. In a long diary entry, Godwin mentions that he examined Watt's manuscript corrections and rewrote major portions of it.[68]

The Watt association lasted until the death of Watt in 1885. His widow then sold the firm to some businessmen who continued the firm under the name of the "Representatives" of the late William Watt and moved the firm from 21 to 10 & 12 Grafton Street. They continued the work of the firm until 1887–88, at which time the firm closed its doors.

ANGLO-JAPANESE FURNITURE

Many of Godwin's most successful designs are in the Anglo-Japanese style, for which he is best known. Plate 8 of Watt's *Art Furniture* shows eight pieces of Anglo-Japanese drawing-room furniture; Plate 14 illustrates an elaborate Anglo-Japanese drawing room decorated with ebonized Anglo-Japanese furniture, patterned walls and ceiling, stained glass windows, Oriental carpets, and striped draperies. According to Godwin, these were "more or less founded on Japanese principles"[69] and not actual specimens since stands, small cabinets, trays, lanterns, hibachi, and folding screens were the only furniture forms to be found in a Japanese interior.

Godwin's study of Japanese arts and crafts probably began in the late 1850s. His friend William Burges was one of the earliest collectors of Japanese prints and Godwin himself, in 1862, decorated his Bristol house with Japanese prints and an array of Oriental objects throughout, many bought in and around Bristol, which was one of the busiest shipping centers importing Japanese artifacts in the second half of the nineteenth century. Godwin was probably also well aware of the Japanese art exhibited at the 1861 Industrial Exhibition in Bristol and the Japanese display at the International Exhibition of 1862.[70] In addition to Japanese prints, he also began to

study contemporary photographs of Japan and foreign accounts of travelers to Japan. Unlike Christopher Dresser, who visited Japan in 1876, Godwin never had the opportunity and had to rely on what was imported into England or reported in the newspapers and journals. Godwin's sketchbooks reveal that both Hokusai's *Manga* and Aimé Humbert's *Le Japon illustré* (1870) were rich sources for furniture forms and architectural details. His two-part article "Japanese Wood Construction," written for *Building News* in 1875, was largely taken from these two well-illustrated sources.[71] He also made frequent visits to the library of the British Museum, which had one of the major collections of Japanese books, manuscripts, and drawings in England. Some notes in his sketchbook are annotated "Douglass [*sic*] Jap. Book Dept. BM,"[72] referring to Robert Kennaway Douglas, Keeper of the Department of Oriental Printed Books and Manuscripts of the British Museum.[73] Moreover, Godwin himself was a collector of Japanese artifacts. An inventory contained in one of his diaries from the late 1860s reveals that he owned Japanese prints, furniture, textiles, ceramics, and bronze ware. This inventory also discloses the shops that he frequented in London in his quest for Japanese objects – notable among them Wareham, Leicester Square; Farmer and Rogers' Oriental Warehouse, Regent Street; and Hewett's, Baker Street.[74]

Godwin adapted many of the motifs and features found on these Japanese forms and in these published sources to suit his Western examples. Although he is often credited with being one of the first designers to combine Western furniture forms with Eastern features, it is not certain who coined the term Anglo-Japanese. Godwin's early ledger books of the 1860s refer to these pieces as Japanese, not Anglo-Japanese. Godwin first uses the term in his 1876 article in *Architect* on Liberty's new Regent Street shop, in which he refers to the Liberty emporium as the "Anglo-Japanese Warehouse."[75] (It is not until 1877, when he was working on designs for William Watt's stand for the 1878 Exposition Universelle in Paris, that Godwin's sketch annotations use the term Anglo-Japanese.[76]) The firm of Shoolbred and Company also does not use the term Anglo-Japanese in the illustrations for its 1874 catalogue – the plate for a bedroom suite with Japanese motifs is entitled "Bed Chamber Furniture in The Japanese Style."[77] Articles from the years 1875 and 1876 highlighting English products influenced by Japanese wares continue to use the term "Japanese style" or "Europeanized Japanese art."[78] The term Anglo-Japanese reappears in the Watt catalogue in 1877 as well as in press reviews of the Watt exhibition stand at the Paris Exposition Universelle of 1878. In June 1878 *Building News* illustrates some of Godwin's furniture for the Paris Exhibition under the title "Anglo-Japanese Furniture" (Fig. 22).[79] The following month, the designer and critic Lewis F. Day, in a review for *British Architect and Northern Engineer*, writes that the furniture in the stand of William Watt "is in the Anglo-Japanese style which we are beginning to associate with the name of Mr. E. W. Godwin."[80]

In any case, the Anglo-Japanese furniture style was one of Godwin's most popular in the late 1860s and 1870s. The Watt catalogue alone illustrated more than a dozen pieces, including an oak washstand now in a private collection in New York. Described as an "Anglo-Japanese wash stand" designed for the bedroom, this piece exhibits many of the features characteristic of this Japanese-influenced style (CR 316): rectilinear outline; combination of closed and open spaces; subtly integrated side drawers of the type found in Japanese *tansu*; cutout or cloud motifs in the leg brackets, derived from Japanese architectural forms; the encasing of the lower legs with brass fittings; and the bail handles with round escutcheons. The use of oak, the paneled cupboard doors, the white marble top and black splat, and the brass casters all speak to Western furniture traditions. Godwin combined these two traditions into a well-designed and aesthetically pleasing piece of furniture that merits the Anglo-Japanese appellation.

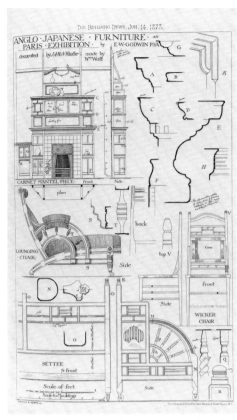

22. Illustration of "Anglo-Japanese Furniture" from the William Watt stand at the Paris Universal Exhibition in 1878. From *Building News*, June 14, 1878, p. 603.

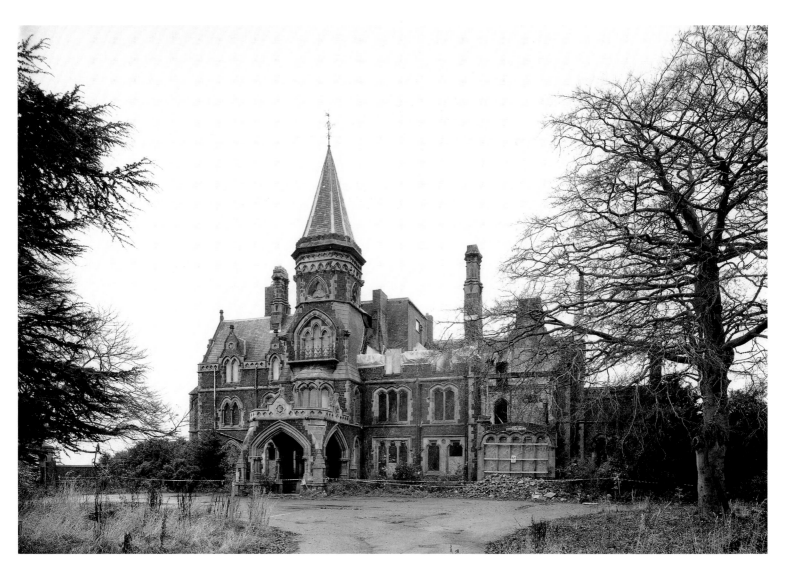

23. John Ross. Grey Towers (1866–68), exterior. Nunthorpe, south of Middlesbrough. National Monuments Record, RCHME.

Godwin did not design Anglo-Japanese furniture exclusively for the firm of William Watt, however. His ledgers and sketchbooks indicate that he also created a great number of pieces in the Japanese style while under contract with Collinson and Lock (1872–74). These pieces, some of which include actual Japanese lacquer panels, represent some of the most beautifully crafted items of Godwin's entire furniture output, and the superior cabinetmaking abilities of Collinson and Lock are in high contrast to the lower-quality work of William Watt's firm.

Two of Godwin's largest commissions for Collinson and Lock involved Anglo-Japanese furniture design and interior decoration. The first was in 1873 for John Wingate McLaren, 69 Addison Road, Kensington, London, and included at least seven pieces of furniture: an easy chair, lady's chair, music cabinet, low cabinet for the drawing room, a drawing-room table, a mantelpiece, and a foliage-decorated fireplace.[81] Unfortunately, none of the furniture designed for this commission has been located or identified.

The second large Collinson and Lock commission was for Grey Towers (1866–68), a large Gothic Revival structure in Nunthorpe, south of Middlesbrough, that was built for William Randolph Innes Hopkins, mayor of Middlesbrough,[82] and redecorated by Collinson and Lock in 1873–74 (Fig. 23). Godwin worked on this commission from April 1873 to July 1874, designing more than twenty-five pieces of

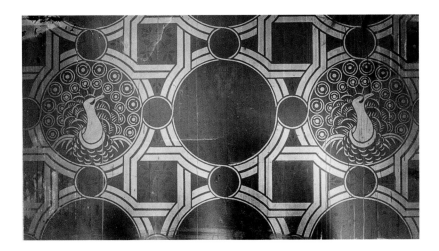

24. E. W. Godwin. Peacock wallpaper, Anteroom, Grey Towers (1873–74).

25. E. W. Godwin. Drawing of Anglo-Japanese Corner Cabinet (ca. 1873). Victoria and Albert Museum PD E.234-1963, fol. 40.

furniture in addition to extensive wall and ceiling decorations.[83] Although Grey Towers still stands – albeit in ruins – and patches of the Anglo-Japanese wall decoration still remain (Fig. 24),[84] there are no surviving pieces of furniture from this commission. Two designs for Anglo-Japanese style coffee tables annotated "Grey Towers" do appear in Godwin's sketchbooks, giving some idea of his furniture designs for this commission (see CR Fig. 223.1).[85] The first of these tables has an open lattice decoration, lower shelf, and rounded top. The second, of smaller dimension, has a cabinet section fronted by sliding doors, a low shelf, and flat top. Both tables were two feet four inches high with thin, squared legs, angled struts, and delicate inlay work. A related table is believed to have been in the possession of Asian ceramics and furniture collector Anthony Gibbs in 1878 when it was last photographed in a bedroom in a tower of Tyntesfield in Wraxall, Bristol (CR 223).

Drawings for other pieces of furniture from this commission that correspond to entries in his ledger books and diaries, especially designs for angle cabinets and hanging cabinets, can also be found in Godwin's sketchbooks.[86] They reveal pieces of furniture with bold outlines and Oriental-inspired cornices reminiscent of his Anglo-Japanese pieces of the late 1860s (Fig. 25). In contrast to his earlier furniture designs, however, these pieces now have fuller proportions and make greater use of curved lines, as can be seen in the aggressive sweep of the top surface of the corner

26. E. W. Godwin. Photograph, ca. 1963, of the White House, Tite Street, London, built for James McNeill Whistler in 1878. Photo by The Royal Borough of Kensington and Chelsea Libraries and Arts Service no. B498

cabinet with its arched rib forms. This expanded form was probably the result of the larger size of the Grey Tower rooms.

To correspond to the Japanese-inspired studio/houses that he devised for the painters James McNeill Whistler (Fig. 26) and Frank Miles, Godwin designed specially commissioned pieces in this style from 1877 to 1879. A drawing for a built-in hanging cabinet with surrounding shelves annotated "Mr. Whistlers House . . . Tite Street Chelsea EWG" shows the type of elegant Japanese-inspired furniture that Godwin designed for Whistler (CR 373).[87] The cabinet's cornice with upturned ends, folding doors, and rounded elbow struts give this piece an unmistakable Japanese feeling. It must have corresponded very well with Whistler's collection of blue-and-white porcelain and his other Oriental accessories.

For Frank Miles's studio/house at 44 Tite Street, London (Fig. 27), in 1879 Godwin designed a pair of built-in settees in an inglenook in the drawing room, integrating Japanese-inspired latticed wall panels to serve as the back and one side of each (CR 170). Godwin may have even used actual Japanese accessories in the interior; a letter from Miles to Godwin dated 14 December 1878 addresses the use of Japanese panels in the door frames: "I will go in for one door with the Japanese work. . . . I have no doubt they are very beautiful and will be very effective: you must decide which door to put them in."[88]

The mahogany tea table with shaped flaps and stepped lower shelf in the National Trust, Ellen Terry Memorial Museum, Smallhythe Place, Kent, the former country home of his lover, actress Ellen Terry, is one of Godwin's most overtly Japanese designs (CR 211-a). Its asymmetrical shelves, latticework stretchers, angled joints bound with tooled brass braces, and rectangular legs encased in gilded brass shoes all point to Japanese influence.

A gong and stand designed by Godwin about 1875, now in the Lady Lever Gallery, Port Sunlight, also shows unmistakable Japanese influence (CR 408). The

27. E. W. Godwin. House built for Frank Miles, 44 Tite Street, London, 1878–79. *Country Life* Picture Library.

lattice panels at the bottom of the stand are reminiscent of Japanese latticework, the top rail or lintel is based on the *tori* gates of Shinto shrines, and the top edges are covered with brasswork attached with rivets, similar to that found on Japanese cabinets.

By the 1880s Godwin's interest in this style was fading but he still produced a number of Anglo-Japanese pieces for W. A. and S. Smee, 89 Finsbury Pavement, London, as the rage for Anglo-Japanese furniture was undiminished. A reviewer in *Cabinet Maker* commented on the persistence of British taste for Japanese furniture and other arts: "For some years the quaint, quietly gay busily dexterous, and in an eminent degree reconciling qualities of Japanese art have taken so strong a hold on the true discernment of Englishmen that such booms are not likely to take flight and disappear in our time, or in that of our children's children."[89]

An oak stand made for Smee with long tapering legs and valanced top decorated with an incised rosette at each corner is one of the most eloquent and decidedly Anglo-Japanese pieces Godwin ever produced (CR 246). In addition, representatives of the firm of William Watt continued to manufacture versions of Godwin's Anglo-Japanese sideboard stenciled with gold chrysanthemums in Australia until 1887. One of these is now in the collection of the National Gallery of Victoria, Melbourne (CR 304-g).[90]

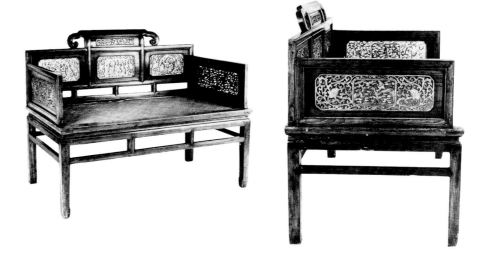

28. Ming dynasty couch-bed with lattice railings. Honolulu Academy of Arts (4961.1). From Robert Hatfield Ellsworth, *Chinese Hardwood Furniture in Hawaiian Collections* (exh. cat., Honolulu Academy of Arts, 1982), fig. 76, p. 90.

29. E. W. Godwin. Drawing of "Wash Hand Stand," from a sketchbook of 1877. Victoria and Albert Museum PD E.243-1963, fol. 31.

CHINESE HARDWOOD FURNITURE AS A SOURCE

Not all of Godwin's Anglo-Japanese work, however, was derived from Japanese specimens. In fact, little differentiation was made in the West between Japanese and Chinese furniture and other crafts in the second half of the nineteenth century, when the study of arts and crafts from China and Japan was in its infancy. Objects from both countries were considered "chinoiserie" in the 1850s and 1860s and the new term *japonisme* was common by the third quarter of the nineteenth century. This change of terminology, however, did little to clarify the confusion. In 1878 critic Ernest Chesneau still commented on the blurring of distinction between Chinese and Japanese objects when he wrote that ". . . these curiosities coming from the Far East were indistinctly confused . . . under the name of chinoiserie."[91]

Chinese hardwood furniture, then, particularly of the Ming and early Qing dynasties, played a crucial role in Godwin's Anglo-Japanese designs. Wilkinson has identified many London shops where Godwin could have viewed or even purchased such items, particularly Hewett's on Baker Street, which was a short distance from Godwin's first London office at 23 Baker Street.[92] Furthermore, Godwin's ledgers indicate that he owned pieces of Chinese furniture as well as other Chinese accessories, including a Chinese carved wooden screen.[93] Not only were a number of details of Chinese furniture adapted, such as the spiral or cloud-shaped feet used in the buffet at Dromore Castle (CR 313), but certain overall forms were appropriated as well. Two forms that are particularly prevalent are the Chinese *kang* or couch, which seems to have been the prototype for Godwin's sofa design,[94] and the Chinese compound wardrobe, which Godwin used for his double wardrobe form. A comparison of a Ming couch-bed with latticed railings (Fig. 28)[95] and a Godwin ebonized mahogany sofa or settee in the Bristol Museums and Art Gallery (CR 119) also reveals interesting similarities to Chinese forms: the rather deep seat, the latticed side railings curving down to meet the front legs, and the boxlike platform elevated high above the floor. The straight legs on casters, upholstered splat and seat, and upright back posts with ball finials, however, are Western furniture adaptations.

Godwin found the Chinese compound wardrobe – it is customary in Chinese bedrooms to have two identical wardrobes stand next to each other (Fig. 30)[96] – particularly useful and his sketchbooks contain many designs for wardrobes/chests of

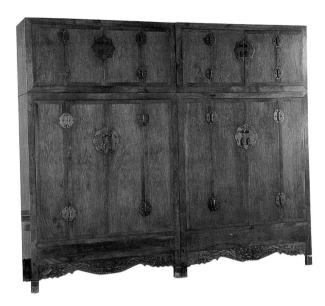

30. One of a pair of Ming dynasty wardrobes, c. 1550–1620. Victoria and Albert Museum FE.73 and FE.74-1983, Addis Bequest. From Craig Clunas, *Chinese Furniture* Far Eastern Series, Victoria and Albert Museum (London: Bamboo, 1988), p. 92.

drawers intended to be made in pairs. Wardrobes made in pairs were used in his own bedroom, which he described in *Architect* in 1876: "My wardrobe was a compound design – half chest of drawers and half hanging wardrobe – and, like the trouser patterns of some years ago, required a pair to show the complete design."[97] Plate 15 of William Watt's catalogue illustrates a bedroom furnished with a pair of wardrobes that are mirror images of each other (CR 349). A similar, single wardrobe in the Bristol Museums and Art Gallery may once have been one of a pair that was used by Godwin himself (CR 307). What is interesting about the relationship of the Godwin wardrobes to their Chinese prototypes is Godwin's decision to adopt their modular arrangement. The Godwin wardrobe has been fabricated in components that can be easily taken apart and reassembled; each section is identified with its own William Watt label (see CR Fig. 307.1). The pine wardrobe in Bristol, for example, is made up of four separate components – chest of drawers, hanging wardrobe, bookcase, and cornice – and a similar version of this wardrobe exists with an additional hanging component (CR 386).[98] These wardrobes could be assembled to meet the storage needs of the individual client, a major innovation for the period which presaged the modular furniture of the twentieth century.

Godwin's adaptation of Chinese forms to suit Western furniture needs is also evident in his design for center tables. These tables, which were major pieces of drawing room furniture in the Victorian period, bear a striking resemblance to the Chinese hardwood stands used for lanterns or water basins in the Ming period.[99] A comparison of a Ming washbasin stand and Godwin's octagonal center table for Collinson and Lock (CR 215) reveals a similar multilegged form with radiating stretchers.[100] That Godwin was aware of these forms is confirmed by the appearance in his sketchbooks of a standard Ming-period stand with carved towel rack annotated "Wash Hand Stand" (Fig. 29).[101] A Qing dynasty flower stand in huali wood that imitates a bamboo form (Fig. 31) has the same elegant curving legs that Godwin used on his center tables (CR 213).[102] Godwin may also have been influenced by the bamboo and cane furniture from China that was imported into England in vast quantities and sold in the Oriental warehouses and bazaars that he frequented.[103] (It was also exhibited in the Chinese sections of the international exhibitions after 1851.) A Chinese watercolor of a bamboo furniture shop in Canton

31. Qing dynasty flower stand on curved legs. Rongbaozhai, Beijing. From Tian Jaiqing, *Classic Chinese Furniture of the Qing Dynasty* (London: Philip Wilson, 1996), p. 168, figure 70.

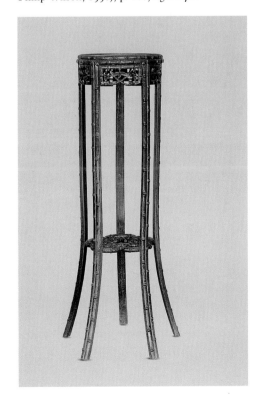

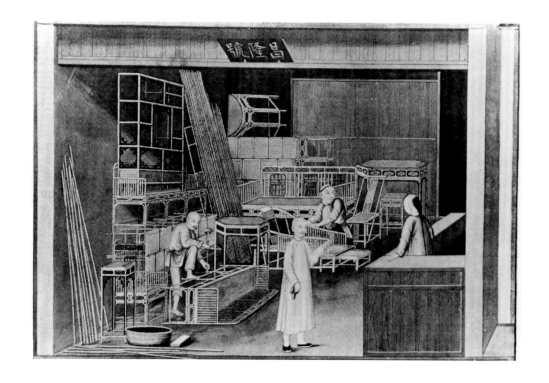

32. Watercolor of a bamboo furniture shop in Canton, 1830. From Gillian Walkling, *Antique Bamboo Furniture* (London: Bell and Hyman, 1979), p. 11, fig. 3.

from 1830 shows the considerable range of bamboo goods made in China at this time for the Western market (Fig. 32).[104] Tables, settees, chairs, stools, bookcases, and other display pieces were all made of latticework bamboo. The lightweight construction and rectilinear outline appealed to Godwin's sense of austere design. He even owned some of it, for in his description of his London drawing room in 1867 he mentions "four cane Japanese armchairs from Baker Street. . . ."[105] Nowhere is the influence of bamboo furniture more apparent than in the music canterbury, or bookcase, which is currently in the National Trust, Ellen Terry Memorial Museum, Smallhythe Place, Kent (CR 338), which Godwin designed for his own use in 1876. The canterbury simulates bamboo furniture in its rounded, splayed legs with incised ring decoration and rounded moldings. Godwin also designed wicker chairs, some of which were illustrated in the Watt catalogue (Plate 2); one is now in a private collection in London. The chair has a split cane seat and back, and lightweight frame with incised ring decoration in imitation of bamboo (CR 107-a).

In addition to adapting Asian features and motifs into Western forms, Godwin at times incorporated actual Chinese and Japanese fragments and accessories into his furniture designs. His celebrated sideboard in the Victoria and Albert Museum (CR 304-b), for example, has panels of embossed Japanese leather paper in its upper and lower cupboard doors. Such panels, originally intended for wallpaper, were for sale in the galleries and bazaars that specialized in Asian arts and crafts in the 1860s and 1870s in London. (William Burges had five examples in his vast collection.)[106] In an article in *Architect* Godwin recommended the use of Japanese leather paper "for filling the small panels of cheap furniture."[107] Another version of the sideboard, now in the Bristol Museums and Art Gallery (CR 304), has had inserted into its upper left cupboard doors pieces taken from a Japanese watercolor that depict a stylized Japanese floral arrangement with a hovering butterfly.[108] Descriptive notes from William Watt's *Art Furniture* indicate that an "Oriental curtain of gold embroidery on yellow satin"[109] hung over this sideboard's right-hand cupboard. A photograph from 1920 showing the sideboard in the Chelsea sitting room of Ellen Terry

33. Photograph (ca. 1920) of Ellen Terry's sitting room in Chelsea, showing the Bristol sideboard. From "Two Interiors at the House of Miss Ellen Terry at Chelsea," *Femina* (October 1920), p. 52.

reveals that this curtain was embroidered with two addorsed peacocks;[110] in addition, an arrangement of Asian accessories sat on the sideboard's many display surfaces, blending with other decorative elements (Fig. 33).

This was not the only instance of Asian-style fabrics being incorporated into a Godwin furniture design. A design for a large oak sideboard (CR 355) shows two pleated curtains (instead of cupboard doors) decorated with Japanese birds, and a design for an ebonized buffet (CR 347) shows a pleated curtain decorated with Japanese chrysanthemums and a zigzag pattern covering one compartment; both designs appear in Watt's *Art Furniture*.

Other Asian accessories can be found in many Godwin pieces. A walnut cabinet in the Victoria and Albert Museum (CR 342) has Japanese carved boxwood floral panels as well as ivory *netsuke* in the form of monkeys for handles (hence its nickname, the "Monkey Cabinet"). Such Japanese boxwood panels and other Asian decorative accessories could be purchased at Liberty's East Indian Art Warehouse or even custom ordered from Japan "to any character of drawing."[111]

Japanese lacquer panels also made their way into Godwin's cabinetwork. He designed a series of cabinets for Collinson and Lock with fragments taken from actual Japanese boxes and articles of furniture. These cannibalized fragments appear on a cabinet illustrated in photographs of the Collinson and Lock stand at the Philadelphia Centennial in 1876 (CR 335). (An annotated drawing in Godwin's sketchbooks reveals that the cabinet was made of panels from a Japanese box framed in ebonized satinwood.[112]) An Anglo-Japanese cabinet with Japanese lacquer panels from about 1875 (CR 337), now in a private collection in London, may have been one of the pieces from this series. Although it does not relate specifically to any of Godwin's sketchbook drawings, it has many unmistakable features common to his Anglo-Japanese forms, including diminutive proportions, complicated play of solids and voids, rounded brackets, feet sheathed in metal, and a combination of U-shaped bail handles and ring pulls with round escutcheons. The Japanese lacquer panels are painted with prunus and cranes on a red metallic background, and the

larger panels on the central cupboard doors are edged at the corners with metal hinges attached with raised rivets identical to those used on the Philadelphia Centennial cabinet (CR 335). Godwin's sketchbooks also show that Japanese panels were used in many of the mantels and cabinets he designed in the 1870s.[113]

Godwin's adornment of Anglo-Japanese furniture was not strictly limited to Asian accessories, however; he also incorporated Western adaptations of Asian designs. Chief among these were the blue-and-white tiles he installed in some of his furniture forms, particularly dressing tables and overmantels, as part of the general trend in the 1870s and 1880s to incorporate artistically decorated tiles into forms as diverse as chairs, sideboards, and plant stands. Because they were durable and easy to clean, tiles were especially suitable for tabletops and the backs of washstands and dressing tables. Godwin even designed some of these tiles. His ledger books and articles in the architectural press indicate that he worked for Minton Hollins and Co. of Stoke-on-Trent, Staffordshire,[114] and Burmantofts of Leeds, both tile manufacturers.[115] A Godwin dressing table in the Bristol Museums and Art Gallery has blue-and-white Minton tiles in a Persian-style floral pattern for its splashboard (CR 317), and an Anglo-Japanese table illustrated by Aslin has Minton tiles on its surface (CR 226-b).[116]

THE INFLUENCE OF GEORGIAN FURNITURE

Georgian furniture forms without doubt had an impact on Godwin. His earliest home in Bristol was furnished in 1862 with "carefully selected Antique furniture . . . a reversion to the taste of the eighteenth century."[117] This unusual appreciation for Georgian furniture was shared by the Pre-Raphaelite painter Dante Gabriel Rossetti, who in 1862 furnished his Chelsea house with an assortment of eighteenth-century furniture mixed with Japanese ceramics and other period furnishings. And Charles Locke Eastlake, in his *Hints on Household Taste*, described early Georgian joinery as "sound" and "artistic,"[118] and in 1874 *Builder* proclaimed the workmanship of the eighteenth century "first-rate."[119] By this time many Queen Anne-style houses sprouting up in London were being furnished with actual Georgian furniture bought in London's many second-hand furniture shops in Leicester Square and Wardour Street, a trend that continues today.

Recognition of the fine craftsmanship of Georgian furniture went hand in hand with the flourishing business of reproducing Georgian furniture that continued throughout the nineteenth century. Many of the large British firms, among them Gillow of Lancaster and Wright and Mansfield, reproduced Sheraton, Hepplewhite, and Adam furniture. The trade periodicals also popularized this trend and in the 1880s devoted a great deal to original late-eighteenth-century furniture and its reproductions. In 1886 *Cabinet Maker* remarked that Wright and Mansfield were "the leaders of that pleasing fashion which has happily brought back into our houses many of the charming shapes of the renowned eighteenth-century cabinet makers."[120]

Godwin's appreciation of Georgian furniture continued throughout his life. In a series of articles in 1876 on the decoration of his London chambers, he wrote that he had "grown tired of modern designs" and thus furnished his dining room "with a bow-fronted sideboard, Chippendale chairs, flap tables, cabinets, bookcases, and a little escritoire, all of admirable colour, design and workmanship."[121] The soberness of execution, rectilinear conception, beautiful proportions, lightness of form, and optimal use of wood grain were prevalent in mid- to late Georgian furniture, all properties that would have appealed to Godwin. His pursuit of Georgian furniture was also fueled by its low cost, which was, he wrote in the same article, "so much below the least expensive of the specially made goods of the present day. . . ."[122]

A tea table Godwin designed in 1877 shows unmistakable Sheraton influence (CR 228).[123] Its slender turned legs, rectilinear stretchers, folding top, shaped apron support, and mahogany wood all point to the "spider-leg" tea tables popular in England in the 1760s. An elegant mahogany example from about 1765 at the Vyne, Hampshire,[124] is quite similar to the Godwin table and may have been the kind of slender so-called flap table that served as a prototype. Moreover, Godwin's sketchbooks reveal that in May 1876 he consulted Sheraton's *Cabinet Maker* in the British Museum for a chest of drawers.[125]

Godwin's "Four Seasons Cabinet" now in the Victoria and Albert Museum (CR 344) also exhibits explicit Georgian characteristics. With its satinwood veneer, thin elegant proportions, splayed feet, reeded moldings, and open shelves, it resembles the open-shelved dwarf bookcases popular in the last decade of the eighteenth century. The top section of this piece, however, has Japanese features integrated into its overall form. The bell-shaped windows filled with brass latticework and horizontal top railings with metal-tipped finials are similar to the Japanese architectural details Godwin illustrated in his articles in 1875 on Japanese wood construction.[126] Despite these Japanese elements, the overall style of the cabinet is decidedly Georgian.

PAINTED AND EBONIZED WORK

Godwin's decorative work embraced far more than Asian arts and crafts. As the mid-nineteenth-century taste for carved decoration declined, Dante Gabriel Rossetti (1828–1882) and William Burges revived the fashion for painted decoration in the late 1850s with their large, medievally inspired cabinets decorated with representational subjects. An example of this vogue is the Yatman cabinet designed in 1858 by William Burges and painted by E. J. Poynter (1836–1919) with classical scenes representing the story of Cadmus.[127] Painted panels became the fashionable mode of decoration in art furniture of the 1870s and 1880s,[128] and panels painted in a Pre-Raphaelite style were especially common in Godwin's designs of the 1870s. With the exception of the panels for his "Butterfly Cabinet" painted by James McNeill Whistler (CR 369; discussed below) and a few other pieces, the panels Godwin used in his furniture continue for the most part the predilection for classical scenes with figures, and were painted by a number of different artists, including Charles Fairfax Murray, Charles Glidden, Godwin's wife Beatrice, and Godwin himself.

The most famous Godwin cabinet with painted figural decoration is a rosewood corner cabinet now in the Detroit Institute of Arts (CR 332). Painted by the Pre-Raphaelite artist and collector Charles Fairfax Murray (1849–1919)[129] and bearing his initials, the cabinet's decoration depicts the legendary Roman figure Lucretia dressed in a classical red garment with a blue cloak; she is holding the long sword with which she took her own life. One of the cabinet's side panels depicts Castitas (Chastity), represented in a crouching position with a nimbus above her; the other depicts Fortitudo (Fortitude), also crouching but with a halo above her head. Known as the "Lucretia Cabinet," the piece was made by Collinson and Lock and later exhibited at their stand at the 1878 Exposition Universelle in Paris.

Classical panels illustrating Jason, Medea, Actaeon, Hercules, and Aesculapius painted by the artist Charles Glidden can also be found on the bottom half of a stained oak bookcase of 1871 that has been separated from the upper structure, one of a series that Godwin designed for the collector Dr. George Bird.[130] In these panels the palette is generally softer, with pastel colors predominating (CR 321).[131]

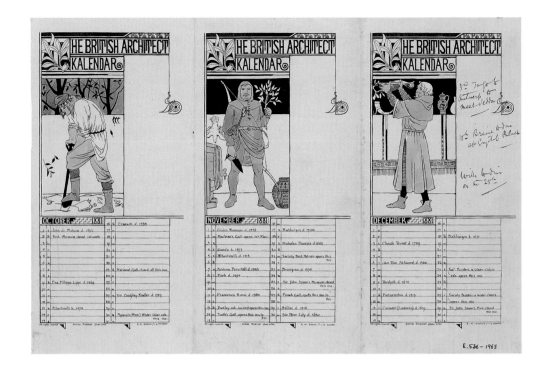

34. E. W. Godwin. Drawing of October, November, and December 1881 for *British Architect Kalendar* published in *British Architect and Northern Engineer* 14 (3 December 1880). Victoria and Albert Museum PD E.536-1963.

Panels painted by Godwin himself are evident in an illustration for a satinwood and ebony cabinet (CR 385) whose panels of classical figures were painted in "black and white by Mr. Godwin" and inset within metal frames.[132] The classical theme of the piece continues in the saber legs adorned with metal winged shields. The cabinet's satinwood and ebony coloring coupled with the black and white of the painted panels reflect the black-and-red color schemes of the antique vases Godwin studied in the British Museum. Godwin used a similar black-and-red color scheme for his 1876 line of Anglo-Greek furniture for Waugh and Sons.[133]

Other painted panels found on Godwin's cabinets were executed by his wife, Beatrice Godwin (1857–1896), who was a painter and designer in her own right."[134] It is believed that she painted the four Pre-Raphaelite-style panels of the upper cupboard of the "Four Seasons Cabinet" (CR 344) after Godwin's figural designs symbolizing the twelve months.[135] Their earth tone colors of red, ocher, and brown on a gilt background blended with the cabinet's golden satinwood veneer and brass hardware. Godwin reused these panels in 1881 for the *British Architect Kalendar* (Fig. 34).[136]

The Four Seasons theme was painted by Beatrice on another Watt cabinet (CR 374), which was exhibited in Watt's Grafton Street showroom in October 1879. This hybrid cabinet, called "A bright and elegant piece of furniture" by the reviewer in *Building News*, combined Gothic and Japanese elements; further, the cabinet's "four painted panels representing the Four Seasons" were credited to "Mrs. Godwin, a daughter of the late Mr. Birnie Philip, the sculptor."[137] The illustration accompanying the review indicates that the "Beatrice Cabinet" was made of red mahogany with yellow mahogany moldings, and had sections of clear beveled glass to frame the painted panels, a mirror inset, and delicate brass handles; a colored drawing of this piece appears in Godwin's sketchbook annotated "Watt. Beatrice Cabinet on Stand. Sep. Paid."[138] An angled cabinet with decorative panels, designed by Godwin in 1873 for Collinson and Lock's Grey Towers commission,[139] also had the Four Seasons painted on its panels.

In addition to panels of classical or Pre-Raphaelite inspiration, Godwin's designs did, of course, include Anglo-Japanese painted panels. A three-section wardrobe (CR 363) had panels painted with a combination of bird, fish, and floral scenes in an Anglo-Japanese style. Other Godwin designs show painted panels of abstract floral design. An ebonized corner cabinet (CR 330) has cupboard doors painted with abstract leaves, and a design for a double-sided wardrobe (CR 380) shows painted panels of stylized Anglo-Japanese floral designs.

The revival of painted panels appeared at about the same time that ebonized finished furniture came into vogue. Many of Godwin's pieces had an ebonized finish. His classic Anglo-Japanese sideboards of about 1867 (CR 304) were ebonized, as was a large suite of mahogany furniture that he designed in 1870 for Dromore Castle. Many of the specimens reproduced in Watt's *Art Furniture* are offered in either a plain wood or an ebonized finish, for example his Anglo-Japanese writing table (CR 234) and his circular center tables (CR 213).

This taste for ebonized furniture was part of a general trend to blacken furniture that began in the first half of the nineteenth century with collectors who wanted to furnish their Romantic interiors with ebony furniture they believed to be of Tudor origin. This trend continued into the 1860s, 1870s, and 1880s with the Art Furniture movement. In 1868, *Building News* commented on the fashion for eboniz-ing furniture "by soaking a soft wood, such as poplar or lime, in a strong dye."[140] The taste for ebonized furniture was also encouraged by the ebonized Regency fur-niture and the even earlier black-painted Sheraton fancy chairs that were available for sale in London's antique shops.[141] Another stimulus was contemporary ebonized French furniture, particularly by cabinetmakers such as Henri-Auguste Fourdinois (1830–1907). These consciously historicizing pieces, meant to evoke the great French tradition of *ébénisterie*, were exhibited at international exhibitions in both London and Paris.[142]

Oriental lacquer furniture also played a crucial role in the popularization of ebonized furniture. Lacquer pieces were represented in many of the Japanese prints that were being imported into London at this time; and black lacquer wares and woodwork were on sale in the shops that sold Oriental accessories in the 1860s and 1870s in London[143] and of course were on view at the Japanese Court of the 1862 International Exhibition in London. Godwin was one of the earliest British collec-tors of Oriental art and furnishings, most likely inspired by the black finish of the Chinese and Japanese furniture and accessories that he so admired.

This appreciation of ebonized furniture was shared by fellow designers Morris, Marshal, Faulkner and Co., who in the 1860s designed and produced a series of Sussex chairs in a black finish. In 1871 the London exhibition of T. E. Collcutt's prized ebonized-wood cabinet inspired a rage for ebonized pieces so widespread that in 1880 Max Beerbohm commented on "aesthetes hurling their mahogany into the streets."[144]

Despite the popularity of ebonized furniture, Godwin recognized the shortcom-ings of using too much of it to decorate a room, stating that if a room were to "look cheerful and even comfortable" the ebonizing must be restricted to a few pieces and those enlivened with "inlay of gold or ivory or both."[145] To make these ebonized pieces more attractive, Godwin also used stenciled floral and abstract ornament – a less expensive alternative to painted panels. Chrysanthemums were a favorite motif in Godwin's designs; for example, they are stenciled in gold on the small doors of an ebonized hanging bookcase that originally belonged to Godwin and is now in the Bristol Museums and Art Gallery (CR 305-b).

Circular medallions derived from Irish illuminated manuscripts were another favorite decoration for Godwin and were often stenciled onto the upper cupboard

doors of Godwin's ebonized sideboards – one example is now in the Neue Sammlung, Munich (CR 304-a), and another, which belonged to Alice and Wilfrid Meynell, was illustrated in *Art Journal* in April 1892 (see CR 304-a.2).[146] This type of decoration was also used by Godwin in the ceiling of the drawing room at Dromore Castle (see CR Fig. 304-a.1).[147]

MIRROR INSERTS

Mirror inserts were another popular device Godwin used to lighten the appearance of his ebonized furniture. For example, one of his hanging cabinets of about 1870, currently in a private collection in London, has a rectangular mirror inserted behind its lower shelf (CR 320), and a display cabinet from about 1877 (CR 341) has a series of rectangular mirrors placed behind its canted side shelves as well as a double tier of beveled rectangular mirror plates above the cabinet section.

Mirrored panels were certainly not limited to Godwin's ebonized pieces, however. They abound in his designs, as we can see from the illustrations in William Watt's *Art Furniture*. A Queen Anne-style cabinet (CR 350), a parlor buffet (CR 354), and a corniced sideboard (CR 355) all have mirrored glass inserts to better reflect the ceramic ware displayed on their shelves and display surfaces. The white deal piano Godwin designed for Collinson and Lock that was illustrated in *Building News* (2 January 1874) has a convex mirror just below its reading shelf (CR 407); a walnut parlor buffet has a rectangular mirrored panel at the back of its superstructure as well as a convex mirror fitted above its gadrooned cornice (CR 365).

The prevalent use of mirror glass in cabinetwork in England in the second half of the nineteenth century was a result of the reduced cost of producing it there, due in large part to the repeal in 1845 of the duty on mirror glass and to general advances in manufacturing.[148] As a result, mirror glass – once the prerogative of the rich – became an affordable feature of furniture design.

Godwin also incorporated mirror glass into a great number of his designs for over-mantels, although he was aware that too much mirror glass could result in "an amount of glitter and reflection which borders on vulgarity."[149] In an article on mantelpieces in 1876 he cautioned readers that: "If looking-glass or mirrors are used at all, it should be with considerable caution. It may be taken as a rule that wherever these are employed they should be boldly used, forming marked and important features in the general design, as pictures would be used, or wholly illusory for the purpose of doubling the composition, which would then be specially designed for this object."

Popular during the Renaissance in both Italy and the North and spreading to France in the 1750s, convex mirrors became fashionable in England by the last decade of the eighteenth century. By the opening years of the nineteenth century, they were considered the only acceptable type of mirror. In fact, in his *Cabinet Dictionary* Thomas Sheraton virtually ignores the other forms of mirrors, writing: "A mirror is a circular convex glass in a gilt frame, silvered on the convex side." The distorted image of the surrounding room produced by this form of mirror clearly appealed to Sheraton, who observed that "the perspective of the room in which they are suspended, presents itself on the surface of the mirror, and produces an agreeable effect."[150]

The painter Dante Gabriel Rossetti in the same decade also promoted the use of convex mirrors, decorating his London drawing room at Tudor House with an array of them. Henry Treffry Dunn, his studio assistant, made reference in his memoirs, published posthumously in 1904, to the mirrors in Rossetti's drawing room: "On gaining admission I was ushered into one of the prettiest and most curiously furnished old-fashioned parlours that I had ever seen. Mirrors and looking-glasses of

all shapes, sizes and designs lined the walls. . . ."[151] A watercolor of Rossetti's dining room shows that there was also a large circular convex mirror above the sideboard,[152] a practice copied by Edward Linley Sambourne, who in the mid-1870s placed a similar convex mirror above his dining room sideboard at 18 Stafford Terrace, London, and also hung two smaller convex mirrors on the side walls.[153] Decorating walls with convex mirrors became so de rigueur that the frontispiece of Clarence Cook's *House Beautiful* of 1878 illustrated a convex mirror above the mantelpiece, flanked by a pair of mirrored sconces.[154]

There seem to be an almost equal number of examples with rectangular mirrored panels as the more fashionable convex mirror forms. For the "Jacobean Furniture" suite in Watt's *Art Furniture* (Plate 7) Godwin designed an overmantel with a rectangular mirror (CR 416), whereas for the walnut overmantel of the "Economic Furniture" for the parlor (Plate 16) he created a convex form (CR 420). Some overmantels incorporated both mirror forms, for example the one that appeared under "Student's Furniture" (Plate 4), which had a central convex mirror plus a combination of rectangular mirror panels in a series of ebonized mantel shelves of Japanese derivation (CR 414).

THE SANITARY APPROACH TO FURNITURE DESIGN

These many decorative additions (i.e. blue-and-white tiles, mirror glass) did not encumber Godwin's streamlined furniture designs. His predilection for moderately scaled furniture devoid of carved ornament was in keeping with his general interest in a sanitary, dust-free environment furnished with pieces that would not attract dirt and germs and could be easily moved and cleaned. This concern for domestic hygiene was a frequent theme in his writings. In an 1872 article for *Globe*, Godwin described the domestic household as a "tainted atmosphere with the seeds of disease in every crevice and corner."[155] And in an article on the furnishing of his own house in London he asserted that "cleanliness . . . I take to be the first consideration in all domestic design."[156]

The cholera epidemics in London in 1832 and 1848 and the incredibly high death rate of the working class in the cities led to increased awareness of the need to maintain adequate sanitary conditions in the Victorian household. Advances made by doctors and scientists in understanding the nature and propagation of disease, how germs were transmitted, and the importance of sterilization also raised the general level of consciousness about the importance of maintaining a clean home.[157] Godwin's phobia for dust and dirt reflected these concerns, perhaps reinforced by his own chronic health problems, which persisted throughout his life and led to his premature death.

Godwin's interest in maintaining high standards of hygiene resulted in numerous design modifications in his furniture. Casters were standard on many of his designs from the 1860s, enabling furniture – chairs as well as case pieces and wardrobes – to be easily moved so that the room could be thoroughly cleaned. Casters varied so greatly in both material (brass, white ceramic, black ceramic) (CR 119, 125-a, 111) and size that they were, as Clive Edwards points out, the most popular category of patents between 1620 and 1885, over two hundred and fifty years.[158] Godwin used casters produced by Cope of Birmingham[159] and Parry of Manchester,[160] among others.

In keeping with his emphasis on hygiene, Godwin's case piece designs, particularly those for bedrooms, are generally austere with little or no ornament to attract germs and accumulate dust. Godwin preferred that case pieces for bedrooms be of a plain wood – preferably deal, birch, or ash – and that they be oiled or polished.[161] They were often made shorter than was customary so that their tops could be dusted

frequently and easily. Case pieces are also designed with the lowest drawer or shelf placed well above the floor so that the area underneath was accessible for cleaning. A pine wardrobe Godwin designed for his own use, now in the Bristol Museums and Art Gallery (CR 307), exhibits all of these design modifications.

Godwin's attention to matters of domestic hygiene carried over into his designs for beds. Designs in his sketchbooks for Collinson and Lock[162] and in Watt's *Art Furniture* (Plate 15) show beds made of minimal sections of brass, without testers or curtains, and mounted on casters so fabrics and surfaces would not accumulate dust and the room could be easily scrubbed and cleaned (CR 413). Washstands and dressing tables were also minimally decorated and therefore easily scoured. In furnishing his own bedroom, Godwin recommended a "dressing table and wash stand of plain light wood, deal or birch or ash, neither oiled nor varnished, and designed with plain surfaces so as to be capable of being cleaned and scrubbed like the kitchen tables."[163] A Godwin washstand currently in the Bristol Museums and Art Gallery (CR 317) may have been the one he described. With its simple yet elegant lines, undecorated surfaces, large casters, white marble top, and splash board of blue-and-white tiles, it met Godwin's requirements for a piece of hygienic furniture.

Godwin's upholstered pieces similarly reflect his concern for a sanitary household. Godwin abhorred the overstuffed, multibuttoned seating forms prevalent in the mid-Victorian home, which he referred to as "arrangements of laziness" that assumed an "almost tyrannical position."[164] Advocating function over comfort, Godwin designed his settees to have enough upholstery to render them functional, but not enough to make them inviting. The lattice-sided settee he designed for Dromore Castle (CR 119) and put into commercial production with the firm of William Watt has the minimum of upholstery in its seat cushion, whereas the back support is mostly open except for three modestly padded sections. An Anglo-Japanese settee reproduced in Watt's *Art Furniture* (Plate 14) and exhibited in Watt's stand at the 1878 Exposition Universelle in Paris (CR 146) has one thinly padded backrest in addition to a padded seat, prompting a reviewer to complain: "With its multiplication of turning and cross bars, where is the rest for the arm? Where is the repose for the back or head?"[165]

Godwin designed a great many chairs in numerous styles with cane seats and backs whose flat surfaces would not harbor dust or germs and could be easily cleaned. An Anglo-Japanese side chair in the Musée d'Orsay (CR 136.1), for example, is one of the many lightweight chairs Godwin designed with cane seats. The editor of *Cabinet Maker* praised a round-back study chair with cane panels, which was shown at the 1885 Art Furniture Exhibition (CR 182) at Kensington for being "cleanly or fairly durable," adding that the panels were well-suited to "the placing of those tempting-looking embroidered chair cushions which the Art-needlework ladies turn out in such perfection."[166] Other study chairs illustrated in Watt's *Art Furniture* displayed similar cane panels (CR 149, 150). In addition, his popular Jacobean or Old English chairs first designed in 1867 had cane seats (CR 109), as did an Anglo-Greek chair in the 1880s (CR 185).

Leather was another popular upholstery material for Godwin, especially chairs for the dining room and library. Leather was particularly suitable for these two rooms, where the odors of food or cigars would permeate fabric. His dining chairs for Dromore Castle were covered in a stamped leather (CR 112, 113), as was a design for a footstool for the library (CR 148).

Godwin was so concerned with the accumulation of dust and dirt that he designed day beds and easy chairs with what he called movable seats, an arrangement that, he wrote, "practically precludes the accumulation of dust, pencils, rings, &c. In the crevice at the back" of the form.[167] A design for an oak armchair uphol-

stered in moroccan leather shows this feature (CR 159), and may have been one of the three easy chairs that Godwin used in his own drawing room along with a pair of sofas that also had movable seats.[168]

However, Godwin's inordinate concern with creating a germ-free environment is not reflected in his designs for display furniture, which typically contain a plethora of small shelves for bric-a-brac and ceramic ware. Many hanging bookcases survive, two in the Bristol Museums and Art Gallery; the hardwood example with a broken pediment (CR 319) is particularly appealing. Godwin also designed mantelpieces and overmantels with projecting display shelves. Two overmantels are reproduced in Watt's *Art Furniture*, one with numerous shelves and compartments to show ceramic ware of different sizes and types (Plate 17; CR 417), the other with a series of narrow curved shelves (Plate 6; CR 415), which was made, according to Godwin, "with a special view to the display of China."[169]

Godwin also designed case pieces for "the exhibition of works of art, and the display of objets de vertu." The display capability of a Japanese-inspired cabinet (CR 388) illustrated in *Building News* in March 1886 was admired by the reviewer: "There is no waste of space, and the compartments are so contrived as to permit of objects of many kinds and sizes being advantageously set out, while the top is broad, and useful for large vases and big pieces of ceramic ware."[170] Another Japanese-style cabinet, designed by Godwin specifically "for the display of works of art in a drawing-room or boudoir" (CR 387) appeared in *Building News* later that year.

Noticing the tendency to overload these pieces with art objects, Godwin stressed the importance of displaying a few well-selected items. In an article he wrote on mantelpieces, he complained that "there are those whose *furore* for 'collecting' has entirely outrun their artistic judgment, and whose mantelpieces are literally nothing more nor less than repetitions of the upper part of the vernacular kitchen dresser – a vulgar heap of costly china, where the close proximity of pot and plate interrupt the full appreciation of one and the other. . . ."[171]

FURNITURE DESIGNS FOR MASS PRODUCTION AND MODERN LIVING

Much of Godwin's furniture has a thin, spindly look, perhaps the result of his belief in the greater importance of the fixed architectural features of a room: "In a well-balanced properly-ordered room, the details of windows, doors, mantelpieces, and, indeed, of all distinctly architectural fixtures, should be always bolder than the details of the furniture or moveables."[172] Turning away from the monumental, heavily decorated furniture that was so much a part of popular Victorian taste, Godwin wrote: "I venture to deny the existence of any satisfactory reasons for producing such weighty furniture or such heavy decoration."[173] His desire to deal with function and utility made massively constructed furniture anathema to Godwin, and lightness of construction – "as light as is consistent with the strength required"[174] – became one of the leitmotivs of his furniture design.

When lightness made a piece seem flimsy, Godwin added inventive supports. An armchair that was "extremely light in appearance" (CR 138) was "rendered more than usually strong by carrying the support of the arms down to the lower rails, thus obtaining for what is commonly the weakest part of an arm chair, two points of support and attachment instead of one."[175] To provide extra support for heavier pieces sitting on thin legs, Godwin often added elegant angled or elbow-shaped braces to join the legs to the framework. An ebonized buffet (CR 347), for example, has only four thin legs to support its six-foot-high framework. Godwin reinforced these in the front with elbow struts and on the sides with stretchers. To an Anglo-

Japanese dining room buffet (CR 304) that looks as though it could topple off its four legs, Godwin added angled supports to connect the legs to the structure, adding balance and strength. These buffets, "generally light and simple-framed on the Japanese principle of not producing more solidity in the supports than actually required," were admired by contemporary reviewers,[176] and this lighter, more practical treatment anticipates themes of modern furniture design.

Unlike William Morris (1834–1896), who was ambivalent toward machinery and preferred the methods of medieval craftsmen, Godwin had no qualms about designing for the many art manufacturers who used machines to mass-produce goods for the growing middle-class market. He was well aware, however, of the consequences of the division of labor in furniture production in late-nineteenth-century London with its highly specialized workshops dominated by wholesalers, and wrote despairingly of its effect on craftsmen who "are not such men as machines":

> One man has past the prime of his life and will spend the fag end of it *in shaping chair legs of one pattern*! Another chains down his being to spindles and another to seats! And with this beautiful, inspiring, soul-raising system, countenanced by us and encouraged by the commercial, that is to say, the soul-snubbing, money-making, middle-men of society, standing between the buyer and the producer, we can find time to pat one another on the backs of swallow-tailed coats and congratulate one another in white kids gloves on the progress of our schools of art as we wander listlessly about at soirée and reception . . . cannot some one . . . comprehend the atrocity of this machine-man system in English trade? The wonder to me is not that there is brutality here and there among the people we are accustomed to class as British workmen, but that there should ever be anything else but brutality.[177]

Godwin shared a certain amount of Morris's nostalgia for the elevated status and accomplished decorative work of the artist of the Middle Ages and the Renaissance, who, Godwin tells us, "filled up the whole of his time for some years in painting and decorating furniture, seats, beds, caskets, &c."[178] Nevertheless, Godwin understood the need to produce well-designed, functional pieces to meet the aesthetic demands as well as the budgets of the middle-class consumers of the nineteenth century.

Godwin, like Morris, grappled with the dilemma of affordability throughout most of his working life. In his architectural commissions it took the form of parsons' houses, cooperative housing, and the affordable housing for Bedford Park residents. His early experience in 1867 with the Art Furniture Company, which went out of business in 1868 because its furniture was beyond the economic reach of its clientele, taught Godwin the seriousness of the exigencies of economic conditions,[179] and producing well-designed furniture at an affordable price was one of his primary aims. In writing of his early pieces he recalled that he "designed a lot of furniture and with a desire for economy, directed it to be made of deal, and to be ebonised."[180] This concern with economy affected the framing elements of his furniture as well. Thus, he wrote of reducing the "scantling or substance of the framing and parts of the furniture . . . to as low a denomination as was compatible with soundness of construction. This seemed desirable for economy's sake in making."[181]

Concern with matters of economy carried over into the advertising and promotional materials linked with his work through the 1870s and 1880s. In his preface to the *Art Furniture* catalogue (1877), Godwin admonished his manufacturer William Watt to "continue . . . producing furniture of refined design, of good workmanship, of reasonable cost. . . ."[182] In addition, Godwin offers "Economic Furniture" (Plate 16) for the parlor and bedroom that he "designed for single people living in small chambers."[183] Even at the end of his career furniture that could be economically produced was at the forefront of his design agenda. An illustration of a hanging

cabinet and a cheap chair he made for *Building News* (18 December 1885) was titled "Working Drawings of Inexpensive Furniture by E. W. Godwin F.S.A." (Fig. 35).[184]

Godwin's views on utility were interrelated with cost effectiveness. He wrote that "the greatest-utility-at-the-least-cost principle is the only certain road to beauty . . . in furniture."[185] Further, to Godwin pretension was a sure road to failure, as it reflected the "vulgar desire of exhibiting money's worth."[186] He admired the plain unadorned table, three-legged stool, plate rack, dresser, and hanging shelves often used in the kitchen, forms which had not changed since the Middle Ages. The Windsor chair was the only new form of furniture he admired, one he claimed "was an innovation supported by genuine merit."[187]

Godwin continually sought to maximize function at affordable cost. To this end, he incorporated multipurpose mechanisms into his furniture forms. A Godwin design for a music stool (CR 163) includes a mechanism to raise its seat in order to accommodate the size of the player and to store music. The same mechanism was used in a Godwin design for a work table (CR 412) to adjust its height. A Godwin daybed reproduced in *Furniture Gazette* had, according to its accompanying description, the mattress and head-rest "arranged to move, so that it can be made up as a bed" (CR 147).[188] A bookstand Godwin made for William Watt (CR 423) that appeared in *Building News* had what the reviewer called "a novel contrivance having four sides, and turning on a centre which stands on a tripod, so that a considerable number of books may be consulted by a reader who may be sitting at a writing table, without quitting his seat."[189]

The most common multipurpose feature Godwin added was the hinged shelf he used on many of his cabinet forms and tables, ranging from the classic sideboard (CR 304) to the Anglo-Japanese table at Smallhythe Place, Kent (CR 211-a). The concept of hinged shelves supported by swinging flaps originated with the Pembroke table of the eighteenth century, which had two drop leaves so that additional surface space was available when needed. Hinged shelves were not an isolated phenomenon, however; eighteenth-century cabinetmakers experimented with and incorporated a wide range of mechanisms to expand the comfort of their products and to appeal to the taste for novelty. This quest for comfort and ingenuity continued throughout the nineteenth century, although Godwin himself was less concerned with comfort than with the increased functionality such mechanisms could bring to traditional furniture forms.

Godwin's interest in functional furniture carried over into designs for the nursery, although few of these pieces survive. He railed against the idea of the nursery as a "show-room" and encouraged the adoption of plain, hygienic furnishings. Cribs and cots were to be of natural wicker and left unadorned, for elaborate trimmings and fabrics would catch dust and all the other impurities in the polluted London air. Preferring wicker chairs with cane seats, Godwin designed for his own children a diminutive version of an ebonized beech chair, which is now in the Bristol Museums and Art Gallery (CR 126). Like his other cabinetwork, Godwin's nursery furniture was designed to have at least nine inches of space below its base, for easy cleaning, and was minimally decorated for sanitation. In addition, he recognized the importance of safety in the nursery, and designed his nursery furniture with rounded corners and squared-off legs to avoid injury. A nursery buffet for Dromore Castle (CR 314), based on a design annotated "Nursery Buffet" (RIBA Ran 7/B/1[62]), which shows an accompanying changing table, is a sensible storage piece yet also attractive, with its combination of open and closed compartments, paneled cupboard doors, and quadrangular shaped stiles. Godwin believed that pleasant furniture and accessories were important to stimulate a child's intellect: "The nursery is the first school in this life, and the eyes of the little inmates are among the first leading channels of unconscious instruction or experience."[190]

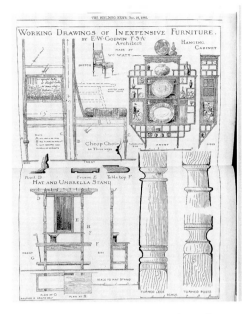

35. E. W. Godwin. "Working Drawings of Inexpensive Furniture by E. W. Godwin F S A," *Building News*, vol. 49, (18 December 1885), p. 1011.

36. E. W. Godwin. Drawing of a drawing table, from a sketchbook of 1872–79. Victoria and Albert Museum PD. E.233-1963, fol. 57.

37. E. W. Godwin. Drawing of "Cheap deal furniture," from a sketchbook of 1872–79. Victoria and Albert Museum PD E.233-1963, fol. 101.

Furniture designed exclusively for the office was another area that fulfilled Godwin's functional approach. He designed all of his own office furniture – "bookcases, plain-cases, drawing-tables, and desks" – to meet his demands for office furniture that was both attractive and useful.[191] Godwin's sketchbooks are full of designs for bookcases and rolltop desks,[192] and a sketch for a drawing table from about 1876 may include a design for his own office furniture (Fig. 36).[193] Godwin even designed Anglo-Greek-style furniture for the offices of the firm of Waugh and Sons in 1876,[194] although the ebonized Solicitor's cabinet (CR 308), commissioned in 1869 by London solicitor Charles T. Lane to keep what his son called "the usual bundles of papers customary with lawyers,"[195] is one of Godwin's few known office furniture commissions.

Although economy and function were key to Godwin, not all of his furniture was practical. His designs for bookcases were particularly flawed. Shelf space was narrow and the shelves were fixed, making it difficult to store books of different sizes (CR 311.I-III). One of these bookcases, with painted panels on the lower cupboard doors, had no handles, so opening the cupboard was difficult (CR 321). Similarly, Godwin's couches, particularly the settee type he originally designed for Dromore Castle (CR 119), have no support other than a back panel attached to the rear legs by two dowels,[196] which has led to a loosening of the back joints and subsequent splitting of the rear legs.

COTTAGE AND QUEEN ANNE STYLES

His appreciation for well-designed furniture may well have inspired what Godwin called "Cottage," a style he first applied to designs for Collinson and Lock in 1873–74. This simple furniture was part of the so-called Queen Anne movement, an eclectic revivalist mix of styles that had little to do with the architecture and interiors of Queen Anne's reign. Godwin possibly intended this furniture to compete with Morris and Co.'s simple wooden furniture, designed by Ford Madox Brown, or with the simple but more elegant furniture of Philip Webb that was so popular.[197] These highly original pieces, though directly inspired by Pugin's structural furniture, were prototypes for the early Arts and Crafts designers of the later 1870s.

Godwin's sketchbooks and ledgers are full of drawings and commissions for Cottage furniture, ranging from angled cabinets, sideboards, and hanging cabinets to washstands, tables, and even couches.[198] However, a mahogany cabinet from 1874, currently in a private collection, is the only piece so far confirmed as part of the Collinson and Lock commission (CR 333). It is based on a drawing in Godwin's sketchbooks annotated "Cottage Drawg rm cabt.,"[199] and the drawing probably corresponds to an entry in his ledgers for Collinson and Lock: "April 23, 1874 Cott. Draw.Rm.cab."[200] With its broad forms, heavy proportions, and minimal ornamentation – limited to a series of ribbed grooves and turned spindles – the cabinet appears to be an abstracted version of his Reformed Gothic-style furniture of the 1860s. The brass hardware consists of the same ring pull handles and rectangular back plates with keyholes he used on some of his pieces for Dromore Castle. What is different, however, is the incorporation of curvilinear elements into the overall form. The strictly rectilinear outline of pieces such as his dressing table or sideboard has been softened into beautiful serpentine lines, particularly in the arched openings at the bottom of the side panels. The same weighty proportions, ribbed grooves, and side-panel arches are evident in another Godwin drawing, which shows a standing corner cabinet and is annotated "cottage L Cabt Notes Ap 23RD 1874."[201] Glazed panels with circular sections are the only noteworthy features (see CR Fig. 336.1).

Godwin revived Cottage-style furnishings in 1876 for William Watt, and his sketchbooks are rich in nearly identical forms. One drawing, annotated "Cheap deal Furniture," shows a low cabinet bookcase, a dressing table with mirror glass,[202] and the drawing room cabinet he designed for Collinson and Lock (Fig. 37).[203] Another sketch from this same series, annotated "Cottage Dresser Done 21.76," shows a dresser, chair, and table (see CR Fig. 336.2).[204] Unlike the Collinson and Lock editions, which were made in mahogany, those for William Watt were made in deal, a much less expensive material. These apparently were not very popular, for Watt's *Art Furniture*, which came out a year later, illustrated only two models – the Cottage dresser (CR 354) and the Cottage chair (CR 155), both of which appear under Parlor Furniture. (To make the dresser more fashionable William Watt called it a buffet, a more upscale-sounding word of French derivation, and executed it in walnut, a more expensive wood than deal.)

Despite Godwin's interest in plain, well-designed furnishings, only one piece of Queen Anne furniture appears in the *Art Furniture* catalogue – a design for a cabinet "in the Queen Anne Style" illustrated under "Drawing Room Furniture" (Plate 12; CR 350). With its broken pediment, dentiled cornice, molded doors, numerous shelves and brackets, and tapered legs, the cabinet features many of the favorite motifs of this style.[205] Godwin's "Butterfly Cabinet" (CR 369) of the following year evidences Queen Anne influence in its broken crested pediment and dentiled cornice moldings, although its painted decoration gives it an overall Oriental look.[206]

It should be pointed out that the "Queen Anne style" in Watt's catalogue was referring not to the Queen Anne style of the first two decades of the eighteenth century, marked by cabriole legs, vase-shaped chair splats, graceful cyma curves, and veneered walnut surfaces, but rather to a new style of furniture which drew its inspiration from the Queen Anne architectural revival of the 1870s and 1880s, led by such architects as J. J. Stevenson (1831–1908) and Richard Norman Shaw (1831–1912). Although Godwin was not particularly fond of the Queen Anne style, he nevertheless designed a number of houses in it in the 1870s, notably the first houses for the "Queen Anne" community of Bedford Park in 1876 and the Gillow Mansions on the Thames Embankment in 1878. This style seemed to be most popular in the late 1870s, yet by 1880 a reviewer for *Furniture Gazette* asked, "Is the rage for Queen Anne furniture over?"[207] Yet the fashion persisted. A drawing-room suite by Shoolbred and Company, illustrated in *Cabinet Maker* in 1880, was described as designed in "the prevailing style of the day, a free treatment of Queen Anne."[208] And a Godwin pedimented Queen Anne over-door (CR 424), which was illustrated in *Building News* the same year, was described as being in accord "with the present taste in furniture matters."[209]

REFORMED GOTHIC FURNISHINGS

Godwin designed Reformed Gothic-style furniture for both ecclesiastical and domestic commissions throughout his career. The "Florence Cabinet" of 1867 for the Art Furniture Company (CR 306), for example, with its pierced quatrefoil decoration, reflects Godwin's taste in the 1860s for domestic medieval furniture in the commercial arena. Godwin's ledgers indicate that in the 1870s he designed at least one Gothic Revival piece of furniture for the firm of Collinson and Lock – a "P[ain]t Cab.[ine]t Medieval" in June 1873[210] – which may have been the last piece of medieval-style furniture they executed, for in a letter dated 30 July 1873 Godwin chastises them for "declining to work out medieval furniture & so meet the demand that is made by clergy & others on this style."[211] He then adopted certain details of medieval furniture such as the pierced roundels for subsequent Collinson and Lock commissions. For example, medieval-inspired pierced roundels reappear in a book-stand (CR 326) for display at the 1873 International Exhibition in Vienna. These same medieval roundels were transformed into openwork chrysanthemums for other Anglo-Japanese pieces for Collinson and Lock – an ebonized Anglo-Japanese sofa, for example, has pierced roundels in its back panels (CR 130) and the same roundels are used in an Anglo-Japanese multilevel table in mahogany (CR 225) of about the same date.

Collinson and Lock's lack of enthusiasm for Godwin's medieval forms did not stop him from designing Gothic-style furnishings for other firms in the 1870s, although he was well aware of the practical limitations of a style that originally was intended for castles and cathedrals. In an article he penned in 1872 for *Globe* Godwin warned readers to be "careful of professedly Gothic or medieval furniture, stop chamfers, Oxford frames, cabinets, with shrine-like roofs, and all the other archeological revivals of the last twenty years with their host of imitators." because they were not easily translated into furniture appropriate for a drawing room or boudoir.[212] Five years later, Godwin designed a series of Gothic-style church furnishings – "Design for stalls &c. for choirs or private chapel"[213] – for Watt's *Art Furniture* (Plate 19).

As late as 1880, when Gothic-style domestic furniture was no longer fashionable, Godwin illustrated "A Gothic Table For a Drawing Room" (CR 242) in *Building News*. The commentator remarked that the six-sided center table with tracery open-

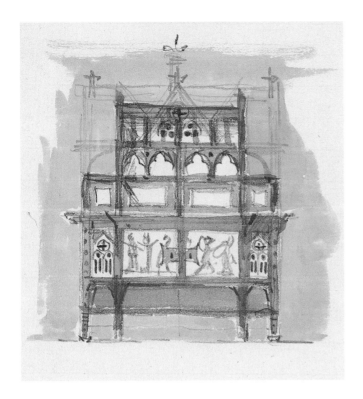

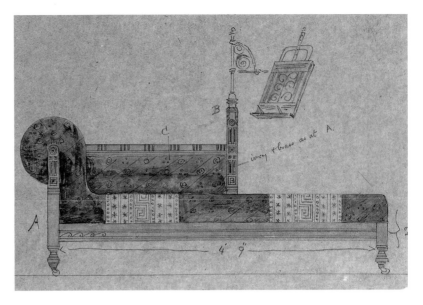

work decoration was "an unusual subject just now for illustration," but one that had "an open air of freshness about it."[214] This was not an isolated event, for Godwin's sketchbooks are evidence of his unflagging interest in medieval-style furnishings – a Gothic-style cabinet with pointed tracery arches and painted panels is one of many examples from the late 1870s (Fig. 38).[215] A sketch for a pointed cabinet with a coved cornice and metal straps, annotated "EWG Early 15TH century," probably relates to the medieval-style cabinet Godwin designed in February 1884 as part of an English fifteenth-century stand (CR 381) for an exhibition of furniture at the Royal School of Art Needlework, South Kensington.

ANGLO-GREEK FURNITURE

Godwin also designed Anglo-Greek furniture for the trade. Godwin's sketchbooks are full of drawings for furniture in the classical style. A couch in classical style with geometric inlay and corresponding embroidered upholstery (Fig. 39),[216] signed and dated "E.W.G. Apl. 9. 73," represents one of Godwin's earliest classically-inspired pieces. Although it is not known for which manufacturer this couch was intended, a ledger entry reveals that by 1876 Godwin was creating a line of Anglo-Greek furniture for Waugh and Sons that included a buffet, mantelpiece, hanging cabinet, a so-called "lady's companion," and even office furniture,[217] although none of these pieces have surfaced. Godwin's sketchbooks do offer some idea of what these Grecian-style furniture pieces looked like – Klismos-type chairs and thrones with cut-out legs and inlaid decoration, and tables in tripod form (Figs. 40, 41).[218] A diary entry from November 1876 reveals that these pieces were to be priced at the same rate as the Anglo-Egyptian pieces Godwin made expressly for Waugh and Sons. Godwin also designed floor cloths, wallpapers, and ceramics, including a so-called Greek wallpaper for James Toleman at 170 Goswell Road, London,[219] and an Anglo-Greek ceramic toilet set for the Staffordshire potters Brownfield and Sons.[220]

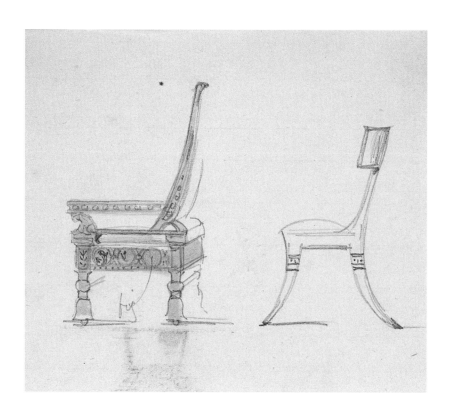

40. E. W. Godwin. Drawing of chairs in the Greek style, from a sketchbook of 1865–80. Victoria and Albert Museum PD E.229-1963, fol. 109.

A sketchbook contains two Anglo-Greek toilet sets, possibly to be made by Brownfield.[221]

In the 1880s, while working on a Greek play, Godwin resurrected the Greek theme and designed a line of Anglo-Greek furniture for William Watt. A Greek-inspired octagonal tripod table with a series of volute-topped supports and inlaid feet (CR 243) in one of Godwin's sketchbooks is of the type he was designing for Watt in 1881.[222] In 1885 *Building News* illustrated an Anglo-Greek chair[223] which had slender attenuated uprights, legs of turned decoration, double seat rails, square seats, and splats that angled back (CR 183). The chair was made in several versions, including one with arms, upright laths in the splat and variations of legs from turned to "cut square"; an oak example with upholstered seat and back and turned decoration on the legs is in the Victoria and Albert Museum (CR 184); and an ash example with cane seat and plain legs (CR 185) is in a private collection in the United States. Sketches in Godwin's notebooks indicate that this series was inspired by nineteenth-century texts on ancient Greek art and by antiquities in the British Museum. One such sketch, dated about 1883 (Fig. 42), shows a stool with a similar rounded leg from the Elgin Marbles at the British Museum and a couch from the *Dictionnaire des Arts Grecques*, which was published in Paris in 1873.[224] Godwin's fascination with ancient Greek furnishings led him to write two articles on the subject. The first, "The Greek Home According to Homer," was published in *Nineteenth Century* magazine in 1886;[225] the second, on ancient Greek, Assyrian, and Phoenician furniture, exists only in draft form in the RIBA.[226]

William Watt was only one of the firms that showcased Godwin's Anglo-Greek furniture. In the 1880s W. A. and S. Smee also manufactured Grecian-style chairs designed by Godwin, and in fact had been producing Grecian-style furniture, inspired by late Georgian examples, since the mid-1850s.[227] One of Godwin's Grecian-style chairs was illustrated in *British Architect*[228] in May 1883 as part of

41. E. W. Godwin. Drawing of a tripod table, from a sketchbook of 1865–80. Victoria and Albert Museum PD E.229-1963, fol. 83.

42. E. W. Godwin. Drawings of museum studies "from the Parthenon Marbles." Victoria and Albert Museum PD E.472-1963.

Smee's stand at the Furniture Trades Exhibition, Agricultural Hall, Islington, in April 1883. A similar example (CR 181) is now in the Mitchell Wolfson Jr. Collection in Miami Beach, Florida. With its sloped back rest, turned legs, and double seat rails, it shows unmistakable Greek influence. Godwin's sketchbooks also indicate that he designed Grecian-style chairs for the firm of James Peddle. A drawing annotated "Greek Furniture Peddle Dec. 1880," shows a Grecian-style chair with sloped back rest, splat, and double seat rails similar to those in his designs for W. A. and S. Smee (CR 174). A stool with ring-turned legs and geometric decoration appears below the chair.[229]

Godwin used similar Anglo-Greek chairs in the dining room he designed for Constance and Oscar Wilde at Tite Street, London, in 1884, where a series of white dining chairs of Greek inspiration, with matching white upholstery and blue and yellow accents, sat in the all-white dining room.[230] A surviving sketch reveals that Godwin also designed a white sideboard for the room (CR 382), a complicated storage piece with a combination of open and closed compartments, reeded edging, and lower cupboard raised high above the floor. This piece was meant to be a bit higher than the picture rail so that its flat cornice could double as a shelf for displaying the large pieces of blue-and-white and yellow porcelain that decorated the room. In fact, Wilde was so taken with the beauty of this room and its furniture that he wrote to Godwin and thanked him "for the beautiful designs of the furniture. Each chair is a sonnet in ivory, and the table is a masterpiece in pearl."[231]

Godwin's fascination with ancient Greece was shared by many fellow designers in the nineteenth century. The style was first promoted by Thomas Sheraton in his *Cabinet Dictionary* of 1803, in which he illustrated a Grecian couch and such Grecian decorative features as animal monopodia and lion's paw feet. Charles Heathcote Tatham's *Etchings of Ancient Ornamental Architecture* of 1799 and 1810 represented a more archaeological approach, with his etchings of objects drawn

43. E. W. Godwin. Drawing of "Anglo-Egyptian" furniture, from a sketchbook of 1872–79. Victoria and Albert Museum PD E.233-1963, fol. 53.

from ancient sites in Italy. The collector and connoisseur Thomas Hope popularized the taste for classical art and architecture with the publication of his book *Household Furniture and Interior Decoration* (1807). Based on specimens in his own collection of antiquities housed in his residence on Duchess Street, Hope designed furniture that made use of classical forms and motifs. Hope's designs were put into wider circulation by publisher George Smith, first in his pattern book *A Collection of Designs for Household Furniture and Interior Decoration* of 1808 and subsequently in his *Cabinet-Maker and Upholsterer's Guide* of 1826.

British furniture catalogues continued to feature a great many Greek-inspired pieces of furniture throughout the first half of the nineteenth century. In 1838 Richard Bridgens illustrated Grecian designs in his *Furniture with Candelabra and Interior Decoration*. Although Grecian furniture styles still appeared mid-century in William Smee and Sons' *Designs for Furniture* (1850–55), by the 1860s they were being eclipsed by an interest in medieval and Jacobean furniture. Grecian-style furnishings could still be found in pattern books in the 1880s, more as part of late Victorian eclecticism, but the style was merely one of many.[232] In fact, in C. and R. Light's catalogue of 1881, *Cabinet Furniture: Designs and Catalogue of Cabinet and Upholstery Furniture*, Grecian-style furnishings were one of thirteen named styles.[233]

ANGLO-EGYPTIAN FURNITURE

Godwin's interest in ancient cultures and his study of Egyptian artifacts inspired him to design a whole range of Anglo-Egyptian furniture in 1876 for Waugh and Sons (for whom he also designed Anglo-Greek specimens). Based on Egyptian forms Godwin studied and sketched in the British Museum,[234] this group of furniture included pieces for the drawing room, bedroom, and office.[235] Although it has not been possible to identify any of these pieces, entries in his diary from November 1876 corroborate the fact that he designed this furniture,[236] and his sketchbooks contain a series of drawings inscribed "Anglo-Egyptian" that gives some idea of what this furniture looked like. One of these sketches reveals austere, thronelike side chairs with elongated uprights and lateral stretchers, an occasional table with dished top and angled supports, and a writing table with splayed legs, incised decoration, and angled stretchers (Fig. 43).[237]

Godwin's interest in Egyptian furniture, however, must have started at least ten years earlier, because unmistakable Egyptian details show up in some of his earliest furniture forms. Angled stretchers and turned, splayed legs reminiscent of those in the Thebes stools and tables at the British Museum appear in the design for an ebonized coffee table he originally created for his own use in 1867, now in the Bristol Museums and Art Gallery (CR 207). Angled underframing and ring-turned legs reappeared in an oak dressing table, which he designed for himself about 1879 and which is now in the National Trust, Ellen Terry Memorial Museum, Smallhythe Place, Kent (CR 241). The most obvious Egyptian borrowing, however, appears in his Eagle chair of 1869 (CR 114), which resembles the ceremonial thrones of dynastic Egypt and has the stylized wings of the hawk-headed gods Horus and Ra carved into the top rail panel of the chair.[238]

Incorporating Egyptianizing details into furniture forms was not unique to Godwin. Ten years earlier Ford Madox Brown designed an "Egyptian chair" for Holman Hunt, based on a Thebes stool in the British Museum,[239] which was stocked by the Morris firm in the 1860s. In 1862 Dante Gabriel Rossetti designed an Egyptian-style sofa "of hard white polished wood with black rings" and palmette finials for the International Exhibition of 1862.[240] Fellow designers Christopher

Dresser and H. W. Batley[241] also designed Egyptian-inspired furniture in the 1870s and 1880s.

The rediscovery of Egypt had begun more than one hundred years earlier with the neoclassicists in Europe.[242] Designers such as Henri Jacob (1753–1824) in France and Thomas Chippendale the Younger (1749–1822) in England had introduced such Egyptianizing details as sphinxes and caryatids into their console tables and chairs in the second half of the eighteenth century. The Napoleonic campaign in Egypt expanded European interest in Egyptian artifacts, many of which were illustrated in Baron Dominique-Vivant Denon's *Voyage dans la Basse et la Haute Egypte* (1802). And in the first decades of the nineteenth century, Egyptianizing details such as sphinxes, hieroglyphs, and lotus and papyrus plants were common features of Regency furniture in England and Empire furniture in France.

The taste for Egyptian artifacts was resparked in England in the middle of the nineteenth century with the erection in 1854 of the "Egyptian Court" at the Crystal Palace, Sydenham, as well as the publication in 1856 of Owen Jones' *Grammar of Ornament*, which contained many richly colored plates of Egyptian ornament. New archaeological excavations and published studies also piqued interest in ancient Egypt. The reissue in 1853 of Sir Gardiner Wilkinson's *Manners and Customs of the Ancient Egyptians*, first published in 1837, documented the domestic furniture rediscovered at Thebes. First uncovered by the British Consul-General Henry Salt in 1815, these pieces were acquired by the British Museum between 1829 and 1835,[243] where their abstract rectilinear forms and geometric decoration influenced the design community throughout the last four decades of the nineteenth century, particularly designers such as Godwin who were interested in the forms of other cultures.

OLD ENGLISH OR JACOBEAN-STYLE FURNITURE

With characteristic versatility Godwin created notable designs in the so-called Old English or Jacobean style that was so popular in the 1870s. One sketch of a sideboard, dated 30 July 76,[244] is probably for the piece put in production for William Watt and illustrated in *Art Furniture* under "Old English or Jacobean" (Plate 15; CR 348); its turned cup-and-cover supports, tiered form with deep lower display shelf mounted on feet, and fluted cornice recall late-sixteenth-century oak cupboards. The sideboard and other Old English dining-room pieces from Watt (Plate 15) had also been reproduced in *Furniture Gazette* the previous year. The reviewer commented that "In the buffet or sideboard, not only the detail but the general form is thoroughly true to the spirit of the style and exhibits a pleasing variety which is capable of development: we mean, particularly the arrangement of the broad second shelf, elaborate old examples of which are to be seen at South Kensington Museum."[245] That Godwin studied surviving examples first-hand is confirmed by the many detailed studies of Jacobean specimens, among them carved and gadrooned baluster supports (see CR Fig. 245.2),[246] in his sketchbooks from the same period.

These were not the earliest Jacobean-style pieces that Godwin designed; he designed two pieces of Jacobean-style furniture for the Collinson and Lock stand for the Vienna Universal Exhibition – a tall side chair (CR 133) and an elaborate sideboard (CR 327). Both pieces were of oak and had the distinctive molded rails and cup-and-cover legs derived from Jacobean specimens. There are also a number of Jacobean-style billiard tables, designed by Godwin for Collinson and Lock in the early 1870s. A Godwin sketch for a billiard table for the McLaren commission shows a Jacobean-style table with heavy cup-and-cover legs and decorative side panels adorned with abstract Japanese floral and sparrow motifs (CR 216).

Although certainly not the most original of his styles, Godwin's furniture in the Jacobean or Old English style must have been quite popular – of the sixteen plates showcasing furniture in William Watt's *Art Furniture*, four illustrate furniture in the Jacobean style.[247] The designs for a Jacobean dining room represent some of the most expensive pieces in Watt's *Art Furniture* (Plate 7), perhaps the result of the carved decoration on pieces such as the oversized sideboard (CR 361) and the cabinet bookcase (CR 362) – plaques of intricately carved floral decoration derived from Jacobean examples are rarely seen on Godwin's furniture. These pieces also had intricately carved baluster supports, molded stiles, mirror glass inserts, and architectural cornices. The side chair with bobbin-turned stiles and carved back panels reproduced a specimen from the dining room at Cotehele, Devon, that was illustrated in Eastlake's *Hints on Household Taste* (CR 160).[248] In another suite of Jacobean-style furniture, reproduced in Watt's *Art Furniture* (Plate 17), Godwin replaced the carved panels with geometrically paneled doors and the baluster-turned legs with rounded tapering legs on casters, also reminiscent of Jacobean cabinetwork; carving was reduced to a few details, such as the spandrels on the overhanging moldings above the sideboard's shelves (CR 358) and the lower cornice of the overmantel (CR 417). What is unusual about this suite of furniture is that it is executed in mahogany rather than oak or walnut, the materials historically associated with Jacobean furniture.

Godwin also designed hall furniture in the Jacobean style. An oak side chair and accompanying hat and coat stand, reproduced in Watt's *Art Furniture* (Plate 2; CR 153, 411), "were derived from 'Old English' examples of woodwork." The bobbin-turned legs and stiles, the bun feet joined by a continuous stretcher, the heavily fluted rails, and the double roundel cornice placed above a floral carved panel are all elements derived from Jacobean specimens.

This style, one of the most popular furnishing styles of the nineteenth century, was part of a national desire to rediscover its past, beginning with the romantic interiors of the first half of the nineteenth century.[249] Houses such as Sir Walter Scott's Abbotsford at Galashiels in Scotland were refurbished to look "somewhat like an old English hall" from 1818 onward.[250] Abbotsford, furnished with a combination of Old English furniture bought from London antique dealers, Old English-style pieces made from old fragments and pieces of carving, and reproductions designed and executed by the firm of George Bullock, became one of the most influential interiors of the period.

Initially the style was an upper-class phenomenon, but with the publication of such books as Richard Bridgen's *Furniture with Candelabra and Interior Decoration* (1825–26), Thomas Hunt's *Exemplars of Tudor Architecture adapted to Modern Habitations* (1830), and Henry Shaw's *Specimens of Ancient Furniture* (1836) the taste for Old English-style furniture spread to the mass market. In 1833 J. C. Loudon, in his *Encyclopedia of Cottage, Farm and Villa Architecture*, commented on the increasing popularity of Old English-style pieces "distinguished by rude and grotesque carvings."[251] English taste for Jacobethan-style furnishings was also fueled by the literature of the period, which included the romantic novels of Sir Walter Scott. By mid-century, the Old English style had become one of the most popular for furnishings. Old English-style pieces appeared in most of the pattern books, and major sections of such popular publications as Blackie's *Cabinet-Maker's Assistant* of 1853 and William Smee and Sons' *Designs for Furniture* of 1850–55 were devoted to Old English- or Tudorbethan-style furniture. This taste continued into the 1860s, 1870s, and 1880s with firms such as Shoolbred and Company, who advertised Old English-style furnishings in their trade catalogues throughout these three decades.[252] William Watt, too, offered Old English- or

Tudorbethan-style furnishings designed by Godwin to keep up with popular demand. What distinguishes Godwin's Old English-style furnishings are their scale and proportions, which were reduced to suit the smaller room sizes of Victorian homes and to be more compatible with more modern and functional needs. A review of some of Godwin's Old English or Jacobean dining room furniture in *Furniture Gazette* in 1876 refers to these lighter proportions: "This 'Old English' or Jacobean dining-room furniture, is given mainly for the purpose of showing how even this somewhat costly and heavy style may be treated as to preserve all its artistic characteristics and yet be reasonably light. . . ."[253]

Godwin's desire to create Old English-style furniture with more modest proportions than the original pieces is reiterated in an article from 1876 in which he criticizes the massiveness of Early English furniture and questions the "reasons for producing such weighty furniture." He argues that "the enormous bulging legs, the many-moulded deep rails, &c. of the Elizabethan and Jacobean style" were designed for rooms that "were also massive" – necessary in an age when "men were too big and blustering in their manner," obviously a nationalist idealization of the Elizabethan and Jacobean periods. Godwin went on to state that with changes in dining habits, appropriate body type, and architectural settings, the "style of furniture suited for our dining-rooms should also be light."[254]

The lightweight, round armchair with cane seat that Godwin referred to as "Old English or Jacobean" (CR 109), is one of his recommended dining chairs, which he describes as "light enough for a child to carry, and strong enough for a child to clamber on."[255] This chair was illustrated in the 1877 Watt catalogue (Plate 15) and Godwin informs us in the descriptive notes that it was taken from an "old English example."[256] (Simon Jervis points out that cane-seated armchairs such as these were derived from ebonized country models in the Sheraton and Regency traditions.[257]) This was certainly one of Godwin's most popular designs – it was even pirated by Collier and Plucknett of Warwick (CR 503) and others[258] – and must have been made in considerable volume, for a large number survive in a great many versions.

Godwin's Jacobean-style dining tables were also smaller in scale than their prototypes and often had dropleaves to extend their dimensions. The earlier, massive dining table – "capable of accommodating at least fourteen people" – was not suited to the requirements of modern-day life, which, according to Godwin, normally involved seating "only four people at a time."[259] Therefore, all three of Godwin's Jacobean-style dining tables illustrated in William Watt's *Art Furniture* catalogue are diminutive, ranging from 3'6" to just 7' in length (CR 231, 232, 236),[260] and his buffets ranged in size from 6' to 7'6" (CR 365, 361)[261] – designed so they could "be moved easily in any direction by one pair of hands."[262]

Godwin's interest in the Jacobean period continued into the 1880s with the oak dining suite for William Watt he called the "Shakspere [*sic*] Dining-Set." An illustration of this set appeared in *Building News* in 1881, complete with court cupboard (CR 377), armchairs (CR 176) and side chairs (CR 175), trestle stool (CR 180), and planked dining table "held together by a grooved ledge at either side" (CR 245). The accompanying description extravagantly claimed that these pieces were "chiefly taken . . . from the original furniture, which is said to be either in the possession of Shakespeare's family at the present time, or known to have belonged to him."[263] Some pieces from this set have survived at Smallhythe Place, Kent. The oak armchairs are based on late-sixteenth-century *caqueteuses* decorated with rows of chip carving (CR 176); the dining table with trestle supports (CR 245) and side chairs with lion's-head back supports (CR 175) recall Flemish examples. These objects come closer to reproductions of historical styles than any of Godwin's other schemes

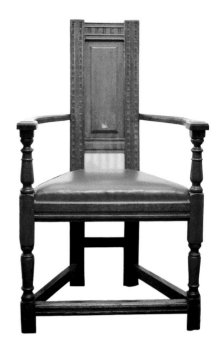

44. "Shakespeare" chair in the collection of George Godwin. From Clare Graham, "Seats of Learning," *Country Life* 184 (30 August 1990), pp. 108–9.

45. Liberty and Company. "Shakespeare" armchair in the style of E. W. Godwin, ca. 1890. Oak. Private collection.

of decoration, leading one contemporary reviewer to comment that "there is something clever in thus capturing those who dote on the antique by certified modern reproductions."[264] Another reviewer was less charitable: "A popular architect looks up a chair attributed to Shakespeare, finds some more old furniture to match, and then reproduces the lot under the title of 'the Shakespeare dining-room set.' The room certainly makes a capital picture from an antiquarian point of view: whether the furniture comfortably meets the requirements of modern dining is another question, which does not matter much."[265]

The Shakespeare chair was extremely popular and was reproduced by many furniture manufacturers; a commentator in *Cabinet Maker and Art Furnisher* noted that "Shakespeare's chair . . . has been frequently reproduced of late – thanks, in the first instance, to Mr. E. W. Godwin – and much used in halls and libraries."[266] A later article in *Cabinet Maker and Art Furnisher* indicates the chair was still popular in 1885: "Mr. Watt seems still to find it worth while to adhere to that thoroughly English Shakespearian furniture which Mr. Godwin designed expressly for him some years ago."[267]

Shakespeare's plays and late-sixteenth-century furniture continued to be popular throughout the second half of the nineteenth century. In 1867 there was an auction sale of the "Relics of Shakespeare and Other Furniture & Effects" belonging to Mary Hornby, a distant descendant of Shakespeare.[268] And other so-called Shakespeare furniture was manufactured by firms such as James Shoolbred and Company, who produced a Shakespeare chair that they marketed as part of a "Jacobean Dining Room" in their 1876 catalogue, five years before the Watt reproduction appeared.[269]

A chair purported to have belonged to the bard himself surfaced in 1877, in the London auction rooms of Messrs. Sotheby, Wilkinson, and Hodge and was followed in *Furniture Gazette* with some interest.[270] George Godwin, editor of *Builder* and an architect himself (no relation to E. W. Godwin), bought this chair as part of a collection of "Suggestive Furniture" he displayed at his house at 6 Cromwell Place, London and in 1878 illustrated it in *Builder* with his other prized pieces.[271] It is of the *caqueteuse* type and possibly was the prototype for the Shakespeare chair

designed for William Watt by Godwin, who conceivably visited George's collection or read his article (Fig. 44).[272]

The sale of Shakespeare artifacts continued throughout the century. In 1893 Thomas Hornby of Kingsthorpe, near Northampton, inherited "the whole of the Shakespearian relics formerly in the possession of his grandmother, Mary Hornby." Apparently a great many relics had remained in family hands after his grandmother's auction sale in 1867, which Thomas Hornby exhibited at his home in Kingsthorpe for friends and Shakespeare scholars.[273] Upon his death in 1895, these pieces were sold at Christie's in London.[274] The continuing interest in Shakespeare articles may account for adaptations of Godwin's Shakespeare chairs that appear with Liberty and Company labels (Fig. 45), which have the same general form and even reproduce the chip carving Godwin used on his model but have an elevated back splat more suited to the more stylized taste at the end of the century.

Late-nineteenth-century trade in Shakespearean artifacts and reproduction of his relics had begun in the previous century. In 1790 Princess Isabel Czartoryska of Poland purchased a Shakespeare chair from Mr. and Mrs. Thomas Hart, Shakespeare's heirs.[275] Another Shakespeare chair was recorded by Washington Irving, who in 1815 ironically remarked that "strange to tell, it [the chair] had found its way back again to the old chimney corner" after being sold to the Polish princess. In addition, Samuel Ireland bought a "Shakespeare Courting Chair" from Thomas Hart in the late eighteenth century.[276]

DESIGNS FOR PIANOS AND OTHER MUSIC-RELATED ITEMS

One of the most common furniture forms found in the drawing rooms of middle-class homes in Victorian England was the piano.[277] And even though Godwin considered it "that pretentious lump of ugliness,"[278] he was well aware of the desirability of having a piano in the drawing room and once admitted that he himself could not live without music.[279]

Unfortunately, however, Godwin's piano designs were the most impractical and controversial of all his furniture forms. In response to an illustration in *Building News* of the piano case in polished white deal with cedar panels and ebony moldings that Godwin designed for Collinson and Lock (CR 407), one outraged reader wrote to the editor that "the design by Mr. Godwin for a piano . . . has scarcely been considered in reference to practical convenience,"[280] noting that the upper section of the piano "is placed at such a height that its lower edge would be about on a level with the player's eyes when seated, and slopes back so rapidly as to place the music at the worst possible angle for reading." The reader goes on to criticize the position of the foot pedals, which are at right angles to the feet rather than in the more conventional parallel position. Even the addition of the convex mirror was judged unsuitable for a piano, annoying the player "by presenting continually a distorted reflection of his or her countenance. . . ."[281] The design of the lower part of the piano with a large arch, was condemned as being "at variance with its internal construction, unless Messrs. Collinson and Lock have invented a new way of stringing a piano, so as to get all the longer strings at the two opposite sides."[282] Another reader commented on the "insecurity of the base, unless it is intended to be fixed to the wall,"[283] while a third, after reiterating the many negative points given in the first letter, concluded: "No one would suppose from the drawing that Mr. Godwin had any practical acquaintance with the instrument he has attempted to design, and it might be worth the trouble it would cost him to acquire a little, as little would suffice to enable him to avoid the errors he has committed in this."[284]

46. Photograph of Ellen Terry at the piano on a Godwin double stool. "Miss Ellen Terry 'at home,'" ca. 1880.

These harsh criticisms did not deter Godwin (who was, in fact, an accomplished organist and pianist) from continuing to design pianos. A walnut piano of his design was illustrated in Watt's *Art Furniture* (Plate 12; CR 405) as one of the necessary pieces of drawing-room furniture, along with a sideboard, center table, and uphol-stered ottoman. Records show that in 1867 Godwin purchased an ebonized piano from the Art Furniture Company for £5.0s.0d.[285] This is probably the same piano he refers to in an article on the decoration of his London rooms in 1867, in which he describes altering the "ordinary piano case in such a manner as to render it so far from displeasing that it should at least not be out of harmony with its surroundings."[286]

Almost ten years later, for his next London drawing room at Taviton Street, Godwin designed a piano that was made, "works and all," especially for him. This piano caused him "no end of trouble," which he attributed to the fact that "piano makers are so stubborn and stiff necked in the matter of appearance that they never will produce anything out of their old well-worn groove, a groove which has been worn so deep that it is entirely out of keeping with all the other furniture grooves of the day."[287]

Godwin was not alone in his desire to design a more attractive piano than those available in the Victorian furniture trade. Charles Bevan (fl. before 1865–83), Ford Madox Brown, and Burne-Jones, among others, also grappled with the issue, and the pianos they produced certainly raised the artistic standard of the nineteenth century.[288] Godwin's sketchbooks and ledgers abound in designs and orders for pianos;[289] one, a design for a grand piano with built-in candelabra (CR 406) can be dated to the mid-1870s[290] and is probably the design for the grand piano listed in

Godwin's cashbooks[291] as one of the many Collinson and Lock entries. These cashbooks also indicate another special commission in May 1873 for Collinson and Lock, for a piano to be made with a French-style case.[292]

To complement his pianos, Godwin designed a variety of piano stools and music cabinets. In addition to the stool with an adjustable seat discussed above (CR 163), others include an ebonized double-seated music stool with a bottom area for storage (CR 123), an example which is now in the Bristol Museums and Art Gallery. Originally owned by Godwin and Ellen Terry, this stool possibly accompanied the ebonized piano Godwin bought from the Art Furniture Company for his own use. (A photograph of Ellen Terry from the 1880s shows her sitting on this music stool in front of an ebonized piano; Fig. 46.[293])

In addition to stools of this type, music was also stored in music stands or music cabinets. Godwin is known to have designed these forms, for his ledgers reveal he designed two models for Collinson and Lock in 1873[294] and one for William Watt in November 1876.[295] One of the most decorative of these is the walnut Anglo-Japanese example now in the National Trust, Ellen Terry Memorial Museum, Smallhythe Place, Kent (CR 338), executed by William Watt in 1876 and probably the example referred to in the ledger entry.[296] A version of this design with an extra top shelf and lower second drawer was registered with the Patent Office in December 1876 by Watt,[297] perhaps because of its vertical storage arrangement, which was an unusual design for a canterbury.

GODWIN'S PUBLICATIONS RELATING TO FURNITURE AND INTERIOR DESIGN

Godwin's reputation and influence spread with the publication of his furniture in the major architectural periodicals. Godwin's designs for furniture were illustrated in *Building News, Furniture Gazette, British Architect,* and *Architect,* among others. Some of these drawings were also reproduced in 1877 in *Art Furniture, from Designs by E. W. Godwin, F.S.A., and Others, with Hints and Suggestions on Domestic Furniture and Decorations,* the Watt catalogue that made his designs available to an even greater audience.

Reviewers took notice and endorsed this collection of designs. In *Building News* it was called "a rather choice collection of designs for domestic furniture . . . [that] display a decided taste for the truthful and simple in workmanship. . . . We recommend the furnisher of a new house to consult Mr. Watt's suggestive guide."[298] The critic for *Furniture Gazette* also praised the Watt furniture catalogue: "[W]e can unhesitatingly recommend to our readers as good examples of the styles now mostly sought after. . . ."[299] This publication was so popular that a second printing was issued the following year.

Godwin's writings as an architectural journalist went hand in hand with the promotion of his work, for he wrote on the main design issues of his day. Articles on the design of furniture and the decoration of rooms appeared frequently in the pages of the leading architectural journals exposing readers to new ways of thinking as well as to particular styles and modes of decoration. In addition, Godwin often used his own work as examples for the general benefit of the public. A series of seven articles for *British Architect* entitled "My House 'In' London" (July–August 1876) gave readers an inside view on how he decorated and furnished his house in Bloomsbury, London.

At the same time as promoting his work, he was of course promoting himself. Nevertheless, the time, energy, and evangelical zeal he put into his writings suggest a genuine concern with a broad range of issues related to art and design. In the

47. Bruce and Smith. Coffee Table (ca. 1880) in the style of E. W. Godwin. From Camden Arts Centre, *The Aesthetic Movement, 1869–1890*, ed. Charles Spencer (exh. cat., London: Academy Editions; New York: St. Martin's Press, 1973), p. 34, cat. no. 14.

48. D. Blythe Adamson & Co. Illustration of a coffee table in the style of E. W. Godwin. From "Drawing Room Furniture Manufactured by D. Blythe Adamson & Co," *The Cabinet-Makers' Pattern Book: Being Examples of Modern Furniture of the Character Mostly in Demand Selected from the Portfolios of the Leading Wholesale Makers* (London: Wyman and Sons, 1877), plate 67. Originally issued as a supplement with *The Furniture Gazette*, n.s., 9 (13 April 1878).

49. Heal and Son. Illustration of a cane chair in the style of E. W. Godwin. From a Heal and Son catalogue of 1884. Illustrated in *Pictorial Dictionary of British Nineteenth Century Furniture Design* (Woodbridge: Antique Collectors' Club, 1977), p. 251.

1880s, under the auspices of *The British Architect*, Godwin ran an "Art Club." He judged designs of architecture and furniture which were submitted to the journal and the best were then published. Not surprisingly, those selected for publication generally reflected his own taste and concerns, but they also played an important role in forming the tastes and attitudes of a new and upcoming generation of architects and designers.

PLAGIARISM OF GODWIN'S DESIGNS

The extensive copying and plagiarizing of his designs by the commercial trade attests to Godwin's popularity as a furniture designer. In the preface to Watt's *Art Furniture* of 1877, Godwin complained that many of the designs he had produced for William Watt some nine or ten years previously had "fortunately secured such attention as to be copied by others in the trade; but have unfortunately been travestied, even caricatured, in the process. A marked example of this is the square coffee table . . . meeting it almost wherever I go, – in private houses, in show-rooms, in pictures, and in books, very prominently in the frontispiece of Miss Garrett's 'Suggestions for House Decoration'" (a reference to Macmillan's "Art at Home" series).[300] An examination of contemporary trade catalogues, advertisements, and illustrations in art and architectural journals reveals many of these plagiarized Godwin coffee tables. Although the overall shape is basically the same, the proportions and treatment of the details differ. For example, the plagiarized example by Bruce and Smith (Fig. 47) of a Godwin table (CR 207) has a different spacing between the angled spindles, less pleasing proportions, and thicker turned legs.[301] Another version by D. Blythe Adamson and Co., 55 and 57, Wilson Street, Finsbury Square, London, which was reproduced in *Cabinet Maker's Pattern Book* (1877) printed by Wyman and Sons for *Furniture Gazette*, exhibits similar variations in proportions and details (Fig. 48).[302] Such poor imitations of Godwin's designs prompted him to write that the "lines and dimensions of the different parts of what

seems to be a very simple bit of furniture constitute its beauty and its art – if it has any. But I have seen the lines changed, the proportions altered, until that which I had regarded as a beauty became to me an offense and an eyesore."[303] Other Godwin pieces extensively copied by the trade included his cane chair, which was produced by Heal and Son as late as 1884 (Fig. 49),[304] and his Old English or Jacobean chair with its round arms and cane seat, which was copied by Collier and Plucknett of Warwick (CR 503)[305] and a number of unidentified furniture makers.

GODWIN FURNITURE AT INTERNATIONAL EXHIBITIONS

Godwin's furniture designs were brought to the attention of the general public and the trade to a great extent through display at some of the leading international exhibitions. Millions of people visited these universal exhibitions and read the many accompanying illustrated catalogues and reports, as well as reviews in the press.[306] Godwin's work was first exhibited in 1873 at the Collinson and Lock stand of the Vienna Exhibition. Although none of the pieces Godwin showed there have survived, contemporary reviews and Godwin's own sketchbooks reveal that he prepared five pieces in different styles for Collinson and Lock's display.[307] He designed a cabinet book stand, or *bibliothek*, in ebonized wood with gold "sparingly applied" (CR 326)[308] plus a Jacobean sideboard in oak (CR 327),[309] which Aslin describes as having quite elaborate decoration that included tortoiseshell, brass, ebony, and "bright red wood" (probably indicating this piece was made of rosewood).[310] In addition, a design survives for two chairs – inscribed "Collinson and Lock Chairs for Vienna Oct '73" (CR 132, 133) – currently in the collection of the National Trust, Ellen Terry Memorial Museum, Smallhythe Place, Kent.[311] One is in the Anglo-Japanese style, the other is a Jacobean adaptation. Godwin's diary entry for 20 March 1873 mentions a visit to "Mr. Lock re Vienna Table parties," so clearly a table was part of the exhibition installation as well.[312] These ledgers also indicate that Godwin was responsible for the decoration of the exhibition stand,[313] and a drawing in his sketchbooks illustrates the paneled room with a carved frieze that he designed for Collinson and Lock (Fig. 50).[314] An account in *Amtlicher Bericht* describes the room as paneled in dark wood, with a frieze consisting of oblong pieces of wood in each of which "one could see a branch blooming or weighed down with fruit, and fluttered by insects and birds, each one of another type of plant . . . in the . . . extraordinary effective, stylistic fashion of Japanese art."[315] Godwin's work must have been well appreciated, for Collinson and Lock exhibited one of his Anglo-Japanese cabinets at the Philadelphia Centennial of 1876, even though by this time Godwin was no longer exclusively designing for them, an octagonal table with ivory inlay (CR 240), and a rosewood cabinet at the 1878 Exposition Universelle in Paris (CR 332).

It was Godwin's "Butterfly Suite," however, designed for the firm of William Watt at the 1878 Exposition Universelle in Paris, that gained him the greatest international prominence. Conceived by Godwin and painted by American expatriate James McNeill Whistler (1834–1903) (whose emblem was a butterfly), the "Butterfly Suite" attracted worldwide press attention. A drawing by Godwin annotated "Paris 22 September 1877"[316] represents the combination fireplace and cabinet with shelves for this extensive suite, which also included lightweight chairs, occasional tables, a sofa, and a case for music.[317] Though Whistler called the suite "Harmony in Yellow and Gold," the exhibition's official catalogue listed it under the heading of William Watt as "Drawing Room Furniture, the Butterfly Cabinet and fireplace, sofa, centre table, music bookcase, coffee table and two chairs designed by E. W. Godwin, FSA. Decorating in yellow and gold designed and painted by J. A. McNeill Whistler, Esq."[318]

50. E. W. Godwin. Drawing of the Collinson and Lock stand for the Vienna Universal Exhibition (ca. 1873) from a sketchbook. Victoria and Albert Museum PD E.234-1963, fol. 79.

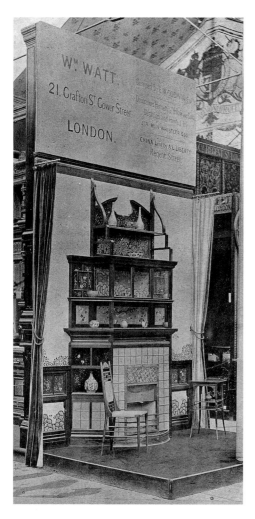

51. E. W. Godwin. Photograph of the William Watt stand, Paris Universal Exhibition of 1878.

A photograph of a portion of the display shows the Butterfly cabinet-fireplace placed between a wicker side chair and a small table (Fig. 51). The modified "Butterfly Cabinet" is in the collection of the Hunterian Art Gallery, Glasgow (CR 369),[319] and one of the lightweight Anglo-Japanese side chairs (CR 141) shown in the contemporary photograph can be found in the Virginia Museum of Fine Arts. The major piece in the suite was originally a fireplace with shelves, but it is now a cabinet, the grate having been replaced with doors taken from the dado paneling. According to the Pennells, Whistler's friends and biographers, the collector Pickford Waller bought the cabinet in a second-hand shop and adapted it.[320] The doors and central panels have painted decoration by Whistler of a Japanese cloud motif with butterflies on a primrose ground. The mahogany panels are sprinkled with butterflies and chrysanthemum petals in gold. This painted decoration, horizontal in orientation, diminishes the cabinet's strong vertical design yet also provides a degree of animation to what otherwise is a ponderous, massive piece of furniture. Aslin attributes the cabinet's size to the fact that Godwin designed it to be the central feature in the exhibition stand, therefore making it more conspicuous in scale than his usual domestic furnishings.[321]

The use of abstract painted decoration to accentuate the design was a common practice at this time, used on panels of floral decoration for ebonized cabinets of the 1870s and 1880s. The cloud, butterfly, and chrysanthemum decorations of the "Butterfly Cabinet" and the dado were unique, however. The Pennells thought that the idea for the decoration might have originated in Whistler's designs for Aubrey House.[322] Drawings for walls and paneling of the dining room show butterflies and chrysanthemum petals; the same theme reappears in the dado of the entrance hall and staircase of Whistler's second Chelsea home, 2 Lindsey Row. A more immediate source may be the paneling of the Peacock Room that Whistler had completed just the year before. The clouds of the Butterfly cabinet resemble the fish-scale motif or peacock-feather motif of the dado of the Peacock Room.

In 1877 or 1878 Godwin invited Whistler to paint the cabinet as well as the surrounding dado of the installation.[323] Godwin's decision to incorporate Whistler's talents in this scheme may have been based on his admiration of the paneled dado of the "Peacock Room."[324] A letter from Whistler to Godwin indicates that Whistler had completed the painting of the fireplace by 25 March 1878 but was forced to repaint it because of the "blundering of Mr. Watt's men."[325]

Although reviewers devoted a great amount of space to describing the suite, not all of the commentary was positive. Many reviewers criticized the "Butterfly Suite" as being impractical and flimsy. As one commentator put it, some of this furniture seemed "rather slight for everyday use."[326] This criticism was echoed in *Society of Arts Artisan Report*, published in 1879, which mentioned that "the tables look weak."[327] Both reviewers also commented on the loudness of the color scheme. *Magazine of Art* stated that "we cannot say that we should care to be surrounded in other houses by this 'agony' in yellow," while *Artisan Report* observed that the colors range from the "extremes of buff, bright mahogany and sage to citron, orange and the most glaring of yellows."

Despite the many negative reviews, there was a positive reception overall. *Society of Arts Artisan Report* published in 1879 credits Godwin for his innovative design.[328] *British Architect and Northern Engineer* commended "the exhibit of Wm. Watt . . . a very pleasant harmony of color. Chairs, mantelpieces, settees, &c. Are all in pale yellowish mahogany, light and even elegant in form . . . the general scheme of colour, which is excellent . . . the manner in which the panel decoration is, as it were, carried through on to the wall, is ingenious and suggestive."[329] The exhibit, though controversial, produced an unprecedented amount of news coverage which spread

interest in Godwin's designs. In fact, a lengthy and detailed account of the stand in the *New York Tribune* closed on the following note: "the carpentry as light as if the long fingers of a saffron-faced artist had coaxed it into shape."[330]

LONDON EXHIBITIONS AND FAIRS

The furniture fairs that became increasingly popular in London in the 1880s were prominent showcases for Godwin's designs. At the Decorative Art Exhibition held in August 1881 at the premises of Mr. T. J. Gulick, 103 New Bond Street, William Watt exhibited some of Godwin's designs, including "an Anglo-Japanese ebonized writing table, and a mahogany writing cabinet."[331] The same year, Jackson and Graham, a firm with which Godwin had no formal arrangement, exhibited a hanging cabinet he designed for William Watt at the Albert Hall furniture exhibition (CR 320).[332] A reviewer for *British Architect* commended Jackson and Graham for this unusual precedent of not being too proud to exhibit a piece of furniture from a rival firm. In 1882 Watt exhibited Godwin's Shakespeare dining room set at the Domestic Electric Exhibition, Victoria Cross Rooms, and at the Crystal Palace. Godwin designed an Early English morning or reception room with the Shakespeare chimney-piece, single and armchairs, a Jacobean sideboard, a Nuremberg hanging cabinet, tables, and a writing desk.[333] In 1883 W. A. and S. Smee exhibited Godwin's latest chair designs at the Furniture Trades Exhibition Number II. A Godwin Anglo-Greek chair with double rail under the seat was singled out for illustration (CR 181). In 1884 Godwin designed a fifteenth-century English room for Watt's stand at the Exhibition of Furniture at the Royal School of Art-Needlework, South Kensington.[334] Contemporary reviews indicate that the oak paneled room had a fireplace in imitation of one at Haddon Hall, and an oak dining-room suite in Jacobean style (which was illustrated in *Building News*).[335] Godwin also designed a sideboard with an unusual extending top (CR 383), a version of his Shakespeare chair, and a table with carved cup-and-cover legs with gadrooned apron and acanthus leaf ends (CR 247). The surprising addition of a circular table, termed Chinese, was described by a contemporary reviewer as "good in itself" but having "thin legs . . . completely out of scale with the rest of the furniture."[336] Another reviewer admired a Watt screen filled with panels of "figures sewn in greenish-brown crewel outline on white sailcloth; though no color but the outline thread is used."[337] Watt also exhibited Godwin's latest designs at the Exhibit of Art Furniture the following year.[338] Of the Godwin-designed furniture, all that is known is a Godwin round back study chair with cane seat and back that he resurrected from Watt's *Art Furniture* (Plate 11).[339] To make the chair more "Old English" in spirit, he added bobbin turning to the front legs (CR 182). This was the last Watt exhibition at a fair.

Godwin pieces could also be seen at the London showrooms of some of the large art furnishing firms that stocked his work. Collinson and Lock, Gillow and Co., Waugh and Company, W. A. and S. Smee, and William Watt all had Godwin-designed articles in stock for purchase at various times during the 1870s and 1880s. These pieces, particularly the Watt ones, would be publicized through articles in the architectural press, which appeared with some regularity from the 1860s to the mid-1880s.

INTERNATIONAL CLIENTELE

Godwin's designs were admired worldwide. Hermann Muthesius wrote that his work was studied and admired in Germany and Austria at a time when English work was not generally well considered.[340] Upon seeing his furniture at the International

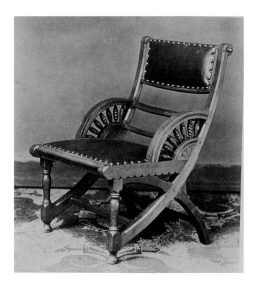

52. H. H. Richardson. Contemporary photograph of a chair (ca. 1878), from Richardson's office album. Houghton Library, Harvard University. From Aslin, *E. W. Godwin*, p. 65, plate 35.

Exhibition in Vienna in 1873, Prince Esterhazy of Vienna commissioned him to design a chair and a ceiling through the firm of Collinson and Lock. Godwin may have even traveled to Vienna for this commission, for a design for an armchair from a sketchbook is annotated "chair for Esterhazy via Collinson and Lock Oct '73 Ordered in Vienna" (CR 134). Another page is annotated "Met Lock Golden Lamb Hotel Leopold Strasse Vienna Oct 18 1873."[341]

By the mid-1870s, Godwin's influence had spread to America, where his commissions again came through Collinson and Lock, in particular one from James Goodwin for his Hartford, Connecticut residence, a high Victorian Gothic mansion built by the amateur architect Reverend Francis Goodwin and English emigré Frederick Clarke Withers in 1871–74.[342] Ledger entries for Collinson and Lock record that Godwin designed a "mantelpiece (America)" in December 1873 and "a table (America)" in January 1874.[343] A note in Godwin's sketchbook confirms the identity of the American client: "Mr. Goodwin – America. Perspective sketch of an octagonal centre table Mantel glass & shelves 6.1 5/8 chimney breast height 11.6."[344] Moreover, surviving photographs of the Goodwin residence from 1873 show E. W. Godwin's bamboo-patterned wallpaper on the walls of the dining room.[345] That the Goodwins imported English wallpaper and furniture is not so surprising, since many rich Americans at this time were buying imported English wallpapers, textiles, and furniture.

The American market was a developing sphere of economic activity for Collinson and Lock and in 1876 they exhibited at their first American exhibition, the Philadelphia Centennial. Although Godwin has been credited in the past as designing most of the pieces for the Collinson and Lock exhibition stand,[346] examination of period photographs and reviews reveals that Godwin designed only the Anglo-Japanese cabinet ornamented with panels taken from actual Japanese boxes (CR 335).[347] A sketch for the Anglo-Japanese cabinet in the Victoria and Albert Museum indicates that it was designed by Godwin some two years earlier in July 1874, when he was still working exclusively for Collinson and Lock (see CR Fig. 335.1). By the time of the exhibition, Godwin was no longer under contract; this may explain why more of his pieces were not shown. In any case, Godwin had a good following in America that was increased with the publication of Watt's *Art Furniture* in 1877. The following year, *Art-Worker*, an American periodical, reproduced twelve plates from *Art Furniture*.[348]

Godwin's designs resonated through the American design world, attracting the attention of American architects, decorators, and designers. Aslin has identified Godwin's influence in the furniture of American architect H. H. Richardson (1838–86), notably his designs for library furniture at Woburn, Massachusetts, from 1878. Richardson's wheel-shaped and spindle-armed sloping-back oak armchair with sunflower petals and cross stretchers (Fig. 52) resembles Godwin's design for an easy chair with stretchers from the Watt catalogue (Plate 8; CR 139).[349] The Anglo-Japanese work of the Herter brothers from the late 1870s also shows influence of Godwin's furniture designs. A comparison of the ebonized cherry side chair dated circa 1877–79 (Fig. 53) with a Godwin side chair made for the dining room of Dromore Castle (CR 113) reveals a similar design approach, characterized by lightweight rectilinear construction, elongated uprights, stretchers underneath the seat, ring-turned front legs, and splayed back rear legs.[350] A wing cabinet probably designed by the firm of A. H. Le Jambre of Philadelphia is the most overt example of Godwin's influence on American design (Fig. 54). At first glance it appears identical to Godwin's design for a wing cabinet in William Watt's *Art Furniture* catalogue (Plate 8; CR 346). Closer examination reveals too many differences to make a Godwin attribution credible. The firm of Cottier and Co. also man-

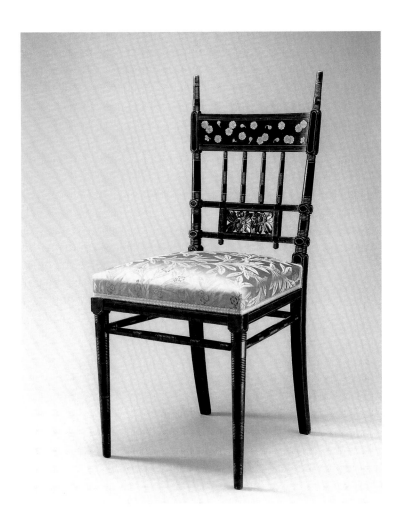

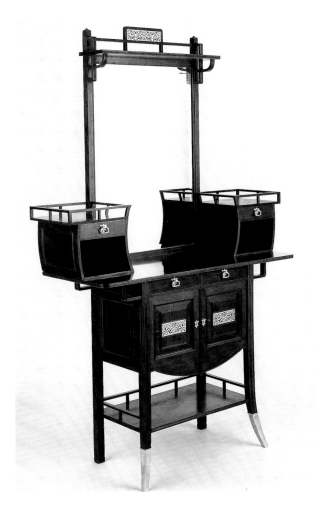

ufactured and marketed Godwin-style furniture in their New York factory and showroom. In addition to making versions of Godwin's Anglo-Japanese models, Daniel Cottier (1838–91) also copied his Anglo-Greek and Jacobean styles. This ebonized and highly painted furniture is often confused with the work of Godwin. For the most part, however, this furniture is heavier in proportion, cruder in execution, and more highly decorated than the Godwin prototypes (CR 501).[351] Many of Cottier's pieces were featured in Clarence Cook's popular manual *House Beautiful* (1878), whose cover was also designed by Cottier.[352]

Godwin's work had such an international following that his designs were copied in India (Fig. 55) for the local and expatriate market in the 1880s by local manufacturers, among them the Bombay Art Manufacturing Company.[353] There is also evidence that copies of Godwin's designs reached Australia through the firm of Cottier and Company, Art Furnishers, who opened branches in Sydney and Melbourne in the 1870s.[354] In addition, an advertisement for Cullis Hill and Company in the *Melbourne Bulletin* in May 1885 shows pieces taken from Plate 12 of William Watt's *Art Furniture*.[355]

REPRODUCTION FURNITURE

The re-publication of *Art Furniture From Designs by E. W. Godwin, F.S.A.* in 1978 by Garland Publishers has brought many of his designs to the attention of a new audience. Private commissions have arisen for the reproduction of Godwin furniture for a particular design scheme. The board room of Apple Computers in

53. Herter Brothers. Side chair (ca. 1877–79). Ebonized cherry with marquetry and gilding (Museum of Fine Arts, Houston, 93.15). Museum purchase with funds provided by the Stella H. & Arch S. Rowan Foundation.

54. Attributed to A. H. Le Jambre, Philadelphia. Wing cabinet (ca. 1878) after a design by E. W. Godwin. Mahogany with brass hardware and mirror glass. Meg Caldwell, New York.

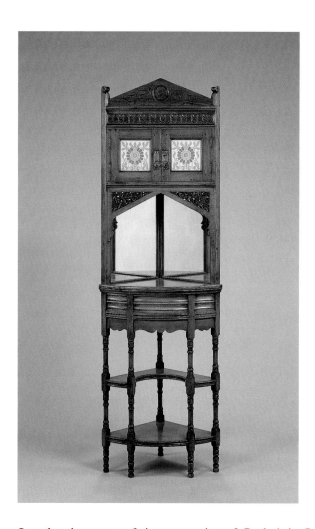

London has a set of sixteen copies of Godwin's Greek Chair. A dressing room in a home in Aspen, Colorado, has Godwin-inspired dressing tables with an actual Godwin slipper chair (CR 173).

With the current interest in nineteenth-century furniture, reproductions of some of Godwin's designs are about to be made. The firm of Indian Summer, Ltd. has begun to work on design reproductions of such prominent British design reformers of the nineteenth and twentieth centuries as Godwin, Webb, and Lutyens. At the present time, the firm is planning to copy two of Godwin's most famous chair designs: his Greek chair (CR 184), and ladies' lounging chair (CR 139) exhibited at the 1878 Exposition Universelle in Paris, both executed by the firm of William Watt. These are to be made by hand by a cabinetmaker in York in the north of England using proper nineteenth-century construction techniques and appropriate woods. They will be stamped with the firm's name so that in future years there will be no confusion between originals and copies.

CATALOGUE RAISONNÉ

CHAIRS

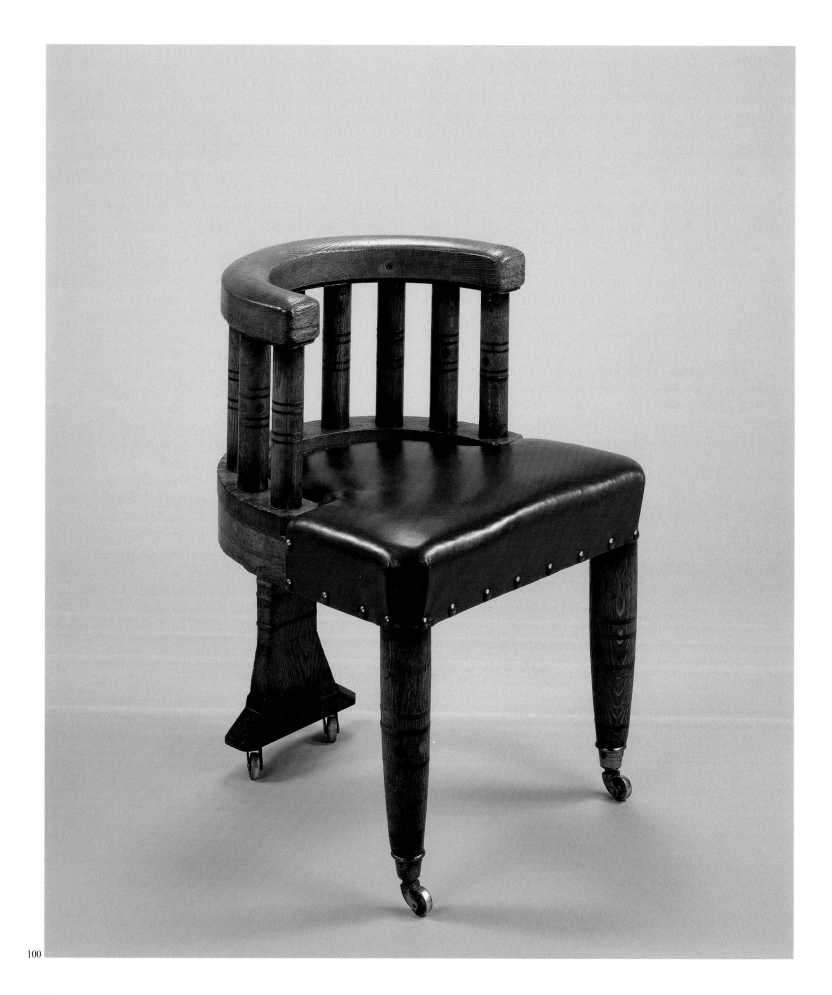

80 THE SECULAR FURNITURE OF E. W. GODWIN

100. *Councillor's Chair*

1865
Made by Green and King
Oak with inlaid decoration; green leather
upholstery; brass casters
$29\frac{3}{8} \times 21\frac{5}{8} \times 20\frac{1}{4}$ in. (74.5 × 55 × 51.5 cm)
Council Chamber, Northampton Guildhall
(formerly Northampton Town Hall)

Literature: Aslin 1986, pl. 3; Reid 1987,
p. 115, fig. 1; M. Hall 1993, pl. 9; Soros
1999, pp. 228–29, fig. 8-8

This barrel-back chair, based on a sketch
for a Councillor's chair for Northampton
Town Hall (Fig. 100.1), was one of twenty-
four originally commissioned for the
members of the town council;[1] a banquet
photograph from about 1892 shows these
chairs placed around the long central table
in the old Council Chamber (Fig. 100.2).
There was a second order, commissioned
in 1891–92 by Matthew Holding and
A. W. Jeffrey from Pratts of Bradford,[2]
and currently more than fifty chairs of this
design are located in rooms throughout the
town hall.

There are differences between the two
commissions: the original chairs were
upholstered in green leather, whereas the
replicas were in red; the support piece for
the rear panel (which substitutes for back
legs and is attached to casters) is longer in
the later version, presumably for greater
stability; and minor constructional
alterations were made in the U-shaped
seats.

The chair form is reminiscent of ancient
stone thrones that continued to be used
through the Middle Ages – at Hexham
Abbey (ca. 680) and Beverly Minster, for
example, as well as the elaborately carved
ivory throne of Archbishop Maximianus of
Ravenna.[3] Fifteenth-century French
manuscripts document this form in wood,
and contemporary Italian examples with
carved tracery, designed for both secular
and ecclesiastical use, were common. The
use of the rear panel in place of legs may
have come from one of these Italian
examples, or from the *sgabello* or stool type
of hall chair popular throughout medieval
and Renaissance Italy.[4] The circular and
double-ringed inlay also points to ancient
thrones recorded in medieval manuscripts
and documented by antiquaries such as
Nicolas Xavier Willemin.[5] The rounded
legs, in addition to the thick spindles and

inlaid geometric decoration, add to the
thronelike feel of these chairs.

100.1 "Furniture of Town Hall Jany/65"
(V&A PD E.619-1963)

100.2 Photograph of Council Chamber,
Northampton Town Hall, ca. 1892
(Northampton Record Office, no. P/3852)

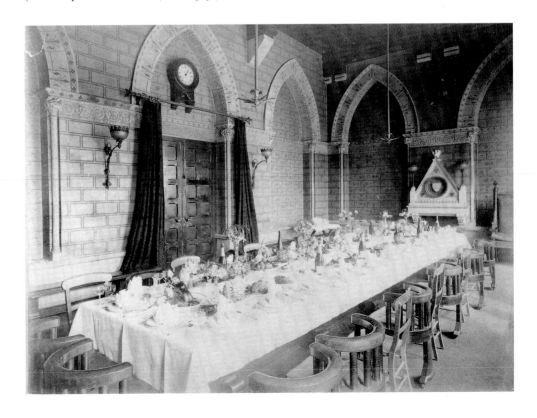

101. *Mayor's Chair*

1865

Made by Green and King

Oak with inlaid decoration; red leather
upholstery; casters

$67\frac{3}{4} \times 30\frac{3}{4} \times 24\frac{5}{8}$ in. ($172 \times 78 \times 62.5$ cm)

Council Chamber, Northampton Guildhall
(formerly Northampton Town Hall)

Literature: Aslin 1986, pl. 2; M. Hall 1993,
pl. 10; Soros 1999, no. 14, pp. 229–30, fig.
8-11

This monumental chair was originally
designed to accompany the Councillors'
chairs (CR 100) and trestle tables (CR 200,
206-b,c) of the old Council Chamber. A
pencil sketch in the Victoria and Albert
Museum (Fig. 101.1) contains Godwin's
design for all three elements. The overall
form is based on the post chair form of the
Middle Ages, which was associated with
persons of authority and is documented in
manuscripts of the fourteenth and fifteenth
centuries. The same turned legs are found
on a chair illustrated in Viollet-le-Duc's
*Dictionnaire raisonné du mobilier français de
l'époque carlovingienne à la Renaissance*, for
example,[6] and the floriated finials also
appear, particularly in the line drawing of
the Bayeux armoire.[7] Godwin used inlaid
roundels – similar to those on the
Councillor's chair – as well as inlaid
chevrons and crosses with trefoil ends to
decorate this Mayor's chair. This ornamen-
tation corresponds to the motifs in the
tiling Godwin designed to border the wood
floor of the old Council Chamber (Fig.
101.2). Located at arm and head height on
each of the turned stiles are metal plates to
which brackets for candleholders were
possibly attached. These plates do not
appear in Godwin's original drawing,
however, so it is likely they were a later
addition.

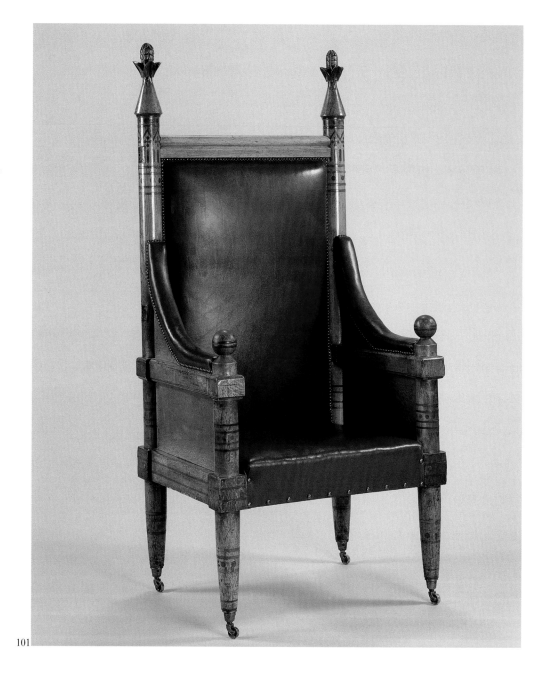

101

101.1 "Furniture of
Town Hall Jany/65"
(V&A PD E.619-1963)

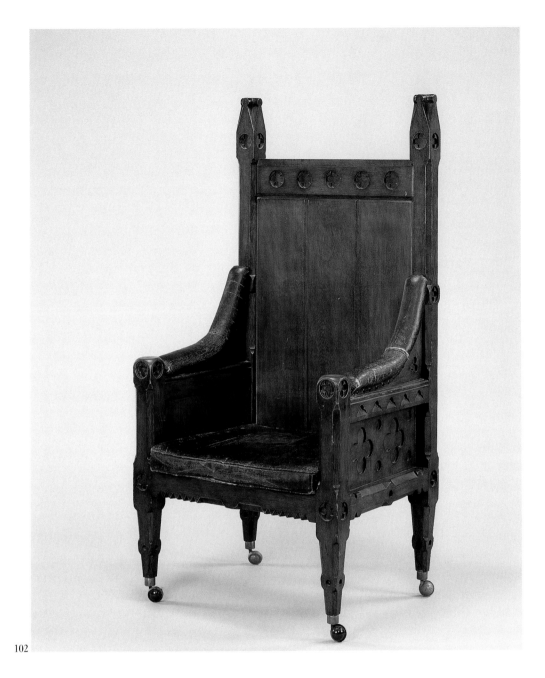

102

102. *Recorder's Chair*

Ca. 1863–65
Made by Smith Brothers
Oak; leather upholstery; brass casters
$61\frac{3}{4} \times 29\frac{3}{4} \times 24\frac{7}{8}$ in. ($157 \times 75.5 \times 63$ cm)
Northampton Guildhall (formerly
Northampton Town Hall)

Literature: *Account of the Town Halls* 1866, p. 51

Godwin designed this large-scale chair for use by the Recorder at Northampton Town Hall. An entry in his ledgers mentions that he began to work on this chair in 1863, after having sent to "Messrs. Smith for drawings of Recorder chair" (V&A AAD 4/9-1980, fol. 16). The *Account of the Town Halls Old and New* comments that "The Recorder's Chair which is elaborately carved, was presented to the Corporation by Messrs. Smith Brothers, Gold Street."

In overall form this chair resembles Godwin's designs for other official chairs, including the Mayor's chair (CR 101) and the State chair (CR 103); all three were modeled on the Coronation chair in Westminster Abbey (see Fig. 103.1). The decorative features – quatrefoils, triangles, and sawtooth and chamfered edges – derive from medieval architectural forms and are repeated in the interior decoration throughout Northampton Guildhall (for example, the stone mantel hood in the old Council Chamber).

101.2 Design for tiled border of floor in the old Council Chamber, Northampton Town Hall (V&A E.598-1963)

103. *State Chair*

Ca. 1865
Maker unidentified
Oak; leather upholstery; brass casters
$81\frac{1}{8} \times 29\frac{3}{4} \times 28\frac{3}{4}$ in. (206 × 75.5 × 73 cm)
Northampton Guildhall (formerly
Northampton Town Hall)

Literature: Campion 1925, p. 45; Soros
1999, pp. 231, fig. 8-12

There are no known drawings that relate
to this elaborate State chair, although
Godwin's ledgers indicate that in June 1863
he made "Designs for State Chair" which
he sent to the Mayor of Northampton,
Pickering Phipps, and for which he received
the sum of £3.3s.od (V&A AAD 4/9-1980,
fols. 15, 16).

The chair, with its sculptural finials and
thronelike appearance, derives from the
Coronation chair in Westminster Abbey
made between 1297 and 1300, which, as one
of the best-known chairs of state, provided
the model for many nineteenth-century
ceremonial and commemorative chairs.[8]
Godwin probably saw an illustration of the
Coronation chair in G. G. Scott's *Gleanings
from Westminster Abbey* of 1863, which
contained the first scholarly treatment of
the Coronation chair,[9] and we know he
sketched it for use in an unidentified
church commission (Fig. 103.1).

Comparison of the Coronation chair and
the State chair reveals many similarities,
including the boxlike form, downward
sweeping arms, triangular crest with
crockets, and other architecturally based
motifs such as arcading and quatrefoils. In
addition, the State chair relates to Godwin's
overall architectural and decorative
ensemble at Northampton, particularly
within the Council Chamber.

The only published reference of this
chair since the 1860s seems to be in Samuel
S. Campion's *Northampton Town Hall*,
which misidentifies it as "The Mayoral
Chair" but goes on to describe it as of "a
handsome character – on one side of it is a
carving of the Figure of Justice, and on the
other a corresponding Figure of Mercy."[10]
The presence of these figures suggests that
the chair was intended for use in a judicial
setting, perhaps by a magistrate. The mis-
identification is understandable, for the
chair is a version (albeit a more elaborate
one) of the Mayor's chair (CR 101). It
shares the same overall form – rectangular

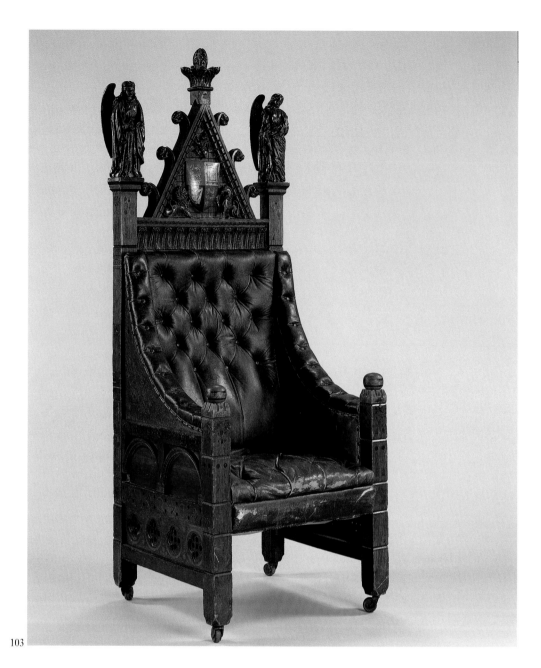

103

103.1 Drawing of the
Coronation Chair for
an unidentified
commission (RIBA
Ran 7/N/6)

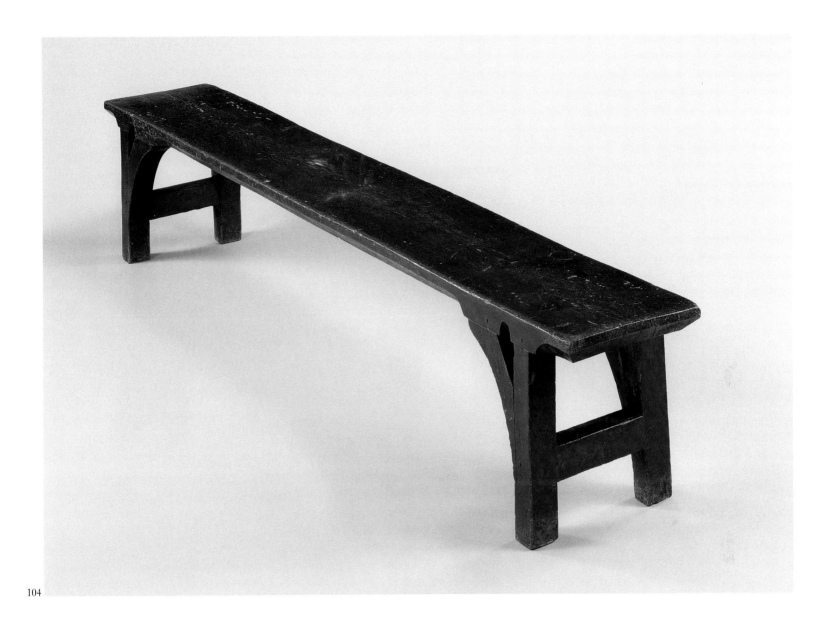

104

seat and downward-sweeping arms; brass casters; brass plates at head and arm height (probably for candleholders that would have been attached with brackets, now missing); inlaid wood decoration of circles, chevrons, and decorated crosses; an angled back panel; and finials decorated with floriated acorns and inlaid spheres.

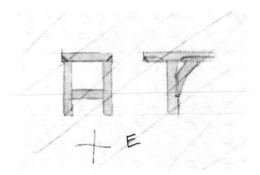

104.1 Design for bench for Northampton Town Hall (V&A PD E.625-1963)

104. *Bench*

1865
Made by Green and King
Oak
$18^1/_8 \times 108^1/_4 \times 13$ in. ($46 \times 275 \times 33$ cm)
Northampton Guildhall (formerly Northampton Town Hall)

This large Gothic-Revival bench is one of four that Godwin designed for the courtroom balconies at Northampton Town Hall, and it is based on a similar bench that appears in a rough drawing depicting furniture for the town hall (Fig. 104.1). In form, with their chamfered tops, cradles, curved braces, and exposed dowels – they are strikingly similar to the medieval fixed benches and tables of dark oak at Winchester College.[11]

105. *Bench*

1865
Made by Green and King
Oak
$41\frac{3}{4} \times 108\frac{1}{8} \times 14\frac{5}{8}$ in. ($106 \times 274.5 \times 37.2$ cm)
Northampton Guildhall (formerly Northampton Town Hall)

Godwin originally designed this Gothic Revival–style bench as a fitted piece for the courtroom in Northampton Town Hall. A drawing in the Victoria and Albert Museum shows this identical bench as part of the fitments for the courtroom (Fig. 105.1; V&A PD E.595-1963). Its chamfered edges, blocklike form, pierced quatrefoil decoration, angled structural supports, and sawtooth edging are features common to medieval forms derived from timber architecture.

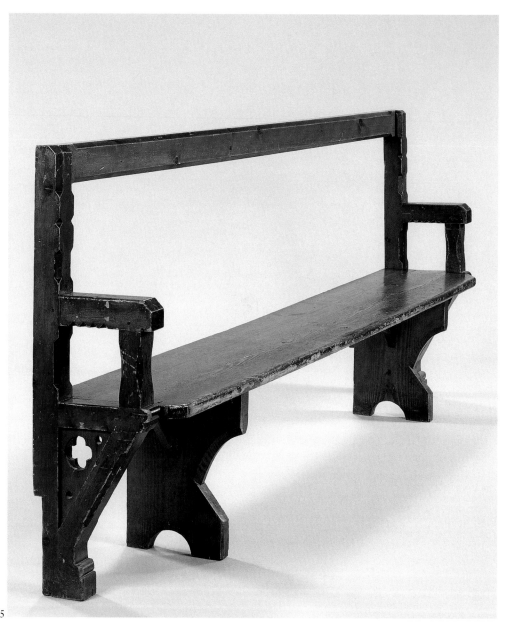

105

105.1 Drawing for courtroom bench for Northampton Town Hall (V&A PD E.595-1963)

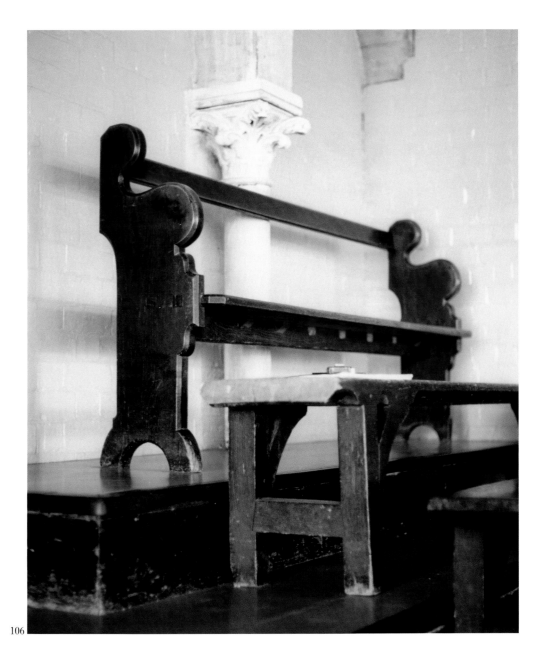

106

106. *Bench*

1865, attributed to E. W. Godwin
Maker unidentified
Oak
36 × 79 × 15 in. (93 × 201 × 39.5 cm)
Northampton Guildhall (formerly
Northampton Town Hall)

Although there is no surviving drawing for
this Gothic-Revival oak bench now located
in the balcony of the courtroom, it has
many characteristics that make a Godwin
attribution possible. These include the
raised arch side supports that resemble
the back supports of his later Eagle chair
(CR 114), exposed construction similar to
other pieces from this commission, and the
dramatic profile of the side supports with
their curved ends that correspond to his
later designs for church pews of the 1870s
such as those he designed for the Cemetery
Chapel, Nottingham (Fig. 106.1).

106.1 Design for church pews for the Cemetery
Chapel, Nottingham (Nottinghamshire Archive
cc/vi/10/17)

107. *Wicker Chair*
Ca. 1867–85
Made by William Watt
Ebonized wood; cane seat and back panel
35 × 17¾ × 16 in. (89 × 45 × 40.5 cm)
Paul Reeves, London

Literature: Aslin 1986, pl. 8

This is a version of the cane chair that
Godwin originally designed in 1867 for his
own home and it was illustrated in William
Watt's *Art Furniture* of 1877 (Plates 2, 8) at
a price of £1.1s.0d. It was also used in
advertisements for "William Watt, Artistic
Furniture Warehouse," which appeared in
British Architect in 1878 (Fig. 107.1). Watt
made the chair in plain as well as ebonized
wood.

Elizabeth Aslin credits this wicker chair
with being the second most popular chair in
an "enlightened household," after the
Sussex chairs by William Morris and Philip
Webb.[12] Its popularity is confirmed by the
many surviving examples as well as by the
fact that it was extensively plagiarized (Heal
and Son, for example, had a version in their
1884 catalogue).

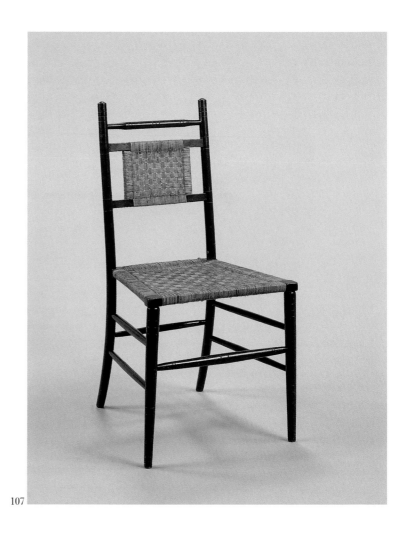

107

107-a. *Wicker Chair*
Ca. 1867–85
Made by William Watt
Ebonized beech; cane seat and back panel
34⅝ × 16⅛ × 16⅛ in. (88 × 41 × 41 cm)
Private collection

107-b. *Wicker Chair*
Ca. 1867–85
Made by William Watt
Ebonized beech; cane seat and back panel
35⅜ × 16⅜ × 16 in. (89.9 × 41.5 × 40.5 cm)
Private collection

107-c. *Wicker Chair*
Ca. 1867–85
Made by William Watt
Ebonized beech; cane seat and back panel
36 × 16½ × 17¾ in. (91.4 × 41.9 × 45.1 cm)
Haslam and Whiteway, London;
Manchester City Art Gallery (1981.32)

107-d. *Wicker Chair*
Ca. 1867–85
Made by William Watt
Stained oak; cane seat and back panel
31¾ × 17 × 15⅞ in. (80.8 × 43.2 × 40.4 cm)
Private collection

107-e. *Wicker Chair*
Ca. 1867–85
Made by William Watt
Ebonized beech; cane seat and back panel
35 × 16⅞ × 15 in. (89 × 42.8 × 38 cm)
H. Blairman & Sons, London;
Kunstgewerbemuseum, Staatliche Museen
zu Berlin (1995.40)

Literature: Kunstgewerbemuseum Berlin
1999, pp.127–28, fig. 141

107.1 Advertisement for William Watt, "Artistic
Furniture Warehouse," *British Architect*, 1878.

108. *Old English or Jacobean Armchair*
Ca. 1867–85
Made by William Watt
Ebonized wood; upholstered seat
Enameled William Watt label affixed to underside of chair
34½ × 20½ × 20½ in. (87.5 × 52 × 52 cm)
Paul Reeves, London; Private collection

Literature: Bridgeman and Drury 1975, fig. 56; Fine Art Society 1981, p. 32, fig. 26; Tilbrook 1986, fig. 60; Soros 1999, no. 42, pp. 252–53, fig. 8-41

This armchair was one of the most popular chairs that Godwin designed and was made in many different versions. Appearing twice in William Watt's *Art Furniture* (the upholstered model in the frontispiece and the cane-seat version in Plate 15 under "Old English or Jacobean Furniture") the chair is described as of ebonized beech and sold for £3.12s.6d. This example is identical to the Watt catalogue version. In a series of articles he wrote about his own home furnishings, Godwin refers to this chair, which he designed in 1867 for his dining room: "The[se] chairs are all circular in plan, and made with arms very light, very open, and fully equal to any work they may have to do, they have cane seats and movable leather cushions. . . . My chairs are light enough for a child to carry, and strong enough for a child to clamber on."[13]

Although Godwin called these chairs "Old English or Jacobean," they do not resemble any sixteenth-century forms, and the lattice back, which is closer in style to Godwin's Anglo-Japanese pieces, led Elizabeth Aslin to suggest that the title was a misnomer.[14] The prototype was probably the black japanned Sheraton painted chairs with rounded cane seats that were fashionable in England in the 1770s and 1780s and sought after by collectors in the 1870s.

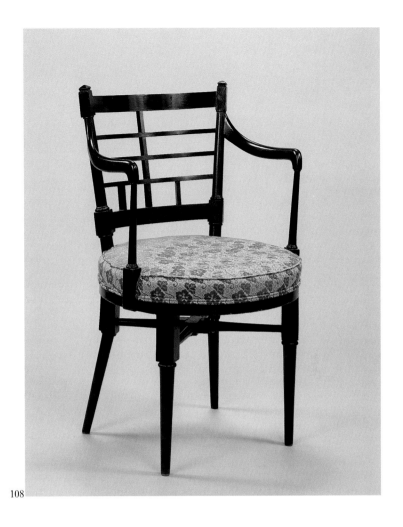

108

108-a. *Old English or Jacobean Armchair*
Ca. 1867–85
Made by William Watt
Oak; upholstered seat
22⅝ × 20¹⁄₁₆ × 20¹⁄₁₆ in. (57.4 × 51 × 51 cm)

Originally in the possession of the designer and Ellen Terry; by descent to Edith Craig; by bequest to The National Trust, Ellen Terry Memorial Museum, Smallhythe Place, Kent (SMA/F/101)

The four turned legs of this circular chair are joined by cross stretchers. At some time the arms and splat were removed, transforming it into a stool with a short backrest of only about six inches.

The fine provenance of this chair confirms that Godwin made these chairs in light woods.

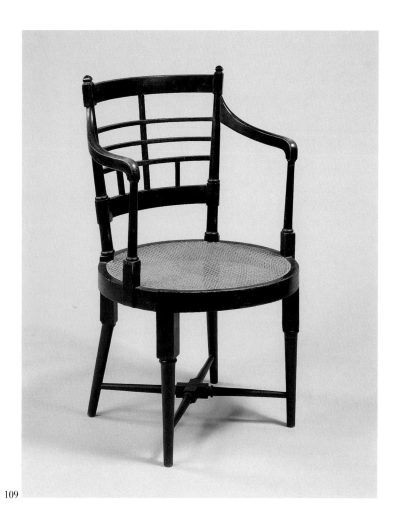

109

109. *Old English or Jacobean Armchair*
Ca. 1867–85
Probably made by William Watt
Ebonized wood; cane seat
33 × 21 × 19½ in. (83.8 × 53.3 × 49.5 cm)
Sotheby's, Belgravia, 11 November 1976, lot 348; Haslam and Whiteway, London; Private collection

Literature: Soros 1999, p. 244, fig. 8-32

This chair is the cane-seat version of the circular armchair (CR 108). It differs from the illustration in William Watt's *Art Furniture* in that the joined cross stretcher is placed a few inches above the floor rather than a few inches below the seat and it lacks the double horizontal rail at the bottom of the splat.

109-a. *Old English or Jacobean Armchair*
Ca. 1867–85
Probably made by William Watt
Ebonized wood; cane seat
Stamped on the underside of the front rail: G
34¼ × 20⅛ × 20⅛ in. (87 × 51.2 × 51.2 cm)
The Country Seat, Huntercombe, near Henley on Thames; Geffrye Museum, London (32/1995)

109-b. *Old English or Jacobean Armchair*
Ca. 1867–85
Probably made by William Watt
Ebonized wood; cane seat
34¼ × 20¾ × 20¾ in. (87.1 × 52.9 × 52.9 cm)
National Gallery of Victoria, Australia (D69/1975)

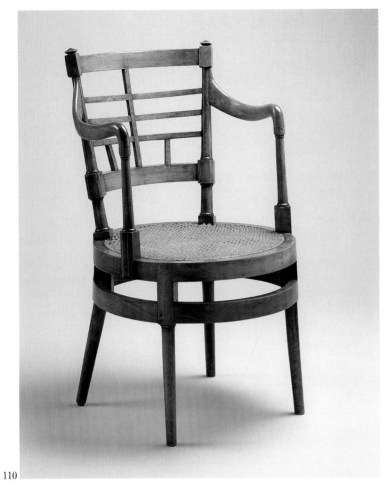

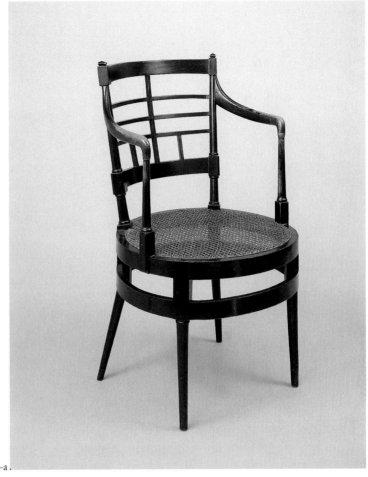

110

110-a

110. *Old English or Jacobean Armchair*
Ca. 1867–85
Probably made by William Watt
Walnut; cane seat
33⅜ × 19¾ × 20½ in. (84.7 × 50.1 × 52 cm)
The Metropolitan Museum of Art, New York; Gift of Paul F. Walter (1986.460)

This chair, probably manufactured by William Watt and reproduced in the 1877 *Art Furniture*, is a walnut version of the "Old English or Jacobean" circular armchair (CR 109). Although this specimen only vaguely resembles the one illustrated in the catalogue (it has a high circular stretcher instead of the cross stretcher close to the floor, for example), an identical chair formerly in the possession of the London dealer Michael Whiteway (now in a private collection) bears the William Watt label on its underside, confirming that a version with a circular stretcher was made by

William Watt's Art Furniture Warehouse (CR 110-a). A third version of this chair is at Standen, West Sussex (CR 110-b).

110-a. *Old English or Jacobean Armchair*
Ca. 1867–85
Made by William Watt
Ebonized wood; cane seat
Enameled William Watt label attached to underside
33½ × 19½ × 19½ in. (85 × 49.5 × 49.5 cm)
Private collection

110-b. *Old English or Jacobean Armchair*
Ca. 1867–85
Probably made by William Watt
Ebonized wood; cane seat
32 × 19¼ × 19¼ in. (81.3 × 49 × 49 cm)
Mr. Arthur Grogan; The National Trust, Standen, West Sussex (STA/F/119)

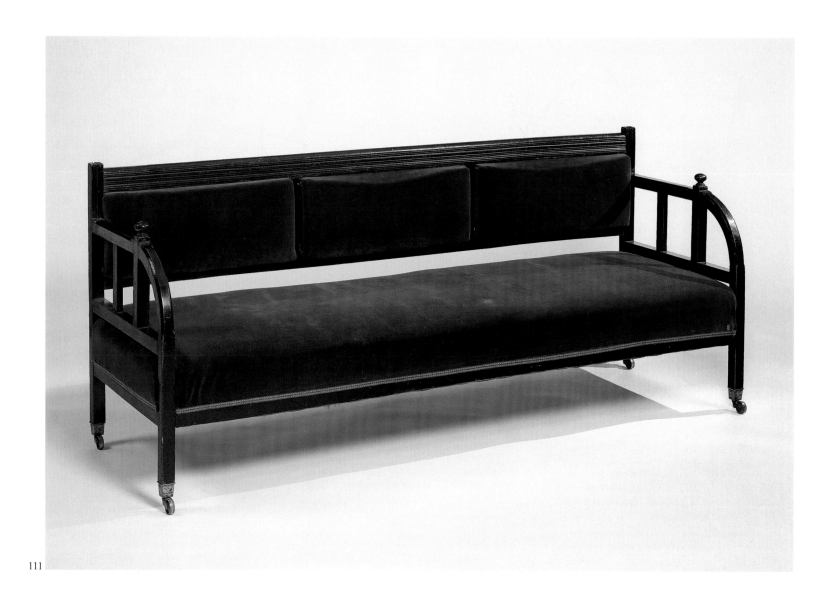

111

111. *Settee*

Ca. 1867
Probably made by William Watt
Ebonized deal; upholstered seat and back
panels; brass casters
$30\frac{3}{8} \times 72 \times 24$ in. (77 × 183 × 61 cm)
Paul Reeves, London; Private collection

This settee is a less elaborate and perhaps earlier version of the three-seat settee Godwin designed for Dromore Castle in 1869 (CR 119). In general outline it is similar to the Dromore version, but there are three major differences: the top rail is reeded rather than plain; the end of the arm is chamfered rather than smooth; and the latticework side panels have been eliminated. These deviations place this piece more firmly in Godwin's Gothic-Revival work than his later Anglo-Japanese style. The downward-arching curve of the

arms is similar to curved elements found on the overtly medieval-style bookcases Godwin designed for Dromore castle (CR 311).

When deal proved to be too soft, Godwin switched to mahogany, so the ebonized deal framework suggests that the settee probably was part of his early work. The brass casters, which are stamped "Copes Patent," were made by Copes of Birmingham.

112.1. *Dromore Dining Chair with Arms (Carver)*
1869
Made by William Watt
Oak; leather upholstery with stamped decoration in gold; brass nails
$42\frac{7}{8} \times 24\frac{5}{8} \times 29$ in. (108.9 × 62.6 × 73.7 cm)
Dromore Castle, Ireland; De Courcy, Dromore Castle, 19–21 October 1949, lot 257 or 258; Colonel Walsh; R. C. MacKenzie, Devon; Victoria and Albert Museum, London (Circ. 719-1966)

Literature: Aslin 1967, p. 7, fig. 5; Tomlin 1972, pp. 143, 147, pl. 199; Cooper 1987, pp. 140–41, pl. 331; Reid 1987, p. 138, fig. 29; Andrews 1992, p. 33; Gere and Whiteway 1993, p. 134, pl. 163; Soros 1999, pp. 194, 244

112.11. *Dromore Dining Chair with Arms (Carver)*
1869
Made by William Watt
Oak; leather upholstery with stamped decoration in gold; brass nails
Dromore Castle, Ireland; De Courcy, Dromore Castle, 19–21 October 1949, lot 257 or 258; Rockwell College, Cashel, Ireland

This pair of armchairs, or carvers, was made to accompany sixteen dining chairs ordered at the same time (CR 113.1–VII) by the Earl of Limerick for the dining room of Dromore Castle. The specifications between the Earl of Limerick and William Watt, drawn up by Godwin, indicate that they were to be made in "wainscot oak oiled with cushions & backs of fine horsehair covered with common tanned uncoloured leather with stamped pattern in gold" (RIBA MC GoE/1/7/4). The stamped pattern is derived from fourteenth- and fifteenth-century textile decoration; Viollet-le-Duc illustrated a canopy with the same pattern, taken from a manuscript of the fifteenth century.[15] The fierce lion heads depicted on the arms of these dining chairs add a dramatic flourish and likely derive from the Limerick family coat of arms, which contains a lion.

The armchairs and all sixteen side chairs were sold at the Dromore auction in 1949.

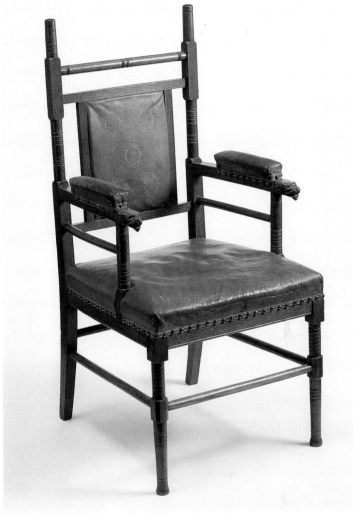

112

113.1. *Dromore Dining Chair*
1869
Made by William Watt
Oak; leather upholstery; stamped pattern in gold; brass nails
$41\frac{7}{8} \times 17\frac{7}{8} \times 20\frac{1}{8}$ in. (106.5 × 45.5 × 51 cm)
Dromore Castle, Ireland; De Courcy, Dromore Castle, 19–21 October 1949, lot 257; Colonel Walsh; Mrs. R. C. MacKenzie; Victoria and Albert Museum, London; Museum für Kunst und Gewerbe, Hamburg (inv. no. 1967.62)

Literature: Spielmann 1996, p. 50; Soros 1999, no. 26, pp. 194, 232, fig. 8-15

113.II–IV. *Dromore Dining Chairs*
1869
Made by William Watt
Oak; leather upholstery; stamped pattern in gold; brass nails
$42\frac{1}{2} \times 18\frac{1}{4} \times 18\frac{7}{8}$ in. (108 × 46.5 × 47.9 cm)
Dromore Castle, Ireland; De Courcy, Dromore Castle, 19–21 October 1949, lot 257; Colonel Walsh; Mrs. R. C. MacKenzie; Victoria and Albert Museum, London; on loan to Leighton House, London

113.V. *Dromore Dining Chair*
1869
Made by William Watt
Oak; leather upholstery; stamped pattern in gold; brass nails
$41\frac{1}{2} \times 18\frac{1}{4} \times 18\frac{7}{8}$ in. (105.5 × 46.5 × 48 cm)
Dromore Castle, Ireland; De Courcy, Dromore Castle, 19–21 October 1949, lot 258; Rockwell College, Cashel, Ireland; Haslam and Whiteway, London; Private collection

113.VI–VII. *Dromore Dining Chairs*
1869
Made by William Watt
Oak; leather upholstery; stamped pattern in gold; brass nails
$42\frac{1}{2} \times 18\frac{1}{4} \times 18\frac{7}{8}$ in. (108 × 46.5 × 48 cm)
Dromore Castle, Ireland; De Courcy, Dromore Castle, 19–21 October 1949, lot 257; Victoria and Albert Museum, London (Circ. 720-721-1966)

Literature: Victoria and Albert Museum 1952a, pl. 123; Aslin 1986, pl. 9; Howe et al. 1994, fig. 194

These dining chairs were part of a set of sixteen side chairs for the dining room of Dromore Castle in Limerick, along with two armchairs (CR 112.I–II). Specifications drawn up by Godwin between the Earl of Limerick and William Watt record an order for "sixteen chairs of wainscot oak oiled with cushions & backs of fine horsehair covered with common tanned uncoloured leather with stamped pattern in gold . . . " (RIBA MC GoE/1/7/4). An entry in Godwin's cashbooks indicates that the design fee for these chairs was £3.15s.0d (V&A AAD 4/2-1988).

The entire set of chairs was sold at the Dromore auction in 1949 and is now dispersed in private and public collections.

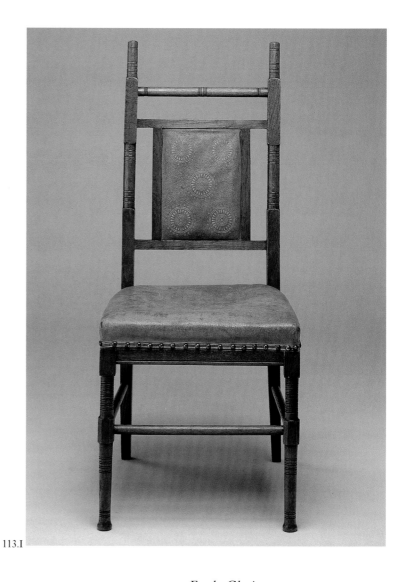

113.I

114.1 Study of hawks from a Godwin sketchbook (V&A PD E.272-1963, fol. 7)

114. *Eagle Chair*
Ca. 1869–85
Made by Art Furniture Company or by William Watt
Oak; leather upholstery; brass casters (rear)
Dimensions unavailable
Dromore Castle, Ireland; Christie's, London, 5 May 1995, lot 30; Private collection

Literature: Aslin 1967, pp. 12, 39, no. 26; Lever 1982, pp. 80–81; Reid 1987, pp. 137–38; "Eagle Eyed" 1989, p. 46; Mallalieu 1995, pl. 5; Soros 1999, p. 250

This dramatic chair, based on a drawing titled "Art Furniture" for Dromore Castle (Fig. 114.2), was designed for the castle's library. Godwin's ledgers reveal that he originally designed an Eagle chair for the Art Furniture Company in 1867 (V&A AAD 4/9-1980, fol. 39). It was later put into general production by William Watt,

and appeared in his *Art Furniture* catalogue under the heading "Library Furniture" – selling for £10.10s.0d, it was quite expensive.

The catalogue example shows that the original upholstery was leather decorated with the same disc design used for the Dromore dining chairs (CR 113). An illustrated interview in *Strand Magazine* with the British actor Sir Henry Irving shows an Eagle chair in his dining room at 15 Grafton Street, London.[16]

This chair, with its rounded back, relates to the Councillor's chair designed for Northampton Town Hall some five years earlier (CR 100). Godwin extended the uprights into sculptural hawk heads and the rounded front legs into scaled legs that terminate in claw-and-ball feet. Like the Councillor's chair, the overall form is borrowed from the round-backed throne chair of ancient Rome mentioned in CR 100. The bird heads carved on the uprights and the stylized wings carved on the top of the splat indicate an Egyptian source, the hawk-headed gods Horus and Ra.[17] Godwin's sketchbooks show that he also studied hawks from life (Fig. 114.1). The idea of the monopodia may have come from N. X. Willemin's *Monuments français*, particularly the illustration of the Throne of Dagobert which was on view in the Cabinet des Medailles of the Bibliothèque Nationale, Paris.[18] This combination of sources is typical of the work Godwin created for Dromore.

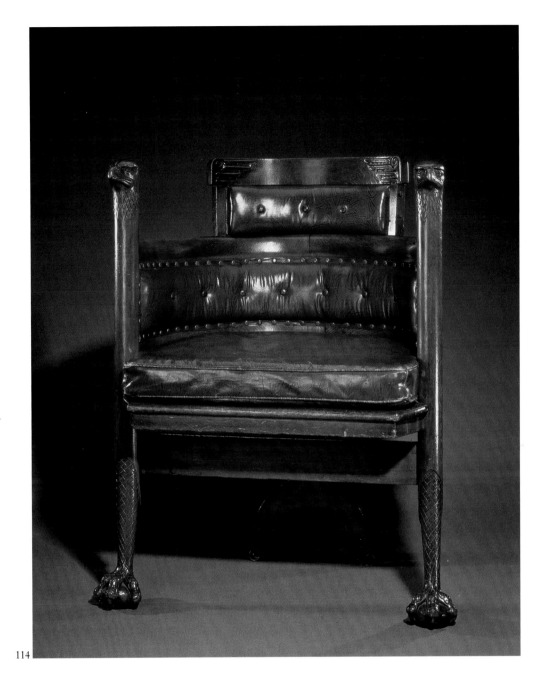

114

114-a. *Eagle Chair*
Ca. 1886
Made by Heirloom, representatives of the firm of William Watt
Mahogany; leather upholstery; brass casters (rear)
$35\frac{1}{2} \times 27\frac{1}{4} \times 23$ in. (90.2 × 69.2 × 58.4 cm)
Fine Art Society, London; Private collection

114.2 "The Eagle Chair," (RIBA Ran 7/B/1 [51])

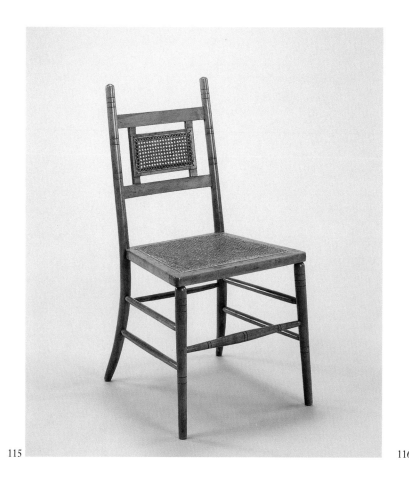

115

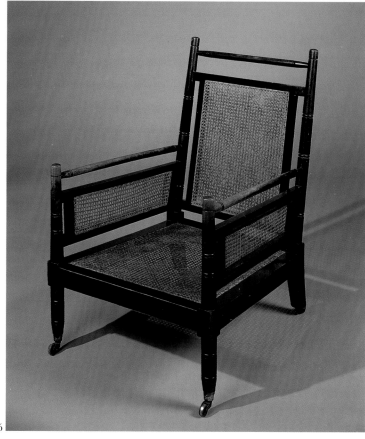

116

115. *Lightweight Chair*

Ca. 1869
Made by William Watt
Wood (beech?); split-cane seat and back
panel
36⅝ × 16⅜ × 16¾ in. (93 × 41.5 × 42.5 cm)
Dromore Castle, Ireland; Private collection

This type of lightweight chair was
designed by Godwin in 1869 for Dromore
Castle. It is included in a drawing for
furniture commissioned by the Earl of
Limerick for the castle (Fig. 115.1), and a
specification prepared by Godwin (RIBA
MC GoE/1/7/4) reveals that he ordered
"One dozen polished bedroom chairs with
basket work & black lines as per drawing.
Wm. Watt." A related entry in Godwin's
ledger (V&A AAD 4/2-1988) indicates that
these chairs were made by William Watt in
June 1869 and that Godwin's design fee was
£1.3s.0d.

115.1 Design for lightweight chair for Dromore
Castle, (RIBA Ran 7/B/1 [53])

116. *Easy Chair*

Ca. 1870, attributed to E. W. Godwin
Probably made by William Watt
Ebonized wood; cane seat (missing), back
and arms; brass casters
35 × 23¾ × 26 in. (90.2 × 60.3 × 67.3 cm)
Paul Reeves, London

This easy chair with its high arms and
straight back framed with rectangular
supports appears to be an easy chair version
of the wicker chair that Godwin originally
designed for his own use about 1867 (see
CR 107) and later for Dromore Castle (see
CR 115). The turning of the supports, the
delineation of the splat, and the raking of
the back legs resemble the armless models.
Similar to Godwin's other designs for easy
chairs, this model has brass casters for ease
of movement.

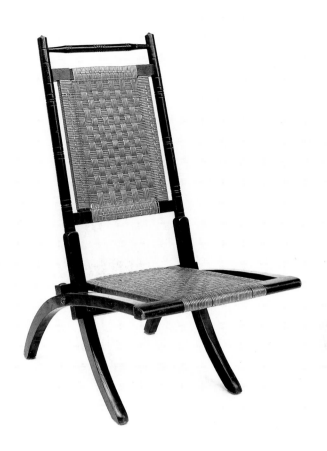

117

118

117. *Folding Chair*
Ca. 1870, attributed to E. W. Godwin
Probably made by William Watt
Ebonized wood; split cane seat and back
31⅞ × 16 × 24¾ in. (81 × 40.4 × 63 cm)
Anneliese Allen, Melbourne; National
Gallery of Victoria, Melbourne D27/1992

This "steamer chair" is a folding version of
Godwin's wicker chair design. The turned
supports and the delineation of the splat
resemble Godwin's lightweight chair model
(CR 107). Godwin also used the same split
cane for his wicker chair design. The idea
of a folding chair would have appealed to
Godwin's functional approach to design.

118. *Design for an Easy Chair*

Godwin designed this round-backed easy
chair in 1869 as one of a pair for Dromore
Castle, and it is illustrated in Godwin's
detailed drawing preserved in the RIBA
(Ran 7/B/1 [53]). The specifications drawn
up between William Watt and Lord
Limerick (RIBA MC GoE 1/7/4) show it
was constructed of ebonized mahogany and
upholstered with yellow satin. The rounded
legs and armrests were turned, and the seat
and back rest were decorated with a heavy
fringe. Godwin later designed a series of
similar round-backed study chairs for
William Watt's *Art Furniture* catalogue (CR
149, 150).

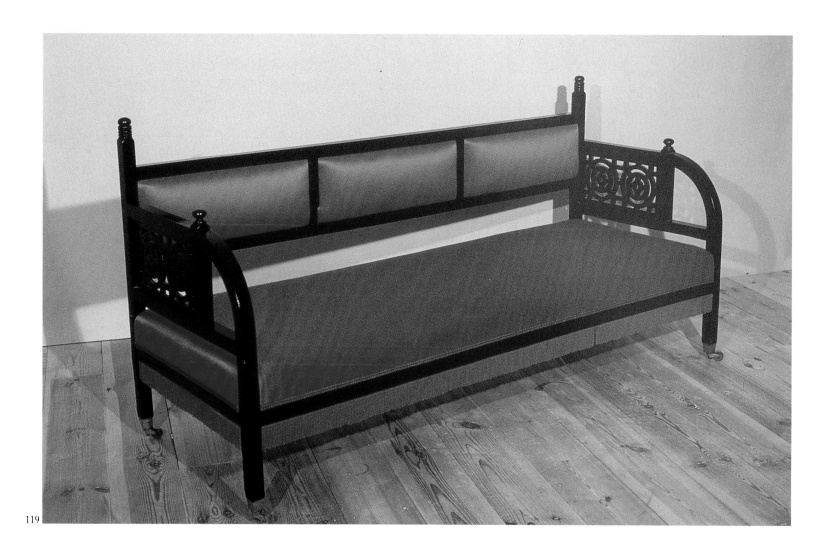

119

119. *Settee*
Ca. 1869
Made by William Watt
Ebonized mahogany painted over with
black paint; upholstered seat and back
panels; brass casters
32⅜ × 66⅛ × 23⅞ in. (82.3 × 168 × 60.8 cm)
Bristol Museums and Art Gallery (N4503)

Literature: R. Spencer 1972a, no. 285;
Bristol Museums and Art Gallery 1976,
no. 3; Gere and Whiteway 1993, p. 134,
pl. 16

A settee similar to this one appears in a
drawing for furniture that was commis-
sioned by the Earl of Limerick for Dromore
Castle (Fig. 119.1). Godwin's specifications
for the furniture (RIBA MC GoE/1/74)
mention "One sofa," which probably
corresponds to this design (Godwin used
the terms "sofa" and "settee"
interchangeably), as does a sofa recorded in
Godwin's ledger as being made in June

1869 by William Watt for the sum of
£15.0s.0d (V&A AAD 4/2-1988). The
Dromore design shows the settee with a
single back panel, however, rather than the
three-part back panel of the example shown
here.

Godwin's design was evidently quite
popular, for a number of these settees,
which were made in both ebonized and
natural mahogany versions, still exist. The
settee is illustrated in William Watt's *Art
Furniture* as a "Sofa-Settee" (1877; Plate
15) and sold for £10.10s.0d. In overall form
it resembles the *k'ang* sofas of China with
their latticework sides and deep seats.

119-a. *Settee*
Ca. 1869–85
Made by William Watt
Mahogany; upholstered seat and back
panels; brass casters
35 × 66⅛ × 22⅞ in. (89 × 168 × 58 cm)
Sotheby's, London, 31 March 1977, lot
435; Fine Art Society, London; Private
collection

Literature: Soros 1999, no. 24, pp.78–79,
195, 235, 243, fig. 3-9

119-b. *Settee*
Ca. 1869–85
Made by William Watt
Mahogany; upholstered seat and back
panels; (casters missing and some
restorations)
30⅜ × 72⅛ × 27 in. (77 × 183 × 68.5 cm)
Paul Reeves, London

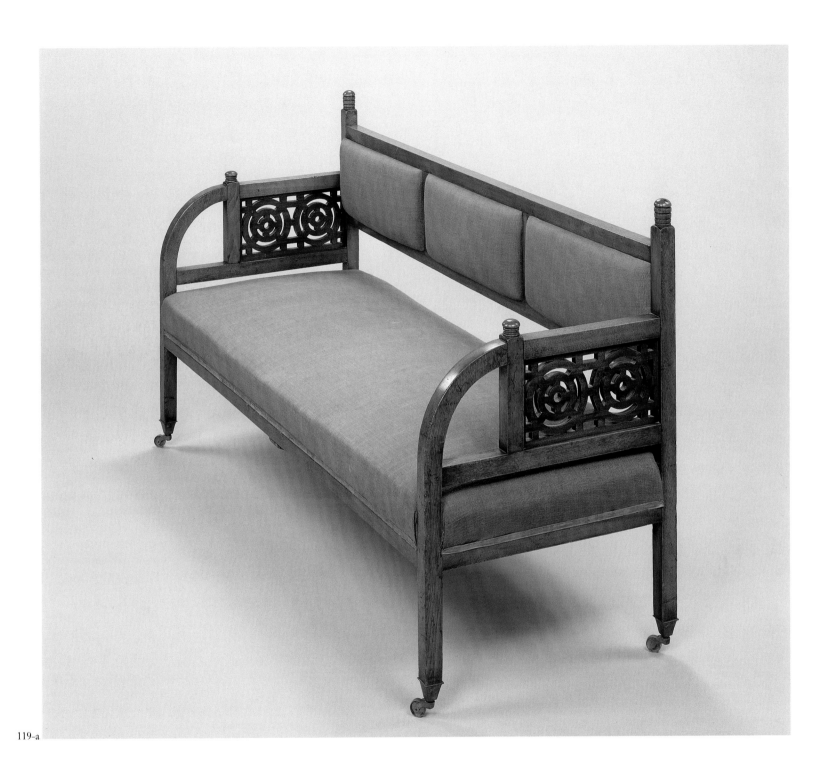

119-a

119-c. *Settee*
Ca. 1869–85
Made by William Watt
Ebonized mahogany; upholstered seat and
back panels; brass casters
$33\frac{1}{2} \times 66 \times 24$ in. (85.1 × 167.6 × 61 cm)
Gift of Thomas Stainton, Victoria and
Albert Museum, London, on loan to
Bodelwyddan Castle, Wales (W. 16-1972)

Literature: R. Spencer 1972a, no. D19

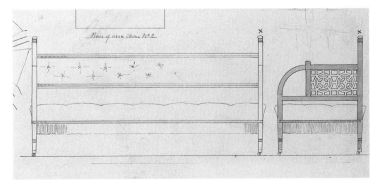

119.1 Design for
settee for Dromore
Castle, (RIBA Ran
7/B/1 [53])

120

120. *Circular Settee*
Ca. 1869
Made by William Watt
Ebonized mahogany; buttoned upholstery
Dromore Castle, County Limerick, Ireland;
whereabouts unknown

Godwin designed this circular settee for the drawing room of Dromore Castle in 1869. An early sketch in a scrapbook belonging to Lord Limerick (Fig. 120.1) and a related drawing (Fig. 120.2) show the details for this settee with its center receptacle for the display of plants. It was listed in the specifications drawn up between Lord Limerick and William Watt as "Circular settee with receptacle for flowers in centre moveable brass lining & double bottom springs & horsehair stuffing & covered with yellow satin in colour like that known in China as Imperial Yellow. 5 cushions 18 inches square filled with swansdown" (RIBA MC GoE 1/7/4).

A later version, five feet wide, was reproduced in William Watt's *Art Furniture* (1877; Plate 12) under "Drawing Room Furniture" and cost £17.17s.0d. It was covered in canvas that was buttoned and fringed, similar to the Dromore prototype.

Upholstered center settees and ottomans were extremely fashionable in the nineteenth century and many firms manufactured inventive versions of this form, including Booth (1864), Wyman (1877), Yapp (1879), C&R Light (1881), and Shoolbred (1876).

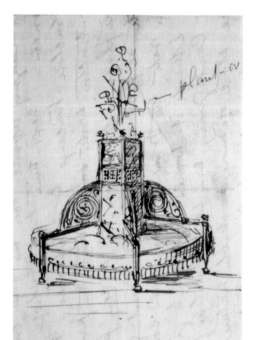

120.1 Sketch for circular settee for Dromore Castle in a scrapbook belonging to Lord Limerick

120.2 Design for a circular settee for Dromore Castle, (RIBA Ran 7/B/1 [53])

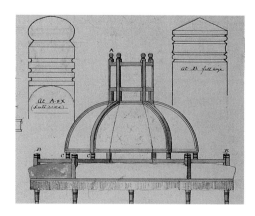

121. *Easy Chair*

Ca. 1869
Made by William Watt
Mahogany frame; seat, back, and armrests upholstered in yellow cotton velour (not original) with fringed seat and armrests; brass nails along side of armpads and bottom of seat cushion
$33\frac{1}{8} \times 23\frac{3}{8} \times 23\frac{7}{8}$ in. (84 × 59.5 × 60.5 cm)
Originally in the possession of the designer and Ellen Terry; by descent to Edith Craig; by bequest to the Bristol Museums and Art Gallery (N4502)

Literature: Bristol Museums and Art Gallery 1976, pl. 10

An armchair similar to this one is illustrated in Godwin's furniture designs for Dromore Castle (Fig. 121.1). His specifications for the Earl of Limerick mention "Two Easy chairs similarly furnished" that were to be made in mahogany and covered with "yellow satin in colour like that known in China as Imperial Yellow" (RIBA MC GoE 1/7/4). An entry in Godwin's ledgers, however, indicates that he designed and commissioned easy chairs for William Watt in June 1869 for which he was paid the sum of £7.10s.0d (V&A AAD 4/2-1988); this example is probably one of them.

The Bristol example presented here has slight differences from the Dromore design, such as the upward curve of the angled block at the end of each arm (on which is carved a large rosette on both the inner and outer side), the turned front legs, the buttoned upholstery on the back, and the absence of casters. It may have even come from Godwin's own drawing room, which he described as being furnished with "Three really easy chairs. . . . The seats are low (not too low) and deep, and the backs are low, being . . . just high enough to form a rest for the head when seated well back."[19] The upholstery, though not original, was done according to Godwin's original sketch and specifications.

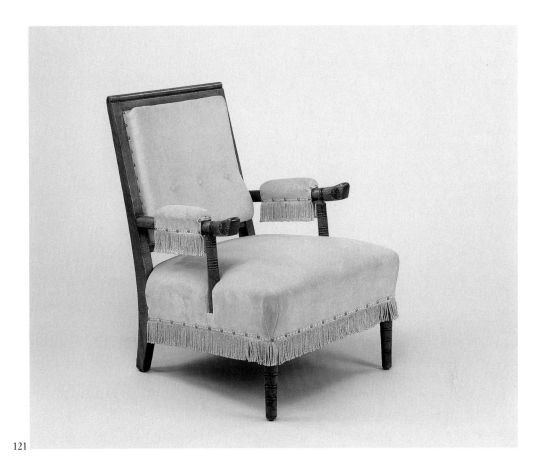

121

121.1 Design for easy chair for Dromore Castle, (RIBA Ran 7/B/1 [53])

122.I–III. *Side Chairs*
Ca. 1870, attributed to E. W. Godwin
Stained beech; cane seats
Maker unidentified
$32\frac{1}{2} \times 17\frac{3}{8} \times 15\frac{3}{8}$ in. (82.4 × 44.2 × 39 cm)
Originally in the possession of the designer
and Ellen Terry; by descent to Edith Craig;
by bequest to the Bristol Museums and Art
Gallery (N4500)

Literature: Bristol Museums and Art
Gallery 1976, no. 5

122.IV–V. *Side Chairs*
Ca. 1870, attributed to E. W. Godwin
Maker unidentified
Stained beech; cane seats
$33\frac{1}{2} \times 16\frac{3}{4} \times 15$ in. (85 × 42.5 × 38.1 cm)
Gift of Donald Sinden, The National
Trust, Ellen Terry Memorial Museum,
Smallhythe Place (SMA/P/120 a, b)

These side chairs, part of a set, represent a
lighter version of bobbin-turned chairs
from the seventeenth century. Bobbin
turning, revived in the 1820s and popular
until late in the nineteenth century,[20] was
not common in Godwin's designs of the
1860s and 1870s. It does appear, however, in
his sketchbooks dating from the late 1870s
(V&A PD E.504-1963) on the back legs of a
chair he designed as part of a Jacobean
dining suite for William Watt's *Art
Furniture* (CR 160). Bobbin-turned legs
reappear in a study chair made by William
Watt that was exhibited in April 1885 and
illustrated in a review of the exhibition (see
CR 182).

It is possible that these bobbin-turned
chairs, which were in Godwin's possession,
were made by an outside designer and later
influenced Godwin's 1885 chair design.
Karen Walton has noted that the turned
members relate to William Morris's
reclining chair designed by Philip Webb
and first made about 1866.[21]

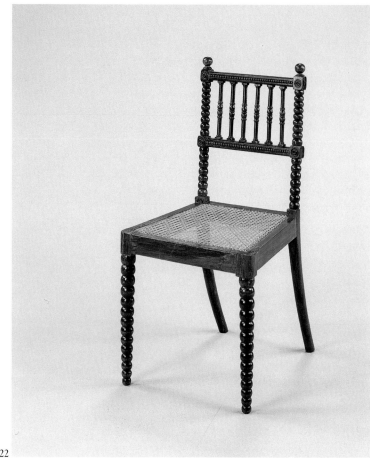

122

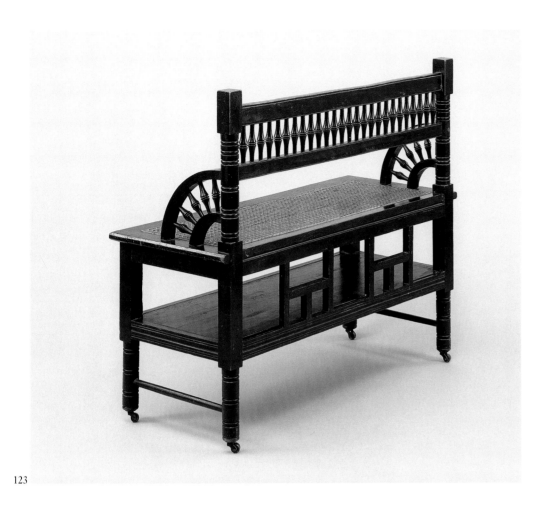

123

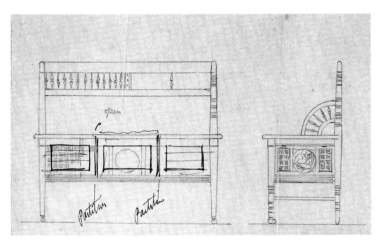

123.1 Sketch for double
music stool
(V&A PD E.486-1963)

123. *Double Music Stool*

Ca. 1870
Probably made by William Watt
Ebonized birch, chestnut, and pine; cane
seat; brass casters
$33\frac{1}{4} \times 38\frac{3}{4} \times 16\frac{1}{8}$ in. (84.6 × 98.4 × 40.9 cm)
Originally in the possession of the designer
and Ellen Terry; by descent to Edith Craig;
by bequest to the Bristol Museums and Art
Gallery (N4508)

Literature: Bristol Museums and Art
Gallery 1976, no. 7; Aslin 1986, pl. 43

This double music stool is based on a
drawing in Godwin's sketchbooks (Fig.
123.1), although it lacks the partitions
under the seat – presumably meant for
storing music – depicted in the original
sketch. Godwin designed a number of
music stools in his lifetime. He was an
accomplished pianist and even designed
pianos, one of which was illustrated in
William Watt's *Art Furniture* (CR 405).
Godwin may have designed this particular
stool in about 1867 for use in his London
flat, to accompany the ebonized piano he
purchased from the Art Furniture
Company for £5.0s.0d (V&A AAD 4/9-
1980, fol. 82). A photograph from the 1880s
shows Ellen Terry seated on it (see Fig. 46).

The arc-shaped arms with spindles
resemble those on the easy chair Godwin
exhibited at William Watt's stand at the 1878
Exposition Universelle in Paris (CR 139).
Alfred Waterhouse used the same arc shape
with spindles in his designs for the seating
furniture for the Earl of Selborne's
Blackmoor House in Hampshire (1869–77),
which may have been the prototype for
Godwin's design.[22]

Although the lattice panels above the
back stretcher reflect Japanese influence, as
a whole the stool is closer to Godwin's
heavy, medieval-style furniture of the mid-
1860s.

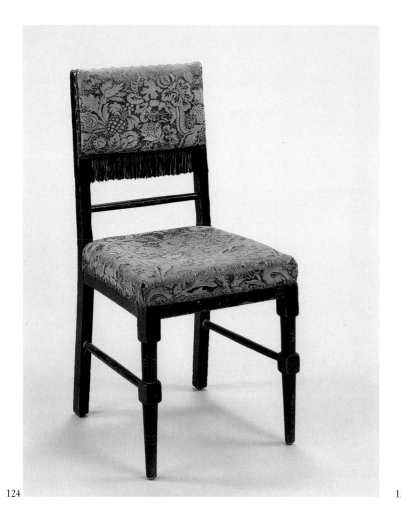

124

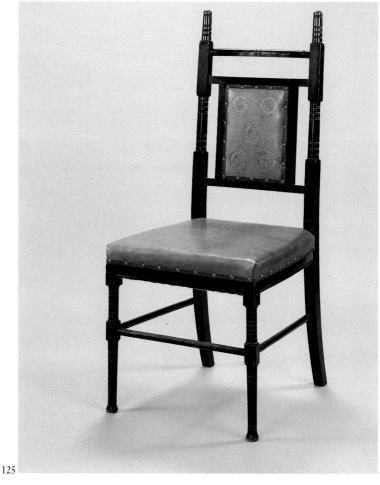

125

124.I–II. Pair of *Side Chairs*
Ca. 1870, attributed to E. W. Godwin
Probably made by William Watt
Ebonized wood; upholstered seats and backs
35⅝ × 18⅛ × 16⅞ in. (90.5 × 46 × 43 cm)
Haslam and Whiteway, London

This side chair, one of a pair, is an earlier version of the upholstered back stool that Godwin designed for his Shakespeare dining set (see CR 175). The combination of turned, tapered legs and rectangular blocks that intersect with the side stretcher rails echoes a seventeenth-century chair-making technique and was favored by Godwin in many of his early chair designs, particularly the dining chairs he designed in 1869 for Dromore Castle (see CR 112, 113). The ebonized finish may refer to seventeenth-century Dutch examples, which were often made in ebony. The floral plush upholstery with its row of black fringe under the padded backrest appears to be original.

125. *Side Chair*
Ca. 1870–85
Made by William Watt
Ebonized wood; leather upholstery; brass nails
41⅞ × 18⅛ × 18½ in. (106.5 × 46 × 47 cm)
Paul Reeves, London; Private collection

This chair is one of the many later versions of the Dromore dining chair executed by William Watt. They were made in oak and ebonized versions. This must have been a popular design, for the chair was still in production in 1877 and appeared in William Watt's catalogue (Plate 11), where it was priced at £4.4s.0d. Notably, however, it appears in the catalogue not as a dining chair but as a chair suitable for the library. A photograph from the 1870s of the smoking room at Tyntesfield, Somerset, for example, shows four similar chairs arranged around a table in a corner of the room (CR 223).[23] Godwin and Ellen Terry had two similar oak dining chairs in their own collection (see CR 125-a, 125-b).

125-a. *Side Chair*
Ca. 1870
Made by William Watt
Oak; simulated suede; leather upholstery; brass nails; white ceramic casters
41¾ × 16⅛ × 18⅞ in. (106 × 41 × 48 cm)
The National Trust, Ellen Terry Memorial Museum, Smallhythe Place, Kent (SMA/F/98)

This version has the unusual addition of white ceramic casters.

125-b. *Side Chair*
Ca. 1870
Made by William Watt
Oak; brown leather upholstery; (missing upholstered back panel)
41 × 18⅛ × 19⅜ in. (105.5 × 46 × 49 cm)
The National Trust, Ellen Terry Memorial Museum, Smallhythe Place, Kent (SMA F/97)

125-c. *Side Chair*
Ca. 1870–1885
Made by William Watt
Ebonized wood; leather upholstery; brass nails
41⅞ × 18⅛ × 18½ in. (106.5 × 46 × 47 cm)
Haslam and Whiteway, London; Private collection

125-d. *Side Chair*
Ca. 1870–85
Made by William Watt
Ebonized wood; leather upholstery; brass nails
41⅞ × 18⅛ × 18½ in. (106.5 × 46 × 47 cm)
Haslam and Whiteway, London; Private collection

125-e. *Side Chair*
Ca. 1870–85
Made by William Watt
Ebonized beech; leather upholstery; brass nails
42⅛ × 18⅛ × 18½ in. (107 × 46 × 46.9 cm)
Paul Reeves, London; Geffrye Museum, London (49/1993)

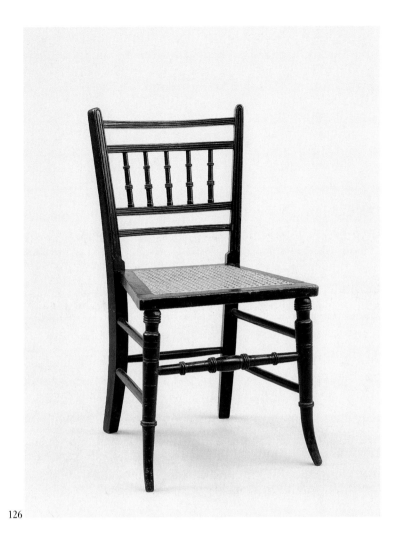

126

126. *Child's Chair*
Ca. 1870
Probably made by William Watt
Ebonized beech; cane seat
24⅜ × 11¼ × 11½ in. (62 × 28.5 × 29.3 cm)
Originally in the possession of the designer and Ellen Terry; by descent to Edith Craig; by bequest to the Bristol Museums and Art Gallery (N4499)

Literature: Bristol Museums and Art Gallery 1976, no. 1

Godwin designed furniture specifically for the nursery, and it is believed that he designed this chair for his daughter, Edith, who was born in 1869. In an article he wrote, Godwin stressed the importance of good design for children, believing that "the nursery is the first school in this life, and the eyes of its little inmates are among the first leading channels of unconscious instruction or experience."[24]

The chair is derived from vernacular Sussex chairs that were marketed by Morris, Faulkner, Marshall and Company in the mid-1860s. The ebonized finish, row of turned spindles on the back, turned legs, and stretchers are all features typical of these lightweight, inexpensive chairs. The gently splayed front legs were typical of Godwin's work at this time,[25] particularly in his designs for circular tables (CR 213).

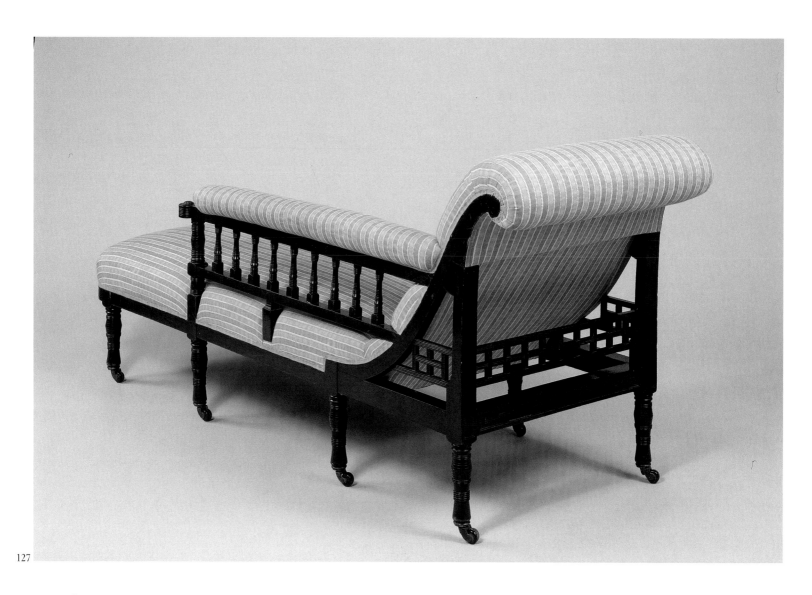

127

127. *Couch*

Ca. 1872–75, attributed to E. W. Godwin
Made by Collinson and Lock
Ebonized mahogany; upholstered seat,
back, and arms; casters
30 × 70 × 26 in. (76.2 × 177.8 × 66 cm)
Stamped on underside of frame: Collinson
and Lock 3301
Haslam and Whiteway, London; Private
collection

Daybeds, called couches by Godwin, were
fashionable upholstered forms in the second
half of the nineteenth century and they
perpetuated a form, popular in the Regency
period, that was derived from antique
specimens. Although often designed as part
of a large suite of upholstered furniture for
the drawing room, Godwin believed they
were also appropriate for use in the bed-
room, placed at the end of the bed. William
Watt's *Art Furniture* shows a similar couch,
also designed by Godwin, under "Parlor
Furniture" (1877; Plate 3; CR 156). This
Collinson and Lock piece shares with
Watt's version the reeded curved rails,
armrest with turned spindles, and sloping
backrest. It differs in having eight legs
(instead of four), a rounded rosette at the
end of the armrest, and latticework on
the back support – design variations
presumably intended to distinguish the
productions of the various makers of his
furniture.

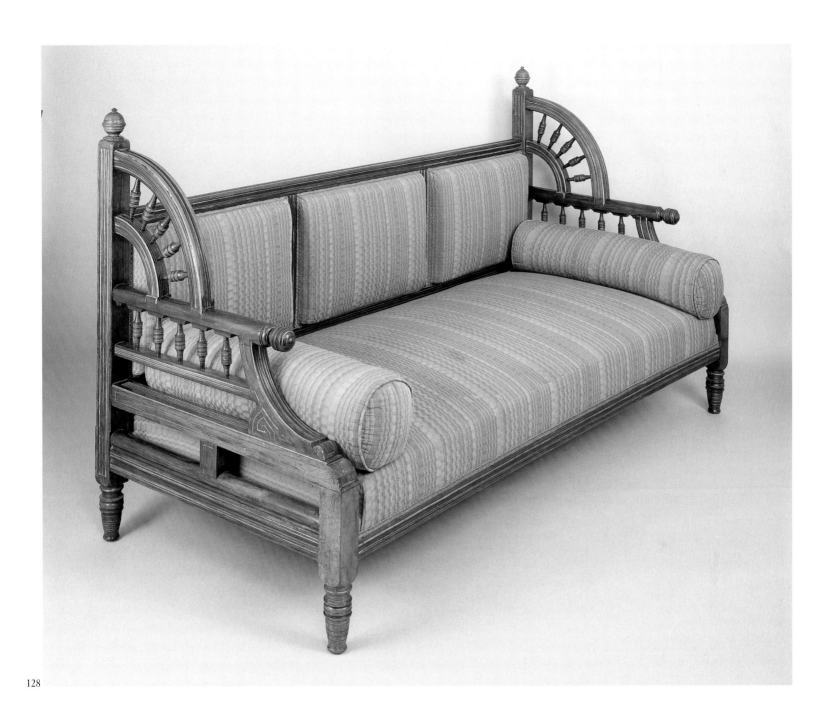

128

128. *Settee* or *Sofa*

Ca. 1872–75, attributed to E. W. Godwin
Probably made by Collinson and Lock
Rosewood, partially gilt; upholstered seat
and back panels; (casters missing)
38⅝ × 70⅛ × 30⅛ in. (98 × 178 × 76.5 cm)
Fine Art Society, London; Private
collection

Literature: Fine Art Society 1981, p. 32,
pl. 27; Cooper 1987, p. 141, pl. 332; Haslam
1991, p. 110, fig. 71

The deep seat and tripartite division of the
back of this sofa relate it to the one Godwin

designed for Dromore Castle (see CR 119).
The rounded finials atop the back uprights
are reminiscent of another piece for Dromore,
the circular settee reproduced in William
Watt's *Art Furniture* (1877; Plate 12).

Although Godwin cannot be confirmed
as the designer of this particular piece, it
does relate to his designs for three-seater
settees or sofas based on the Chinese *k'ang*
form. The incorporation of spindles in the
overall form of the arms was common to
many of Godwin's seating designs, for
example his double music stool (CR 123)
and easy chair (CR 139) of the 1870s.

Double rails were also used by Godwin,
often on chairs of Greek inspiration (see,
for example, CR 184).

The use of rosewood points to the
manufacturing firm of Collinson and Lock,
who made a great number of pieces in
rosewood at this time. In addition, Godwin's
ledgers (V&A AAD 4/13-1980, fol. 17, 5
September 1873) indicate that between 1872
and 1875 he designed at least two sofas for
Collinson and Lock – one of them was for
Grey Towers, Nunthorpe, for William
Randolph Innes Hopkins, perhaps his most
overtly Anglo-Japanese decoration scheme.

129. *Easy Chair*

Ca. 1872–75, attributed to E. W. Godwin
Probably made by Collinson and Lock
Mahogany; upholstered seat and back;
casters
$31\frac{7}{8} \times 24 \times 24$ in. ($81 \times 61 \times 61$ cm)
Stamped on underside: 92145
Fine Art Society, London; Private
collection

Literature: Fine Art Society 1992, p. 28,
pl. 34; Fiell and Fiell 1997, p. 59

This easy chair shows striking similarities
to a lounge chair and settee which were
shown by William Watt at the 1878
Exposition Universelle in Paris and
illustrated that same year as "Anglo-
Japanese Furniture" in *Building News*
(Fig. 129.1). The ways in which this chair
differs, however, indicate that it was
perhaps an earlier model, less inspired by
Japanese design. The type of spindles and
the arched openings link this piece to the
Cottage-style furnishings Godwin was
designing in 1873–74 for Collinson and
Lock and, later, for William Watt. The
double rail was a feature characteristic of
many of Godwin's chair designs of the
1870s and 1880s (see, for example, CR 138).

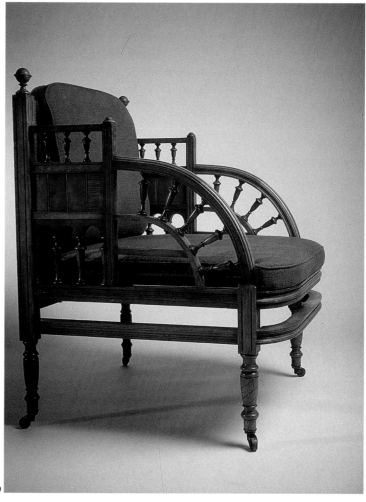

129

129.1 Lounging chair from an illustration of
"Anglo-Japanese Furniture" in *Building News*,
1878

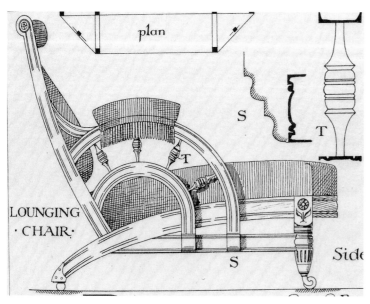

130. *Sofa*

Ca. 1873, attributed to E. W. Godwin
Made by Collinson and Lock
Ebonized wood; upholstered seat and back
$27\frac{3}{8} \times 82\frac{1}{2} \times 25\frac{1}{2}$ in. ($69.5 \times 209.6 \times 64.5$ cm)
Paul Reeves, London; Moderne Gallery,
Philadelphia

Literature: Moderne Gallery 1995, p. 17,
no. 91

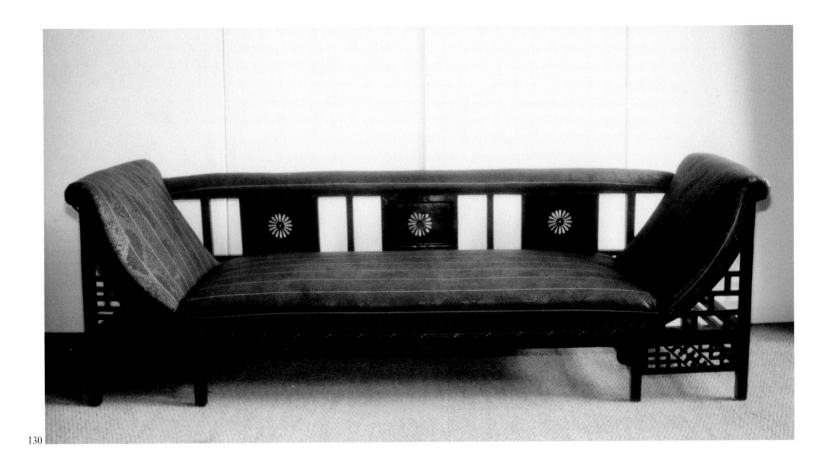

130

This sofa has been attributed to Godwin primarily because of its many Anglo-Japanese elements (latticework, pierced sunburst motifs, and ebonized finish). The attribution is strengthened by the fact that a second example, in a private collection, is stamped "Collinson and Lock" (CR 130-a), and the pierced sunburst motif – common to Godwin's designs of the 1870s – appears in the reading stand he designed for Collinson and Lock for the 1873 Universal Exhibition in Vienna (CR 326).

130-a. *Sofa*
Ca. 1873
Collinson and Lock
Ebonized wood; upholstered seat and back
Measurements unknown
Stamped Collinson and Lock, London, on underside
Private collection

131

131. *Design for a Side Chair*
Literature: Aslin 1986, pp. 31, 76, fig. 53

This side chair is known from a drawing in Godwin's sketchbooks circa 1872 that is annotated "5W," indicating it was made for William Watt (V&A PD E.233-1963, fol. 17). It is one of Godwin's most exciting chair designs, with a semicircular splat containing radiating spokes and rounded stiles that curve back and extend aggressively upward. Godwin's masterful handling of openings is in evidence in the treatment of the splat, which is segmented into a long rectangular opening at the top, multiple triangular sections in the middle, and a row of three rectangular openings along the bottom. The chair's thin, rounded legs are connected by stretchers placed at different heights, continuing the dissection of space.

132, 133. *Chair Designs for Vienna Exhibition*

Literature: Aslin 1986, pp. 28, 58, fig. 27; Cooper 1987, p. 129, figs. 208–09; Soros 1999, no. 50, p. 255, fig. 8-44

These two chairs are known from a pen-and-ink drawing in the collection of The National Trust, Ellen Terry Memorial Museum, Smallhythe Place, Kent (D.24). The drawing is inscribed "Collinson & Lock. Chairs for Vienna Oct '73," indicating they were designed for Collinson and Lock's stand at the Vienna Universal Exhibition in 1873. The chair at left is Anglo-Japanese, with a latticework crest panel and extended uprights that arc dramatically backward. Two horizontal panels of carved chrysanthemums frame the central back panel, which is upholstered in a Japanese-derived pattern of cranes and stylized florals that matches the seat. Brass plaques with raised rivets, reminiscent of Japanese brasswork, adorn the stiles.

The high-backed chair at right is Jacobean in style, having many features derived from seventeenth-century chairs, including cup-and-cover legs joined by a continuous stretcher close to the floor, a crested top rail and lower crosspiece positioned several inches above the seat, extended uprights with rounded finials, and floral carving on the seat rails and splat. Its ample proportions and elegant upholstery are typical of joined furniture of the Jacobean period.

134

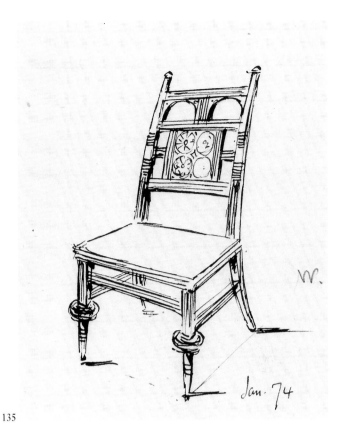

135

134. *Design for a Dining Chair*

Literature: Aslin 1986, pp. 15, 57, fig. 26

This design, which appears in one of Godwin's sketchbooks (V&A PD E.234-1963, fol. 20), is believed to have been the model for the chairs Collinson and Lock commissioned him to design for Prince Esterhazy in 1873. An entry in Godwin's ledgers states that he received payment of £3.3s.0d for "Dining Room chair Prince Esterhazy Oct 10, 1873" (V&A AAD 4/13-1980, fol. 18), and sketchbook notes refer to a "chair for Esterhazy via Collinson & Lock Oct' 73 Ordered in Vienna" as well as to a "Drawing rm Chair Esterhazy panel, moulding stopped Dec leather back of chair" (V&A PD E.234-1963, fol. 19). Godwin also designed a ceiling for Esterhazy, which appears in his sketchbooks as well.

This chair is basically a standard armchair with a slightly curved form. An H-shaped stretcher connects the shaped legs, which rest on casters. The upholstered seat and back, covered in elaborately decorated leather, were shaped to conform to the chair's elegant curved outline.

135. *Design for a Greek-Style Chair*

This chair is known from a drawing in Godwin's sketchbooks annotated "W. 13 / Jan. 74" (V&A PD E.233-1963, fol. 63), indicating that it was commissioned by William Watt in 1874. Its ring-turned front legs with projecting discs, molded stiles terminating in turned finials, raked back, and splayed rear legs reflect a knowledge of ancient chair forms. Typical of Godwin's best work of the 1870s is the sophisticated interplay of open and closed spaces, particularly evident in his treatment of the splat, which is dominated by a central upholstered panel with paired rectangular openings on either side, a pair of arched openings beneath the top rail, and a large rectangular void between the bottom of the splat and the seat rail. This complex treatment of space is continued in the placement of the stretchers.

136.I–II. *Pair of Anglo-Japanese Chairs*

Ca. 1875
Probably made by William Watt
Ebonized wood; cane seats
$39 \times 16\frac{7}{8} \times 16\frac{1}{8}$ in. ($99 \times 43 \times 41$ cm)
Phillips, London, 13 October 1992, lot 255;
Fine Art Society, London; Musée d'Orsay,
Paris (OAO 1302)

Literature: Gere and Whiteway 1993,
p. 156, pl. 192; Musée d'Orsay 1996, p. 106;
Tokyo Metropolitan Art Museum 1996,
p. 180, no. 120; Soros 1999, no. 70, p. 244,
fig. 8-31

This ebonized wood chair, one of a pair,
with latticed splat and cane seats is in
Godwin's Anglo-Japanese style. A similar
chair is illustrated in a watercolor in one of
his sketchbooks (Fig. 136.1, from about
1875), although in that version the lower
half of the splat has a wicker or straw panel
instead of the parallel laths in our example.
Godwin used similar lath sections in the
splats of his Greek chairs of the 1880s (see
CR 505). The latticework of the back and
the arched opening formed by the shaped
top rail derive from examples of Japanese
wood construction which appeared in
contemporary travel accounts and
photographs that Godwin studied. One of
his sketchbook drawings, annotated
"Interior Court Yokohama" (V&A PD
E.280-1963, fol. 4), shows the lintel and
lattice railings that he incorporated into the
form of the chair. The extreme
rectilinearity of this chair as well as its
attenuated supports, ebonized finish,
interplay of open and closed spaces, and
round and perpendicular shapes at the
intersections of the seat frame all point to
the masterful hand of Godwin.

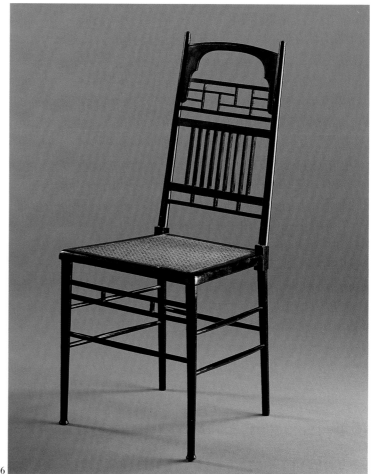

136

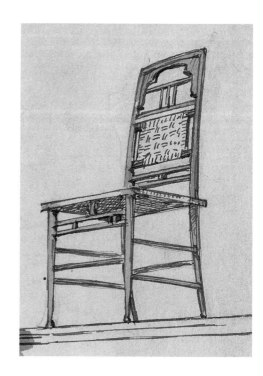

136.1 Design for Anglo-Japanese chair from a
watercolor (V&A PD E.482-1963)

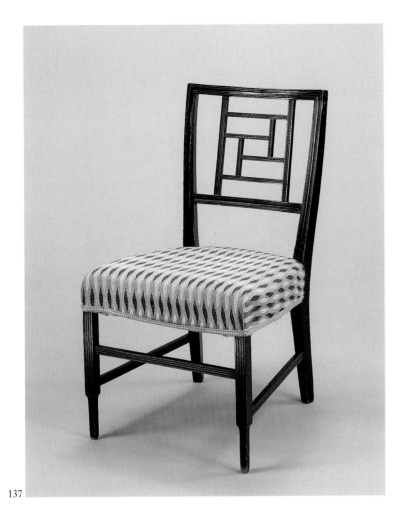

137

138

137. *Chair*

Ca. 1875, attributed to E. W. Godwin
Probably made by William Watt
Ebonized wood; upholstered seat
$29\frac{1}{2} \times 17\frac{1}{2} \times 18\frac{1}{8}$ in. (75 × 44.5 × 46 cm)
Private collection

The chair presented here is similar to one illustrated in William Watt's *Art Furniture* (1877; Plate 6) under "Dining Room Furniture" (the accompanying price list states it was available in oak or Spanish mahogany for the sum of £3.3s.0d). This example lacks the stretcher connecting the rear legs that appears in the illustrated version as well as the front legs composed of rods that appear on Godwin's Anglo-Greek chairs (CR 184, 185), derived from ancient Greek specimens in the British Museum. The splat of both versions is composed of an Asian fretwork pattern.

Lattice-back chairs were extremely popular in the 1870s, and the combination of Asian and ancient Greek sources in a sleek chair form is typical of Godwin's designs.

138. *Design for an Armchair*

This armchair was illustrated under "Parlor Furniture" in William Watt's *Art Furniture* catalogue (1877; Plate 3), priced at £3.10s.0d. An earlier drawing for it in a Godwin sketchbook from about 1876 (V&A PD E.233-1963, fol. 30) is annotated "W.10," indicating it was originally commissioned by Watt.

The chair has a series of curving elements that are well combined in this form, from the rounded crest rail to the incurvate arms which bend down to connect to the stretchers, which are also curved. The catalogue description informs us that this treatment had the practical effect of making the chair "extremely light in appearance . . . [and] more than usually strong by carrying the support of the arms down to the lower rails, thus obtaining for what is commonly the weakest part of an armchair, two points of support and attachment, instead of one." (p. vii) The upholstered seat and small upholstered back panel have also been shaped to conform to the chair's form.

139. *Easy Chair* or *Lounging Chair*

Ca. 1876
Made by William Watt
Ebonized wood; upholstery (seat, back, arms) in an Art Nouveau tapestry over a silk, wool, and cotton Jacquard floral textile; brass casters
$32\frac{1}{8}$ × 23 × $30\frac{7}{8}$ in. (81.5 × 58.5 × 78.5 cm)
Ivory disc attached to underside indicates Patent Office Registration of the design on 14 November 1876 (Fig. 139.1)
Phillips, London, 5 July 1984, lot 305; Fine Art Society, London; Private collection

Literature: "Anglo-Japanese Furniture at Paris Exhibition," 14 June 1878, p. 596, ill.; Aslin 1962a, pl. 34; Cooper 1972, p. 122, pl. 290; Harris 1983, p. 11; Hoare 1983, p. 31; Fine Art Society 1986, p. 29, no. 34, p. 64; N. Wilkinson 1987, pp. 250–51; Fine Art Society 1989, p. 63; Johnson 1989, p. 96; Soros 1999, no. 81, pp. 256–57, fig. 8-46

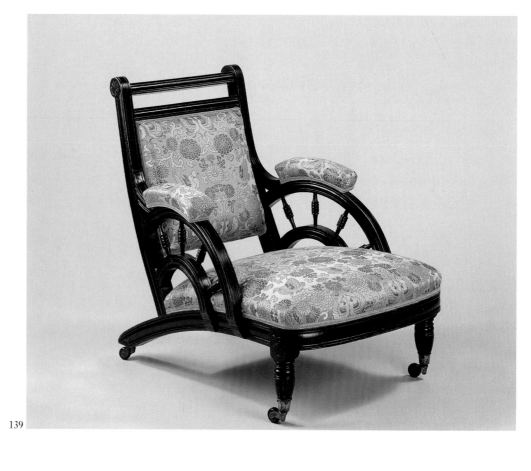

139

139.1 Ivory disc showing Patent Office Registration.

139.2 "Ornamental Design for Easy Chair or Settee" (Public Record Office)

This easy chair is very similar in design to one that appeared in William Watt's 1877 *Art Furniture* as part of an Anglo-Japanese drawing-room suite (see Plate 8). It was described as a "Ladies Drawing Room Easy Chair" and sold for £6.6s.0d. Watt registered the design with the Patent Office in 1876 as "Ornamental Design for Easy Chair or settee / Class 2" (Fig. 139.2), under the number 305188. An illustration in *Building News* (14 June 1878) shows that the chair was exhibited as a "lounging chair" in William Watt's display at the 1878 Exposition Universelle in Paris (Fig. 139.3); the entry for Watt in the accompanying exhibition catalogue lists it as part of "Drawing Room Furniture. The Butterfly Cabinet and Fireplace, sofa, centre table, music bookcase, coffee table and two chairs, designed by EW Godwin."

The chair presented here differs from the illustrated version in that it has upholstered armrests and lacks both the upholstered

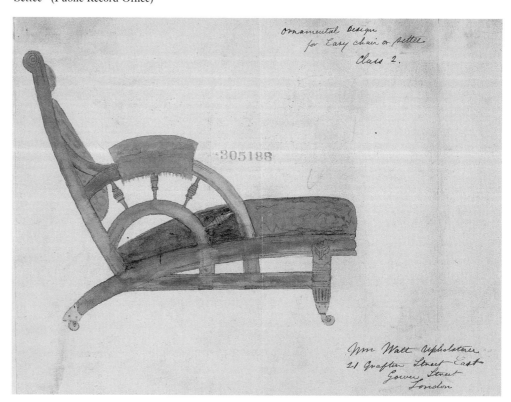

headrest and the bottom stretcher. The descriptive text for the *Building News* illustration also indicates that this chair was exhibited with a cushion of "yellow plush," and it was available with some variations, including additional spindles in the wheel-shaped arms "if four, as shown, [we]re thought to be insufficient."[26] It was available in both ebonized wood and walnut versions.

Low-slung easy chairs with wide armrests, designed to accommodate the large crinolines of contemporary women's wear, were popular in the second half of the nineteenth century. The use of spindles, the sunflower design incised on the side of the front legs (a popular Aesthetic motif), and the ebonized finish were elements typical of art furniture, particularly in Great Britain in the 1870s and 1880s.

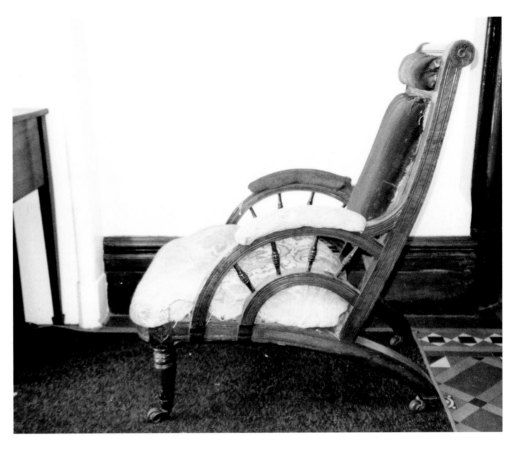

139-a.1 Stamped disc showing Patent Office Registration.

139.3 Lounging chair from an illustration of "Anglo-Japanese Furniture" in *Building News*, 1878

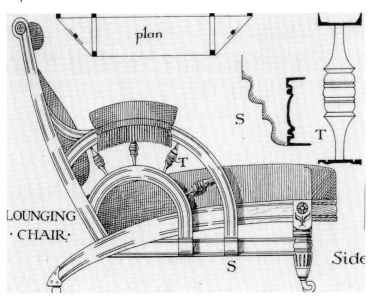

139-a. *Easy Chair* or *Lounging Chair*
Ca. 1876
Made by William Watt
Walnut; upholstered seat, back and arms; brass casters
37 × 25¾ × 25 in. (95.3 × 65.4 × 63.5 cm)
Enameled William Watt label attached to underside of chair; stamped patent office disk on underside of chair (Fig. 139-a.1)
Paul Reeves, London; Private collection

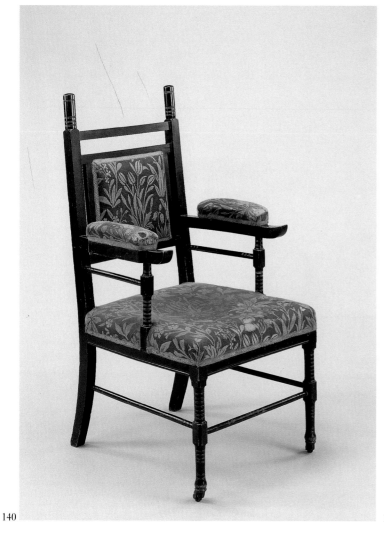

140

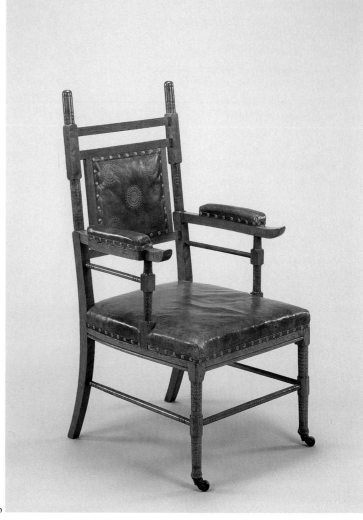

140-b

140. *Armchair*
Ca. 1876
Made by William Watt
Ebonized mahogany; upholstery of stylized
flowers and foliage on a green ground; black
ceramic casters (front)
42$\frac{1}{8}$ × 20$\frac{1}{8}$ × 21$\frac{1}{4}$ in. (107 × 51 × 54 cm)
Jeffrey and Co., Mortimer Street show-
room; by descent to Roger Warner; his
daughter Deborah Warner; on loan to
Lotherton Hall, Aberford

Literature: Fiell and Fiell 1997, p. 60

This armchair is an ebonized version of the
wainscot oak carver originally designed in
1869 for Dromore Castle (CR 112). It
differs in that the arms terminate in an
upward curve and are decorated with
shallow-cut rosettes instead of carved lion
heads, adding an Asian quality (a feature
also found on the easy chair in the Bristol
Museum; see CR 121). A version without

arms was illustrated in William Watt's 1877
Art Furniture catalogue (Plate 11) under
"Library Furniture."

The armchair was produced in both
natural and ebonized wood for many years,
as attested by the great number that still
survive.

140-a. *Armchair*
Ca. 1876
Made by William Watt
Ebonized wood; plush upholstery; black
ceramic casters (front)
42$\frac{1}{4}$ × 20$\frac{1}{4}$ × 22$\frac{1}{4}$ in. (107.4 × 51.5 × 56.5 cm)
William Watt label affixed to bottom of seat
Private collection

This version features the upward-curving
arms but lacks the rosette seen in CR 140.

140-b. *Armchair*
Ca. 1876
Made by William Watt
Mahogany; burgundy leather upholstery;
black ceramic casters (front)
41$\frac{3}{4}$ × 20$\frac{1}{8}$ × 20$\frac{7}{8}$ in. (106 × 51 × 53 cm)
Paul Reeves, London; Private collection

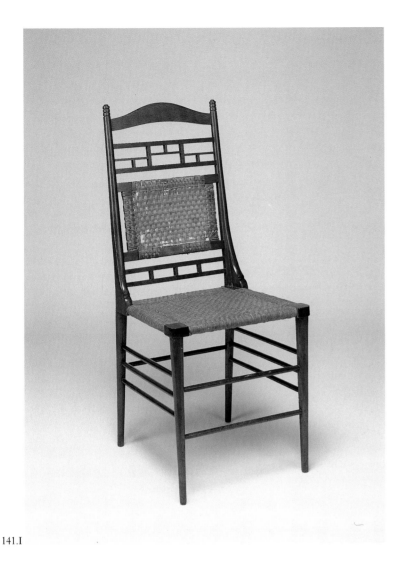

141.I

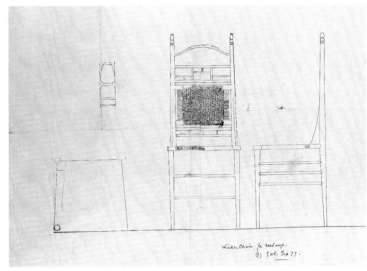

141.1 Design for Anglo-Japanese side chair
(V&A PD E.479-1963)

141.2 Wicker chair from an illustration of
"Anglo-Japanese Furniture" in *Building News*,
1878

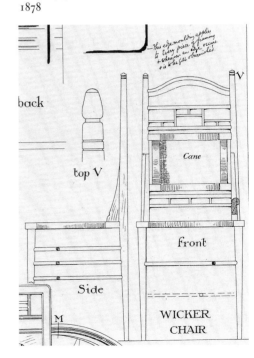

141-I. *Anglo-Japanese Side Chair*
1877
Made by William Watt
Light mahogany; cane seat and back
$38^3/_{16} \times 16^5/_{16} \times 16$ in. (97 × 41.5 × 40.6 cm)
Haslam and Whiteway, London; Virginia
Museum of Fine Arts, Richmond (96.99)

Literature: "Anglo-Japanese Furniture at
Paris Exhibition," 14 June 1878, p. 596, ill.;
Fiell and Fiell 1997, p. 60, ill.

141-II. *Anglo-Japanese Side Chair*
1877
Made by William Watt
Light mahogany; cane seat and back
$38^3/_{16} \times 16^5/_{16} \times 16$ in. (97 × 41.5 × 40.6 cm)
Paul Reeves, London

With their openwork lattice splats, triple
side stretchers, thin tapering rods, and cane
seats and back panels, this pair of side
chairs are examples of a lightweight, elegant
chair form with Japanese-inspired motifs. A
contemporary photograph of the William
Watt stand from the 1878 Exposition
Universelle in Paris (V&A photo collection)
shows a similar chair exhibited as part of
the "Butterfly Suite."[27] It was also
exhibited by Watt at the Exposition and
illustrated in *Building News* (Fig. 141.2) as
"Anglo-Japanese Furniture at Paris
Exhibition by E. W. Godwin, F.S.A." A
signed drawing in the Victoria and Albert
Museum (Fig. 141.1) dates this design to
September 1877.

142

142. *Stool*

Ca. 1877, attributed to E. W. Godwin
Maker unidentified
Mahogany; upholstered seat
17½ × 16¾ × 18¼ in. (44.5 × 42.6 × 46.4 cm)
Private collection

Although there is no known drawing for this Anglo-Japanese stool, Godwin's ledgers and cashbooks indicate that he designed a number of stools throughout his career. The turned legs and lattice stretcher of this model are reminiscent of his table and chair designs of the 1870s (CR 212, 224; CR 131, 141).

143

144

143. *Design for an Armchair*

This wicker armchair was illustrated in a watercolor in Godwin's sketchbooks annotated "Anglo-Japanese Designs by EW Godwin" from about 1875 (V&A PD E.482-1963). It is one of his most elaborate chair designs, with rounded arms and a rounded top rail in imitation of bamboo chair forms, and an upholstered back and seat with an Anglo-Japanese fabric design of chrysanthemums and H-shaped diagonals, which complements the latticework in the arms and back panel.

The categorization given to chairs such as this reflect the general confusion in terminology at the end of the nineteenth century between Chinese and Japanese specimens. No wicker chairs were being imported from Japan at this time, so Godwin, who is known to have owned wicker chairs imported from China, should more correctly have called this chair Anglo-Chinese in design.

An earlier drawing for a similar chair appears in Godwin's sketchbooks from about 1873 (V&A PD E.234-1963, fol. 10) and was probably made by William Watt, who is known to have executed many of the other designs in this watercolor.

144. *Design for a Side Chair*

This side chair was illustrated in a watercolor in Godwin's sketchbooks annotated "Anglo-Japanese Designs by E. W. Godwin" from about 1875 (V&A PD E.482-1963). It has a distinctive splat of vertical slats, which Godwin later used in his Anglo-Greek chair designs executed by William Watt (see CR 505), and, like many of his side chairs, has a cane seat. The unusual square elbow strut attached to the side stretcher gives it an overall Japanese quality.

This chair was probably made by William Watt, who executed many of the other designs shown in this watercolor.

145

145. *Design for an Ottoman*

This ottoman appears in a Godwin watercolor sketch annotated "Anglo-Japanese Designs by EW Godwin" (V&A PD E.482-1963) from about 1875. It is the only ottoman design other than the Dromore Castle model (CR 120) known to be by Godwin. The low, round cushion, one side of which was upholstered in fabric with a diagonal pattern, sat on out-turned bracket feet. The unusual wedge-shaped back support was covered in an Anglo-Japanese bird-and-tree design. The center table and side chairs in this watercolor were made by William Watt, so presumably he made the ottoman as well.

146

147

149

146. *Design for a Settee*

Literature: "Anglo-Japanese Furniture at Paris Exhibition," 14 June 1878, p. 596, ill.; "'Art' Furniture–So-Called," 15 February 1879, p. 108, ill.

This Anglo-Japanese settee design was for the suite of furniture Godwin designed for William Watt's stand at the 1878 Exposition Universelle in Paris. The settee, which was six feet long, appeared in *Building News* on 14 June 1878 (see Fig. 129.1); however, since two versions of this design (with canvas seats and priced at £15.15s.od apiece) were reproduced in William Watt's *Art Furniture* (Plate 14), we know they had already been designed by 1877. There is also a related drawing from about 1876 in one of Godwin's sketchbooks (V&A PD E.254-1963, fol. 2).

The latticework and pierced cloud motif on the sides of the settee shown here, as well as the brass-edged feet and turned finials, are all Japanese-inspired features. It also has a dramatic semicircular arm with four turned spindles, and, typical of much of Godwin's furniture, rested on casters for easy movement.

147. *Design for a Couch*

This armless couch, or settee, appears in William Watt's *Art Furniture* catalogue (1877; Plate 15) at a price of £5.10s.od. It has a plain upholstered seat and the shaped back cushion conforms to the arch of the carved side panels. The design is distinguished by the side panels and a double seat rail as well as uprights that terminate in turned finials. The couch was designed to be placed at the foot of a bed, and is mounted on brass casters for easy movement.

148

148. *Design for a Footstool*

This footstool is illustrated in William Watt's *Art Furniture* (1877; Plate 11) under the heading "Library Furniture." Made of oak, it was covered with embossed moroccan leather, and cost £1.10s.od. It has a checkerboard inlay design and turned legs reminiscent of ancient forms. A similar ancient-style form appears in a Godwin sketch that is annotated "footstool 3 Aug. 73 inlay & ebony" (V&A PD E.229-1963, fol. 80).

149. *Design for a Study Chair*

This study chair was reproduced in William Watt's *Art Furniture* (1877; Plate 2) where it is described as a "Study Chair" and priced at £7.7s.od. Made of oak and covered in moroccan leather with a thick fringe, it is one of the most elaborate in the series of study chairs Godwin designed for Watt's catalogue. In keeping with his others, this study chair is a variation of the barrel-back form, based on a sketch in Godwin's drawing book from about 1875 of an antique chair with rounded back from the British Museum (V&A PD E.278-1963, fol. 1). This example has a heavier frame than Godwin's cane versions, thick, baluster-shaped turned legs and arm supports, and a deep upholstered seat. Godwin has also exaggerated the width and depth of the curved top rail, providing a chair that is both comfortable and sturdy.

Godwin used a quirky talon-shaped support instead of rear legs, and for easy mobility added casters to the front legs and rear support.

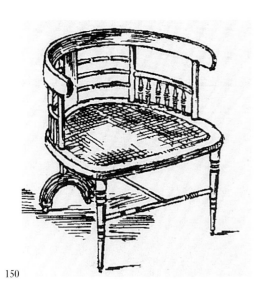

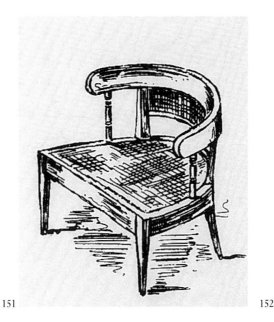

150

151

152

150. *Design for a Study Chair*

This cane-seat armchair was made of oak and appeared in William Watt's *Art Furniture* (1877; Plate 2) at a price of £3.3s.od. The overall form derives from ancient throne chairs, but its rounded splat and unusual crescent-shaped back leg support relate to some of Godwin's earlier chair designs, particularly his Councillor's chair for Northampton Town Hall (CR 100) and his Eagle chair for Dromore Castle (CR 114). The turned, circular front legs are connected to a back support by an H-type stretcher, which provides additional support to this unusual leg configuration. Godwin's sophisticated use of open and closed spaces is amply demonstrated in his treatment of the splat. The side panels consist of a row of tightly spaced turned spindles set vertically beneath a horizontal rectangular void and are connected by a central section composed of three more openly spaced horizontal rails. The flat cane seat balances well with the complicated spatial organization of the splat.

151. *Design for a Study Chair*

This study chair was reproduced in William Watt's *Art Furniture* (1877; Plate 2) as a "cane seat arm chair" and cost £3.0s.od. It is another version of the rounded back form that Godwin favored. This rather simple example has a curved cane back panel that matches the rounded cane seat. Unlike the other two models for study chairs in Watt's catalogue (CR 149, 150) which have unusual rear supports, this chair has tapered back legs that splay backward for extra stability. The seat rail is comprised of a flat rectangular panel that counterbalances the thick top rail. For added strength the top rail is attached to the seat rail with a baluster-turned support at either end, adding to the sophisticated play of open space in the chair's back design.

152. *Design for a Smoking Chair*

This chair appeared in William Watt's *Art Furniture* (1877; Plate 2) under "Library or Study Arm Chairs" and was priced at £4.4s.od. The catalogue described it as a stuffed seat smoking chair, with its "moveable seat and drawers beneath [f]or pipes and tobacco" (p. vii). The ceremonial quality of the design – found in the tall, straight uprights which terminate in carved lion heads, the turned railings, and the large knobbed finials – is counteracted by the sloping backrest and rounded seat cushion.

153

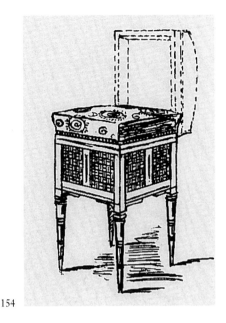

154

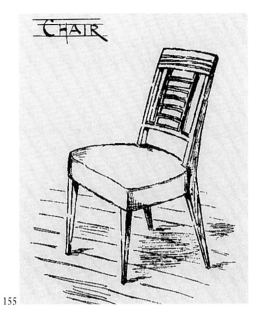

155

153. *Design for a Hall Chair*

This chair appears in William Watt's *Art Furniture* as "Hall Furniture" (1877; Plate 2). Made of oak and priced at £3.3s.od, the chair was intended to accompany the hat and coat stand with which it appears (CR 411). The catalogue's description indicates that Godwin derived it "from 'Old English' examples of woodwork" (p. vii).

The bobbin-turned legs and stiles, the bun feet connected to a continuous stretcher, the heavily fluted rails, and the double roundel cornice sitting above a floral carved panel are all elements derived from Jacobean specimens.

Godwin felt that since a visitor's first impression of a home was formed upon entering the hallway, the furniture there should be more decorative and solid in character. The introductory notes to the Watt catalogue suggest that hallway furniture "should be of a substantial character and made of oak or teak." (p. v). In keeping with that, this chair is one of Godwin's most massive domestic designs.

154. *Design for a Music Stool*

Reproduced in William Watt's *Art Furniture* under "Various Furniture" (1877; Plate 2), this music stool cost £3.10s.od. Made of walnut, it was upholstered with moroccan leather stamped with Godwin's typical gilded roundels. One of many such ingenious designs that Godwin created during his lifetime, this example includes a rising top and well for music, tapered rectangular legs with turned decoration, an apron with a high arched curve, and latticed panels.

155. *Design for a Chair*

This chair was reproduced in William Watt's *Art Furniture* under "Parlor Furniture" (1877; Plate 3) and it was priced at £2.10s.od. A sketch of it appears in Godwin's sketchbook from 1876 (V&A PD E.233-1963, fol. 11).

The chair's rectilinear splat with its ladderback divisions and reeded stiles and top panel is counterbalanced by curvilinear elements such as a raked splat (for additional comfort), rear legs that curve backward (for additional stability), and a rounded seat cushion covered in canvas. Unlike most of Godwin's side chairs, this model is made without stretchers, indicating somewhat heavier construction.

156. *Design for a Couch*

This oak couch appeared in William Watt's *Art Furniture* under "Parlor Furniture" (1877; Plate 3) priced at £8.10s.0d; it is covered in canvas. The shaped side panels and the top panel, which attaches to the crest of the backrest, are caned. The main stiles are quadrangular, with inlays of circles and stripes, and topped with turned finials reminiscent of decoration found on ancient specimens. The feet are also turned, in keeping with Egyptian prototypes.

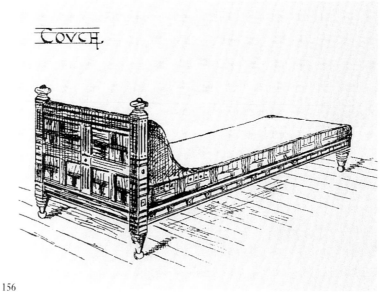

156

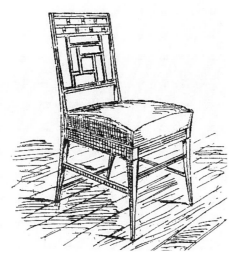

157

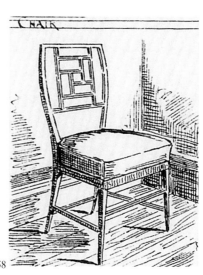

158

157. *Design for a Dining Room Chair*

This chair is reproduced in William Watt's *Art Furniture* under "Dining Room Furniture" (1877; Plate 5); it cost £3.3s.0d, is a rectangular version of Godwin's popular lattice-back dining chair (CR 158) and has a corresponding seat cushion. It was made of oak and upholstered in moroccan leather. Godwin combined two different lattice patterns, both derived from Japanese architectural details, into an original splat design. Stretchers reinforce the tapering rectangular legs.

Such latticework chairs were very popular in the 1870s and 1880s, and were manufactured by a great number of art furnishers.

158. *Design for a Dining Room Chair*

This chair, made of oak and upholstered in moroccan leather, is a variation of Godwin's favored lattice-back chair design (CR 157) and is illustrated in William Watt's *Art Furniture* under "Dining Room Furniture" (1877; Plate 6). It sold for £3.3s.0d.

For this model, Godwin curved the outer side rails of the splat and the seat cushion. The tapering rectangular legs splay gently outward and are strengthened by artfully placed stretchers. The asymmetrical latticework in the splat is derived from Japanese architectural details that Godwin studied and which appear frequently in his sketchbooks.

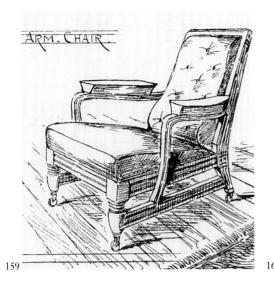

159

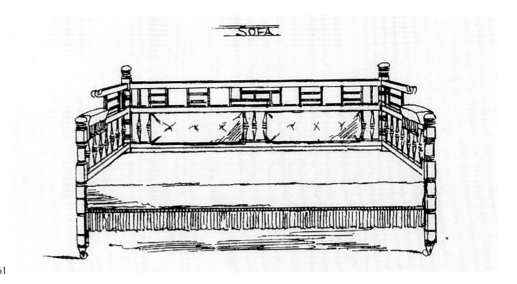

161

159. *Design for an Armchair*

This armchair, executed in oak and upholstered in leather, was reproduced in William Watt's *Art Furniture* under "Dining Room Furniture" (1877; Plate 6) and sold for £8.0s.0d. With its deeply padded back cushion and armrests it is one of the largest and most comfortable chairs designed by Godwin, and presumably was meant to be placed at one end of the dining-room table. The curved armrest, raked back legs, and double side rail add interesting design details to this solid form, and its casters facilitate easy movement.

The text accompanying the catalogue illustration remarks that this "easy chair" was designed "so as to render the seat moveable, an arrangement that practically precludes the accumulation of dust, pencils, rings &c., in the crevice at the back of the seat" (p. viii).

A related drawing can be found in Godwin's sketchbooks from about 1875 (V&A PD E.235-1963, fol. 28).

160. *Design for a Carved Side Chair*

This side chair, which was made of oak and cost £5.0s.0d, is one of Godwin's most elaborate chair designs. It was part of an Old English-style dining-room suite reproduced in William Watt's *Art Furniture* (1877; Plate 7), and many of its features – boxlike form, carved lunette decoration along the top rail, turned finials surmounting the uprights, bobbin-turned stiles, and block-tenoned feet connected by a continuous stretcher and mounted on knobs – relate it to English joined back stools of the seventeenth century.[28]

161. *Design for a Sofa*

This ebonized sofa was one of a series of three-sided sofas that Godwin designed in the 1860s and 1870s. It is illustrated in William Watt's *Art Furniture* under "Anglo-Japanese Drawing Room Furniture" (1877; Plate 8), and was priced at £13.13s.0d.

Japanese details appear in the turned cap finials, the upturned side brackets, and the latticed frame, which is mounted on the rail above the two padded backrests and extends around the back corners. The turned balusters along the side panels and backrest place this sofa within the Art Furniture movement. The stepped-down padded armrests and buttoned backrests add comfort; the casters enhance mobility.

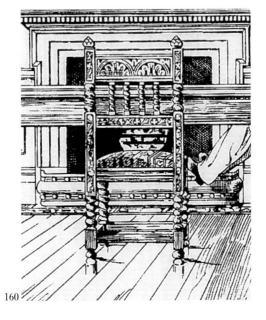

160

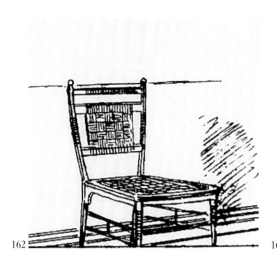

162

163

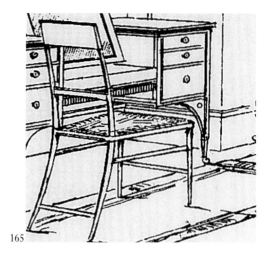

165

162. *Design for a Side Chair*

This "drawing room chair in wicker" is reproduced in William Watt's *Art Furniture* as part of Godwin's "Anglo-Japanese Drawing Room Furniture" (1877; Plates 8, 14), and it was priced at £2.2s.0d. It is a variation of Godwin's popular wicker chair (CR 107) that had already been in production by Watt for almost ten years. The back uprights in this model are more rounded, and Godwin has added an apron to the side seat rails as well as a second side stretcher – small changes that make the chair more elegant.

163. *Design for a Music Stool*

This design for a revolving music stool was illustrated in William Watt's *Art Furniture* (1877; Plate 12). It is not listed, however, in the list of prices attached to the catalogue. It shows a round seat with a swivel mechanism on a square platform. There is a related drawing, ca. 1875, in Godwin's sketchbooks (V&A PD E.233-1963, fol. 17).

164. *Design for an Armchair*

This lightweight ebonized armchair was reproduced in William Watt's *Art Furniture* as part of Godwin's "Anglo-Japanese Drawing Room" (1877; Plate 14) and sold for £6.6s.0d. It has a thin raked back, and high flat arms with rectangular side panels with open space. The stability of the chair was reinforced by joining the thin tapered legs to a continuous stretcher. The side panels and splat appear to be made of wicker woven in an unusual diagonal pattern.

165. *Design for a Bedroom Chair*

This lightweight bedroom chair appears in William Watt's *Art Furniture* alongside the pine dressing table it was designed to accompany (1877; Plate 15). It has a willow seat and cost £0.12s.0d, making it the least expensive Godwin chair available through the Watt catalogue.

The chair's delicate legs are reinforced with stretchers, and although the front legs are straight, the rear legs curve backward, saberlike. The back of chair is almost totally open, with only a plain top rail and thin middle rail joining the uprights.

Another chair of this design can be found in Godwin's sketchbooks in a drawing annotated "May 29, 1876" (V&A PD E.233-1963, fol. 15).

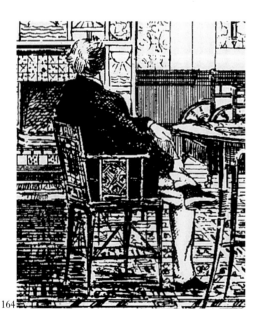

164

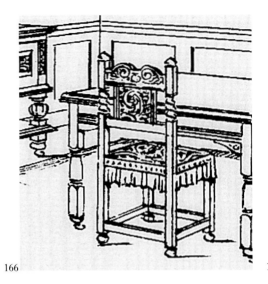

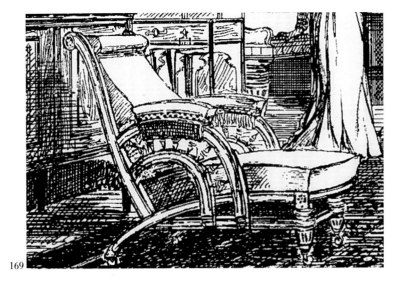

166

167

169

166. *Design for a Side Chair*

Made of oak and priced at £3.15s.0d, this side chair was reproduced in William Watt's *Art Furniture* under "Old English or Jacobean Furniture" (1877; Plate 15). (A matching armchair, not illustrated in the catalogue, was available in canvas for £4.4s.0d.) This example has an upholstered seat and back in stamped velvet as well as a decorative row of dense fringe around its seat rails. With its boxlike shape, double curved top rail, finials, and blocked or quadrangular legs sitting on knobs and joined with a continuous stretcher, it resembles the joined seats popular during the seventeenth century.

167. *Design for a Side Chair*

A portion of this side chair appears in William Watt's *Art Furniture* (1877; Plate 16) under "Economic Furniture" for the parlor and bedroom. Made of walnut and priced at £2.0s.0d, this chair corresponds to the other inexpensive pieces of this suite. It is lightweight with a woven splat, extended back uprights, and a square seat with a high, arched top rail. It has thin, tapering legs and appears to lack stretchers.

168. *Design for a Chair*

This lightweight chair appears in William Watt's *Art Furniture* as part of his suite of Jacobean furniture (1877; Plate 17), although the small upholstered back panel made up of a series of spindles is the only reference to Jacobean design in the entire form.

The chair, made of mahogany with a seat covered in canvas, sold for £2.7s.0d. A drawing of the front and side elevations appears in one of Godwin's sketchbooks and is annotated "done" (V&A PD E.506-1963). The drawing shows a diagonal stretcher that joins the rear legs to the side stretchers, an element that strengthens the chair's thin, turned legs, as does the curve of the back legs.

169. *Design for a Ladies' Drawing Room Easy Chair*

This ebonized easy chair, which appears in William Watt's *Art Furniture* (1877; Plate 14), is a more elaborate version of the one reproduced in Plate 8 (CR 139). With its padded arms and more dramatically shaped semicircular arm, it is closer to the version Watt exhibited at the 1878 Exposition Universelle in Paris, which was illustrated in *Building News* under the title "Lounging Chair" (14 June 1878) (see Fig. 139.3).

The chair was registered with the Patent Office by William Watt in 1876 and sold for £8.8s.0d.

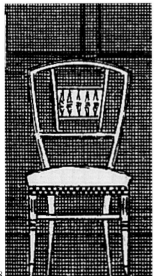

168

170

170. *Pair of Settees*

Literature: "House and Studio at Chelsea,"
11 June 1880, p. 282, ill.; Girouard 1977,
183, fig. 170; Harper 1987–88, p. 15; Soros
1999, p. 211, fig. 7-37

These built-in settees were designed by
Godwin in 1879–80 as part of his inglenook
design for the drawing room of artist Frank
Miles's studio-house at 44 Tite Street,
London.

They were built, facing each other, into
the corners of the inglenook. The portion
of the wall below the chair rail, which has a
decorative lattice pattern, serves as the
backrest and interior side of each settee.
The exposed side has a high flat armrest
with notched undersides and turned finials,
and below the seat is a double rail segmented
by stiles. A single upholstered cushion
covers the seat, for comfort, and under the
interior half of the seat are two rectangular
storage units with molded fronts. They are
still in the house today.

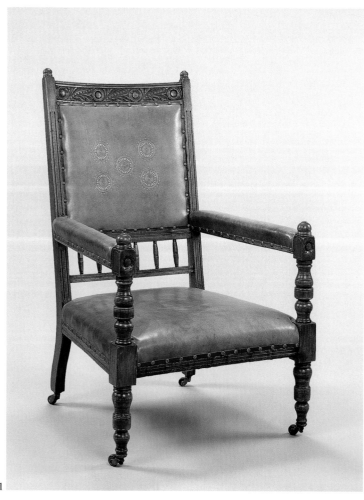

171

171. *Armchair*

Ca. 1880, attributed to E. W. Godwin
Probably made by William Watt
Oak; leather upholstered seat and back
panel; brass nails; brass casters
$40\frac{1}{2} \times 25\frac{1}{4} \times 23\frac{3}{8}$ in. (103 × 64 × 59.5 cm)
Paul Reeves, London; Private collection

This armchair is based on a Godwin
illustration of a Jacobean dining room in
William Watt's *Art Furniture* (Fig. 171.1;
1877; Plate 7), and its form is derived from
A. W. N. Pugin's armchair designed for the
House of Lords.[29] This chair has the same
eight-petaled flower carved into three sides
of the upright of each arm. Godwin has
added several decorative flourishes to make
it more suitable for a domestic setting: a
crest rail carved with a row of eight-petaled
flowers with stylized leaves; turned finials
on the uprights; kick-back rear legs; reeded
stiles and rails; and a row of turned
spindles in the back.[30] It is covered in the
same untanned leather with embossed discs
that Godwin had used ten years before for
the dining-room chairs for Dromore Castle
in Limerick (CR 112, 113).

172. *Side Chair*

Ca. 1880
Made by William Watt
Oak; upholstered leather seat and back
panel; brass nails
$37\frac{3}{8} \times 18\frac{1}{8} \times 18\frac{1}{8}$ in. (95 × 46 × 46 cm)
Enameled William Watt label affixed to
underside
Paul Reeves, London; Private collection

This side chair corresponds to the armchair
shown in CR 171. It has the same ring-
turned legs with square stretchers, reeded
stiles and rails, upper splat band carved
with eight-petaled flowers interspersed with
stylized leaves, lower splat made of a series
of six ring-turned spindles, and brass-
tacked leather upholstery. The H-shaped
stretcher arrangement recalls the stretchers
used in the standard House of Lords chair
designed by A. W. N. Pugin.

A large set of oak chairs, similar to this
side chair but with arched top rails, was
sold at auction in 1982 at Adare Manor,
Ireland.[31] They were mounted on brass
casters, stamped "Cope's Patent," identical
to those found on an ebonized settee
(CR 111) attributed to Godwin.

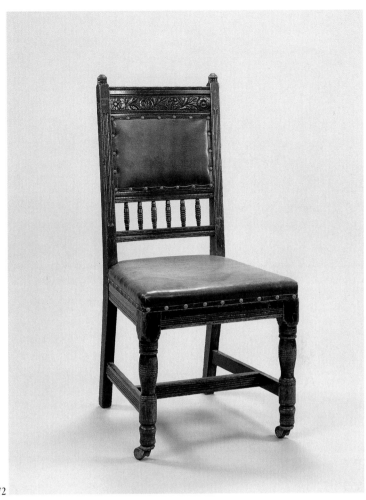

172

171.1 Armchair from the Jacobean dining room
in William Watt's *Art Furniture* (Plate 7)

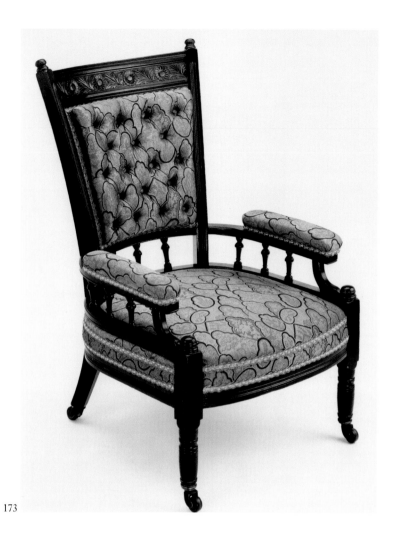

173

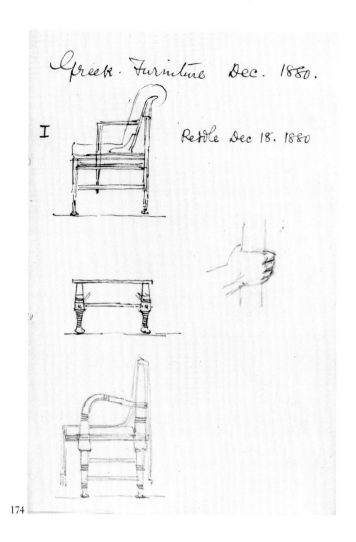

174

173. *Slipper Chair*

Ca. 1880, attributed to E. W. Godwin
Probably made by William Watt
Ebonized wood; upholstered seat, back, and
arms; black ceramic casters
34 × 23 × 23 in. (86.4 × 58.4 × 58.4 cm)
Private collection

This curvaceous slipper chair, with its top
rail of multipetaled blossoms interspersed
with stylized leaves, reeded stile and rails,
and domed finials, relates to a Godwin arm-
chair and side chair (CR 171, 172). The
rounded spindle decoration and the double
side rail can be found on another Godwin
easy chair from 1880 (CR 129). Godwin
also favored buttoned upholstery on the
splat and smooth upholstery on the seat
cushion, as in this example.

174. *Design for a Greek Chair*

This is a design for a Greek chair that
Godwin is known to have produced for
James Peddle, Chair and Couch Maker, 35
Cranmer Road, Lambeth (V&A PD
E.229-1963, fol. 114). It is annotated
"Greek Furniture Dec. 1880 Peddle
Dec. 18, 1880" and relates to an item in
his diaries from 18 December 1880 for
£16.16s.0d from Peddle for furniture
designs (V&A AAD 4/5 1880). With its
sloped backrest, turned uprights and double
seat rail, it is almost identical to a Greek-
style chair that he later designed for W. A.
and S. Smee in 1883 (see CR 181).

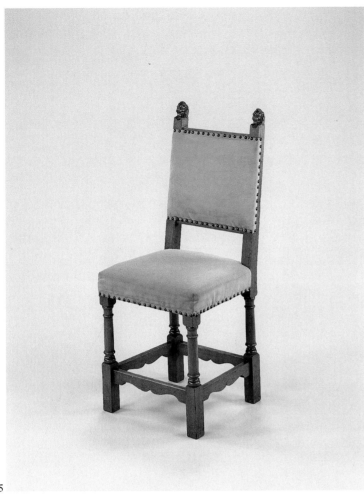

175

175.1 "Furniture from Dutch Paintings Teniers 1630–1690" (V&A PD E.229-1963, fol. 62)

175.I–III. *Set of Side Chairs*
Ca. 1881
Made by William Watt
Oak; woven upholstery in imitation of suede; brass nails
I: 39⅜ × 17⅞ × 15⅜ in. (100 × 44 × 47 cm);
II, III: 39¾ × 16⅞ × 15⅜ in. (101 × 43 × 39 cm)
Ellen Terry; by descent to her daughter Edith Craig; by bequest to The National Trust, Ellen Terry Memorial Museum, Smallhythe Place, Kent (I: SMA/F/49; II, III: SMA/F/99–100)

Literature: "Shakespeare Dining-Room Set," 11 November 1881, p. 626, ill.

This side chair, one of three from an original set of eight, were part of Godwin's Shakespeare dining room set, which he designed for William Watt (see Fig. 176.1). They copy the joined upholstered back stools popular during Shakespeare's lifetime. The incor-poration of carved lion heads at the tops of the uprights and the apron-shaped stretcher, however, indicate a Flemish prototype. As an antiquary and collector, Godwin was aware of Flemish specimens – a drawing in one of his sketchbooks annotated "Furniture from Dutch Paintings Teniers 1630–1690" (Fig. 175.1), taken from the *Handbook of Painting: The German, Flemish, and Dutch Schools . . . ,*[32] depicts a similar back stool. Godwin may also have been aware of the furniture engravings of the Northern Renaissance designer Crispin de Passe II, which were published in Amsterdam in 1642 and which the designer A. W. N. Pugin is known to have owned.[33] Godwin also borrowed from Pugin's X-frame chairs, made in 1836 by John Webb for the Prince's Chamber in the House of Lords, Palace of Westminster, which have almost identical carved lion heads.[34] Godwin was an admirer of Pugin's work and likely was aware of these nineteenth-century interpretations, if not the original seventeenth-century examples.

176. *The Shakespeare Armchair*

Ca. 1881
Made by William Watt
Oak
40½ × 24 × 20 in. (103 × 61 × 51 cm)
Paul Reeves, London

Literature: "Shakespeare Dining-Room Set," 11 November 1881, p. 626, ill.; "The love of old things," 1 December 1881, p. 103; "Our Museum," 1 April 1882, pp. 182–83, 187; Soros 1999, no. 119, pp. 253–54, fig. 8-43

This armchair is one of a pair that was part of a suite of Elizabethan-Revival furniture Godwin designed for William Watt under the title "The Shakespeare Dining-Room Set." The suite included "eight small chairs, one stool, two armchairs, a sideboard and a table" and was illustrated in *Building News* (Fig. 176.1; 11 November 1881). Although the armchair was not registered with the Patent Office, the accompanying sideboard was registered by William Watt on 14 November 1881.

The chair is a reproduction of a late-sixteenth-century *caqueteuse* armchair, probably Scottish in origin of the type made in Aberdeen.[35] According to *Building News* this chair was "chiefly taken from the original furniture, which is said to be either in the possession of Shakespeare's family at the present, or known to have belonged to him." It is not possible to substantiate this claim for such a chair is not to be found in any of the nineteenth-century engravings and drawings of the interior of Shakespeare's house in Stratford-upon-Avon nor in the many published accounts of travelers to his birthplace.[36] There are, however, several chairs that appeared in the eighteenth and nineteenth centuries in England that are purported to be Shakespeare's own chair. The architect George Godwin (no relation to E. W. Godwin) had one in his collection of "Suggestive Furniture" (illustrated in *Builder*, 30 March 1878)[37] that shows a similar *caqueteuse* form from which Godwin may have derived his version (see Fig. 44). Godwin's original model also reappeared in *Building News* (14 March 1884) as part of a "Jacobean Suite of Dining Room Furniture."

The chair was in production for many years and was made by a great number of other art furnishers including Liberty and Company. These later reproductions often had a back panel raised above the seat in a

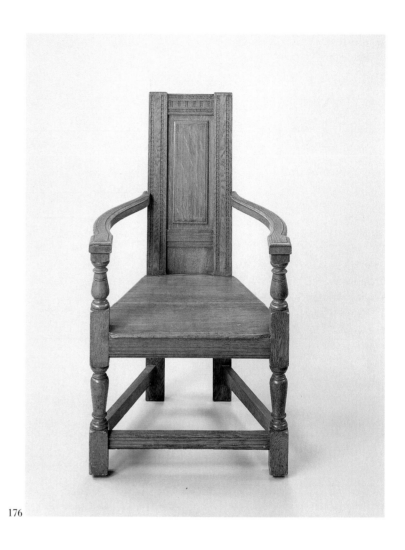

176

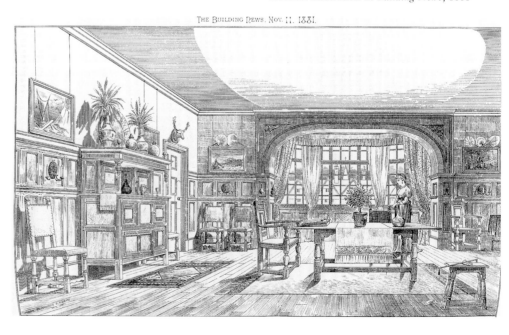

176.1 "The Shakespeare Dining Room Set," from an illustration in *Building News*, 1881

manner similar to Godwin's later uphol-
stered version, which distinguishes them
from the Godwin prototype (see Fig. 45).

These chairs became so fashionable
by the late 1880s that a commentator in
Cabinet Maker claimed they could be seen
in almost every upholsterer's showroom.[38]

176-a. *The Shakespeare Armchair*
Ca. 1881
Made by William Watt
Oak
40⅛ × 24¾ × 22⅞ in. (102 × 63 × 58 cm)
Enameled label, affixed to underside:
William Watt – Art Furniture Warehouse –
21 Grafton Street and Gower St.
Ellen Terry; by descent to her daughter,
Edith Craig; by bequest to The National
Trust, Ellen Terry Memorial Museum,
Smallhythe Place, Kent (SMA/F/47)

Literature: Aslin 1986, pl. 68

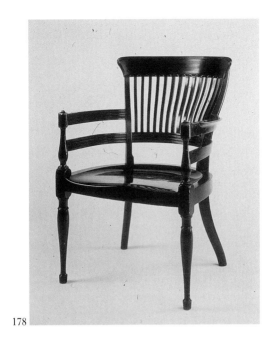

178

177 A Shakespeare Chair, by Messrs. W. Watt and Co.

177. *Design for a Shakespeare Armchair*

Literature: "Domestic Electric Lighting,"
1 April 1882, p. 202

This upholstered version of the so-called
Shakespeare chair (see CR 176) was
exhibited as part of William Watt's
exhibition stand at the Electric Exhibition
at the Crystal Palace in April 1882. A
sketch of it, illustrated in *Cabinet Maker
and Art Furnisher* (1 April 1882), was
described as being made by "Messrs. Watt
. . . in a lighter style and upholstered . . . in
a figured fabric." The seat and back were
rounder than those of the original version
and the back panel is raised a couple of
inches above the seat.

178. *Armchair*
1881, attributed to E. W. Godwin
Made by James Peddle
Ebonized wood; (upholstered seat missing)
31³⁄₁₆ × 21 × 18¾ in. (79.2 × 54.6 × 47.7 cm)
Stamped with design registration for 24
March 1881
Fine Art Society, London

This ebonized armchair made by James
Peddle may have been designed by Godwin.
It is based on a design registered by James
Peddle in the Public Record Office (no.
362068) for March 1881 (Fig. 178.1). The
curved back design corresponds to a series
of similarly curved armchairs in Godwin's
sketchbooks from 1880–1881 related to the
Peddle commission (see Fig. 181.1). The
chair's turned front legs, raked back legs,
and double arm supports can be found in
many of his chair designs of the 1870s and
1880s. The inclusion of the slatted back
laths, however, is an unusual feature and
may indicate a designer other than Godwin.

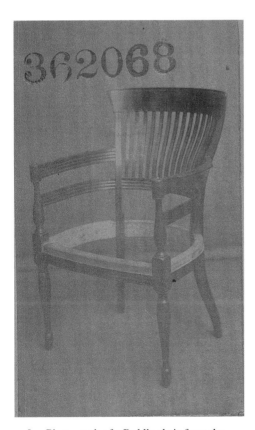

178.1 Photograph of a Peddle chair from the
Public Record Office

179. *Armchair*

1881, attributed to E. W. Godwin
Made by James Peddle
Ebonized wood with upholstered seat
Measurements unknown
Stamped with design registration diamond
mark for 1 February 1881
Phillips sale, 13 October 1992, lot 253;
Haslam and Whiteway, London; Private
collection

This elaborate armchair made by James
Peddle may be one of Godwin's designs for
this firm. Godwin designed a number of
chairs for James Peddle in December 1880
for which he was paid, according to his
diaries, £16.16s.od (V&A AAD 4/5-1880).
This design was registered in the Public
Record Office (no. 361375) on 1 February
1881, just a month and a half after Peddle's
payment to Godwin (Fig. 179.1). The
chair's horizontal ribbing, carved sunflower,
fretwork panels and rounded elbow struts
in the sides of the splat give this chair an
unmistakable Anglo-Japanese appearance.

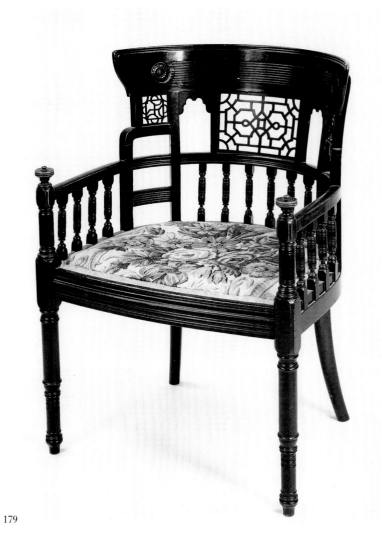

179

179.1 Photograph of a Peddle chair from the
Public Record Office

180

180. *Design for a Stool*

Literature: "Shakespeare Dining-Room Set," 11 November 1881, p. 626

This oak trestle stool was part of the Shakespeare dining-room set that Godwin designed for William Watt which was reproduced in 1881 in *Building News.*[39] Drawings for similar stools derived from period sources can be found in Godwin's sketchbooks, for example one that is annotated "Pictures of, Life of X–9th cent p. 212" (V&A PD E.229-1963, fol. 62) from about 1872, and another, appearing later in the same sketchbook, annotated "medieval furniture" (V&A PD E.229-1963, fol. 139). This type of stool was common throughout the seventeenth and eighteenth centuries in England. Godwin's example, with its splayed baluster legs terminating in an extension of the square tenoned blocks, plain rectangular seat board with molded edge, and overhanging apron, is very close to period prototypes, and in fact duplicates joined oak stools of the early seventeenth century.[40]

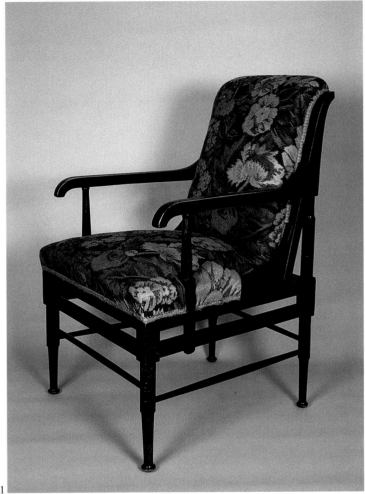

181

181. *Armchair*
Ca. 1882
Made by W. A. and S. Smee
Ebonized mahogany; upholstered seat and back
32 × 16¼ × 21½ in. (81.3 × 41.3 × 54.6 cm)
The Mitchell Wolfson Jr. Collection,
The Wolfsonian-Florida International University, Miami Beach, Florida (85.11.14)

Literature: "Furniture Trades Exhibition," 11 May 1883, p. 236; Soros 1999, p. 249

This chair is based on a sketch Godwin originally made in about 1873 (Fig. 181.1; V&A PD E.496-1963) which shows a similar chair with a sloped backrest and turned uprights that curve backward. Related to Godwin's series of Greek-style chairs made for William Watt in the 1880s (CR 183, 184, 185), the design for this chair was a reformulation for W. A. and S. Smee, a firm for whom Godwin is known to have designed in the early 1880s.

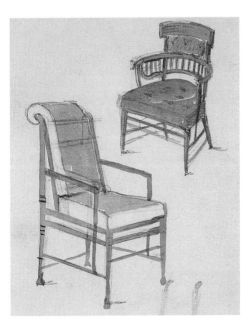

181.1 Sketch for a Greek-style chair (V&A PD E.496-1963)

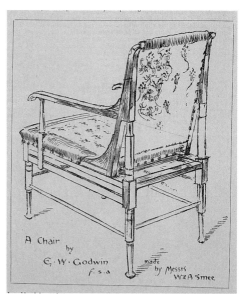

181.2 "A Chair by E. W. Godwin," illustrated in *British Architect*, 1883.

A study-chair, by Mr. Watt.

182

183. *Design for a Greek Armchair*

Literature: "Greek Armchair," 29 May 1885, p. 850; Harbron 1949, p. 142, ill.; Paolini, Ponte, and Selvafolta 1990, p. 360, ill.

This Greek armchair, made by William Watt from a Godwin design, was illustrated in *Building News* in 1885.[43] In the series of Greek-style chairs that Godwin began to design in 1880, this version, made of rosewood, was the most complicated. It has high arms with elbow ends joined to the seat frame by an angled conical support; the splat is comprised of a series of upright laths. A loose textile with fringed ends covers the bottom section of the back and continues over the seat, giving the chair an authentic touch. All four chair legs were cut square but the front two end in round tapered sections. The extended conical uprights and high straight arms give this chair its thronelike appearance.

A similar Godwin armchair, exhibited in April 1883 in the Furniture Trades Exhibition, Islington, and illustrated in *British Architect* (11 May 1883), is credited to Messrs. W. A. and S. Smee (Fig. 181.2) and was singled out by one reviewer for "being extra strongly made with a double seat rail under the seat."[41] The Smee design contains the same sloped backrests, double seat rails, and turned legs of the Watt production but is distinguished by the downward-sloping arms and the fully upholstered back that curves backward. A similar chair is in a private collection in the United States.

182. *Design for a Study Chair*

Literature: "At Kensington," 1 April 1885, p. 183

This study chair appeared as part of William Watt's stand at the Exhibition of Art Furniture at Kensington School of Art-Needlework in April 1885. It was illustrated in *Cabinet Maker*, in a review of the exhibition, which stated: "The round-backed chair with caned panels which is just below is in Mr. Watt's department, and is a most comfortable type of chairs [*sic*] which are fortunately becoming extremely fashionable. The use of cane for such chairs is highly commended, for there is nothing more cleanly or fairly durable. Moreover, these chairs with cane backs and seats give an opportunity for the placing of those tempting-looking embroidered chair cushions which Art-needlework ladies turn out in such perfection."[42]

Although Godwin is not mentioned here by name, the chair resembles an earlier chair he designed which was illustrated in William Watt's *Art Furniture* (1877; Plate 11).

181-a. *Armchair*

Ca. 1882
Made by W. A. and S. Smee
Ebonized mahogany; upholstered seat and back; (some restorations)
$31\frac{1}{8} \times 20\frac{1}{8} \times 21$ in. (79 × 51 × 53.5 cm)
Haslam and Whiteway, London; Private collection

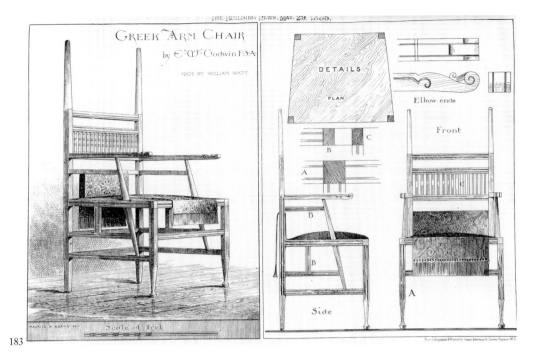

183

184. *Greek Chair*

Ca. 1885
Made by representatives of William Watt
Oak; upholstered seat and back panel
$40^3/_4 \times 16^7/_8 \times 19^1/_4$ (103.5 × 43 × 49 cm)
Vereker Hamilton; by descent to Lady
Kilbracken; gift of Mrs. Katherine Godley,
Victoria and Albert Museum, London
(Circ. 258-1958)

Literature: "Working Drawings of
Inexpensive Furniture," 18 December 1885,
p. 1011, ill.; Symonds and Whineray 1962,
p. 76, pl. 85; Aslin 1967, p. 8, fig. 8; Jervis
1968, p. 66, pl. 62; Pevsner 1968, p. 126,
pl. 17; Honour 1969, p. 256; Royal
Academy 1972, pl. 18; Garner 1980, p. 10;
Anscombe 1981, p. 61; Cooper 1987, pl.
341; Andrews 1992, p. 34; Miyajima 1994,
p. 60, no. 40; Soros 1999, p. 249, fig. ii

This chair was illustrated in *Building News*
under the heading "Working Drawings of
Inexpensive Furniture by E. W. Godwin,
F.S.A., Architect."[44] It was part of a group
of furniture "executed by representatives of
the late Mr. Wm. Watt, of Grafton-street
W.C." that included a hat-and-umbrella
stand and a hanging cabinet (Fig. 184.1).
According to the illustration's descriptive
text this so-called "cheap chair" was made
in four different versions, one of which had
arms. The most elaborate was Version A,
with the seat and back upholstered and
with turned legs: "The seat can be stuffed
or not, and the back is designed to be
finished in the same material as the seat, or

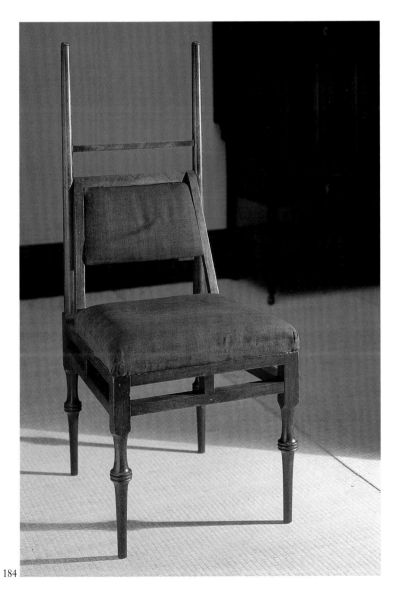

184

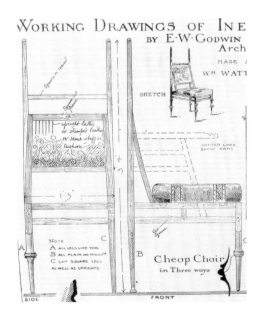

184.1 Detail of
"Cheap Chair"
illustrated in
Building News, 1885

with upright laths." Version B had legs that were "all plain no mould," and Version C had "cut square legs as well as uprights."

This chair has been traditionally called a "Greek" chair because the legs were in imitation of those on Greek thrones and stools, which Godwin sketched from the Elgin marbles in the British Museum, as well as from the *Dictionnaire des arts grecques*. Two similar chairs are in a private collection in London (CR 184-a, CR 184-b).

184-a. *Greek Chair*
Ca. 1885
Made by William Watt
Oak; upholstered seat and back panel
$40^3/_4 \times 16^3/_4 \times 19^1/_4$ in. (103.5 × 42.6 × 48.9 cm)
William Watt label affixed to underside
Private collection

184-b. *Greek Chair*
Ca. 1886
Made by Heirloom, William Watt's representatives
Oak; upholstered seat and back panel
$40^1/_2 \times 16^3/_4 \times 19^1/_2$ in. (102.9 × 42.6 × 49.5 cm)
Heirloom label affixed to underside
Private collection

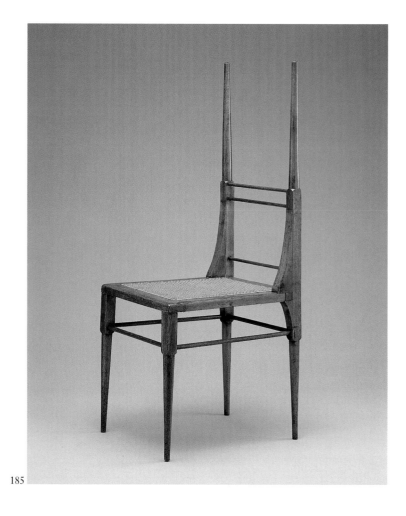

185

185. *Greek Side Chair*
Ca. 1885
Made by representatives of William Watt
Ash; cane seat
$39^3/_4 \times 14 \times 16^3/_4$ in. (101 × 35.6 × 42.6 cm)
Private collection

Literature: "Working Drawings" 18 December 1885, p. 1011, ill; Barnet and Wilkinson 1993, p. 13, pl. 12; Soros 1999, no. 103, pp. 244–45, 249, fig. 8-33

This chair is close to Version B of Godwin's Greek chair design (see CR 184), the so-called "cheap chair" with plain legs and no molding that he designed in 1885 for the representatives of the late William Watt. Illustrated in *Building News* under the heading "Working Drawings of Inexpensive Furniture" (see Fig. 184.1),[45] this is the most austere of all of Godwin's chair designs, with its open back and cane seat. He sketched a similar chair in about 1875 that shows extended uprights made of thin tapering rods, a square seat, and three horizontal back supports.[46]

It is clear Godwin based this chair on an ancient chair form on view in London. He even replicated furniture-making techniques of the ancient world in his use of mortise-and-tenon joints with exposed wooden dowels.[47]

185-a. *Greek Side Chair*
Ca. 1885
Made by William Watt
Ash; cane seat
$39^3/_4 \times 13^3/_4 \times 16^3/_4$ in. (101 × 35 × 42.5 cm)
Haslam and Whiteway, London; Musée d'Orsay, Paris (OAO 1197)

Literature: Musée d'Orsay 1990, p. 105; Gere and Whiteway 1993, p. 155, pl. 191; Fiell and Fiell 1997, p. 61

TABLES

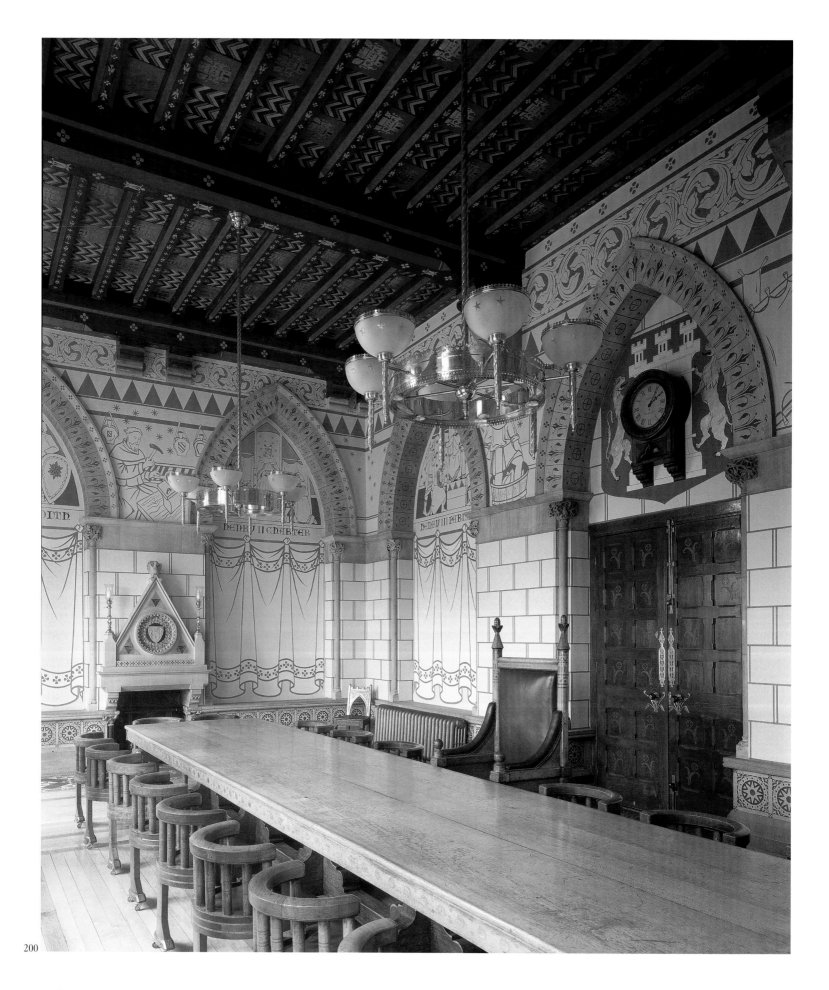

200. *Trestle Table*

1865
Made by Green and King
Oak; brass corner mounts and braces
30 × 240 × 53 in. (76.2 × 609.6 × 134.6 cm)
Council Chamber, Northampton Guildhall
(formerly Northampton Town Hall)

Literature: Cruickshank 1993, p. 74, fig. 2;
Hall 1993, fig. 4

This large Gothic-style trestle table, which appears in a drawing dated "Jany. 65" (see Fig. 100.1; V&A PD E.619–1963) that also shows the corresponding Councillor's chair (CR 100) and Mayor's chair (CR 101), was designed by Godwin for the old Council Chamber at Northampton Town Hall. Another drawing in the Victoria and Albert Museum (Fig. 200.1) shows an elevation for this table with directions for the manufacturer. Of particular interest in the drawing are the notes specifying that the large inlaid roundels around the table's apron be of red mahogany and the smaller ones be of rosewood. Godwin's use of inlaid circles may have come from the inlay design of red and blue stripes and circles on the Greek thrones and beds illustrated in Nicolas Xavier Willemin's 1839 *Monuments français inédits pour servir à l'histoire des arts depuis le VI^e siècle jusqu'au commencement du XVII^e* . . . (see Fig. 15). The table differs from what is depicted in the original drawing in two ways: it has no striped inlay on its base and it has a series of curved metal braces (to hold the massive top firmly to the base) which are quite compatible

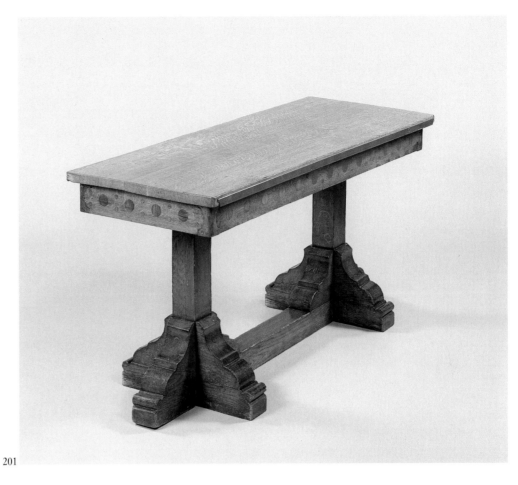

201

with the brass corner plates used to finish off the apron. The tabletop is supported on trestles with crocketed moldings and cruciform feet that are similar to the trestles of the massive oak table of the late fifteenth century at Penshurst Place, Kent, for example.[1]

201. *Side Table*

1865
Made by Green and King
Oak; brass corner mounts
29¾ × 23½ × 60 in. (75.6 × 59.7 × 152.5 cm)
Council Chamber, Northampton Guildhall
(formerly Northampton Town Hall)

This side table relates in design to the main trestle table in the Council Chamber at Northampton Town Hall (CR 200) and was intended to correspond to the general furnishing scheme of that room. The table has the same inlaid roundels in the apron and brass corner mounts at the edge of the apron but is one-quarter the size of the central trestle table.

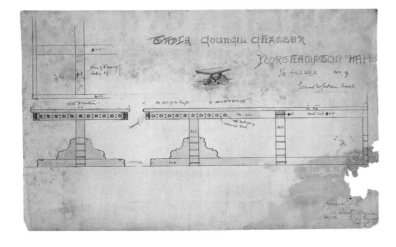

200.1 "Table
Council Chamber"
(V&A PD E.618-
1963)

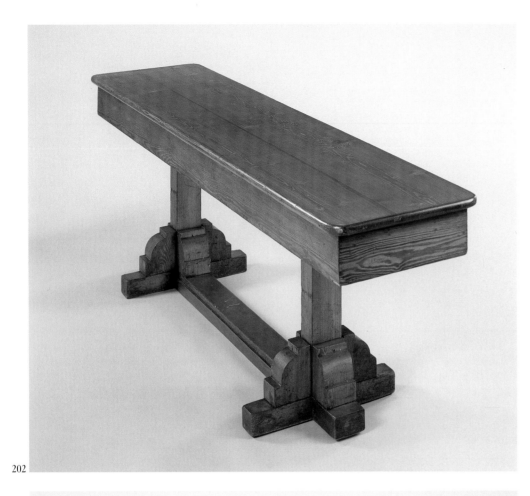

202

202. *Side Table*
1865, attributed to E. W. Godwin
Probably made by Green and King
Pine
29 × 108 × 17³⁄₄ in. (75 × 275.5 × 45 cm)
Mayors' Names Gallery, Northampton
Guildhall (formerly Northampton Town
Hall)

This narrow side table is a plainer and
smaller version of the inlaid side table
designed for the old Council Chamber at
Northampton Town Hall (CR 201). It lacks
the inlaid roundels and the decorative
corner mounts at the edges of the apron,
and the pedestals or trestles are simplified,
with fewer scrolled brackets.

203. *Table*
1865, attributed to E. W. Godwin
Probably made by Green and King
Oak
28¹⁄₄ × 96¹⁄₄ × 47⁵⁄₈ in. (71.8 × 244.5 × 121
cm)
Mayors' Names Gallery, Northampton
Guildhall (formerly Northampton Town
Hall)

This plain oak table with its slightly arched
apron and overhanging top resembles the
Old English- or Jacobean-style dining tables
that Godwin designed for William Watt in
the 1870s. Unlike the baluster turned legs
represented in William Watt's *Art Furniture*
(CR 231, 232, 236), however, these legs
taper inward. The influence of late-
eighteenth-century English design is
revealed in the stepped and squared-off feet
as well as in the tapered legs.

203

204-a, b. *Two Tables*
1865
Made by Green and King
Oak
35 × 71¾ × 29¾ in. (89 × 182.3 × 75.5 cm)
Northampton Guildhall (formerly
Northampton Town Hall); (a) Shields
Gallery (RB 2); (b) Members' Room
(RB 14)

Literature: Soros 1999, p. 231, fig. 8-13

These Gothic-style tables with their
decorative ends of vertical rods and
quatrefoils are based on a drawing in the
Victoria and Albert Museum which is
annotated "Furniture Northampton Town
Hall Drawing No. 5" and signed by
Godwin (Fig. 204.1). The ends of the table
differ slightly from those in the drawing:
two small quatrefoils replace the large
single one depicted in the drawing, and
their placement in relation to the rods has
been reversed.

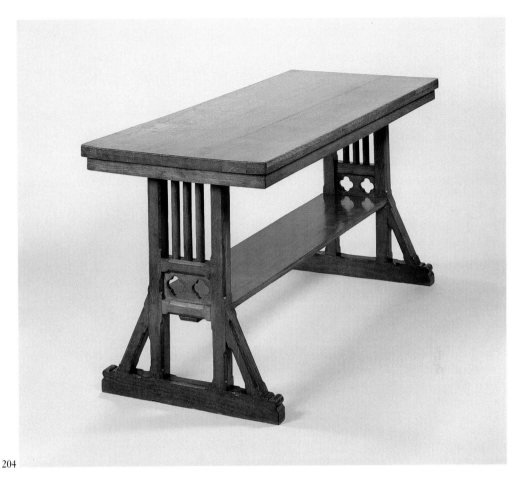

204

204.1 Table from "Furniture Northampton
Town Hall Drawing No. 5" (V&A PD E.625-
1963)

205

205. *Small Table*
1865, attributed to E. W. Godwin
Probably made by Green and King
Oak
30¼ × 19¾ × 17¾ in. (76.8 × 50.2 × 45 cm)
Basement, Northampton Guildhall
(formerly Northampton Town Hall)

This square table is devoid of decoration
except for the chamfering of the upper legs
intended to imitate the roughly hewn
wooden beams of early Gothic furniture.
A. W. N. Pugin often used this technique
in his Gothic-Revival furniture to emulate
the bold forms of fifteenth-century oak
furniture.

206. *Trestle Table*

1865
Made by Green and King
Pine
30 × 48 × 27 in. (76 × 122 × 68.6 cm)
Court Room Gallery Number Two,
Northampton Guildhall (formerly
Northampton Town Hall) (RB 13)

Trestle tables were a popular form, especially for architect-designers of the nineteenth century, and a variety of these pine trestle tables in a variety of sizes were made for Northampton Town Hall. A signed drawing annotated "Furniture Northampton Town Hall Drawing No. 5" (Fig. 206.1) shows a trestle table with the same crossed supports and pegged construction but without the chamfers on the legs. Godwin's notations ("Jurys retiring rooms 5 Committee rooms. Surveyors office 6 in Reading room.") indicate that he commissioned at least eleven of these trestle tables to furnish various rooms at Northampton Town Hall. The planked tops, chamfered legs, and pegged construction of this trestle table are reminiscent of fifteenth-century Gothic furniture.

Godwin also designed more elaborate versions (for commissions such as Dromore Castle, Ireland) with inlaid tops, molded edges, and legs with curved ends (RIBA Ran 7/B/1[50]).

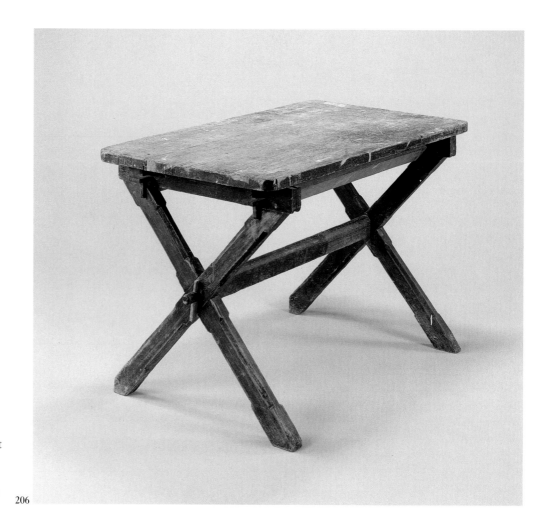

206

206-a. *Trestle Table*

1865
Made by Green and King
Pine
31⅛ × 48⅛ × 26¾ in. (79 × 122 × 68 cm)
Court Room Gallery Number Two,
Northampton Guildhall (formerly
Northampton Town Hall) (RB 14)

206-b. *Trestle Table*

1865
Made by Green and King
Pine
28¾ × 38⅝ × 23⅜ in. (73 × 98 × 59.5 cm)
Court Room Balcony Number Two,
Northampton Guildhall (formerly
Northampton Town Hall) (RB 15)

206.1 Trestle table from "Furniture Northampton Town Hall Drawing No. 5" (V&A PD E.625-1963)

207. *Coffee or Occasional Table*

Ca. 1867
Made by William Watt
Ebonized mahogany; ebonized deal top
$27\frac{1}{2} \times 27\frac{1}{2} \times 15\frac{7}{8}$ in. (69.8 × 69.8 × 40.3 cm)
Originally in the possession of the designer
and Ellen Terry; by descent to Edith Craig;
by bequest to Bristol Museums and Art
Gallery, 1949 (N4059)

Literature: Victoria and Albert Museum
1952a, pl. K4; Victoria and Albert Museum
1952b, pl. 18; Bristol Museums and Art
Gallery 1976, no. 2; N. Wilkinson 1987,
pp. 190–91

A drawing of this table in Godwin's
sketchbooks is dated 1875 (Fig. 207.1).
Godwin's writings, however, indicate that
he first designed this table for his own use
as early as 1866 or 1867, when he moved
from Bristol to London. In his preface to
William Watt's *Art Furniture*, Godwin
complains about the extensive plagiarism of
the designs he commissioned Watt to
execute, particularly "the square coffee
table you first made or [*sic*] me, nine or ten
years ago" (p. iii). An early date for this
table is also suggested by the fact that the
top is of ebonized deal, a material Godwin
used for much of his early furniture due to
a limited budget but soon abandoned
because it proved too soft. Although this
version is in ebonized mahogany, a plain
mahogany version was also made. Two
citations in Godwin's ledger books – one
from 1869 (V&A AAD 4/10-1980, fol. 8)
and the other from 14 December 1876
(V&A AAD 4/12-1980, fol. 13) – confirm
that Godwin continued to design these
coffee tables for William Watt throughout
the late 1860s and 1870s, which may
explain some of the minor differences in
size.

Godwin labeled this table in the Watt
catalogue as an Old English or Jacobean
coffee table, but its lattice bracing and
turned legs refer more to ancient Egyptian
furniture – which Godwin sketched from
samples in the British Museum – than to
seventeenth-century English forms. A
drawing of ancient Egyptian chairs and
tables inscribed "B.M." (British Museum)
in one of Godwin's sketchbooks, for
example, reveals the same angled brackets
and turned legs used in this coffee-table
form (Fig. 207.2).

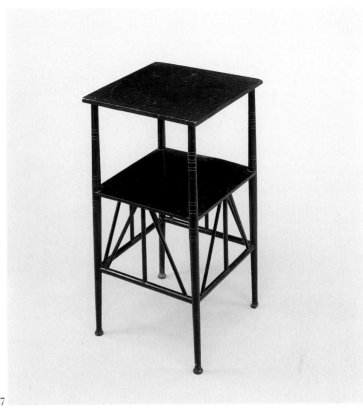

207

207.1 Sketch for a coffee table dated 1875
(V&A PD E.239-1963, fol. 24)

207.2 Sketch for ancient Egyptian chairs and
tables (V&A PD E.278-1963, fol. 1)

Although this example is made of mahogany, the price list that accompanied the Watt catalogue indicates that this table also was made in oak, for £2.5s.od, or with an ebonized finish, for £2.10s.od. The table was used in advertisements for Watt's firm that appeared in various trade and architectural journals in the 1870s and 1880s (see Fig. 106.1).

The popularity of these tables is confirmed by the great number that survive in collections throughout the world, and we can assume that because few of the surviving examples are in plain wood, the ebonized wood versions were more in demand.

207-a. *Coffee or Occasional Table*
Ca. 1867–85
Made by William Watt
Mahogany
$27^1/_2 \times 15^3/_4 \times 15^3/_4$ in. (70 × 40 × 40 cm)
Gift of Michael Whiteway to the Victoria and Albert Museum, London (W. 71-1981)

Literature: Pevsner 1952 (1968 ed.), p. 125, pl. 16; Victoria and Albert Museum 1952b, pl. 18; Aslin 1962a, pl. 68; Symonds and Whineray 1962, p. 125, pl. 85; Aslin 1969, pl. 24; Conner 1983, p. 102, pl. 213; Honour 1969, p. 257; Aslin 1986, p. 51, pl. 18; Nationalmuseum 1987, pl. 25, ill. p. 43, text p. 42; Miyajima 1994, no. 39, p. 61; Lambourne 1996, p. 159

207-b. *Coffee Table*
Ca. 1867–85
Made by William Watt
Ebonized wood
$27^1/_4 \times 16^1/_8 \times 16^3/_8$ in. (69 × 41 × 41.5 cm)
China Drawing Room, Castle Ashby, Northamptonshire

207-c. *Coffee Table*
Ca. 1867–85
Made by William Watt
Ebonized wood
$27^1/_4 \times 16^1/_8 \times 16^3/_8$ in. (69 × 41 × 41.5 cm)
H. Blairman and Sons, London; Private collection

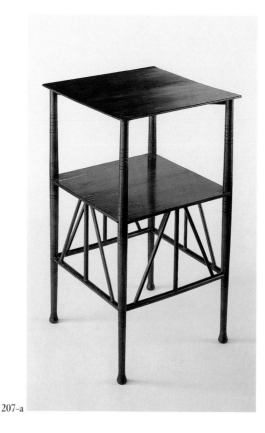

207-a

207-d. *Coffee Table*
Ca. 1867–85
Made by William Watt
Ebonized wood
$27^1/_2 \times 16^3/_4 \times 16^1/_8$ in. (69.4 × 42.5 × 41 cm)
Private collection

207-e. *Coffee Table*
Ca. 1867–85
Made by William Watt
Ebonized wood
$27^1/_4 \times 16^1/_8 \times 16^3/_8$ in. (69 × 41 × 41.5 cm)
Private collection

207-f. *Coffee Table*
Ca. 1867–85
Made by William Watt
Ebonized wood
27 × 16 × 16 in. (68.6 × 40.6 × 40.6 cm)
Private collection

208.I. *Dining Table*
1870
Made by Reuben Burkitt
Oak
$29^1/_2 \times 52^3/_4 \times 32^3/_4$ in. (75 × 134 × 83.2 cm) (reduced in size)
Dromore Castle, Ireland; De Courcy, Dromore Castle, 19–21 October 1949, lot 255; Colonel Walsh; Mrs. H. A. McKenzie; Private collection

Literature: Soros 1999, p. 194

208.II. *Dining Table*
1870
Made by Reuben Burkitt
Oak
Measurements: unknown
Dromore Castle, Ireland; De Courcy, Dromore Castle, 19–21 October 1949, lot 256; Rockwell College, Cashel, Ireland; whereabouts unknown

This pair of refectory tables was designed by Godwin – along with sixteen wainscot oak chairs (CR 113), two carvers (CR 112), and a large buffet (CR 313) – for the dining room of Dromore Castle. The tables do not appear on the furniture specifications drawn up between the Earl of Limerick and William Watt (RIBA MC GoE/1/7/4), so it is likely they were made by Reuben Burkitt, who also executed furniture for the Dromore commission.

The tables resemble Jacobean refectory tables of the sixteenth century, with their planked tops, ring turned legs, and exposed tenons. At the time one of them (208.I) was located by Peter Floud in 1951 (V&A Registry file VEDA, Part 1), it had a larger top, made of planked boards, and a rectangular stretcher. Subsequently, however, the stretcher was removed and the surface reduced. The original dimensions are not available since the whereabouts of the second of the pair are unknown.

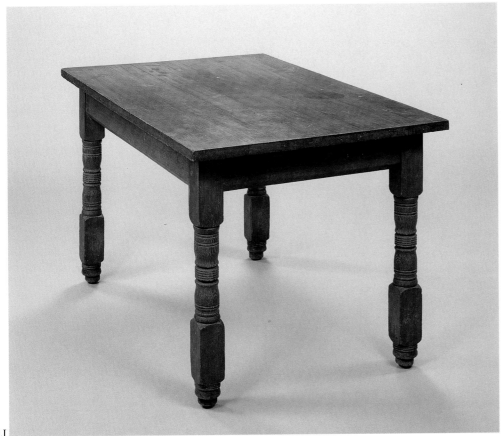

208.I

209. *Design for a Chess Table*

Literature: Lever 1982, fig. 55; Aslin 1986, pp. 26, 40, fig. 6; Reid 1987, p. 136; Lambourne 1996, p. 158, col. ill.; Soros 1999, no. 22, pp. 194–95, 234, fig. 7-13

This chess table of ebonized mahogany was one of Godwin's 1869 designs for furniture for Dromore Castle. It appears in a detailed drawing now in the RIBA (RIBA Ran 7/B/1 [55]) as well as one in the Victoria and Albert Museum (V&A PD E.500–1963). It is also listed in the specifications between the Earl of Limerick and William Watt where it is described as "1 Chess table inlaid with ivory & ebony for the squares with a drawer on two sides" (RIBA MC GoE 1/7/4).

The game board was inlaid with ivory and boxwood squares, and the sides were made up of pierced boxwood panels. The large central panels on each side carried depictions of lions and harts, which relate to the armorial shield of the Limerick family. The table had wells for candle stands and a large central drawer on both sides for storing chess pieces. It sat on brass casters for easy movement.

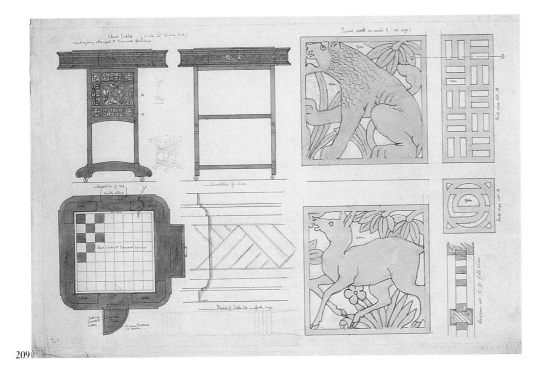

209

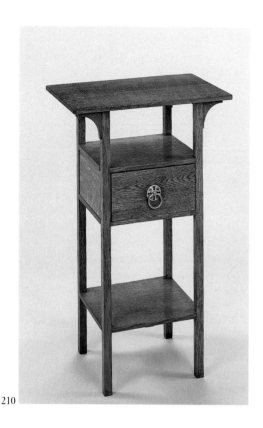

210

210. *Occasional Table with Drawer*
Ca. 1870, attributed to E. W. Godwin
Possibly made by William Watt
Oak; brass ring pull
$29^7/_8 \times 17^7/_8 \times 11^3/_4$ in. (76 × 45.5 × 29.8 cm)
Paul Reeves, London; Private collection

The plain oak finish of this small occasional table with elongated proportions is in keeping with much of the furniture that Godwin designed for Dromore Castle, Ireland, and may have been designed at the same time. Its circular brass-ring pull handle with pierced backplate is reminiscent of the hardware used on his sideboards of the 1860s and 1870s (see, for example, CR 304).

In order to maximize the display and storage potential of this small piece of furniture, Godwin located the drawer well below the tabletop, an unusual yet effective design solution.

211

211.1 Sketch for a table with folding shelves (V&A PD E.255-1963, fol. 21)

211. *Table with Folding Shelves*
Ca. 1872
Probably made by Collinson and Lock
Walnut; gilt brass fittings
$29^7/_{16} \times 16 \times 32^1/_8$ in. (74.7 × 40.6 × 81.5 cm)
Haslam and Whiteway, London; The Metropolitan Museum of Art, New York (1991.87)

Literature: Metropolitan Museum 1991, p. 32; Gere and Whiteway 1993, pl. 2; Gruber 1994, p. 245; Soros 1999, no. 71, pp. 70, 81–82, 235, 247, fig. 3-1

This table is one of the most overtly Anglo-Japanese pieces in Godwin's oeuvre, and likely was based on a drawing in Godwin's sketchbooks that dates from 1872 (Fig. 211.1). The asymmetrical shelves fitted at varying levels, the fretwork stretchers, the brass fitted corner mounts, and the tall, thin proportions all point to Japanese influence. Nancy Wilkinson has identified drawings in Godwin's sketchbooks of Japanese *tansu* (V&A PD E.280-1963, fol. 5) taken from Aimé Humbert's *Le Japon illustré* (1870) that show similar features,

confirming Godwin's awareness of these forms when he designed this table.[2] The folding shelves seem to be a Godwin adaptation, taken from late-eighteenth-century Sheraton flap tables, since there is no precedent in Japanese furniture forms. An identical table (CR 211-a), now in the National Trust, Ellen Terry Memorial Museum, Smallhythe Place, Kent, originally came from Godwin's own collection.

211-a. *Table with Folding Shelves*
Ca. 1872
Probably made by Collinson and Lock
Mahogany; gilt brass fittings
29½ × 32⅜ × 16 in. (74.8 × 82.3 × 40.6 cm)
Originally in the possession of the designer and Ellen Terry; by descent to Edith Craig; by bequest to The National Trust, Ellen Terry Memorial Museum, Smallhythe Place, Kent (SMA/F/14)

Literature: Cooper 1987, pp. 140–41, pl. 326; N. Wilkinson 1987, pp. 226–28; Reid 1992, p. 39, fig. 8

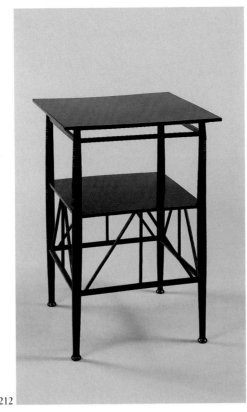

212

212.1 Sketch for a coffee table dated 29 July 1872 (V&A AAD 4/9-1980)

212. *Coffee Table*
Ca. 1872–75
Made by Collinson and Lock
Ebonized mahogany
27¼ × 20⅛ × 19⅝ in. (69 × 51 × 50 cm)
Stamped on underside of top: Collinson and Lock 7001
Paul Reeves, London; Private collection

Literature: Soros 1999, no. 41, pp. 250–51, fig. 8-39

This table is a larger version of the coffee table that Godwin originally designed for his own use and was later put into production by William Watt (see CR 207). The continuous stretcher directly under the tabletop, however, does not appear in Godwin's sketches (Fig. 212.1) or in the Watt versions, and may have been an element introduced by Collinson and Lock. An entry in one of Godwin's cashbooks reads "1874 Apr. 10 Coffee Table Grey Towers designed for the sum of 3-3-0" (V&A AAD 4/13-1980, fol. 23), indicating that Godwin designed special versions of this type of table for Collinson and Lock in the 1870s, and an identical coffee table designed by Godwin and made by Collinson and Lock is in a private collection. Furthermore, Godwin's letters to Collinson and Lock contain frequent complaints about the liberties they took with his designs (30 July 1873; V&A AAD 4/23-1988, fols. 62–64).

The Collinson and Lock coffee tables with the extra stretcher were copied – as were the Watt versions – by many art firms in the 1870s and 1880s. A pirated version is illustrated in Wyman and Sons' *Cabinet- Makers' Pattern Book* of 1877 (originally published as a supplement to *Furniture Gazette,* 13 April 1878) and another, plagiarized by the firm of Bruce and Smith, was exhibited in the "Aesthetic Movement" exhibition held at the Camden Arts Centre in 1973.[3]

212-a. *Coffee Table*
Ca. 1873
Made by Collinson and Lock
Ebonized wood
27¼ × 20 × 19⅝ in. (69 × 51 × 50 cm)
Haslam and Whiteway, London; Private collection

213. *Circular Eight-Legged Center Table*

Ca. 1870
Made by William Watt
Ebonized mahogany
H. 29⅛ × 41⅞ × 41⅞ in. (74 × 106.5 × 106.5 cm)
Originally in the possession of the designer and Ellen Terry; by descent to Edith Craig; by bequest to the Bristol Museums and Art Gallery, 1949 (N4504)

Literature: Victoria and Albert Museum 1952a, pl. K3; Bristol Museums and Art Gallery 1976, no. 6; R. Spencer 1972a, no. 286; N. Wilkinson 1987, p. 178

This circular table was likely made for Godwin's own use since it was in his collection. A similar table is illustrated in William Watt's *Art Furniture* (Plates 12, 14). The accompanying price list shows it was available in ebonized wood for £7.15s.0d and in walnut for £7.7s.0d; brass shoes, for added "stability and decoration" (p. vii), were available at an additional charge of £1.10s.0d. This table pictured here differs only in the arched frieze, which is flatter than the more angular frieze of the Watt illustration. The arched frieze, reeded tabletop edge, and turned legs which splay so elegantly are all characteristic of Godwin's furniture designs. Chinese stands designed for water basins or lanterns may have been the source for the eight-legged support and the placement of the stretcher[4] – a drawing for a Chinese washstand in Godwin's sketchbooks (see Fig. 30; V&A PD E.247-1963, fol. 31) depicts the same radiating stretcher design in a six-legged form.

Circular tables continued to be fashionable in the 1880s, almost twenty years after they were initially designed by Godwin. Considered one of the most significant pieces of drawing-room furniture, they were often placed in the center of the room, used to display many of the family's prized possessions (bibles and art objects, for example).[5]

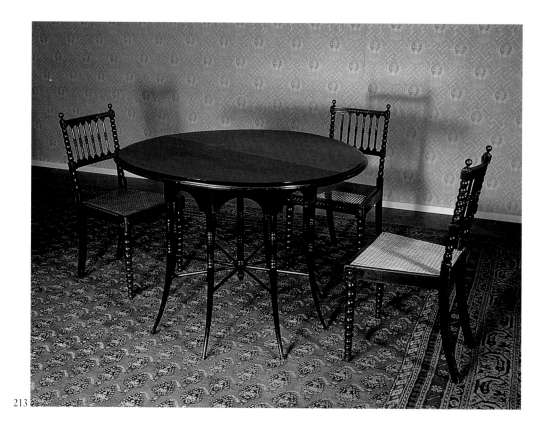

213

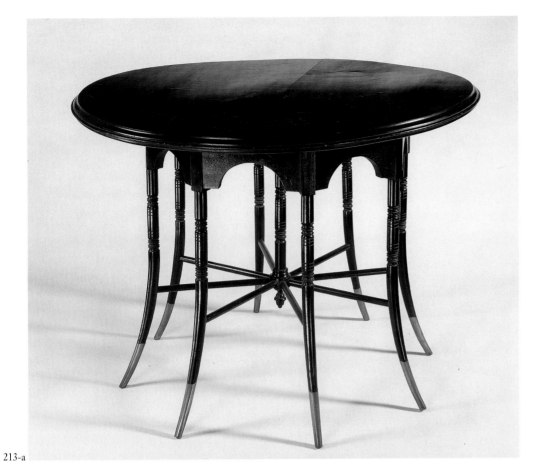

213-a

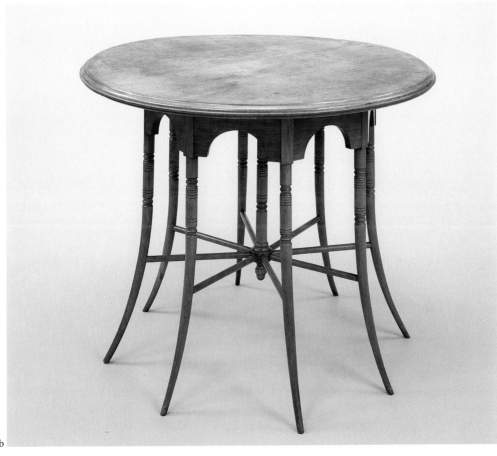

213-b

213-a. *Circular Eight-Legged Center Table*
Ca. 1876–85
Made by William Watt
Ebonized wood with turned decoration, brass shoes
30 × 39 × 39 in. (76 × 99 × 99 cm)
Letham Antiques, Edinburgh, 1980; Victoria and Albert Museum, London (W. 54-1980)

Literature: Aslin 1986, p. 53, pl. 20; Hinz 1989, pl. 761; Paolini, Ponte, and Selvafolta 1990, p. 364; Lambourne 1996, p. 159

213-b. *Circular Eight-Legged Center Table*
Ca. 1876–85
Made by William Watt
Walnut
30 × 39 × 39 in. (76 × 99 × 99 cm)
Prudential Auctioneers, Chichester (December 1987); Private collection

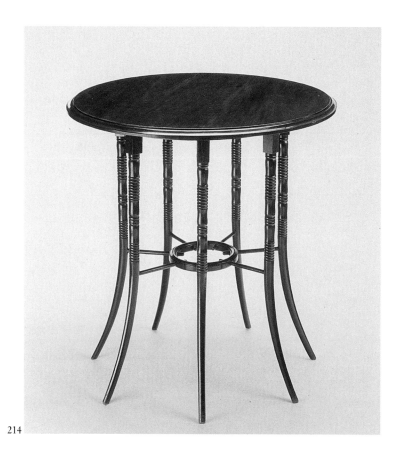

214

214. *Seven-Legged Center Table*

Ca. 1872–75, attributed to E. W. Godwin
Made by Collinson and Lock
Mahogany
29 × 41 × 42 in. (73.5 × 104 × 106.8 cm)
Fine Art Society, London; Andrew
McIntosh Patrick

Literature: Lambourne 1996, p. 159

This is the only known seven-legged version of a Godwin center table. Its reeded edge, turned decoration, and slightly splayed legs all point to the work of Godwin, although the more aggressive turnings of the legs and the large circular hub of the stretcher distinguish this center table from those executed by William Watt (see, for example, CR 213, 216). Godwin frequently used decorative flourishes to the distinguish pieces he designed for Collinson and Lock from those he designed for William Watt, which may account for the design differences of this table.

215. *Octagonal Eight-Legged Center Table*

Ca. 1872–75
Probably made by Collinson and Lock
Rosewood veneer; brass caps; brass casters
29 × 41 × 41 in. (73.5 × 104 × 104 cm)
Fine Art Society, London

This octagonal table is based on a drawing from about 1875 in one of Godwin's sketchbooks (Fig. 215.1), and the model must have been quite popular given the many surviving examples.[6] Many were made with rosewood veneer, which, with its rich figure and deep coloration, regained popularity in the 1870s and 1880s after an initial period of favor during the Regency. Mechtild Baumeister, of the Conservation Department of the Metropolitan Museum of Art, New York, has identified enhanced graining on the legs and stretchers of the rosewood examples shown here, indicating a high level of craftsmanship.[7]

215-a. *Octagonal Eight-Legged Center Table*

Ca. 1872–75
Made by Collinson and Lock
Rosewood veneer; brass caps; brass casters
29 × 41 × 42 in. (73.5 × 104 × 106.7 cm)
Stamped on underside of tabletop:
Collinson & Lock London 7494
Fine Art Society, London; Private collection

Literature: Fine Art Society 1984, fig. 38

215-b. *Octagonal Eight-Legged Center Table*

Ca. 1872–75
Made by Collinson and Lock
Rosewood; brass caps; brass casters
28¾ × 40 × 40 in. (73 × 101.6 × 101.6 cm)
Stamped on underside of tabletop:
Collinson & Lock London, 7635
Gift of Paul Walters to the Museum of Modern Art, New York (107.96)

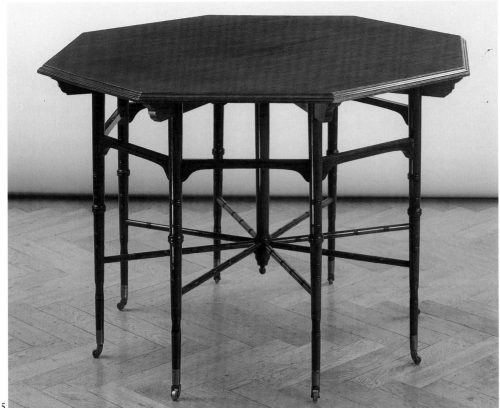

215

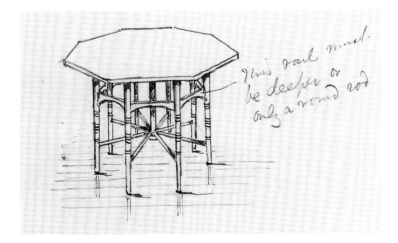

215.1 Sketch for an octagonal eight-legged table (V&A PD E.278-1963, fol. 15)

215-e. Octagonal Eight-Legged Center Table

Ca. 1872–75
Probably made by Collinson and Lock
Rosewood veneer; brass caps; brass casters
$29 \times 39\frac{3}{4} \times 39\frac{3}{4}$ in. ($73.5 \times 101 \times 101$ cm)
Private collection

215-f. Octagonal Eight-Legged Center Table

Ca. 1872–75
Made by Collinson and Lock
Rosewood; brass caps; brass casters
$29\frac{1}{8} \times 40\frac{1}{4}$ in. (74×102.2 cm)
Stamped on underside of tabletop:
Collinson & Lock London/6543, ER/VIII
[twice], applied label 44
Gift of Mrs. Herbert Heidelberger,
Museum of Fine Arts, Boston (1986.343)

215-g. Octagonal Eight-Legged Center Table

Ca. 1872–75
Made by Collinson and Lock
Rosewood veneer; brass caps; brass casters
$29\frac{1}{2} \times 37\frac{7}{8} \times 37\frac{7}{8}$ in. ($75 \times 96 \times 96$ cm)
Stamped on underside of tabletop:
Collinson and Lock, London 5832
Private collection

215-h. Octagonal Eight-Legged Center Table

Ca. 1872–75
Made by Collinson and Lock
Rosewood with rosewood veneer on
mahogany; brass caps; brass casters
$29\frac{1}{8} \times 39\frac{1}{4} \times 39\frac{1}{4}$ in. ($74.3 \times 99.7 \times 99.7$ cm)
Stamped on underside of tabletop:
Collinson and Lock, London 6543
Private collection

215-c. Octagonal Eight-Legged Center Table

Ca. 1872–75
Probably made by Collinson and Lock
Rosewood veneer on mahogany; brass caps,
brass casters; (tabletop has been reduced)
$29 \times 39\frac{1}{2}$ in. (73.7×97.8 cm)
Kurland and Zabar, New York; H. Blairman
and Sons, London; Rhode Island School of
Design, Museum of Art (1990.048)

Literature: Monkhouse 1991, p. 18

215-d. Octagonal Eight-Legged Center Table

Ca. 1872–75
Made by Collinson and Lock
Rosewood veneer; brass caps; brass casters
$28\frac{3}{8} \times 36\frac{1}{4} \times 36\frac{1}{4}$ in. ($72 \times 92 \times 92$ cm)
Stamped on underside of tabletop:
Collinson and Lock London 5626
Fine Art Society, London; Private
collection

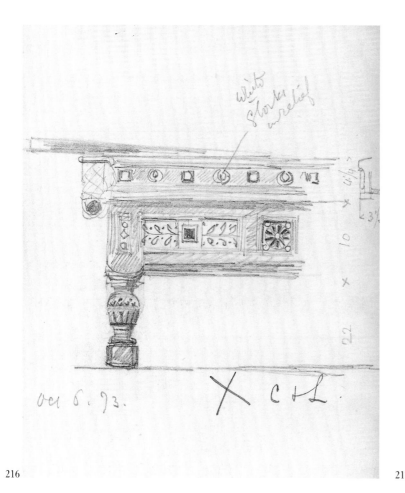

216

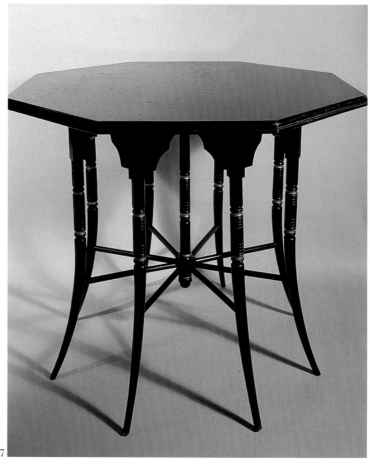

217

216. *Design for a Billiard Table*

Annotated "Oct. 6 73 X C&L," this sketch depicts a billiard table Godwin designed for Collinson and Lock in 1873 (V&A PD E.229-1963, fol. 110). The table is Jacobean in style, with thick cup-and-cover gadrooned legs, molded edges, and an apron with carved floral panels. Its frame has a series of circular decorations of "white storks in relief" interspersed with square panels. There is a corresponding entry in Godwin's ledgerbooks from 7 October 1873 for a design fee of £3.3s.od. The entry reveals that the billiard table was made for the McLaren house, a major commission that Godwin undertook at Addison Road, Kensington, in 1873.

A similar Jacobean-style table, adorned with floral and Japanese sparrow motifs, also appears in Godwin's sketchbooks (V&A PD E.234-1963, fol. 18).

217. *Octagonal Eight-Legged Center Table*

Ca. 1875
Made by William Watt
Ebonized wood; turned and gilt decoration
35 × 28 × 28 in. (88.9 × 71.1 × 71.1 cm)
Enameled William Watt label attached to underside
Handley-Read Collection, London; Cecil Higgins Art Gallery, Bedford (F33)

Literature: Victoria and Albert Museum 1952a, p. 64, pl. D20; R. Spencer 1972a, p. 45, pl. 283; Aslin 1986, p. 54, pl. 21

This is an octagonal version of the circular eight-legged center table made by William Watt (CR 213-a). A watercolor in one of Godwin's sketchbooks from about 1875 annotated "Anglo-Japanese Designs by E. W. Godwin" (Fig. 217.1) illustrates a similar table. The table shown here differs in three ways: its finish is ebonized rather than plain wood; it has a single not a double row of radiating spokes; and its legs are splayed rather straight. The arched frieze connecting the tops of the legs, the reeded

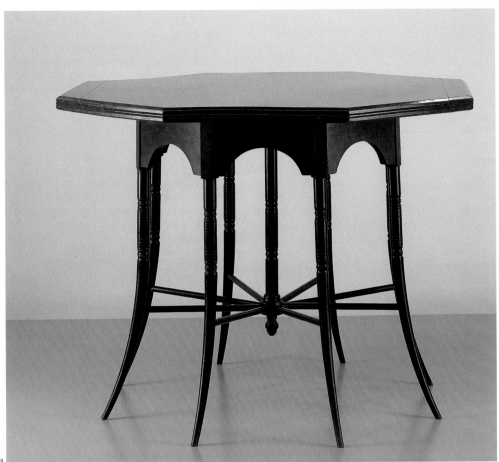

top, and the turned splayed legs are all typical of Godwin's tables of the 1870s. A similar version of this table, in which the arch of the frieze more closely resembles that found in Watt's version (CR 217-a), is currently in the Carnegie Museum of Art, Pittsburgh. The proportions and finish of this ebonized octagonal table are cruder than those of the circular examples, perhaps indicating that the octagonal versions were made at an earlier date.

The octagonal tabletop form was popularized in the nineteenth century with A. W. N. Pugin's Reformed Gothic-style octagonal table in walnut, first published in 1835 in *Gothic Furniture in the Style of the Fifteenth Century* and subsequently exhibited in the Medieval Court at the London Great Exhibition in 1851. Pugin later designed octagonal tables for the Palace of Westminster and Eastnor Castle.[8]

Octagonal tables remained popular forms in the second half of the nineteenth century, particularly among architect-designers: William Burges designed one for Treverbyn Vean (1858); Alfred Waterhouse designed one for the Manchester Assize Courts (1859); and T. E. Collcutt designed some for Collinson and Lock.

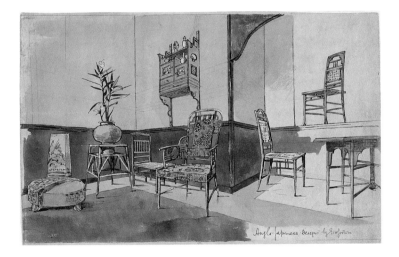

217.1 "Anglo-Japanese Designs by E. W. Godwin" (V&A PD E.482-1963)

217-a. *Octagonal Eight-Legged Center Table*
Ca. 1875
Probably made by William Watt
Ebonized oak; oak veneer on pine; beech; turned decoration
28¾ × 39 × 38 in. (73 × 99 × 96.5 cm)
Margot Johnson, New York; Carnegie Museum of Art, Pittsburgh (85.35)

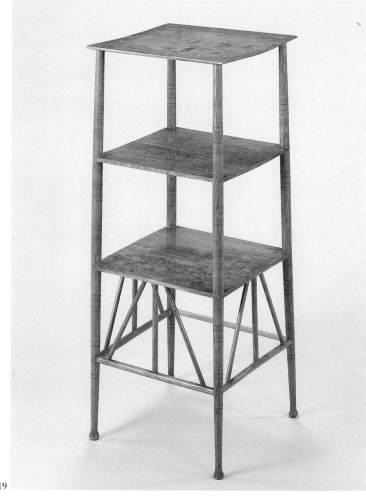

218

219

218. *Design for a Table*

This table was illustrated in Godwin's
sketchbooks in a watercolor, ca. 1875,
annotated "Anglo-Japanese Designs by
E. W. Godwin" (V&A PD E.482-1963). A
second drawing of it appears alongside his
"Monkey Cabinet" (CR 342) of about the
same year (V&A PD E.233-1963, fol. 75).

This is a variation of Godwin's classic
coffee table with angled spindled supports
and a double shelf (CR 207). Godwin made
the form more square and enlarged the
table's proportions; in addition, the legs
have been splayed slightly, giving the table
more of an exotic look. Presumably it was
executed by William Watt, since it is certain
the firm made the other table and one of
the chair forms illustrated in this
watercolor.

219. *Table with Two Shelves*
Ca. 1875, attributed to E. W. Godwin
Probably made by William Watt
Ash
$38\frac{1}{4} \times 16 \times 16$ in. (97 × 40.5 × 40.5 cm)
Private collection

This is a two-shelved version of the classic
coffee table Godwin designed for William
Watt (CR 207). Although there is no known
drawing for this example, its angled
stretchers, round tapered legs with incised
rings, and overall proportions resemble the
prototype. As with Godwin's small oak table
with drawer (CR 210), this table has an
extra shelf for optimum display surface.

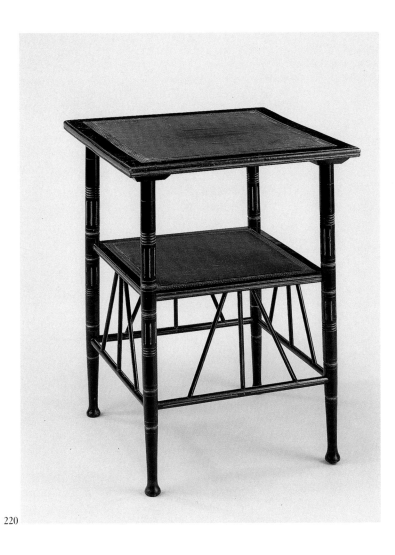

220

220. *Coffee Table*
Ca. 1875, attributed to E. W. Godwin or
George Freer Roper
Made by Gillow and Company
Ebonized mahogany
66 × 51 × 51 in. (167.6 × 129.5 × 129.5 cm)
Impressed (twice) on a brace on the
tabletop's underside: Gillow and Co 12367
Haslam and Whiteway, London; Lotherton
Hall, Aberford (23/1988)

Literature: Gilbert 1998, p. 667, no. 835

This larger and more elaborate version of
Godwin's classic coffee table (CR 207) was
made by the firm of Gillow and Company,
London. Although Godwin is known to
have worked for them between 1874 and
1875, there are no entries in his ledgers or
sketchbooks that correspond to this design.
It could very well be the work of George
Freer Roper, who was an assistant to
Godwin for many years and was known to
have worked for Gillow (as well as a
number of other firms) after he left
Godwin's employ. Indeed, even though
examination of the Gillow estimate and
sketchbooks reveals very few Anglo-
Japanese designs, those that do appear are
for the most part by Roper, whose designs
are frequently more Godwinlike than
Godwin's own and tend to be a bit more
decorative. In contrast to the more popular
Watt model, this table has panels of maroon
plush fabric bordered by tooled leather on
the tabletop and shelf, reeded edges
throughout, and vertical striations on the
turned legs. The striations and edges are
highlighted with gold, giving the table a
more exotic appearance. The fabric inserts
reflect the growing fashion in the 1870s and
1880s to add fabrics to tables. This deluxe
model, with its refined details, reflects the
superior cabinetmaking abilities of Gillow
and Company.

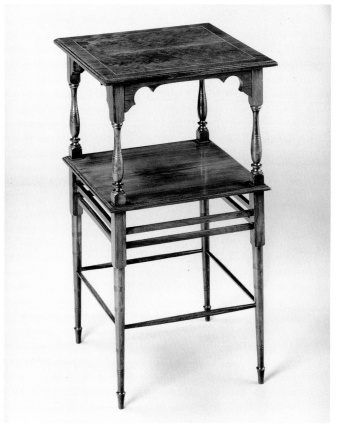

221

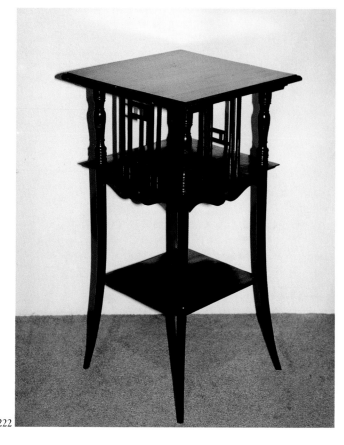

222

221. *Double Tier Table*

Ca. 1875, attributed to E. W. Godwin
Probably made by Collinson and Lock or
Gillow and Company
Mahogany
28 × 16 × 16 in. (71 × 41 × 40.6 cm)
H. Blairman and Sons, London; Private
collection

In overall form this small but elaborate
table resembles Godwin's classic coffee table
(CR 207). The rounded stretcher, the
turned decoration on the lower legs, the
reeded edges of the horizontal surface, and
the integration of rectangular and rounded
elements in a tiered fashion recall Godwin's
Dromore chair stiles (see CR 112, 113).
The double-lattice stretcher under the
lower shelf, however, relates to his Japanese
cabinet designs for Collinson and Lock
(CR 335).[9] The comparatively ornate frieze
under the tabletop resembles that found in
a Godwin sketch for a table, now in a
private collection (Fig. 221.1).[10]

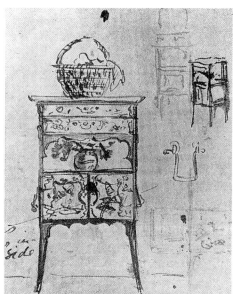

221.1 Sketch for a table with drawers (Pevsner
1952)

222. *Occasional Table*

Ca. 1875, attributed to E. W. Godwin
Maker unidentified
Ebonized wood
32¾ × 18 × 18 in. (83 × 45.7 × 45.7 cm)
Paul Reeves, London; Private collection

Although there is no known drawing or
sketch for this table, many of its features
link it to the work of Godwin. The elegantly
splayed legs, the valanced apron under the
middle shelf, the baluster-turned supports,
and the latticework side panels are all
features found in many of Godwin's
furniture designs, and make this piece
surprisingly rich in detail.

223. *Table*

Ca. 1873–75
Probably made by Collinson and Lock
Materials unknown
Dimensions unknown
Mr. Anthony Gibbs, Tyntesfield;
whereabouts unknown

Literature: N. Wilkinson 1987, pp. 243–44;
Soros 1999, p.203

This square, Anglo-Japanese table with latticework side panels is believed to have been in the possession of Anthony Gibbs, who was a collector of Asian ceramics and furniture in the 1870s. The table was photographed by Mark Girouard in 1978, in a bedroom called the "Louvre Room" (incorrectly identified as the "Smoking Room") in the tower of Tyntesfield in the village of Wraxall, near Bristol (CR Fig. 125.1).[11]

The table is based on a sketch Godwin drew in 1873 of coffee tables intended for Collinson and Lock's Grey Towers commission (Fig. 223.1). The angled leg brackets, latticework side panels, double rail under the openwork section, and brass leg attachments are all typical of Godwin's Anglo-Japanese furniture designs.

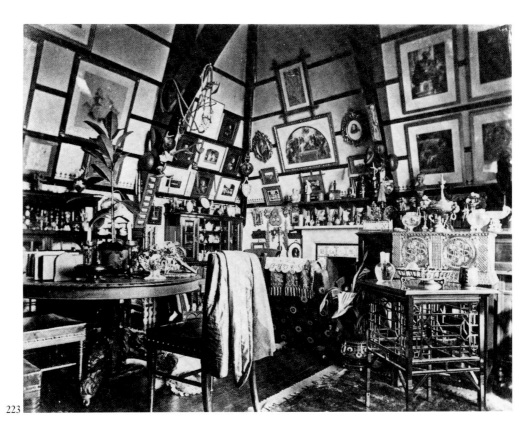

223

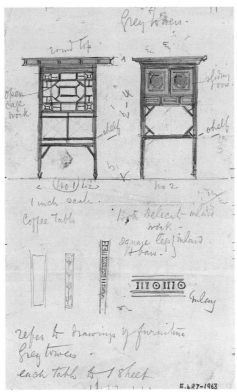

223.1 Design for Anglo-Japanese tables for Grey Towers (V&A PD E.487-1963)

224. *Double-Width Coffee Table*
Ca. 1875, attributed to E. W. Godwin
Probably made by William Watt
Ebonized wood
27 × 34 × 19½ in. (68.5 × 86.5 × 49.5 cm)
Bishop Henry Room, Castle Ashby,
Northamptonshire

Although there are no illustrations of this
table in the Watt catalogue, there are
drawings for double-width coffee tables in
Godwin's sketchbooks from the mid-1870s
(Fig. 224.1), and we know he designed both
ebonized and mahogany versions. This
ebonized version at Castle Ashby, for
example, where Godwin worked in 1868
and 1869 for the Marquess of
Northampton, has an interesting
modification: rather than the repeated
diagonal transection of the space between
the stretcher and the shelf common to his
classical coffee table (CR 207), Godwin has
transected only opposite corners and left
the central section open, creating a more
complicated yet lively interplay of open and
closed space. The same effect can be seen in
a Godwin drawing of an ancient Egyptian
stool in the British Museum, suggesting an
Egyptian source for this design (Fig. 224.2).
A similar version, combining plain and
ebonized mahogany, was sold at the Phillips
sale of 26 May 1992 (CR 224-b).[12] The
appearance of plain with ebonized
mahogany may indicate that the ebonized
top lost its original finish.[13]

A mahogany version of this table, with
the diagonal spindle pattern on all four
sides of the lower section, is in a private
collection in London (CR 224-a).

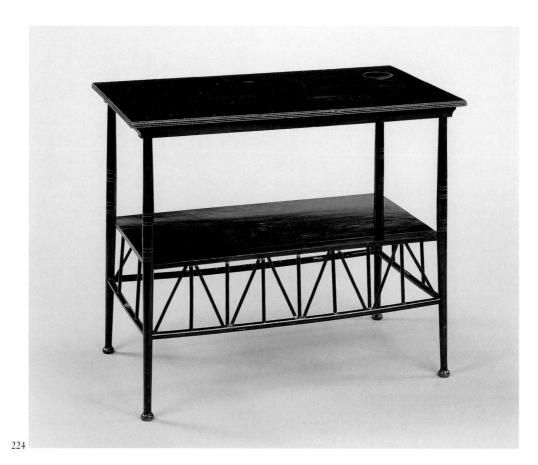

224

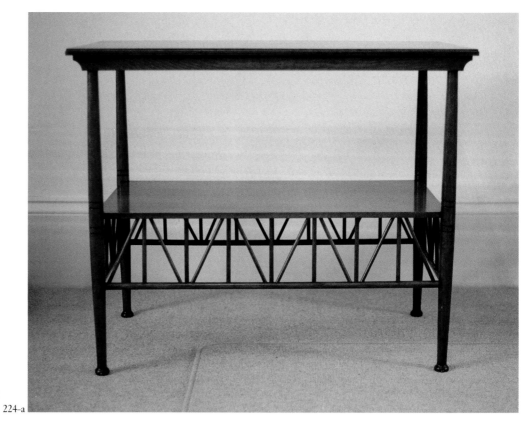

224-a

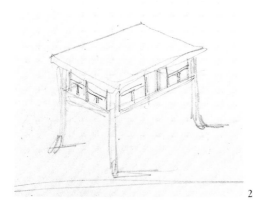

224.1 Sketch for a double-width coffee table
(V&A PD E.235-1963, fol. 22)

224-a. *Double-Width Coffee Table*
Ca. 1875, attributed to E. W. Godwin
Probably made by William Watt
Mahogany
$27\frac{1}{2} \times 34 \times 19\frac{3}{4}$ in. (69.9 × 86.4 × 50.2 cm)
Private collection

224-b. *Double-Width Coffee Table*
Ca. 1875, attributed to E. W. Godwin
Probably made by William Watt
Mahogany top and lower shelf; ebonized
framework and details
W 39 in. (99 cm)
Fine Art Society, Edinburgh; Phillips,
Edinburgh, 26 May 1992, lot 365; Private
collection

224-c. *Double-Width Coffee Table*
Ca. 1875, attributed to E. W. Godwin
Probably made by William Watt
Mahogany
$27 \times 34 \times 19\frac{3}{4}$ in. (68.6 × 86.4 × 50.2 cm)
Paul Reeves, London

This version has vertical spindles instead of
the more common angled ones.

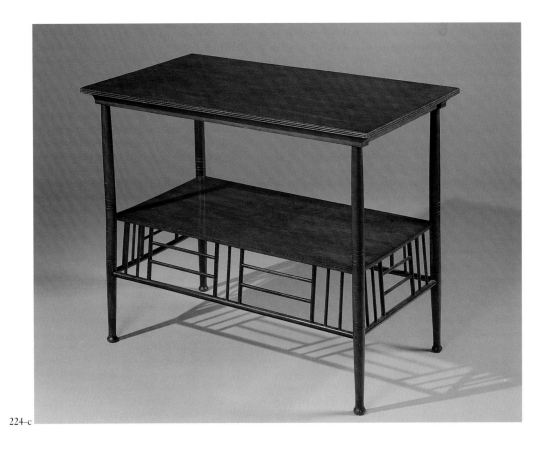

224-c

224.2 Sketch of an Egyptian stool in the British
Museum (V&A PD E.278-1963, fol. 13)

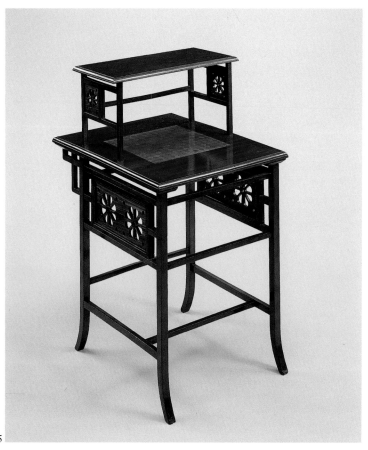

225

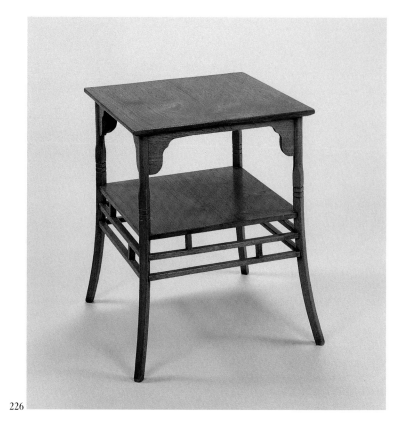

226

225. *Table*

Ca. 1875, attributed to E. W. Godwin
Mahogany
Maker unidentified
Dimensions unavailable
Paul Reeves, London; Private collection

Although there is no known drawing for this table, it corresponds to a series of Anglo-Japanese side tables with upper structures that Godwin designed in the 1870s. The elbow struts and pierced chrysanthemums are some of Godwin's best Anglo-Japanese design features. Similar pierced floral decoration can be found on his easel for Dromore Castle dating from 1870 (CR 401) as well as on a large ebonized sofa designed for Collinson and Lock about the same time (CR 130). The table's complicated interplay of stretchers and thin, splayed legs are also characteristic of Godwin's work. The tabletop wood inlay imitates woven Asian material.

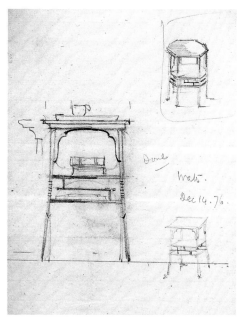

226.1 Sketch for a two-tiered table annotated "Done Watt Dec, 14 76" (V&A PD E.233-1963, fol. 81)

226. *Two-Tiered Table*

Ca. 1876
Probably made by William Watt
Mahogany
24⅜ × 22 × 21½ in. (62 × 56 × 54.5 cm)
H. Blairman and Sons, London; Private collection

Literature: Soros 1999, p. 79

A drawing in Godwin's sketchbooks for a version of this table, annotated "Done Watt Dec. 14 76" (Fig. 226.1), was registered with the Public Record Office in November 1876 by the firm of William Watt as Ornamental Design No. 306237 (Fig. 226.2). A similar table appears in Watt's *Art Furniture* (Plate 8), listed under "Anglo-Japanese Drawing Room Furniture" as a coffee table. An annotated version of the catalogue indicates that ebonized versions were available for £4.4s.0d.

A lighter example of this table, with brass fittings on its legs, was part of the William Watt exhibit at the 1878 Exposition Universelle in Paris and appears in a period photograph of the "Butterfly Suite." A version of this table with Minton tiles inset into its top (CR 226-b) was published by Elizabeth Aslin.

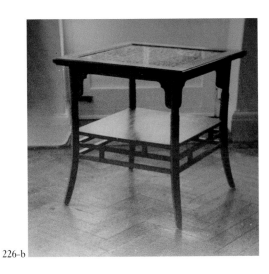

226-b

226-a. *Two-Tiered Table*
Ca. 1876
Probably made by William Watt
Mahogany
$24^3/_4 \times 20^7/_8 \times 20^7/_8$ in. (63 × 53 × 53 cm)
Paul Reeves; Private collection

226-b. *Two-Tiered Table*
Ca. 1880
Probably made by William Watt
Mahogany; top inset with Minton tiles
$23^1/_4 \times 22^1/_2 \times 22^1/_2$ in. (59 × 57 × 57 cm)
Whereabouts unknown

Literature: Aslin 1986, pp. 30, 67, fig. 39;
Soros 1999, p. 239

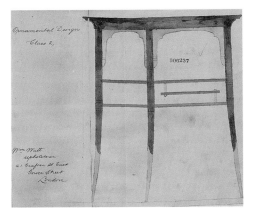

226.2 Table, "Ornamental Design" (Public
Record Office)

227. *Jardiniere,* or *Flower Stand*
Ca. 1876–85, attributed to E. W. Godwin
Probably made by William Watt
Ebonized wood
$32^3/_4 \times 18$ in. (83 × 45.5 cm)
Paul Reeves, London; Private collection

Godwin's ledgers indicate that he first
designed a jardiniere in oak in 1867 for the
Art Furniture Company (V&A AAD
4/9-1980, fol. 39), although he designed
flower stands for many different firms
throughout his career. This example was
probably made by William Watt, since it
resembles one illustrated twice in Watt's
Art Furniture – in Plate 12 and in Plate 14
(as one of a pair of Anglo-Japanese flower
stands for the drawing room).

This stand, with diagonal supports
connecting the shelf and the stretcher,
represents an elongated version of Godwin's
classic coffee table (CR 207) and sold for
£3.3s.0d. The splayed legs seen in the Watt
illustration, however, have been replaced in
this example with round tapered turned
legs, making a firm attribution to Watt
impossible.

Flower stands, which originally were
designed during the reign of Louis XVI in
France, became popular in England in the
second half of the nineteenth century with
the increased appearance of flowers and
plants in middle-class homes. Godwin
incorporated flower stands into the deco-
ration of his own interiors; his hallway at
Taviton Street, for example, had "two
stands for plants" (in addition to two side
tables, and two white wicker chairs).[14]

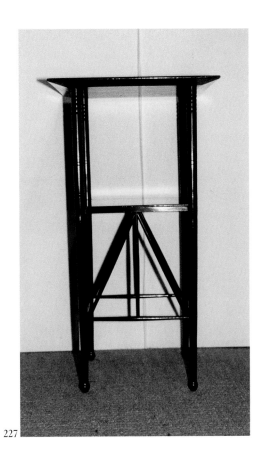

227

228. *Tea Table*
1877
Made by William Watt
Mahogany
$27\frac{1}{2} \times 33\frac{3}{8} \times 29\frac{5}{8}$ in. (69.9 × 84.9 × 75.4 cm)
H. Blairman and Sons, London; Private
collection

Literature: Blairman and Sons 1994, pl. 17;
Soros 1999, pp. 241–42, fig. 8-29

The design for this table, inscribed "Tea
Table for Paris" and signed "EWG Sep
77," is in the Drawings Collection of
the Royal Institute of British Architects
(Fig. 228.1).[15] The table contains elements
typical of Godwin's tables of the 1870s –
the arched frieze, turned legs, and thin
proportions – and was probably designed
for William Watt's exhibit at the 1878
Exposition Universelle in Paris. This
attribution to Watt is strengthened by the
existence of an identical table in ebonized
wood (CR 228-a) that has the maker's label
of William Watt.

Martin Levy has noted the similarity
between this table and the spider-leg tea
tables popular in England at the middle of
the eighteenth century with which Godwin,
as an admirer and collector of Georgian
furniture, was very likely familiar.[16]

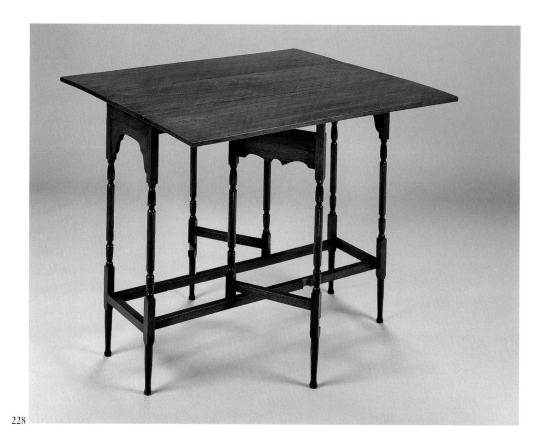

228

228-a. *Tea Table*
1877
Made by William Watt
Ebonized mahogany
$28 \times 33\frac{3}{4} \times 31\frac{3}{4}$ in. (71.1 × 85.7 × 80.6 cm)
Metal William Watt label attached to
underside of tabletop
Haslam and Whiteway, London; Private
collection

228.1 "Tea Table
for Paris" (RIBA
Ran 7/N/14)

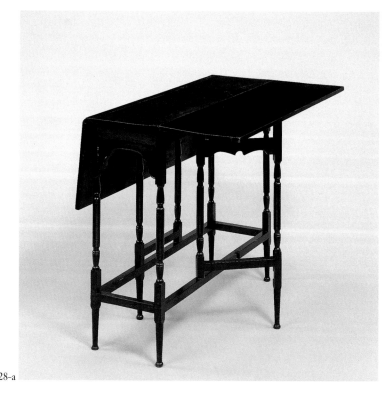

228-a

229. *Circular Eight-Legged Center Table*

Ca. 1877–85
Made by William Watt
Walnut veneer
28 × 41 in. (71 × 104 cm)
J. Aldon Heaton (1885); J. Walter Beckh;
Haslam and Whiteway, London; Private
collection

Literature: Gere and Whiteway 1993,
pp. 152–53, pl. 187

This circular eight-legged center table has a
walnut veneer and is identical to one in
Godwin's sketchbooks inscribed "Table for
Watt Aug 12 '76" (Fig. 229.1) except that it
lacks brass shoes. Sold by the decorator J.
Aldon Heaton to his client Walter Beckh,
Esq., in 1885, the table was described in the
invoice as an "8 legged walnut table for
Drawing Room" and cost £7.7s.od. It is
also similar to a table illustrated in William
Watt's *Art Furniture* (Plate 12).

These tables were made in both walnut
and ebonized versions, but this is the only
known example with rounded frieze
molding.

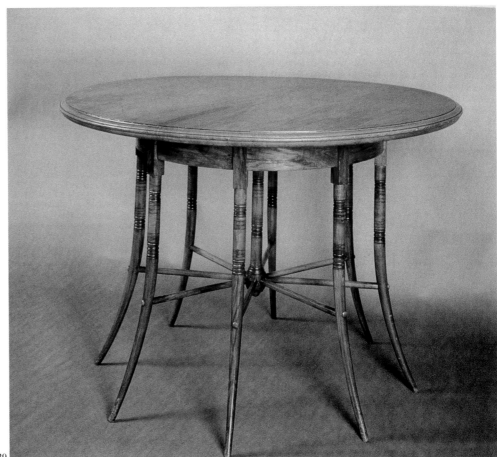

229

229.1 "Table for
Watt Aug 12 '76"
(V&A PD E.494-
1963)

230

231

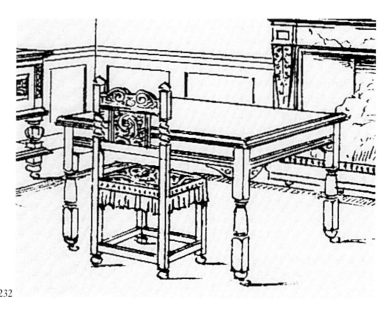

232

230. *Design for a Table*

This table is known through a drawing that
appears in one of Godwin's sketchbooks
(V&A PD E.242-1963, fol. 22). The
drawing is annotated "X W / Jan 3 77,"
indicating the table was commissioned by
William Watt in 1877. The elegant oval
tabletop has a molded edge and is supported
on four ring-turned legs terminating in paw
feet. The legs splay outward and are con-
nected by two independent stretchers: the
first is continuous and is placed a few
inches below the tabletop; the second is
x-shaped and is placed about two-thirds
of the way down from the top. The dual
stretchers, ring-turned legs, and paw feet
all reflect Egyptian influence.

231. *Design for a Dining Table*

This simple rectangular dining table
appears as part of an Old English-style
dining-room suite in William Watt's *Art
Furniture* (1877; Plate 7) where it is listed
at £12.12s.0d. It measures 7 feet in length
and 3 feet 6 inches in height.

 The table is an adaptation of the joined
dining table popular in England during the
seventeenth century.[17] Godwin followed the
rectangular shape, thick plain top with
molded edge, simple apron, and baluster-
turned legs common to early Jacobean
examples, but eliminated the continuous
stretcher. Brass casters were added for
additional mobility.

232. *Design for a Table*

Although no surviving example is known,
this four-foot wide oak table is illustrated
in William Watt's *Art Furniture* (1877;
Plate 15), priced at £7.0s.0d. The form is
simple – rectangular with baluster-turned
legs, a plain top with molded edge, and an
undecorated apron. It is reminiscent of the
joined dining tables popular in England
during the seventeenth century, though it
lacks their continuous stretcher.

233

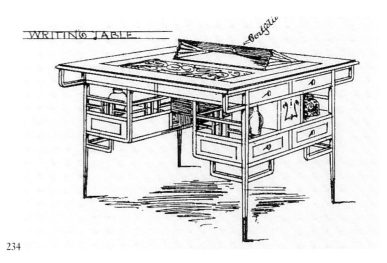

234

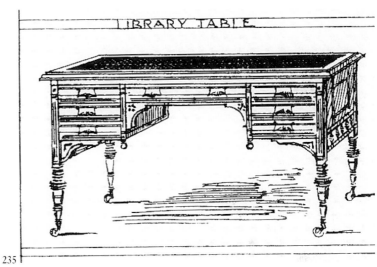

235

233. *Design for a Writing Table*

This table is reproduced in William Watt's *Art Furniture* under "Old English or Jacobean Furniture" (1877; Plate 15), priced at £7.7s.0d, although no surviving examples are known. It measures 4 feet by 22 inches and has a large kneehole, central drawer, and nests of drawers on either side – standard for writing tables. The molded top edge and baluster-turned legs joined by a stretcher give this table a Jacobean quality.

234. *Design for a Double-sided Writing Table*

Literature: N. Wilkinson 1987, p. 176

This unusual writing table, which measures 4 feet in width, appears in William Watt's *Art Furniture* under "Anglo-Japanese Furniture" (1877; Plate 8). Walnut versions were available (£25.0s.0d) as well as ebonized wood (£26.0s.0d). The table has many details characteristic of Godwin's Anglo-Japanese style, including S-shaped elbow struts, complex interplay of solids and voids, narrow tapering legs ending in gilded shoes, delicate construction, and display shelves. A portfolio for storing paper was designed to sit on the writing surface.

The idea of the double-sided table probably came from the Georgian partner's library table, a form that was extremely popular throughout the eighteenth century.

235. *Design for a Library Table*

This table, which measures 5 feet 6 inches by 4 feet, is listed in William Watt's *Art Furniture* under "Library Furniture" (1877; Plate 11) and sold for £15.15s.0d. The form is traditional, with a drawer above the kneehole in the center and a nest of three shallow drawers on either side. It has a leather top, turned legs, and sat on casters.

The kneehole section lightened the proportions of the desk, and several Jacobean-style details were added: cup-and-cover turned legs, turned spindles along the bottom of each side panel, carved bracket arches flanking the kneehole as well as beneath each bottom drawer, and pendant turnings at the kneehole.

236

236. *Design for a Dining Table*

This small dining table, which measures 3 feet 6 inches by 5 feet, is reproduced in William Watt's *Art Furniture* (1877; Plate 16) under "Economic Furniture" for a parlor. It is made of walnut and sold for £6.6s.od. The table has baluster-turned legs, an apron with carved bracket ends, and a plain top with molded edge. Godwin illustrated it with a rectangular cloth runner with semicircular embroidered corners and fringed ends.

237, 238. *Designs for a Washstand and a Writing Table*

Literature: Soros 1999, pp. 212–13, fig. 7-38

This drawing depicts the combination washstand and dressing table and the matching writing table Godwin designed for the bedroom of Frank Miles at 44 Tite Street, London, in 1878 (V&A AAD 4/131-1988). The designs were minimal, with decoration limited to a fluted section on the rounded legs and slightly rounded moldings. An estimate from the commission reveals that the writing table had drawers that could be locked (V&A PD E.248-1963, fols. 72, 73).

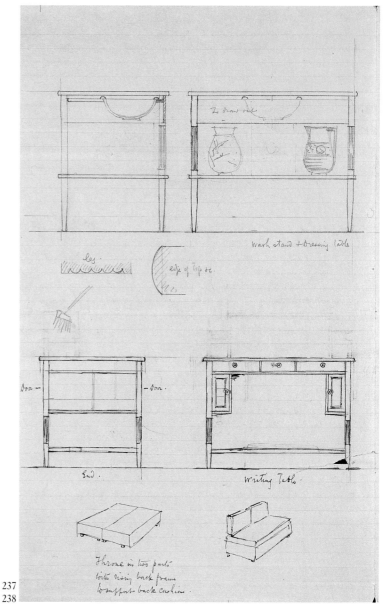

237
238

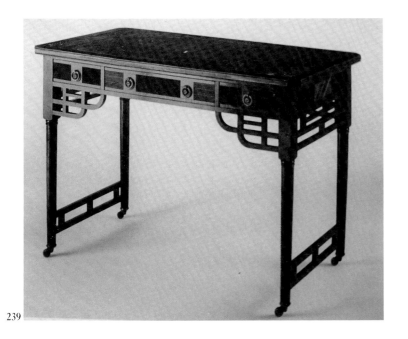

239

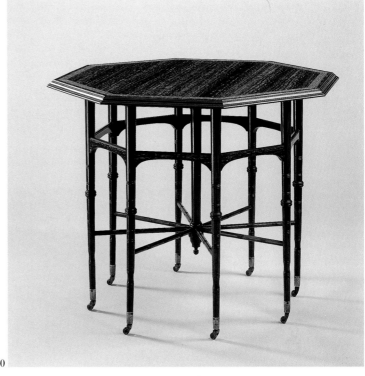

240

239. *Writing Table*
Ca. 1878, attributed to E. W. Godwin
Maker unidentified
Ebonized wood; tooled leather; brass
handles and fittings; casters
29½ × 41¾ × 21⅝ in. (74.9 × 106.2 × 55 cm)
Christie's, London, 2 November 1995, lot
47; Private collection

Although Godwin designed writing tables
throughout his career, there is no known
drawing for this piece in his sketchbooks or
in William Watt's *Art Furniture*. Many of its
features, however, closely resemble elements
in firmly attributed Godwin pieces. For
example, the electroplated loop handles
with their square escutcheons are similar
to the ones Godwin used in his famous
ebonized sideboards (see CR 304). The
curved lattice struts, which are another
feature typical of his work, correspond to
those found on his hanging cabinet illus-
trated in *Building News* (see CR 384). The
tooled leather top relates to his library table,
reproduced in William Watt's *Art Furniture*
(Plate 11), which also sat on casters (CR 235).

240. *Octagonal Eight-Legged Center Table*
Ca. 1878
Collinson and Lock
Macassar ebony veneer on rosewood; ivory
inlay; brass caps; brass casters
27 × 27 × 27 in. (68.6 × 68.6 × 68.6 cm)
Stamped on underside of tabletop:
Collinson and Lock, London
H. Blairman and Sons, London; Private
collection

Literature: "Furniture at the Paris
Exhibition," 7 September 1878, p. 159;
Cooper 1987, pl. 327; Soros 1999, no. 93,
pp. 237, 255, fig. 8–22

This version is the most luxurious of the
octagonal tables Godwin designed for
Collinson and Lock. One matching this
description was exhibited by Collinson and
Lock at the 1878 Exposition Universelle in
Paris and was described by a reviewer as a
"light, slender eight-legged octagonal
center table of rosewood inlaid with ivory,
all the thin rails of which meet in a central
boss – a marvel of constructive skill and
strength."[18] The ivory inlay and engraved
arabesque ornamentation would become a
common and very popular element of
Collinson and Lock's furniture production
in the 1880s and 1890s. The catalogue of

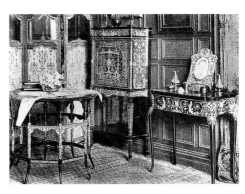

240.1 Ivory inlaid furniture from the Gillow and
Company catalogue

Gillow and Company (who absorbed
Collinson and Lock in 1897) of about
1900 reveals that a group of rosewood
furniture with similar ivory inlaid
arabesque decoration was still in produc-
tion (Fig. 240.1).[19]

241. *Dressing Table*

1879

Made by William Watt

Oak; brass handles and fittings

$28\frac{1}{2} \times 41\frac{7}{8} \times 31\frac{1}{4}$ in. (72.5 × 106.5 × 79.4 cm)

Enameled metal label attached to underside of tabletop: William Watt, Art Furniture Warehouse 21 Grafton Street London W.C. Ellen Terry; by descent to Edith Craig; by bequest to The National Trust, Ellen Terry Memorial Museum, Smallhythe Place, Kent (SMA/F/60)

Literature: "Bed-Room Furniture," 24 October 1879, p. 490, ill.; Aslin 1986, pl. 50; Cooper 1987, pl. 325; Reid 1992, p. 37, fig. 4; Soros 1999, p. 250

A drawing in Godwin's sketchbooks for this dressing table is annotated "gave this to S. & E. for self. Oct 6, 79" (Fig. 241.1). In addition to being made for Godwin's own use, this dressing table (and accompanying mirror) was marketed as part of a suite of bedroom furniture made by William Watt. It was illustrated in *Building News* (Fig. 241.2) with the following text: "They were designed by Mr. E. W. Godwin, F.S.A. and have been executed by Mr. Wm. Watt of Grafton Street W.C. in whose warehouse the articles may be seen. They are made of oak and are simple practical pieces of furniture, whose lines have been determined chiefly by the use for which they were intended. . . ."[20]

The dressing table's turned splayed legs, angled spindled struts, and thin proportions all point to the ancient Egyptian furniture that Godwin studied and sketched in the British Museum. The table's form, however, with its hinged side leaves and support wings, points to a mid- or late-Georgian source. Godwin admired Georgian furniture and even decorated his London dining room with examples of what he called "flap tables," undoubtedly a reference to the Pembroke tables of the late eighteenth century. The versatility of the Pembroke table – its adjustable size and adaptable uses – would certainly have appealed to Godwin's sense of utility.

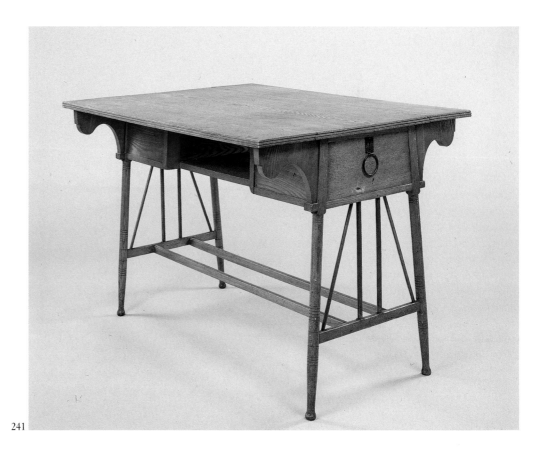

241

241.1 Sketch for a dressing table (V&A PD E.233-1963, fol. 108).

241.2 Dressing table from an illustration in *Building News*, 1879

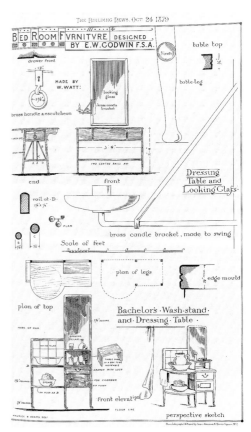

242. *Design for a Gothic Table*

Literature: "Furniture by E. W. Godwin," 5 November 1880, p. 528, ill.; Soros 1999, p. 241

This oak six-sided table, designed by Godwin for a drawing room, is known from an illustration that appeared in *Building News* in 1880.[21] With its rectilinear outline and openwork panels of pointed arches and four-petaled tracery, it exhibits many Gothic-Revival features. Although Gothic-Revival furnishings were no longer considered fashionable in the 1880s, Godwin remained comfortable with its vocabulary, streamlining its customarily heavy, massive proportions and adding the more popular brass shoes and casters to give it a more up-to-date appearance. Godwin used similar tracery patterns on his church furniture pieces which were reproduced in William Watt's *Art Furniture* (1877; Plate 19).

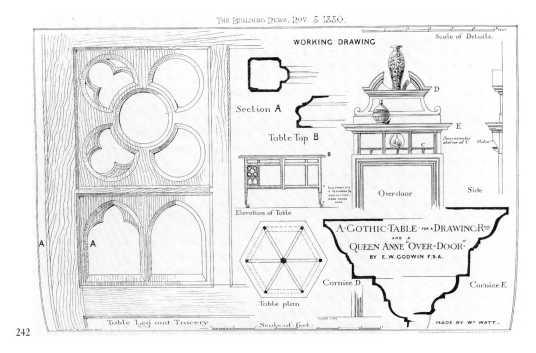

242

243. *Design for a Table*

This octagonal table is known from a drawing in Godwin's sketchbooks (V&A PD E.422-1963). The drawing's annotation, "W. July 1881 inlay foot," indicates the table was designed for William Watt during that year. This is one of Godwin's most elaborate table designs, with elegant volute-topped supports ending in inlaid feet, the open sectioned cradle for the top, and the beautifully detailed top edging. The idea probably originated with the Roman circular table that rested on three curved animal legs which was originally borrowed by Regency cabinetmakers in the nineteenth century and continued to influence table design throughout the rest of the century.

Earlier drawings for tripod stands that date from the mid-1870s also appear in Godwin's sketchbooks (see Fig. 41; V&A PD E.229-1963, fol. 83).

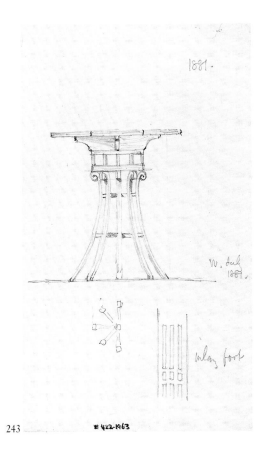

243

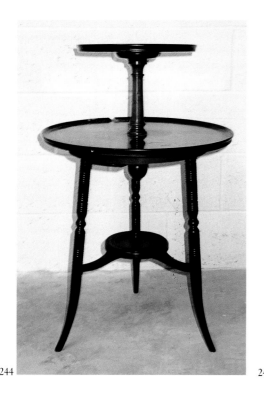

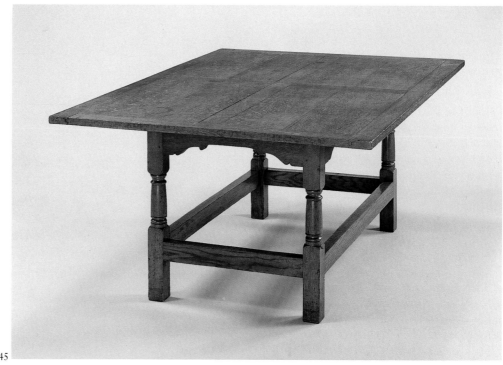

244 245

244. *Work Table*

Ca. 1881, attributed to E. W. Godwin
Maker unidentified
Mahogany
35 × 22 × 22½ in. (88.9 × 57 × 57.2 cm)
Paul Reeves, London

Although there are no known surviving
drawings for this mahogany work table, it
resembles Godwin's Sheraton-inspired
designs of the 1870s. Its outward ring-
turned legs are typical of some of his table
designs and overall it compares favorably
with his circular seven-legged center table
made for Collinson and Lock about 1872
(CR 214). The form is based on English
dumbwaiters of the seventeenth and
eighteenth centuries. The tripod form and
central bottom shelf can be found in some
of Godwin's furniture designs in his
sketchbooks. A sketch for a stand for a
toilet set from about 1876, for example,
shows Godwin experimenting with the
tripod form (V&A PD E.233–1963, fol. 76).

245.1 Studies of Jacobean furniture (V&A PD
E.233-1963, fol. 3)

245. *Dining Table*

Ca. 1882
Made by William Watt
Light oak
$27\frac{1}{2} \times 46 \times 25\frac{3}{4}$ in. (70 × 117 × 65.3 cm)
Enameled label attached to underside of tabletop: William Watt-Art Furniture Warehouse-21 Grafton Street and Gower Street, London W.C.
Ellen Terry; by descent to Edith Craig; by bequest to The National Trust, Ellen Terry Memorial Museum, Smallhythe Place, Kent (SMA/F/48)

Literature: "Shakespeare Dining-Room Set," 11 November 1881, p. 626, ill.; Soros 1999, p. 253

This dining table was part of Godwin's Shakespeare dining-room set, a suite of Jacobean-style furniture he designed for William Watt which included "eight small chairs, one stool, two armchairs and a sideboard."[22] The suite was illustrated in *Building News* on 11 November 1881 (see CR Fig. 176.1) and the accompanying descriptive text informs us that "The whole of the work is in oak finished with a beeswax polish. . . . The top of this latter piece of furniture [the dining table] is made in planks, held together by a grooved ledge at either end . . ." (p. 626).

The rectangular table, with its four baluster-turned legs connected by a stretcher close to the floor, reproduces seventeenth-century dining tables used in England and the Netherlands. The use of oak, which was used in original Jacobean tables, is also historically correct. (Godwin's sketchbooks are full of drawings of late sixteenth- and early seventeenth-century pieces of furniture drawn from museum collections in London [Fig. 245.1]). This is one of only two Godwin dining tables to have been identified, even though his sketchbooks indicate that he designed many more, including one, with casters, that is reproduced in William Watt's *Art Furniture* (Plate 7).

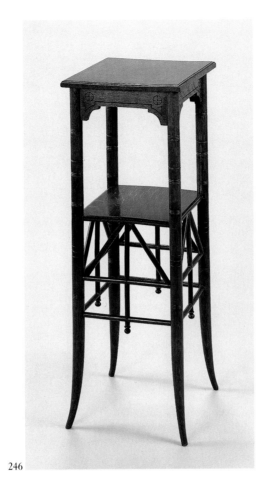

246

246. *Stand*

Ca. 1883, attributed to E. W. Godwin
Made by William A. and S. Smee
Stained oak
$32\frac{1}{2} \times 12 \times 11\frac{3}{4}$ in. (82.5 × 30.5 × 30 cm)
Metal label attached to underside of top: Willm. A. S. Smee Manufacturer 89 Finsbury Pavement London
Paul Reeves, London; Private collection

This stand was manufactured by William A. and S. Smee, for whom Godwin worked in the 1880s, and it displays unmistakable Godwin touches: the arched frieze, which he used in many of his circular tables of the 1870s (see, for example, CR 213), the slightly splayed turned legs, which he utilized in his occasional tables of the 1860s and 1870s (CR 222, 225), and the angled spindles, which he employed in his coffee tables (CR 207). The addition of a double stretcher integrated into the form by the extension of a central spindle that terminates in a rounded pendant is reminiscent of his eight-legged circular table forms (CR 213). Another identifiable Godwin touch is the use of staggered turning on the legs, the result of varying the space between the turned incisions which give this work a more varied, handcrafted feel. The shaped apron and the incised rosette in the apron's corners differentiate this stand from the flower stand Godwin designed for William Watt in the previous decade (CR 227).

247. *Design for a Dining Table*

Literature: "Jacobean Suite of Dining Room Furniture," 14 March 1884, p. 406, ill.

This oak table was part of a suite of Jacobean dining-room furniture illustrated in *Building News* in 1884 and appeared as part of William Watt's display at the art furniture exhibition at the School of Art-Needlework, South Kensington. The table, which was described as "totally Jacobean in style," had carved cup-and-cover supports connected by stretchers, a gadrooned apron with acanthus-leaf edge, and a molded top reminiscent of Jacobean refectory tables. Godwin reprised his earlier Shakespeare-style chair (CR 176) to accompany the table for this suite.

247

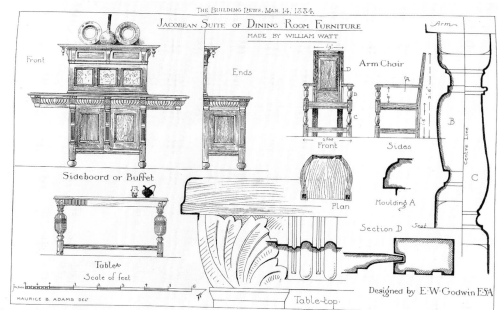

CABINETS

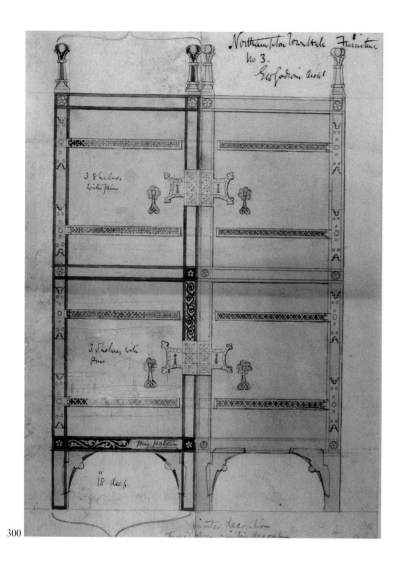

300

300. *Design for a Cupboard*

Literature: Aslin 1986, pp. 11, 23, 65, fig. 1; Cruickshank 1993, p. 79, fig. 11

This design for a Gothic-Revival cupboard for Godwin's Northampton Town Hall commission (V&A PD E.622-1963) dates from ca. 1863. It was annotated "Northampton Town Hall Furniture No. 3 signed E. W. Godwin Archt." Detailed instructions for the maker Green and King indicate the use of painted decoration, iron door hardware, and three shelves with pins for the interior fittings. It is not known whether it was executed or not. It resembles the armoire at Bayeux, drawn by Viollet-le-Duc in his *Dictionnaire raisonné du mobilier français* of 1858 (7, fig. 6) which Godwin is known to have admired.

301. *Design for a Corner Bookcase*

This design for a Gothic-Revival style corner bookcase with triangular pediment for Godwin's Northampton Town Hall commission dates from ca. 1863 (V&A PD E.624-1963). It is not known whether it was executed or not. It is shown with iron straps and ring handles. The side supports have high arched sections. This is Godwin's earliest known design for a bookcase. Godwin would later use this corner form for a washstand for Dromore Castle in 1870 (see CR 310).

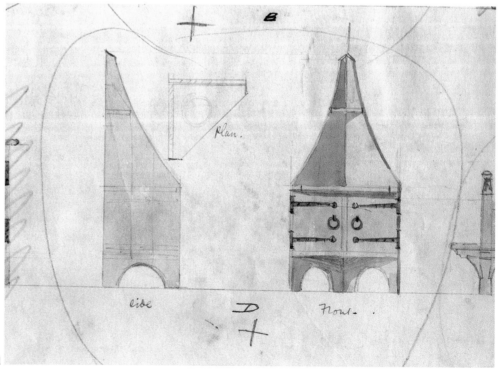

301

302. *Design for a Cabinet Bookcase*

This design for a Gothic-Revival cabinet bookcase for Godwin's Northampton Town Hall commission dates from ca. 1863 (V&A PD E.624-1963). It is not known whether the design, which is annotated "Bookcase for Rooms," was ever executed. Similar in style to Godwin's corner bookcase design (CR 301), it is illustrated with iron strapwork and round handles. The bookcase is shown to have three open shelves with vertical boarded back panels and a lower cabinet section with two cabinet doors. The side supports have high arched sections to elevate it above the floor.

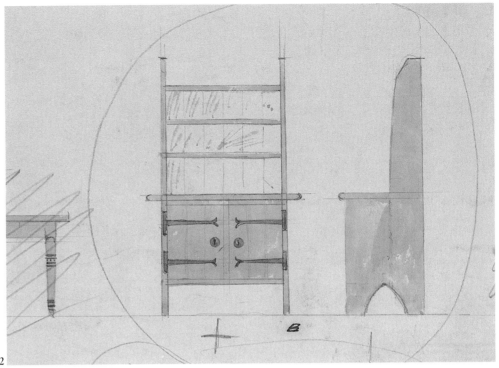

302

303. *Design for a Double-Pedestal Table*

This design for a Gothic-Revival double-pedestal table for the front offices of Godwin's Northampton Town Hall dates from ca. 1863 (V&A PD E.623-1963). It is not known whether the piece was executed. Similar to Godwin's designs for bookcases (CR 301, 302), it is illustrated with Gothic-Revival strapwork, round handles, and boarded construction.

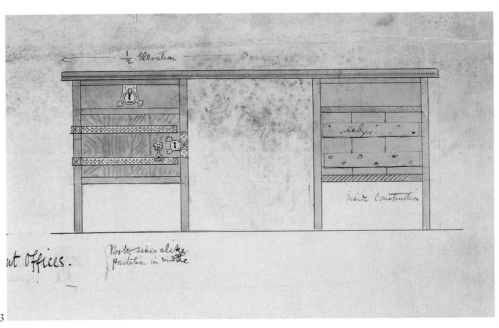

303

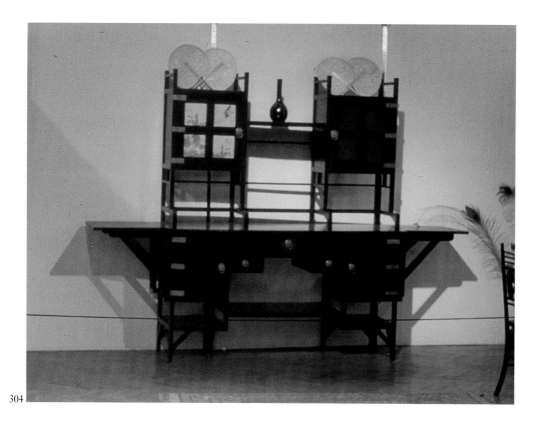

304

304. *Sideboard or Buffet*
Ca. 1867
Made by Abercrombie
Ebonized mahogany and deal; brass handles
and fittings; upper right-hand door and
fittings replaced; cutlery tray inside lower
right cupboard
71 × 99 × 20¼ in. (180.5 × 251.5 × 51.3 cm)
Stamped: Abercrombie
Originally in the possession of the designer
and Ellen Terry; by descent to Edith Craig;
by bequest to the Bristol Museums and Art
Gallery (N4507)

Literature: "Two Interiors" 1920, p. 52;
Aslin 1986, p. 27; Bristol Museums and Art
Gallery 1976, no. 4; N. Wilkinson 1987, pp.
190–93; Sato and Watanabe 1991, p. 1116,
no. 101; Squire 1991, p. 37; Watanabe 1991,
pp. 191–93; Reid 1992, p. 38, fig. 5; Watson
1994, p. 6; Watson 1997, pp. 66–68; Wilk
1996, p. 168, fig. 1; Soros 1999, p. 238

This sideboard, Godwin's most famous
furniture design, was produced in at least
ten versions between 1867 and 1888. It
appeared in William Watt's *Art Furniture*
under "Dining Room Furniture" (1877;
Plate 6), with accompanying text that
described it as "originally made for
Mr. Godwin in black and gold, with a

curtain of gold embroidery on yellow satin.
It also has been made with a door in the
place of the curtain. The projecting ends
are hinged so as to turn down when
required" (p. viii). The sideboard shown
here, which did originally have a curtain
on the left cupboard door, could be the
one that Godwin designed in 1867 for his
own use and that Watt described in his
catalogue. It was not Godwin's first version,
which was made in deal (CR 304-a), but
rather a later, ebonized version which

replaced the first in his dining room.[1]
The sideboard appears in a 1920 photo-
graph of Ellen Terry's sitting room in
Chelsea (304.1) with its Japanese watercolor
panels, hanging curtain, and eclectic
accessories.[2]

304-a. *Sideboard*
Ca. 1867
Probably made by the Art Furniture
Company
Ebonized deal; stenciled decoration; silver-
plated handles and fittings
67⅜ × 60¼ × 18⅞ in. (171 × 153 × 48 cm)
Paul Reeves, London; Die Neue Sammlung,
Staatliches Museum für Angewandte
Kunst, Munich (470/93)

Literature: Hufnagl 1993, pp. 88–89;
Breuer 1994, pp. 325–326, ill.; Dry 1994,
pp. 20–22, fig. 1; Reeves 1994, p. 36, fig. 1;
Burg 1995, p. 288; Watson 1997, pp. 66–67,
fig. 3; Soros 1999, pp. 240–41, fig. 8-28

Unlike other known versions, the sideboard
shown here lacks the drop leaves and the
square framework of stiles atop the cabinets.
In addition, the drawer configuration in this
design is different, the edges of the front
horizontal brackets are square rather than
rounded, and the location of the bottom
shelf is at a modified level, placed between
the lowest end of the bottom cupboards
rather than between the open shelves at the
left- and right-hand sides of the sideboard.
The fact that this sideboard is made of
ebonized deal whereas all the other versions
are of ebonized mahogany has led to

304.1 Photograph
of Ellen Terry's
sitting room in
Chelsea

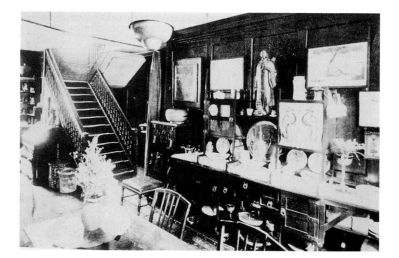

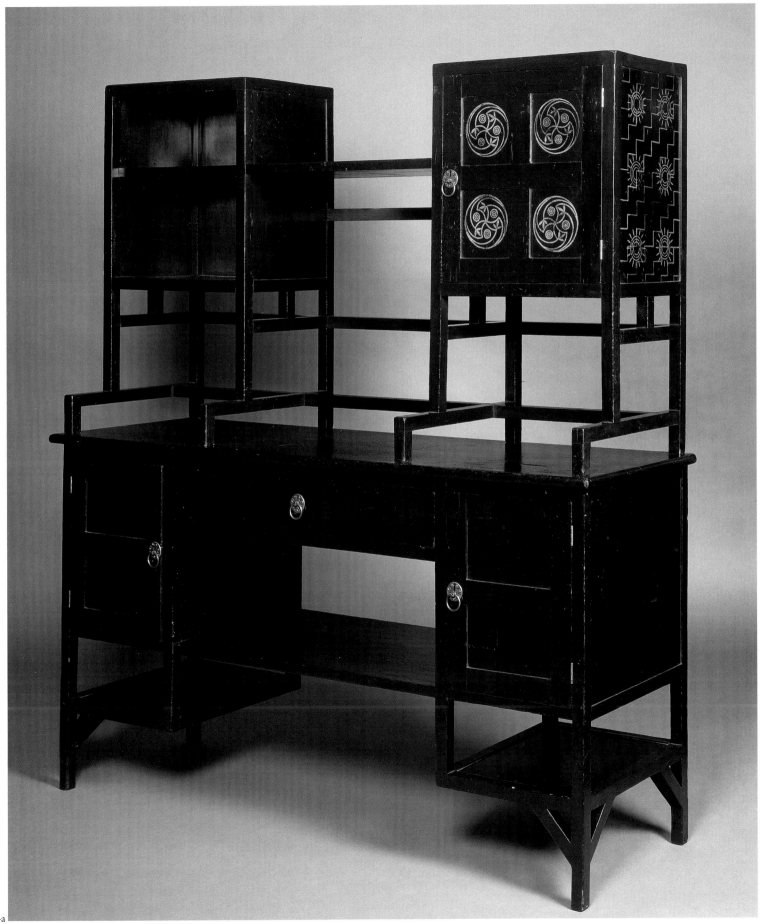

304-a

speculation that it is one the earliest versions of Godwin's most famous furniture design.[3] Godwin's own writings provide evidence for the early dating of this sideboard in that he admits using deal, a less expensive but softer wood, for his earliest pieces of furniture for reasons of economy. In an article in *Architect*, he describes his early furniture as being "made of deal, and to be ebonised . . . but I found deal to be a mistake, and had very soon to get rid of it, and have a new lot made of mahogany, also ebonised and decorated with a few gold lines in the panels."[4]

Some of this early furniture was made by the Art Furniture Company, London, a short-lived firm of the 1860s. It is possible that an entry from 1867 in Godwin's ledger books for the Art Furniture Company (V&A AAD 4/9-1980, fol. 81), which mentions a "deal Buffet ebon." being made for him, may well refer to this piece.

The painted decoration also makes a date of 1867 credible, for it uses the same Celtic interlacings, medieval discs, and stepped lines that Godwin used in his decorative work for Dromore Castle, Ireland. The circular emblems and the stepped lines can be found in the ceiling decoration as well as the decorative metalwork for the doors of Dromore Castle (Fig. 304-a.1).[5] Although most writers on this subject claim these emblems were derived from Japanese sources,[6] in fact they were derived from Godwin's study in 1868 of Irish artifacts and illuminated manuscripts in the Royal Irish Academy, Dublin.[7]

A similar sideboard with the same painted decoration was illustrated in *Art Journal* (1892) as belonging to Alice and Wilfrid Meynell (Fig. 304-a.2).[8] It was "cut up and dispersed and the pieces used for mending and supplementing cupboards and book-cases."[9] The Meynell sideboard had the top rail structure that is absent from the Munich one.

304-a.1 Design of ceilings for drawing room and music room, Dromore Castle, County Limerick, ca. 1870 (RIBA Ran 7/B/1 [82])

304-a.2 Sideboard owned by Alice and Wilfrid Meynell as illustrated in *Art Journal* (April 1892)

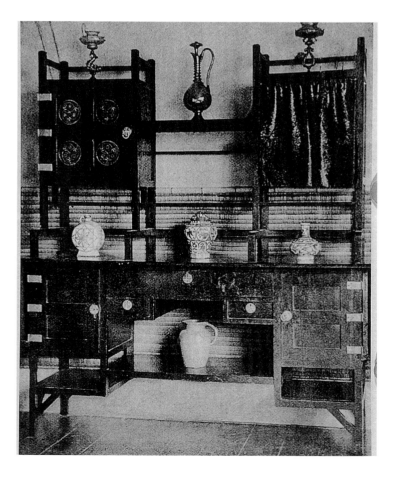

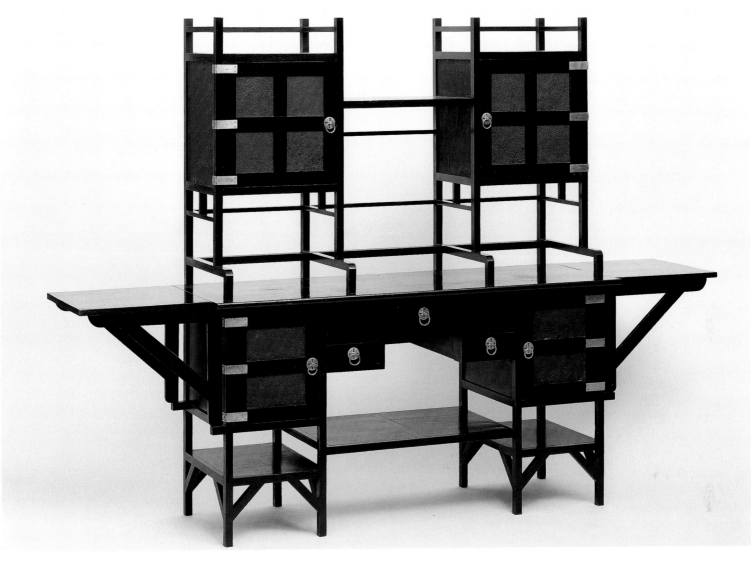

304-b

304-b. *Sideboard*
Ca. 1867–85
Made by William Watt
Ebonized mahogany; silver-plated handles
and fittings; embossed Japanese leather
paper inserts
With leaves down: 70⅛ × 63⅞ in. (178 ×
162 cm); with leaves extended: 100¾ × 34¼
in. (256 × 87 cm)
Frederick Jameson, father of Evelyn
Hartree; Mrs. E. M. Hartree, Plymouth,
Devon; Victoria and Albert Museum,
London (Circ. 38-1953)

Literature: Victoria and Albert Museum
1952a, pl. K2; Pevsner 1952b, p. 273; Floud
1957, p. 25, pl. 4(a); Aslin 1962b, p. 784, fig.
6; Symonds and Whineray 1962, pp. 76–77,
fig. 84; Handley-Read 1965, p. 224, fig. 848;
Aslin 1967, pp. 4–5, figs. 1–2; Jervis 1968,

pl. 60; Honour 1969, pp. 252–53; Hayward
1972, p. 8, fig. 38; Molesworth and
Kenworthy-Browne 1972, fig. 515; R.
Spencer 1972b, p. 36; Tomlin 1972, pp. 143,
151, fig. 207; Bridgeman and Drury 1975,
p. 42; Laver 1975, pl. 207; Tschudi-Madsen
1975, pp. 189, 192, fig. 99; Fleming and
Honour 1977, p. 351; Impey 1977, p. 187,
fig. 218; Farr 1978, pl. 64a; Garner 1980,
p. 10, ill.; Andrews 1985, p. 33; Aslin 1986,
pp. 27, 50–51, fig. 16; Bolger Burke et al.
1986, p. 148, ill. 5.3; Cooper 1987, pl. 324;
N. Wilkinson 1987, pp. 176–77; Grand
Palais 1988, fig. 232; Hinz 1989, fig. 761;
Payne 1989, p. 137, ill.; Paolini, Ponte, and
Selvafolta 1990, p. 354, ill.; Dry 1994, p. 21,
fig. 2; Snodin and Howard 1996, pp. 12–13,
fig. 234; Wilk 1996, pp. 168–69, fig. 3;
Watson 1997, p. 75, fig. 6; Soros 1999, pp.
238–39, fig. 8-25

This eight-legged sideboard, currently on
display in the Victoria and Albert Museum,
London, has embossed Japanese leather
paper panels applied to its doors. Elizabeth
Aslin dates this sideboard to 1876 because
that is when Liberty and Company began
importing such leather papers. Nancy
Wilkinson has discovered other possible
sources of Japanese leather papers in
London in the 1860s, however, thereby
throwing the later date into question.[10]
Godwin recommended the use of Japanese
leather papers for the decoration of
furniture.[11]

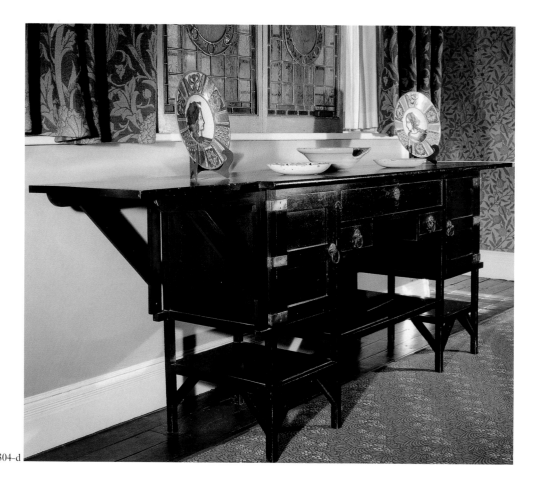

304-d

304-d. *Sideboard*
Ca. 1877–85
Made by William Watt
Ebonized mahogany; brass handles and
fittings
25¼ × 65⅜ × 20⅛ in. (64 × 166 × 51 cm)
Collection of Lady Mander, The National
Trust, Wightwick Manor (WIG/F/233)

This eight-legged sideboard is missing its
top cupboards. The sideboard was not part
of the original furnishing scheme of
Wightwick Manor, but a later acquisition
probably bought in the 1950s.[13]

304-c. *Sideboard* (photograph unavailable)
Ca. 1870–85
Made by William Watt
Ebonized mahogany; brass handles and
fittings; (replacement struts and
restorations)
73 × 101 in. (184 × 256 cm), with leaves
extended
Stamped: W. Watt, Upholsterer, 21 Grafton
Street, Gower Street, London WC
Sotheby's, Belgravia, 11 November 1976,
lot 351; Private collection (on extended loan
to The Museum of Modern Art, New York
until 1995)

Literature: Watson 1994, p. 8

This is the only version of this sideboard to
have the William Watt stamp. Unlike the
six-legged version depicted in Watt's *Art
Furniture*, this example has eight legs. In
the past, the number of legs was used as a
means to establish the date of manufacture,
for it was believed that later versions had
additional legs, presumably for greater
stability, and, therefore, those with fewer
legs were made earlier. Anne Watson points
out, however, that if this were true William

Watt would have illustrated an eight-legged
version in his 1877 catalogue, not the four-
legged one.[12]

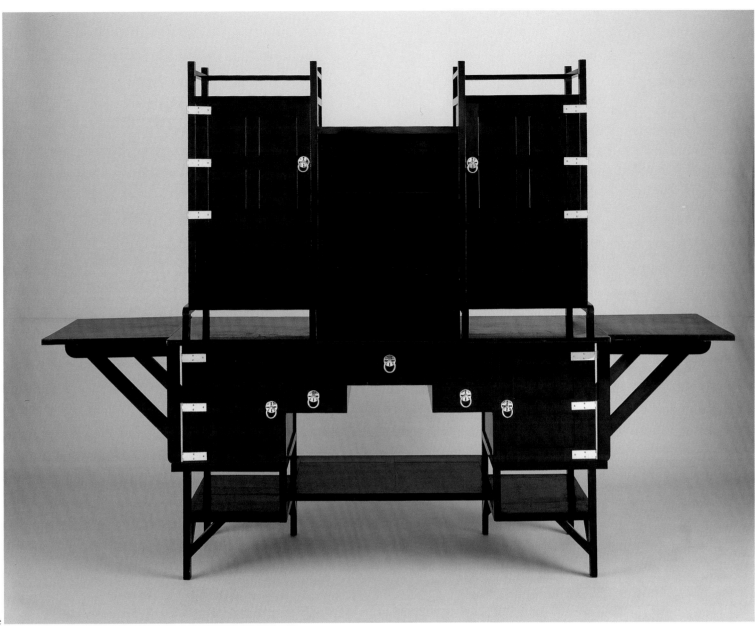

304-e

304-e. *Sideboard*
Ca. 1870–85
Made by William Watt
Ebonized mahogany; silver-plated handles
and fittings
With leaves down: 73 × 64¼ × 20 in. (185.4
× 163.2 × 50.9 cm); with leaves extended: 73
× 100⅝ × 20 in. (185.4 × 255.6 × 50.9 cm)
Sotheby's, Belgravia, 28 May 1975, lot 138,
ill.; Private collection; Mitchell Wolfson Jr.
Collection, The Wolfsonian–Florida
International University, Miami Beach
(TD1989,137.1)

Literature: Agius 1978, pl. 70; Andrews
1985, p. 47, fig. 4; Reeves 1994, p. 37, fig. 2;

Kaplan 1995, p. 117, fig. 4.07, p. 315, no. 4;
Watson 1997, p. 74, fig. 9

This is a six-legged version of the classic
sideboard, and is the only one that has
middle shelves, as well as shelves below the
upper cupboards, which are closed at the
back.

304-f. *Sideboard*

Ca. 1870–85
Made by William Watt
Ebonized mahogany; brass handles and
fittings; glass panels
With leaves extended: $72\frac{1}{2} \times 100\frac{1}{2} \times 19\frac{3}{4}$ in.
($184.2 \times 255.3 \times 50.2$ cm)
Private collection

Literature: Barnet and Wilkinson 1993, no.
11; Gere and Whiteway 1993, pp. 134–35,
pl. 164;Reeves 1994, p. 37, fig. 2; Watson
1997, p. 73; Soros 1999, no. 57, p. 247,
fig. 4-1

This eight-legged version is the only
Godwin sideboard known to have glass
doors in the upper cupboards.

304-g. *Sideboard*

Ca. 1885–88
Ebonized mahogany with painted
decoration; silver-plated handles and
fittings
Made by Heirloom, representatives of
William Watt
With end leaves down: $72\frac{1}{2} \times 64\frac{1}{2} \times 20\frac{1}{4}$
in. ($184 \times 164 \times 51.5$ cm); with leaves
extended: $72\frac{1}{2} \times 100\frac{3}{4} \times 20\frac{1}{4}$ in. ($184 \times
256 \times 51.5$ cm)
Metal label affixed to the back: Made by
Heirloom Wm Watt's Representatives,
London
Fine Art Society, London; National Gallery
of Victoria, Melbourne (D154/1977)

Literature: "Unique Comparison" 1994,
p. 12, ill.; Watson 1994, pp. 5–6, ill.;
Watson 1997, p. 72, fig. 7

This eight-legged, ebonized version of the
sideboard is the most elaborately decorated
of all the known designs. The upper
cupboards doors are stenciled with gold
chrysanthemums, and the lower ones are
adorned with geometric decoration. On the
basis of its Heirloom label, Anne Watson
has dated it between 1885 and 1888, the
period following William Watt's death when
his business was continued by
representatives (Fig. 304-g.1).[14]

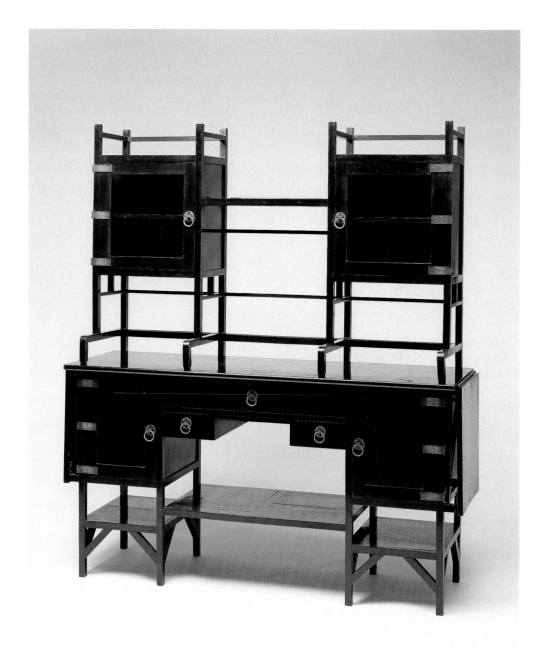

304-f

304-g.1 Metal Heirloom
label affixed to the back
of sideboard

304-h. *Sideboard*

Ca. 1870–85
Made by William Watt
Oak and pine; brass handles and fittings
$70\frac{7}{8} \times 100\frac{3}{4} \times 20\frac{1}{2}$ in. ($180 \times 256 \times 52$ cm)
Lindsey Stewart, Sydney, 1960s; Private
collection; Powerhouse Museum, Sydney,
MAAS, 1991 (91/81)

Literature: *Powerline*, no. 24 (Summer
1991–92), p. 8, ill.; "Unique Comparison"
1994, p. 12, ill.; Watson 1994, cover, p. 4,
ill.; Watson 1997, p. 70, fig. 5

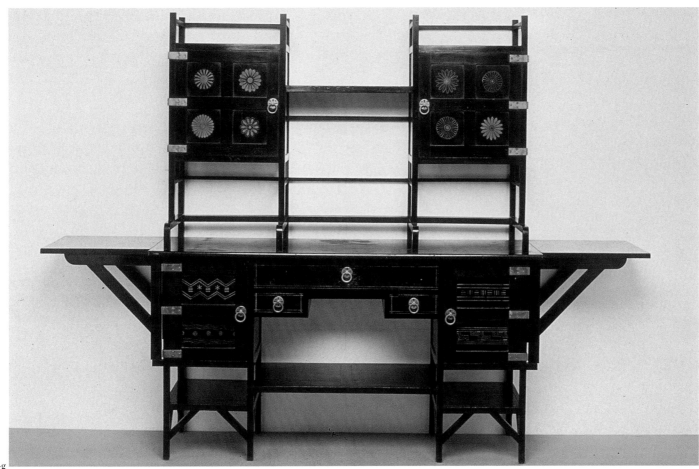

304-g

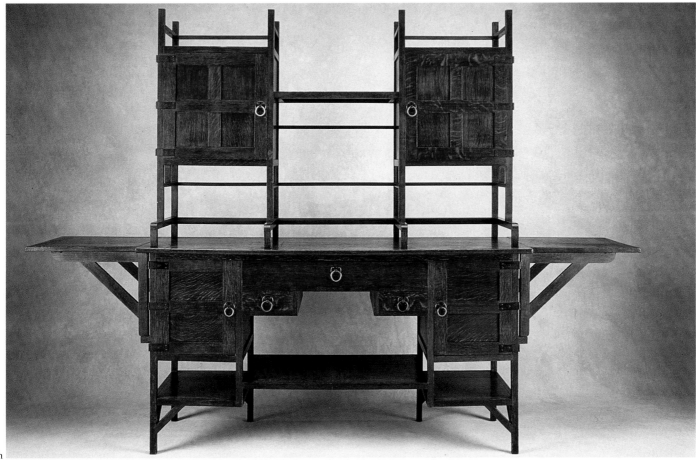

304-h

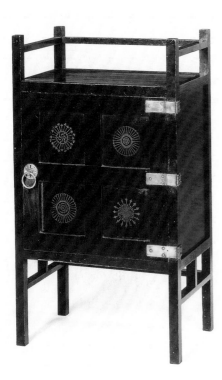

304-i

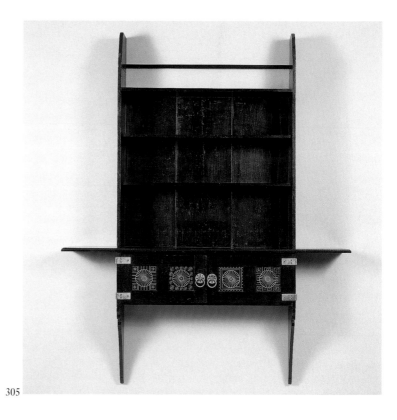

305

This is the only known version of the Godwin sideboard that is made of oak, and it possibly is the "light oak" sideboard once owned by the nineteenth-century dramatist and art critic Joseph Comyns Carr.[15] An annotated price list that accompanies Watt's catalogue (V&A AAD 4/508-1988) indicates that the oak model sold for £30, two pounds more than the popular ebonized wood version which sold for £28.

The oak version has a door instead of a curtain on the upper right cupboards and brass hardware (silver-plated hardware was used on the ebonized ones). Anne Watson has identified the brass locks as being made by the "Bose Bros." firm, which prior to 1871 did business under the name of Cluse and Bose. She therefore dates the sideboard between 1871, the year that Bose Bros. changed its name, and 1888, when the William Watt firm was taken over by Heirloom, representatives of the late William Watt.[16]

304-i. *Part of a Sideboard Cabinet*

Ca. 1885–88
Probably made by Heirloom, representatives of the late William Watt
Ebonized wood; brass handles and fittings
34 × 19½ × 13 in. (86.5 × 49.5 × 33 cm)
Sotheby's, London, 4 December 1985, lot 149; Private collection

This piece represents the upper right quadrant of one of Godwin's sideboards, made by Heirloom after the death of William Watt in 1885. It is probably part of a Godwin sideboard that was dismantled. Its quartered paneled door is decorated with the same gilt chrysanthemums found on a Godwin sideboard now in the National Gallery of Victoria, Melbourne (see 304-g).

305. *Hanging Bookcase*

Ca. 1867–85
Made by William Watt
Ebonized mahogany; gilded decoration; brass handles and fittings; (side shelves restored)
62⅜ × 32⅛ × 8⅞ in. (158.5 × 81.5 × 22.5 cm); with flaps extended: 62⅜ × 52 × 8⅞ in. (158.5 × 132.1 × 22.5 cm)
Christie's, London; Paul Reeves, London; Private collection

Literature: Soros 1999, no. 38, p. 240, fig. 8-27

This hanging bookcase, which may have been originally designed for Godwin's own use, was illustrated in William Watt's *Art Furniture* (1877; Plate 6) under the heading "Dining Room Furniture."[17] It is shown with two shelves for books, a third shelf curtained off, and a top shelf intended for the display of china. The side flaps also seem to have been meant for the display of objects. Strips of leather attached to the front of the shelves protected the tops of the books from dust accumulation.

Although Godwin had misgivings about designing bookcases, he particularly liked his hanging bookcase form, claiming it was "the best and cheapest thing I ever

designed."[18] The combination of shelves – for the display of books and porcelain – with cupboards at the bottom was common to late-eighteenth-century hanging shelves, which may have been the prototype. Some later Sheraton examples even display the canted sides utilized in this design.[19] Godwin's addition of side flaps and a horizontal top rail was an ingenious way to increase display capability. The gilt chrysanthemums stenciled in the panels are identical in all of these pieces, indicating that they were made in some quantity for standardized decoration. Every hanging bookcase is adorned with the same pierced round escutcheons and corner hinges associated with Godwin's sideboards (CR 304) and his cabinet designs for Dromore Castle (CR 314).

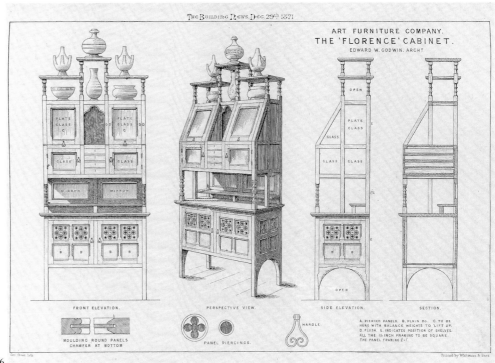

306

305-a. *Hanging Bookcase*
Ca. 1867–85
Made by William Watt
Ebonized mahogany; gilded decoration; brass handles and fittings
$63\frac{3}{8} \times 32\frac{1}{4} \times 8\frac{7}{8}$ in. (161 × 82 × 22.5 cm)
Fine Art Society, London; Private collection

Literature: Fine Art Society 1994, p. 36, fig. 47

305-b. *Hanging Bookcase*
Ca. 1867
Made by William Watt
Ebonized mahogany; gilded decoration; brass handles and fittings; (missing the original side flaps and lower support brackets)
$49\frac{5}{8} \times 32\frac{1}{8} \times 8\frac{7}{8}$ in. (126 × 81.6 × 22.4 cm)
Originally in the possession of the designer and Ellen Terry; by descent to Edith Craig; by bequest to the Bristol Museums and Art Gallery (N4510)

Literature: Bristol Museums and Art Gallery 1976, no. 8

306. *Design for the "Florence Cabinet"*

Literature: "Art Furniture Company, the 'Florence Cabinet,'" 29 December 1871, p. [495]

This cabinet was illustrated in 1871 in *Building News*[20] as made by the Art Furniture Company, although it must have been designed much earlier, perhaps the mid-1860s, since the company went out of business in 1868. It is listed in Godwin's cash book as a design for the Art Furniture Company for a fee of £2.0s.0d in 1867 (V&A AAD 4/9, fol. 39).

The cabinet, with its paneled construction, pierced decoration, and high, arched side openings, relates to Gothic-Revival pieces. The incorporation of mirror glass, turned spindles, and myriad compartments and shelves for bric-a-brac display places it in the center of the Art Furniture movement of the late 1860s and 1870s.

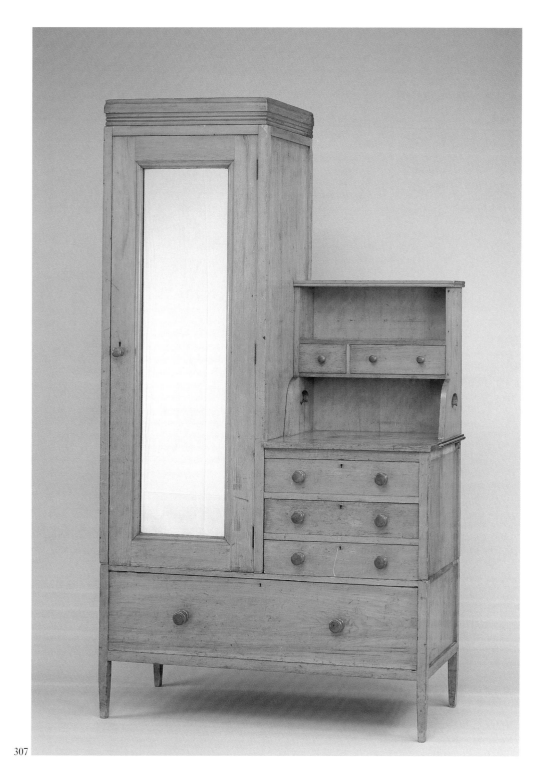

307

Gallery 1976, pl. 11; Aslin 1986, p. 71, fig. 45; N. Wilkinson 1987, p. 190; Soros 1999, no. 37, pp. 236, 243, fig. 8-19

Each component of this multipurpose piece of furniture – wardrobe, chest of drawers, and bookshelf – has William Watt's label affixed to its back panel, highlighting its modular capabilities (Fig. 307.1). It is likely that Godwin made this wardrobe for his own use when he was living with Ellen Terry at Harpenden in 1868 or the Red House in 1869. It was subsequently put into production by William Watt (sometime after 1868/69) and appears in reverse as an Anglo-Japanese wardrobe in William Watt's *Art Furniture* (1877; Plate 13), under "Bed Room Furniture." The catalogue price list indicates that the commercial examples, which sold for £26, were smaller (5 ft.) and made of ash.

In addition to differences in size and type of wood, the Bristol wardrobe also differs from the one illustrated in the Watt catalogue in that it has two drawers, side by side, in the upper section rather than one long one, and the legs are straight and taper rather squarely in contrast to those in the catalogue, which curve slightly inward. There is also evidence that the pull-out runner at one time supported a folding shelf.

Although Godwin referred to this piece as Anglo-Japanese, the only real evidence of borrowing from Japanese sources, aside from the asymmetry of its design, is the crescent-shaped cutout on the sides of the book-shelf section, a motif derived from Japanese doors and balustrades. Godwin illustrated similar cutouts in an article on Japanese wood construction.[21]

The wardrobe's plain finish, lack of ornamentation, casters, and elevated bottom drawer are in keeping with Godwin's sanitary ideas on minimal and flexible furnishings for the bedroom.[22]

307. *Wardrobe*

Ca. 1868
Made by William Watt
Pine with turned wooden knobs
82⅞ × 47⅜ × 18⅝ in. (210.4 × 120.4 × 47.2 cm)
Enameled William Watt labels affixed to back of hanging section, chest of drawers and bookshelf sections of wardrobe

On back of wardrobe door, in pencil in Ellen Terry's hand: "This my bedroom at Farm E. T"
Originally in the possession of the designer and Ellen Terry; by descent to Edith Craig; by bequest to Bristol Museums and Art Gallery (N4505)

Literature: Bristol Museums and Art

307.1 Enameled William Watt label

308. *Solicitor's Cabinet*

1869

Made by William Watt

Ebonized mahogany; silver-plated handles and fittings

96 × 105⅞ × 18⅛ in. (244 × 269 × 46 cm)

Charles T. Lane; by descent to his son W. A. P. Lane; Sotheby's, Belgravia, 6 December 1978, lot 168; Private collection on extended loan to the City of Portsmouth Museum and Art Gallery; Sotheby's, Belgravia, 21 October 1988, lot 115; Fine Art Society, London, 1991; Virginia Museum of Fine Art, The Sydney and Frances Lewis Endowment Fund (92.2 a/b)

Literature: C. Spencer 1973, pp. 36, 37, no. 20, ill.; C. Spencer 1979, p. 23, ill.; N. Wilkinson 1987, p. 177; Gere and Whiteway 1993, p. 136, pl. 165

According to one of Godwin's ledgers, this large combination desk and cupboard was made for the solicitor Charles Lane of Dangstein, Petersfield, Hampshire at 3 Lombard Court, Lombard Street, London and was used to hold what his son called "the usual bundles of papers customary with lawyers."[23] The ledger entry contains an order in 1869 for a "Cabinet for C. T. Lane Esq" from William Watt (V&A AAD 4/10-1980, fols. 15–16). The same ebonized cabinet is also listed under Charles Lane as "1869 Design for Ebonized Cabinet made by Watt £3-3-0" (V&A AAD 4/10-1980, fols. 43–44).

It was not unusual for Godwin to design furniture for the office: he recognized the need to custom design "book-cases, plain-cases, drawing-tables, and desks . . . to supply the demands for office furniture . . ."[24] for his own chambers, and in 1876 he also designed a suite of Anglo-Greek office furniture for the firm of Waugh and Sons. The roomy cupboards and fall-front doors provide ample storage capacity, and the drop-leaf shelves (which when unfolded rest on angled braces) on either side of the cabinet provide additional surface space.

This cabinet is closely related to a sideboard made two years earlier (CR 304) – it has the same ebonized finish, three-quarter gallery, hinged shelves, quartered paneled doors, square tapering legs with conforming brackets, corner brackets, and pierced escutcheons with round bail handles. The slanted front desk compartments are reminiscent of Georgian bookcases.

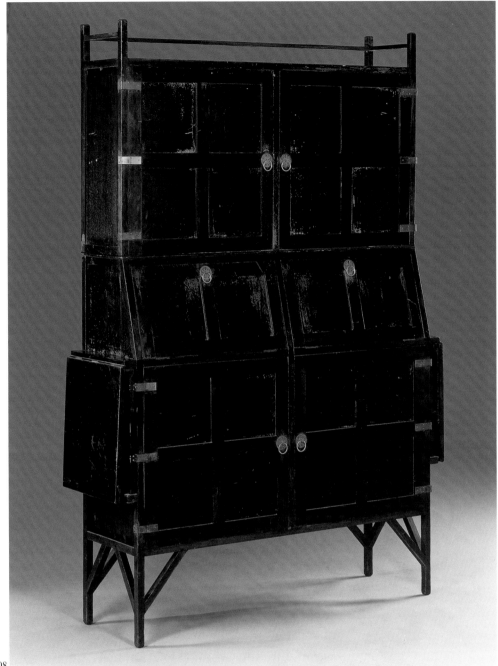

308

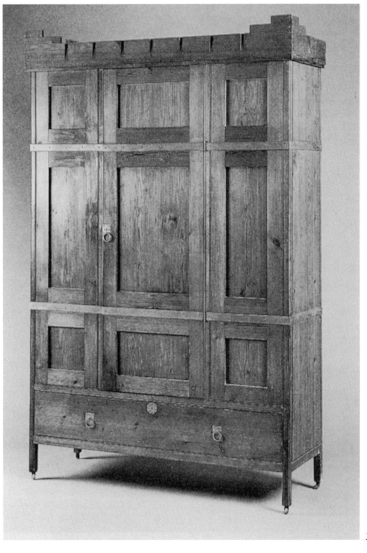

309.I

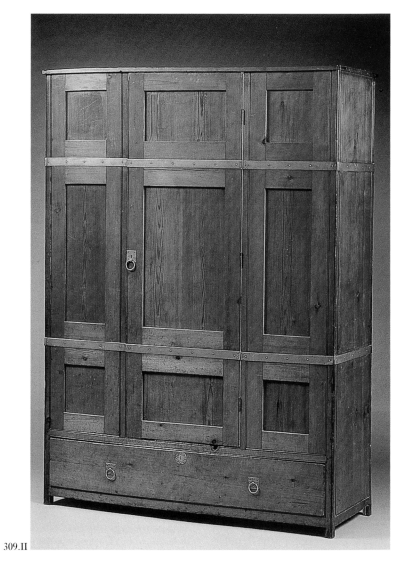

309.II

309.I. *Wardrobe*

1869

Probably made by Reuben Burkitt

Pine; brass handles and fittings; casters

$95\frac{1}{2} \times 60\frac{1}{8} \times 14$ in. ($241.5 \times 152.5 \times$
35.2 cm)

Dromore Castle, Ireland; De Courcy,
Dromore Castle, 19–21 October 1949,
lot 696 or 704; Christie's, London,
5 February 1992, lot 127; Private collection

Literature: Soros 1999, pp. 233–34, fig. 8-16

309.II. *Wardrobe*

1869

Probably made by Reuben Burkitt

Pine; brass handles and fittings; (castellated
cornice, legs and casters missing)

$81\frac{1}{4} \times 60\frac{1}{8} \times 21\frac{1}{8}$ in. ($206.4 \times 152.7 \times$
53.5 cm)

309.1 "Dromore
Castle Metalwork to
Furniture," (RIBA
Ran 7/B/1 [65])

Dromore Castle, Ireland; De Courcy, Dromore Castle, 19–21 October 1949, lot 696 or 704; Christie's, London, 2 May 1996, lot 23; Private collection

These Gothic-style wardrobes, probably designed for Dromore Castle, Ireland, have in the past been attributed to William Watt. They do not appear in the furniture specifications drawn up between the Earl of Limerick and William Watt (RIBA MC GoE/1/7/4), however, and it is therefore more likely they were made by Reuben Burkitt, the firm that executed the majority of the furniture for the Dromore commission. The studded brass bands, castellated cornice, and brass ring handles give this piece a Gothic quality typical of Godwin's designs for this Gothic-Revival castle. Its overall rectangular form, crenellated cornice, ring handles, and boards reinforced with riveted iron bands resemble sixteenth-century armoires such as those in the chapel at York Minster.[25]

A drawing in the RIBA shows brass fittings identical to those used by Godwin in his designs for bedroom furniture for Dromore (Fig. 309.1). Annotated in Godwin's hand as "Wardrobe Drawer" and identified as A and B are sketched the square lock plates edged with a circle of rivets, drop-ring handles affixed to a small square holder, and the central circular escutcheon. Although most of the furniture for the Dromore commission was made in wainscot oak – in keeping with the medieval decor of this castle – many of the pieces were made of pine, especially those intended for the bedrooms.

These examples were probably the two large wardrobes from Dromore's banquet hall that were sold at the Dromore sale in 1949 (lots 696, 704).

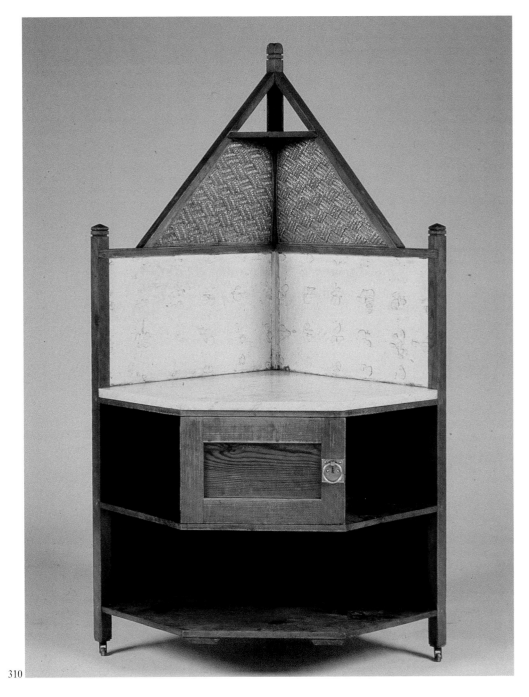

310

310. *Corner Washstand*
1869
Probably made by Reuben Burkitt
Pine; raffia panels; marble top; brass handles and fittings; brass casters
59½ × 24¾ in. (151 × 63 cm)
Dromore Castle, Ireland; De Courcy, Dromore Castle, 19–21 October 1949, lot 699; Christie's, London, 8 June 1993, p. 52, lot 104; Private collection

Literature: Haslam 1993, pp. 26–27; Soros 1999, pp. 232–33, fig. 8-14

This corner washstand was probably designed for the Banqueting Hall of Dromore Castle, Ireland, and, as with all the Dromore furniture, was attributed to the firm of William Watt. Close examination of the furniture specifications drawn up between the Earl of Limerick and William Watt (RIBA MC GoE/1/7/4), however, indicates that this washstand was not part of this order and therefore was probably executed by Reuben Burkitt, the firm that made most of the furniture for Dromore.

Angled washstands were popularized by such late-eighteenth-century designers as Thomas Sheraton in *Cabinet-Maker and*

Upholsterer's Drawing Book (1793) and Thomas Shearer in *Designs for Household Furniture* (1788).[26] Godwin may have formulated his designs based on one of these pattern books, which he is known to have consulted at the British Museum, or even from some late-Georgian specimens he might have found in the second-hand shops he frequented. Similarly angled cabinets can be found in his drawings for Northampton Town Hall (see CR 301; V&A PD E.624-1963), which date from about 1863.

The original back splash of this piece was apparently tiled, although the tiles are now missing. The triangular pediment is typical of Godwin's medieval forms of the 1860s, and the addition of raffia panels indicates his awareness of Japanese decorative arts. Malcolm Haslam points out that this material was on view in the Japanese section of the 1862 International Exhibition and was also used by Godwin in the decoration of the dado of his own house.[27] An entry in Godwin's ledger (V&A AAD 4/9-1980, fol. 39) indicates that in 1867 he had already designed what he called an "angle wash stand" for the Art Furniture Company for a fee of £6.12s.0d. Godwin apparently liked this form, for there is another drawing of an angled washstand, dated September 1872, in his sketchbook (Fig. 310.1).

The paneled door, ring handles, and the play of solid and open forms are all typical of Godwin's work for Dromore Castle, and it is likely that this is the "Three corner Washstand" from the Dromore banquet hall sold at auction in 1949 (lot 699).

310.1 Sketch of an angled washstand dated September 1872 (V&A PD E.229-1963, fol. 35)

311.I. *Bookcase*
1869
Probably made by Reuben Burkitt
Oiled wainscot oak; brass handles and fittings
$87\frac{7}{8} \times 48\frac{7}{8} \times 21\frac{1}{2}$ in. (223.3 × 124 × 54.7 cm)
Dromore Castle, Ireland; De Courcy, Dromore Castle, 19–21 October 1949; Christie's, London, 15 February 1989, lot 55; Private collection

311.II. *Bookcase*
1869
Probably made by Reuben Burkitt
Oiled wainscot oak; brass handles and fittings
$87\frac{3}{4} \times 49 \times 21\frac{5}{8}$ in. (223 × 124.5 × 55 cm)
Dromore Castle, Ireland; De Courcy, Dromore Castle, 19–21 October 1949; Haslam and Whiteway, London; Private collection

Literature: Aslin 1986, pp. 26, 43, fig. 10

311.1 Bookcases in a hallway at Dromore Castle, ca. 1940

311.III. *Bookcase*

1869

Probably made by Reuben Burkitt

Oiled wainscot oak; brass handles and fittings

$87\frac{7}{8} \times 48\frac{7}{8} \times 21\frac{1}{2}$ in. (223.3 × 124 × 54.7 cm)

Dromore Castle, Ireland; De Courcy, Dromore Castle, 19–21 October 1949; Christie's, London, 16 February 1994, lot 37; Fine Art Society, London

Literature: Fine Art Society 1994, p. 37

These bookcases, part of a series of six commissioned by the third Earl of Limerick for the large corridor of Dromore Castle, were among the most overtly medieval of Godwin's furniture designs. The vertical boards of the back panels, the arched supports, the quartered paneled doors (which correspond to the hallway doors at Dromore), and the pierced lattice decoration all point to medieval sources. A surviving photograph shows these bookcases in situ (Fig. 311.1). The whereabouts of the other three bookcases are unknown.

All of the Godwin-designed furniture in the 1949 Dromore auction catalogue is listed as Austrian oak. The "Corridor" section of the 1949 Dromore auction catalogue lists lots 382, 389, 420, 445, and 469 with the description "Austrian oak dresser."[28] Although in the past these bookcases have been credited to William Watt, the fact that the furniture specifications drawn up between the Earl of Limerick and William Watt for this commission (RIBA MC GoE/1/7/4) do not include bookcases makes this attribution unlikely.

Bookcases were among Godwin's most problematic forms. In an 1876 article he wrote, "My bookcases I never liked much; bookcases never are satisfactory."[29]

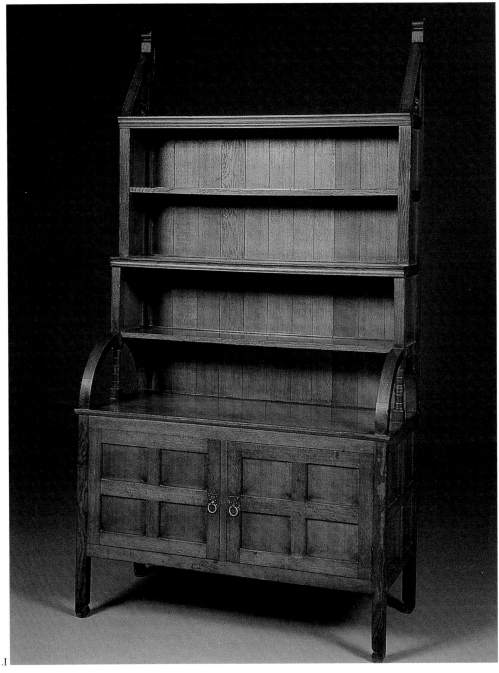

311.I

312.I. *Dressing Table*
1869
Probably made by Reuben Burkitt
Pine; glass mirror; pewter handles and
fittings; casters
$73\frac{1}{4} \times 58\frac{1}{4} \times 19$ in. ($186 \times 148 \times 48$ cm)
Dromore Castle, Ireland; De Courcy,
Dromore Castle, 19–21 October 1949, lot
895a or 896a; Haslam and Whiteway,
London; Private collection

312.II. *Dressing Table*
1869
Probably made by Reuben Burkitt
Pine; glass mirror; pewter handles and
fittings; casters
$73\frac{5}{8} \times 59 \times 18\frac{7}{8}$ in. ($187 \times 150 \times 48$ cm)
Dromore Castle, Ireland; De Courcy,
Dromore Castle, 19–21 October 1949, lot
895 or 896; Christie's, London, 6 February
1994, lot 38; H. Blairman and Sons,
London; Musée d'Orsay, Paris (OAO 1280)

Literature: Gere and Whiteway 1993,
p. 134, pl. 162, detail ill.; Bascou 1995,
p. 92; Musée d'Orsay 1996, pp. 106–7;
Soros 1999, p. 196, fig. 7-14

These dressing tables, probably designed
for the bedrooms at Dromore Castle, are
among the pieces from the Dromore
commission that have been wrongly
attributed to William Watt. There is no
mention of them in the specifications for
furniture drawn up between Watt and the
Earl of Limerick, so it is more likely they
were made by the firm of Reuben Burkitt.

With its full-length, pivoting central
mirror flanked by a pair of side tables with
overhead cupboards, the dressing table is an
original form. It probably derives from the
"horse or cheval dressing glasses" invented
at the end of the eighteenth century when
improvements in the casting of mirror glass
led to mirrors that could reflect one's whole
body;[30] they were often mounted on a four-
legged frame, or "horse," and attached by
swivel screws. These forms, which were
popular throughout the nineteenth century,
were illustrated by Thomas Sheraton in his
Drawing Book of 1793 and his *Cabinet
Dictionary* of 1803. Candle holders were
often affixed to the framework, as in these
examples.

The plain pine finish and lack of
superfluous ornament or carving, the

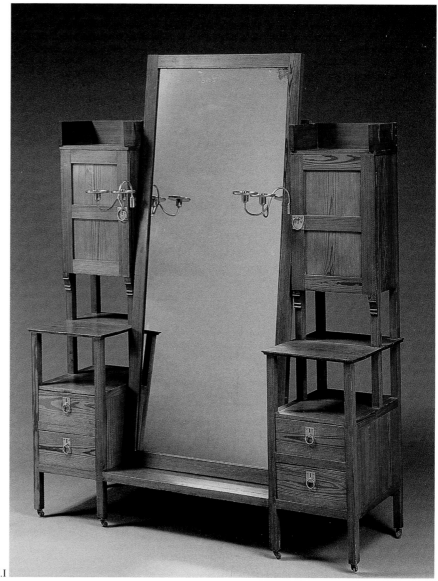

312.I

casters, and the bottom shelf elevated at
least nine inches above the ground are all
features in keeping with Godwin's
specifications for sanitary bedroom
furniture. The three-quarter crenellated
gallery at the top, the paneled doors, and
the ring handles with square back plates all
add medieval touches to what can be
considered an innovative furniture form.

Two dressing tables designed for
Dromore Castle were sold at the Dromore
auction in 1949, and probably correspond
to the ones presented here.[31] Drawings for
the metalwork illustrate the candle arms
and the square escutcheons with round loop
handles and are annotated "Dressing
Table" (see Fig 315.2; RIBA Ran 7/B/1
[65]).

313. *Buffet*

1869
Oak
Made by Reuben Burkitt
Dromore Castle, Ireland; De Courcy,
Dromore Castle, 19–21 October 1949, lot
260; whereabouts unknown

Literature: Aslin 1986, pp. 26, 38, fig. 4;
N. Wilkinson 1987, pp. 187–88; Soros 1999,
pp. 193–94, 234–35, fig. 8-17

This large buffet made for the dining room
of Dromore Castle was last recorded as
being sold with the contents of Dromore
in 1949.[32] It is known only through a
number of detailed drawings in the
RIBA (Ran 7/B/1 [73]) and in a scrap-
book that belonged to the Earl of Limerick
(Fig. 313.1). A related letter in the Victoria
and Albert Museum firmly identifies
Reuben Burkitt as the maker as it states:
"The little doors containing pierced work
in Buffet will be sent to Wolverhampton &
made right."[33]

The buffet has the rectilinear outline of
Godwin's Anglo-Japanese furniture. There
are so many Gothic elements, however, that
it seems more medieval in inspiration:
wainscot oak; paneled cupboards; stiles that
extend into block legs; the central portion's
gabled canopy, with carved roundels and
the Limerick family's coat of arms; the tall,
floriated finials; and the circular escutcheon
with the type of round pull handles
frequently used in medieval furniture.
Furthermore, a peacock sits on the pinnacle
of the central gable, a symbol of the
resurrection from medieval sources.

The central portion of the buffet has a tall
archway so the butler could exit through a
concealed door in the back of the piece.

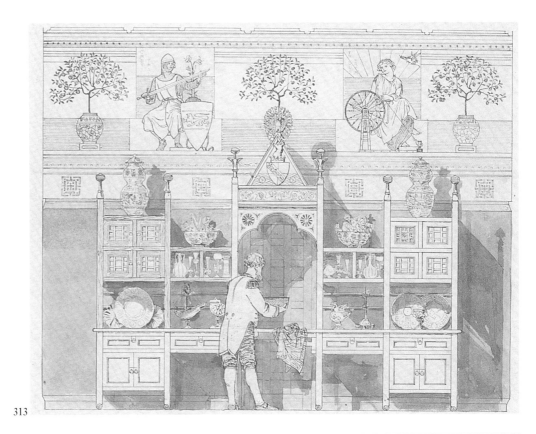

313

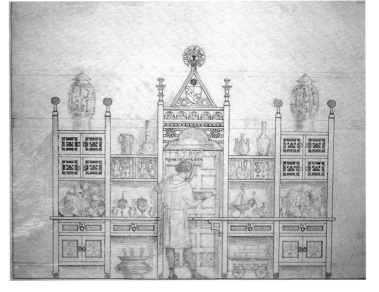

313.1 Drawing for a
buffet for Dromore
dining room, from a
scrapbook

314. *Nursery Buffet*

1869
Probably made by Reuben Burkitt
Oak; brass handles and fittings
$71\frac{3}{8} \times 50\frac{7}{8} \times 19\frac{1}{2}$ in. (181.2 × 129.2 × 49.5 cm)
Dromore Castle, Ireland; De Courcy, Dromore Castle, 19–21 October 1949; Christie's, London, 8 June 1993, lot 106; Private collection

Literature: N. Wilkinson 1987, p. 192; Haslam 1993, pp. 26–27, ill.

This buffet was part of the furniture Godwin designed for Dromore Castle in 1869. It is identical in form to a design that is annotated "Nursery Buffet" (Fig. 314.1). Its traditional attribution to William Watt has been thrown into doubt because it does not appear in the furniture specifications Watt prepared for the Earl of Limerick. More likely it was made by Reuben Burkitt, who made most of the other pieces for this commission.

The buffet shares many features with the Dromore escritoire (CR 315), including turned columns, a tripartite horizontal design, and a square-sectioned top balustrade shelf, suggesting the same maker. This piece demonstrates a sophisticated interplay of two major elements in Godwin's furniture designs: solid-and-void, and a broken outline. Malcolm Haslam has explained how Godwin achieved this desired effect: "the outline of this piece is subtly interrupted by the rail on top and the framework in front of the upper cupboards. By throwing these cupboards forwards and extending the framework downwards to the top of the lower section, a void is created which plays almost as significant a role in the design as the two solid sections."[34]

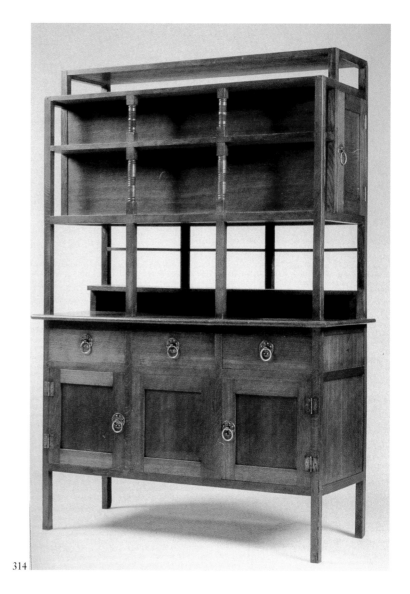

314

314.1 "Nursery Drawing" for Dromore Castle (RIBA Ran 7/B/1 [52])

315. *Escritoire*

1869

Probably made by Reuben Burkitt

Oak; brass handles and fittings; brass casters; (the left candleholder is missing)

$56\frac{3}{4} \times 48 \times 21$ in. ($144 \times 122 \times 53.2$ cm)

Dromore Castle, Ireland; Christie's, London, 8 June 1983, lot 105; Private collection

Literature: Gere and Whiteway 1993, p. 133, pl. 160; Haslam 1993, p. 27, ill.; Soros 1999, p. 233

This writing desk is part of the group of furnishings that Godwin designed for Dromore Castle. It is based on a detailed drawing (Fig. 315.1), indicating the details of construction, that has been strictly followed by the cabinet maker. A drawing also exists that details the handles for the small drawers and doors, and the larger handles carry an annotation: "The handles for Escritoire . . . to be circular like no. 4 specimen plate & ring to be $1\frac{3}{4}$ in diameter" (Fig. 315.2).

With its monumental proportions, wainscot oak, ring pull handles, paneled doors, and exposed construction, this desk has a medieval flavor but in fact has no medieval precedent, although slant-front writing boxes were known. The prototype was probably an eighteenth-century late-Georgian escritoire, for Godwin mentions "a little escritoire . . . of admirable colour, design and workmanship" that was in his dining room in London.[35]

The oak of this desk was oiled rather than varnished, in keeping with Charles Eastlake's recommendation in his 1868

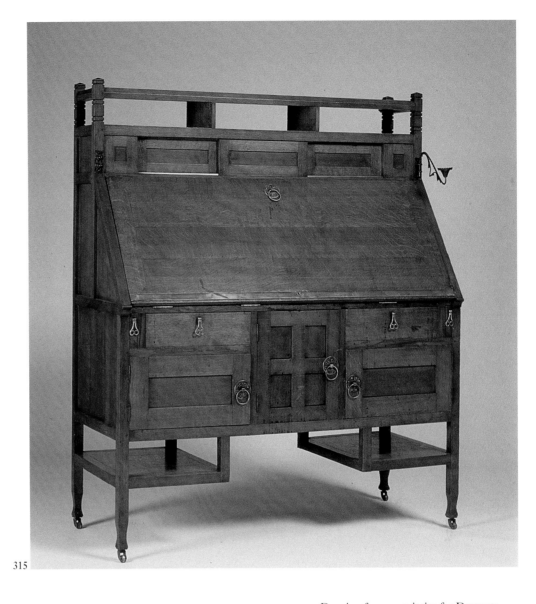

315

315.1 Drawing for an escritoire for Dromore Castle (RIBA Ran 7/B/1 [50])

315.2 "Dromore Castle Metalwork to Furniture" (RIBA Ran 7/B/1 (65])

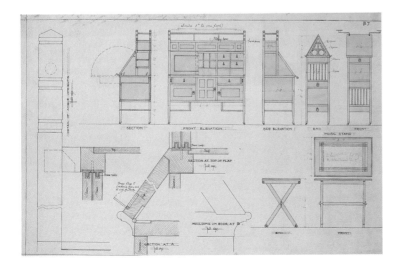

Hints on Household Taste.[36] The use of casters, absence of carved ornamentation, and elevation of the bottom shelf well above the ground to allow the floor underneath to be cleaned were all in keeping with Godwin's concern for hygiene. Very likely the slanted front flap also stemmed from this concern, for when closed it protected the papers and writing implements on the desk from dust and other contaminants. The sliding doors at the top of the upper cupboard space not only reflect Godwin's interest in the woodwork of Asia, but are also a clever way to protect the contents of these compartments while at the same time not interfering with the opening and closing of the drop-down writing flap.[37]

Godwin favored this desk form. The same year he designed a slant-front desk/cabinet for the solicitor Charles T. Lane that was made by William Watt (see CR 308). In addition, Watt's *Art Furniture* illustrates another of Godwin's escritoires (1877; Plate 8; CR 345), although that example is closer to the Davenport desk, a form believed to derive from a desk made for a Captain Davenport by Gillow and Company in the early nineteenth century.

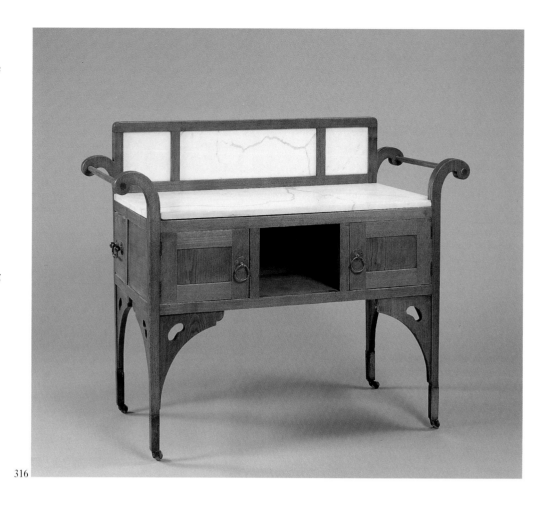

316

316. *Washstand*

Ca. 1869
Probably made by William Watt
Pine; brass handles and fittings; brass casters
$14\frac{1}{4} \times 17\frac{3}{4} \times 8\frac{5}{8}$ in. ($36 \times 45 \times 22$ cm)
Haslam and Whiteway, London; Collection of the author

A washstand similar to this one is illustrated in William Watt's *Art Furniture* (1877; Plate 13) as an "Anglo-Japanese Wash Stand" designed for the bedroom. Ash versions, which included a mirrored and shelved upper structure as well as a lower shelf, were also available and sold for the price of £15.15s.0d. This example has side drawers with bail handles and round escutcheons of the type Godwin used on his Bristol washstand (CR 317) and Smallhythe wardrobe (CR 318). The cutout motifs on the leg brackets and the brass "socks" on the lower part of the legs are both derived from Japanese architectural forms.

Most firms supplied a separate towel rail for their bedroom suites until the mid-1880s. The incorporation of scrolling arms to accommodate towels was thus unusual for washstands of the nineteenth century. Godwin may have been one of the first designers to utilize this feature, whose functionality was so popular that it prompted the designer H. Pringuer to write in 1891 that "the towel rail as a separate institution has almost become a thing of the past . . . its incorporation with the washstand is certainly a happy idea."[38]

The plain finish, paneled cupboard doors, straight rectangular legs, and brass hardware are reminiscent of the pine pieces Godwin designed for the bedrooms at Dromore Castle (CR 309, 312), and it is quite possible that this specimen was one of the numerous Dromore washstands sold at auction in 1949.

317. *Washstand*

Ca. 1869
Made by William Watt
Pine; white marble top; mirror glass; blue-and-white tiles; brass handles and fittings; white ceramic casters; (the right candleholder is missing)
$63\frac{7}{8} \times 36 \times 19\frac{7}{8}$ in. (162.4 × 91.5 × 50.5 cm)
Enameled William Watt label affixed to the back panel
Originally in the possession of the designer and Ellen Terry; by descent to Edith Craig; by bequest to the Bristol Museums and Art Gallery (N4506)

Literature: Bristol Museums and Art Gallery 1976, no. 12; Soros 1999, pp. 239–40, 243, fig. 8–30

This washstand belonged to the designer and was probably used ensuite with the wardrobe now in Smallhythe Place, which has identical hardware (CR 318). The brass candle bracket attached to the left side of the mirror frame (the one on the right side is missing) matches the one Godwin used for dressing tables for Dromore Castle (CR 312.I–II), which we know was made in 1869, and therefore it is likely that this washstand was made about the same time. A sketch of a similar washstand (Fig. 317.1), annotated "Bachelors Furniture and Watts Sep.," is dated about 1879, indicating that Godwin designed similar washstands for William Watt throughout the 1870s. This is confirmed by the publication of an oak version, also manufactured by Watt, in *Building News* the same year.[39] The illustration of the oak version, entitled a "Bachelor's Wash-stand and Dressing Table," indicates several deviations from the present example – the introduction of a three-sided, removable shelf in front of the mirror glass; a lack of brass candle brackets; tiles of white instead of blue and white; rectangular tapering legs rather than turned ones; and an additional pair of legs supporting the cupboard. The drawing also indicates that the cupboard held a chamber pot, the marble top a basin and ewer, and the lower shelf a basin and sponge; a towel rail was located at the left side of the piece (see CR Fig. 241.2).

The six blue-and-white tiles with stylized floral decoration might have been supplied by Minton and Hollins, who made floor and decorative tiles for many of Godwin's commissions at this time.

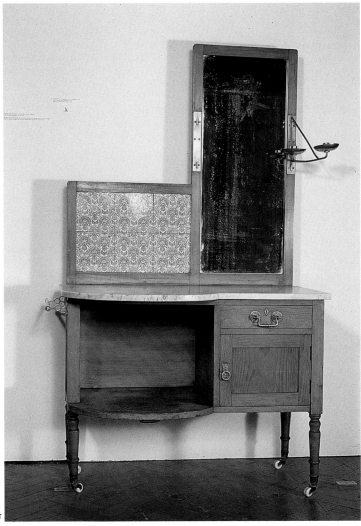

317

A drawing entitled "Anglo-Japanese Washstand Dressing Table" which depicts an almost identical washstand can be found in Gillow's Estimate Sketch Book for April 1880 (City of Westminster Archives Centre, London, 10809). Although Godwin is not identified as its designer, his influence is unmistakable.

317.1 Sketch for a washstand (V&A PD E.233-1963, fol. 90)

318. *Wardrobe*

Ca. 1869
Probably made by William Watt
Pine; brass handles and fittings; mirror
glass
73 × 41⅜ × 19¾ in. (185.6 × 105 × 50 cm)
Originally in the possession of the designer
and Ellen Terry; by descent to Edith Craig;
by bequest to The National Trust, Ellen
Terry Memorial Museum, Smallhythe
Place, Kent (SMA/F/105)

This wardrobe, with its long bottom drawer
and hanging compartment paneled with
mirror glass, was designed by E. W. Godwin
for his own use, probably for one of the
bedrooms at the Red House. It has suffered
losses to its legs but presumably had the
thin tapering legs on casters typical of
Godwin-designed wardrobes. There is a
drawing in Godwin's sketchbooks from the
mid-1870s (V&A PD E.233-1963, fol. 13)
that shows a wardrobe form supported by
thin rectangular legs (Fig. 318.1). The
sketch also reveals the same configuration
as the Smallhythe wardrobe, with a long
bottom drawer, a series of four short
drawers, a closed upper compartment, and
a side compartment for hanging space.
The sketch is annotated "one of a pair of
wardrobes," indicating that perhaps all of
these were available in reversed pairs.

The thick reeding on the door and
drawer panels of the Smallhythe wardrobe
is a decorative feature that Godwin used in
the early 1870s on his "Cottage" series for
both Collinson and Lock and William Watt
(CR 333). The brass hardware, a combin-
ation of ring pulls and bail handles with
back plates (detailed with rivets) and
diamond-shaped escutcheons, is identical to
the hardware Godwin used on a washstand
(Bristol Museums and Art Gallery, N4506)
that bears William Watt's label, making an
attribution to William Watt plausible (see
CR 317).

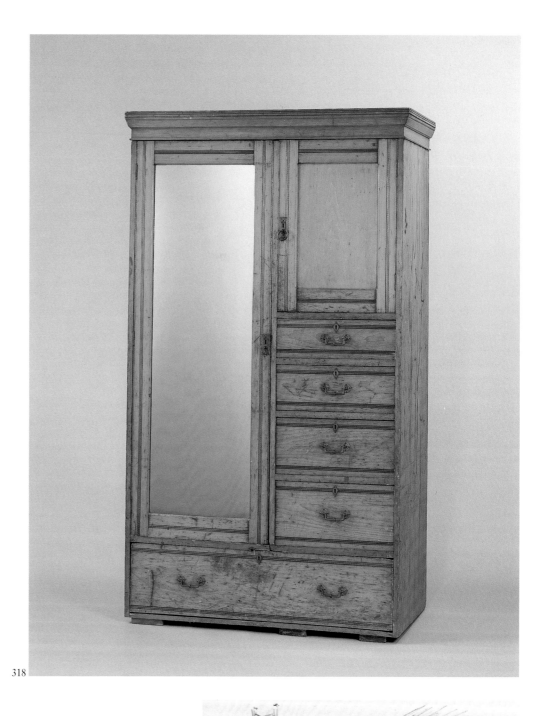

318

318.1 Sketches for wardrobes
(V&A PD E.233-1963, fol. 13)

319. *Hanging Bookcase*

Ca. 1869
Made by William Watt
Walnut with brass handles
$55\frac{5}{8} \times 28\frac{7}{8} \times 9$ in. (141.2 × 73.4 × 22.8 cm)
Originally in the possession of the designer
and Ellen Terry; by descent to Edith Craig;
by bequest to the Bristol Museums and
Art Gallery (N4501)

Literature: Bristol Museums and Art
Gallery 1976, no. 9, ill.; N. Wilkinson 1987,
p. 190; Reid 1992, p. 39, fig. 9

A drawing for a hanging bookcase similar to
this one appears in Godwin's sketchbooks
(Fig. 319.1); it is annotated "£8.8.0 and
Beatrice G sent Watt June." It is obviously
a later version and has a series of panels
painted by Beatrice Godwin. The present
example has had its lower brackets reduced
in order for it to stand on the floor.

The upper section of the bookcase has
the same rear cresting and broken pediment
form that Godwin would later use in his
"Butterfly Cabinet" (CR 369) and other
pieces in the Queen Anne style.

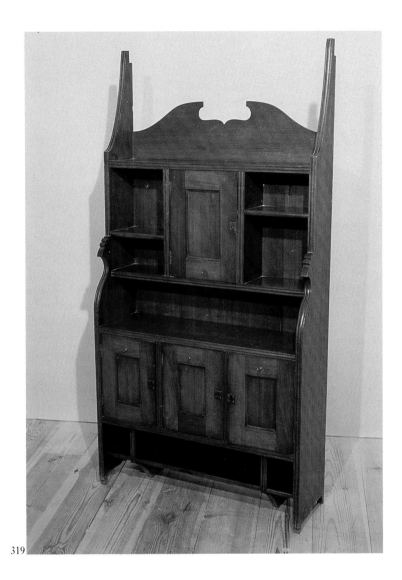

319

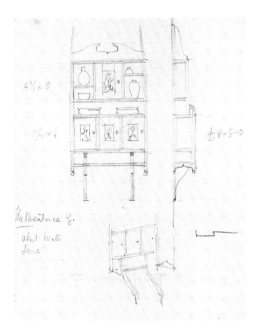

319.1 Sketch for a hanging bookcase (V&A PD
E.233-1963, fol. 113)

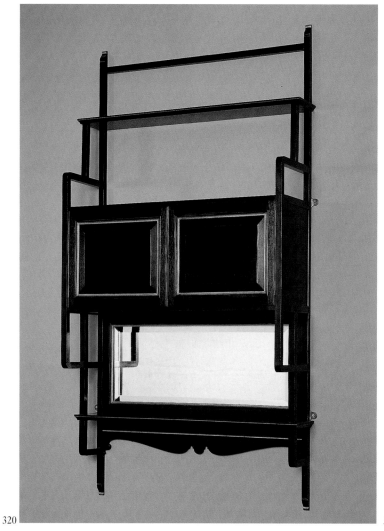

320

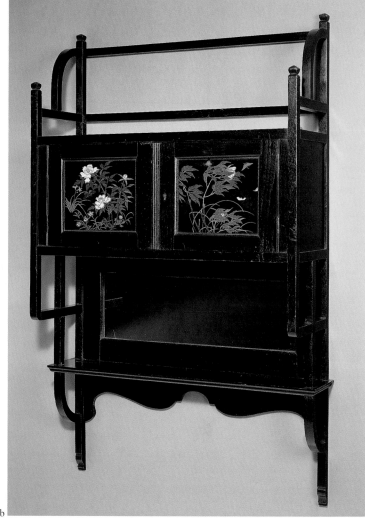

320-b

320. *Hanging Cabinet*
Ca. 1870–85
Made by William Watt
Ebonized wood; beveled mirror glass;
beveled glass
52¼ × 27 × 9 in. (132.5 × 68.5 × 23 cm)
Paul Reeves, London; Private collection

Godwin's hanging cabinet was illustrated
in William Watt's *Art Furniture* under
"Student Furniture" (1877; Plate 4) and
as one of a pair in the decoration of an
"Anglo-Japanese Drawing Room" (Plate
14), with the addition of decorated doors
as in CR 320-b below. The corresponding
price list indicates they sold for £5.5s.0d.

The different shelves of this multi-
functional cabinet allowed for the display of
a great variety of objects. (It is interesting
to note that in the student version in the
Watt catalogue only a few vases are placed
on the shelves, whereas the Anglo-Japanese
version is almost crowded with vases and
assorted objects.) The rounded brackets,
galleried superstructure, and bottom apron
flourish are all typical of Godwin's Anglo-
Japanese work.

Godwin's fondness for mirrors in his
interior design work is in evidence in Watt's
Plate 14: the cabinets have been hung on
either side of a mantelpiece that has a
rectangular glass overmantel which is
surmounted by circular convex mirror and
flanked by a pair of sconces with mirror
insets.

This cabinet was also illustrated by
Robert Edis in 1881.[40]

320-a. *Hanging Cabinet*
Ca. 1870–85
Made by William Watt
Ebonized wood; beveled mirror glass;
beveled glass
52 × 27⅜ × 9¼ in. (132 × 69.5 × 23.5 cm)
Haslam and Whiteway, London; Fine Art
Society, London; Musée d'Orsay, Paris
(OAO 578)

Literature: Fine Art Society 1981, no. 25,
ill.; Musée d'Orsay 1988, pp. 114–15

320-b. *Hanging Cabinet*
Ca. 1870–85
Probably made by William Watt
Ebonized wood; beveled mirror glass;
beveled glass; cloisonné panels
41¾ × 25¾ × 8 in. (106.1 × 65.4 × 21.6 cm)
Paul Reeves, London

This example has the addition of cloisonné
paneled doors.

321. *Bookcase* (lower half)
1871
Made by William Watt
Stained oak with painted decoration; brass
handles and fittings
35¼ × 19 × 39 in. (89.5 × 48.3 × 99 cm)
Dr. George Bird; by descent to Mrs. Luke
Ionides (née Elfrida Bird); by descent to
Alexander Ionides; by descent to Mrs.
Lewis Clarke; by descent to Mr. Mathew
Argenti

Literature: Harbron 1949, ill. opp. p. 46

This is the lower half of a bookcase that was
cut down some time after it was last
photographed by Dudley Harbron in 1949
for the publication of his biography of
Godwin (Fig. 321.1).[41] Harbron attributed
ownership of the bookcase to Dr. George
Bird, who was a friend of Ellen Terry.[42]
This probably relates to an entry in
Godwin's ledgerbooks for 27 September
1871 (V&A AAD Ledger 4/10, fol. 47
Sundries) which lists "Bird Dr Bookcase
des . . . curtain for Do. 4-4-0." We know
that this bookcase was one of a pair that
was in Mrs. Lewis Clarke's possession in
1952, three years after it was reproduced
in Harbron's biography of Godwin, and
that she had inherited the pair from her
grandfather Alexander Ionides, son of the
famous collector and art patron Luke
Ionides.[43] A third bookcase is known to
have been in the possession of Mrs. Alecco
Ionides about the same time.[44] Recent
correspondence with descendants of the
Ionides family reveals that both the third
version and the partner to the present
example have both been destroyed.

Although these bookcases are basically of
the same form as the Dromore versions
(CR 311.I–III) Godwin endowed them with
more of a late-eighteenth-century appearance
in various ways: he added conforming angle
brackets to the heightened leg forms, stained
the finish to a traditional dark brown color,
and abandoned the overtly medieval quarter-
paneled doors and six-petaled emblems.
The sliding doors at the bottom depict
scenes from Greek mythology illustrating
Jason, Medea, Actaeon, Hercules, and
Aesculapius, whose names are written in
Greek on the left panel. This interest in
Greek themes was shared by two of Godwin's
friends, the painters Albert Moore and
James McNeill Whistler. These panels
would have placed such bookcases at the

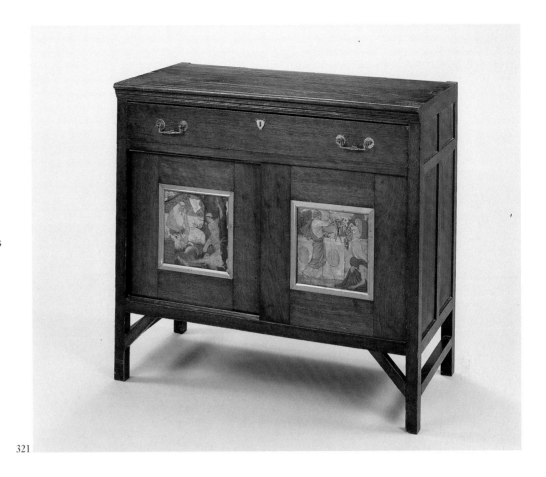

321

center of fashion for the 1870s, when
painted decoration was typical of art
furniture. The panels were originally
thought to have been painted by Burne-
Jones,[45] although Harbron maintains
they were by Charles Glidden, an
artist who died at the age of twenty.[46]

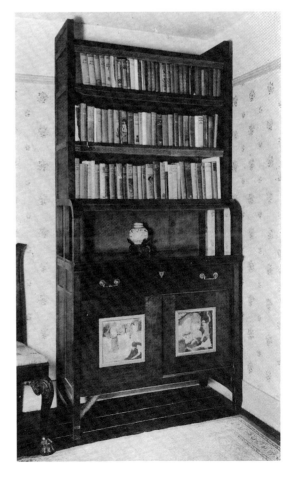

321.1 The bookcase before it was cut
down, photographed by Harbron in 1949

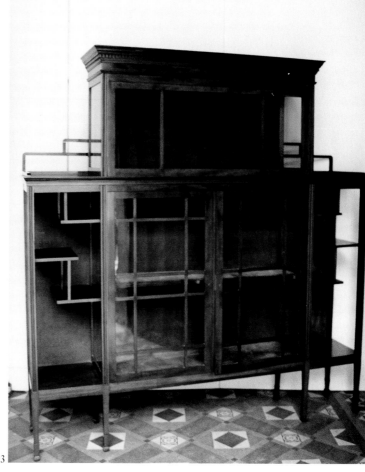

322

323

322. *Hanging Cabinet*
Ca. 1872–75, attributed to E. W. Godwin
Probably made by Collinson and Lock
Ebonized wood; brass handles and fittings;
glass mirror insets
$47\frac{7}{16} \times 25\frac{3}{8} \times 7\frac{5}{16}$ in. (120.5 × 64.5 ×
18.5 cm)
Private collection

No known sketch for this hanging cabinet
exists, but in general outline it resembles
the ebonized versions Godwin designed for
William Watt and illustrated in Watt's *Art
Furniture* (Plate 4; see CR 320). Though
less elaborate, the general proportions and
main elements of the design are so similar
that a Godwin attribution is plausible. The
latticework on the side, top, and bottom
panels and the riveted brass corner fittings
give this piece an unmistakable Anglo-
Japanese appearance and relate to many
of Godwin's pieces of the early 1870s,
particularly those designed for Collinson
and Lock. This is the most decorative
hanging cabinet attributed to Godwin.

323. *Display Cabinet*
Ca. 1872–75, attributed to E. W. Godwin
Made by Collinson and Lock
Mahogany
$62\frac{1}{2} \times 60 \times 12\frac{5}{8}$ in. (159 × 152.5 × 32 cm)
Stamped on top of door: Collinson and
Lock
Paul Reeves, London; Private collection

This display cabinet, with its combination
of open and closed compartments, dentiled
straight cornice, reeded outline, curved
lattice support brackets, and stepped
shelves, resembles a hanging cabinet
Godwin designed for William Watt which
was illustrated in *Building News* (CR 384).[47]
The cabinet's rectangular tapering legs,
ultra-thin proportions, and elevated lower
section high above the floor all point to the
work of Godwin. The use of curved lattice
supports and stepped shelves reveal Asian
influence. The curved supports or brackets
derived from Chinese hardwood prototypes,
particularly Ming tables, appear in many of
Godwin's designs for furniture.[48] The idea

of the stepped shelves comes from Japanese
tansu, which Godwin studied and collected.
The dentiled cornice and the fluted grooves
on the outline of the cabinet, however,
point to eighteenth-century Georgian
furniture design. These two design
traditions have been successfully combined
in this stylish cabinet form.

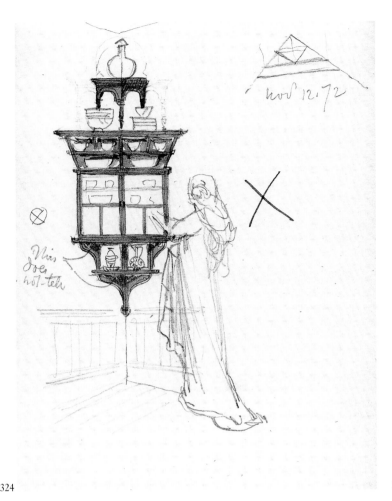

324

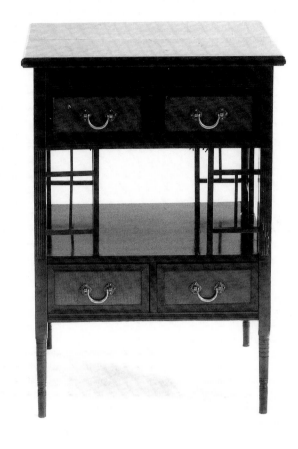

325

324. *Design for a Corner Hanging Cabinet*

This Jacobean-style cabinet is known from a drawing in one of Godwin's sketchbooks annotated "× Nov 12. 72," indicating that it was a commission completed in 1872 for an unidentified client (V&A PD E.229-1963, fol. 75).

The design shows the cabinet is composed of a cupboard which is mounted on a corner bracket with a double-shelved superstructure surmounted by a cornice of two scalloped arcades with turned baluster supports. The arcaded cornice, reminiscent of those on seventeenth-century joined oak cabinets and chair top rails in the Derbyshire and Yorkshire regions, give this piece a distinctive Jacobean look.[49] Typically, it had multiple shelves for the display of ceramic ware.

325. *Side Cabinet*

Ca. 1872–75, attributed to E. W. Godwin
Probably made by Collinson and Lock
Ebonized wood; walnut drawer fronts; brass handles
$20^{7}/_{8}$ wide (53 cm)
Phillips, Edinburgh, 26 May 1992, lot 392; Private collection

This square, ebonized cabinet is in the style of Godwin's Anglo-Japanese work. Its tapered legs, latticed middle supports, and U-shaped brass handles all conform to Godwin's designs of the mid-1870s. The location of the second drawer two-thirds down in order to add an open compartment for display purposes is also typical, for Godwin often varied the drawer arrangements of his table and side cabinet forms to maximize storage and display capability (see CR 210, 221). Moreover, the high elevation of this drawer is in keeping with Godwin's desire to keep the floor accessible for cleaning.

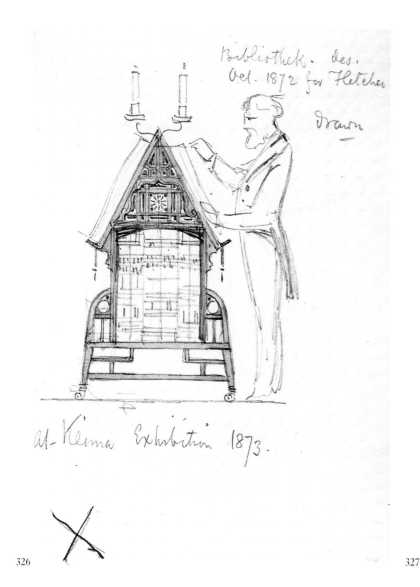

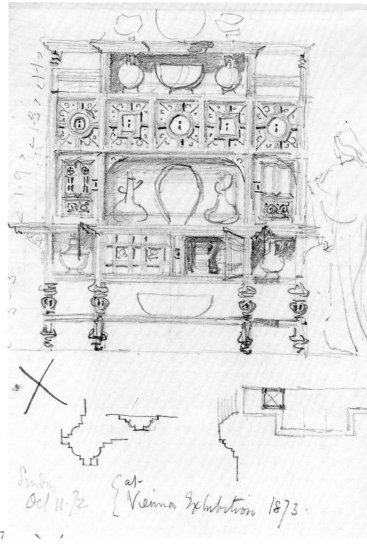

326. *Design for a Bookstand or Bibliothek*

Literature: Aslin 1986, pp. 28, 57, fig. 25; Soros 1999, p. 255

This sketch shows the double-sided bookstand Godwin designed for Collinson and Lock which was exhibited at the Universal Exhibition in Vienna in 1873. The design is annotated "Bibliothek des. Oct 1872 for Fletcher. Drawn. at Vienna Exhibition 1873" (V&A PD E.229-1963, fol. 39).

Constructed of ebonized wood and with gilded details, the form is quite old-fashioned, based on the double bookrests or music stands of the eighteenth century which were designed to support manuscripts or folio volumes. To make it more functional, Godwin added a pair of candle brackets for improved lighting, inserted a central cup-board for additional storage, and mounted the whole piece on casters for easy movement. The design combines Asian and medieval details: the top structure resembles the timber roof of a medieval building, while the lower stand on which the books sit is conceived as a series of latticed openings reminiscent of Japanese balustrade railings.

327. *Design for a Sideboard*

Literature: Aslin 1986, pp. 28, 56, fig. 24; Soros 1999, p. 255

This Jacobean-style oak sideboard appears in one of Godwin's sketchbooks (V&A PD E.229-1963, fol. 47). The drawing is annotated "Sunday Oct 11–72 at the Vienna Exhibition," indicating it was designed for the Collinson and Lock stand at the 1873 Universal Exhibition in Vienna, which is confirmed in visitor guidebooks for the exhibition.[50]

Godwin has taken many elements from Jacobean furniture, including the cup-and-cover legs, molded rails, fielded cupboard panels, and architectural cornice. The piece is not a mere reproduction, however, for he designed it to better suit standards of nineteenth-century living: the bottom display shelf is shown elevated well above the floor, for easy access when cleaning, and many of the compartments have been left open, thereby maximizing the display potential. Godwin's inclusion of a top compartment would have made this piece taller than most Jacobean specimens, in addition to providing a greater amount of storage space.

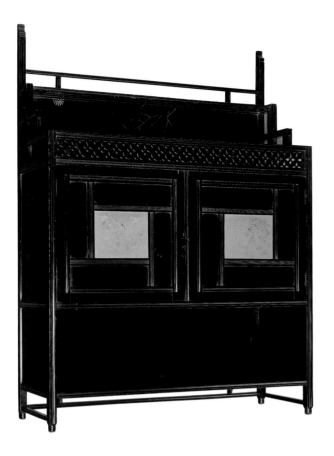

328

329

328. _Hanging Cabinet_
Ca. 1873, attributed to E. W. Godwin
Probably made by Collinson and Lock
Ebonized wood with lacquer panels; (lower
vertical brackets missing)
51 × 45 × 13 in. (129.5 × 114.3 × 33 cm)
Paul Reeves, London

There is no known drawing for this hanging
cabinet, yet it has many features that link it
to Godwin's Anglo-Japanese work of the
mid-1870s for Collinson and Lock – the
asymmetrically organized latticed sides as
well as the inclusion of actual Japanese
lacquer panels into the cupboard doors.
The reeded stiles terminating in flat, turned
knobs are another Godwin design element,
and the addition of both upper and lower
display shelves link this piece to Godwin's
other hanging cabinets. Unfortunately, the
lower vertical brackets are missing, making
it difficult to analyze the cabinet's lower
section.

 The panel of pierced decoration of
Japanese derivation below the cupboard is
striking. This pierced work is known in
Godwin's Gothic-Revival oeuvre, making
the attribution to him more likely.

329. _Hanging Cabinet_
Ca. 1873, attributed to E. W. Godwin
Probably made by Collinson and Lock
Oak with brass handles and fittings
45 1/4 × 49 5/8 × 9 7/8 in. (115 × 126 × 25 cm)
Paul Reeves, London

Although there is no known drawing for
this hanging cabinet, it shares so many
features with Godwin's style that an
attribution to him is reasonable. For
example, the sliding doors in the center of
the cabinet, in imitation of Japanese sliding
doors, are similar to the ones Godwin used
on his oak escritoire for Dromore Castle
(CR 315). Furthermore, the notched
treatment of the back hanging brackets is
identical to many of his brackets, parti-
cularly one illustrated in William Watt's
Art Furniture (1877; Plate 16; CR 410),
and the front stiles terminating in knobbed
finials are identical to those on Godwin's
mantelpiece reproduced in Plate 6 of that
catalogue (CR 415). In addition, the reeded
edging and the addition of a bottom shelf to
increase the cabinet's display capability are
both typical Godwin design elements.

 The circular openings within the curved
railings of the side compartments appear
in a series of "Cottage" designs Godwin

made for Collinson and Lock. This, in
combination with the unusual brass drawer
pulls with hatched escutcheons that were
made exclusively by Collinson and Lock,
strengthens the attribution to this maker.

330. *Corner Cabinet*

Ca. 1873, attributed to E. W. Godwin
Probably made by Collinson and Lock
Ebonized wood with painted panels; brass
handles and shoes; mirror glass
$83\frac{1}{2} \times 33\frac{7}{8} \times 17\frac{3}{4}$ in. (212 × 86 × 45 cm)
H. Blairman and Sons, London; Private
collection

Angled corner cabinets were popular forms
in England in the 1870s. Godwin's ledgers
and cashbooks indicate that in 1873 he
designed three for Collinson and Lock
(V&A AAD 4/13, fols. 14, 20), one of
which was later displayed at the Paris
Exposition Universelle in 1878. A reviewer
for *Furniture Gazette* wrote the following
description:

> Corner cabinets are, as every one
> knows, most difficult pieces of
> furniture to treat successfully and in
> proportion to the difficulties
> overcome ought to be the credit
> bestowed; and certainly the treatment
> here is highly successful and the
> finished article is the very ideal of
> what a cabinet should be. It neither
> intrudes into the room, or recedes too
> much into the corner, but just
> sufficiently breaks the angle of the
> wall, and this helps to furnish the
> room.[51]

Although there is only one sketch for a
Cottage-style corner cabinet in Godwin's
sketchbooks, this cabinet resembles his
other high-style work for Collinson and
Lock in the 1870s; the *shoji* lintel, the
elevation of the bottom shelf, the thin
proportions, and the arched side brackets
all point to the hand of Godwin.

330

331. *Display Cabinet*

Ca. 1873, attributed to E. W. Godwin
Made by Collinson and Lock
Rosewood; brass handles and fittings;
glass doors
$63\frac{1}{4} \times 30\frac{1}{2} \times 17\frac{1}{2}$ in. (160.7 × 77.5 ×
44.5 cm)
Stamped: Collinson and Lock 7485
H. Blairman and Sons, London; Private
collection

This must have been one of Collinson and
Lock's popular models, for two other
examples of it are in private collections in
the United States, both of which are of
ebonized mahogany (CR 331-a, 331-b).
This model is perhaps one of the three
display cabinets Godwin is known to have
designed for Collinson and Lock in 1873

331

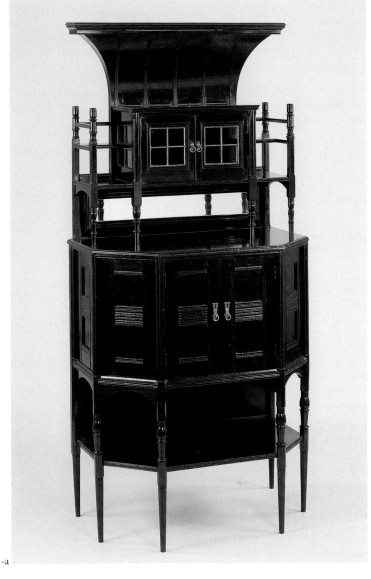

331-a

(V&A AAD 4/13-1963, fols. 14, 20).
Although unusual for Godwin, coved
cornices were used by him in the 1870s.
There is a drawing for a coved mantelpiece
for Grey Towers in Godwin's sketchbooks
and another coved cornice is featured on a
sideboard he designed for William Watt's
Art Furniture (1877; Plate 5; CR 354). The
hardware is similar to that used on the
corner cabinet known as the "Lucretia
Cabinet" (CR 332).

331-a. *Display Cabinet*
Ca. 1873, attributed to E. W. Godwin
Made by Collinson and Lock
Ebonized mahogany; brass fittings; glass
mirror inset; glass doors
64 × 29 × 16½ in. (162.5 × 73.8 × 41.9 cm)
Haslam and Whiteway, London; Private
collection

331-b. *Display Cabinet*
Ca. 1873, attributed to E. W. Godwin
Made by Collinson and Lock
Ebonized mahogany; brass glazing bars and
handles; glass doors and glass mirror insert
64¼ × 30½ × 18 in. (163.2 × 77.5 × 45.7 cm)
Stamped: Collinson and Lock
Phillips, London, 13 October 1992, lot 251;
Haslam and Whiteway, London; Mitchell
Wolfson Jr. Collection, The Wolfsonian-
Florida International University, Miami
Beach, Florida

332. *Corner Cabinet, known as the "Lucretia Cabinet"*

1873
Made by Collinson and Lock
Rosewood with painted panels; brass
handles and fittings
75 × 32 × 23 in. (190.5 × 81.3 × 58.4 cm)
Stamped inside third drawer: Collinson and
Lock; stamped inside top drawer: Edwards
and Roberts
Lord Glenconnor (Colin Tennant); Haslam
and Whiteway, London; Fine Art Society,
London; The Detroit Institute of Arts,
1985 (1985.1)

Literature: Kinchin 1979, pp. 51–52, fig. 8;
Hoare 1983, p. 31, ill.The Detroit Institute
of Arts 1985, p. 32, fig. 23; Aslin 1986,
pp. 17, 30, figs. 18, 42; Barnet 1986, p. 505;
Bolger Burke et al. 1986, pp. 150–51,
fig. 5.9; Cooper 1987, pl. 330; Darr 1988,
p. 500, fig. 115; Soros 1999, no. 49, pp. 224,
239–40, fig. 8-1

This cabinet is one of many Godwin designed
for Collinson and Lock, for whom he was
under contract. It appears to be listed as a
"Murray Cabinet" in Godwin's cashbooks
(V&A AAD 4/13-1980), designed on 17
November 1873, for a fee of £3.3s.0d.
Collinson and Lock later exhibited it at the
1878 Exposition Universelle in Paris, where
it was described as a "corner cabinet, the
panels of which have been ably treated by
Mr. Murray."[52]

The decoration of this cabinet was painted
by Charles Fairfax Murray (1849–1919), a
student of Burne-Jones (1833–1898) and
Dante Gabriel Rossetti (1828–1882), and
the central panel, inscribed "Lucretia,"
bears his initials. The smaller side panels
depict the figures of Castitus and Fortitudo,
whose names are inscribed in the nimbus
(Castitus) and halo (Fortitudo).

The meander decoration of the cornice
comes from a series of repeating patterns
that Godwin sketched in the Royal Irish
Academy in 1868,[53] and a similar group of
patterns appears in one of his sketchbooks
(V&A PD E.361-1963).

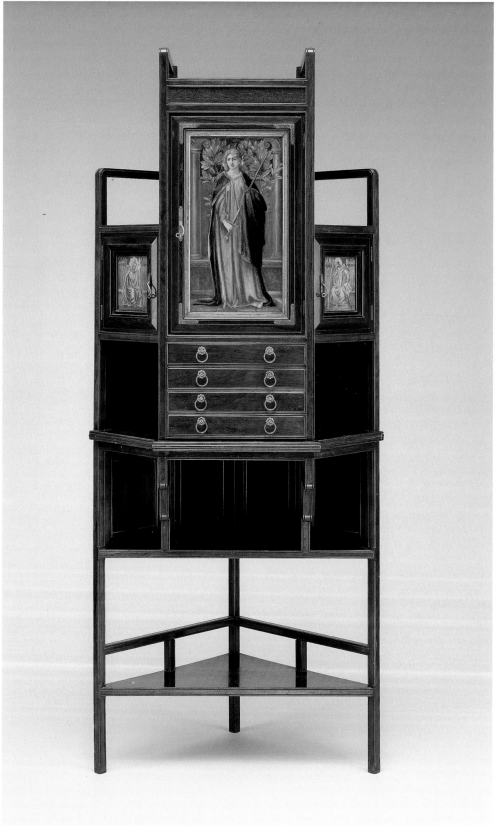

332

333. *Drawing Room Cabinet*
1874
Made by Collinson and Lock
Mahogany; brass handles and fittings; glass
doors
50 × 66 × 16⅞ in. (127 × 167.5 × 43 cm)
H. Blairman and Sons, London; Private
collection

Literature: Soros 1999, no. 51; pp. 248–49,
fig. 8-36

This cabinet is part of a series of Cottage-
style furniture which Godwin designed for
Collinson and Lock in 1874 that included
seating furniture as well as cabinets. The
molded framework, turned spindles, and
ring pull handles are typical of Godwin's
work, and the cabinet generally corresponds
to a drawing in one of his sketchbooks
(Fig. 333.1), although it does not have the
circular openings in the side panels. An
entry for 23 April 1874 (V&A AAD 4/13-
1963, fol. 19) lists a "Cott. Draw. Rm. cab"
for the sum of £3.3s.0d under the account
of Collinson and Lock, and probably refers
to this cabinet.

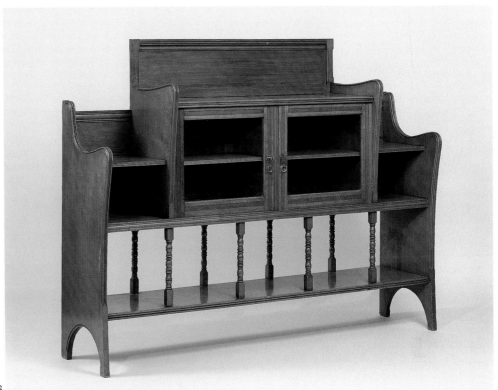

333

333.1 Sketch for a
drawing room
cabinet (V&A PD
E.235-1963, fol. 32)

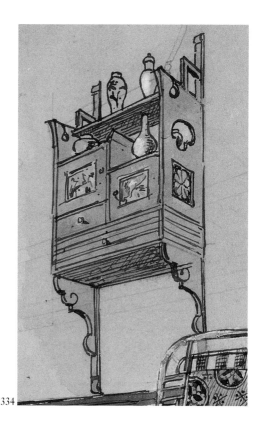

334

334. *Design for a Hanging Cabinet*

Literature: Soros 1999, p. 85, fig. 3-21

This hanging cabinet appears in a Godwin watercolor of about 1875 which he annotated "Anglo-Japanese Designs by E. W. Godwin" (V&A PD E.482-1963). The cabinet is elaborately decorated with painted cupboard panels, cloud motif cutouts, and carved chrysanthemums on the side panels derived from Japanese sources. Asymmetrically organized shelves continue the Japanese styling. Side brackets which attach to the chair rail support the structure.

Many of the other pieces illustrated in this watercolor were executed by William Watt so it is likely he executed this cabinet as well.

335

335. *Anglo-Japanese Cabinet*
1876
Made by Collinson and Lock
Satinwood and mahogany; Japanese lacquer panels; brass handles and fittings
Whereabouts unknown

Literature: Aslin 1986, pp. 30, 68–69, figs. 40–41; Soros 1999, pp. 238, 240, 257, fig. 8-26

This Anglo-Japanese cabinet was shown at the Collinson and Lock stand at the 1876 Centennial Exhibition in Philadelphia. It was part of a series of Anglo-Japanese cabinets that Godwin designed for Collinson and Lock in the early 1870s. A detailed drawing for the one shown here appears in Godwin's sketchbooks (Fig. 335.1) and indicates it was designed as early as 1874 with lacquer panels taken from a Japanese box and framed in satinwood and mahogany. Other elements derived from Asian furniture are also present – the brass riveted corner mounts, the *shoji*-inspired lintel, and the asymmetrical arrangement of space and shelves.

335.1 Design for a cabinet (V&A PD E.478-1963)

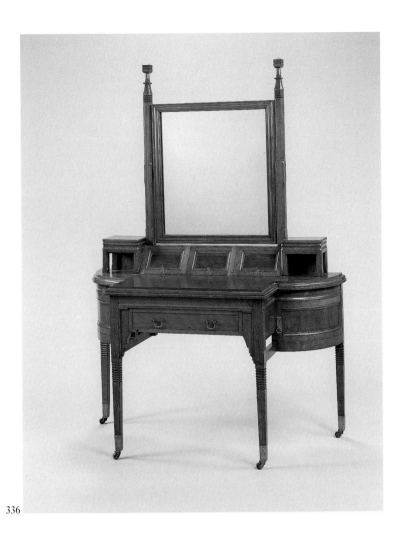

336

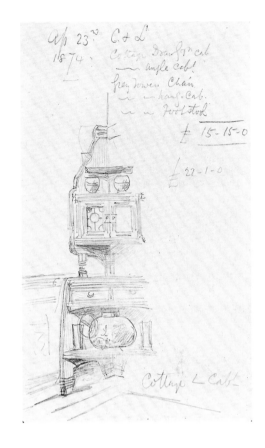

336.1 Sketch for an
angled cabinet
(V&A PD E.235-
1963, fol. 16)

336.2 Sketch for a
dresser (V&A PD
E.233-1963, fol. 11)

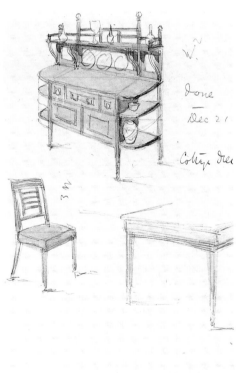

336. *Dressing Table*
Ca. 1874, attributed to E. W. Godwin
Made by Collinson and Lock
Walnut; brass handles and fittings; plate
glass; brass casters
$64\frac{1}{8} \times 45\frac{7}{8} \times 20\frac{1}{8}$ in. (163 × 116.5 × 51 cm)
Stamped: Collinson and Lock
Paul Reeves, London

Although there is no known drawing for it,
this dressing table resembles the Cottage
furniture that Godwin designed for
Collinson and Lock in 1874 and for William
Watt in 1876. The horizontal ribbing on the
legs is a feature that he used for his angled
cabinet for Collinson and Lock (Fig. 336.1),
and the same attenuated finials and U-
shaped handles appear in a sketch he made
of a dresser for Watt (Fig. 336.2). In
addition, the complicated play of solid-and-
void spaces with the open side cupboards,
the tier of covered niches whose doors lift
up, the tapered rectangular legs, and the

Egyptian-inspired front bracket in the form
of stylized wings all point to Godwin's
hand. A similar wing decoration appears on
a satinwood and ebony cabinet illustrated in
Building News in 1885 (CR 385). Godwin's
ledgers for Collinson and Lock indicate this
piece might be the dressing table he
designed on 19 May 1873, for a fee of
£3.3s.0d (V&A AAD 4/13-1980).

337. *Cabinet*

Ca. 1875, attributed to E. W. Godwin
Probably made by Collinson and Lock
Ebonized wood with Japanese lacquer
panels; brass handles and fittings; glass
panels
72 × 42½ × 16¾ in. (183 × 108 × 41.6 cm)
Sotheby's, London, 21 October 1988, lot
117; H. Blairman and Sons, London;
Private collection

There is no identifiable sketch for this
Anglo-Japanese cabinet, but it has many
features common to Godwin's style of the
1870s: rounded brackets, brass "socks,"
Japanese lacquer panels, reeded stiles, play
of open and closed spaces, cabinetry
elevated high above the floor, and brass
hardware reminiscent of that used for his
Dromore escritoire (CR 315). The inclusion
of Japanese lacquer panels was not unusual
for Godwin, and may relate this cabinet to a
series he designed in the 1870s for Collinson
and Lock. One cabinet from that series was
exhibited at the Philadelphia Centennial of
1876 (CR 335).

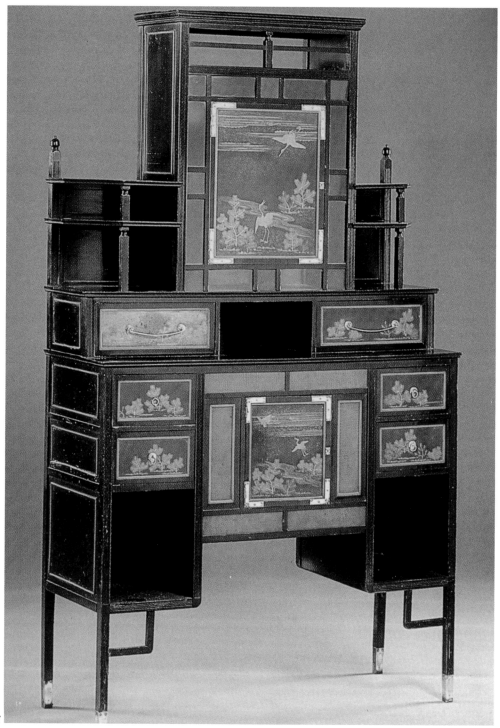

337

338. *Music Canterbury or Wagon*

Ca. 1876
Made by William Watt
Walnut; brass handle and fittings
$24\frac{1}{8} \times 20\frac{5}{8} \times 14\frac{1}{8}$ in. (61.2 × 52.3 × 36 cm)
Enameled label attached to the reverse:
William Watt Grafton Street
Originally in the possession of the designer
and Ellen Terry; by descent to Edith Craig;
by bequest to The National Trust, Ellen
Terry Memorial Museum, Smallhythe
Place, Kent (SMA/F/83)

Literature: Aslin 1986, pp. 29, 66, fig. 36;
N. Wilkinson 1987, p. 250; Reid 1992, p. 39;
Soros 1999, pp. 237–38, fig. 8-23

Music canterburys, used to hold bound
volumes of music, were popular forms in
the early nineteenth century. This one,
which Godwin called a "music wagon,"
was illustrated in William Watt's *Art
Furniture* (1877; Plate 8) under "Anglo-
Japanese Drawing Room Furniture." The
design was registered with the Patent Office
(no. 305888) by the maker, "William Watt
Upholsterer 21 Grafton Street East Gower
Street London," in December 1877 (Fig.
338.1). The catalogue lists a walnut version
for £9.9s.0d and one in ebonized mahogany
for £9.12s.6d.

The Smallhythe Place version lacks the
upper stage and the lower second drawer
(both of which are seen in the catalogue and
the Patent Office versions). The canterbury
appears in the left-hand side of an undated
photograph of Ellen Terry in the study of
her home in Barkston Gardens (Fig. 338.2).

The canterbury's splayed legs, rounded
moldings, and turned decoration imitate
Asian bamboo work, and the addition of a

cutout cloud pattern, taken from Japanese
architectural construction, gives this piece a
decidedly Japanese flavor. The top drawer
and the vertical storage arrangement were
both unusual features for a canterbury and
perhaps explain why William Watt decided
to register this design. Most canterburys of
the period conformed to the type described
in Sheraton's *Cabinet Dictionary* of 1803: "a
small music stand, with two or three hollow
topped partitions, formed in light slips of
mahogany, about three inches apart from
each other, and about eight inches deep, for
holding music books. These have sometimes
a small drawer, 3 inches deep, and the
whole length of it which is 18 inches; its
width 12 inches, and the whole height 20
inches."[54]

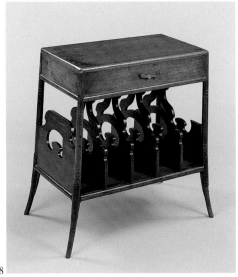

338

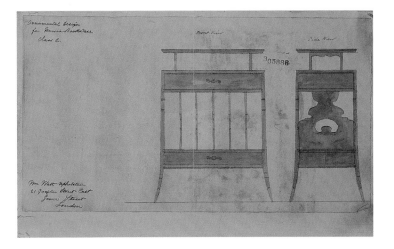

338.1 "Ornamental design for Music Bookcase"
(Public Record Office)

338.2 Photograph of Ellen Terry in the study of
her home in Barkston Gardens, London

339

339. *Design for a Double Hanging Bookcase*

This drawing from Godwin's sketchbooks (V&A PD E.233-1963, fol. 23) is annotated "Deal furniture W.7 done," indicating it was a design executed by William Watt. It was part of a series of plain, economical furnishings Godwin designed for Watt in the mid-1870s, and probably relates to an entry in Godwin's ledger from 29 December 1876 for "Hanging Bookshelve" for William Watt, for which he received a fee of £1.1s.0d (V&A AAD 4/12-1980, fol. 21).

The bookcase is composed not only of two shelves for books but also a top shelf, intended for the display of ceramics, with elbow struts forming a side rail. Godwin used similar arched bracket supports on his hanging bookcase in the Bristol Museums and Art Gallery (CR 305-b).

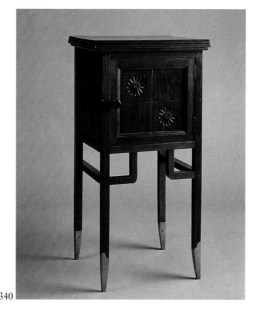

340

340.1 Sketch for a small cabinet
(V&A PD E.233-1963, fol. 15)

340. *Small Cabinet*
Ca. 1876, attributed to E. W. Godwin
Probably made by William Watt
Mahogany; brass shoes; wooden knob
31 × 16 × 15 in. (78.7 × 40.6 × 38.1 cm)
Haslam and Whiteway, London; Private collection

Literature: *Birth of Modern Design* 1990, p. 26

There is no identifiable drawing or illustration for this small Anglo-Japanese cabinet. It has many features typical of Godwin's work, however, including round brackets, slightly splayed legs with brass shoes, reeded edging, and a quarter-paneled door with chip-carved chrysanthemums. It is similar in style to a bedside cabinet Godwin designed for Collinson and Lock in the 1870s (Fig. 340.1; V&A PD E.233-1963, fol. 15). At one time it was overpainted with red chinoiserie decoration, which has been removed.

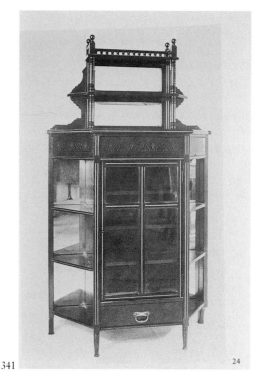

341

24

341. *Display Cabinet*
Ca. 1877, attributed to E. W. Godwin
Made by William Watt
Ebonized wood; mirror-backed shelves; glazed doors
56 × 32 × 14½ in. (142.2 × 81.3 × 36.8 cm)
Enameled William Watt label attached to back
Whereabouts unknown

Literature: C. Spencer 1973, p. 38, no. 4

Although there is no known drawing for this cabinet, many features (in addition to the Watt label) link it to Godwin's work of the 1870s: turned, ring-incised legs; canted sides; slender proportions; ebonized finish with gilt highlights; incised chrysanthemums ornamenting the apron of the cupboard section; and the elevated bottom shelf. A similar cabinet was manufactured in the mid-1870s by James Shoolbred and Co.[55]

342. *"Monkey Cabinet"*

Ca. 1876
Probably made by William Watt
Walnut; carved boxwood; ivory handles;
brass casters
$75\frac{1}{2} \times 78 \times 19\frac{1}{2}$ in. (190.5 × 198 × 49.5 cm)
Originally in the possession of the designer;
by descent to his son, Edward Gordon
Craig; purchased from Edward Gordon
Craig's estate in 1958; Victoria and Albert
Museum, London (Circ. 34-1958)

Literature: Victoria and Albert Museum
1952b, pl. K2; Handley-Read 1965, p. 225,
fig. 854; Aslin 1967, p. 6, fig. 4; Jervis 1968,
pl. 63; Honour 1969, p. 254; Cooper 1987,
pl. 342; N. Wilkinson 1987, pp. 177–78;
Yorke 1990, p. 120, ill.; Soros 1999,
pp. 79–80, fig. 3-11

This cabinet is based on a drawing in
Godwin's sketchbooks from the years
1870–76 (Fig. 342.1). Although the drawing
is not dated, the fact that it occurs near the
end of the sketchbook indicates a date of
1876. The sketch is inscribed "1/2 in scale
and &18."

The cabinet has come to be known as the
"Monkey Cabinet" because of its ivory
netsuke handles, which are in the form of
monkeys. It may relate to Burges's Tower
House from the same period which,
according to Godwin's description of the
interior (V&A PD E.245-1963, fol. 19), had
a "Monkey attic" with "monkeys on the
mantel hood as corbels." Monkeys had
made appearances in Godwin's designs
since the mid-1860s. On the verso of a
detail for fabrics for Dromore Castle is a
sketch of a monkey (RIBA Ran 7/B/1 [90])
that could have been drawn from life, since
it is known that Godwin had a pet monkey
when he was living with Ellen Terry at
Harpenden in the late 1860s.[56] The curved
brackets at the top of the cabinet have been
identified by Nancy Wilkinson as
influenced by Chinese chair backs.[57] Both
the *netsuke* and the carved boxwood panels
might have been acquired from Liberty's
East Indian Art Warehouse on Regent
Street, where Godwin often shopped in the
1870s; Elizabeth Aslin has pointed out that
Japanese carved wooden panels were in
stock at Liberty's at the time this cabinet
was made and could also be ordered from
Japan "to any character of drawing" by the
early 1880s.[58] Nor was it unusual for
Godwin to incorporate actual Japanese

articles of decoration in his pieces. An early
sideboard at the Bristol Museums and Art
Gallery, for example, has pieces of Japanese
watercolor inserted into its top panels
(CR 304), and a cabinet he designed for
Collinson and Lock has panels cut from a
Japanese lacquer box (CR 335).

Other features typical of Godwin's
designs for this period include folding
shelves, casters (for mobility), and an
elevated bottom shelf (for easy cleaning).

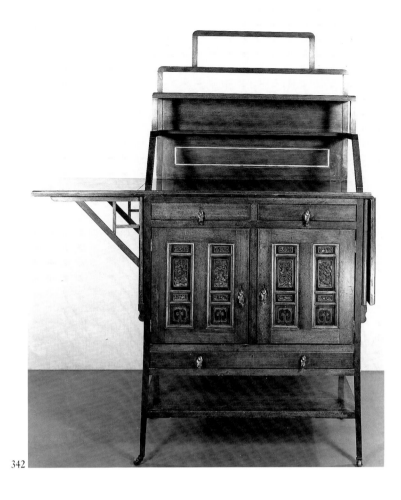

342

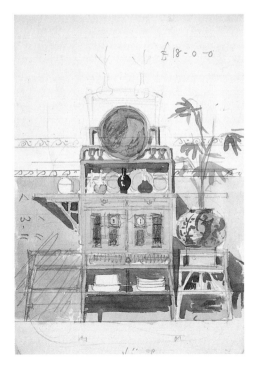

342.1 Sketch for
a small cabinet
(V&A PD E.233-
1963, fol. 75)

343. *Cabinet*
Ca. 1877, attributed to E. W. Godwin
Maker unidentified
Mahogany; brass handles and fittings;
Delft tiles
$30\frac{1}{2} \times 33\frac{3}{4} \times 21\frac{1}{2}$ in. (77.5 × 85.7 × 54.6 cm)
Private collection

Although there is no known drawing for this cabinet, it displays many features common to Godwin's furniture: the brass fitments, which are a combination of scalloped back plates with bail handles and ring pull handles with round escutcheons; the ring turned legs; the vertically planked side panels; the reeded door panels and top edge. Moreover, the use of blue-and-white tiles can be found on other Godwin pieces, including a coffee table identified by Elizabeth Aslin (CR 226-b) and a washstand in the Bristol Museums and Art Gallery (CR 317). The corbeled flaps on which the top of the cabinet sits are also a prevalent feature of Godwin's designs, reminiscent of the supports used on Sheraton flap tables. These features, taken from different historical periods, have been combined into an attractive, well-designed piece of furniture typical of Godwin's best work.

The cabinet's horizontal orientation with its flap-supported top resembles the everted-flange altar cabinets common among Ming hardwood furniture. Another source of inspiration may have been the Chinese hardwood dwarf cabinets popular in England in the second half of the nineteenth century. In his *Chinese Hardwood Furniture in Hawaiian Collections*[59] Robert Ellsworth illustrates an altar cabinet of the kind that could have been the prototype for Godwin's cabinet design.

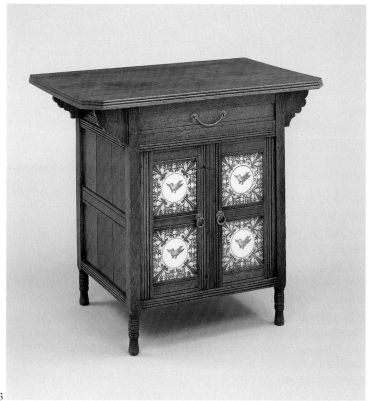

343

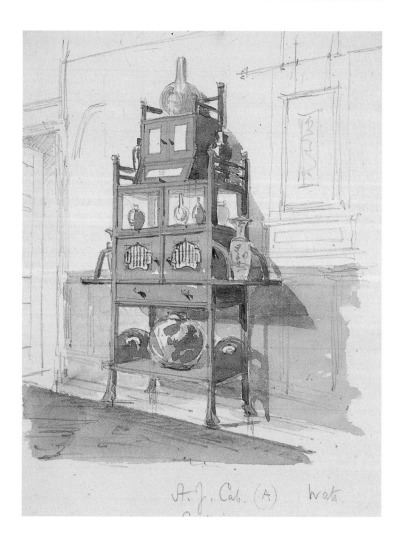

344.1 Design for an Anglo-Japanese cabinet (V&A PD E.233-1963, fol. 85)

344. *"Four Seasons Cabinet"*

Ca. 1877
Made by William Watt
Satinwood; brass fittings; ivory handles; painted panels on a gilt ground
70 × 16 × 50½ in. (177.8 × 40.6 × 128.3 cm)
Handley-Read Collection, London; gift to the Victoria and Albert Museum, London (W. 15-1972)

Literature: R. Spencer 1972a, p. 42, no. 279, ill.; Royal Academy 1972, pp. 18–19, D18, ill.; Aslin 1986, fig. 10; N. Wilkinson 1987, p. 241; Gere and Whiteway 1993, p. 154, pl. 189; Bendix 1995, pp. 156, 158, fig. 599; Lambourne 1996, p. 161, ill.; Soros 1999, pp. 86–87, 240–42, fig. 3-23

This display cabinet is based on a design in Godwin's sketchbooks (Fig. 344.1) that is annotated "A. J. Cab (A) Wats [*sic*] Exhibition Cabinet." It probably was one of the Anglo-Japanese designs Godwin proposed to Watt for the 1878 Exposition Universelle in Paris, although examination of photographs, guidebooks, and contemporary reviews and articles has yielded no evidence that this cabinet was ever displayed there. The satinwood veneers and gilded backgrounds of the painted decoration suggest this was originally intended for William Watt's stand, which was to be designed in a harmony of yellow and gold, and in fact this same sketch was later reproduced in *Building News* as "An Art Cabinet" designed by E. W. Godwin and made by William Watt (CR 387). The accompanying descriptive text states that it was "intended for the display of works of art in a drawing-room or boudoir."[60] Perhaps the upper structure seen in both the sketch and the *Building News* illustration was judged too fussy for actual production. Deanna M. Bendix suggests that this cabinet was originally designed for Whistler's White House, where it would have harmonized with the yellow color schemes,[61] but this theory also lacks evidence.

This cabinet is often called the "Four Seasons Cabinet," as the painted panels depict figures that represent each of the four seasons.[62] It is believed that the panels were executed by Godwin's wife, Beatrice, who is known to have done decorative painting.[63] The bell-shaped lattice openings on the lower doors were copied from volume five of the Hokusai *Manga* (1816),

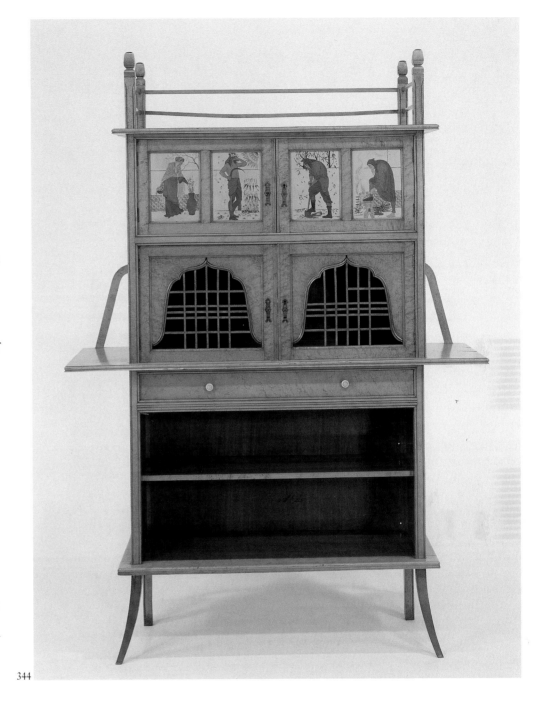

344

which Godwin is known to have possessed,[64] and the stiles of the upper section with their square-shaped brass finials are also borrowed from Japanese architectural sources – exterior balustrades.[65] Although these elements certainly give the piece Japanese quality, the overall form is very close to late-eighteenth-century Sheraton cabinetry, and its slender proportions, horizontal emphasis, reeded moldings, and use of satinwood all are reminiscent of eighteenth-century specimens.

345

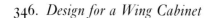

ANGLO-JAPANESE WING CABINET

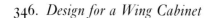

346

345. *Design for an Escritoire*

Literature: N. Wilkinson 1987, p. 175, fig. 47

This sloping escritoire, which has an ebonized finish, appeared under "Anglo-Japanese Drawing Room" in William Watt's *Art Furniture* (1877; Plate 8), although the only Anglo-Japanese elements are the elbow-shaped struts. Godwin, who used the terms davenport and escritoire interchangeably, added struts, an upper cupboard with display shelf, and thin pointed feet to the davenport form that was popular in nineteenth-century Great Britain. It was priced at £18.18s.0d.

346. *Design for a Wing Cabinet*

Literature: N. Wilkinson 1987, p. 250

This design, one of Godwin's most inventive for cabinets, was reproduced in William Watt's *Art Furniture* under "Anglo-Japanese Drawing Room" (1877; Plate 8). It was made of ebonized wood and cost £35.0s.0d. Watercolors of related designs appear in Godwin's sketchbooks: one, annotated "Anglo-Jap. winged / Drawg Cabinet / done for Watt." shows the same cabinet in satinwood and mahogany. Another depicts a version with a convex mirror and shinto shrine lintel (Fig. 346.1). There is visual play on the term "wing"

with the incorporation of an eagle's scaled legs and talon feet, in addition to the two upper side cabinets, or wings. The scaled work is continued on the central molding of the carved section's left door (the square panels of all the doors have carved decoration). The dramatic central keyhole comes from Japanese architectural design. The bottom edge of the lower cupboard doors are arched, as though a part of a circle, corresponding to the circular form created by the concave arch of the inner edge of the three wing drawers, and the railed display shelf. According to Nancy Wilkinson, the cabinet relates to "Chinese cabinets which open with wings swinging out on both sides."[66] Delicately curved elbow supports bear the weight, however improbably, of these side sections, which hang dramatically over the main stand. A framed rectangular mirror, placed in back of the side sections, is surmounted by a bracketed display shelf that acts as a cornice and by stiles, which extend into out-turned finials.

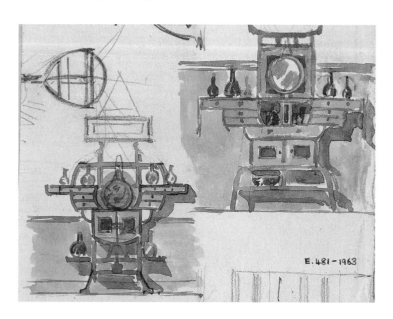

E.481-1963

346.1 Two designs for wing cabinets (V&A PD E.481–482-1963)

347. *Design for a Buffet*

This buffet, which stands 6 feet high, appears in William Watt's *Art Furniture* under "Students' Furniture" (1877; Plate 4), priced at £33.0s.0d. Although it lacks the side flaps and bottom display shelves of his classic buffet (CR 304), Godwin has added a central cupboard covered with pleated fabric as well as extra drawers to the lower section. Minor adjustments to the panel doors and the top stiles also distinguish this model.

348. *Design for a Sideboard*

Literature: Soros 1999, p. 250

This oak sideboard appears in William Watt's *Art Furniture* under "Old English or Jacobean Furniture" (1877; Plate 15). It is six feet wide and cost £30.0s.0d. A related sketch, dated 30 July 1876, is in one of Godwin's sketchbooks (V&A PD E.233-1963, fol. 41).

This piece has many features derived from Jacobean furniture, including baluster-turned legs and supports, fielded panels, volute-shaped brackets, carved lunette and floral decoration, and an architectural cornice. Godwin added mirrored glass insets and extra shelves to meet the demands of the nineteenth-century dining room. He also elevated the bottom shelf well above the floor for easy cleaning.

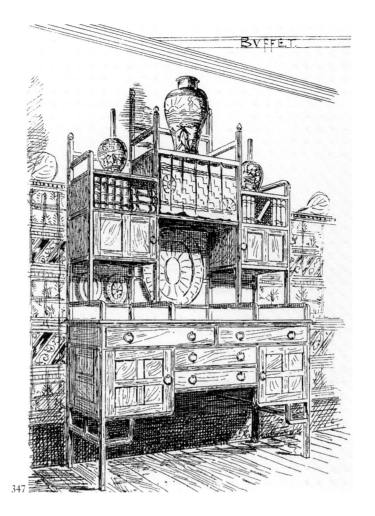

347

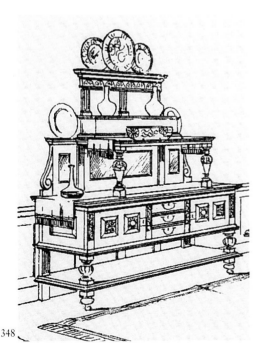

348

349. *Design for a Double Wardrobe*

Literature: "Bed-Room Furniture," 24 October 1879, p. 490

This wardrobe, made of pine with plate glass doors and priced at £42.0s.0d, appears in William Watt's *Art Furniture* under "Old English or Jacobean Furniture" (1877; Plate 15). Its appearance under that heading is hard to understand, however. It is a double version of the Anglo-Japanese wardrobe illustrated in the same catalogue (Plate 13), and in fact the double wardrobe form is derived from the Chinese classic compound wardrobe. Moreover, this wardrobe's detailing and proportions are more in keeping with Sheraton-style furniture.

This piece has a crisp, defined outward edge with a series of reeded moldings, sleekly graduated drawers, tall narrow proportions, and a classically inspired cornice reminiscent of Sheraton case pieces. To accommodate the double form, Godwin made some minor adjustments, such as adding a bottom drawer and casters. It was described in *Building News* as being "screwed together with thumb-screws."[67]

349

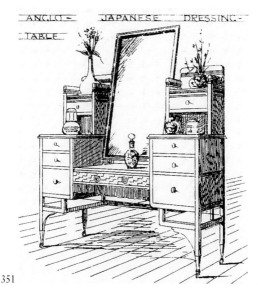

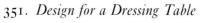

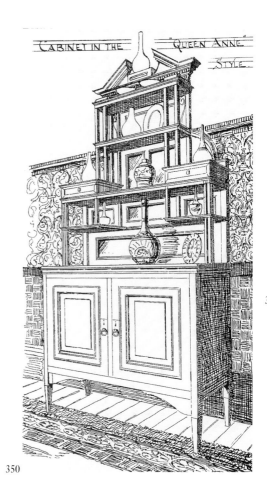

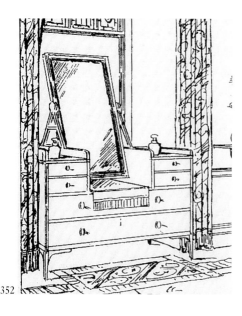

350

351

352

350. *Design for a Cabinet in the "Queen Anne" Style*

Literature: "Art Furniture," 24 August 1877, p. 174; Girouard 1977, p. 32, ill. p. 117

This ebonized cabinet was reproduced in William Watt's *Art Furniture* (1877; Plate 12) under "Drawing Room Furniture" and sold for £35.0s.0d. It has a series of shelves for the display of ceramics, some with mirrored back panels. The lower section has a pair of paneled cupboard doors, adorned with a pair of round bail handles and rectangular escutcheons, and a shaped apron. Despite its typical Queen Anne–style broken pediment cornice, the cabinet's tall narrow proportions and tapered rectangular legs are more in keeping with Sheraton-style furniture than with Queen Anne specimens.

 A contemporary review of Watt's *Art Furniture* which appeared in *Building News* singled out this cabinet as being "exceedingly good" and the raising of the lower cupboard on high legs "sensible."[68]

351. *Design for a Dressing Table*

Literature: N. Wilkinson 1987, p. 251

This Anglo-Japanese dressing table, which measures 4 feet 6 inches wide, appears in William Watt's *Art Furniture* under "Bed Room Furniture" (1877; Plate 13) and sold for £17.17s.0d. A large, rectangular central mirror is placed above the counter and center drawer (which has stenciled zigzag-pattern decoration and two round brass handles) and set between two nests of drawers. Godwin's Japanesque elbow struts connect the lower drawer of each nest to the tapered rectangular legs, which fit into casters. The recessed upper sections of the side cabinets have a fourth drawer upon which items could be displayed.

 A less expensive, pine version of this dressing table appears in Plate 16 of Watt's catalogue as part of a bedroom suite (CR 352).

352. *Design for a Dressing Table*

Designed for Godwin's line of "Economic Furniture" for the bedroom, this dressing table is illustrated in William Watt's *Art Furniture* (1877; Plate 16) where it is listed at £10.1s.0d, making it the least expensive Godwin dressing table in the Watt catalogue. Several factors kept the cost of this piece low: it is made of deal, casters are noticeably absent, wooden knobs are used, and decoration is minimal. Godwin illustrated the table with a fringed linen runner and a pair of bottles on either side of the mirror.

353

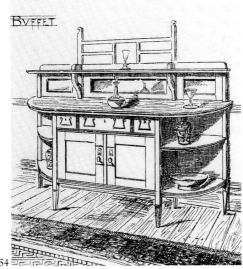

354

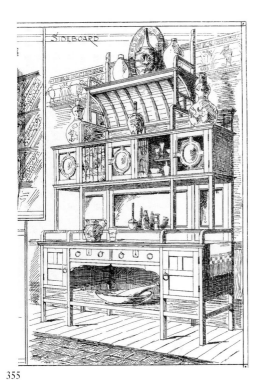

355

353. *Design for a Washstand*

Literature: N. Wilkinson 1987, p. 251

This stand, made of pine and selling for £10.10s.0d, appears in William Watt's *Art Furniture* under "Old English or Jacobean Furniture E.W.G." (1877; Plate 15). It is composed of a central cupboard flanked by two open cupboards and a pair of side arms for hanging towels. The back splash of plain tiles is surmounted by a pair of side shelves and a top shelf for the display of ceramics. The central cupboard has a carved panel which adds a decorative touch to this otherwise quite simple piece of furniture. A plain ewer and basin are illustrated on the counter.

354. *Design for a Buffet*

This six-foot-wide buffet was designed for the parlor. It appears in William Watt's *Art Furniture* (1877; Plate 3) where it is priced at £25.0s.0d and described as "an example of an inexpensive and roomy sideboard . . . capable of enrichment to suit a costlier style of furnishing" (p. vii). It was probably part of the line of Cottage-style furniture Godwin originally designed for Collinson and Lock in the early 1870s and a few years later redesigned for William Watt. A related drawing, showing an almost identical piece, appears in one of Godwin's sketchbooks with the annotation "Cottage Dresser done Dec. 27 76" (V&A PD E.233-1963, fol. 11).

The buffet's demilune form and elegant tapered legs shod in brass speak more of the tradition of Sheraton and early Regency than of simple rustic furniture. Its open side shelves relate to the high-style chiffoniers that were prominent in late-eighteenth- and early-nineteenth-century England. Chiffoniers were first made in France, particularly by the *ébéniste* Adam Weisweiler. A pair of rosewood demilune chiffoniers surmounted by a bookcase, attributed to Henry Holland and dated to about 1800, are probably of the type Godwin followed for this buffet design.[69]

355. *Design for a Sideboard*

This sideboard, made of oak and 6 feet 6 inches high, appears in William Watt's *Art Furniture* under "Dining Room Furniture" (1877; Plate 5) and was priced at £45.0s.0d. The design was one of Godwin's most elaborate for sideboards, particularly the upper section, with its coved cornice, mirror glass inserts, mirrored doors, and open compartments covered with a pleated fabric showing addorsed peacocks. Godwin's distinctive elbow-shaped struts are featured, along with paneled doors and round handles with square escutcheons. The legs are plain extensions of the stiles and they are attached to a shelf which, characteristically, Godwin has elevated high above the ground.

This piece, with all its drawers, cupboards, and shelves, would have provided ample storage and display space. There is even a shelf above the coved cornice suitable for the display of large objects.

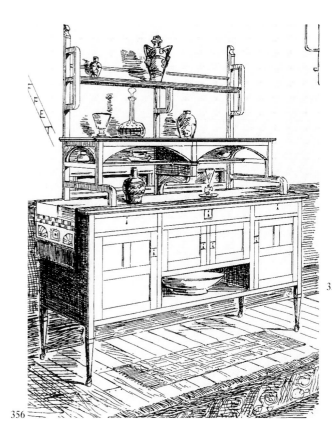

356

357

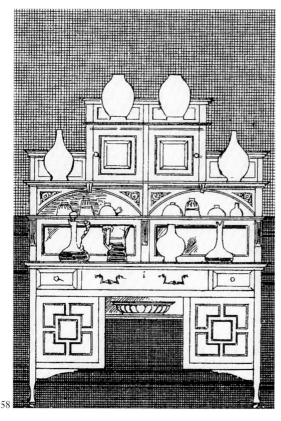

358

356. *Design for a Buffet*

This buffet, made of oak and six feet high, appears in William Watt's *Art Furniture* under "Dining Room Furniture" (1877; Plate 5) and was priced at £36.0s.0d. It features an upper recessed structure made of a series of shelves for storage or display with mirror glass backs. The lower dresser was composed of three drawers, three cupboards, and an open bottom shelf. The dresser is of plain design with paneled cupboard doors with square escutcheon plates. Thin tapering legs shod in brass sit on casters for easy movement. The upper structure features Godwin's characteristic s-shaped elbow struts. A new element is the introduction of low arched openings above the first shelf of the upper section.

357. *Design for a Hanging Cabinet*

This mahogany hanging cabinet appears in William Watt's *Art Furniture* (1877; Plate 17) under "Jacobean Furniture" and sold for £8.8s.0d. The cabinet has five different levels for display, two with mirrored back plates, and an architectural cornice with a central arcade flanked by ornamental volutes. Two arched side brackets with carved panels extend to the chair rail. Despite the catalogue heading for this piece, Godwin's use of mahogany and mirrored glass is not typical of authentic Jacobean furniture.

358. *Design for a Cabinet*

This oak cabinet is reproduced in William Watt's *Art Furniture* (1877; Plate 17) as part of Godwin's design for an Old English-style dining room. It measures 5 feet 6 inches wide and cost £55.0s.0d. A related drawing of the same cabinet appears in one of Godwin's sketchbooks (V&A PD A123D, fol. 504).

The cabinet has many features derived from Jacobean cabinets, including carved floral and lunette decoration, baluster-turned legs, and molded edges. Godwin's favored elbow struts appear, as does the high elevation of the cabinet's base, which, according to *Art Furniture*, was "for the use of the housemaid's brush" (p. vii).

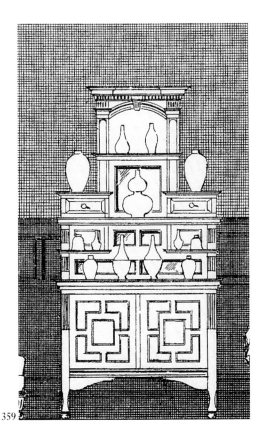

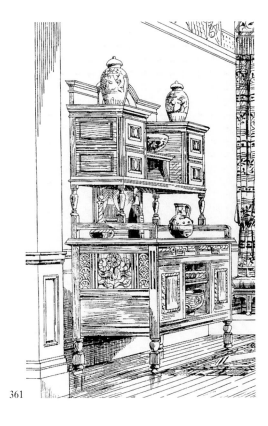

359. *Design for a Cabinet*

This mahogany cabinet, which sold for £30.0s.0d, appears in William Watt's *Art Furniture* as part of Godwin's line of Jacobean furniture (1877; Plate 17). Godwin apparently felt the title was "a misnomer," for he wrote in the catalogue that "the furniture shown being no more Jacobean than that shown on Plate 8 is Japanese" (p. viii). Additionally, the piece was made of mahogany, a strange choice given that seventeenth-century furniture of this type was generally made of oak or walnut. The geometrically paneled cupboard doors, molded edging, and architectural cornice, however, speak of the Jacobean period.

The strangely configured apron brackets and rounded legs with tapering ankles, the double shelf with mirrored back plates surmounted with a central mirror, which itself is flanked by two drawers and topped by yet another cornice, make this piece one of Godwin's least balanced cabinet designs.

360. *Design for a Hanging Cabinet*

This oak hanging cabinet is reproduced in William Watt's *Art Furniture* as part of Godwin's Old English-style dining room (1877; Plate 7). It was three feet wide and cost £12.12s.0d. A drawing showing the same hanging cupboard is in one of Godwin's sketchbooks (V&A PD E.504–1963).

The cabinet has a mirrored central section with canted sides and an architectural cornice surmounted by a second, receding cornice. The double-cornice feature allows for greater display of ceramic ware, as does a receding bottom shelf, demonstrating Godwin's characteristic concern with maximizing display space. The stiles are composed of fluted pilasters that extend down to the chair rail. Baluster supports on either side of the mirrored section correspond to the baluster-turned legs of the other pieces in this dining room suite.

361. *Design for a Sideboard*

This oak sideboard is reproduced in William Watt's *Art Furniture* as part of an Old English-style dining room (1877; Plate 7). It was available in two widths: 7 feet 6 inches and 6 feet 6 inches. The larger version cost £75.0s.0d and the smaller one £65.0s.0d, making them the most expensive pieces of furniture illustrated in the catalogue. In part this was due to the addition of carved panel decoration.

The sideboard is an adaptation of typical Jacobean furniture, with carved floral panels, baluster supports, molded stiles, and an architectural cornice. Godwin added mirrored panels and open side compartments to increase its conformity with the Jacobean Revival style of furniture prevalent in nineteenth-century England.

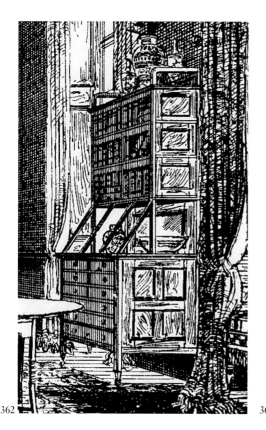

362

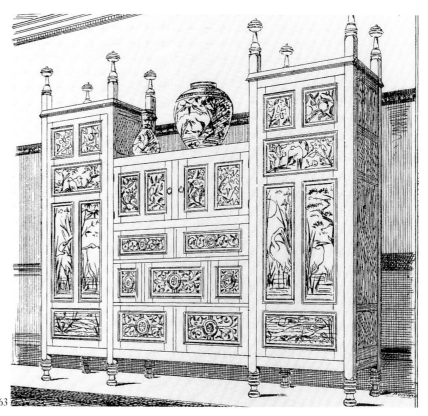

363

362. *Design for a Cabinet Bookcase*

The design for this four-foot-wide cabinet bookcase appears in William Watt's *Art Furniture* (1877; Plate 14) priced at £48.0s.0d. The upper section is composed of three bookshelves and the lower has a series of drawers for general storage. The two sections are attached by a series of slanted front supports and quadrangular side posts, and a mirrored panel is inserted in the middle. The top portion is surmounted by rounded side rails for the display of ceramic ware.

363. *Design for a Large Painted Wardrobe*

Literature: N. Wilkinson 1987, p. 251

This three-section wardrobe is illustrated in William Watt's *Art Furniture* under "Bed Room Furniture" (1877; Plate 13). Standing 7 feet 6 inches high, it is one of the largest known Godwin case pieces, and it was priced starting at £45.0s.0d. The descriptive text in the catalogue noted: "The large painted wardrobe is however of a more massive construction than that usual. . . . The paintings in the panels may be after the manner of the Japanese or may be of plain or carved wood, the general form and arrangement of the panels being compatible with almost any style" (p. viii).

The panels are painted with a combination of bird, fish, and floral scenes in an Anglo-Japanese style. The two cupboards are made for hanging items and their long doors are decorated with a playful arrangement of square and rectangular panels. Large ring-turned finials atop the four posts above each side cupboard continue the upward thrust of the design. The central section consists of cupboards for flat storage. Eight ring-turned feet elevate the wardrobe high above the ground.

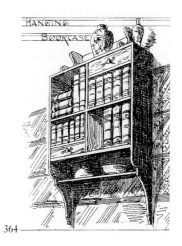

364

364. *Design for a Hanging Bookcase*

This oak hanging bookcase is illustrated in William Watt's *Art Furniture* under "Dining Room Furniture" (1877; Plate 5) and could be purchased for £5.0s.0d.

The four central sections were intended for book storage, and the upper and lower shelves for the display of ceramics. The unusual brass handle in the shape of an elongated S, found on each of the drawers, can also be found on a Godwin design for a canterbury, or music wagon (CR 338). The source for these handles is unknown.

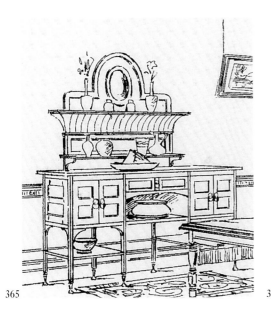

365

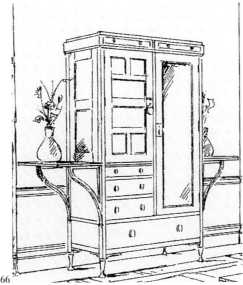

366

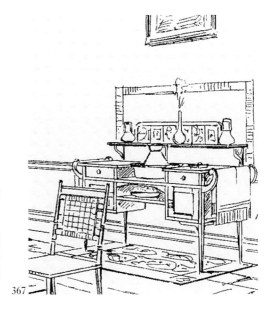

367

365. *Design for a Buffet*

This walnut buffet appears in William Watt's *Art Furniture* as part of Godwin's line of "Economic Furniture" for the parlor (1877; Plate 16). It is six feet wide and cost £30.0s.0d.

The buffet has plain paneled doors with round handles on round escutcheons, curved apron brackets, and a coved and fluted cornice, above which is a superstructure in which an oval convex mirror is framed. The elevated bottom shelf and two cupboards in the lower portion provide more than ample storage capability. The fluted cornice, the most prominent design feature, is intended to correspond to the similar mantel shelf of this parlor suite (see CR 420).

366. *Design for a Wardrobe*

This wardrobe is reproduced in William Watt's *Art Furniture* as part of Godwin's line of "Economic Furniture" for the bedroom (1877; Plate 16). It measures four feet in width and was priced at £18.18s.0d. The wardrobe is made of deal with a glass mirror inset and, though small, was described as "usually enough for a gentleman whose means were limited" (p. viii). The piece has minimal decoration and rounded wooden knobs, similar to the dressing table designed for this suite (CR 352). Godwin added some molded square and rectangular panels to the cupboard and cornice sections, to enliven its design. He also added his distinctive side shelves on brackets to provide surface area for the display of ceramics.

367. *Design for a Washstand*

This washstand, made of deal and four feet in width, appears in William Watt's *Art Furniture* as part of Godwin's line of "Economic Furniture" for the bedroom (1877; Plate 16) and could be purchased for £6.15s.0d. It is another of Godwin's designs for a washstand that includes built-in towel arms. A cupboard is placed on either side of a central well, on which sits the basin and ewer. A central display shelf with a tiled splash is attached to the superstructure that makes up the top framework. The stand sits on thin tapered legs. Casters are noticeably absent.

368. *Design for a Hanging Cabinet*

Literature: Aslin 1986, p. 78, fig. 58; Soros 1999, pp. 82–83, fig. 3-16

This design for a hanging cabinet from Godwin's sketchbooks (V&A PD E.229-1963, fol. 73) was probably the basis for a William Watt commission of about 1877. It is one of Godwin's most decidedly Anglo-Japanese hanging cabinet forms. The cornice is derived from *tori* gate lintels, and the S-shaped elbow struts at the side of the top display shelf, and the latticed side panels and cupboard doors, all reveal the Japanese influence on this piece.

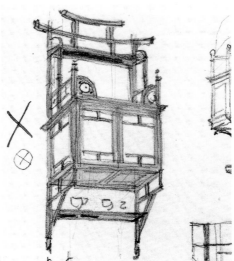

368

369. *"Butterfly Cabinet"*

1878
Made by William Watt
Painted decoration by James McNeill
Whistler
Mahogany with oil-painted decoration;
yellow tiles; brass moldings; glass
119¼ × 74¾ × 18¾ in. (303 × 190 × 47.6 cm)
William Watt; Pickford Waller, 1908–1930;
Sybil Waller, 1930–1973; Christie's, London,
4 October 1973, lot 196; Hunterian Art
Gallery, Glasgow

Literature: "Discovering Antiques," 14 June
1878; "Anglo-Japanese Furniture, Paris
Exhibition," 14 June 1878, p. 596; "Exhibits
for the Paris Exhibition," 22 March 1878,
p. 287; Paris, Exposition Universelle, 1878,
Royal Commission, vol. 1, pp. 69, 78; "Paris
Universal Exhibition," part 5, 1878, p. 116;
Smalley, 27 July 1878, p. 36; *Artist and
Journal of Home Culture*, December 1882,
pp. 387–88; Pennell and Pennell 1908, vol. 1;
Pennell and Pennell 1911, p. 156; Pennell
and Pennell 1912, p. 506; Aslin 1962a, p. 64;
Sutton 1963, pp. 86–87, 100; Aslin 1967, pp.
151–53; Jullian 1967, p. 84; R. Spencer
1972a, p. 60; "Cabinet Sold to University"
1973; Davis 1973, p. 1543, fig. 5; Norman
1973, p. 21; "Whistler Cabinet Bought by
University" 1973; Lumley 1975, p. 155; Farr
1978, pp. 141–42; Taylor 1978, p. 85, pl. 61;
Young, MacDonald, and Spencer 1980, pp.
113–14, no. 195, pl. 131; Hoare 1983, p. 31;
Curry 1984a, pp. 66–67; Curry 1984b, pp.
1196–97, fig. 14; Prince 1984, pp. 18–19;
Chapel and Gere 1985; Kimura 1985, p. 19;
Aslin 1986, pp. 13–14, 24, pls. 9, 28, 29;
Powell 1986, p. 226; S. Adams 1987, p. 101;
Curry 1987, p. 81, n. 37; Lloyd-Jones 1987,
p. 8; Soros 1987, pp. 57–65, 142–44, pls. 48,
49; Walker and Jackson 1987, pp. 77–78; N.
Wilkinson 1987, pp. 303–5; R. Spencer 1989,
p. 196, pl. 66; Broun 1990, p. 54, fig. 49;
Paolini, Ponte, and Selvafolta 1990, pp.
355–58; Banham, MacDonald, and Porter
1991, pp. 115, 116, 153, fig. 120; Hudson
1991, p. 59; Ikegami 1993, fig. 96; Anderson
and Koval 1994, p. 211; Gruber 1994, p. 244;
Koval 1994, p. 60, pl. 57; Bendix 1995, pp.
97, 150, 156–57, 164–66, fig. 58; Lambourne
1996, p. 64; MacDonald 1997, p. 309; Soros
1999, pp. 205, 255–56, fig. 8-45

This cabinet, known as the "Butterfly
Cabinet," was one of the most publicized
pieces of furniture of the 1870s and was the
main feature of the William Watt stand at
the 1878 Exposition Universelle in Paris.
The original design for it is inscribed "Watt
Paris 22 Sep '77" (Fig. 369.1).

The Japanese cloud motifs and butterflies
on a gold ground were designed and painted
by James McNeill Whistler (Godwin's diary
records that William Watt paid Whistler
£50 for the decoration in October 1877).[70]
According to correspondence between
Godwin and Whistler, Whistler had to do
some repainting of the cabinet later that
year because of the "blundering of Mr.
Watt's men."[71]

The "Butterfly Cabinet" was one of the
largest pieces of furniture Godwin ever
designed, perhaps due to its role as an
exhibition piece. A surviving photograph
from the Exposition shows the "Butterfly
Cabinet," flanked by a wicker side chair and
occasional table, at the entrance to William
Watt's display, which was called a
"Harmony in Yellow and Gold" (see
Fig. 51). The gold-and-yellow painted
decoration corresponded to the yellow
fireplace tiles, brass grate and fender, and
the *kaga* porcelain which, with its yellowish
highlights, was displayed on the cabinet's
open shelves. The side chair was
upholstered in yellow velvet with yellow
fringes, and a brownish yellow carpet
covered the floor. The entire suite was
listed in the official catalogue, under the
heading of William Watt, as: "Drawing
Room Furniture, the Butterfly Cabinet and
fireplace, sofa, centre table, music bookcase,
coffee table and two chairs designed by
E. W. Godwin F.S.A. Decorating in yellow
and gold designed and painted by
J. A. McNeill Whistler. Esq." Elizabeth
and Joseph Pennell, Whistler's biographers,
believed that this mantelpiece/cabinet unit
was designed for the White House in
Chelsea.[72] This seems unlikely, since after
the Exhibition the cabinet was returned to
the Gower Street showroom of William
Watt, where it was converted to a cupboard
by covering the grate with a pair of doors
featuring matching painted decoration
taken from the dado. Furthermore, a
reporter in *Artist* commented on it still
being for sale in Watt's showroom four
years later.[73]

The cabinet's horizontal orientation
counterbalances the strong vertical design,
and Whistler's abstract decoration provides
a degree of animation to what is otherwise a
ponderous and massive piece of furniture.
The use of painted decoration on cabinets
was common, being part of the fashion of
the 1860s and 1870s,[74] and the broken
pediment and dentiled cornice are typical of
Queen Anne-style furnishings of the 1870s.

369.1 "Watt Paris 22 Sep '77" (V&A PD E.229-
1963, fol. 73)

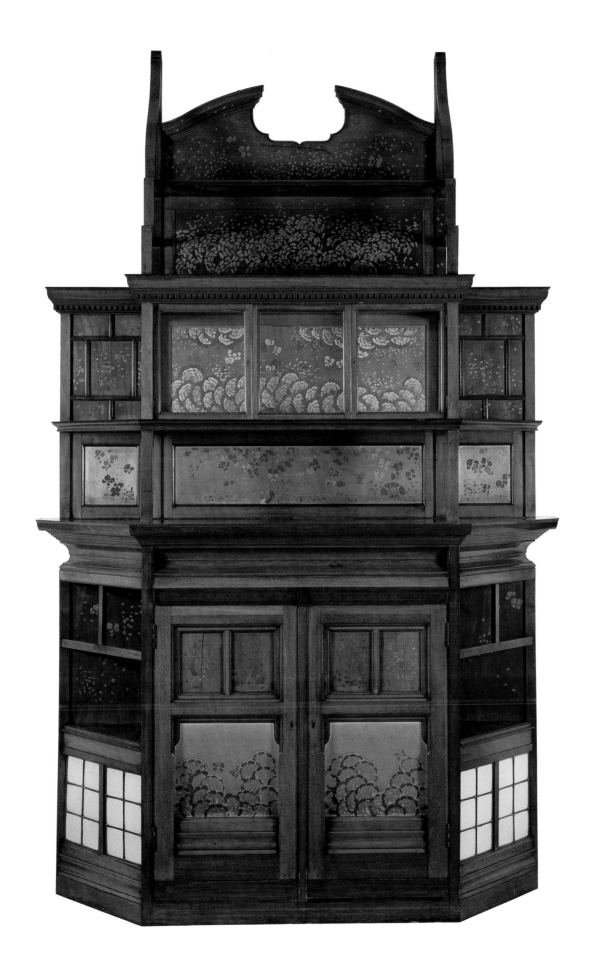

369

370. *Wardrobe*

Ca. 1878

Made by William Watt

Ash; brass handles and fittings

84 × 64 × 25½ in. (213.4 × 162.6 × 64.8 cm)

Stamped along edge of long drawer:

W Watt 26 Grafton Street Gower Street, London, W1

A. R. Kennard, 1937; Victoria and Albert Museum, London (W. 75-1982)

Literature: Aslin 1986, p. 72, pl. 47

This multipurpose wardrobe is the largest and most elaborately decorated of all of Godwin's identified wardrobes. Among the notes in his sketchbook dating from 1878–79 (V&A PD E.248-1963, fol. 42), a list of furniture for an unidentified client includes a "Wardrobe ash 14/1/" with a corresponding ash dressing table and washstand with glass, possibly referring to this wardrobe. Ash was commonly used by William Watt for more expensive bedroom furniture (the less expensive pieces were made of deal or pine).

The wardrobe's carved decoration of petaled flowers and diamond shapes, as well as its classically inspired frieze of vertical lines interspersed with floral forms, and highly figured ash veneers on the doors and drawer fronts make this wardrobe a very showy piece. The petal design is continued in the rosette-shaped back plates that hold the ribbed bail handles.

Although this piece is larger and more elaborate than other Godwin wardrobes, it shares with them the asymmetrical, multipurpose form that Godwin pioneered. This form was especially fashionable in the 1880s.[75]

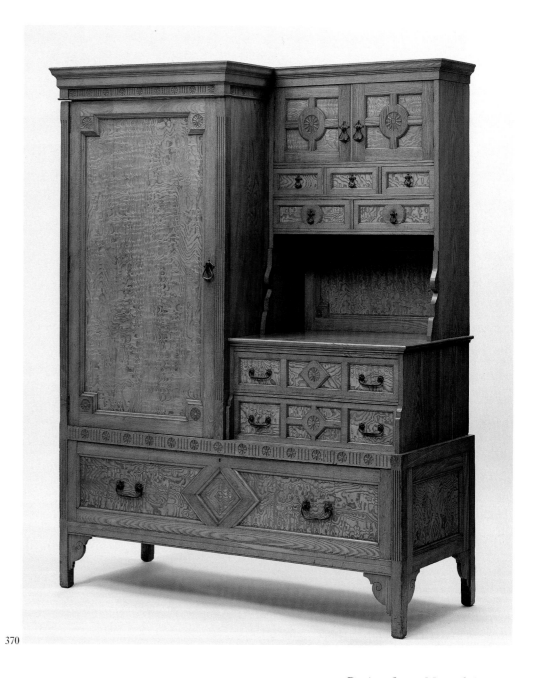

370

371, 372. *Design for a Mantelpiece and Corner Cabinet*

Literature: Soros 1999, pp. 207–08, fig. 7-34

Godwin designed the mantelpiece and corner cabinet depicted in this drawing (V&A PD E.548-1963) in 1878 for the dining room of James McNeill Whistler's White House.

The mantelpiece had rows of square tiles, which framed the opening, and a Greek dentiled cornice. Tiers of panels flanked the vertical rows of tiles – the top tier was a looking glass and the bottom two were paneled. The overmantel was composed

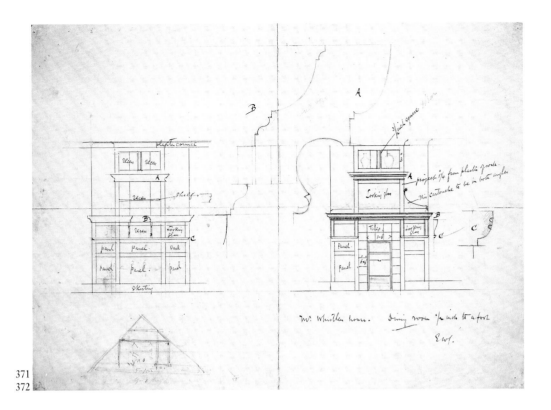

371
372

of a rectangular mirror framed by two cartouches. Surmounting the mirror was a Greek cornice on which rested a two-door cupboard for porcelain display. The corresponding corner cabinet designed for Whistler's dining room shows the same rectangular panels with the upper two of mirror glass. Recesses provided for the display of porcelain.

Significantly, the overall form of the mantelpiece resembles the cabinet-mantelpiece that Godwin designed and Whistler decorated for the 1878 Exposition Universelle in Paris (CR 369).

373. *Design for a Hanging Cabinet*

Literature: N. Wilkinson 1987, p. 320; Soros 1999, pp. 207–09, fig. 7-35

This drawing shows the hanging cabinet that Godwin designed for Whistler's White House in 1878 (V&A PD E.550-1963). It is annotated "Mr. Whistlers House . . . Tite Street Chelsea. EWG."

The cabinet consists of tiers of open shelves that flank a central cupboard with paneled doors. There are cornices above and below the cupboard, the top one with upturned ends, and the bottom one serving as a divider between the cupboard and a drawer, somewhat wider, beneath. Uprights run from the bottom shelves, which are placed lower than the drawer, through the cornice surmounting the cupboard. The uprights are capped with a third cornice, narrower than the other two and centered above them, which forms a boxlike frame suitable for a mirror or painting.

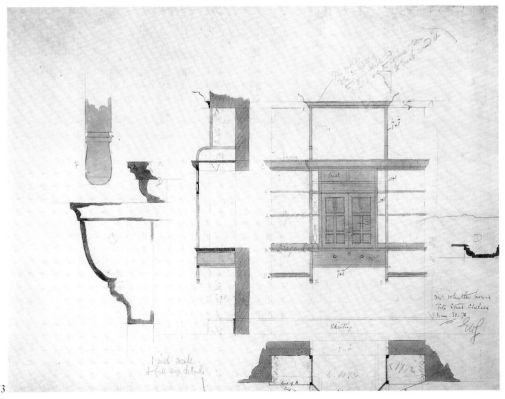

373

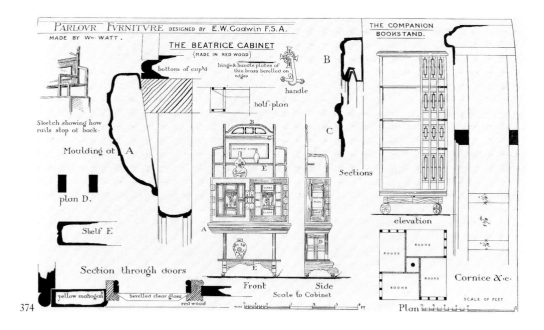

374. *"Beatrice Cabinet"*
1879
Made by William Watt
Dimensions unavailable
Whereabouts unknown

Literature: "Parlour Furniture," 31 October 1879, p. [531]; Aslin 1986, pp. 24, 61, fig. 11

A colored drawing of this cabinet on stand appears in one of Godwin's sketchbooks (Fig. 374.1) with the annotation "Watt, Beatrice Cabinet on Stand. Watt Sep. Paid." It is probably one of the two pieces listed in Godwin's ledger entries for Watt from May and June 1879 (V&A AAD 4/2-1980). Godwin named the cabinet after his wife Beatrice, who painted its panels, each representing one of the four seasons.

The mahogany cabinet was illustrated in *Building News* in 1879 where it was praised as "a bright and elegant piece of furniture" for the parlor.[76] A comparison of this illustration with the colored drawing, however, reveals that Watt had made a few subtle changes to Godwin's original design. For example, the protruding medieval runner feet were replaced with an arched plinth with crossed spindles. The curved vertical rails that connect the top and bottom of the piece add Asian details to this medieval form. The addition of the lower open shelf allowed for the accommodation of extra objects of art or ceramic ware.

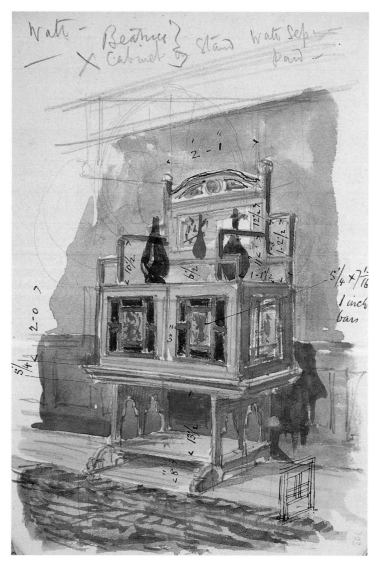

374.1 Design for the "Beatrice Cabinet" (V&A PD E.233-1963, fol. 103)

375. *Design for a Chest of Drawers*

Literature: Soros 1999, pp. 212–13, fig. 7-39

This detailed drawing shows the chest of five drawers that Godwin designed to sit under the stairs of the studio at Frank Miles's house/studio at 44 Tite Street, London, in 1878 (V&A PD E.570-1963). The drawers are made of Honduran mahogany with pairs of bail handles regularly aligned on the left side but staggered on the right side of the piece to correspond to the graduated right side of the cabinet. The chest stands on thin splayed legs and has a bottom display shelf instead of an extra drawer for more flexible storage capability. This chest of drawers no longer exists at 44 Tite Street.

375

376. *Design for a Sideboard*

Literature: "A Dining Room Sideboard," 15 October 1880, p. 442

This "Sideboard for a Dining Room," made by William Watt, appeared in *Building News* in 1880, where it was described as "an ordinary piece of furniture, with useful cupboards, drawers, and shelves."[77] It has plain paneled cupboard doors, Egyptian-inspired molded turned legs, and a superstructure supported by three columns with a cornice composed of two extended Queen Anne-style broken curves. The superstructure, which includes a rectangular looking glass, is not well integrated with the cupboard section. Decoration is limited to a small molding of carved floral ornament on the mirror frame and some nondescript carved side panels. Although Godwin designed many superb sideboards during his career, this one is so ordinary it prompted a reviewer to write: "little really remains to be said."

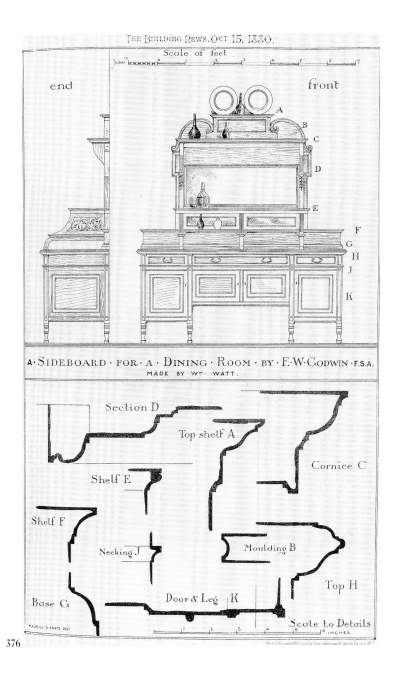

376

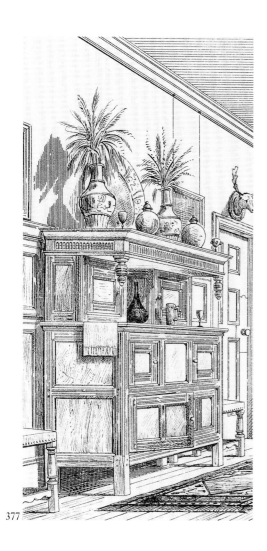

377

377. *Design for a Sideboard*

Literature: "Shakespeare Dining-Room Set," 11 November 1881, p. 626

This oak sideboard, which was illustrated in *Building News* in 1881,[78] was part of the "Shakespeare Dining-Room Set" that Godwin designed for William Watt. It was registered with the Patent Office in London on 14 November 1881 (no. 372557) where a colored sketch for it still exists (Fig. 377.1).

In overall form the sideboard resembles the court cupboards of the sixteenth century. Godwin has simplified the decoration by eliminating the customary floral carving and inlay work and the turned cup-and-cover balusters, instead providing reeded panels and a pair of simple turned supports. He also reduced the scale of the form to accommodate smaller nineteenth-century rooms of modern living, and elevated the bottom section high above the floor to facilitate cleaning underneath.

377.1 "The Shakespeare Sideboard" (Public Record Office)

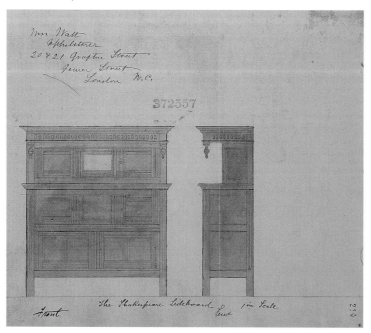

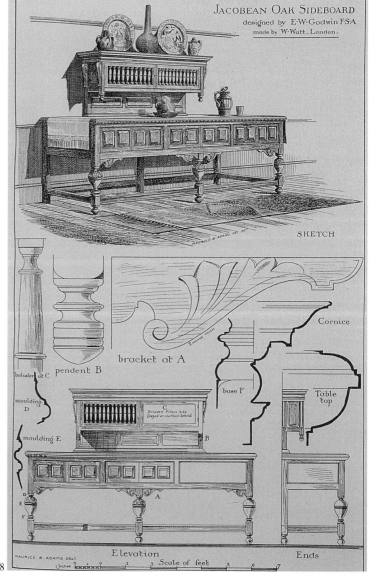

378

379

379. *Design for a Double Wardrobe and Chest of Drawers*

Literature: Soros 1999, pp. 214–15, fig. 7-43

This sketch depicts "two wardrobes & chest of drawers . . . with outside framing . . . of Honduras [*sic*] mahogany, . . . all the rest to be done of pine" (RIBA DC Ran 7/J/5). These pieces were designed by Godwin in 1882 for the master bedroom of Hermann Vezin's house in London at 10 Lancaster Place, Westminster; the cabinetwork was done by C. Greaves of 40 Queens Road, Chelsea. A related, roughly worked sketch for these cabinets, which probably represents an earlier design, is in the Victoria and Albert Museum (V&A PD E.257-1963, fol. 49).

These Sheraton-style wardrobes were unusual in that they were angled to fit into the corner of the bedroom. The decoration was quite modest, with reeded moldings, paneled doors, and a curved apron at the bottom of the chest of drawers.

Of particular interest here is the annotation, which reads, "This top piece to be screwed to the ceiling line and the wood ceiling of wardrobe to be fitted against top as to get as much height as possible in wardrobe." Previous wardrobe specifications stressed modest height dimensions and movability for easy access for cleaning. This piece might represent another design solution for a sanitary environment – fitted furniture schemes, particularly in bedrooms.

378. *Design for a Sideboard*

Literature: "Jacobean Oak Sideboard," 15 May 1885, p. 766

This oak sideboard appeared in *Building News* in 1885 as a "Jacobean Oak Sideboard by E. W. Godwin" made by William Watt, and the accompanying review praised the spacious design for establishing "a character of hospitable comfort so necessary in every well-appointed home."[79] Its cupboards, however, were described as being "perhaps too low in proportion for their depth to be really convenient and as drawers they would be necessarily deep."[80]

Overall the sideboard resembles the English open high dresser form of the seventeenth and eighteenth centuries.[81] This particular piece was one of the larger Jacobean-style pieces designed by Godwin, who stayed close to Jacobean prototypes not only in terms of material and scale but also in decoration and motifs. The baluster turned front legs sitting on bun feet and the low, continuous stretcher, the narrow, straight rear legs and pendant-shaped finials, the row of turned balusters, the dentiled molding and molded panel cupboard doors, and the acanthus-leaf brackets are all design elements common to Jacobean furniture. Godwin has even

illustrated the traditional fringed linen runner on the lower cupboard section.

The upper section is fitted with cupboards and has a top shelf for the display of pottery and works of art.

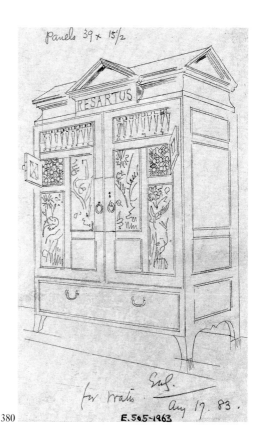

380

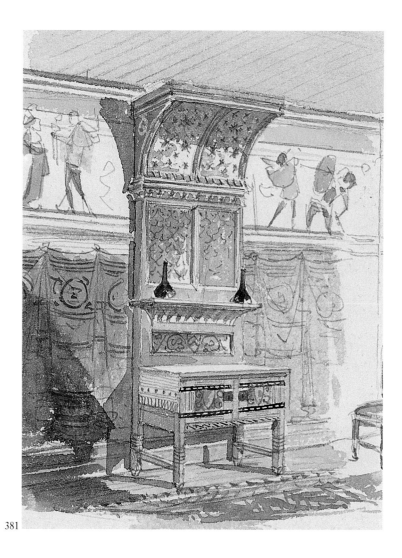

381

380. *Design for a Double-sided Wardrobe*

This double-sided wardrobe is known from a drawing annotated "EWG for Watts Aug 17. 83" in one of Godwin's sketchbooks (V&A PD E.505-1963). Sheraton influence is apparent in the shaped bracket feet, valanced side apron pieces, the pair of U-shaped bail handles on the bottom drawer, and the cabinet's overall configuration. Decorated panels of stylized Anglo-Japanese floral work, rows of turned balusters, and inscribed lettering set this piece off as part of the Art Furniture movement of the 1870s and 1880s. The classically shaped balusters, for example, are of the type Godwin favored on seating forms in the 1870s (CR 129).

A pair of faux cabinet doors open to reveal not niches but carved panels, a novel decorative addition.

381. *Design for a Cabinet*

This watercolor of a painted cabinet is annotated "EWG Early 15th century" in Godwin's own hand (V&A PD E.378-1963), and is probably his sketch for the English fifteenth-century room that he designed for the William Watt display at the exhibition of furniture sponsored by the Royal School of Art Needlework, South Kensington, in February 1884.[82]

The cabinet's heavy, solidly joined construction, thick quadrangular legs extending from the stiles, coved cornice, and metal strap handles all emulate fifteenth-century specimens. The abundance of painted decoration, the incorporation of heraldic shields on the cupboard doors, and the star motif on the coved cornice continue the fifteenth-century theme and reflect Godwin's thorough knowledge of Gothic painted motifs.

382

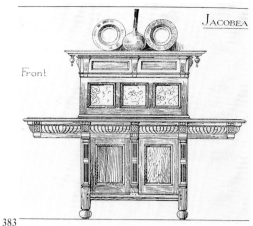

383

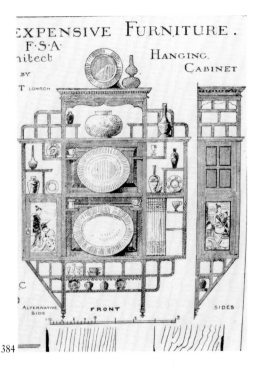

384

382. *Design for a Sideboard*

Literature: Soros 1999, p. 217, fig. 7-45

The sideboard depicted in this pen-and-ink drawing on paper, annotated "Oscar Wilde" with various measurements (Hyde Collection, New Jersey), is part of an entire suite of white furniture that Godwin designed in 1884–85 for Oscar Wilde and his wife Constance, for their new house at 16 Tite Street, London. It is a complicated storage piece of asymmetrical design, 6 feet 8 inches high and 7 feet 9 inches wide. The upper structure has paneled cupboard doors, extended side brackets, and a flat architectural cornice. The lower section has a combination of drawers, cupboards, and open compartments with reeded moldings. It is supported high above the floor by rounded tapering legs that are extensions of the side stiles. The flat cornice, which is meant to be a bit higher than the picture rail, doubles as a shelf for displaying the large pieces of blue-and-white and yellow porcelain that decorated the room.

383. *Design for a Sideboard or Buffet*

Literature: "Jacobean Suite of Dining Room Furniture," 14 March 1884, p. [406]

This sideboard or buffet was part of a suite of Jacobean dining-room furniture that appeared in *Building News* in 1884. It was part of the William Watt stand at the Art Furniture Exhibition at the School of Art-Needlework, South Kensington. The buffet has an unusual "extended table top or board projecting considerably on either side, and the back . . . is surmounted by a wide cornice shelf for the display of decorative ware."[83] In keeping with the Jacobean theme, the shelf has a heavily gadrooned edge, the cabinet sits on bun feet, and turned pendants are attached to the cornice shelf.

384. *Design for a Hanging Cabinet*

Literature: "Working Drawings," 18 December 1885, p. 1011, ills.

This hanging cabinet is part of a group of inexpensive furnishings executed by the representatives of the late William Watt. Although an extant example is not known, it appears in *Building News* in 1885, where it was described as being "well adapted to the suitable display of works of art and Ceramic ware, . . . made in ebonised wood, with panels fitted with Japanese designs, the whole being conceived somewhat in that manner or style of wood treatment."[84]

The overall style of the cabinet is Anglo-Japanese, with staggered shelves, rounded elbow struts, and brass-tipped bottom finials. Panels with reeded outlines, one depicting kimono-clad figures and one of pleated fabric, give this piece an overtly Japanese quality. With its complicated play of solid and void and its bizarre asymmetrical combinations around a decidedly central axis, this is one of Godwin's most intricately designed hanging cabinets. Despite its enormous capacity for displaying a wide variety of different sized ceramic wares, however, it is one of Godwin's most over-designed and least appealing forms.

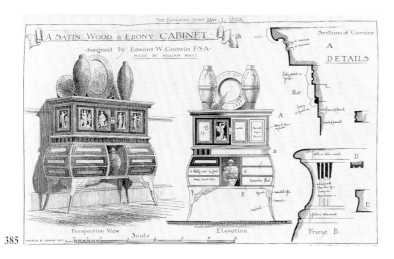

385

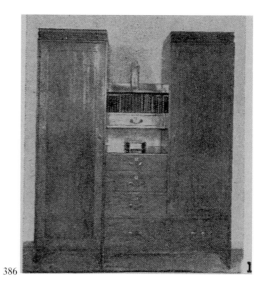

386

385. *Design for a Cabinet*

Literature: "Satinwood and Ebony Cabinet," 1 May 1885, p. 686, ill.

This satinwood and ebony cabinet made by William Watt, known only through a description and illustration in *Building News* in 1885, is decorated with panels of classical figures, inset within metal frames, that were painted in "black and white by Mr. Godwin."[85] The classical theme continues in the outward-curving saber legs adorned with metal winged shields. The colors of the satinwood and ebony recall the Greek black-and-red-figure vases that Godwin studied in the British Museum.

The bombé form is unusual for Godwin, although one of his sketchbooks from the 1870s contains a drawing for a chest of drawers with convex outline (V&A PD E.233-1963). The upper cupboard section is attached to the lower by a waisted area inlaid with thin lines of ivory or sycamore. Particularly inventive in this design is the incorporation of a central niche between the two nests of drawers.

386. *Wardrobe*
Ca. 1885
Made by William Watt
Pine with brass handles and fittings
Dimensions unavailable
Ian Hamilton; whereabouts unknown

Literature: Pevsner 1952a, p. 125

This multipurpose wardrobe was illustrated in *Architectural Review* in 1952.[86] At that time it was in the possession of Ian Hamilton, who believed it was purchased as late as 1886 from William Watt's shop, as part of a suite of bedroom furniture. It is composed of an asymmetrical section of combined chest of drawers and hanging compartment, with an extra hanging section to the left of the piece. Typical of Godwin's complex wardrobe designs, the nest of drawers and upper shelf provide an area for book storage and double the amount of suitable display surface. The modular capability of these pieces was first demonstrated in the wardrobe currently in the Bristol Museums and Art Gallery (CR 307) and is evident in this piece, his last known wardrobe.

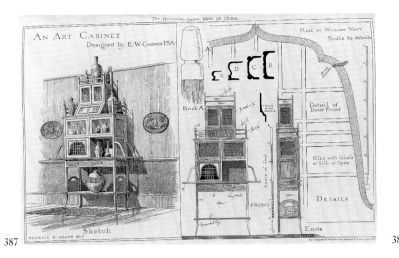

387

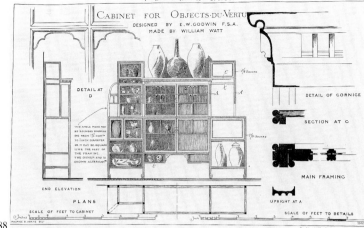

388

387. *Design for an Art Cabinet*

Literature: "Art Cabinet," 19 March 1886, p. 456; Aslin 1986, pp. 24, 59, fig. 7

This illustration from *Building News* in 1886[87] is a reworking of an earlier Godwin design for an Anglo-Japanese cabinet for William Watt's stand at the 1878 Exposition Universelle in Paris (V&A PD E.233-1963, fol. 83). The accompanying review in *Building News* indicates that the cabinet was "intended for the display of works of art in a drawing room or boudoir."[88] The bell-shaped latticed windows, cloud-shaped openings in the lower side panels, and the square-shaped knob finials all point to Japanese sources. With the addition of a high superstructure, this cabinet closely resembles Godwin's "Four Seasons Cabinet" in the Victoria and Albert Museum (CR 344); however, here Godwin has eliminated the painted panels, one of the bell-shaped windows, and one of the shelves in the lower cabinet section, and has opened the side panels.

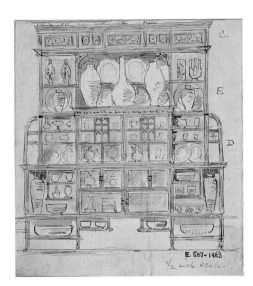

388.1 Design for a display cabinet (V&A PD E.507-1963)

388. *Design for a Cabinet for* Objets de Virtu

Literature: "Cabinet for Objects Du [sic] Virtu," 5 March 1886, p. 376.

This cabinet, one of the last pieces of furniture Godwin designed (for the representatives of the late William Watt), was reproduced in *Building News* in 1886 as a design "for the purpose of exhibiting works of art, and the display of articles de virtu."[89]

Japanese sources are still apparent in this late design, for example the incurving feet, reeded panels in imitation of bamboo, and staggered shelves. As in many of Godwin's later pieces, the arrangement of spaces and voids is more playful. The reeded stiles, however, reinforce the cabinet's rectilinear construction. To counterbalance the cabinet's almost gridlike compartments, Godwin has introduced rounded elements such as incurvate feet, a shaped arch in the center of the skirt, an angled piece at one side, and a series of valanced arches in the two upper central cupboards.

There is a related drawing in one of Godwin's sketchbooks of a display cabinet (Fig. 388.1). The Jacobean-style cornice evident in this drawing was eliminated in the version published in *Building News*.

MISCELLANEOUS PIECES

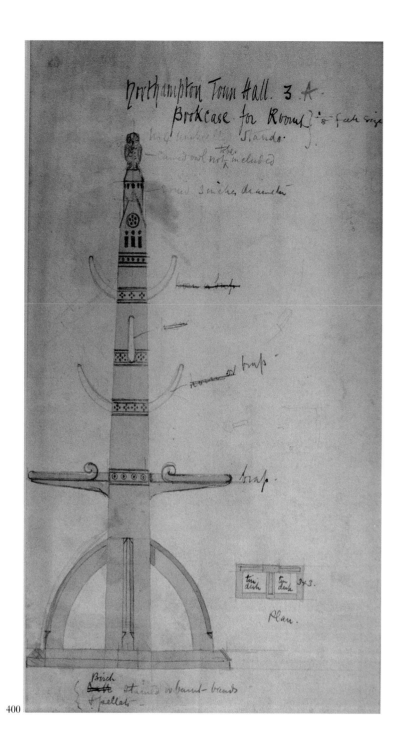

400

401.1 Design for a reading stand
(V&A PD E.502-1963)

400. *Design for a Hat and Umbrella Stand*

Literature: Aslin 1986, p. 11, 23, 65, fig. 1.

This whimsical design for a hat and umbrella stand for Godwin's Northampton Town Hall commission dates from ca. 1863 (V&A PD E.622-1963). It is not known whether it was executed. The drawing is annotated with details for the manufacturer such as carved owl not to be included and stained birch. Godwin adapted a Gothic tower for use as the central support. Punctuated with bands of Gothic-Revival ornament such as quatrefoils and discs, it rests on a plinth base with circular supports. Hats could be suspended from a series of upturned brass brackets attached to the central form.

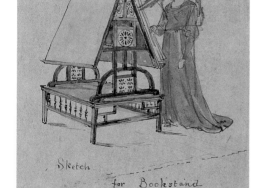

401. *Easel*

Ca. 1870
Probably made by William Watt or
Reuben Burkitt
Ebonized wood; tooled leather; brass
fittings
$65\frac{3}{4} \times 35\frac{7}{8} \times 52$ in. ($167 \times 91 \times 132$ cm)
Sotheby's, London, 21 October 1988, lot
116; Fine Art Society, London; Mitchell
Wolfson Jr. Collection, The Wolfsonian-
Florida International University, Miami,
Florida (TD1989.149.2)

Literature: Fine Art Society 1989, fig. 59;
Soros 1999, pp. 244, 246, fig. 8-43

Easels were among Godwin's favorite pieces
of drawing-room furniture. His own
drawing room had "light, easily movable
easels of different choice woods to hold
choice drawings, and easel pictures occupy
the centre of the floor."[1] Although Godwin's
sketchbooks contain no designs for easels,
there is one for a reading stand (Fig. 401.1)
that shares many features with the
Wolfsonian easel: turned balustrade, pierced
lattice brackets, square-sectioned legs
curving inward at the bottom of the feet,
molded frame, and pierced floral decoration
in the openwork section toward the top of
the easel. The gilt leather decoration
matches that on the chairs Godwin designed
for Dromore Castle (CR 112, 113) and may
indicate the same provenance. The curled
feet – which can be found on the series of
hallway bookcases designed for Dromore
(CR 311) as well as the dining-room buffet
(CR 313) – also relate this piece to the
Dromore commission. It is possible,
therefore, that the mahogany easel shown
here was the one originally in the drawing
room at Dromore Castle that sold in 1949.[2]

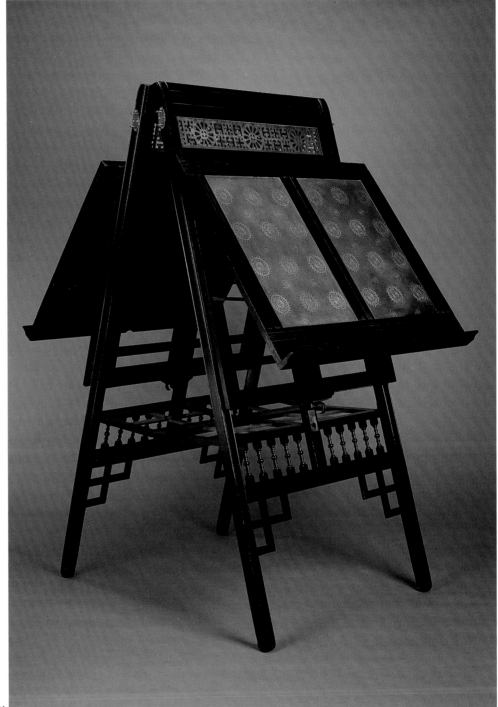

401

402. *Whatnot*

Ca. 1870, attributed to E. W. Godwin
Maker unidentified
Mahogany
$80\frac{7}{8} \times 23 \times 8\frac{3}{4}$ in. (205.5 × 58.3 × 22.2 cm)
Sir Henry Irving; Ellen Terry; by descent
to her daughter Edith Craig; by bequest to
The National Trust, Ellen Terry Memorial
Museum, Smallhythe Place, Kent
(SMA/F/82)

Whatnots – shelf stands for the display of a
variety of objects – came into existence at
the beginning of the nineteenth century.
They were rectangular, with two or three
shelves supported by corner columns, often
fitted with one or two drawers, and usually
made of mahogany.[3] This whatnot is the
only surviving example of this form
designed by Godwin, and it is unusual in
that it is taller than most and has more
tiers, or shelves. The reeded edges of the
shelves, the varied turnings of the supports,
and the turned columns that fit into rectan-
gular supports are typical of Godwin's
designs for Dromore Castle in 1869,
particularly his designs for dining room
chairs (CR 112; 113). Godwin did design
similar whatnots for Dromore, with reeded
shelves and turned columns, as can be seen
in a drawing for that commission (Fig.
402.1).

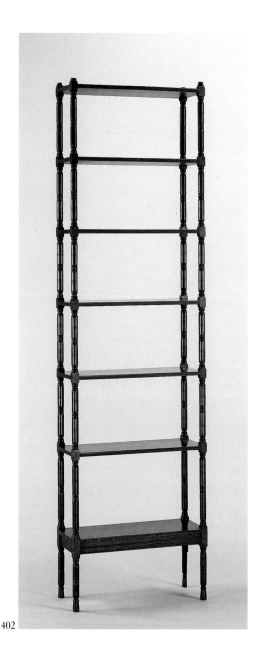

402

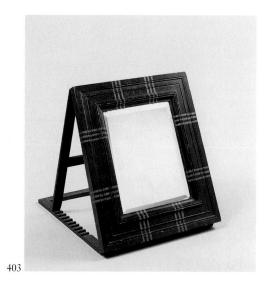

403

403. *Standing Mirror*

Ca. 1870
Made by William Watt
Ebonized wood; beveled mirror glass
$15\frac{3}{4} \times 14\frac{1}{4} \times 1\frac{5}{8}$ in. (40 × 36 × 4 cm)
Enameled metal William Watt label
attached to back of mirror
Paul Reeves, London; Private collection

This small paneled mirror is the only
standing mirror to be attributed to Godwin.
With its beveled glass insert and its notched
stand – allowing it to be adjusted for
different viewing angles – it probably was
designed to sit on a dressing table. In
overall form it resembles the square ebony
mirrors and frames popular in the
Netherlands in the second half of the
seventeenth century.[4] The decorative gold
striping adds an exotic element to this
traditional form, and is in keeping with
Godwin's use of gold lines on his ebonized
furniture to make the pieces less somber.
The William Watt label affixed to its back
strongly supports the attribution to
Godwin.

402.1 Design for a whatnot for Dromore Castle
(RIBA Ran 7/B/1 [53])

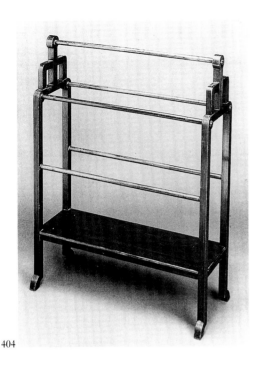

404

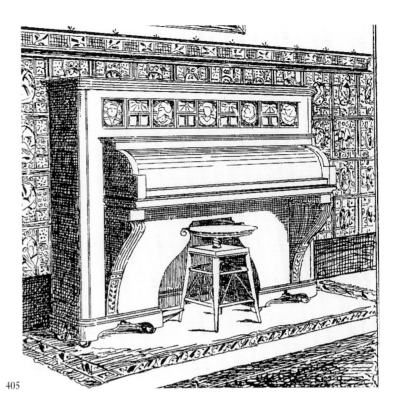

405

404. *Towel Horse*

Ca. 1872–75, attributed to E. W. Godwin
Possibly made by Collinson and Lock
Mahogany
37⅝ × 29⅛ × 10⅝ in. (95.5 × 74 × 27 cm)
Stamped: L13500
Christie's, London, 16 February 1994,
lot 39; Private collection

Towel horses, usually designed to stand
alongside wash basins, were popular forms
in the eighteenth and nineteenth centuries.
The one shown here displays many design
features found on other Godwin pieces,
such as a bottom shelf set well above the
ground, reeded decoration, curved lattice
supports, five turned rails with rosettes, and
curved feet. In a letter to Collinson and
Lock dated July 1872 Godwin mentions
work on a commission for a washstand; he
adds, "Towel Horse if not part of it" (V&A
AAD 4/9-1988), suggesting that washstands
and towel horses were at times designed as
companion pieces.

405. *Design for a Piano*

This walnut piano appears in William
Watt's *Art Furniture* under "Drawing Room
Furniture" (1877; Plate 12) and cost
£45.0s.0d. The design is based on an earlier
drawing, signed "EWG Oct. 1872," (RIBA
Ran 7/N/13) and annotated "Lower Paper
(The Kane Paper)," indicating that some
of its insets might have been filled with
embossed Japanese paper, like Godwin's
sideboard in the Victoria and Albert
Museum, London (CR 304-b).

Godwin was unhappy with the
illustration in the *Art Furniture* catalogue,
which he felt misrepresented the piece:
"The illustration of the piano is unfor-
tunate, as it gives this design a heavy look,
more like stone than woodwork. This,
however, is not the case in reality" (p. vii).

406. *Design for a Grand Piano*

This drawing from Godwin's sketchbooks for a Jacobean-style grand piano represents a commission from Collinson and Lock in 1873 (V&A PD E.501-1963). A related entry in Godwin's cashbooks for 22 August 1873 shows he received a design fee of £3.3s.0d for a grand piano (V&A AAD 4/13-1980, fol. 17).

The piano is standard in form except it has an elaborate pair of built-in candelabra, each of which is designed to hold three lights. The front and back supports, joined by a long stretcher, are baluster turned and each has a row of turned spindles at the top. Parts of the piano case are decorated with carved panels of abstract design.

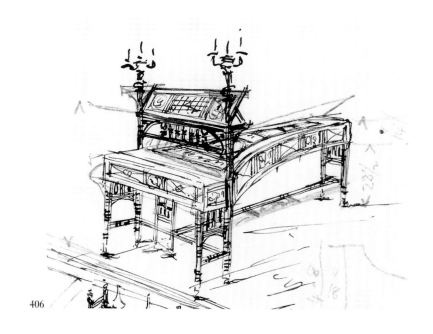

406

407. *Design for a Piano*

Literature: "Piano Case," 2 January 1874, ill, p. [10]; "Design for a Piano Case," 9 January 1874, p. 54; "Furniture Manufacturer," 16 January 1874, p. 81; "Design for a Pianoforte," 23 January 1874, p. 10.

This piano was reproduced in *Building News* in 1874 for Collinson and Lock. The detailed illustration reveals that the piano case was made "in polished white deal with cedar panels and ebony mouldings."[5] It had stamped leather panels, a convex mirror, and elaborately carved lozenge-shaped side panels.

This was one of Godwin's most controversial designs, criticized by reviewers for incorporating elements that sacrificed function – its high arched central opening and the relocation of the footpedals, as well as the extreme height of its reading shelf.

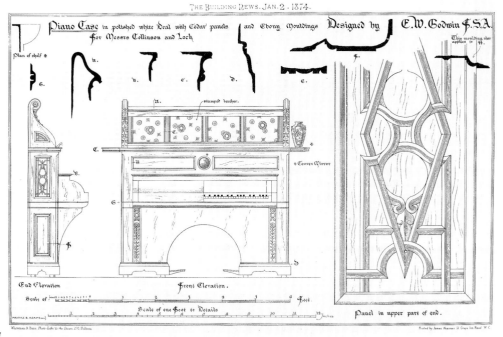

407

408. *Gong and Stand*

Ca. 1875
Possibly made by William Watt
Oak and iron frame; bronze gong;
wood hammer
$32\frac{1}{2} \times 17\frac{3}{4} \times 17\frac{1}{8}$ in. (82.6 × 45.1 × 43.5 cm)
Phillips, London, 13 October 1992, lot 255;
H. Blairman and Sons, London; National
Museums and Galleries on Merseyside
(WAG 1994.17)

Literature: Gere and Whiteway 1993,
p. 156, pl. 193; National Art-Collections
Fund 1994, no. 4043; Soros 1999, no. 1, pp.
82, 235, fig. 3-15

Gongs are a part of Buddhist temple
furniture in East Asia and this one is based
on a drawing in one of Godwin's sketch-
books (Fig. 408.1). Its top rail or lintel
based on the *tori* gates of Shinto shrines
and the riveted brass edge covers at its top
add to the unmistakable Japanese style of
this piece. It is apparent that Godwin
studied such architectural elements from
contemporary photographs and books on
Japanese architecture,[6] and his article on
Japanese wood construction in *Building
News* (12 February 1875) contains illus-
trations of similar gates. The latticework
toward the bottom of the stand is another of
Godwin's adaptations of Japanese archi-
tectural elements – taken from Japanese
balustrades – and can be found in his

408.1 Sketch for a gong (V&A PD E.486-1963)

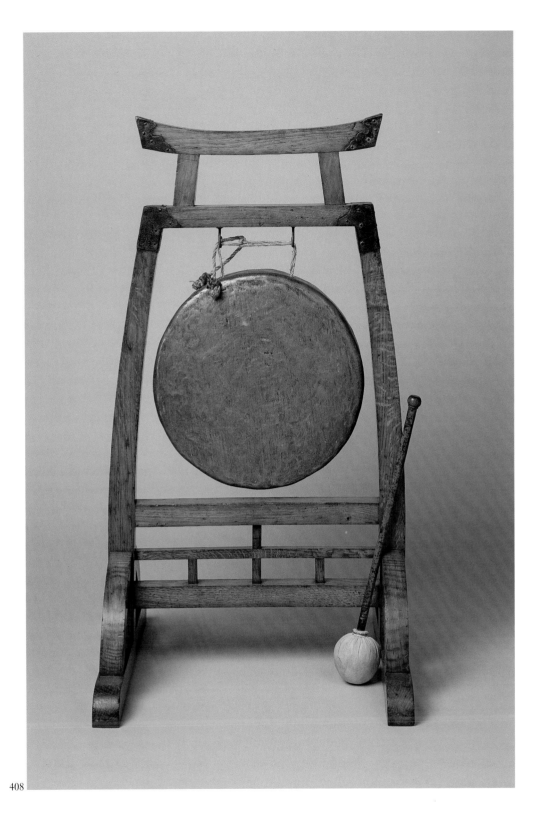

408

sketchbooks as well (Fig. 408.2). Despite these East Asian influences, Godwin's appreciation for medieval forms is revealed in the circular brackets supporting this stand that recur frequently in his Gothic-Revival pieces, such as the bookcases he designed for Dromore Castle (CR 311).

East Asian gongs were popular in England in the nineteenth century and Godwin was not the only designer in England to develop a western model: the printers Wyman and Sons illustrated two gongs with similar medieval framing both in their *Cabinet Makers' Pattern Book* (1877) and in a later supplement (1886), and the cabinetmakers Charles and Richard Light highlighted a series of gongs in their *Cabinet Furniture: Designs and Catalogue of Cabinet and Upholstery Furniture* (1881).[7]

409

410

408.2 Sketch of Japanese architectural details (V&A PD E.280-1963, fol. 2)

409. *Design for a Folding Screen*

This four-paneled folding screen is illustrated in William Watt's *Art Furniture* under the heading "Furniture &c Various" (1877; Plate 2). Screens were a popular accessory in the Victorian home (when Asian goods were the rage), but this is the only surviving design by Godwin.

The screen was six feet high and came in walnut (which cost £18.18s.0d) and oak (which cost £21.0s.0d). Panels with Anglo-Japanese bird and floral motifs provide the main decoration, and latticework insets at the top of the panels as well as bamboo reeded sections continue the Japanese theme. An arched opening decorates the bottom of each panel.

410. *Design for a Corner Bracket*

Corner brackets and corner cabinets, pieces intended for room corners, were a design feature of the Art Furniture movement. This walnut corner bracket is reproduced in William Watt's *Art Furniture* (1877; Plate 16), where it is shown supporting a vase of flowers and mounted at the top of the chair rail. The bracket was part of Godwin's series of "Economic Furniture" for the parlor and sold for £1.1s.0d.

This bracket and its three curvaceous elements provide an elegant setting for ceramic ware in the parlor.

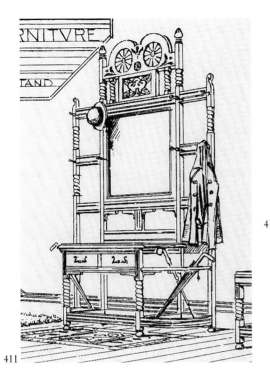

412

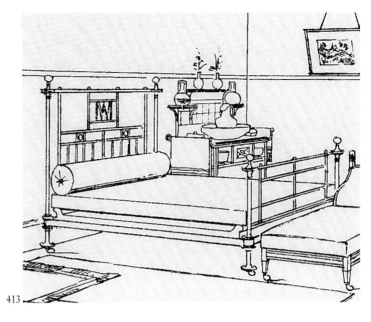

413

411. *Design for a Hat and Coat Stand*

This hat and coat stand, which is four feet tall, appears in William Watt's *Art Furniture* under "Hall Furniture" (1877; Plate 2). Derived from "Old English" woodwork (p. vii), Godwin had it made in oak for the sum of £18.18s.0d.

The stand's bobbin-turned rails, carved cornice roundels and floral panel, heavy fluted moldings, acorn-shaped finials, and small bun feet all add to the sturdy appearance of this small stand. Godwin limited the potential heaviness of the piece, however, by including a large rectangular mirror and piercing much of the stand's framework. The pair of arched brackets beneath the mirror frame and a pair of outward-turning rails at either side add a graceful touch. The stand is shown with a corresponding side chair (CR 153), which was also available.

412. *Design for a Workstand*

Workstands were used by women in the nineteenth century for sewing and needlework. This mahogany model is reproduced in William Watt's *Art Furniture* as part of Godwin's suite of "Jacobean Furniture" (1877; Plate 17); it sold for £4.4s.0d.

The top of the stand has a molded edge and the four legs are long and tapered. Godwin used the same rotating swivel mechanism for this piece as he had for his piano stools (see CR 154), although here the mechanism is used to adjust the height of the work surface rather than the seat. The main section has a rectangular well with latticed sides, which was used to store sewing materials and accessories.

413. *Design for a Brass Bedstead*

This brass bedstead is reproduced in William Watt's *Art Furniture* (1877; Plate 15) and was available in four widths: 3 feet 6 inches (£8.0s.0d); 4 feet (£8.4s.0d); 4 feet 6 inches (£8.8s.0d); and 5 feet (£8.12s.0d). The bed, with its foot and head boards of brass tubing, rested on brass castors for easy movement. A woven spring mattress could be ordered for an additional £3.3s.0d to £4.4s.0d, depending on size, and a fitted coverlet and matching bolster completed the piece.

There are many related sketches for brass beds in Godwin's sketchbooks from the 1870s; one, for example, has a maltese cross worked into its central panel and is annotated "1876" (V&A PD E.233-1963, fol. 15). Godwin also designed brass beds for the firm of Collinson and Lock in 1873.

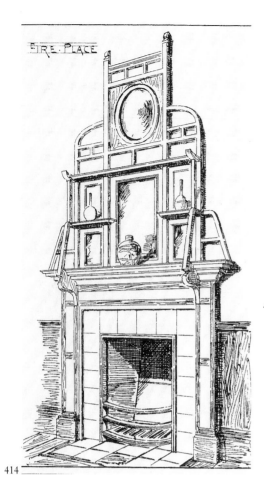

414

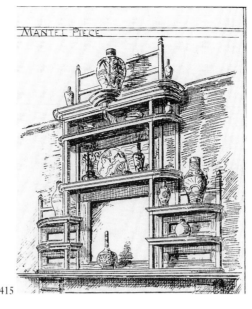

415

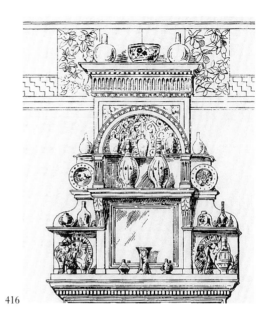

416

415. *Design for a Mantelpiece*

This elaborate oak mantelpiece is reproduced in William Watt's *Art Furniture* under "Dining Room Furniture" (1877; Plate 6) and listed at £20.0s.0d. The accompanying description stated it was "made with a special view to the display of china" (p. vii). The curved shelves are attached to a gridlike system of rails and supports that terminate in rounded finials. The sides are artfully designed, the right side larger and having greater curve than the left.

416. *Design for a Chimney Glass*

This chimney glass, or mantel mirror, appears in William Watt's *Art Furniture* as part of the Old English-style dining room (1877; Plate 7). It is 5 feet 6 inches wide and cost £26.0s.0d. The central section, which has a square mirror and a series of shelves on either side, is surmounted by a semicircular cove, or apse, that has an architectural cornice with fluted arcade and is flanked by a pair of fluted pilasters. An almost identical chimney glass can be found in one of Godwin's sketchbooks (V&A PD A123D, fol. 504).

Godwin's design incorporates a seemingly infinite variety of shelves and compartments to accommodate the display of a wide range of ceramic wares.

414. *Design for a Fireplace*

Literature: "Art Furniture," 24 August 1877, p. 174

This fireplace appears as part of Godwin's line of "Students' Furniture" in William Watt's *Art Furniture* (1877; Plate 4). The ebonized mantel shelves cost £14.14s.0d. Japanese influence is apparent in this design, particularly in the latticework, upcurving rails, and shaped elbow struts that attach the shelves to the mantel. A contemporary reviewer criticized this piece, finding it "rather too fanciful an adaptation of Japanese to our minds. . . . There is . . . a danger in seeking to introduce the forms of Japanese to English wants, and a forced style is to be reprehended."[8]

The inclusion of a combination of mirror forms, ranging from convex to rectangular, was part of a general trend popularized by artists such as Dante Gabriel Rossetti at his home, Tudor House, in Chelsea.

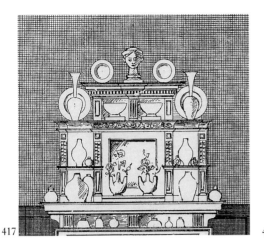

417

418

419

417. *Design for Chimney Shelves*

These chimney shelves of mahogany with beveled glass are reproduced in William Watt's *Art Furniture* under "Jacobean Furniture" (1877; Plate 17) and cost £20.0s.0d.

With its combination of carved or fluted pilasters, double cornice, and dentiled top frieze, this is one of Godwin's architecturally oriented designs for chimney shelves. The abundance of floral carving and the applied spindles are reminiscent of Jacobean decoration.

418. *Design for Chimney Shelves*

These chimney shelves, made of walnut and priced at £15.15sd.0d, are reproduced in William Watt's *Art Furniture* (1877; Plate 14). A circular, convex mirror topped with a dentiled frieze and an architectural cornice with small display compartments at the sides sits atop a second architectural cornice and overmantel mirror, this one rectangular and framed. This double overmantel treatment was preferred by Godwin.

To give this design a Japanese quality, carved chrysanthemums decorate the four corners of the convex mirror, and Japanese ceramics are displayed on all of the shelves.

419. *Design for a Chimney Frame*

This oak chimney frame appears under "Old English or Jacobean Furniture" in William Watt's *Art Furniture* (1877; Plate 15) where it was priced at £8.8s.0d. The frame, a simple rectangle with pilasters on either side and an architectural cornice with fluted arcade, could be used as a surround for either a mirror or a picture.

420

420. *Design for Chimney Shelves*

These chimney shelves appear in William Watt's *Art Furniture* as part of Godwin's "Economic Furniture" for the parlor (1877; Plate 16); they are made of walnut and cost £10.10s.0d.

The shelves frame a large central convex mirror; a lower and upper shelf are for the display of ceramic ware and brackets with round-topped finials form the top element. The coved mantel shelf corresponds to the cornice of the buffet designed as part of this suite (CR 365).

421

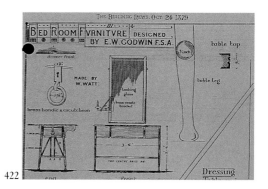

422

421. *Design for a Daybed*

Literature: Soros 1999, pp. 212–13, fig. 7-38

This drawing shows the deal daybed (in both open and closed positions) that Godwin designed in 1878 for the studio of Frank Miles at 44 Tite Street, London. It is annotated "Throne in two parts with rising back frame to support back cushion" (V&A AAD 4/131-1988). Notes in Godwin's sketchbooks indicate this daybed was to be covered "with same stuff as curtains" and was on french rollers (V&A PD E.248-1963, fols. 72, 73).

422. *Design for a Looking Glass*

Literature: "Bedroom Furniture Designed by Godwin," 24 October 1879, p. 490

This large, rectangular looking glass with candle bracket, which was reproduced in *Building News* in 1879,[9] was designed to accompany an oak dressing table, like the one at Smallhythe that originally belonged to Godwin and Ellen Terry (CR 241). Both the looking glass and the corresponding dressing table were executed by William Watt and were on view at the Watt premises at the time of their publication. A related sketch appears in one of Godwin's sketchbooks and is annotated "Gave this to S. & E. for self. Oct. 6. 79." (V&A PD E.233-1963, fol. 108). Neither the illustration nor the sketch indicates the material of the looking glass surround, but the illustration reveals that the swinging candle arm was made of brass. The functional candle brackets resemble those on Godwin's washstand in Bristol (CR 317) of a similar date.

This is one of the few freestanding rectangular mirror frames that Godwin designed. He incorporated rectangular mirror glass in many of his cabinet forms and dressing tables (see, for example, CR 351), although he preferred the more popular convex mirror form

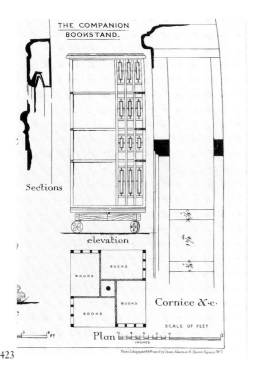

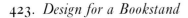

423

424

423. *Design for a Bookstand*

Literature: "Parlour Furniture," 31 October 1879, p. 522; Aslin 1986, pp. 31, 74, fig. 51; Soros 1999, p. 247, fig. 8-35

Godwin designed this companion bookstand in 1879 for the firm of William Watt. An early drawing for a three-shelved version – annotated "Watt pd" – appears in one of Godwin's sketchbooks (V&A PD E.233-1963, fol. 105). This four-shelved model was reproduced in *Building News* with an accompanying review that described it as a "novel contrivance having four sides, and turning on a centre which stands on a tripod, so that a considerable number of books may be consulted by a reader who may be sitting at a writing table without quitting his seat."[10] The vertical latticed decoration is both attractive and practical, allowing for the retention of books in place as the bookstand revolved, with partial visibility to identify titles. Another functional feature is the varying height of the four tiers, allowing for the accommodation of books of many different sizes.

Revolving bookcases with circular shelves originated in the early years of the nineteenth century.[11] The idea of a rectangular revolving bookcase was not unique to Godwin, however. In 1833, J. C. Loudon illustrated a mobile three-tiered bookcase in his *Encyclopedia of Cottage, Farm, and Villa Architecture and Furniture*,[12] and a revolving bookcase for the Tabard Inn at Bedford Park dates from about 1870, some nine years before the Godwin model. By the 1890s the revolving bookstand was so popular that the firm of William Morris and Company advertised three of them in its catalogue of about 1890.[13]

424. *Design for a Queen Anne Overdoor*

Literature: "Furniture by E. W. Godwin," 5 November 1880, p. 528; Soros 1999, pp. 241, 249

This overdoor, made by William Watt, appeared in *Building News* in 1880, where the reviewer noted it was in accord "with the present taste in furniture matters."[14] The overdoor was paired with a Gothic-Revival style center table (see CR 242), also by Watt.

Godwin abstracted the broken pediment form common to Queen Anne designs and added a central panel with curled volutes at its ends. The molded frame of the pediment corresponds to the molding of the door frame. The architectural cornice is supported by a second cornice, which is made up of a series of semicircular shelves with fluted columns. This double-cornice effect appears frequently in Godwin's designs for overmantels.

425

HAT AND UMBRELLA STAND

426

425. *Design for an Overmantel*
1884
Pen and ink on paper
Signed: "EWG"
Annotated: present frame & panel / thin
panels bronze / bevelled glass
Hyde Collection, New Jersey

Literature: Soros 1999, pp. 217–18, fig. 7-
47

This overmantel design for the drawing
room of Oscar and Constance Wilde at 16
Tite Street, London, was sketched by
Godwin in 1884. The framed, rectangular
beveled mirror sits directly on the
mantelpiece, and above it is a panel with a
framed plaque of a young girl by the
sculptor John Donoghue.[15] The plaque is
flanked by two shorter side panels, whose
thin panels of bronze correspond to the
decoration of the center panel and whose
orientation corresponds to the mirror
below. Flat architectural cornices complete
the design.

426. *Design for a Hat and Umbrella
Stand*

Literature: "Working Drawings of Inex-
pensive Furniture," 18 December 1885,
p. 1011, ill.

This oak hat and umbrella stand was part of
a group of inexpensive furnishings made for
the representatives of the late William Watt
and illustrated in *Building News* in 1885.
Credited as being "a useful piece of
furniture with nothing pretentious about
it,"[16] the stand offered a simple alternative
to the many elaborate interpretations of this
hybrid form. It allowed for the handy
storage of coats on its nine hooks, hats on
its waist-level surface, walking sticks and
umbrellas in its side compartments, and
packages and footwear on its bottom shelf.
Decoration was minimal, limited to the
turned legs and posts, and a rectangular
mirror was added for convenience.

An earlier Jacobean-style stand for a
hallway by Godwin (CR 411) was repro-
duced in William Watt's *Art Furniture*
(1877; Plate 2).

IN THE STYLE OF GODWIN

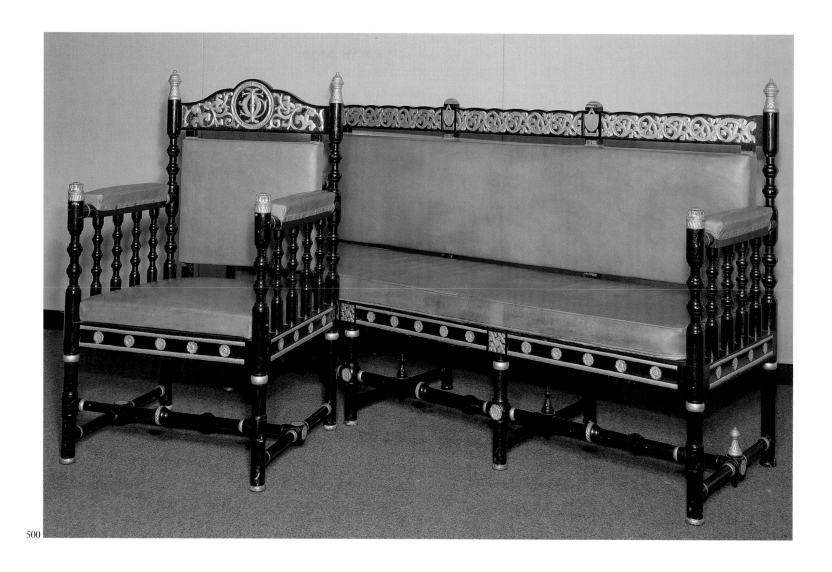

500

500. I–III. *Pair of Armchairs and Matching Settee*
1868
Maker unidentified
Painted wood with gilt details and pale natural leather upholstery
Chairs: 40½ × 23 × 21 in. (102.9 × 58.4 × 53.3 cm); settee: 40½ × 68 × 21 in. (102.9 × 172.7 × 53.3 cm)
Carved into the top of the back of the sofa:
A.D. MDCCCLXVIII
Handley-Read Collection, London; Cecil Higgins Art Gallery, Bedford (F.82, F.83, F.84)

Literature: Royal Academy 1972, p. 61, pls. D2–4

These chairs and matching settee have been attributed to Godwin ever since Simon Jervis first exhibited them at the historic "Victorian and Edwardian Decorative Art" exhibition at the Royal Academy in 1972, where he declared that "[a]lthough there is no documentary evidence, it seems very probable that this suite, which is extremely advanced for its date, is the work of E. W. Godwin." Jervis himself weakened this attribution, however, when he stated, "if it is indeed by him it is an attenuated and elegant version of [furniture-maker William] Burges's archaeology."[1]

The notable lack of stylistic analysis and documentary evidence makes an attribution to Godwin difficult to support.[2] The pieces are extremely crude and bear no resemblance to any of Godwin's work, particularly that of 1868, the date of this suite. In addition, the monogram *CIG* on the back of the settee is not traceable to any of Godwin's known clients.

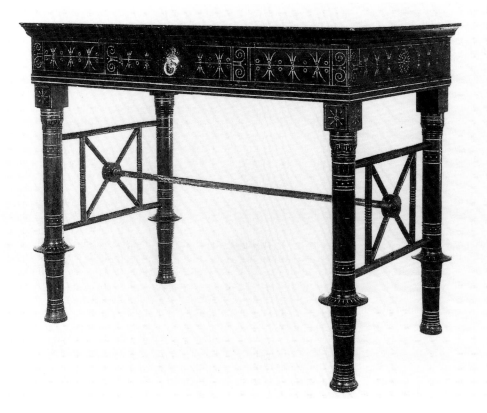

501

501. *Table*

Ca. 1876, in the style of E. W. Godwin
Probably made by Cottier and Co.
Black lacquered wood; painted and gilt
decoration
28 × 36 × 21¼ in. (71 × 91.5 × 53.5 cm)
Fine Art Society, London; Private
collection

Literature: Conner 1983, p. 102, fig. 212;
Aslin 1986, p. 80, pl. 61; Cooper 1987,
pp. 342–43, fig. 337

This table has been attributed to Godwin
because of its similarity to a table in one of
his sketchbooks (Fig. 501.1), but the tables
are significantly different: one drawer
versus three; crossed lattice braces versus
angled ones; thick, bulbous turned legs
versus thin, elongated cluster-columned
legs; and straight side supports versus
curved ones – in addition to the differing
proportions overall. Furthermore, the
incised and gilded decoration does not
resemble any of Godwin's known decorative
work. It is, however, very close to the
Greek-inspired decoration on many of the
pieces by Daniel Cottier, an admirer of
Godwin's work who, it is believed,
manufactured Godwin-style furniture to be
sold in his showrooms in New York,
Glasgow, and Melbourne.

501.1 Sketch for a table (V&A PD E.229-1963,
fol. 38)

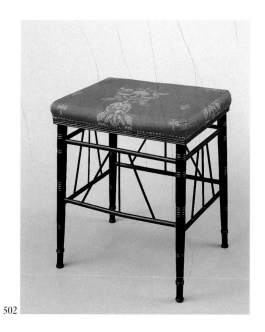

502

502. *Stool*

Ca. 1875, in the style of E. W. Godwin
Maker unidentified
Ebonized wood; upholstered seat
$19\frac{1}{2} \times 18\frac{1}{8} \times 14\frac{1}{8}$ in. (49.5 × 46 × 36 cm)
Private collection

Stools based on forms from ancient Thebes
were common in the second half of the
nineteenth century and this example is
probably one of many interpretations.
While it does resemble Godwin's classic
coffee table design (CR 207), a firm
attribution is not possible: the turned legs
are proportionately thicker and squatter
than other Godwin prototypes; the angled
spindles do not make the same V-shape
configuration that his examples usually
feature; and overall it lacks the grace and
well-balanced design of his furniture.
Moreover, there are no known drawings or
sketches in Godwin's sketchbooks or in
William Watt's *Art Furniture* that relate to
this design.

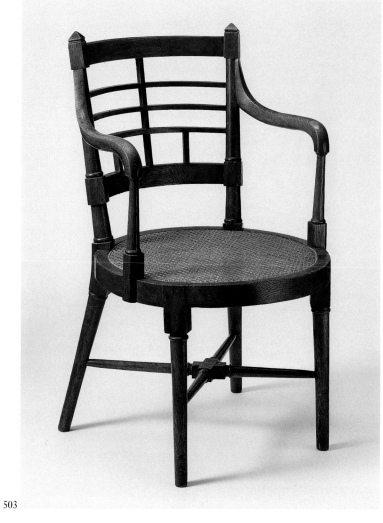

503

503. *Old English or Jacobean Armchair*

Ca. 1878, in the style of E. W. Godwin
Made by Collier and Plucknett of Warwick
Oak; cane seat
$36 \times 20\frac{1}{2}$ in. (91.5 × 52 cm)
Brass label on front inside rail reads:
"Collier & Plucknett Cabinet Makers And
Upholsterers Warwick & Leamington"
Gift of William Wenrick, Esq.; Victoria and
Albert Museum, London (Circ. 643-1962)

Literature: Handley-Read 1965, p. 224,
fig. 853; Aslin 1967, p. 8, fig. 7; R. Spencer
1972a, p. 44; C. Spencer 1973, p. 38, no. 23;
Atterbury 1978, p. 2, no. 148

This is one of the many pirated versions of
the Godwin prototype (CR 109). It was
made by Collier and Plucknett of Warwick,
a firm with which Godwin had no recorded
association,[3] and almost exactly duplicates
the one illustrated in William Watt's 1877

Art Furniture (Plate 15). Another example
of this Collier and Plucknett chair is in a
private collection in England.

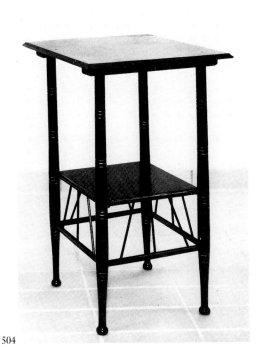

504

504. *Coffee or Occasional Table*
Ca. 1880, in the style of E. W. Godwin
Maker unidentified
Ebonized wood
26 × 17 in. (66 × 43 cm)
Cecil Higgins Art Gallery, Bedford

This coffee table is likely one of the many plagiarized examples of Godwin's designs that were prevalent in the art furniture trade in the 1870s and 1880s. In the preface to William Watt's 1877 *Art Furniture* Godwin wrote that some of his designs have unfortunately

> secured such attention as to be copied by others in the trade; having been travestied even charicatured, in the process. A marked example of this is the square coffee table you first made [f]or me nine or ten years ago. The lines and dimensions of the different parts of what seems to be a very simple bit of furniture constitute its beauty and its art – if it has any. But I have seen the lines changed, the proportions altered, until that which I regarded as a beauty became to me an offense and an eyesore. (p. iii).

A comparison of this version – with its thicker elements and less graceful proportions – and a Godwin original (CR 207, for example) bears the truth of his remarks.

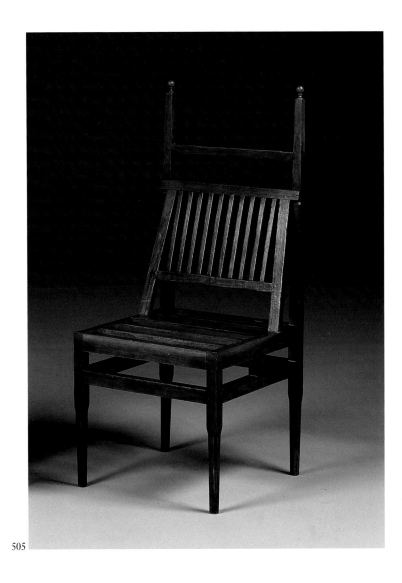

505

505. *Greek Chair*
Ca. 1885, in the style of E. W. Godwin
Maker unidentified
Stained pine
Dimensions unavailable
Christie's, London, 2 November 1995, lot 49; Private collection

Literature: Sato and Watanabe 1991, p. 99, no. 109

This chair is similar to Godwin's "Cheap Chair," which was illustrated in *Building News* (CR Fig. 184.1; 18 December 1885), and was designed in a number of versions, including this example with vertical laths in the back splat. The shorter uprights, thicker double seat rails, and the addition of small ball finials make an attribution to Godwin difficult to sustain. The auction catalogue lists E. W. Godwin as the original owner but does not provide evidence for this provenance.

506. *Sideboard*

Ca. 1880, in the style of E. W. Godwin
Maker unidentified
Ebonized wood; brass handles and fittings
$77\frac{3}{4} \times 50\frac{5}{8} \times 14\frac{7}{8}$ in. (197.4 × 128.6 × 37.9 cm)
Christie's, London, 18 July 1985, lot 225;
Christie's, London, 28 January 1986, lot 142; Private collection

Literature: Andrews 1985, pp. 45–47, fig. 1; Watson 1997, p. 63

Christie's attributed this sideboard to Godwin in 1985, and although in overall form it does resemble Godwin's classic sideboard (CR 304) there are too many substantial differences for an attribution to Godwin to stand. John Andrews has analyzed this example in great detail, comparing it to two known Godwin sideboards – one in Bristol (CR 304), the other in the Victoria and Albert Museum (CR 304-b). Andrews points out several major differences in this piece: the shiny black surface (versus the dull, worn finish more characteristic of a piece this age); the mirrored back, which the Godwin originals do not have; pegged joints versus dovetailed ones; circular escutcheons with ring pull handles versus long thin escutcheon plates with fleur-de-lis tops and oblong drop handles; mitered lower cupboard doors versus paneled ones; thin framing and corresponding stiles in the top left-hand cupboard versus the thicker proportions of the classic panels; support strutting which runs along the top of the entire piece (whereas in the Godwin originals it frames just the upper cupboards); lack of extending shelves or leaves; rounded front brackets versus strangely angled, smaller ones; and a missing central bottom shelf.

Andrews concludes that the sideboard presented here was made at the turn of the century. It is impossible to attribute it to a particular maker, however, since copies of Godwin's designs were made as far away as America and India at this time.

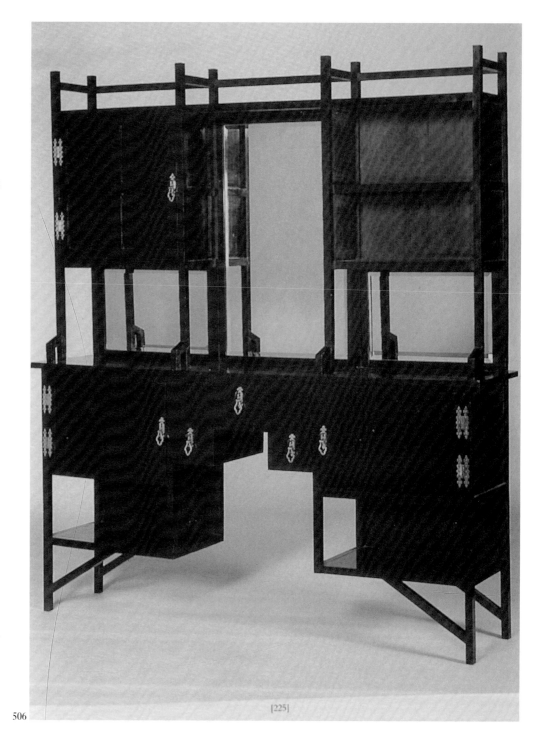

506

[225]

507. *Cabinet*

Ca. 1880, in the style of E. W. Godwin
Probably made by Liberty and Company
Oak; brass handles and fittings
$50^7/_{16} \times 55^1/_8 \times 15$ in. ($128 \times 140 \times 38$ cm)
Sotheby's, London, 3 March 1988, lot 252;
Sotheby's, London, 3 March 1989, lot 219;
Andrew McIntosh Patrick

This design is slightly reminiscent of the Cottage-style furnishings Godwin designed in the first half of the 1870s for both William Watt and Collinson and Lock. While the asymmetrical composition, paneled doors, arched side supports, and brass pull handles are typical, other features do not relate to any of Godwin's known work – for example the high vertical bobbin rails, which are not found on any other pieces, and the handles, which are of a coarser quality. The proportions are heavier and the integration of the multiple components is less accomplished. Additionally, the asymmetrical right-hand shelf supported by angled brackets is curious, for Godwin generally preferred the more flexible arrangement of folding shelves on brass wing supports. Perhaps this piece relates to the mid-level oak pieces that firms such as Liberty produced in the 1880s and 1890s, which were loosely based on Godwin designs (Fig. 507.1).[4]

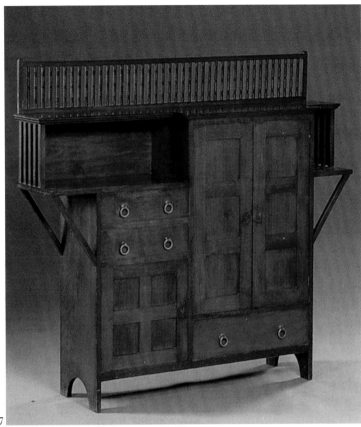

507

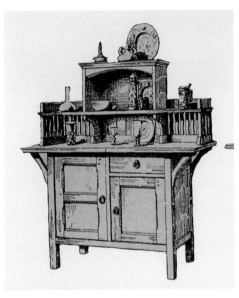

507.1 Drawing of cabinet from Liberty and Company catalogue, 1890

508. *Greek Chair*
Ca. 1885, after a design by E. W. Godwin
Maker unidentified
Oak; rush seat
H. 41½ in. (105.3 cm)
Christie's, London, 29 October 1997,
lot 17; Private collection

Literature: Fine Art Society 1998, fig. 11

This chair is a version of the Greek-
inspired chairs Godwin designed for
William Watt in the 1880s (see CR 184)
and was illustrated twice in *Building News*,
first on 29 May 1885 under "Greek Arm-
chair"[5] (CR 183), then on 18 December
1885 under "Working Drawings of Inex-
pensive Furniture" (CR 184; see CR Fig.
184.1).[6] This example shares many features
with the ones reproduced in these articles:
the use of oak; the similar overall form and
proportions; the square-sectioned uprights
with elongated tapering finials; the
staggered location of the stretchers; and the
mushroom-shaped front feet. The rush
seat, however, is an unusual feature – most
of these Greek-style chairs either had
slatted seats, upon which cushions would
be placed, or cane seats. The rush seat gives
these chairs a rustic quality that is
somewhat incongruous, perhaps indicating
that this is a later copy of the Watt versions.

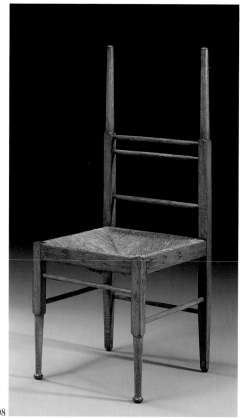

508

APPENDIX

THE ART FURNITURE CATALOGUE

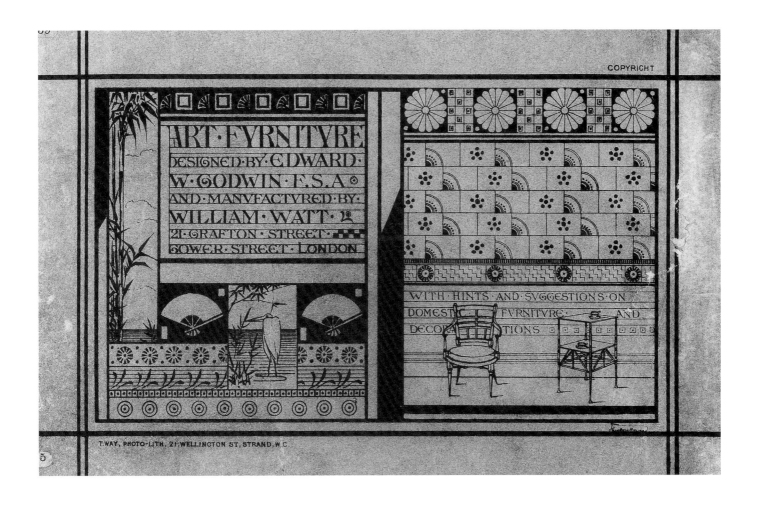

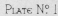

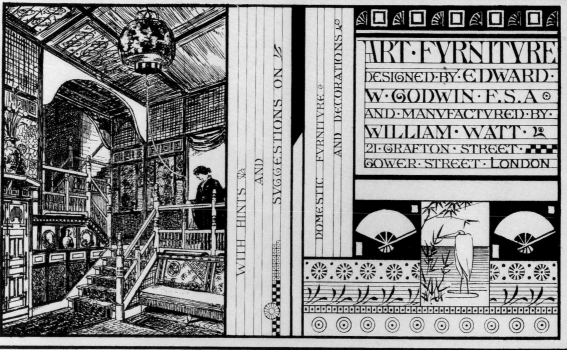

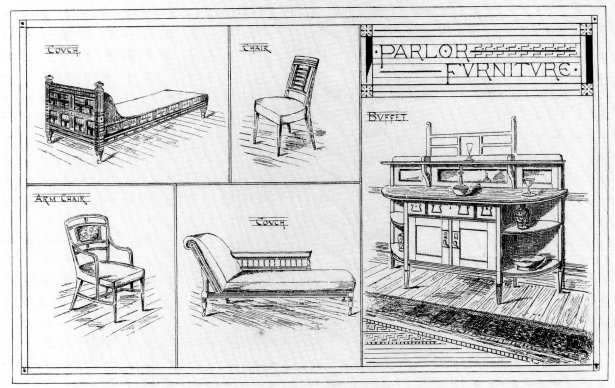

COUCH.

CHAIR.

ARM CHAIR

COUCH.

·PARLOR· FVRNITVRE·

BVFFET

ART FVRNITVRE WAREHOVSE,
21. GRAFTON STREET, GOWER STREET, LONDON.

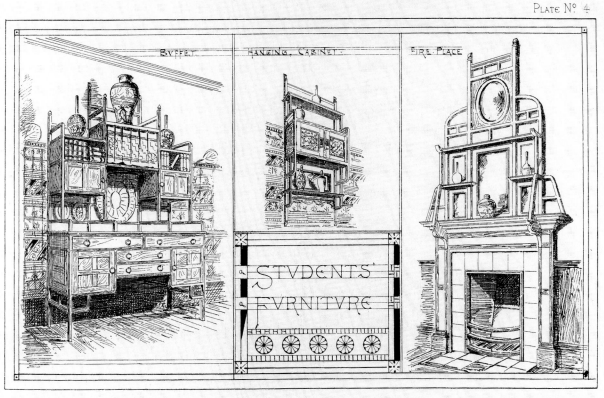

BVFFET

HANGING CABINET·

FIRE·PLACE

STVDENTS' FVRNITVRE

ART FVRNITVRE WAREHOVSE,
21. GRAFTON STREET, GOWER STREET, LONDON.

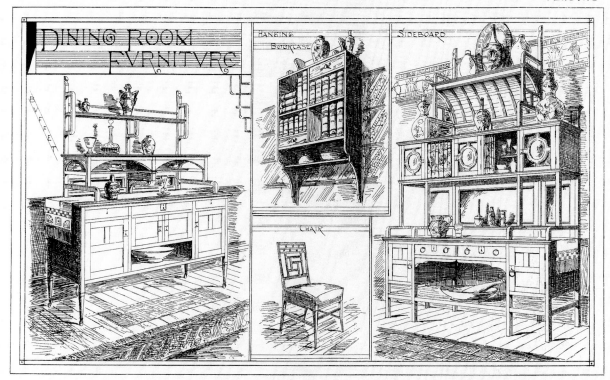

ART FVRNITVRE WAREHOVSE,
21. GRAFTON STREET. GOWER STREET. LONDON.

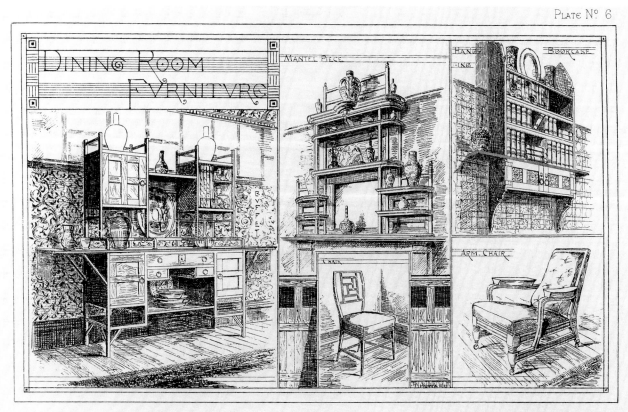

ART FVRNITVRE WAREHOVSE,
21. GRAFTON STREET. GOWER STREET. LONDON.

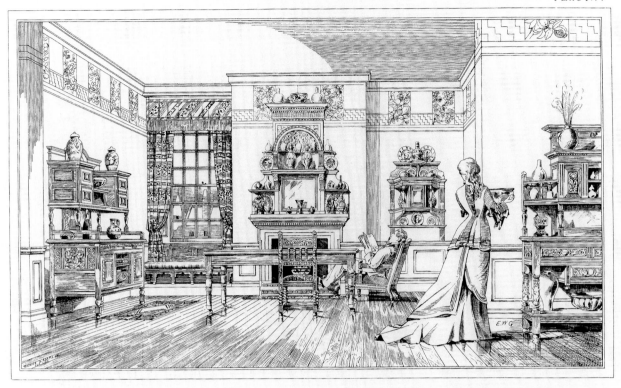

ART FVRNITVRE WAREHOVSE,
21, GRAFTON STREET, GOWER STREET, LONDON.

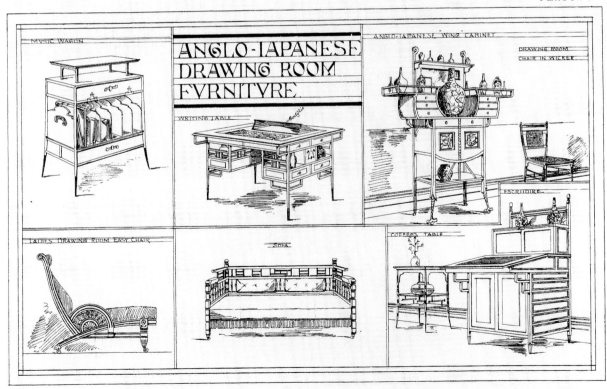

ART FVRNITVRE WAREHOVSE,
21, GRAFTON STREET, GOWER STREET, LONDON.

ART FVRNITVRE WAREHOVSE,
21, GRAFTON STREET, GOWER STREET. LONDON.

ART FVRNITVRE WAREHOVSE,
21, GRAFTON STREET, GOWER STREET. LONDON.

ART FVRNITVRE WAREHOVSE,
21. GRAFTON STREET. GOWER STREET. LONDON.

ART FVRNITVRE WAREHOVSE,
21. GRAFTON STREET. GOWER STREET. LONDON.

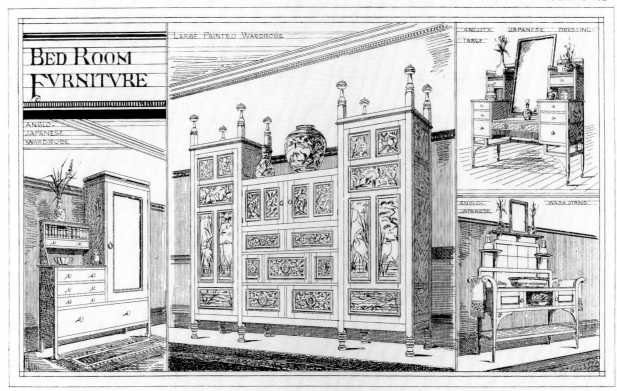

BED ROOM FVRNITVRE

ANGLO-JAPANESE WARDROBE

LARGE PAINTED WARDROBE

ANCIENT JAPANESE DRESSING-TABLE

ANGLO-JAPANESE WASH STAND

ART FVRNITVRE WAREHOVSE,
21, GRAFTON STREET, GOWER STREET, LONDON.

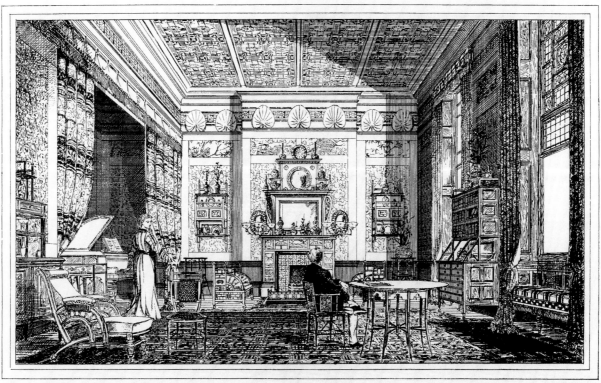

ART FVRNITVRE WAREHOVSE,
21, GRAFTON STREET, GOWER STREET, LONDON.

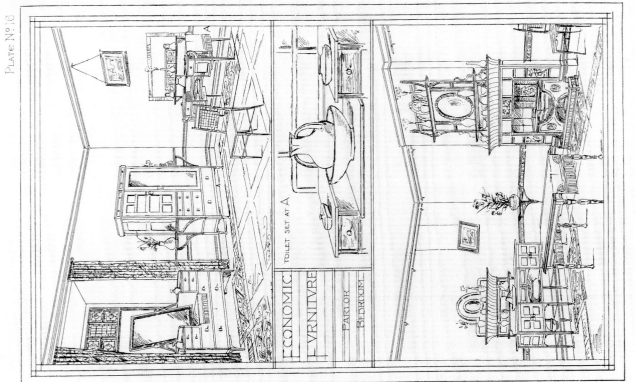

Plate. Nº.15

ART FVRNITVRE WAREHOVSE,
21. GRAFTON STREET. GOWER STREET. LONDON.

Plate. Nº.16

ART FVRNITVRE WAREHOVSE,
21. GRAFTON STREET. GOWER STREET. LONDON.

Iacobean·Furniture

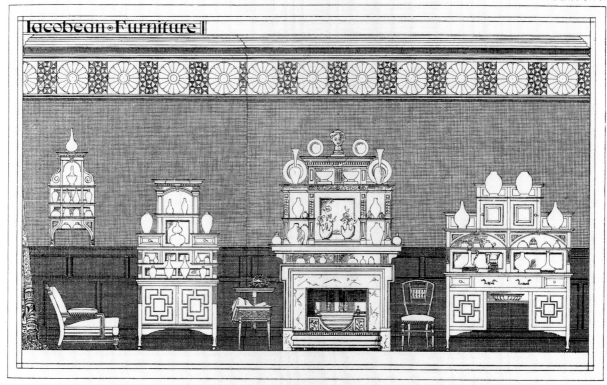

ART FVRNITVRE WAREHOVSE,
21, GRAFTON STREET, GOWER STREET, LONDON.

STAINED &
PAINTED
GLASS

WINDOW BLINDS &c

ART FVRNITVRE WAREHOVSE,
21, GRAFTON STREET, GOWER STREET, LONDON.

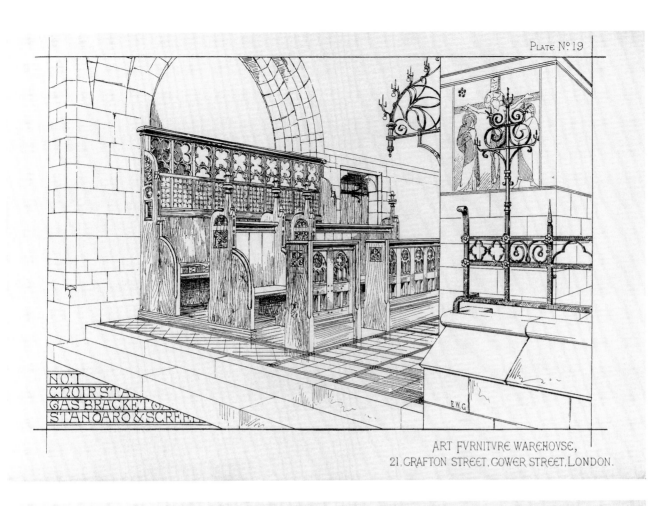

NO.1
CHOIR STALL
GAS BRACKET &
STANDARD & SCREEN

E.W.G.

ART FVRNITVRE WAREHOVSE,
21, GRAFTON STREET, GOWER STREET, LONDON.

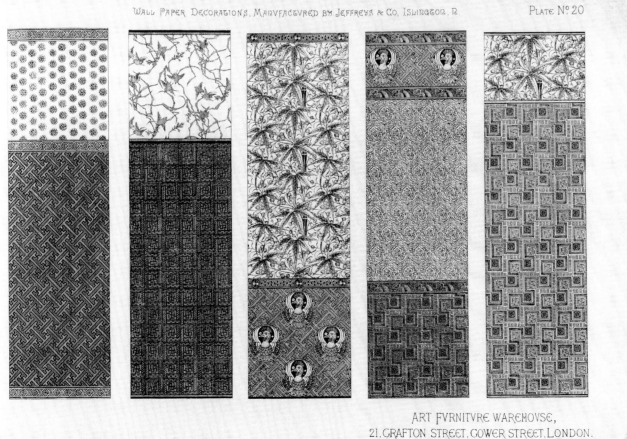

WALL PAPER DECORATIONS, MANVFACTVRED BY JEFFREYS & CO, ISLINGTON, N.

ART FVRNITVRE WAREHOVSE,
21, GRAFTON STREET, GOWER STREET, LONDON.

Plate	Item	£	s.	d.
PLATE 1.	Estimates free for Staircases and Interiors, according to design and sizes.			
PLATE 2.	Cane seat arm chair	3	3	0
	Stuffed seat smoking chair in canvas	4	4	0
	Cane seat arm chair	3	0	0
	Screen in walnut, 6 ft. high	18	18	0
	„ oak „	21	0	0
	Oak hall stand, 4 ft. wide	18	18	0
	„ chair to match	3	3	0
	„ willow chair	1	1	0
	Ebonized ditto	1	1	0
	Walnut music stool, with rising top and well for music	3	10	0
	Oak study chair in morocco	7	7	0
PLATE 3.	Oak couch, No. 1, in canvas	8	10	0
	Walnut ditto, No. 2 „	7	7	0
	Chair in canvas	2	10	0
	Arm chair „	3	10	0
	6-ft. walnut buffet	25	0	0
PLATE 4.	6-ft. ebonized buffet	33	0	0
	Ebonized hanging cabinet	5	5	0
	„ mantel shelves	14	14	0
PLATE 5.	6-ft. oak sideboard	36	0	0
	6-ft. 6 high oak sideboard	45	0	0
	Oak hanging bookcase	5	0	0
	„ chair in morocco	3	3	0
PLATE 6.	5 ft. 6 oak buffet	30	0	0
	5 ft. 6 ebonized buffet	28	0	0
	Oak mantel shelves	20	0	0
	Ebonized book shelves decorated	7	7	0
	Oak easy chair in morocco	8	8	0
	Oak dining room chair in ditto	3	3	0
	Spanish mahogany ditto in ditto	3	3	0
PLATE 7.	Oak sideboard, 7 ft. 6 wide	75	0	0
	„ „ 6 ft 6	65	0	0
	„ cabinet, 5 ft. 6	55	0	0
	„ hanging cabinet, 3 ft.	12	12	0
	„ chimney glass, 5 ft. 6	26	0	0
	„ table, 7 ft. × 3 ft. 6 wide	12	12	0
	„ easy chair in morocco	8	8	0
	„ carved chair	5	0	0
PLATE 8.	Walnut Canterbury	9	9	0
	Ebonized Canterbury	9	12	6

Plate	Item	£	s.	d.
PLATE 8—continued.				
	4 ft. walnut writing table	25	0	0
	4 ft. ebonized „ „	26	0	0
	Ebonized cabinet	35	0	0
	„ willow chair	2	2	0
	„ Lady's easy chair in canvas	6	6	0
	„ sofa ditto	13	13	0
	„ coffee table	4	4	0
	„ Davenport	18	18	0
PLATES 9 & 10.	Painting and paper-hanging. Decorations at various prices, as per special estimate.			
PLATE 11.	Oak stuffed back chair in embossed morocco	4	4	0
	Oak footstool	1	10	0
	„ eagle chair in embossed morocco	10	10	0
	„ 5 ft. 6 × 4 ft. table	15	15	0
	„ mantel piece	26	0	0
	„ reading desk	6	6	0
	„ arm chair in morocco	8	8	0
	Estimates free for bookcases, to design and sizes.			
PLATE 12.	Piano in decorated walnut case	45	0	0
	3 ft. 3 ebonized Queen Anne cabinet	35	0	0
	Mahogany cabinet	32	0	0
	3 ft. 3 ebonized centre table	7	15	0
	3 ft. 3 walnut	7	7	0
	If mounted with brass shoes, extra	1	10	0
	Ebonized or walnut lamp stand	3	3	0
	5-seat centre ottoman in canvas	17	17	0
PLATE 13.	5 ft. ash wardrobe with plate glass doors	26	0	0
	4 ft. 6 ash dressing table	17	17	0
	4 ft. 6 ash washstand	15	15	0
	7 ft. 6 large painted wardrobe, from	45	0	0
PLATE 14.	Walnut chimney shelves	15	15	0
	3 ft. 6 cabinet	34	0	0
	4 ft. wide cabinet book case	48	0	0
	Ebonized willow chair	2	2	0
	„ easy chair in canvas	8	8	0
	Settee, 6 ft. long in canvas seat	15	15	0
	Ebonized arm chair	6	6	0
	Hanging cabinet	5	5	0
PLATE 15.	6 ft. oak sideboard	30	0	0
	Writing table, 4 ft. long 22 in. wide	7	7	0
	Oak chimney frame for glass or picture	8	8	0

Plate	Item	£	s.	d.
PLATE 15—continued.				
	4 ft. oak table	7	0	0
	Oak chair in stamped velvet	3	15	0
	„ arm chair in canvas	4	4	0
	Ebonized chair with caned seat	3	12	6
	„ sofa in canvas	10	10	0
	„ coffee table	2	5	0
	Oak coffee table	2	10	0
	3 ft. 6 brass bedstead	8	0	0
	Wove spring mattress for ditto	3	3	0
	4 ft. wide brass bedstead	8	4	0
	Wove spring mattress for ditto	3	10	0
	4 ft. 6 brass bedstead	8	8	0
	Wove spring mattress for ditto	3	17	6
	5 ft. brass bedstead	8	12	6
	Wove spring mattress for ditto	4	4	0
	Bedroom couch	5	10	0
	Bedroom chair, willow seat	0	12	6
	Pine dressing table	15	15	0
	„ wash stand	10	10	0
	9 ft. pine double wardrobe with plate glass doors	42	0	0
PLATE 16.	6 ft. walnut buffet with mirror	30	0	0
	Walnut chimney shelves	10	10	0
	„ chair	2	0	0
	3 ft. 6 × 5 ft. walnut table	6	6	0
	Walnut corner bracket	1	1	0
	4 ft. deal dressing table, with glass	10	10	0
	4 ft. deal wardrobe, ditto	18	18	0
	4 ft. deal washstand	6	15	0
PLATE 17.	Mahogany hanging cabinet	8	8	0
	„ easy chair in morocco	9	9	0
	„ cabinet, 3 ft. 6	30	0	0
	„ work stand	4	4	0
	„ chimney shelves, with bevelled glass	20	0	0
	Mahogany chair in canvas	2	7	6
	6 ft. mahogany sideboard	38	0	0
PLATE 18.	Estimates free for stained glass, according to design and sizes.			
PLATE 19.	Choir seats, estimates free, according to designs.			
PLATE 20.	Paperhanging at different prices, according to quality.			

NOTES

NOTE TO THE READER

1. Soros 1998.

PREFACE

1. Quoted in Harbron 1949, p. xiii.
2. Godwin, 30 December 1881, p. 655.
3. Godwin, 6 March 1874, p. 269.
4. Banham, MacDonald, and Porter 1991, p. 45.
5. A belief that had, for example, been articulated for an international audience at "The Great Exhibition" of 1851. See Prince Albert's opening speech for that exhibition in Ffrench [1950], pp. 51–52.
6. For more information on the Grand Tour, see Wilton and Bignamini 1996 and Black 1992.
7. Habermas 1962 (1991 ed.).
8. See, e.g., Margaret Belcher, "Pugin Writing," in Atterbury and Wainwright 1994, pp. 105–10, in which she refers to Pugin's book *Contrasts* (1836).
9. On the dominance of the aristocratic mores and taste on the bourgeoisie, see Mayer 1981.
10. Hill 1977, pp. 138–39.
11. Godwin, 29 November 1878, p. 211.
12. The United States expedition to Japan was led by Commodore Perry in 1853. See "Matthew C. Perry and the Opening of Japan" in Hosley 1990, pp. 17–28. The first treaty between Britain and Japan, the Treaty of Edo, was signed in August 1858. See "The Aesthetic Dialogue Examined: Japan and Britain, 1850–1930," in Sato and Watanabe 1991, pp. 14–17.
13. N. Wilkinson 1987, pp. 24–30.
14. See Joan Corwin, "Travel Literature," in Mitchell 1988, pp. 818–19. See also F. A. Kirkpatrick, "The Literature of Travel 1700–1900," in *The Cambridge History of English Literature*, vol. 14 (1917); and Joanne Shattock, "Travel Writing Victorian and Modern: A Review of Recent Research," in Dodd 1982.
15. Said 1978, pp. 38–39.
16. Greenhalgh 1990, pp. 1–24.
17. Richard Riemerschmidt designed modular furniture or what he called "build-on" furniture in the first decade of the twentieth century. See Heskett 1986, p. 97.
18. See, e.g., Sekler 1985; Schildt 1986; Kirkham 1995.
19. Godwin, 15 July 1876, p. 35.
20. For more information on hygiene and health reform during this period, see Wohl 1983.
21. Austrian emigré Josef Frank would later grapple with these same concerns – the need to diversify interiors through patterns and color – in his designs for Svenskt Tenn from the 1930s until the 1960s. See, e.g., Stritzler-Levine 1996, p. 11.

22. In the introduction to his study of the Aesthetic movement, Lionel Lambourne (1996, p. 7) writes of the 1890s as a time of "decadence" that he sees as an outgrowth of the affectations of the Aesthetic movement. Oscar Wilde's involvement with aestheticism added to its reputation for decadence.
23. Arnold 1869 (1994 ed.).
24. See Berman 1988.
25. Letter from Lady Archibald Campbell to W. A. Godwin, dated 30 November 1907, Ellen Terry Archive, the National Trust, Ellen Terry Memorial Museum, Smallhythe Place, Kent.
26. Obituary, "Edward W. Godwin," *British Architect*, 15 October 1886, pp. 347–48.
27. See, e.g., Day, June 1887, p. 195; Smith 1887, p. 71; and Vallance, April 1892, p. 112.
28. Jennings 1902, p. 55.
29. Fry 1919, p. 529.
30. H. Muthesius 1904–5 (1979 ed.), p. 157.
31. Pevsner 1936.
32. M. Adams 1912, p. 643.
33. *Dictionary of National Biography* 1939, p. 505.
34. Voysey 1931, p. 91. Voysey also acknowledged his debt to Godwin in a speech to the Royal Institute of British Architects in 1927; see Voysey 1927, p. 53.
35. Harbron 1945, pp. 48–52.
36. Pevsner 1948, p. 99. I am indebted to Clive Wainwright for this information.
37. Harbron 1949.
38. Hyde 1951, pp. 175–76.
39. Pevsner 1952a.
40. I am indebted to Clive Wainwright for this information; Pevsner 1952b.
41. Victoria and Albert Museum, acc. no. 38.1953, purchased from Mrs. E. M. Hartree, Devon; originally in the possession of her father, Frederick Jameson.
42. Bøe 1957 (1979 ed.); Kauffman 1958.
43. See, e.g., Lancaster 1952; and Tschudi-Madsen 1975.
44. Floud 1957, p. 25.
45. Symonds and Whineray 1962, pp. 75–76.
46. Handley-Read 1965, pp. 224–25.
47. Honour 1969, pp. 252–57.
48. Pevsner 1960, pp. 62–64.
49. Aslin 1962a, pp. 63–64.
50. Aslin 1967.
51. Aslin 1969.
52. Royal Academy 1972. In fact, Victorian decorative arts were still largely viewed in such a derisive manner that the collection had been turned down by several English museums, who did not want it as part of their permanent collections. I am indebted to Clive Wainwright for this information.
53. Davis 1973.
54. See, e.g., R. Spencer 1972a, which illustrates five

of the eight Godwin furniture pieces that were exhibited, and C. Spencer 1973, which illustrates five Godwin pieces.
55. Jervis 1974a.
56. Bristol Museums and Art Gallery 1976.
57. *Art Furniture and Artistic Conservatories* 1978.
58. Fine Art Society 1981. Four pieces of furniture and one sample of Godwin's wallpaper were included in this catalogue.
59. Acquired by the Musée d'Orsay in 1981 (OAO 578).
60. Aslin 1986.
61. "From Nankin to Bedford Park," in Cooper 1987, pp. 115–52.
62. N. Wilkinson 1987.
63. Tilbrook 1986, p. 9.

INTRODUCTION

1. Pevsner 1960, p. 62.
2. Godwin, 13 June 1874, p. 335.
3. *Art Furniture from Designs by E. W. Godwin, F.S.A., and Others, with Hints and Suggestions on Domestic Furniture and Decorations* (1877), p. viii.
4. This lecture was reproduced as a typeset article, copies of which are in the Victoria and Albert Museum (AAD 4/561-1988) and the Royal Institute of British Architects (MC GoE/7/8/1).
5. Report on St. John the Baptist's Church, Colerne, ca. 1853, V&A AAD 4/235.
6. RIBA MC GoE/4/4.
7. Wainwright, in Atterbury and Wainwright 1994, pp. 128–29.
8. Godwin, 29 November 1878, p. 210.
9. V&A PD E.267-1963, fols. 2, 3.
10. Harbron 1949, p. 3; currier: "a preparer of tanned hides for use by soaking, coloring or other processes." *The American Heritage Dictionary*, 2nd ed., 1976.
11. Godwin, 13 August 1880, p. 70.
12. Ibid.
13. V&A AAD 4/58-1998.
14. RIBA MC GoE/7/1/17.
15. Quoted in Cunningham and Waterhouse 1992, p. 174.
16. Godwin, 13 June 1874, p. 335.
17. V&A AAD 4/11-1980, fol. 32 and n.p.; V&A AAD 4/13-1980, n.p.
18. See Wainwright, "Furniture," Atterbury and Wainwright 1994, pp. 127–42.
19. Harbron 1945, p. 48.
20. Hitchcock 1960, pp. 145–71.
21. Atterbury and Wainwright 1994, p. 16. For more information on William White, see S. Muthesius 1972, pp. 53–54.
22. V&A AAD 4/9-1980, fol. 43.
23. Aslin 1986, p. 11.

24. Mercer 1969, pp. 53–60.
25. Willemin 1839, vol. 1, pl. 52, "A Développement d'un Chapiteau de l'Abbaye de St. Georges de Boscherville Fondée l'An 1066 par Raoul Sire de Tancarville."
26. Ibid., vol. 1, pl. 14.
27. Ibid., vol. 1, pl. 9.
28. I am grateful to Clive Wainwright for this information. Charles Eastlake also suggested the use of green leather ("Green is incomparably the best suited to oak") in his *Hints on Household Taste in Furniture, Upholstery, and Other Details* (1878; 1969 ed.), p. 136.
29. Atterbury 1995, pp. 322–23.
30. Hunt 1836, pl. xxxi.
31. See Eames 1977, pl. 70A.
32. V&A AAD 4/10-1980, fol. 87.
33. Kelly's Directories 1868 lists "Burkitt, Reuben and Co. hardware merchants, Cleveland Road."
34. V&A AAD 4/10-1980, fol. 87.
35. V&A AAD 4/22-1988, fols. 60–62.
36. Letter from F. V. Hart to E. W. Godwin, dated 2 November 1869, V&A AAD 4/184-1988.
37. V&A AAD 4/10-1980, fol. 87.
38. Godwin, 19 February 1875, p. 200.
39. Godwin, 12 February 1875, p. 173.
40. Burges, July 1862, pp. 10–11.
41. Harbron 1949, p. 78.
42. "Wall-papers," 11 October 1872, p. 291.
43. RIBA DC Ran 7/B/1 (7).
44. Haslam 1993, p. 26.
45. Godwin, 25 May 1872, pp. 267–68.
46. De Courcy, Dromore Castle, 19–21 October 1949, lots 257, 258. One of these tables is now in the personal collection of Paul Reeves and has been reduced in size. The location of the second table is unknown.
47. This piece was, in fact, built and was last recorded as sold in the 1949 sale of Dromore's contents (De Courcy, Dromore Castle, 19–21 October 1949, lot 260). It was catalogued as "Large Austrian Oak Sideboard with Arms of the Earl of Limerick."
48. Harbron 1949, pp. 22–23.
49. Yoshikazu, Japanese Wood Block Print, 1853, Collection of William Burges. V&A PD, 93 E.5:56, acq. no. 8827: (115); mentioned in N. Wilkinson 1987, p. 71.
50. V&A PD E.272-1963, fol. 35. Although at the bottom of this sketch is a cockerel under which is inscribed "Aug. 14, 1870 Conventionalized from Nature," other drawings for birds in his sketchbooks date from as early as 1861 and indicate that Godwin was drawing bird forms from life throughout the 1860s.
51. Christie's, London, "British Decorative Arts from 1880 to the Present," sale cat., 5 February 1992, lot 127.
52. Godwin selected Nesfield's book to be presented by the Bristol Society of Architects (of which Godwin was Honorary Secretary) for the best student drawing. The prize was awarded to W. V. Gough in 1864. Bristol Society of Architects, minutes of a meeting held 4 May 1864.
53. Eames 1977, appendix 2, pp. 247–49, no. 3, pl. 4.
54. These dressing tables have been separated. One is in the Musée d'Orsay, Paris (OAO 1280), the other is in a private collection in Great Britain.
55. RIBA DC Ran 7/B/1 (73).
56. For Ming hardwood furniture with these types of feet see Wang and Evarts 1995, pls. 4, 47.
57. RIBA DC Ran 7/B/1 (55).
58. Wang 1986, p. 39.
59. RIBA MC GoE/1/7/3.
60. Godwin, 1 July 1876, p. 5.
61. Quoted in Cooper 1987, pp. 128–29; Aslin 1986, p. 22.

62. V&A AAD 4/9-13-1980, fol. 39.
63. "Art Furniture," 5 June 1868, p. 375.
64. V&A AAD 4/2-1988.
65. However, their relationship was hardly exclusive, for Godwin was under contract from 1872 to 1874 with Collinson and Lock, who paid him a monthly retainer. Moreover, he had Reuben Burkitt of Wolverhampton make much of the cabinetwork for Dromore Castle in 1870.
66. Advertisement for William Watt, *British Architect*, 25 January 1878.
67. This catalogue is reproduced in its entirety in Appendix A. That Watt took over many of the Godwin designs first executed by the Art Furniture Company is confirmed by the appearance in his catalogue of both the Anglo-Japanese ebonized buffet (Plate 6) and the Eagle chair (Plate 11).
68. Godwin Diaries, V&A AAD 4/2-1980, 25 December 1876.
69. *Art Furniture*, p. viii.
70. Halén 1990, p. 35.
71. Godwin, 12 February 1875, pp. 173–74, ill. p. [189]; Godwin, 19 February 1875, pp. 200–201, ill. p. [214].
72. V&A PD E.226-1963, fol. 63.
73. N. Wilkinson 1987, p. 146.
74. Ibid., p. 154.
75. Godwin, 23 December 1876, p. 363.
76. V&A PD E.481-1963. The drawing is annotated "Anglo-Jap winged Drawing cabinet Done for Watt."
77. Shoolbred and Co. 1874. Illustrated in Agius 1978, p. 55, pl. 58.
78. "Many People Know," 8 October 1875, p. 409.
79. "Anglo-Japanese Furniture at Paris Exhibition," 14 June 1878, p. 596, ill. p. [603].
80. Day, 12 July 1878, p. 16.
81. V&A AAD Cashbook 4/13-1980, n.p. ("Collinson and Lock," 24 August 1873; 10 October 1873).
82. Dungavell 1992.
83. V&A AAD 4/13-1980 n.p. Collinson and Lock, June 1873; October 1873; November 1873; January 1874; April 1874.
84. For a full description of this wall decoration, see Purslow 1995, pp. 3–5.
85. V&A PD E.487-1963. These two designs relate to an order in Godwin's cashbook dated 10 April 1874. V&A AAD 4/13-1980, n.p. "Collinson & Lock."
86. V&A PD E.234-1963, fols. 40, 41.
87. V&A PD E.550-1963.
88. V&A AAD 4/158-1988.
89. "Anglo-Japanese Furniture," 1 October 1880, p. 56.
90. Acq. no. D154/1977.
91. Chesneau 1878, p. 386.
92. N. Wilkinson 1987, pp. 184–85.
93. "List of articles of Vertu in large office." V&A AAD 4/10-1980, n.p.
94. N. Wilkinson 1987, p. 174.
95. Ellsworth 1982, pl. 76.
96. Clunas 1988, p. 79.
97. Godwin, 1 July 1876, p. 5.
98. Pevsner 1952a, p. 47, pl. 17.
99. N. Wilkinson 1987, p. 178.
100. Wang 1986, fig. 170.
101. V&A PD E.243-1963, fol. 31.
102. Tian 1996, p. 168, fig. 70.
103. Walkling 1979, p. 29.
104. Ibid., p. 11, pl. 3.
105. Godwin, 1 July 1876, p. 5.
106. V&A PD 93 E.5 (acq. no. 8827).
107. Godwin, 23 December 1876, p. 363.
108. Bristol Museums and Art Gallery, acq. no. N4507.
109. *Art Furniture*, p. viii.

110. "Two Interiors" 1920, p. 52.
111. Liberty and Co., *Eastern Art Manufactures and Decorative Objects*, 1881, quoted in Aslin 1986, p. 10, n. 7.
112. V&A PD E.478-1963.
113. See V&A PD E.480-1963.
114. V&A AAD 4/12-1980, n.p. ("Minton & Hollins").
115. "Rambling Sketches," 2 September 1881, pp. 444–45.
116. Aslin 1986, p. 67, pl. 39.
117. Harbron 1949, p. 33.
118. Eastlake 1869 (1969 ed.), p. 74.
119. Banham, MacDonald, and Porter 1991, p. 210.
120. *Cabinet Maker and Art Furnisher* 7 (1 July 1886), p. 23, quoted in Collard 1985, p. 237.
121. Godwin, 8 July 1876, p. 19.
122. Ibid.
123. Blairman and Sons 1994, fig. 17. A signed and dated drawing for this table (RIBA Ran 7/N/14) is annotated "September 77 for Paris." Perhaps it was meant to be exhibited on William Watt's stand at the Paris Exposition Universelle of 1878.
124. Illustrated in Macquoid and Edwards 1986, p. 240, fig. 26.
125. V&A PD E.279-1963, insert between fols. 4 and 6.
126. Godwin, 12 February 1875, ill. p. [189]; Godwin, 19 February 1875, ill. p. [214].
127. Crook 1981a, p. 296. See also Wainwright, "Pre-Raphaelite Furniture," in Crook 1981b, pp. 67–70.
128. Aslin 1962a, p. 60.
129. For more information on Charles Fairfax Murray, see Barrington 1994, pp. 15–21; and Robinson 1975, pp. 348–51.
130. This relates to an entry in Godwin's ledger books for 27 September 1871 which lists "Bird Dr Bookcase des. . . ." V&A AAD 4/10-1980, fol. 93 ("Sundries").
131. Dudley Harbron (1949, p. 82) has identified the painter as Charles Glidden, whom he describes as "a brilliant young artist . . . who died when he was twenty."
132. This cabinet was illustrated in *Building News*, 1 May 1885.
133. An entry in one of his ledger books (V&A AAD 4/12-1980, fol. 14) lists "three panels black & red" for Waugh and Sons executed in August 1876.
134. For more information on Beatrice Godwin, who later married James McNeill Whistler, see MacDonald 1997.
135. Aslin 1986, p. 24, no. 10. The acquisition number of the "Four Seasons Cabinet" is W.15-1972.
136. V&A PD E.533–536-1963.
137. "Parlour Furniture," 31 October 1879, p. 522.
138. V&A PD E.233-1963, fol. 103.
139. V&A AAD Cashbook 4/13, fol. 20.
140. Quoted in N. Wilkinson 1987, p. 193. The use of ebonized furniture is a complicated issue. Important historical prototypes were the turned Tudor-style ebony chairs of the second half of the eighteenth century and most of the nineteenth century that collectors believed were of Tudor origin and considered appropriate for the furnishing of Romantic interiors. For more information on the nineteenth-century trend for ebony furniture, see Wainwright 1985, pp. 250–55.
141. I am indebted to Clive Wainwright for this observation.
142. For more information on Fourdinois see Ledoux-Lebard 1984 (1989 ed.), p. 208.
143. London, International Exhibition, 1862, pp. 338–39.
144. Quoted in Banham, MacDonald, and Porter 1991, p. 125.
145. Godwin, 8 July 1876, p. 19.

146. Vallance, April 1892, p. 112.
147. RIBA Ran 7/B/1 (82).
148. Kirkham 1981, p. 122.
149. Godwin, 3 June 1876, p. 353.
150. Fastnedge 1983, p. 76.
151. Quoted in Banham, MacDonald, and Porter 1991, pp. 49–50.
152. Ibid., p. 148, fig. 154.
153. Ibid., p. 126, fig. 130.
154. Ibid., p. 108, fig. 111.
155. Godwin, 15 June 1872, pp. 1–2.
156. Godwin, 22 July 1876, p. 45.
157. See Canadian Centre for Architecture 1991.
158. Edwards 1993, p. 145.
159. A sofa designed by Godwin in a private collection has Cope of Birmingham brass casters. See CR 111.
160. A drawing of table legs with attached casters appears in one of Godwin's sketchbooks and is annotated "Parrys direct bearing castor City Rd. Manchester." V&A PD E.233-1963, fol. 49.
161. Godwin, 12 August 1876, p. 86.
162. For example, V&A PD E.233-1963, fol. 15.
163. Godwin, 12 August 1876, p. 86.
164. Ibid.
165. "'Art' Furniture So-Called," 15 February 1879, p. 109.
166. "At Kensington," 1 April 1885, p. 183.
167. Art Furniture, p. viii.
168. Godwin described these sofas as having "movable seats, so that there is no difficulty whatever in keeping the crevices free from dust" (Godwin, 5 August 1876, p. 73).
169. Art Furniture, p. vii.
170. "Cabinet for Objects Du Vertu [sic]," 5 March 1886, p. 376.
171. Godwin, 3 June 1876, p. 353.
172. Ibid.
173. Godwin, 29 July 1876, p. 58.
174. Ibid., p. 59.
175. Art Furniture, p. viii.
176. "Art Furniture," 24 August 1877, p. 174.
177. Godwin, 19 August 1876, p. 101.
178. Art Furniture, p. iii.
179. "Art Furniture," 5 June 1868, p. 375.
180. Godwin, 1 July 1876, p. 5.
181. Ibid.
182. Art Furniture, p. iii.
183. Ibid., p. viii.
184. "Working Drawings of Inexpensive Furniture," 18 December 1885, p. 1011, ill. pp. [1008–9].
185. Godwin, 19 August 1876, p. 100.
186. Ibid.
187. Ibid.
188. "Design for Bedroom Furniture," 23 September 1876, p. 186; reproduced in Art Furniture (1877; Plate 15).
189. "Parlour Furniture," 31 October 1879, p. 522, ill. p. [531].
190. Godwin, 19 August 1876, pp. 100–101.
191. Ibid., p. 101.
192. V&A PD E.233-1963, fols. 10, 18.
193. V&A PD E.233-1963, fol. 57.
194. V&A AAD 4/12-1980, n.p. ("Messrs. Waugh & Son, 65 Tottenham Court Road," 1876).
195. Letter from W. A. P. Lane to Peter Floud, 15 September 1952, V&A Nominal file.
196. Bristol Museums and Art Gallery 1976, no. 3.
197. For more information on Morris and Co. furniture, see Parry 1996; and Collard 1985, pp. 155–79.
198. V&A AAD 4/13-1980, n.p. ("Collinson & Lock," 9 April 1873, "Cott table"; 25 February 1873, "Cott. Couch"; 25 February 1873, "Cott. Sideboard"; 28 March 1873, "Cott. Hanging cabt"; 10 April 1874, "Cott. L. cab."; 10 April 1874, "cott. Dr. rm cab").

199. V&A PD E.235-1963, fol. 32.
200. V&A AAD 4/13-1980 n.p. ("Collinson & Lock," 23 April 1874).
201. V&A PD E.235-1963, fol. 38.
202. Compare sketches for Collinson and Lock (V&A PD E.235-1963, fol. 7) with those for William Watt (V&A PD E.233-1963, fol. 101).
203. V&A PD E.233-1963, fol. 101.
204. V&A PD E.233-1963, fol. 11.
205. Girouard 1977, p. 132.
206. Cooper 1987, p. 143.
207. "Is the Rage for Queen Anne Furniture Over?" 17 July 1880, pp. 33–34.
208. Agius 1978, p. 45.
209. "Furniture by E. W. Godwin," 5 November 1880, p. 528, ill. p. [534].
210. V&A AAD 4/13-1980, n.p. ("Collinson and Lock," 9 June 1873).
211. V&A AAD 4/23-1988, fols. 62–64.
212. Godwin, 15 June 1872, p. 2.
213. Art Furniture, p. viii.
214. "Furniture by E. W. Godwin," 5 November 1880, p. 528, ill. p. [534].
215. V&A PD E.233-1963, fol. 43.
216. V&A PD E.493-1963.
217. V&A AAD 4/12-1980 n.p. ("Messrs Waugh & Son" and "Constable & Waugh & Son").
218. V&A PD E.229-1963, fols. 109, 83.
219. V&A AAD 4/12-1980 n.p. ("Js. Toleman").
220. V&A AAD 4/12-1980 n.p. ("Sundries").
221. V&A PD E.233-1963, fol. 27.
222. V&A PD E.422-1963.
223. "Greek Armchair by E. W. Godwin," 29 May 1885, p. 850, ill. p. [862].
224. V&A PD E.472-1963.
225. Godwin, June 1886, pp. 914–22.
226. RIBA MC GoE/5/1.
227. Some of these forms were illustrated in their catalogue Designs for Furniture of 1850–55; see Joy 1977, p. xxix.
228. "Furniture Trades Exhibition," 11 May 1883, p. 236.
229. V&A PD E.229-1963, fol. 114.
230. Hyde 1951, p. 175.
231. Ibid.
232. I am indebted to Alan Crawford for this information.
233. Banham, MacDonald, and Porter 1991, p. 39.
234. V&A PD E.278-1963, illustrated in Aslin 1986, p. 80.
235. V&A AAD 4/12-1980 n.p. ("Messrs Waugh & Son").
236. See, e.g., entry for 23 November 1876, V&A AAD 4/2-1980, Diary 1874 and 1876.
237. V&A PD E.233-1963, fol. 53.
238. Lever 1982, p. 81.
239. An example is in the Victoria and Albert Museum; see Ormond 1965, pp. 55, 58.
240. Quoted in Aslin 1986, pp. 32–33, pl. 67.
241. For more information on H. W. Batley, see Soros spring 1999, pp. 2–41.
242. For more information on the Egyptian revival, see Curl 1994.
243. Gere and Whiteway 1993, p. 69.
244. V&A PD E.233-1963, fol. 41.
245. "Old English Furniture," 19 August 1876, p. 112, ill.
246. V&A PD E.233-1963, fol. 3.
247. It is interesting to note that Plate 15, which is titled "Old English or Jacobean," also includes Godwin's coffee table with its Egyptian-inspired elements. And Godwin himself wrote that "the furniture shown [is] no more Jacobean than that shown on Plate 8 is Japanese." This blurring of design sources indicates the manufacturer's need to name furniture in particular historical styles. I am indebted to Alan Crawford for this observation.

248. Eastlake 1878 (1969 ed.), pl. IV opp. p. 34.
249. For more information on the antiquarian craze in the first half of the nineteenth century, see Wainwright 1989.
250. Unattributed quotation found in Banham, MacDonald, and Porter 1991, p. 57.
251. Ibid., p. 59.
252. Shoolbred and Co. 1874, 1876, and 1889.
253. "Old English Furniture," 19 August 1876, p. 112, ill.
254. Godwin, 29 July 1876, p. 58.
255. Ibid.
256. Art Furniture, p. viii.
257. Jervis 1974b, p. 99.
258. Aslin 1986, pp. 27 (notes), 49, pl. 15.
259. Godwin, 29 July 1876, p. 58.
260. The walnut dining table in Plate 16 is 3 ft. 6 in. by 5 ft.; the oak table in Plate 15 is 4 ft.; and the oak table in Plate 7 is 7 ft. by 3 ft. 6 in. These measurements are listed in the annotated price list that accompanied each catalogue. Godwin's own copy is in the Victoria and Albert Museum, London. V&A AAD 4/508-534-1988.
261. The smallest is the oak buffet in Plate 16, which measured 6 ft.; the largest is the oak buffet in Plate 7, which measured 7 ft. 6 in.
262. Godwin, 29 July 1876, p. 59.
263. "The Shakespeare Dining-Room Set," 11 November 1881, p. 626, ill. p. [634].
264. "Love of Old Things," 1 December 1881, p. 103.
265. "Our Museum," 1 April 1882, p. 187.
266. "Furniture and Decoration at the Royal Albert Hall," 1 December 1885, p. 142.
267. "At Kensington," 1 April 1885, p. 183.
268. "A Catalogue of Relics of Shakespeare and Other Furniture and Effects Which Will Be Sold by Auction by William Hutchings on Monday Next, Aug. 12th, 1867, on the Premises of Mr. John James (a Bankrupt), No. 23, High-street, Stratford-on-Avon."
269. Shoolbred and Co. 1876, pl. 20.
270. "Shakespearian Furniture Relic," 3 March 1877, p. 137; "Shakespeare's Chair," 10 March 1877, p. 146.
271. "Suggestive Furniture," 30 March 1878, pp. 325, 327.
272. For more information on George Godwin's collection, see Graham 1990, pp. 108–9.
273. "Shakespeare Relics," 1 April 1893, p. 342.
274. "Sale Of The Kingsthorpe Relics of Shakespeare," Christie's, London, 5 June 1896, copy in the Shakespeare Birthplace Trust, Stratford-upon-Avon.
275. See Zygulski 1965, pp. 392–97.
276. I am indebted to Ann Donnelly, Museum Curator, The Shakespeare Birthplace Trust, Stratford-Upon-Avon, for this information.
277. Briggs 1989, p. 248.
278. Godwin, 1 July 1876, p. 5.
279. Ibid.
280. "Piano Case," 2 January 1874, ill. p. [10].
281. Ibid.
282. "Design for a Piano Case," 9 January 1874, p. 54.
283. Furniture Manufacturer, 16 January 1874, p. 81.
284. "Design for a Pianoforte," 23 January 1874, p. 105.
285. V&A AAD 4/9-1980, fol. 82.
286. Godwin, 1 July 1876, p. 5.
287. Godwin, 5 August 1876, p. 73.
288. Michael Wilson (1972) contends that Burne-Jones was the first Victorian designer to model a modern grand piano on earlier piano and harpsichord cases dating from about 1800. Yet this cannot be so, because Burne-Jones worked on this design in 1878, five years after Godwin's piano designs for Collinson and Lock. I am indebted to Alan Crawford for this observation.
289. V&A PD E.470-1963; Godwin's designs for

pianos may have been influenced by the "Loan Exhibition of Musical Instruments" at the South Kensington Museum in 1872.

290. V&A PD E.501-1963.
291. The design is dated 22 August 1873. V&A AAD 4/13-1980 n.p.
292. Ibid.
293. Hulton Getty Images, London, H/The/Port/ Terry/Ellen. Neg HI 9354 box 214 5/4.
294. V&A AAD 4/13-1980 n.p. "Collinson & Lock" entry for 17 November 1873 "Music cabinet Grey Towers"; AAD 4/13-1980 n.p. "Collinson & Lock" entry for 25 August 1873 "Music Cabinet McLaren."
295. V&A AAD 4/12-1980 n.p. ("William Watt").
296. An enameled label affixed to the underside of this piece reads: "William Watt Grafton Street."
297. Public Record Office, Kew, London. Board of Trade records BT 43/58, no. 305888.
298. "Art Furniture," 24 August 1877, p. 174.
299. Review of *Art Furniture*, 25 August 1877, p. 145.
300. *Art Furniture*, p. iii.
301. Illustrated in C. Spencer 1973, p. 34, no. 14.
302. "Drawing Room Furniture Manufactured by D. Blythe Adamson & Co.," 13 April 1878, pl. 67.
303. *Art Furniture*, p. iii.
304. See Joy 1977, pl. 251.
305. An example is in the Victoria and Albert Museum, London, Circ. 643-1962.
306. For more information about the influence of the International Exhibitions, see Greenhalgh 1988.
307. "English Art Furniture at the Vienna Exhibition," 22 May 1873, pp. 1–2.
308. Aslin 1986, p. 15.
309. V&A PD E.229-1963, fol. 47.
310. Aslin 1986, p. 15.
311. The National Trust, Ellen Terry Memorial Museum, Smallhythe Place, Kent. SMA/D/24.
312. V&A AAD 4/1-1980, n.p. (20 March 1873).
313. V&A AAD 4/13-1980 n.p. ("Collinson & Lock"); 8 February 1873 ("A decn Vienna 3-3-0").
314. V&A PD E.234-1963, fol. 79.
315. Vienna, Universal Exposition, 1873, Central-commission des deutschen Reiches 1874–77, pp. 471–72.
316. V&A PD E.233-1963, fol. 98.
317. Much of this information on the "Butterfly Suite" appears in Soros 1987.
318. Paris, Exposition Universelle, 1878, Royal Commission, Third Group, Furniture and Accessories, p. 78.
319. The "Butterfly Cabinet" was sold at auction by Christie's, London, 4 October 1973, lot 196. It was purchased by the University of Glasgow for £8,400.
320. Pennell and Pennell 1908, vol. 1, p. 219.
321. Aslin 1986, p. 14.
322. Pennell and Pennell 1908, vol. 1, p. 219.
323. Young, MacDonald, and Spencer 1980, p. 113, no. 195.
324. Godwin visited and reviewed Whistler's Peacock Room; see Godwin, 24 February 1877, pp. 118–19.
325. Glasgow University Library, Special Collections, Birnie Philip Collection II, G 106. Letter from Whistler to Godwin, 25 March 1878.
326. "Paris Universal Exhibition," 24 February 1877, pp. 118–19.
327. A copy of *Society of Arts Artisan Report* 1879 is in the "Butterfly Cabinet" curatorial file of the Hunterian Art Gallery, Glasgow.
328. *Society of Arts Artisan Report* 1879.
329. Day, 12 July 1878, pp. 15–16.
330. Smalley, 6 July 1878, p. 2.
331. "Decorative Art Exhibition," 1 August 1881, p. 23.
332. "Messrs. Greory & Co., Messrs. Howard &

Sons," 27 May 1881, p. 269.
333. "Domestic Electric Lighting," 1 April 1882, p. 202.
334. "Mr. Robert Christie Has Nothing," 22 February 1884, p. 86.
335. "Jacobean Suite of Dining Room Furniture," 14 March 1884, p. 404, ill. p. [418].
336. "Mr. Robert Christie Has Nothing," 22 February 1884, p. 86.
337. "Furniture at the School of Art Needlework," April 1884, p. 22.
338. "At Kensington," 1 April 1885, p. 183.
339. Ibid.
340. H. Muthesius 1904–5 (1979 ed.), p. 157.
341. V&A PD E.234-1963, fols. 20, 25.
342. Howe et al. 1994, pp. 166–69.
343. V&A AAD 4/13-1980 n.p. ("Collinson & Lock").
344. V&A PD E.234-1963, fol. 50.
345. See Bolger Burke et al. 1986, pp. 68–69.
346. Aslin 1986, p. 17.
347. Gere and Whiteway 1993, p. 164.
348. "Art Furniture by E. W. Godwin," parts 1–9, February–October 1878.
349. Aslin 1986, p. 15.
350. Howe et al. 1994, p. 193.
351. In his ground-breaking study *Victorian and Edwardian Decor*, Jeremy Cooper (1987, p. 152) suggests that many of the pieces attributed to Godwin might actually be the work of Cottier. Two of the pieces Cooper attributes to Godwin (ibid., p. 142, pls. 337, 343), however, are now believed to have been designed by Cottier.
352. For more information on Cottier, see Bolger Burke et al. 1986, pp. 414–15; and Juliet Kinchin's entry on "Cottier," in Banham 1997, pp. 325–27.
353. Andrews 1985, p. 46.
354. Bolger Burke et al. 1986, pp. 414–15.
355. *Melbourne Bulletin*, 15 May 1885, p. 7; Watson 1994, n. 4.

NOTES TO THE CATALOGUE RAISONNÉ
1. CHAIRS

1. Campion 1925; Glazebrook 1970, p. 28.
2. M. Hall 1993, p. 50.
3. See Eames 1977, p. 197.
4. Boger 1969, pl. 34; Metropolitan Museum 1994, p. 391, fig. 47.
5. Willemin 1839, vol. 2, pl. 14.
6. Viollet-le-Duc 1854–75 (1926 ed.), vol. 1, p. 44, fig. 4.
7. Ibid., p. 7, fig. 6.
8. Graham 1994, p. 85.
9. Scott 1863, p. xxv. I am indebted to Clive Wainwright for this reference.
10. Campion 1925, p. 45.
11. Eames 1977, pl. 70a.
12. Aslin 1986, p. 12.
13. Godwin, 29 July 1876, pp. 58–59.
14. Aslin 1986, p. 27, fig. 15.
15. Viollet-le-Duc 1854–75 (1926 ed.), vol. 1, p. 95, fig. 3. Godwin is known to have owned this work by Viollet-le-Duc and even reviewed it on its publication in England. See Godwin, 29 June 1872, pp. 337–39.
16. How 1892a, p. 281.
17. Lever 1982, p. 80.
18. Willemin 1839, vol. 1, pl. 4.
19. Godwin, 5 August 1876, p. 73.
20. Wainwright 1989, p. 59.
21. Bristol Museums and Art Gallery 1976, no. 5.
22. See Cooper 1987, p. 106, fig. 229.
23. Girouard 1979, p. 250, fig. 237.
24. Godwin, 19 August 1876, p. 100.
25. Bristol Museums and Art Gallery 1976, no. 1.

26. "Anglo-Japanese Furniture at Paris Exhibition," 14 June 1878, p. 596, ill.
27. For a general discussion of the "Butterfly Suite," see pp. 73–75 of my essay herein; additional information can be found in the entry on the "Butterfly Cabinet," CR 369.
28. Chinnery 1979, pp. 278–80.
29. See Atterbury 1995, p. 322, pl. 83.
30. The architect-designer Alfred Waterhouse designed similar chairs for Manchester Town Hall between 1869 and 1876 based on Pugin's House of Lords design. See Cooper 1987, p. 106, fig. 232.
31. Christie's (London) 1982, lot 265.
32. Waagen 1860.
33. Wainwright, "Furniture," in Atterbury and Wainwright 1994, p. 131.
34. See ibid., pp. 132, 231.
35. I wish to thank Victor Chinnery for this information.
36. I have acquired this information from Ann Donnelly, Museum Curator, The Shakespeare Center, Stratford-upon-Avon.
37. See Graham 1994, pp. 89–91.
38. Timms, 1 April 1887, p. 260.
39. "Shakespeare Dining-Room Set," 11 November 1881, p. 626.
40. For examples of joined stools, see Chinnery 1979, pp. 263–67, figs. 3:86, 3:87.
41. "Furniture Trades Exhibition," 11 May 1883, p. 236.
42. "At Kensington," 1 April 1885, p. 183.
43. "Greek Armchair," 29 May 1885, p. 850.
44. "Working Drawings of Inexpensive Furniture," 18 December 1885, p. 1011, ill.
45. Ibid., p. 1011, ill.
46. This sketch (V&A PD E.278-1963) was part of a series of drawings of antique chairs and stools that are inscribed BM, for British Museum.
47. See Richter 1966, p. 125

2. TABLES

1. Edwards 1964, p. 532, fig. 2.
2. N. Wilkinson 1987, pp. 227–28.
3. C. Spencer 1973, p. 34, pl. 14.
4. N. Wilkinson 1987, p. 178.
5. Grier 1988, pp. 86–87.
6. A photograph by H. Bedford Lemere, ca. 1892, of G. W. Allen's sitting room at 179 Queen's Gate shows one of these octagonal tables in the center of the room (Gere 1989, p. 387, pl. 485). Another photograph, from the 1870s, of Norman Shaw's back drawing room at Ellerdale Road, Hampstead, reveals a version of Godwin's octagonal table in the left corner (Saint 1976, p. 181, pl. 143).
7. The Herter Brothers firm in New York also used enhanced rosewood graining in the treatment of some of their commissioned pieces.
8. See Atterbury 1995, p. 351, pl. 351.
9. Part of the Collinson and Lock stand, Centennial Exhibition 1876; photograph from the Free Library of Philadelphia.
10. See Pevsner 1952a (1968 ed.), pl. 12.
11. Girouard 1979, fig. 237. I am grateful to the current Baron Wraxall for this information. Examination of this photograph reveals that this room also contained four Dromore-style Godwin dining chairs; see, for comparison, CR 125.
12. Phillips (Edinburgh), 26 May 1992, lot 365.
13. I am indebted to David Bonsall for this information.
14. Godwin, 22 July 1876, p. 46.
15. Lever 1973, p. 44, no. 147.
16. Blairman and Sons 1994, pl. 17.
17. Chinnery 1979, pp. 289–92.
18. "Furniture at the Paris Exhibition," 7 September

1878, p. 159.

19. Cooper 1987, p. 149, pl. 378.
20. "Bed-Room Furniture," 24 October 1879, p. 490, ill.
21. "Furniture by E. W. Godwin," 5 November 1880, p. 528, ill.
22. "Shakespeare Dining-Room Set," 11 November 1881, p. 626.

3. CABINETS

1. Godwin, 1 July 1876, p. 5.
2. Watson 1994, p. 6; "Two Interiors" 1920, p. 52.
3. Dry 1994, pp. 20–22; Watson 1997, pp. 66–67.
4. Godwin, 1 July 1876, pp. 4–5.
5. Reeves 1994, p. 38.
6. Anne Watson (1997, p. 68), for example, refers to this painted decoration as "Japanese-style decoration," and Graham Dry (1994, p. 21) writes that "the painted golden ornament on the door and on the left side of the upper left element point to Japan as the source of inspiration for this design."
7. Reid 1987, p. 135. A drawing in Godwin's sketchbook from the time that he was studying these specimens at the Royal Academy shows the same circular emblem (V&A PD E.232-1963, fol. 45).
8. Vallance, April 1892, p. 112.
9. Letter from Francis Meynell to Peter Floud, 7 March 1952, V&A Nominal file.
10. N. Wilkinson 1987, pp. 45–46, 53–54, 177.
11. Godwin, 23 December 1876, p. 363.
12. Watson 1994, n. 8.
13. I am indebted to Clive Wainwright for this information.
14. Watson 1997, p. 73.
15. In a letter to Peter Floud dated 27 July 1952, Joseph Carr's son, Philip, wrote: "My father . . . had a replica of the Jameson sideboard by Godwin, but his [Godwin's] was in black wood, ours in light oak. I don't know what has become of it." Victoria and Albert Museum file 38-1953, quoted in Watson 1994, p. 7, n. 9.
16. Watson 1997, p. 69.
17. The annotated price list refers to "Ebonized book shelves decorated" that sold for £7.7s.0d.
18. Godwin, 1 July 1876, p. 5.
19. See "Mahogany Hanging shelves with canted sides, cupboards and drawers, ca. 1785, Sir John Ramsden Collection," in R. Edwards 1964, p. 470, fig. 9.
20. "Art Furniture Company, the 'Florence Cabinet,'" 29 December 1871, p. [495].
21. Godwin, 12 and 19 February 1875.
22. These ideas were outlined in his six-part series on the decoration of his London home, "My House 'in' London," Architect, July and August 1876.
23. Letter from W. A. P. Lane to Peter Floud, 15 September 1952, V&A Nominal file.
24. Godwin, 19 August 1876, p. 101.
25. Eames 1977, pl. 4.
26. Sheraton 1793, pl. XLII: "Engraved Designs for Three 'Corner Bason-Stands,'" dated 1792.
27. Haslam 1993, p. 26.
28. De Courcy, Dromore Castle, 19–21 October 1949.
29. Godwin, 1 July 1876.
30. Macquoid and Edwards 1986, p. 369.
31. De Courcy [1949], lots 895a, 896a.
32. Ibid., lot 260.
33. Letter from F. V. Hart to E. W. Godwin, dated 2 November 1869, V&A AAD 4/184-1988.
34. Haslam 1993, p. 26.
35. Godwin, 8 July 1876, p. 19.
36. Haslam 1993, p. 27.

37. Ibid.
38. Quoted in Agius 1978, p. 132.
39. "Bed-Room Furniture," 24 October 1879, p. 490, ill.
40. Edis 1881, p. 214.
41. Harbron 1949, ill. opp. p. 46.
42. Ibid., p. 82.
43. Letter from Mrs. Lewis Clarke to Peter Floud, 6 May 1952, V&A Nominal file, London.
44. Letter from G. Dudley Harbron to Peter Floud, 21 May 1951, V&A Nominal file, London.
45. Ibid.
46. Harbron 1949, p. 82.
47. "Working Drawings of Inexpensive Furniture," 18 December 1885, p. 1011, ills.
48. N. Wilkinson 1987, p. 175.
49. See Chinnery, pp. 337–341.
50. Vienna, Universal Exposition, 1873, Central-commission des deutschen Reiches 1874–77, pp. 471–72.
51. "Furniture at the Paris Exhibition," 7 September 1878, p. 159. Collinson and Lock were not the only firm to display the corner cabinet at the Exposition. One reviewer praised the "charming corner cupboard" of Jackson and Graham in the British furniture section, Illustrated Paris Universal Exhibition (London), no. 29 (16 November 1878), p. 329. Another remarked that several complete sets of furniture "are there seen . . . and scarcely a mantel-piece, dressoir, cabinet, bonheur du jour, étagère or corner cupboard is without chine faïence, enamels, or other objects. . ." Ibid., p. 341.
52. "Furniture at the Paris Exhibition," 7 September 1878, p. 159.
53. Reid 1987, p. 135.
54. Quoted in R. Edwards 1964, pp. 493–94.
55. Atterbury 1978, p. 41.
56. A copy of Harbron's Conscious Stone belonging to E. W. Godwin's descendants has an annotation in the margin on page 69 stating that a bulldog and a monkey kept Godwin and Ellen Terry company at Gustard Wood Common.
57. N. Wilkinson 1987, p. 178.
58. Aslin 1986, p. 10.
59. Ellsworth 1982, p. 59, fig. 52.
60. "Art Cabinet Designed by E. W. Godwin," 19 March 1886, p. 456.
61. Bendix 1995, p. 156.
62. Godwin designed a series of similar figures for the British Architect "Kalendar" in 1881. British Architect 14 (3 December 1880).
63. The "Beatrice Cabinet," for example, which was designed by E. W. Godwin and made by William Watt, was decorated with identical panels executed by Mrs. Godwin (CR 374).
64. Aslin 1986, p. 24.
65. Godwin reproduced both of these Japanese-derived elements in his article on Japanese wood construction in Building News, 12 February 1875.
66. N. Wilkinson 1987, p. 250.
67. "Bed-Room Furniture," 24 October 1879, p. 490.
68. "Art Furniture," 24 August 1877, p. 174.
69. R. Edwards 1964, p. 212, fig. 1.
70. Godwin's Diaries, V&A AAD4/3-1980, 2 October 1877.
71. Glasgow University Library, Birnie Philip Collection II, G 106, Letter from Whistler to Godwin, 25 March 1878.
72. Pennell and Pennell 1908, p. 219.
73. Artist, December 1882, p. 387.
74. Whistler used similar cloud, butterfly, and chrysanthemum motifs in his designs for Aubrey House in 1873, and the chrysanthemum and butterfly motifs reappear in the dado of the entrance hall and staircase of Whistler's second Chelsea home, No. 2 Lindsey Row, 1878; see

Soros 1987, p. 60.

75. Godwin's form became so popular, in fact, that in February 1886 Cabinet Maker commented that a similarly arranged "lopsided but useful" wardrobe by W. Timms, called the Beaconsfield, had become one of the most popular wardrobes on the market; quoted in Agius 1978, p. 128.
76. "Parlour Furniture," 31 October 1879, p. [531].
77. "Sideboard for a Dining Room," 15 October 1880, p. 442.
78. "Shakespeare Dining-Room Set," 11 November 1881, p. 626.
79. "Jacobean Oak Sideboard," 15 May 1885, p. 766.
80. Ibid.
81. Chinnery 1979, p. 345, fig. 3:339.
82. "Mr. Robert Christie Has Nothing," 22 February 1884, p. 86.
83. "Jacobean Suite of Dining Roome Furniture," 14 March 1884, p. [406].
84. "Working Drawings of Inexpensive Furniture," 18 December 1885, p. 1011, ills.
85. "Satinwood and Ebony Cabinet," 1 May 1885, p. 686, ill.
86. Pevsner 1952a, p. 125.
87. "Art Cabinet," 19 March 1886, p. 456.
88. Ibid.
89. "Cabinet for Objects Du Virtu," 5 March 1886, p. 376.

4. MISCELLANEOUS PIECES

1. Godwin, 5 August 1876, p. 73.
2. De Courcy, Dromore Castle, 19–21 October 1949, lot 364.
3. Edwards 1964, p. 638.
4. See Child 1990, pp. 219–20.
5. "Design for a Piano Case," 9 January 1874, p. 54.
6. See, for example, the sketch annotated "Principles of Construction fr. J. book on Archt" in the Victoria and Albert Museum, London (V&A PD E.280-1963, fol. 13).
7. Joy 1977, p. 556.
8. "Art Furniture," 24 August 1877, p. 174.
9. "Bedroom Furniture Designed by Godwin," 24 October 1879, p. 490.
10. "Parlour Furniture," 31 October 1879, p. 522.
11. Macquoid and Edwards 1986, p. 96.
12. Joy 1977, p. 415.
13. Andrews 1992, p. 59.
14. "Furniture by E. W. Godwin," 5 November 1880, p. 528.
15. Ellmann 1988, p. 258.
16. "Working Drawings of Inexpensive Furniture," 18 December 1885, p. 1011, ill.

5. IN THE STYLE OF GODWIN

1. Royal Academy 1972, p. 61.
2. The Cecil Higgins Art Gallery, Bedford, the current owner of the suite, also has no evidence to link this suite to the work of Godwin.
3. Aslin 1986, p. 27.
4. See, for example, the Liberty catalogue of 1890, reproduced in Joy 1977, p. 448.
5. "Greek Armchair," 29 May 1885, p. 850.
6. "Working Drawings of Inexpensive Furniture," 18 December 1885, p. 1011.

SELECTED BIBLIOGRAPHY

ARCHIVES CONSULTED

Bristol Record Office.

Chelsea Library, Local Studies Collection, London.

City of Westminster Archives Centre, London. Gillow and Co., and Liberty and Co. Archives.

Compton Family Documents, Castle Ashby, Northamptonshire, England.

Craig Family. Papers. Private Collection, England.

Crisp, Henry. Papers held by the architectural firm Proctor and Palmer (formerly Oatley and Brentnall), Clevedon, Somerset, England.

Free Library, Philadelphia, Pennsylvania.

Glasgow University Library, Glasgow. Department of Special Collections, Whistler Collection.

Guildhall Library, Manuscript Division. Corporation of London.

Hunterian Art Gallery, Butterfly Cabinet Curatorial Papers. Glasgow, Scotland.

Hyde Collection. Four Oaks Farm, Somerville, New Jersey.

Hulton Getty Photo Archive, London.

Lambeth Palace Library, London. Records of the Incorporated Church Building Society.

Library of Congress, Washington, D.C. Rosenwald Collection, Box 1977.

Library of Congress, Washington, D.C. Whistler Clippings, Pennell Collection, Volume 36.

Nottinghamshire Archives, Nottinghamshire.

Northamptonshire Record Office, Northampton-shire.

National Monuments Record Centre. Royal Commission on the Historic Monuments of England, London and Swindon, England.

Public Record Office, Kew, Richmond, Surrey, England.

Royal Institute of British Architects, Drawings Collection. British Architectural Library, London.

Royal Institute of British Architects, Manuscripts and Archives Collection. British Architectural Library, London.

Ellen Terry Archives. The National Trust, Ellen Terry Memorial Museum, Smallhythe Place, Kent, England.

Victoria and Albert Museum, London. Archive of Art and Design.

Victoria and Albert Museum, London. Archive of the Theatre Museum, Blythe House.

Victoria and Albert Museum, London. Archive of the Theatre Museum, Covent Garden.

Victoria and Albert Museum, London. Department of Prints, Drawings, and Paintings.

E. W. GODWIN'S WRITINGS AND PUBLISHED DRAWINGS, INCLUDING PERIOD SOURCES AND ILLUSTRATIONS OF HIS WORKS

Citations are arranged by publication date. Square brackets indicate unsigned articles that are attributed to Godwin on the basis of records (including the architect's ledgers) in the Archive of Art and Design and the Department of Prints, Drawings, and Paintings at the Victoria and Albert Museum, London.

1851

Godwin, Edward William, et al. *Architectural Antiquities of Bristol and Its Neighbourhood*, by William Corbett Burder, James Hine, and Edward William Godwin. Bristol: Burder, Hine, and Godwin, 1851.

20 April 1861

"Northampton Town Council: The New Town Hall." *Northampton Herald*, 20 April 1861, 6.

27 April 1861

"The Northampton Town-Hall Competition." *Builder* 19 (27 April 1861), p. 282.

8 November 1861

Illustrations. "Ground Plan of Town Hall, Northampton"; "View of the Town Hall, Northampton: Mr. Edward W. Godwin, Architect." *Building News and Architectural Review* 7 (8 November 1861), pp. 892–93.

June 1862

Burges, William. "The International Exhibition." *Gentleman's Magazine and Historical Review* 212, n.s., 12 (June 1862), p. 665.

July 1862

Burges, William. "The International Exhibition." *Gentleman's Magazine and Historical Review* 213, n.s., 13 (July 1862), pp. 3–12.

September 1862

Burges, William. "The Japanese Court in the International Exhibition." *Gentleman's Magazine and Historical Review* 213, n.s., 13 (September 1862), pp. 243–54.

1865

Godwin, Edward William. *A Handbook of Floral Decoration for Churches*. London: J. Masters and Sons, 1865.

21 December 1867

"Grey Towers, Nunthorpe." *Builder* 25 (21 December 1867), pp. 923–25.

5 June 1868

"Art Furniture." *Building News and Engineering Journal* 15 (5 June 1868), p. 375.

25 December 1868

"Messrs. Walford and Donkin's Art Furniture." *Building News and Engineering Journal* 15 (25 December 1868), pp. 869–70.

1870

"Pompeii in London." *Art Journal* (1870), p. 278.

29 December 1871

Illustration. "Art Furniture Company, the 'Florence Cabinet,' Edward W. Godwin, Archt." *Building News and Engineering Journal* 21 (29 December 1871), p. [495].

25 May 1872

["The Article 'Maison' in M. Viollet Le Duc's [*sic*] Dictionnaire."] *Architect* (London) 7 (25 May 1872), pp. 267–68.

15 June 1872

["Furniture."] *Globe and Traveller* (London), 15 June 1872, pp. 1–2.

29 June 1872

["The Article 'Maison' in M. Viollet Le Duc's [*sic*] Dictionnaire."] *Architect* (London) 7 (29 June 1872), pp. 337–39.

11 October 1872

"Wall-Papers." *Building News and Engineering*

Journal 23 (11 October 1872), p. 291 and illustrations [286–87].

15 November 1872
E. W. C. [*sic*] "Gothic Furniture." Letter to *Building News and Engineering Journal* 23 (15 November 1872), pp. 393–94.

21 March 1873
Our Lithographic Illustrations. "Dromore Castle." *Building News and Engineering Journal* 24 (21 March 1873), p. 330 and illustration [339].

4 April 1873
Our Lithographic Illustrations. "Decorations of Dromore Castle." *Building News and Engineering Journal* 24 (4 April 1873), p. 390 and illustration [402].

10 May 1873
"The International Exhibition." *Furniture Gazette*, n.s., 1 (10 May 1873), p. 75.

17 May 1873
Charles, R. "The International Exhibition." Letter to *Furniture Gazette*, n.s., 1 (17 May 1873), p. 89.

22 May 1873
"English Art Furniture at the Vienna Exhibition." *Globe and Traveller* (London), 22 May 1873, 1–2.

28 June 1873
"From the Vienna International Exhibition." *Builder* 31 (28 June 1873), pp. 500–501.

5 July 1873
"From the Vienna Exhibition." *Builder* 31 (5 July 1873), pp. 518–19.

19 July 1873
"An Architect's Report on Furniture in the Vienna Exhibition." *Furniture Gazette*, n.s., 1 (19 July 1873), p. 229.

16 August 1873
"Vienna International Exhibition." *Builder* 31 (16 August 1873), p. 640.

30 August 1873
"The Vienna Exhibition." *Builder* 31 (30 August 1873), pp. 678–80.

2 January 1874
Illustration. "Piano Case." *Building News and Engineering Journal* 26 (2 January 1874), p. [10].

9 January 1874
A Pianoforte Player. "Design for a Piano Case." Letter to *Building News and Engineering Journal* 26 (9 January 1874), p. 54.

16 January 1874
A Furniture Manufacturer. "Design for a Piano-Case"; "Mr. E. W. Godwin's Design for Piano-Case." Letters to *Building News and Engineering Journal* 26 (16 January 1874), p. 81.

17 January 1874
"Architects and Furniture." Letter to *Furniture Gazette*, n.s., 2 (17 January 1874), pp. 72–73.

23 January 1874
Free Lance. "Design for a Pianoforte." Letter to *Building News and Engineering Journal* 26 (23 January 1874), p. 105.

27 February 1874
"Measured Drawings by E. W. Godwin, F.S.A." *Building News and Engineering Journal* 26 (27 February 1874), p. 228.

6 March 1874
Godwin, Edward William. "The New European Style." *Building News and Engineering Journal* 26 (6 March 1874), p. 269.

24 April 1874
King, E. M. "Co-operative Housekeeping." *Building News and Engineering Journal* 26 (24 April 1874), pp. 459–60.

12 June 1874
Godwin, Edward William. "Mr. E. W. Godwin on Lady Architects." *British Architect* 1 (12 June 1874), p. 378.

13 June 1874
Godwin, Edward William. "Lady Architects." *Architect* (London) 11 (13 June 1874), p. 335.

12 and 19 February 1875
Godwin, Edward William. "Japanese Wood Construction." Parts 5 and 6 of "Woodwork." *Building News and Engineering Journal* 28 (12 February 1875), pp. 173–74 and illustration [189]; (19 February 1875), pp. 200–201 and illustration [214].

16 April 1875
Godwin, Edward William. "The Ex-Classic Style Called 'Queen Anne.'" *Building News and Engineering Journal* 28 (16 April 1875), pp. 441–42.

8 October 1875
Our Office Table. "Many people know . . ." *Building News and Engineering Journal* 29 (8 October 1875), p. 409.

8 April 1876
"'Artistic' Furnishing." *Furniture Gazette*, n.s., 5 (8 April 1876), p. 222.

15 April 1876–27 May 1876
Godwin, Edward William. "Scraps for Students." Parts 1–6. *Architect* (London) 15 (15 April 1876), pp. 237–38; (22 April 1876), pp. 252–53; "Selection of Studies" (6 May 1876), pp. 284–85; "'The Office'" (13 May 1876), pp. 303–5; "Competition and Clients" (20 May 1876), p. 320; "At Home" (27 May 1876), pp. 338–39.

27 May 1876
"Furniture at the Centennial." *Furniture Gazette*, n.s., 5 (27 May 1876), pp. 331–32.

3 June 1876
Godwin, Edward William. "Mantelpieces." *Architect* (3 June 1876), p. 353.

1 July 1876–8 July 1876
Godwin, Edward William. "My Chambers and What I Did to Them." Parts 1 and 2. *Architect* (London) 16, "Chapter 1: A.D. 1867," (1 July 1876), pp. 4–5; "Chapter 2: A.D. 1872," (8 July 1876), pp. 18–19.

15 July 1876–19 August 1876
Godwin, Edward William. "My House 'In' London." Parts 1–6. *Architect* (London) 16 (15 July 1876), pp. 33–34; "The Hall" (22 July 1876), pp. 45–46; "The Dining-Room" (29 July 1876), pp. 58–59; "The Drawing-Room" (5 August 1876), pp. 72–73; "The Bedrooms" (12 August 1876), p. 86; "Tops and Bottoms" (19 August 1876), pp. 100–101.

19 August 1876
Our Separate Plate. "Old English Furniture." *Furniture Gazette*, n.s., 6 (19 August 1876), p. 112, ill.

26 August 1876
Godwin, Edward William. "From the House-Top." *Architect* (London) 16 (26 August 1876), pp. 112–13.

23 September 1876
"Design for Bedroom Furniture by E. W. Godwin, F.S.A." *Furniture Gazette*, n.s., 6 (23 September 1876), p. 186.

18 November 1876
"Decorative Fine-Art Work at Philadelphia: Furniture in the British Section." *American Architect and Building News* 1 (18 November 1876), pp. 372–73.

23 December 1876
Godwin, Edward William. "Afternoon Strolls." *Architect* (London) 16 (23 December 1876), pp. 363–64.

1877
Watt, William. *Art Furniture, from Designs by E. W. Godwin, F.S.A., and Others, with Hints and Suggestions on Domestic Furniture and Decorations.* London: B. T. Batsford, 1877. Reprinted 1878. Reprinted with Messenger and Company's *Artistic Conservatories* as *Art Furniture and Artistic Conservatories*, by E. W. Godwin, New York: Garland, 1978.

24 February 1877
Godwin, Edward William. "Notes on Mr. Whistler's 'Peacock Room.'" *Architect* (London) 17 (24 February 1877), pp. 118–19.

3 March 1877
News, Notes and Comments. "A Shakespearian Furniture Relic." *Furniture Gazette*, n.s., 7 (3 March 1877), p. 137.

9 March 1877
"The Villas on the Bedford-Park Estate." *Building News and Engineering Journal* 32 (9 March 1877), p. 253.

10 March 1877
"Shakespeare's Chair." *Furniture Gazette*, n.s., 7 (10 March 1877), p. 146.

14 April 1877
"A Unique Style of Dining-Room Decoration." *Furniture Gazette*, n.s., 7 (14 April 1877), p. 237.

7 July 1877
"The Furniture Gazette Directory." *Furniture Gazette*, n.s., 8 (7 July 1877), p. 9.

24 August 1877
"Art Furniture." Building News and *Engineering Journal* 33 (24 August 1877), p. 174.

25 August 1877
Review of *Art Furniture from Designs by Edward W. Godwin, F.S.A., and others . . .* , *Furniture Gazette*, n.s., 8 (25 August 1877), p. 145.

21 December 1877
Our Lithographic Illustrations. "Art Furniture." *Building News and Engineering Journal* 33 (21 December 1877), p. 614 and illustration [617].

1878a
Chesneau, Ernest. "Le Japon à Paris." *Gazette des beaux-arts*, n.s., 18 (1878), p. 386.

1878b
"The Paris Universal Exhibition," parts 5, 7. *Magazine of Art* 1 (1878), pp. 113, 187–91.

25 January 1878
Advertisement. "Wm. Watt, Artistic Furniture Warehouse." *British Architect and Northern Engineer* 9 (25 January 1878), p. 11.

February 1878–October 1878
Illustrations. "Art Furniture by Edward W. Godwin, F.S.A." Parts 1–9. *Art Worker* (New York) 1 (February 1878), pls. 12, 13; (March 1878), pl. 22; (April 1878), pl. 30; (May 1878), pl. 37; (June 1878), pl. 46; (July 1878), pl. 53; (August 1878), pls. 60, 61; (September 1878), pl. 69; (October 1878), pl. 76.

22 March 1878
"Exhibits for the Paris Exhibition." *Building News and Engineering Journal* 34 (22 March 1878), pp. 287–88.

30 March 1878
"Suggestive Furniture." *Builder* 36 (30 March 1878), pp. 325, 327.

13 April 1878
"Drawing Room Furniture Manufactured by D. Blythe Adamson and Co." *Cabinet-Makers' Pattern Book: Being Examples of Modern Furniture of the Character Mostly in Demand . . .* London: Wyman and Sons, 1877–79. Originally issued as a supplement with *Furniture Gazette*, n.s., 9 (13 April 1878), pl. 67.

17 May 1878
"The report has reached us . . ." *British Architect and Northern Engineer* 9 (17 May 1878), p. 229.

21 May 1878
"Letters from Paris." *Illustrated Paris Universal Exhibition* (London), no. 3 (21 May 1878), p.27.

14 June 1878
"Discovering Antiques: Anglo-Japanese Furniture." *Times Past* 78, no. 6 (14 June 1878), p. 596.

14 June 1878
Our Lithographic Illustrations. "Anglo-Japanese Furniture at Paris Exhibition by E. W. Godwin, F.S.A." *Building News and Engineering Journal* 34 (14 June 1878), p. 596 and illustration [603].

19 June 1878
"A Last Breakfast in Cheyne Walk." *World*, 19 June 1878.

12 July 1878
Day, Lewis F. "Notes on English Decorative Art in Paris." Part 3. *British Architect and Northern Engineer* 10 (12 July 1878), pp. 15–16.

19 July 1878
Advertisement. "Wm. Watt, Artistic Furniture Warehouse." *British Architect and Northern Engineer* 10 (19 July 1878), p. xii.

27 July 1878
Smalley, George W. "A Harmony in Yellow and Gold." *American Architect and Building News* 4 (27 July 1878), p. 36. First published in *New York Tribune*, 6 July 1878, 2.

7 September 1878
"Furniture at the Paris Exhibition." *Furniture Gazette*, n.s., 10 (7 September 1878), pp. 153–65.

13 September 1878
Our Illustrations. "Art Furniture." *British Architect and Northern Engineer* 10 (13 September 1878), p. 104 and illustration.

29 November 1878
Godwin, Edward William. "On Some Buildings I Have Designed." *British Architect and Northern Engineer* 10 (29 November 1878), pp. 210–12.

30 November 1878
"An Architect's Residence." *Furniture Gazette*, n.s., 10 (30 November 1878), p. 375.

3 January 1879
Advertisement. "Wm. Watt, Artistic Furniture Warehouse." *British Architect and Northern Engineer* 11 (3 January 1879), p. xiv.

15 February 1879
Our Separate Plate. "'Art' Furniture So-Called." *Furniture Gazette*, n.s., 11 (15 February 1879), p. 108 and illustration.

22 March 1879
"Mr. Godwin's Furniture Designs." Letter to *Furniture Gazette*, n.s., 11 (22 March 1879), p. 199.

26 September 1879
Godwin, Edward William. "Some Facts about 'The White House,' Chelsea." *British Architect and Northern Engineer* 12 (26 September 1879), p. 119.

24 October 1879
Our Lithographic Illustrations. "Bed-Room Furniture Designed by E. W. Godwin, F.S.A." *Building News and Engineering Journal* 37 (24 October 1879), p. 490 and illustration [499].

31 October 1879
Our Lithographic Illustrations. "Parlour Furniture." *Building News and Engineering Journal* 37 (31 October 1879), p. 522 and illustration [531].

9 April 1880
Notes on Current Events. "As a handbook to conservatory building . . ." *British Architect and Northern Engineer* 13 (9 April 1880), p. 170.

11 June 1880
"House and Studio at Chelsea for F. Miles Esq." *British Architect* (11 June 1880), p. 282 and illustration.

17 July 1880
"Is the Rage for Queen Anne Furniture Over?" *Furniture Gazette* (17 July 1880), pp. 33–34.

30 July 1880–27 August 1880
Godwin, Edward William. "To Our Student Readers." Parts 1–3. *British Architect and Northern Engineer* 14 (30 July 1880), pp. 48–49; (13 August 1880), p. 70; (27 August 1880), p. 95.

1 October 1880
Anon. "Anglo-Japanese Furniture." *Cabinet Maker* 1 (1 October 1880), p. 56.

15 October 1880
Our Lithographic Illustrations. "A Dining-Room Sideboard." *Building News and Engineering Journal* 39 (15 October 1880), p. 442 and illustration [453].

5 November 1880
Our Lithographic Illustrations. "Furniture by E. W. Godwin, F.S.A." *Building News and Engineering Journal* 39 (5 November 1880), p. 528 and illustration [534].

3 December 1880
E. W. Godwin. Drawings of October, November, and December 1881 for *British Architect Kalendar*, published in *British Architect and Northern Engineer* 14 (3 December 1880).

18 March 1881
Godwin, Edward William. "Messrs. Minton, Hollins, and Co. . . ." *British Architect and Northern Engineer* 15 (18 March 1881), p. 143.

27 May 1881
Notes on Current Events. "Messrs. Gregory and Co. . . ." *British Architect and Northern Engineer* 15 (27 May 1881), p. 269.

1 July 1881
Godwin, Edward William. Illustration. "Outline of Interior Decoration." *British Architect and Northern Engineer* 16 (1 July 1881).

1 August 1881
"The Decorative Art Exhibition." *Cabinet Maker and Art Furnisher* 2 (1 August 1881), p. 23.

6 August 1881
"The Furniture Exhibition at Islington." *Furniture Gazette*, n.s., 16 (6 August 1881), pp. 72–73.

12 August 1881
Godwin, Edward William. Illustration. "Art Objects from a Private Collection." *British Architect and Northern Engineer* 16 (12 August 1881), p. 402 and illustration.

2 September 1881
"Rambling Sketches." Part 14. *British Architect and Northern Engineer* 16 (2 September 1881), pp. 444–45 and illustration.

11 November 1881
Our Lithographic Illustrations. "The Shakespeare Dining-Room Set." *Building News and Engineering Journal* 41 (11 November 1881), p. 626 and illustration [634].

1 December 1881
"The love of old things. . . ." *Cabinet Maker and Art Furnisher* 2 (1 December 1881), p. 103.

30 December 1881
Godwin, Edward William. "Friends in Council: No. 40, a Retrospect." *British Architect and Northern Engineer* 16 (30 December 1881), pp. 655–57.

6 January 1882
Robins, E. C. "Our Own Affairs." *British Architect and Northern Engineer* 17 (6 January 1882), p. 2.

1 April 1882
"Domestic Electric Lighting: Furniture and Decoration." *Furniture Gazette*, n.s., 17 (1 April 1882), pp. 201–3.

1 April 1882
Pen and Ink Notes. "Our Museum." *Cabinet Maker and Art Furnisher* 2 (1 April 1882), pp. 181–84, 187.

1 May 1882
Illustrated Guide to the Second Annual Furniture Exhibition. Supplement to *Furniture Gazette*, n.s., 17 (1 May 1882).

28 September 1882
"Persons of taste have long been annoyed. . . ." *Standard*, 28 September 1882, 5.

December 1882
Artist and Journal of Home Culture (December 1882), pp. 387–88.

1 December 1882
"The recently formed Costume Society . . ." *British Architect and Northern Engineer* 18 (1 December 1882), p. 570.

27 April 1883–11 May 1883
"The Furniture Trades Exhibition." Parts 1 and 2. *British Architect and Northern Engineer* 19 (27 April 1883), pp. 205–8 and illustration; (11 May 1883), p. 236.

1884
Godwin, Edward William. *Dress and Its Relation to Health and Climate.* London: William Clowes and Sons for the Executive Council of the International Health Exhibition and for the Council of the Society of Arts, 1884.

22 February 1884
Notes on Current Events. "Mr. Robert Christie Has Nothing. . . ." *British Architect and Northern Engineer* 21 (22 February 1884), p. 86.

14 March 1884
Our Lithographic Illustrations. "Jacobean Suite of Dining Room Furniture." *Building News and Engineering Journal* 46 (14 March 1884), p. 406 and illustration [418].

April 1884
"Furniture at the School of Art Needlework, Exhibition Road, South Kensington." *Decoration* (April 1884), p. 22.

2 May 1884
"The London International and Universal Exhibition, 1884." *British Architect and Northern Engineer* 21 (2 May 1884), pp. 223–24.

1885
Godwin, Edward William, ed. *Faithfull Shepherdesse,* by *John Fletcher.* London: G. Hill, 1885.

1 April 1885
Pen and Ink Notes. "At Kensington." *Cabinet Maker and Art Furnisher* 5 (1 April 1885), pp. 181–83.

1 May 1885
Our Lithographic Illustrations. "A Satinwood and Ebony Cabinet." *Building News and Engineering Journal* 48 (1 May 1885), p. 686 and illustration [702].

15 May 1885
Our Lithographic Illustrations. "Jacobean Oak Sideboard, by E. W. Godwin, F.S.A." *Building News and Engineering Journal* 48 (15 May 1885), p. 766 and illustration [785].

29 May 1885
Our Lithographic Illustrations. "Greek Armchair, by E. W. Godwin, F.S.A." *Building News and Engineering Journal* 48 (29 May 1885), p. 850 and illustration [862].

1 December 1885
Pen and Ink Notes. "Furniture and Decoration at the Royal Albert Hall." *Cabinet Maker and Art Furnisher* 6 (1 December 1885), pp. 141–45.

18 December 1885
Godwin, Edward William. "The British Architect Special Correspondence." *British Architect* 22 (18 December 1885), p. 262.

18 December 1885
"Working Drawings of Inexpensive Furniture by E. W. Godwin, F.S.A." *Building News and Engineering Journal* 49 (18 December 1885), p. 1011 and illustrations [1008–9].

[ca. 1886]
Godwin, Edward William. "Ancient Greek, Assyrian and Phoenician Furniture." [ca. 1886]. MS GoE/5/1, Manuscripts Collection, Royal Institute of British Architects, London.

[ca. 1886]
Godwin, Edward William. "The Greek House According to Homer: Its Furniture and the Costume of Its Inhabitants." [ca. 1886]. MS GoE/5/1, Manuscripts Collection, Royal Institute of British Architects, London.

5 March 1886
Our Lithographic Illustrations. "Cabinet for Objects Du [sic] Vertu." *Building News and Engineering Journal* 50 (5 March 1886), p. 376 and illustration [390].

19 March 1886
Our Lithographic Illustrations. "An Art Cabinet Designed by E. W. Godwin, F.S.A." *Building News and Engineering Journal* 50 (19 March 1886), p. 456 and illustration [471].

June 1886
Godwin, Edward William. "The Greek Home According to Homer." *Nineteenth Century* (London) 19 (June 1886), pp. 914–22.

July–December 1886
Obituary. *Building* 5 (July–December 1886), p. 257.

15 October 1886
Obituary. "Edward W. Godwin." *British Architect* (15 October 1886), pp. 347–48.

15 October 1886
"The Late E. W. Godwin, F.S.A." *Building News and Engineering Journal* 51 (15 October 1886), p. 589.

15 October 1886
Obituary. "The Week." *Architect* (London) 36 (15 October 1886), p. 217.

15 October 1886
Seddon, John P. "Friends in Council: The Late Mr. E. W. Godwin." *British Architect* (15 October 1886), p. 348.

16 October 1886
"Obituary." *Builder* 51 (16 October 1886), pp. 572, 660.

22 October 1886
Obituary. *Nottinghamshire Guardian*, 22 October 1886.

23 October 1886
"Mr. Godwin." *Northampton Mercury*, 23 October 1886.

30 October 1886
Obituary. *American Architect and Building News* 20 (30 October 1886), p. 202.

November 1886
Obituary of E. W. Godwin. "It is with sincere regret" *Art Journal* (November 1886), p. 352.

1 November 1886
Obituary. "E. W. Godwin." *Artist* (1 November 1886), p. 367.

4 November 1886
Obituary. "The Late E. W. Godwin, F.S.A." *Pictorial World*, 4 November 1886, 461.

1 December 1886
"The Late Mr. E. W. Godwin." *Cabinet Maker and Art Furnisher* 7 (1 December 1886), p. 147.

1 April 1887
Timms, W. "Economic Art Furniture in the Prevailing Styles." *Cabinet Maker and Art Furnisher* 7 (1 April 1887), pp. 258–60.

June 1887
Day, Lewis F. "Victorian Progress in Applied Design." *Art Journal* (June 1887), pp. 185–202.

25 August 1887
"Civil List Pensions." *Pall Mall Gazette*, 25 August 1887.

11 August 1888
"Art and Artists." *Brooklyn Daily Times*, 11 August 1888, 7.

April 1892
Vallance, Aymer. "The Furnishing and Decoration of the House." Part 4, "Furniture." *Art Journal* (April 1892), pp. 112–18.

1 April 1893
"Shakespeare Relics." *Graphic* (1 April 1893),
p. 342.

21 February 1913
"The House of Liberty and Its Founder." *Daily
Chronicle*, 21 February 1913, 7.

27 May 1924
"Liberty's New Shop." *Morning Post*, 27 May
1924, 11.

SECONDARY SOURCES

Account of the Town Halls 1866
*Account of the Town Halls, Old and New with
Illustrations*. Northampton: J. Taylor and Son,
1866.

A. Adams 1992
Adams, Annmarie. "Architecture in the Family
Way: Health Reform, Feminism, and the
Middle-Class House in England, 1870–1900."
Ph.D. diss., University of California at
Berkeley, 1992.

A. Adams 1996
Adams, Annmarie. *Architecture in the Family
Way: Doctors, Houses, and Women, 1870–1900*.
Montreal and Kingston: McGill-Queen's
University Press, 1996.

J. Adams 1940
Adams, James Truslow. *Empire on the Seven
Seas: British Empire, 1784–1939*. New York:
Scribner's, 1940.

M. Adams 1912
Adams, Maurice B. "Architects from George IV
to George V." Part 2. *Journal of the Royal
Institute of British Architects*, 3d ser., 19
(27 July 1912), pp. 643–45.

S. Adams 1987
Adams, Steven. *Arts and Crafts Movement*.
Baldock: Apple Press, 1987.

Agius 1978
Agius, Pauline. *British Furniture, 1880–1915*.
Woodbridge, England: Antique Collectors'
Club, 1978.

Anderson and Koval 1994
Anderson, Ronald, and Anne Koval. *James
McNeill Whistler: Beyond the Myth*. London:
J. Murray, 1994.

Andrews 1985
Andrews, John. "The Curious Case of the
Godwin Sideboard." *Antique Collecting: The
Journal of the Antique Collectors' Club* 20
(September 1985), pp. 45–47.

Andrews 1992
Andrews, John. *Victorian and Edwardian
Furniture: Price Guide and Reasons for Values*.
Woodbridge, England: Antique Collectors'
Club, 1992.

Anscombe 1981
Anscombe, Isabelle. "Furniture by Architects."
Connoisseur 207 (May 1981), pp. 60–61.

Arnold 1869 (1994 ed.)
Arnold, Matthew. *Culture and Anarchy*. Edited

by Samuel Lipman. 1869. Reprint, New Haven
and London: Yale University Press, 1994.

Art Furniture and Artistic Conservatories 1978
Messenger and Company. *Artistic Conservatories,
and Other Horticultural Buildings Designed . . .
from Rough Sketches by E. W. Godwin, F.S.A.,
and from Designs and Drawings by Maurice
B. Adams, A.R.I.B.A*. London: B.T. Batsford,
1880. Reprinted with Watt's *Art Furniture* as
Art Furniture and Artistic Conservatories, by
E. W. Godwin, New York: Garland, 1978.

Aslin 1962a
Aslin, Elizabeth. *Nineteenth Century English
Furniture*. London: Faber and Faber, 1962.

Aslin 1962b
Aslin, Elizabeth. "E. W. Godwin and the
Japanese Taste." *Apollo*, n.s., 76 (December
1962), pp. 779–84.

Aslin 1967
Aslin, Elizabeth. "The Furniture Designs of E. W.
Godwin." London: Victoria and Albert Museum,
1970). Reprinted from the *Victoria and Albert
Museum Bulletin* 3 (October 1967), pp. 145–54.

Aslin 1969
Aslin, Elizabeth. *Aesthetic Movement: Prelude to
Art Nouveau*. New York: Praeger, 1969.

Aslin 1986
Aslin, Elizabeth. *E. W. Godwin: Furniture and
Interior Decoration*. London: J. Murray, 1986.

Atterbury 1978
Atterbury, Paul, comp. *Aspects of the Aesthetic
Movement, Including Books, Ceramics, Furniture,
Glass, Textiles*. Exh. cat., Julian Hartnoll,
London. London: Dan Klein Ltd., 1978.

Atterbury 1995
Atterbury, Paul, ed. *A. W. N. Pugin: Master of
Gothic Revival*. Texts by Megan Aldrich et al.
Exh. cat. Bard Graduate Center for Studies in
the Decorative Arts, New York. New Haven
and London: Yale University Press, 1995.

Atterbury and Wainwright 1994
Atterbury, Paul, and Clive Wainwright, eds.
Pugin: A Gothic Passion. Exh. cat., Victoria
and Albert Museum, London. New Haven
and London: Yale University Press, 1994.

Banham 1997
Banham, Joanna, ed. *Encyclopedia of Interior
Design*. London: Fitzroy Dearborn, 1997.

Banham, MacDonald, and Porter 1991
Banham, Joanna, Sally MacDonald, and Julia
Porter. *Victorian Interior Design*. London:
Cassell, 1991.

Barnet 1986
Barnet, Peter. "From the Middle Ages to the
Victorians." *Apollo*, n.s., 124 (December
1986), pp. 499–505.

Barnet and Wilkinson 1993
Barnet, Peter, and MaryAnn Wilkinson.
*Decorative Arts 1900: Highlights from Private
Collections in Detroit*. Exh. cat. The Detroit
Institute of Arts, 1993.

Barrington 1994

Barrington, Robert. "Copyist, Connoisseur, Col-
lector: Charles Fairfax Murray (1849– 1919)."
Apollo, n.s., 140 (November 1994), pp. 15–21.

Bascou 1995
Bascou, Marc. "Acquisitions: Dressing-Table."
Revue du Louvre 4 (October 1995), p. 92.

Bence-Jones 1964
Bence-Jones, Mark. "An Aesthete's Irish Castle:
Dromore Castle, Co. Limerick." *Country Life*
136 (12 November 1964), pp. 1274–77.

Bence-Jones 1990
Bence-Jones, Mark. *A Guide to Irish Country
Houses*. 2d rev. ed. London: Constable, 1990.

Bendix 1992
Bendix, Deanna Marohn. "James McNeill
Whistler as a Designer: Interiors and
Exhibitions." Ph.D. diss., University of
Minnesota, 1992.

Bendix 1995
Bendix, Deanna Marohn. *Diabolical Designs:
Paintings, Interiors and Exhibitions of James
McNeill Whistler*. Washington, D.C.:
Smithsonian Institution Press, 1995.

Berman 1988
Berman, Marshall. *All That Is Solid Melts into
Air: The Experience of Modernity*. New York:
Penguin, 1988.

Birth of Modern Design 1990
Birth of Modern Design. Exh. cat. Tokyo: Sezon
Bijutsukan, 1990.

Black 1992
Black, Jeremy. *British Abroad: The Grand Tour in
the Eighteenth Century*. Stroud, Gloucester-
shire: Sutton Publishing Ltd., 1992.

Blackie and Son 1853
Blackie and Son. *Cabinet-Maker's Assistant, a
Series of Original Designs for Furniture. . . .*
London: Blackie and Son, 1853.

Blairman and Sons 1994
H. Blairman and Sons. *Furniture and Works of
Art*. London: H. Blairman and Sons, 1994.

Bøe 1957 (1979 ed.)
Bøe, Alf. *From Gothic Revival to Functional
Form: A Study in Victorian Theories of Design*.
Reprint of 1957 ed. New York: Da Capo
Press, 1979. Originally the author's thesis,
Oxford, 1954.

Boger 1969
Boger, Louise Ade. *Complete Guide to Furniture
Styles*. Enl. ed. New York: Scribner, 1969.

Boger and Boger 1967
Boger, Louise Ade, and H. Batterson Boger,
comps. and eds. *Dictionary of Antiques and the
Decorative Arts: A Book of Reference for Glass,
Furniture, Ceramics, Silver, Periods, Styles,
Technical Terms, &c.* [Rev. ed.] New York:
Scribner, 1967.

Bolger Burke et al. 1986
Bolger Burke, Doreen, et al. *In Pursuit of Beauty:
Americans and the Aesthetic Movement*. Exh.
cat. New York: Metropolitan Museum of Art
and Rizzoli, 1986.

Brandreth 1983
Brandreth, Eric. *Harpenden in Old Picture Postcards*. Zaltbommel, Netherlands: European Library, 1983.

Brémont 1911
Brémont, Anna Dunphy, Comtesse de. *Oscar Wilde and His Mother: A Memoir*. London: Everett, 1911.

Breuer 1994
Breuer, Gerda, ed. *Arts and Crafts: Von Morris bis Mackintosh – Reformbewegung zwischen Kunstgewerbe und Sozialutopie*. Exh. cat. Darmstadt: Institut Mathildenhöhe, 1994.

Bridgeman and Drury 1975
Bridgeman, Harriet, and Elizabeth Drury, eds. *Encyclopedia of Victoriana*. New York: Macmillan, 1975.

Bridgens 1838
Bridgens, Richard. *Furniture with Candelabra and Interior Decoration*. London: W. Pickering, 1838.

Briggs 1989
Briggs, Asa. *Victorian Things*. Chicago: University of Chicago Press, 1989.

Bristol Museums and Art Gallery 1976
Furniture by Godwin and Breuer. Exh. cat. Bristol City Museum and Art Gallery, 1976.

Broun 1989
Broun, Elizabeth. *Albert Pinkham Ryder*. Texts by Eleanor L. Jones et al. Exh. cat. Washington, D.C.: National Museum of American Art, Smithsonian Institution Press, 1989.

Burg 1995
Burg, Detlev von der, ed. *Pinakothek der Moderne: Eine Vision des Museums für Kunst, Architektur und Design des 20. Jahrhunderts in München*. Munich: Prestel, 1995.

"Cabinet Sold to University" 1973
"Cabinet Sold to University for 8,000 gns." *Daily Telegraph*, 5 October 1973.

Campion 1925
Campion, S. S. *Northampton Town Hall: Its Story, Told by Itself*. Northampton: W. Mark, 1925.

Canadian Centre for Architecture 1991
Corpus sanum in domo sano: L'architecture du mouvement en faveur de la salubrité domestique, 1870–1914/ The Architecture of the Domestic Sanitation Movement, 1870–1914. Exh. cat. Montreal: Canadian Centre for Architecture, 1991.

Carrick 1968
Carrick, Edward [pseud. Edward Anthony Craig]. *Gordon Craig: The Story of His Life*. New York: Knopf, 1968; London: Victor Gollancz, 1968.

Chapel and Gere 1985
Chapel, Jeannie, and Charlotte Gere. *Fine and Decorative Art Collections of Britain and Ireland: The National Art-Collections Fund Book of Art Galleries and Museums*. London: Weidenfeld and Nicolson, 1985.

Child 1990
Child, Graham. *World Mirrors 1650–1900*. London: Sotheby's Publications, 1990.

Chinnery 1979
Chinnery, Victor. *Oak Furniture, The British Tradition. A History of Early Furniture in the British Isles and New England*. Woodbridge, England: Antique Collectors' Club, 1979.

Clunas 1988
Clunas, Craig. *Chinese Furniture*. Far Eastern Series, Victoria and Albert Museum. London: Bamboo, 1988.

Collard 1985
Collard, Frances. *Regency Furniture*. Woodbridge, England: Antique Collectors' Club, 1985.

Collins 1987
Collins, Michael. *Towards Post-Modernism: Design Since 1851*. London: British Museum Publications, 1987.

Colvin and Harris 1970
Colvin, Howard, and John Harris, eds. *Country Seat: Studies in the History of the British Country House Presented to Sir John Summerson on His Sixty-Fifth Birthday Together with a Select Bibliography of His Published Writings*. London: Allen Lane, The Penguin Press, 1970.

Conner 1983
Conner, Patrick, ed. *Inspiration of Egypt: Its Influence on British Artists, Travellers and Designers, 1700–1900*. Exh. cat. Brighton Museum and Manchester City Art Gallery. Brighton: Brighton Borough Council, 1983.

Cooper 1972
Cooper, Jeremy. "Victorian Furniture: An Introduction to the Sources." *Apollo*, n.s., 95 (February 1972), pp. 115–22.

Cooper 1987
Cooper, Jeremy. *Victorian and Edwardian Decor: From the Gothic Revival to Art Nouveau*. New York: Abbeville Press, 1987.

Craig 1931
Craig, Edward Gordon. *Ellen Terry and Her Secret Self*. London: Sampson Low, Marston, 1931.

Craig 1957
Craig, Edward Gordon. *Index to the Story of My Days: Some Memoirs of Edward Gordon Craig, 1872–1907*. London: Hulton Press, 1957.

Crook 1981a
Crook, J. Mordaunt, ed. *Strange Genius of William Burges 'Art-Architect,' 1827–1881: A Catalogue to a Centenary Exhibition Organised Jointly by the National Museum of Wales, Cardiff, and the Victoria and Albert Museum, London in 1981*. Exh. cat. Cardiff: National Museum of Wales, 1981.

Crook 1981b
Crook, J. Mordaunt. *William Burges and the High Victorian Dream*. London: John Murray; Chicago: University of Chicago Press, 1981.

Cruickshank 1993
Cruickshank, Dan. "Good Godwin." *Architectural Review* 194 [193] (August 1993), pp. 74–79.

Cunningham 1981
Cunningham, Colin. *Victorian and Edwardian Town Halls*. London: Routledge and Kegan Paul, 1981.

Cunningham and Waterhouse 1992
Cunningham, Colin, and Prudence Waterhouse. *Alfred Waterhouse, 1830–1905: Biography of a Practice*. Oxford: Clarendon Press, 1992.

Curl 1990
Curl, James Stevens. *Victorian Architecture*. Newton Abbot: David and Charles, 1990.

Curl 1994
Curl, James Stevens. *Egyptomania: The Egyptian Revival, a Recurring Theme in the History of Taste*. Manchester: Manchester University Press, 1994.

Curry 1984a
Curry, David Park. *James McNeill Whistler at the Freer Gallery of Art*. Exh. cat. New York: W. W. Norton for the Freer Gallery of Art, Smithsonian Institution, 1984.

Curry 1984b
Curry, David Park. "Whistler and Decoration." *Magazine Antiques* 126 (November 1984), pp. 1186–99.

Curry 1987
Curry, David Park. "Total Control: Whistler at an Exhibition." *Studies in the History of Art* 19 (1987), pp. 67–82.

Darr 1988
Darr, Alan. "European Sculpture and Decorative Arts Acquired by the Detroit Institute of Arts, 1978–87." *Burlington Magazine* 130, no. 1023 (June 1988), p. 500, fig. 115.

Davis 1973
Davis, Frank. "Talking About Salerooms: Europe's Favourite Porcelain." *Country Life* 154 (15 November 1973), pp. 1542–43.

De Breffny and Ffolliott 1975
De Breffny, Brian, and Rosemary Ffolliott. *Houses of Ireland: Domestic Architecture from the Medieval Castle to the Edwardian Villa*. London: Thames and Hudson, 1975.

Denon 1802
Denon, Vivant. *Voyage dans la Basse et la Haute Égypte, pendant les campagnes du Général Bonaparte*. Paris: P. Didot, 1802.

Detroit Institute of Arts 1985
"The Annual Report, 1985." *Bulletin of the Detroit Institute of Arts* 62, no. 2 (1985).

Dictionary of National Biography 1939
Dictionary of National Biography, Founded in 1882 by George Smith: The Concise Dictionary from the Beginnings to 1930. Oxford: Oxford University Press, 1939.

Dodd 1982
Dodd, Philip, ed. *Art of Travel: Essays on Travel Writing*. London and Totowa, N.J.: F. Cass, 1982.

Dorment and MacDonald 1994
Dorment, Richard, and Margaret F. MacDonald. *James McNeill Whistler*. With contributions by Nicolai Cikovsky, Jr., Ruth Fine, and Genevieve Lacambre. Exh. cat. Tate Gallery, London; Musée d'Orsay, Paris; National Gallery of Art, Washington, D.C. London: Tate Gallery Publications, 1994.

Dry 1994
Dry, Graham. "Ein Meisterwerk des anglo-japanischen Stils." *Kunst und Antiquitäten*, no. 12 (December 1994), pp. 20–22.

Dungavell 1992
Dungavell, Ian. "A Lost House Rediscovered: Godwin's Grey Towers." Unpublished ms, 1992.

Dunn 1904
Dunn, Henry Treffry. *Recollections of Dante Gabriel Rossetti and His Circle*. London: Mathews, 1904.

"Eagle Eyed" 1989
"Eagle Eyed." *Traditional Interior Decoration*, May 1989, p. 46.

Eames 1977
Eames, Penelope. *Furniture in England, France and the Netherlands from the Twelfth to the Fifteenth Century*. London: Furniture History Society, 1977.

Eastlake 1869
Eastlake, Charles Locke. *Hints on Household Taste in Furniture, Upholstery, and Other Details*. 1869. Reprinted, with an introduction by John Gloag, New York: Dover, 1969.

Eastlake 1872
Eastlake, Charles Locke. *A History of the Gothic Revival: An Attempt to Show How the Taste for Mediaeval Architecture, Which Lingered in England during the Two Last Centuries, Has since Been Encouraged and Developed*. London: Longmans, Green, 1872.

Edis 1881
Edis, Robert William. *Decoration and Furniture of Town Houses: A Series of Cantor Lectures Delivered before the Society of Arts, 1880*. 1st ed. London: C. Kegan Paul, 1881.

C. Edwards 1993
Edwards, Clive D. *Victorian Furniture: Technology and Design*. Manchester: Manchester University Press, 1993.

R. Edwards 1964
Edwards, Ralph. *Shorter Dictionary of English Furniture: From the Middle Ages to the Late Georgian Period*. London: Country Life, 1964.

R. Edwards 1970
Edwards, Ralph. *English Chairs*. 3d ed. Victoria and Albert Museum Large Picture Book, no. 10. London: Her Majesty's Stationery Office, 1970.

Ellmann 1988
Ellmann, Richard. *Oscar Wilde*. New York: Knopf, 1988.

Ellsworth 1982
Ellsworth, Robert Hatfield. *Chinese Hardwood*

Furniture in Hawaiian Collections. Exh. cat. Honolulu Academy of Arts, 1982.

Farr 1978
Farr, Dennis. *English Art, 1870–1940*. Oxford: Clarendon Press, 1978.

Fastnedge 1983
Fastnedge, Ralph. *Sheraton Furniture*. Woodbridge, England: Antique Collectors' Club, 1983.

Ferriday 1964
Ferriday, Peter, ed. *Victorian Architecture*. Philadelphia: J. B. Lippincott, 1964.

Ffrench [1950]
Ffrench, Yvonne. *Great Exhibition: 1851*. London: The Harvill Press, Ltd [1950].

Fiell and Fiell 1997
Fiell, Charlotte, and Peter Fiell. *1,000 Chairs*. Cologne: Taschen Verlag, 1997.

Fine Art Society 1981
Architect-Designers: Pugin to Mackintosh. Exh. cat. London: Fine Art Society and Haslam and Whiteway, 1981.

Fine Art Society 1984
Fine Art Society. *Spring '84*. Exh. cat. London: Fine Art Society, 1984.

Fine Art Society 1989
Fine Art Society. *Spring '89*. Exh. cat. London: Fine Art Society, 1989.

Fine Art Society 1992
Fine Art Society. *Spring '92*. Exh. cat. London: Fine Art Society, 1992.

Fine Art Society 1994
Fine Art Society. *Spring '94*. Exh. cat. London: Fine Art Society, 1994.

Fine Art Society 1998
Fine Art Society. *Spring '98*. Exh. cat. London: Fine Art Society, 1998.

Fischer Fine Art 1982
Aspects of Victorian and Edwardian Decorative Arts. Exh. cat. London: Fischer Fine Art in association with Dan Klein Limited, 1982.

Fitz-Gerald 1988
Fitz-Gerald, Desmond John Villiers (the Knight of Glin), David J. Griffin and Nicholas K. Robinson. *Vanishing Country Houses of Ireland*. Dublin: The Irish Architectural Archive and the Irish Georgian Society, 1988.

Fleming 1940
Fleming, James. "Historic Irish Mansions, no. 225." *Weekly Irish Times*, 24 August 1940.

Fleming and Honour 1977
Fleming, John and Hugh Honour. *Dictionary of the Decorative Arts*. New York: Harper and Row, 1977.

Floud 1957
Floud, Peter. "Victorian Furniture." In *Concise Encyclopedia of Antiques*, Compiled by the Connoisseur, edited by Leonard Gerald Gwynn Ramsey. Vol. 3. New York: Hawthorn Books, 1957.

Fox 1969
Fox, Grace Estelle. *Britain and Japan, 1858–1883*. Oxford: Clarendon Press, 1969.

Fry 1919
Fry, Roger. "The Ottoman and the Whatnot." *Athenaeum*, January 1919, p. 529.

Garner 1980
Garner, Philippe. *Twentieth-Century Furniture*. Oxford: Phaidon Press, 1980.

Gell 1832
Gell, William. *Pompeiana: The Topography, Edifices, and Ornaments of Pompeii*. Rev. ed. 2 vols. London: Jennings and Chaplin, 1832.

Gere 1989
Gere, Charlotte. *Nineteenth-Century Decoration: The Art of the Interior*. New York: Harry N. Abrams, 1989.

Gere and Whiteway 1993
Gere, Charlotte, and Michael Whiteway. *Nineteenth-Century Design from Pugin to Mackintosh*. London: Weidenfeld and Nicolson, 1993.

Gilbert 1998
Gilbert, Christopher. *Furniture at Temple Newsham House and Lotherton Hall: A Catalogue of the Leeds Collection*. Vol. 3. [Leeds]: Leeds Art Collections Fund and W. S. Maney and Son, 1998.

Girouard 1972
Girouard, Mark. "Chelsea's Bohemian Studio Houses: The Victorian Artist at Home." Part 2. *Country Life* 152 (23 November 1972), pp. 1370–74.

Girouard 1977
Girouard, Mark. *Sweetness and Light: The "Queen Anne" Movement, 1860–1900*. Oxford: Clarendon Press, 1977.

Girouard 1979
Girouard, Mark. *Victorian Country House*. Rev. ed. New Haven and London: Yale University Press, 1979.

Glazebrook 1970
Glazebrook, Christopher John. *History of Northampton's Town Halls*. Northampton: J. Glazebrook and Sons, 1970.

Gomme 1979
Gomme, Andor Harvey, Michael Jenner, and Bryan Little. *Bristol, an Architectural History*. London: Lund Humphries in association with Bristol and West Building Society, 1979.

Graham 1990
Graham, Clare. "Seats of Learning." *Country Life* 184 (30 August 1990), pp. 108–9.

Graham 1994
Graham, Clare. *Ceremonial and Commemorative Chairs in Great Britain*. London: Victoria and Albert Museum, 1994.

Grand Palais 1988
Le Japonisme. Exh. cat. Galeries nationales du Grand Palais, Paris; Kokuritsu Seiyo Bijutsukan Gakugeika, Tokyo. Paris: Éditions de la Réunion des musées nationaux et Ministère de la Culture et de la Communication, 1988.

Greenhalgh 1988
Greenhalgh, Paul. *Ephemeral Vistas: The*

Expositions Universelles, Great Exhibitions and World's Fairs, 1851–1939. Manchester: Manchester University Press, 1988.

Greenhalgh 1990
Greenhalgh, Paul, ed. *Modernism in Design.* London: Reaktion Books, 1990.

Greeves 1967
Greeves, T. Affleck. "London's First Garden Suburb: Bedford Park, Chiswick." Part 1. *Country Life* 142 (7 December 1967), pp. 1524–29.

Greeves 1975
Greeves, T. Affleck. *Bedford Park: The First Garden Suburb.* London: Anne Bingley, 1975.

Grier 1988
Grier, Katherine C. *Culture and Comfort: People, Parlors, and Upholstery, 1850–1930.* Rochester: The Strong Museum, 1988.

Gruber 1994
Gruber, Alain, ed. *L'Art décoratif en Europe: du neoclassicisme à l'art nouveau.* Vol. 3. Paris: Citadelles and Mazenod, 1994.

Grubert 1985
Grubert, Halina. "The Passionate Pursuit of Charles and Lavinia Handley-Read." *Antique Collector* 56 (April 1985), pp. 64–69.

Habermas 1962 (1991 ed.)
Habermas, Jürgen. *Structural Transformation of the Public Sphere: An Inquiry into a Category of Bourgeois Society.* 1962. Reprint, Cambridge, Mass.: MIT Press, 1991.

Halén 1990
Halén, Widar. *Christopher Dresser.* Oxford: Phaidon, 1990.

J. Hall 1979
Hall, James. *Dictionary of Subjects and Symbols in Art.* Rev. ed. New York: Harper and Row, 1979.

M. Hall 1991
Hall, Michael. "Chinese Puzzle." *Country Life* 185 (25 July 1991), pp. 78–81.

M. Hall 1993
Hall, Michael. "Modern Gothic: Restoration of Northampton Guildhall." *Country Life* 187 (4 February 1993), pp. 48–51.

Handley-Read 1965
Handley-Read, Charles. "England, 1830–1901." *In World Furniture: An Illustrated History*, edited by Helena Hayward. London: Hamlyn, 1965.

Harbron 1943
Harbron, Dudley. "Queen Anne Taste and Aestheticism." *Architectural Review* 94 (July 1943), pp. 15–18.

Harbron 1945
Harbron, Dudley. "Edward Godwin." *Architectural Review* 98 (August 1945), pp. 48–52.

Harbron 1949
Harbron, Dudley. *Conscious Stone: The Life of Edward William Godwin.* London: Latimer House, 1949.

Harper 1987–88
Harper, Maureen. "Here's to the Ingle where True Hearts Mingle: The Revival of the Settle and Inglenook by Nineteenth-Century English Architects." *Journal of the Decorative Arts Society, 1850 to the Present*, no. 12 (1987–88), pp. 10–17.

Harris 1983
Harris, Jonathan. "Pieces of the Past." in *Grosvenor House Antique Fair Catalogue.* London, 1983.

Haslam 1991
Haslam, Malcolm. *Art and Crafts Carpets.* London: David Black; New York: Rizzoli, 1991.

Haslam 1993
Haslam, Malcolm. "Some Furniture from Dromore Castle Designed by E. W. Godwin." *Christie's International Magazine* 10 (May/June 1993), pp. 26–27.

Hayward 1972
Hayward, John Forrest. *English Cabinets in the Victoria and Albert Museum.* London: Her Majesty's Stationery Office, 1972.

Henderson 1967
Henderson, Philip. *William Morris: His Life, Work and Friends.* London: Thames and Hudson, 1967.

Heskett 1986
Heskett, John. *German Design, 1870–1918.* New York: Taplinger, 1986.

Hill 1977
Hill, C. P. (Charles Peter). *British Economic and Social History: 1700–1975.* London: Edward Arnold, 1977.

Hinz 1989
Hinz, Sigrid. *Innenraum und Möbel: Von der Antike bis zur Gegenwart.* 3d ed. Berlin: Henschelverlag Kunst und Gesellschaft, 1989.

Hitchcock 1960
Hitchcock, Henry-Russell. "G. E. Street in the 1850s." *Journal of the Society of Architectural Historians* 19 (December 1960), pp. 145–71.

Hoare 1983
Hoare, Peter. "Lost and Found." *Interiors* 142 (July 1983), p. 31.

Honour 1969
Honour, Hugh. *Cabinet Makers and Furniture Designers.* London: Weidenfeld and Nicolson, 1969.

Hope 1807
Hope, Thomas. *Household Furniture and Interior Decoration. . . .* London: Longman, Hurst, Rees, and Orme, 1807.

Hosley 1990
Hosley, William. *Japan Idea: Art and Life in Victorian America.* Exh. cat. Hartford, Conn.: Wadsworth Atheneum, 1990.

How 1892a
How, Harry. "Illustrated Interviews: No. xv, Mr. Henry Irving." *Strand Magazine* 4 (1892), pp. 280–91.

How 1892b
How, Harry. "Illustrated Interviews: No. xvii, Miss Ellen Terry." *Strand Magazine* 4 (1892), pp. 489–503.

Howe et al. 1994
Howe, Katherine S., et al. *Herter Brothers: Furniture and Interiors for a Gilded Age.* Exh. cat. Museum of Fine Arts, Houston; Metropolitan Museum of Art, New York; and High Museum of Art, Atlanta. New York: Harry N. Abrams, 1994.

Hudson 1991
Hudson, Kenneth. *Cambridge Guide to the Museums of Europe.* Cambridge: Cambridge University Press, 1991.

Hufnagl 1993
Hufnagl, Florian. *Tatigkeitsbericht der Ernst von Siemens-Stiftung, 1983–1993.* Munich, 1993.

Humbert 1870
Humbert, Aimé. *Le Japon illustré.* 2 vols. Paris: Librairie de L. Hachette, 1870.

Hunt 1836
Hunt, Thomas F. *Exemplars of Tudor Architecture, Adapted to Modern Habitations.* London: Longman, Rees, Orme, Brown, Green, and Longman, 1836.

Hyde 1951
Hyde, H. Montgomery. "Oscar Wilde and His Architect." *Architectural Review* 109 (March 1951), pp. 175–76.

Hyde 1975
Hyde, H. Montgomery. *Oscar Wilde: A Biography.* New York: Farrar, Straus and Giroux, 1975.

Ikegami 1993
Ikegami Chuji. *Inshoha jidai (Impressionist Period).* Tokyo: Shogakukan, 1993.

Impey 1977
Impey, Oliver. *Chinoiserie: The Impact of Oriental Styles on Western Art and Decoration.* New York: Charles Scribner's Sons, 1977.

Jackson-Stops 1986
Jackson-Stops, Gervase. "Castle Ashby, Northamptonshire: A Seat of the Marquess of Northampton," part 2. *Country Life* 179 (6 February 1986), pp. 310–15.

Jenkyns 1992
Jenkyns, Richard. *Dignity and Decadence: Victorian Art and the Classical Inheritance.* Cambridge: Harvard University Press, 1992.

Jennings 1902
Jennings, H. J. *Our Homes, and How to Beautify Them.* 2d ed. London: Harrison and Sons, 1902.

Jervis 1968
Jervis, Simon. *Victorian Furniture.* London: Ward Lock, 1968.

Jervis 1972
Jervis, Simon. "Victorian Decorative Art at the Royal Academy: Charles Handley-Read's Collecting Achievements." *Connoisseur* 179 (February 1972), pp. 89–98.

Jervis 1974a
Jervis, Simon. *High Victorian Design/Le style de la grande époque victorienne.* Exh. cat. Ottawa: National Gallery of Canada, 1974.

Jervis 1974b
Jervis, Simon. "'Sussex' Chairs in 1820." *Furniture History* 10 (1974), p. 99.

Jervis 1984
Jervis, Simon. *Penguin Dictionary of Design and Designers*. Harmondsworth: Penguin, 1984.

Johnson 1989
Johnson, Peter. *Phillips Guide to Chairs*. London: Merehurst Press, 1989.

Joy 1970
Joy, Edward T. "The Overseas Trade in Furniture in the Nineteenth Century." *Furniture History* 6 (1970), pp. 62–72.

Joy 1977
Joy, Edward T. *Introduction to Pictorial Dictionary of British Nineteenth Century Furniture Design*. Woodbridge, England: Antique Collectors' Club, 1977.

Kaplan 1995
Kaplan, Wendy, ed. *Designing Modernity: The Arts of Reform and Persuasion, 1885–1945. Selections from the Wolfsonian*. Exh. cat. Miami Beach, Wolfsonian Foundation. New York: Thames and Hudson, 1995.

Kauffman 1958
Kauffman, Edgar, Jr. "Edward Godwin and Christopher Dresser: The 'Esthetic' Designers, Pioneers of the Eighteen-Seventies." *Interiors* 118 (October 1958), pp. 162–65.

Kelly's Directories 1868
Kelly's Directories Ltd. *Post Office Directory of Birmingham, Staffordshire, Warwickshire and Worcestershire*. London: Kelly and Co., 1868.

Kimura 1985
Kimura, Hiroaki, ed. *Charles Rennie Mackintosh*. Tokyo: Japan Art and Culture Association, 1985.

Kinchin 1978
Kinchin, Juliet. "Collinson and Lock: Manufacturers of Artistic Furniture, 1870–97." Master's thesis, Victoria and Albert Museum, 1978.

Kinchin 1979
Kinchin, Juliet. "Collinson and Lock." *Connoisseur* 201 (May 1979), pp. 47–53.

Kirkham 1981
Kirkham, Pat. "Furniture-Making in London c. 1700–1870: Craft, Design, Business and Labour." Ph.D. diss., Westfield College, University of London, 1981.

Kirkham 1995
Kirkham, Pat. *Charles and Ray Eames: Designers of the Twentieth Century*. Cambridge, Mass.: MIT Press, 1995.

Koval 1994
Koval, Anne. *Whistler in His Time*. Exh. cat. Tate Gallery, London; Musée d'Orsay, Paris; and National Gallery of Art, Washington, D.C. London: Tate Gallery, 1994.

Kunstgewerbemuseum Berlin 1999
Architekten als Designer: Beispiele in Berlin. Exh. cat. Berlin: Kunstgewerbemuseum, Staatliche Museen zu Berlin, 1999.

Lambert 1983
Lambert, Susan, ed. *Pattern and Design: Designs for the Decorative Arts, 1480–1980*. Exh. cat. London: Victoria and Albert Museum, 1983.

Lambourne 1986
Lambourne, Lionel. "Pyrrhic Success: E. W. Godwin and the Theatre." *Country Life* 80 (2 October 1986), pp. 1024–25.

Lambourne 1996
Lambourne, Lionel. *Aesthetic Movement*. London: Phaidon Press, 1996.

Lancaster 1952
Lancaster, Clay. "Oriental Contributions to Art Nouveau." *Art Bulletin* 34 (December 1952), pp. 297–310.

Lasdun 1981
Lasdun, Susan. *Victorians at Home*. New York: Viking Press, 1981.

Latimer 1987–88
Latimer, Clare. "The Division of the Wall: The Use of Wallpapers in Decorative Schemes, 1870–1910." *Journal of the Decorative Arts Society, 1850 to the Present*, no. 12 (1987–88), pp. 18–25.

Laver 1975
Laver, James. *Victoriana*. Princeton: Pyne Press, 1975.

Ledoux-Lebard 1989
Ledoux-Lebard, Denise. *Les ébénistes du XIXᵉ siècle, 1795–1889: Leurs oeuvres et leurs marques*. Paris: Éditions de l'Amateur, 1984. Revised as *Le mobilier français de XIXᵉ siècle, 1795–1889: Dictionnaire des ébénistes et des menuisiers*. Paris: Éditions de l'Amateur, 1989.

van Lemmen 1989
van Lemmen, Hans. *Tiled Furniture*. Princes Risborough: Shire, 1989.

Lever 1973
Lever, Jill, ed. *Catalogue of the Drawings Collection of the Royal Institute of British Architects. Vol. 5, G–K. Sir Banister Fletcher Library*. London: Gregg International, 1973.

Lever 1982
Lever, Jill. *Architects' Designs for Furniture*. London: Trefoil Books, 1982.

Liberty and Co. 1881
Liberty and Co. *Eastern Art Manufactures and Decorative Objects*. London: Liberty, 1881.

Liberty and Co. 1887
Liberty and Co. *"Liberty" Art (Dress) Fabrics and Personal Specialties, 1887*. London: Liberty, 1887. Copy in the Liberty and Co. Archives, Westminster Library, London.

Lloyd-Jones 1987
Lloyd-Jones, David. Review of *E. W. Godwin: Furniture and Interior Decoration*, by Elizabeth Aslin. *Charles Rennie Mackintosh Society Newsletter* 15 (spring 1987), p. 8.

Loudon 1833
Loudon, John Claudius. *An Encyclopedia of Cottage, Farm and Villa Architecture and Furniture . . .* London: Longman, Rees, Orme, Brown, Green and Longman, 1833.

Lubbock 1978
Lubbock, Jules. "Victorian Revival." *Architectural Review* 163 (March 1978), pp. 161–67.

Lucas 1921
Lucas, Edward Verrall. *Edwin Austin Abbey, Royal Academician: The Record of His Life and Work*. 2 vols. New York: Charles Scribner's Sons; London: Methuen, 1921.

Luckhurst 1951
Luckhurst, Kenneth W. *Story of Exhibitions*. London: The Studio Publications, 1951.

Lumley 1975
Lumley, John. "The Pickford Wallers." In *Christie's Review of the Season, 1974*, edited by John Herbert. London: Hutchinson, 1975.

MacCarthy 1972
MacCarthy, Fiona. *All Things Bright and Beautiful: Design in Britain, 1830 to Today*. London: George Allen and Unwin, 1972.

MacDonald 1997
Beatrice Whistler: Artist and Designer. [Text by Margaret F. MacDonald.] Exh. cat. Glasgow: Hunterian Art Gallery, 1997.

Macquoid and Edwards 1986
Macquoid, Percy, and Ralph Edwards. *Dictionary of English Furniture from the Middle Ages to the Late Georgian Period*. Rev. and enl. ed. 3 vols. Woodbridge, England: Antique Collectors' Club, 1986.

Malcolm 1984
Malcolm, John. *Godwin Sideboard: The Second Tim Simpson Adventure*. London: Collins, 1984.

Mallalieu 1995
Mallalieu, Huon. "Around the Salerooms." *Country Life* 189 (6 July 1995), pp. 82–83.

Mayer 1981
Mayer, Arno J. *Persistence of the Old Regime: Europe to the Great War*. New York: Pantheon Books, 1981.

McCabe 1876 (1975 ed.)
McCabe, James D. *Illustrated History of the Centennial Exhibition, Held in Commemoration of the One Hundredth Anniversary of American Independence*. Philadelphia: The National Publishing Company, 1876. Reprint, 1975.

Measham 1994
Measham, Terence. *Treasures of the Powerhouse Museum*. Sydney: Powerhouse Publishing and Beagle Press, 1994.

Melville 1997
Melville, Joy. *Ellen Terry and Smallhythe Place*. Kent: National Trust, 1997.

Menpes 1904
Menpes, Mortimer. *Whistler As I Knew Him*. London: Adam and Charles Black, 1904.

Mercer 1969
Mercer, Eric. *Furniture, 700–1700*. London: Weidenfeld and Nicolson, 1969.

Metropolitan Museum 1991
Metropolitan Museum of Art. "Recent Acquisitions: A Selection, 1990–1991."

Metropolitan Museum of Art Bulletin 49 (Fall 1991).

Metropolitan Museum 1994
Metropolitan Museum of Art. *The Metropolitan Museum of Art Guide.* 2d ed. New York: The Metropolitan Museum of Art, 1994.

Meyrick and Shaw 1836
Meyrick, Samuel Rush, and Henry Shaw. *Specimens of Ancient Furniture Drawn from Existing Authorities by Henry Shaw . . . with Descriptions by Sir Samuel Rush Meyrick.* London: W. Pickering, 1836.

Mitchell 1988
Mitchell, Sally, ed. *Victorian Britain: An Encyclopedia.* New York and London: Garland Publishing, Inc., 1988.

Miyajima 1994
Miyajima, Hisao, ed. *British Design at Home: The Victoria and Albert Museum.* Exh. cat. Osaka: NHK Kinki Media Plan and the Victoria and Albert Museum, 1994.

Moderne Gallery 1995
Rethinking English Arts and Crafts: The Modernist Tradition in Turn-of- the-Century British Design. Sale cat. Philadelphia: Moderne Gallery, 1995.

Molesworth and Kenworthy-Browne 1972
Molesworth, Hender Delves, and John Kenworthy-Browne. *Three Centuries of Furniture in Color.* New York: Viking Press, 1972.

Monkhouse 1991
Monkhouse, Christopher. "Department of Decorative Arts: Recent Activities and Acquisitions." *Rhode Island School of Design Museum Notes 78* (October 1991), pp. 18–19.

Mundt 1981
Mundt, Barbara. *Historismus: Kunstgewerbe zwischen Biedermeier und Jugendstil.* Munich: Keyser, 1981.

Musée d'Orsay 1988
Musée d'Orsay, Paris. *Catalogue sommaire illustré des arts décoratifs.* Paris: Ministère de la Culture at la Communication and Éditions de la Réunion des musées nationaux, 1988.

Musée d'Orsay 1990
De Manet à Matisse. Exh. cat. Musée d'Orsay. Paris: Éditions de la Réunion des musées nationaux, 1990.

Musée d'Orsay 1996
De l'impressionnisme à l'art nouveau: Acquisitions du Musée d'Orsay, 1990–1996. Exh. cat. Musée d'Orsay. Paris: Éditions de la Réunion des musées nationaux, 1996.

Museum of Fine Arts 1962
Furniture of H. H. Richardson. Exh. cat. Boston: Museum of Fine Arts, 1962.

H. Muthesius 1904–5 (1979 ed.)
Muthesius, Hermann. *The English House.* Edited by Dennis Sharp; translated by Janet Seligman. London: Crosby Lockwood Staples, 1979. Published in German, Berlin, 1904–5.

S. Muthesius 1972
Muthesius, Stefan. *The High Victorian Movement in Architecture, 1850–1870.* London: Routledge and Kegan Paul, 1972.

National Art-Collections Fund 1994
National Art-Collections Fund Review. London, 1994.

Nationalmuseum 1987
British Design: Konstindustri och Design, 1851–1987. Exh. cat. Stockholm: Nationalmuseum, 1987.

National Trust 1995
National Trust. *Ellen Terry's House: Smallhythe, Tenterden, Kent.* London: The National Trust, 1995.

Nesfield 1862
Nesfield, W. Eden. *Specimens of Mediaeval Architecture Chiefly Selected from Examples of the Twelfth and Thirteenth Centuries in France and Italy and Drawn by W. Eden Nesfield, Architect.* London: Day and Son, 1862.

Norman 1973
Norman, Geraldine. "Price in the Clouds for Whistler's Butterflies." *Times* (London), 5 October 1973, p. 21.

O'Callaghan 1976
O'Callaghan, John. "The Fine Art Society and E. W. Godwin." In *Fine Art Society: Centenary Exhibition, 1876–1976.* Exh. cat. London: Fine Art Society, 1976.

O'Callaghan 1982
O'Callaghan, John. "Godwin, Edward William." In *Macmillan Encyclopedia of Architects*, edited by Adolf K. Placzek. Vol. 2. New York: Free Press, 1982.

Ormond 1965
Ormond, Richard. "Holman Hunt's Egyptian Chairs." *Apollo*, n.s., 82 (July 1965), pp. 55–58.

Paolini, Ponte, and Selvafolta 1990
Paolini, Claudio, Alessandra Ponte and Ornella Selvafolta. *Il bello "ritrovato": Gusto, ambienti, mobili dell'Ottocento.* Novara, Italy: Istituto Geografico de Agostini, 1990.

Paris, Exposition Universelle, 1878a
Paris, Exposition Universelle, 1878. *English Guide to the Paris Exhibition*, 1878. London: Mason, 1878.

Paris, Exposition Universelle, 1878b
Paris, Exposition Universelle, 1878. *Illustrated Catalogue of the Paris International Exhibition, 1878.* London: George Virtue, 1878.

Paris, Exposition Universelle, 1878, Royal Commission
Paris, Exposition Universelle, 1878. Royal Commission. *Official Catalogue of the British Section.* 2 vols. London: G. E. Eyre and W. Spottiswoode for Her Majesty's Stationery Office, 1878.

Paris, Exposition Universelle, 1878. Royal Society of Arts 1879
Paris, Exposition Universelle, 1878. Royal

Society of Arts. *Society of Arts Artisan Reports on the Paris Universal Exhibition of 1878.* London: Sampson Low, Marston, Searle and Rivington, 1879.

Parry 1996
Parry, Linda, ed. *William Morris.* Exh. cat. London, Victoria and Albert Museum. London: Philip Wilson, 1996.

Payne 1989
Payne, Christopher, ed. *Sotheby's Concise Encyclopedia of Furniture.* London: Conran Octopus, 1989.

Pemsel 1989
Pemsel, Jutta. *Die Wiener Weltausstellung von 1873: Das gründerzeitliche Wien am Wendepunkt.* Vienna: Böhlau Verlag, 1989.

Pennell and Pennell 1908
Pennell, Elizabeth Robins and Joseph Pennell. *Life of James McNeill Whistler.* 2 vols. London: William Heinemann; Philadelphia: J. B. Lippincott, 1908.

Pennell and Pennell 1911
Pennell, Elizabeth Robins and Joseph Pennell. *Life of James McNeill Whistler.* 5th ed. Philadelphia, 1911.

Pennell and Pennell 1912
Pennell, Elizabeth Robins and Joseph Pennell. *Life of James McNeill Whistler.* 6th ed. Philadelphia, 1912.

Pennell and Pennell 1921
Pennell, Elizabeth Robins and Joseph Pennell. *Whistler Journal.* Philadelphia: J. B Lippincott, 1921.

Pevsner 1936
Pevsner, Nikolaus. *Pioneers of the Modern Movement from William Morris to Walter Gropius.* London: Faber and Faber, 1936.

Pevsner 1948
Pevsner, Nikolaus. Cobb Lecture: "Design and Industry through the Ages." *Journal of the Royal Society of Arts* 42 (1948), p. 99.

Pevsner 1952a
Pevsner, Nikolaus. "Art Furniture of the Eighteen-Seventies." *Architectural Review* 111 (January 1952), pp. 43–50. Reprinted in Nikolaus Pevsner, *Studies in Art, Architecture and Design: Vol. 2, Victorian and After.* (London: Thames and Hudson, 1968; Princeton: Princeton University Press, 1968).

Pevsner 1952b
Pevsner, Nikolaus. "Furniture: A Godwin Sideboard." *Architectural Review* 111 (April 1952), p. 273.

Pevsner 1960
Pevsner, Nikolaus. *Pioneers of Modern Design: From William Morris to Walter Gropius.* 3d ed. Harmondsworth, England: Penguin, 1960.

Pevsner 1968
Pevsner, Nikolaus. *Studies in Art, Architecture and Design.* Vol. 2, *Victorian and After.* London: Thames and Hudson; Princeton: Princeton University Press, 1968.

Post 1976
Post, Robert C., ed. *A Treatise upon Selected Aspects of the Great International Exhibition Held in Philadelphia on the Occasion of Our Nation's One-Hundredth Birthday, with Some Reference to Another Exhibition Held in Washington Commemorating That Epic Event, and Called 1876, a Centennial Exhibition.* Washington, D.C.: National Museum of History and Technology, Smithsonian Institution, 1976.

Powell 1986
Powell, Nicolas. Review of *E. W. Godwin: Furniture and Interior Decoration* by Elizabeth Aslin. *Apollo* 124, n.s., 295 (September 1986), p. 226.

Powerhouse Museum 1991
Powerhouse Museum, Sydney. *Decorative Arts and Design from the Powerhouse Museum.* Haymarket, N.S.W.: Powerhouse Publishing, 1991.

Prince 1984
Prince, Geraldine. "The Peacock Painter." *Scottish Portrait Magazine*, October 1984, pp. 18–19.

Pugin 1836
Pugin, A. W. N. (Augustus Welby Northmore). *Contrasts; or, A Parallel Between the Noble Edifices of the Fourteenth and Fifteenth Centuries, and Similar Buildings of the Present Day; Shewing the Present Decay of Taste; Accompanied by Appropriate Text.* London: printed for the author, 1836.

Purslow 1994
Purslow, Martin. "Middlesborough's Grey Towers." *Victorian Society Northeastern Newsletter*, 28 January 1994.

Purslow 1995
Purslow, Martin. "A Seminal Discovery." *Wallpaper History Review*, 1995, pp. 3–5.

Reeves 1994
Reeves, Paul. "The Anglo-Japanese Buffet by E. W. Godwin: Variations on and Developments of a Design." *(Journal of the) Decorative Arts Society, 1850 to the Present*, no. 18 (1994), pp. 36–40.

Reid 1987
Reid, Aileen. "Dromore Castle, County Limerick: Archaeology and the Sister Arts of E. W. Godwin." *Architectural History* 30 (1987), pp. 113–42.

Reid 1992
Reid, Aileen. "Homes Fit for Hera." *Country Life* 186 (10 December 1992), pp. 36–39.

Reid 1996
Reid, Aileen. "Godwin, E(dward) W(illiam)." In *Dictionary of Art*, edited by Jane Turner. Vol. 12. New York: Grove, 1996.

Reynolds 1956
Reynolds, Ernest. *Northampton Town Hall.* Northampton: Belmont Press, 1956, 1974.

Richter 1966
Richter, Gisela M. A. *Furniture of the Greeks, Etruscans, and Romans.* London: Phaidon, 1966.

Robinson 1975
Robinson, Duncan. "Burne-Jones, Fairfax Murray, and Siena." *Apollo*, n.s., 102 (November 1975), pp. 348–51.

Rosen 1973
Rosen, George. "Disease, Debility, and Death." In *Victorian City: Images and Realities*, edited by Harold James Dyos and Michael Wolff, vol. 2. London: Routledge and Kegan Paul, 1973.

Royal Academy 1972
Royal Academy of Arts. *Victorian and Edwardian Decorative Art: The Handley-Read Collection.* Exh. cat. London: Royal Academy of Arts, 1972.

Rudoe 1991
Rudoe, Judy. *Decorative Arts, 1850–1950: A Catalogue of the British Museum Collection.* London: British Museum Press, 1991.

Ruskin 1851–53
Ruskin, John. *Stones of Venice.* 3 vols. London: Smith, Elder, 1851–53.

Rydell 1984
Rydell, Robert W. *All the World's a Fair: Visions of Empire at American International Expositions, 1876–1916.* Chicago: University of Chicago Press, 1984.

Said 1978
Said, Edward. *Orientalism.* New York: Vintage Books, 1978.

Saint 1976
Saint, Andrew. *Richard Norman Shaw.* New Haven: Yale University Press for the Paul Mellon Centre for Studies in British Art, 1976.

Sato and Watanabe 1991
Sato, Tomoko, and Toshio Watanabe, eds. *Japan and Britain: An Aesthetic Dialogue, 1850–1930.* With essays by Hugh Cortazzi, Shuji Takashina, and Ellen P. Conant. Exh. cat. Barbican Art Gallery and the Setagaya Art Museum. London: Lund Humphries, 1991.

Schildt 1986
Schildt, Göran. *Aalto Interiors, 1923–1970.* Exh. cat. Jyväskylä: Alvar Aalto-museo, 1986.

Scott 1863
Scott, George Gilbert. *Gleanings from Westminster Abbey.* 2d enl. ed. Oxford: J. Henry and J. Parker, 1863.

Sekler 1985
Sekler, Eduard F. *Josef Hoffmann: The Architectural Work.* Translated by the author and John Maass. Princeton: Princeton University Press, 1985. Originally published in German, Salzburg, 1982.

Service 1973
Service, Alastair. "James MacLaren and the Godwin Legacy." *Architectural Review* 154 (August 1973), pp. 111–18.

Service 1975
Service, Alastair. *Edwardian Architecture and Its Origins.* London: Architectural Press, 1975.

Sheraton 1793
Sheraton, Thomas. *Cabinet-Maker and Upholsterer's Drawing Book.* London: T. Bensley, 1793.

Sheraton 1803
Sheraton, Thomas. *Cabinet Dictionary. . . .* London: W. Smith, 1803.

Shoolbred and Co.
James Shoolbred and Co. *Designs of Furniture Illustrative of Cabinet Furniture and Interior Decoration. . . .* London, 1874, 1876, 1889.

Smee and Son 1855
William Smee and Son. *Designs of Furniture of 1850–55.* London: J. Betts, [1855].

Smith 1808
Smith, George. *A Collection of Designs for Household Furniture and Interior Decoration in the Most Approved and Elegant Taste . . .* London: J. Taylor, 1808.

Smith 1826
Smith, George. *Cabinet-Maker and Upholsterer's Guide, Being a Complete Drawing Book* London: Jones, 1826.

Snodin and Howard 1996
Snodin, Michael, and Maurice Howard. *Ornament: A Social History since 1450.* New Haven and London: Yale University Press in association with the Victoria and Albert Museum, 1996.

Somerville-Large 1995
Somerville-Large, Peter. *Irish Country House: A Social History.* London: Sinclair-Stevenson, 1995.

Soros 1987
Soros, Susan Weber. "Whistler as Collector, Interior Colorist and Decorator." Master's thesis, Cooper-Hewitt Museum, 1987.

Soros 1998
Soros, Susan Weber. "E. W. Godwin: Secular Furniture and Interior Design." Ph.D. diss., Royal College of Art, London, 1998.

Soros 1999
Soros, Susan Weber ed. *E. W. Godwin: Aesthetic Movement Architect and Designer.* Exh. cat. Bard Graduate Center, New York, 1999.

Soros spring 1999
Soros, Susan Weber. "Rediscovering H. W. Batley (1846–1932) British Aesthetic Movement Artist and Designer." *Studies in the Decorative Arts* 6 (spring 1999), pp. 2–41.

C. Spencer 1973
Spencer, Charles, ed. *Aesthetic Movement, 1869–1890.* Exh. cat. Camden Arts Centre. London: Academy Editions; New York: St. Martin's Press, 1973.

C. Spencer 1979
Spencer, Charles. "Anglo-Japanese Furniture." *Arts and Antiques Weekly* 36 (5 May 1979), pp. 22–23.

R. Spencer 1972a
Spencer, Robin, ed. *Aesthetic Movement and the Cult of Japan.* Exh. cat. London: Fine Art Society, 1972.

R. Spencer 1972b
Spencer, Robin. *Aesthetic Movement: Theory and Practice.* London: Studio Vista, Dutton Pictureback, 1972.

R. Spencer 1989
Spencer, Robin, ed. *Whistler: A Retrospective.* New York: H. L. Levin Associates, 1989.

H. Spielmann 1996
Spielmann, Heinz, ed. *Die Jugendstil-Sammlung, Kunstler G-K,* vol. 2. Hamburg: Museum für Kunst und Gewerbe, 1996.

Squire 1991
Squire, Geoffrey. "Orienteering." *Art Quarterly of the National Art-Collections Fund,* no. 7 (autumn 1991), pp. 34–37.

Stamp and Amery 1980
Stamp, Gavin, and Colin Amery. *Victorian Buildings of London, 1837–1887: An Illustrated Guide.* London: Architectural Press, 1980.

Stamp and Goulancourt 1986
Stamp, Gavin, and André Goulancourt. *English House, 1860–1914: The Flowering of English Domestic Architecture.* Chicago: University of Chicago Press, 1986.

Stokes 1972
Stokes, John. "An Aesthetic Theatre: The Career of E. W. Godwin." Chap. 2 of the author's *Resistible Theatres: Enterprise and Experiment in the Late Nineteenth Century.* London: Elek Books, 1972.

G. Street 1855
Street, George Edmund. *Brick and Marble in the Middle Ages: Notes of a Tour in the North of Italy.* London: J. Murray, 1855.

Stritzler-Levine 1996
Stritzler-Levine, Nina, ed. *Josef Frank, Architect and Designer.* Exh. cat. Bard Graduate Center for Studies in the Decorative Arts. New Haven and London: Yale University Press, 1996.

Sutton 1963
Sutton, Denys. *Nocturne: The Art of James McNeill Whistler.* London: Country Life, 1963.

Symonds and Whineray 1962
Symonds, Robert Wemyss, and Bruce Blundell Whineray. *Victorian Furniture.* London: Country Life, 1962.

Tatham 1799 (1810 ed.)
Tatham, Charles Heathcote. *Etchings Representing the Best Examples of Ancient Ornamental Architecture; Drawn from the originals in Rome, and Other Parts of Italy, during the Years 1794, 1795, and 1796.* London: printed for the author, 1799. 3d ed., London, 1810.

Taylor 1978
Taylor, Hilary. *James McNeill Whistler.* London: Studio Vista, 1978.

Thornton 1984
Thornton, Peter. *Authentic Decor: The Domestic Interior, 1620–1920.* New York: Viking, 1984.

Tian 1996

Tian Jiaqing. *Classic Chinese Furniture of the Qing Dynasty.* Translated by Lark E. Mason Jr. and Juliet Yung-Yi Chao. London: Philip Wilson, 1996.

Tilbrook 1986
Tilbrook, Adrian J. *Truth, Beauty and Design: Victorian, Edwardian and Later Decorative Art.* Exh. cat. London: Adrian J. Tilbrook and Fischer Fine Art, 1986.

Tokyo Metropolitan Art Museum 1996
La Modernité: Collection du Musée d'Orsay. Exh. cat. Tokyo Metropolitan Art Museum; and Kobe. Tokyo: Nihon Keizai Shimbun, 1996.

Tomlin 1972
Tomlin, Maurice. *English Furniture: An Illustrated Handbook.* London: Faber and Faber, 1972.

Tschudi-Madsen 1975
Tschudi-Madsen, Stephan. *Sources of Art Nouveau.* New York: Da Capo Press, 1975.

"Two Interiors" 1920
"Two Interiors at the House of Miss Ellen Terry at Chelsea." *Femina,* October 1920, p. 52.

"Unique Comparison" 1994
"A Unique Comparison." *Powerline,* spring 1994, p. 12.

Vallance 1897 (1986 ed.)
Vallance, Aymer. *William Morris, His Art, His Writings, and His Public Life: A Record.* London: Bell, 1897. Facsimile ed., London: Studio Editions, 1986.

Veblen 1899 (1992 ed.)
Veblen, Thorstein. *Theory of the Leisure Class.* New York: Macmillan, 1899. Reprinted, New Brunswick, N.J.: Transaction Publishers, 1992.

Victoria and Albert Museum 1952a
Victoria and Albert Museum. *Exhibition of Victorian and Edwardian Decorative Arts.* Exh. cat. London: Her Majesty's Stationery Office, 1952.

Victoria and Albert Museum 1952b
Victoria and Albert Museum. *Victorian and Edwardian Decorative Arts.* Small Picture Book No. 34. London: Her Majesty's Stationery Office, 1952.

Vienna, Universal Exposition, 1873. Centralcommission 1874–77
Vienna, Universal Exposition, 1873. Centralcommission des deutschen Reiches für die Wiener Weltausstellung, ed. *Amtlicher Bericht über die Wiener Weltausstellung im Jahre 1873.* 5 vols. Braunschweig: Vieweg, 1874–77.

Vienna, Universal Exposition, 1873. Royal Commission 1874
Vienna, Universal Exposition, 1873. Royal Commission for the Vienna Universal Exhibition of 1873. *Reports on the Vienna Universal Exhibition of 1873.* 4 vols. London: G. E. Eyre and W. Spottiswoode for Her Majesty's Stationery Office, 1874.

Viollet-le-Duc 1854–75 (1926 ed.)

Viollet-le-Duc, Eugène-Emmanuel. *Dictionnaire raisonné du mobilier français de l'époque carlovingienne à la Renaissance.* 6 vols. Paris: Gründ et Maguet, 1854–75. Reprinted 1926.

Voysey 1927
Voysey, C. F. A. "Report of Dinner Given by President and Council to Mark the Jubilee Year of His Practice." *Royal Institute of British Architects Journal* 35 (November 1927), p. 53.

Voysey 1931
Voysey, C. F. A. "1874 and After." *Architectural Review* 70 (October 1931), p. 91.

Waagen 1860
Waagen, Gustav Friedrich. *Handbook of Painting: The German, Flemish, and Dutch Schools Based on the Handbook of Kugler.* Enl. and rewritten by Waagen. 2 vols. London: J. Murray, 1860.

Wainwright 1978
Wainwright, Clive. "The Dark Ages of Art Revived, or Edwards and Roberts and the Regency Revival." *Connoisseur* 198 (June 1978), pp. 95–117.

Wainwright 1985
Wainwright, Clive. "Only the True Black Blood." *Furniture History Society* 21 (1985), pp. 250–57.

Wainwright 1989
Wainwright, Clive. *Romantic Interior: The British Collector at Home, 1750–1850.* New Haven and London: Yale University Press, 1989.

Walker and Jackson 1987
Walker, Annabel, and Peter Jackson. *Kensington and Chelsea: A Social and Architectural History.* London: John Murray, 1987.

Walkley 1994
Walkley, Giles. *Artists' Houses in London, 1764–1914.* Aldershot, England: Scolar Press, 1994.

Walkling 1979
Walkling, Gillian. *Antique Bamboo Furniture.* London: Bell and Hyman, 1979.

Wang 1986
Wang Shixiang. *Classic Chinese Furniture: Ming and Early Qing Dynasties.* Translated by Sarah Handler and the author. Hong Kong and San Francisco: Joint Publishing Company, 1986.

Wang and Evarts 1995
Wang Shixiang and Curtis Evarts. *Masterpieces from the Museum of Classical Chinese Furniture.* Exh. cat. Chicago and San Francisco: Chinese Art Foundation, 1995.

Watanabe 1991
Watanabe, Toshio. *High Victorian Japonisme.* Swiss Asian Studies, Research Studies, vol. 10. Bern: Peter Lang, 1991.

Watson 1994
Watson, Anne. *Godwin Variations: Designs on a Single Theme.* Brochure Series, Powerhouse Museum. Sydney: Powerhouse Museum, 1994.

Watson 1997
Watson, Anne. "Not Just a Sideboard: E. W. Godwin's Celebrated Design of 1867." *Studies in the Decorative Arts* 4 (spring–summer 1997), pp. 63–84.

Watt 1877
Watt, William. *Art Furniture, from Designs by E. W. Godwin, F.S.A., and Others, with Hints and Suggestions on Domestic Furniture and Decorations.* London: B. T. Batsford, 1877. Reprinted 1878. Reprinted with Messenger and Company's *Artistic Conservatories* as *Art Furniture and Artistic Conservatories*, by E. W. Godwin, New York: Garland, 1978.

"Whistler Cabinet Bought by University" 1973
"Whistler Cabinet Bought by University," *Glasgow Herald*, 1973

Whitworth Art Gallery 1985
A Decorative Art: 19th Century Wallpapers in the Whitworth Art Gallery. Exh. cat. Manchester: Whitworth Art Gallery, 1985.

Wilde 1930
Wilde, Oscar. "The Truth of Masks." In *Intentions.* New York: Albert and Charles Boni, 1930.

Wilde 1962
Wilde, Oscar. *Letters of Oscar Wilde.* Edited by Rupert Hart-Davis. London: Rupert Hart-Davis, 1962.

Wilk 1996
Wilk, Christopher, ed. *Western Furniture: 1350 to the Present Day in the Victoria and Albert Museum, London.* London: Philip Wilson in association with the Victoria and Albert Museum, 1996.

J. Wilkinson 1853
Wilkinson, John Gardner. *Manners and Customs of the Ancient Egyptians* Rev. and abridged ed. 3 vols. New York: Harper Brothers, 1853.

N. Wilkinson 1987
Wilkinson, Nancy Burch. "Edward William Godwin and Japonisme in England." Ph.D. diss., University of California, Los Angeles, 1987.

Willemin 1839
Willemin, Nicolas Xavier. *Monuments français inédits pour servir à l'histoire des arts depuis le VI^e siècle jusqu'au commencement du XVII^e. . .* 2 vols. Paris: Chez Mlle. Willemin, 1839. Engraved frontis., dated 1806, in vol. 1, preceding the plates.

Wilson 1972
Wilson, Michael I. "The Case of the Victorian Piano." *Victoria and Albert Museum Yearbook*, no. 3 (1972), pp. 133–53.

Wilton and Bignamini 1996
Wilton, Andrew, and Ilaria Bignamini, eds. *Grand Tour: The Lure of Italy in the Eighteenth Century.* Exh. cat. London, Tate Gallery; Rome, Palazzo delle Esposizioni. London: Tate Gallery, 1996.

Winwar 1941
Winwar, Frances. *Oscar Wilde and the Yellow Nineties.* Garden City, N. Y.: Blue Ribbon Books, 1941.

Wohl 1983
Wohl, Anthony S. *Endangered Lives: Public Health in Victorian Britain.* Cambridge, Mass.: Harvard University Press, 1983.

Woolfe 1990
Woolfe, Vivienne. "Smallhythe Place, Kent: A Property of the National Trust." *Country Life* 184 (30 August 1990), pp. 78–81.

Yorke 1990
Yorke, James. *English Furniture.* New York: Gallery Books, 1990.

Young, MacDonald, and Spencer 1980
Young, Andrew McLaren, Margaret MacDonald, and Robin Spencer. *Paintings of James McNeill Whistler.* 2 vols. New Haven and London: Yale University Press for the Paul Mellon Centre for Studies in British Art, 1980.

Zygulski 1965
Zygulski, Zdzislaw Jr. "Shakespeare's Chair and the Romantic Journey of Isabel Czartoryska." *Apollo*, n.s., 82 (November 1965), pp. 392–97.

INDEX

Numbers in **bold** refer to main entries for items of furniture in *Catalogue Raisonné*. Numbers in *italic* refer to figures in Preface and Introduction.

PHOTOGRAPHIC CREDITS

Aberford, Lotherton Hall, photos by David Allison 140 220; photos by David Allison fig. 9 fig. 10 fig. 11 fig. 12 142 213-b 331-a; the Estate of Elizabeth Aslin 226-b; photo by Catherine Arbuthnott fig. 45; Matthew Argenti, photo by David Allison 321; courtesy of Castle Ashby, photo by David Allison 224; Bedford, the Trustees, The Cecil Higgins Art Gallery, 217 500 504; courtesy of David Bonsall, photos by David Allison 224-a 343; Ivor Braka, photos by David Allison 110-a 128 501 502; The Brant Foundation, photo by David Allison 139; Bristol Museums & Art Gallery 119 213 304 317 319, photos by David Allison 121 122.I-II 123 126 207 307, photo by Catherine Arbuthnott 307.1; courtesy of Meg Caldwell, New York fig. 54; Chinese Art Foundation fig. 20; courtesy of Helen Craig fig. 1; The Detroit Institute of Arts 304-f, Founders Society Purchase, European Sculpture and Decorative Arts General Fund, Honorarium and Memorial Gifts Fund 332; Edinburgh, courtesy of Phillips 325; courtesy of The Fine Art Society PLC 129 178, photos by David Allison 115 119-a 140-b 226 312.1, courtesy of The Fine Art Society PLC/Andrew McIntosh Patrick Esq. 214 507; Glasgow, Hunterian Museum and Art Gallery, University of Glasgow 369; Stuart Grimshaw, photo by David Allison 228-a; Hamburg, Museum für Kunst und Gewerbe 113.I; Harper Collins Publishers Ltd fig. 32; Honolulu Academy of Arts, gift of Mrs. Charles M. Cooke, 1981 (4961.1) fig. 28; Houghton Library, Harvard University, Richardson Photography Album fig. 52; Houston, The Museum of Fine Arts, museum purchase with funds provided by the Stella H. and Arch S. Rowan Foundation fig. 53; Hong Kong, Joint Publishing Co. Ltd fig. 31; Hulton Getty Images/ Liaison Agency fig. 46; courtesy of the Hyde Collection, photos by David Allison 381, 425; courtesy of James Joll 311; Gary Kemp, photos by David Allison 108 125 171 172 210 212 246 305 320 403; Kent, The National Trust, Ellen Terry Memorial Museum, Small-hythe Place, photos by David Allison 132-33 175 241 245 318 338 338.2 402; Latimer House Ltd 321.1; courtesy of Lord Limerick 120 120.1 311.1 313.1; London, courtesy of H. Blairman & Sons, 228 330 331, photo by Prudence Coming Associates 221; London, British Architectural Library, RIBA, photos A.C. Cooper, London, fig. 6 fig. 8 fig. 17 fig. 22 103.1 114.1

115.1 118 119.1 120.2 121.1 209 228.1 304-a.1 309.1 313 314.1 315.1 315.2 379 402.1; London, The British Library fig. 2 fig. 22 fig. 35 129.1 138 139.3 141.1 138 146–69 176.1 177 180 183 184.1 231–36 241.2 242 245.1 247 306 345–67 374 376 377 378 383 384 385 387 388 405 407 409–20 422 423 424 426 appendix; London, Camden Arts Centre, 341; London, Christie's Images Ltd, 1999 114 239 309.1 309.II 310 314 315 404 505 506 508; London, Country Life Picture Library fig. 27 fig. 44 170; London, courtesy of Haslam & Whiteway Ltd, fig. 4 179 229 340 (photos by David Allison 124.I-II); London, National Art Library, Victoria and Albert Museum fig. 33; London, Paul Reeves, (photos by David Allison 107 176 208.1 225 336) fig. 55 111 116 130 139-a 222 224-c 227 244 320-a 323 328 329; London, The Royal Borough of Kensington & Chelsea Libraries and Arts Service fig. 26; London, courtesy of Phillips, 139.1; London, Sotheby's 304-I 308 337; London, V&A Picture Library figs. 7 19 25 29 30 34 36 37 38 39 40 41 42 43 50 51; CR 100.1 101.1 101.2 104.1 105.1 112.1 114.2 123.1 131 134 135 136.1 141.2 143 144 145 174 175.1 181.1 184 200.1 204.1 206.1 207.1 207.2 207-a 211.1 212.1 213-a 215.1 216 217.1 218 223.1 224.1 224.2 226.1 229.1 230 237–238 241.1 243 245.2 300 301 302 303 304.1 304-b 339 310.1 317.1 318.1 319.1 324 326 327 333.1 334 335.1 336.1 336.2 339 340.1 342 342.1 344 344.1 346.1 368 369.1 370–73 374.1 375 380 382 388.1 400 401.1 406 408.1 408.2 421 501.1 503; courtesy of Brendan Mc Mahon fig. 16; Manchester City Art Galleries fig. 3; Melbourne, National Gallery of Victoria 117 (D154/1977) 304-g 304-g.1; Melbourne, Private Collection, photo by Gary Sommerfeld 322; Miami Beach, Florida, The Mitchell Wolfson Jr Collection, The Wolfsonian-Florida International University, 171.1 181 304-e 401; Munich, Die Neue Sammlung, State Museum for Applied Art and Design 304-a; National Museums and Galleries on Merseyside, Walker Art Gallery 408; reproduced with the permission of the National Monuments Record, English Heritage fig. 5 (Crown Copyright NMR) fig. 23; New York, Avery Architectural and Fine Arts Library, Columbia University in the City of New York 181.2 182 221.1 304-a.2; New York, The Bard Graduate Center Library fig. 18 107.1 240.1; New York, The

Metropolitan Museum of Art 110; New York, The Metropolitan Museum of Art, purchase, Rogers Fund; Margaret A. Darrin Gift; gift of Ogden Mills, by exchange; gift of Bernard Baruch, by exchange; Anne Eden Woodward Foundation and Friends of European Sculpture and Decorative Arts Gifts, 1991 (1991.87) photograph © 1998 Metropolitan Museum of Art 211; New York, Thomas J. Watson Library, The Metropolitan Museum of Art figs. 14 15; Northampton Borough Council, photos by David Allison 100 101 102 103 104 105 200 201 202 203 204-a 205 206-a, photo by Catherine Arbuthnott 106; Principal Archivist, Nottinghamshire Archives 106.1; Northamptonshire Libraries and Information Service fig. 13 100.2; Paris, Musée d'Orsay, 136; Philadelphia, The Free Library of Philadelphia 335; Pittsburgh, Carnegie Museum of Art, Decorative Arts purchase 217-a; Richmond, Virginia Museum of Fine Arts, gift of Mr David K.E. Bruce; the Estate of Mrs Edna Grumbach; Miss Elsie Murphy; John Barton Payne; Mrs E.A. Rennolds in memory of Mr and Mrs John Kerr Branch; Mr Raphael Stora; and bequest of John C. and Florence S. Goddin; by exchange, with additional funds from the Arthur and Margaret Glasgow Fund, photo Katherine Wetzel, © Virginia Museum of Fine Arts 141; courtesy of Mr & Mrs Stewart Resnick 173; Sheri Sandler; photo by David Allison 240; Susan Weber Soros, photo by David Allison 316; Sydney, Powerhouse Museum 304-h; William and Ellen Taubman 185 304-f; United Kingdom Public Record Office 178.1 179.1 226.2; United Kingdom Public Record Office Patent no. 305188 139.2 Patent no. 305888 338.1 Patent no. 372557 377.1; Paul Walter, photos by David Allison 109 127; Wightwick Manor, The National Trust 304-d; John Wiley and Sons fig. 47; Reg Wingfield, photos by David Allison 137 219; courtesy of Cyril Winskell fig. 24; Yale University Press 223

Pictorial Dictionary of British Nineteenth Century Furniture Design, first published in 1977 by Antique Collectors' Club, Woodbridge fig. 48 fig. 49 507.1; Joint Publishing (Hong Kong) Co. Ltd; Tian Jiaqing, *Classic Furniture of the Qing Dynasty*, London: Philip Wilson, 1996, plate 95 fig. 21